By Henry Horenstein

Black and White Photography: A Basic Manual
Beyond Basic Photography: A Technical Manual

BEYOND BASIC PHOTOGRAPHY

BEYOND

BASIC PHOTOGRAPHY

A Technical Manual

Henry Horenstein

With photographs by the author
and drawings by Henry Isaacs

Little, Brown and Company *Boston Toronto*

FIRST EDITION

T 06/77

Library of Congress Cataloging in Publication Data

Horenstein, Henry.
 Beyond basic photography.

 Includes bibliographies and index.
 1. Photography. I. Title.
TR145.H62 770'.28 77-4852
ISBN 0-316-37312-5

Designed by Janis Capone

*Published simultaneously in Canada
by Little, Brown & Company (Canada) Limited*

PRINTED IN THE UNITED STATES OF AMERICA

To my parents

Acknowledgments

Thanks to the many people who helped me write this book:

To Henry Isaacs, who did all the drawings with help from Lisa De-Francis and Joanne Dougherty.

To all who read part of the manuscript and/or made suggestions about its content: Brendan Boyd, Bobbie Carey, Lisa DeFrancis, Joe DeMaio, Sharon Fox, Bob Harmon, Margaret Harris, Peter Hunsberger, Paul Krot, Peter Lorenz, Bill Saunders, Mimi Sinkler, Craig Stevens, Jim Stone, and Joe Wiellette.

To all who patiently posed for illustrations: Brendan and Joan Boyd; Lynn Cummings; Ruth, David, Sam, and Ann Glicksman; Margaret Harris and Dolly; Doris and Fred Horenstein and Chammie; Michel Knapp; Lewis Rosenberg; Adam, Barbara and Paul Sher; Jennifer Knapp Stumpp; and Peter Stumpp.

To all at Little, Brown who helped put the book together: Casey Cameron, Janis Capone, Melissa Clemence, and Dick McDonough.

To all who helped in other ways: Betty Grove, Jon Holmes, Hope Norwood, David Otte, and Elsa Dorfman.

And to the companies that also helped out: Polaroid, Incorporated, with film and materials for illustrations; Sprint Systems, East Street Gallery, and Zone V, Incorporated, for technical suggestions and information; and to Eastman Kodak Company, GAF Corporation, and Ilford, Incorporated.

Introduction

This text is a guide to photographic techniques and controls, aimed at those who are "beyond basic photography." A working knowledge of how to use a camera, develop film, and make a print is assumed. Photographers at a basic level can use simple techniques to produce adequate prints most of the time; more advanced photographers must have more control so they can consistently produce excellent prints.

The techniques and controls covered are simply defined and explained and, when appropriate, are supplemented with direct instructions and formulas. None of the topics is covered definitively; at the end of each chapter a list of further reading is provided for those requiring more information on a particular topic.

Contents

BEYOND BASIC PHOTOGRAPHY

CHAPTER ONE

The Negative

Basic Principles of Negative-Making

To make consistently good negatives, you must have full understanding of and control over the exposure/development process. Film exposure is the most difficult technical problem. A perfectly exposed negative will produce good prints with relative ease; a poorly exposed negative may never produce a good print. Film development is also important, but the mechanics of development are easier to master than the mysteries of exposure. Besides, a minor error in the amount of exposure is almost always more critical than a minor error in the amount of development.

Some photographers thrive on elaborate exposure/development systems, and some are contemptuous of them. But all systems rely on the same basic principles.

Before we go on, it may be useful to define terms as they will be used in this text:

Indicated exposure means the f-stop / shutter speed combination suggested by a light-meter reading.

A negative of correct density

A thin negative — too little density

A dense negative

Corrected exposure means the adjusted f-stop / shutter speed combination, based on your interpretation of the indicated exposure.

Amount of development refers to development activity. The following factors yield greater film development:

Fresh developers (newly mixed)
Concentrated solutions (little or no dilution)
Long developing times
High developing temperatures
Vigorous agitation methods

The opposite factors yield less film development.

Stop means a doubling or halving of exposure, through a change of f-stop or shutter speed. For example, if the metered exposure is f 8 at 1/60, one stop more exposure would be f 5.6 at 1/60, or f 8 at 1/30. Two stops less exposure would be f 16 at 1/60, or f 11 at 1/125, or f 8 at 1/250.

How Exposure and Development Affect the Negative

Film contains light-sensitive silver halide crystals that, upon exposure, clump together. This reaction creates an invisible or *latent*

image which turns black when chemically developed. The blackness is literally a silver buildup on the film, and its thickness *(density)* is measurable. The amount of density on the negative is determined by both exposure and development:

The greater the film exposure, the denser the negative; the greater the amount of development, the denser the negative.

A negative with little silver is referred to as *thin;* one with a lot of silver is called *dense.*

Negatives have a wide range of densities, depending upon the light values of the subject. White reflects light and black absorbs light, so bright areas of the subject reflect more light back to the film than dark areas, causing greater silver clumping and more density. White or bright areas are called *highlights* — that is, bright in the original subject, dense on the negative, and bright in the print; black or dark areas are called *shadows* — dark in the subject, thin on the negative, and dark in the print. Different negative densities create the variety of tonal values *(tones)* produced in the final print.

highlights

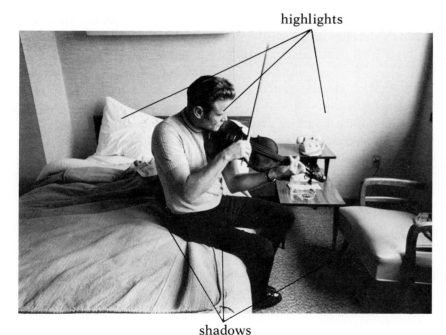

shadows

Highlight areas are dense on the negative and bright in the print; shadow areas are thin on the negative and dark in the print

highlights

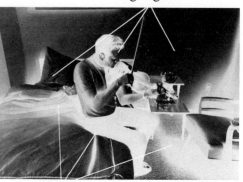

shadows

Exposure affects the negative density of both shadow and highlight areas, but its most important role is guaranteeing adequate shadow density:

Exposure controls shadow density.

An underexposed negative will not produce enough silver in the shadows to print adequate detail, so the shadows will print as flat, textureless, muddy-gray tones. An overexposed negative will print enough shadow detail, but may also lead to other problems. The highlights may "block up" (become opaque), and print as a flat, bright white, without detail or texture. Also, an overexposed negative — because of the excessive silver buildup — is likely to have more graininess and less apparent sharpness than a correctly exposed negative.

Development mostly affects highlight density. Since the shadow areas reflect relatively little light, they result in a minimum of silver clumping, and development proceeds rapidly. The highlights reflect much more light, so there is more active silver clumping, and development continues for a longer period of time. Practically, if the manufacturer recommends a twelve-minute development time, the shadows develop almost fully after approximately six minutes, but the highlights continue to develop for long past twelve minutes. So:

Development controls highlight density.

In effect, the amount of development, by primarily affecting highlight density, controls the negative *contrast* — the difference between the highlights and shadows:

> *Increased development raises highlight density, so increases contrast; decreased development lowers highlight density, so decreases contrast.*

Remember, within reason, the amount of development barely affects shadow density. The well-worn rule of thumb is:

Expose for the shadows; develop for the highlights.

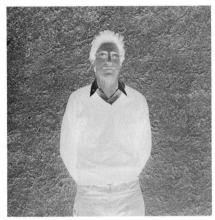

A negative exposed for 1/60 at f 11, developed for six minutes

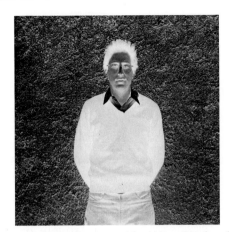

A negative also exposed for 1/60 at f 11, but developed for twelve minutes. Note: Increased development primarily increases highlight density. Shadow density is barely affected.

A print from that negative. Note: Increased development increases contrast.

A print from that negative

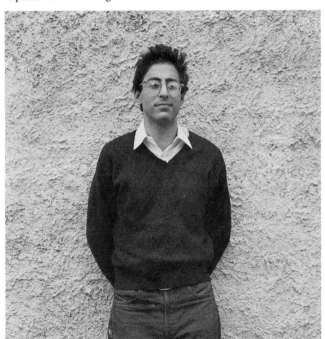

It could be restated as:

Expose for the correct shadow density; develop for the desired contrast.

How Subject Contrast Affects the Negative

The light conditions of the subject will naturally affect the contrast of the negative. In high-contrast lighting, shadow areas are particularly dark and highlights particularly bright; the negative will render this difference as thinner shadows and denser highlights. In low-contrast lighting, shadow areas are relatively light and highlights relatively dark; the negative will render this difference as denser shadows and thinner highlights.

The *subject brightness range* is a measurement of subject contrast: it is the total difference between, and inclusive of, the important highlight and shadow areas that should print with full texture and detail. To determine the subject brightness range, take a light-meter reading off the darkest important shadow (the darkest shadow where you want to render detail) of the subject. Assume the indicated exposure is 1/60 at f 4. Now take a reading of the brightest important highlight (the brightest highlight where you want to render detail). If the indicated exposure is 1/60 at f 16, the brightness range is the total difference between, and inclusive of, the indicated exposures for the shadows and the highlights, in this case five stops:

f 16
f 11
f 8
f 5.6
f 4

The contrast of the subject lighting can be described as follows:

Average contrast — five-stop range
High contrast — range of more than five stops
Low contrast — range of less than five stops

If in doubt, overexpose

A correctly exposed negative

A negative underexposed by two stops

A negative overexposed by two stops

A print from that negative

A print from that negative

A print from that negative

Note: An overexposed negative will produce a better print than an equally underexposed negative. Not so evident in these illustrations is the danger of excessive graininess and/or flat white highlights from overexposed negatives.

The key to a good print is negative exposure. Correctly exposed negatives, since they render good shadow detail, will almost always print well. Underexposed negatives, lacking shadow detail, will print flat and muddy. Overexposed negatives, as a rule, make better prints than underexposed negatives, since their shadows will always render full detail. Within reason:

If in doubt, overexpose.

A negative that is underexposed by two stops will produce a poor print; a negative that is overexposed by two (or even more) stops will produce an acceptable print.

The limits to overexposure vary with the subject brightness range and the amount of development. When the negative highlights become so dense that they are opaque (such as in high-contrast light or when overdeveloped), they will print as flat, blank white. But if the negative highlights are not too dense (such as in low-contrast light or when underdeveloped), the negative can be overexposed quite a bit and still produce reasonably good prints. However, overexposed negatives will be more grainy and appear less sharp than normally exposed negatives. (These advantages are somewhat outweighed when using large-size negatives that produce relatively sharper and less grainy prints than smaller negatives.)

Printing papers offer the most common means of controlling print contrast. Most brands have several contrast grades, ranging from #0 to #6, with #2 or #3 considered average-contrast (depending upon the brand used); the higher the paper grade, the greater the contrast. A normal-contrast negative assumes a five-stop brightness range, correct exposure, and normal development; it will print well on a #2 or #3 paper grade. A high-contrast negative could be due to a subject brightness range of greater than five stops, overexposure, and/or overdevelopment; use a #1 paper grade to compensate. A low-contrast negative could be due to a subject brightness range of less than five stops, underexposure, and/or underdevelopment; use a #4, #5, or #6 paper grade to compensate.

Assuming a normal subject brightness range, here are the effects of exposure and development on a negative and a print:

if the negative is:	underexposed	normally exposed	overexposed
under-developed	*negative:* thin overall; lacks density in both shadows and highlights *print:* low contrast; little or no shadow detail	*negative:* good shadow density, but thin highlights *print:* low contrast with full detail in both shadows and highlights	*negative:* somewhat dense overall; but adequate density in both shadows and highlights *print:* low contrast; a good range of tones; possibly some reduction in sharpness
normally developed	*negative:* thin overall; lacks shadow density *print:* low contrast; little or no shadow detail	*negative:* good overall density in both shadows and highlights *print:* average contrast with full detail in both shadows and highlights	*negative:* too dense overall; plenty of shadow density, but highlights may be blocked up (opaque) *print:* usually average contrast; full detail in shadows, although highlights may be too bright; likely to have increased graininess and reduced sharpness
over-developed	*negative:* good density overall; but lacks shadow density *print:* high contrast with little or no shadow detail; probably increased graininess	*negative:* full shadow density but highlights are too dense *print:* high contrast; good shadow detail but highlights may be too bright; increased graininess and probably reduced sharpness	*negative:* very dense overall; may have blocked up (opaque) highlights *print:* contrast normal or low; full shadow detail, but highlights are too bright; very grainy and reduced sharpness

Controlling Exposure and Development

Film Speed

Film speed is a measure of the sensitivity of film to light. It is rated by the manufacturer according to set industry standards. The rating criterion is the ability of a film to produce shadow density with the least possible exposure. *Fast* films respond to light more readily than *slow* or *medium*-speed films, so they require less exposure to render shadow density.

A.S.A. (American Standards Association) film speed ratings are the most commonly used in the United States (and in many other parts of the world).

> *The higher the A.S.A. number, the greater the film sensitivity. Also, each doubling of the A.S.A. number indicates a doubling of film sensitivity.*

Film rated at 400 A.S.A. is twice as sensitive as film rated at 200 A.S.A., so it requires half as much exposure to render similar shadow densities. Four hundred A.S.A. film exposed at 1/60 at f 11 will render the same shadow density as 200 A.S.A. film exposed at 1/60 at f 8.

Film speed is set by the manufacturer, but its actual effect may vary from camera to camera and person to person. There are several variables that can affect your effective film speed, such as inaccurate shutter speeds and f-stop markings, as well as poorly calibrated light meters.

The term *exposure index* (E.I.) is a measure of effective film speed, according to your own equipment. In theory, everyone should test his or her cameras, lenses, and meters to determine their ideal exposure indexes. In practice, few people make tests, but you can extrapolate from past results.

To compensate for consistent underexposure, try cutting the manufacturer's speed by one-half, so rate:

400 A.S.A. film at E.I. 200
125 A.S.A. film at E.I. 64
64 A.S.A. film at E.I. 32

This change will effect a doubling of exposure. If the negatives are still underexposed, cut the A.S.A. by one-fourth, rating:

400 A.S.A. film at E.I. 100
125 A.S.A. film at E.I. 32
64 A.S.A. film at E.I. 16

To compensate for consistent overexposure, try doubling the manufacturer's speed, so rate:

400 A.S.A. film at E.I. 800
125 A.S.A. film at E.I. 250
64 A.S.A. film at E.I. 125

These guidelines should serve for most general film speed adjustments. Appendix 1 offers a simple testing method for a more controlled determination of effective film speed.

The Light Meter

The key instrument for determining film exposure is the *light meter,* which measures light and translates the measurement to a workable combination of f-stops and shutter speeds. Too often, the meter's reading is accepted as gospel when it is meant to serve as a guide requiring interpretation and sometimes correction.

Light meters are calibrated to indicate an average, or *middle gray,* print value — one that reflects 18 percent of the light reaching it — regardless of the subject's brightness. If you point the meter at a solid white wall, the indicated exposure will produce a medium density (on the negative) and a middle gray wall (on the print); if you point the meter at a solid black wall, the indicated exposure will still produce a medium density and a middle gray wall. So:

Meters read for gray.

Meters read for gray

For a correct exposure, point the meter at a bright area, and increase the indicated exposure by one or two stops; or point the meter at a dark area, and decrease the indicated exposure by one or two stops

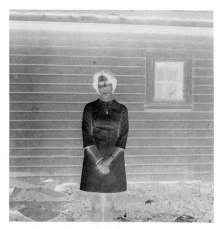

A light-meter reading, taken off the white uniform, produced an indicated exposure of 1/60 at f 16. The resultant negative was underexposed.

Here the indicated exposure was increased by two stops to 1/60 at f 8 for a correctly exposed negative

A print from that negative. Note: The indicated exposure off the uniform produced a middle-gray tone; meters read for gray.

A print from that negative

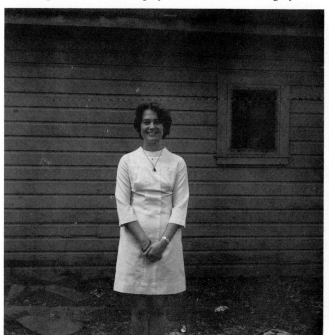

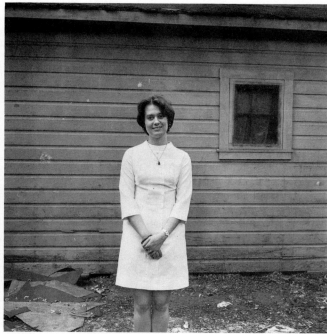

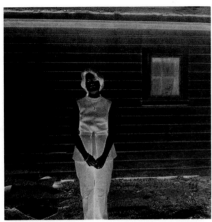

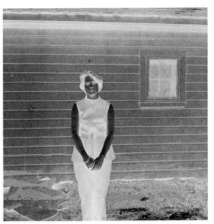

A light-meter reading, taken off the dark dress, produced an indicated exposure of 1/60 at f 4. The resultant negative was overexposed.

Here the indicated exposure was decreased by two stops to 1/60 at f 8 for a correctly exposed negative

A print from that negative. Note: The indicated exposure off the dress produced a middle-gray tone; meters read for gray.

A print from that negative

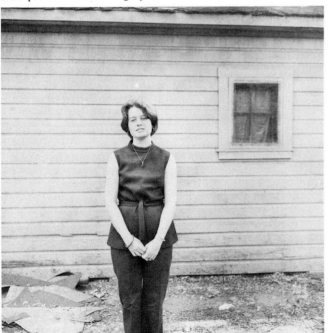

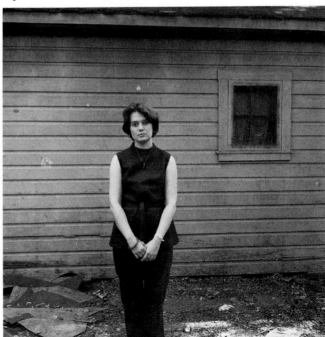

This gray calibration works fine if the subject contains approximately equal amounts of highlight and shadow values; the values average out to gray, and the dark and bright values fall into place on the negative, depending upon their relative reflectance. However, if either dark or light areas dominate, the indicated exposure will favor the dominant value and produce an under- or overexposed negative.

If the indicated exposure includes primarily light values, the negative will be underexposed; if the indicated exposure includes primarily dark values, the negative will be overexposed.

Highlights must render as greater than medium negative density to produce bright print tones, so they require more than the indicated exposure. Shadows must render as less than medium negative density to produce dark print tones, so they require less than the indicated exposure. Therefore, for correct exposure:

Take the meter reading off a middle gray area or off a subject with approximately equal amounts of dark and light values. Or, point the meter at a bright area, and increase the indicated exposure by one or two stops; or point the meter at a dark area, and decrease the indicated exposure by one or two stops.

For example, if you meter different parts of a subject, the indicated exposures might be:

> black pants — 1/250 at f 4
> gray sweater — 1/250 at f 8
> white hat — 1/250 at f 16

Obviously all three readings cannot be correct. Each indicated exposure will render the metered area gray on the print. Since the sweater is the only area you want to render gray, the correct exposure is 1/250 at f 8. If you use the reading off the dark value, that is, 1/250 at f 4, the negative will be overexposed. But you can correct the indicated exposure by decreasing it two stops, or 1/250 at f 8.

If you use the indicated exposure for the white hat, that is, 1/250 at f 16, the negative will be underexposed, but you could adjust it by increasing the exposure by two stops, or 1/250 at f 8.

Here are some suggested exposure corrections for various subjects:

If you meter the following subjects (or their equivalents)	Correct the indicated exposure by
dark shadow that still renders detail, such as: black hair, black clothes, mahogany furniture	decreasing it 2 stops
gray shadow, such as brown hair, new blue jeans, average shadows under trees	decreasing it 1 stop
middle gray, such as 18% gray card,* dark skin, average grass and foliage	no correction necessary
gray highlight, such as light hair, concrete, snow or sand in shadow	increasing it 1 stop
bright highlight that still renders detail, such as average snow or sand, white clothes, white house	increasing it 2 stops

*See p. 22.

Bracketing Exposures

Bracketing means making different exposures around the indicated exposure to guarantee an excellent negative. Assume that the indicated exposure is 1/125 at f 11. Make an exposure at that reading and bracket one stop over and one stop under: 1/125 at f 8 (or 1/60 at f 11), and 1/125 at f 16 (or 1/250 at f 11).

Sometimes bracketing is used for safety purposes (when you want to be absolutely sure of capturing the correct exposure), and sometimes it is necessary for difficult lighting conditions (as in low light when meters are not totally reliable).

Bracketing is especially useful for shooting slide film when poor exposure cannot be corrected in a printing process. For important exposures with slides, you may choose to bracket one-half stop and then one full stop on each side of the indicated exposure.

Bracketing is expensive, since it requires more film and chemicals than usual, but to a professional photographer, the added expense is insurance against having to reshoot a job. To a nonprofessional, it can be a burden. To minimize expense, bracket only important shots.

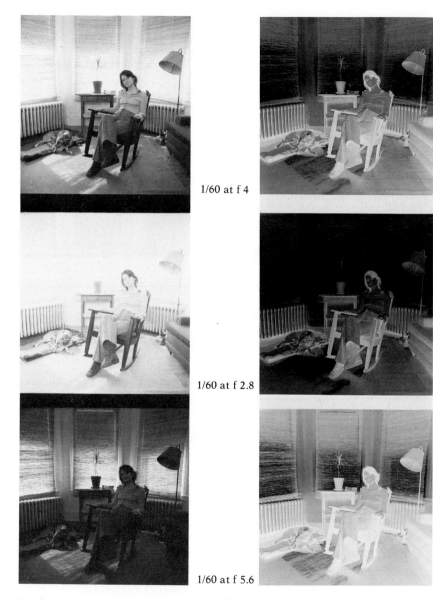

1/60 at f 4

1/60 at f 2.8

1/60 at f 5.6

Bracketing exposures to guarantee an excellent negative. The top exposure was made at 1/60 at f 4; the middle at 1/60 at f 2.8; the bottom at 1/60 at f 5.6.

Sometimes, with black-and-white negatives, half-bracketing is sufficient. Expose for the calculated reading, and then overexpose by one stop. Remember an overexposed negative is more likely to print well than an underexposed negative.

Also, some situations are not suited to bracketing. Candids and action shots, for example, can rarely be bracketed, because each exposure will be of a slightly different image.

Bracketing is a useful tool, but can be dangerous if you rely on it to obviate careful exposure techniques. This reliance discourages real control over exposure. The only way to guarantee consistently good negatives is through confidence in your metering and exposing techniques. Always aim first for the best possible exposure, and use bracketing only as a safety valve.

Simple Negative-Making Methods

Exposure Charts

Most packages of film contain a data sheet or chart that provides information about exposure (in natural and artificial light) and development. Many photographers dismiss these sheets and their funny little drawings, because they seem amateurish. Actually, the information can be useful. The sheets provide good, average exposure suggestions for a variety of lighting situations.

Another type of exposure chart, usually found in packages of film or in instruction books, provides aperture and shutter speed settings for difficult lighting conditions. These charts are more useful than meters when the light is low or the circumstances are difficult. For example, if you are forced to sit twenty rows back in a theater, you are too far away to accurately measure stage light. Here is a typical exposure chart for 400 A.S.A. film:

Home interiors at night	
bright light	1/30 at between f 2.8 and f 4
average light	1/30 at f 2
Interiors with bright, fluorescent light	1/60 at f 4
Brightly lit, downtown streets at night	1/60 at between f 2.8 and f 4

Signs at night	1/125 at between f 4 and f 5.6
Store windows at night	1/60 at between f 4 and f 5.6
Floodlighted buildings, fountains, monuments	1/15 at f 2
Fairs, carnivals at night	1/30 at between f 2.8 and f 4
Night outdoor sports lighting (race-tracks, baseball, football)	1/125 at between f 2.8 and f 4
Night indoor sports lighting (basketball, hockey, bowling)	1/125 at between f 2 and f 2.8
Stage shows average lighting bright lighting	1/60 at between f 2.8 and f 4 1/125 at between f 4 and f 5.6
School stage and auditorium	1/30 at between f 2 and f 2.8

Low-level lighting conditions vary greatly. The above chart represents average exposures that may need to be corrected or bracketed.

A General Exposure Reading

A general reading is made by pointing the meter directly at the subject, and using the indicated exposure. This method assumes that highlights and shadows approximately balance out, and that the indicated exposure represents an accurate average of the subject's tones.

A general reading is simple and quick, but its accuracy is dependent upon a proper mixture of highlights and shadows. Correct the indicated exposure by opening up the lens if light values dominate, or closing down the lens if dark values dominate.

If possible, avoid measuring dominant light or dark parts of the subject. For example, a bright sky typically dominates (since it usually reflects much more light than the ground), so point the meter down, away from the sky, and take a substitute exposure reading. Include the sky in the picture, but use the substitute exposure.

When necessary, move close to the subject to take your readings, and then move back for the exposure. If the subject is in the shade, the bright area around him or her will dominate and throw off the read-

A general light-meter reading works fine if highlights and shadows approximately balance out

Here a general reading would have created an underexposed negative, since the subject is in the shade. For a correct exposure, a general reading was made in the shaded area, then used without correction even though the photograph was made back, away from the shade and including the bright surroundings. As an alternative, a general reading could have been made and the exposure increased one or two stops.

21

A gray-card reading. Take a meter reading off the gray card, and use the indicated exposure.

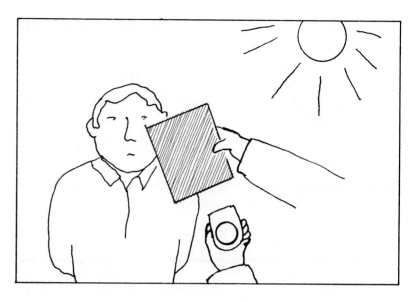

ing, causing an underexposed negative. So, move right into the shaded area, take a reading, and move back to make the exposure.

Gray Card

An *18 percent gray card* is gray on one side and white on the other. The gray side acts as a substitute middle gray subject — the same tone that meters are calibrated to read. By metering the gray card instead of the subject, you avoid confusing shadow and highlight tones, and receive an average estimate of the light reflecting off the subject. The gray side, if included in the photograph, will render a medium gray density on the negative and a middle gray tone on the print. Highlights and shadows of the subject will render appropriate negative densities (according to their reflective values, greater or less than 18 percent), and print accordingly.

To take a gray card reading, place the card in front of the subject with the gray side facing the camera. Take a meter reading of the light reflecting off the card. Be careful not to cast a shadow on the card when taking the reading, since the shadow will influence the measurement. Use the indicated exposure without correction.

The white side of the card reflects 90 percent of the light reaching it. It is useful in low illumination levels when the gray side cannot reflect enough light for an accurate reading. If you take a measure-

ment off the white side, you must correct the reading or the negative will be underexposed. So, take a meter reading off the white side and increase the exposure by two and one-half stops. If the indicated exposure off the white side is 1/60 at f 5.6, use instead 1/60 at between f 2 and f 2.8.

Average the Shadows and Highlights

The shadow and highlight readings can be averaged to produce a good negative, since the correct exposure will always be located near the middle of the subject brightness range. Read separately the important shadows and important highlights of the subject, avoiding extreme darks and extreme lights. If the shadow area measures 1/60 at f 4, and the highlight area measures 1/60 at f 16, then average the two readings and use 1/60 at f 8.

Incident Light

Incident light is the light that falls onto the subject. It is measured by a light meter with a white diffusing material covering its cell. Some meters read only incident light and some read both incident and reflected light (the light that reflects off the subject).

The diffusing material accepts a wide angle of light and spreads it out evenly for measurement by the cell. The diffuser is made to absorb just enough light to produce an exposure reading similar to a gray card reading (or to a general reading of a normal-contrast subject).

To make a reading, hold the incident meter at the subject position and point it back toward the camera position. Use the indicated exposure without correction. Like a gray card, an incident meter avoids specific subject tones and provides an average reading.

Developing the Film

If you shoot an entire roll of film in varying light conditions, develop it normally, that is, according to the manufacturer's or your own estimate of a normal amount of development. But if an entire roll is shot in either high- or low-contrast light, you may want to modify the amount of development. Here are *very* general guidelines:

To increase contrast, extend development by 50 percent more than the normal time.

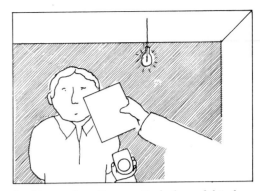

A white-card reading, particularly useful in low light. Take a meter reading off the white card, and increase the indicated exposure by two and one-half stops.

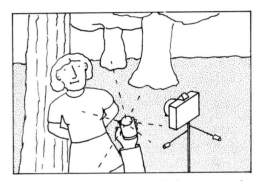

An incident light reading. Hold the meter at the subject position, and point it back toward the camera position. Use the indicated exposure without correction.

To decrease contrast, reduce development by 25 percent less than the normal time.

In Conclusion

There is a major disadvantage of these simple exposure systems: lack of control. They all depend upon average readings and average conditions to produce average negatives. They can be modified to produce more consistently accurate results, but for precise negative and print control you can use more complex exposure/development methods.

More Complex Negative-Making Methods

Exposing for Minimum Shadow Density

As stated, a correctly exposed negative has the minimum density required to render shadow detail in the print. By careful use of the meter, you can control, or *place*, the minimum shadow density.

Expose for minimum density

To expose for minimum shadow density, take a reading off the darkest important shadow in the subject — for example, black hair

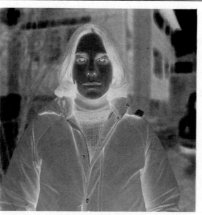

Here the indicated exposure, 1/60 at f 8, produced this overexposed negative

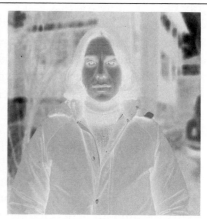

Minimum shadow density is two stops less exposure, so the corrected exposure, 1/60 at f 16, produces this well-exposed negative

*Minimum shadow density (on the negative) is defined as two
stops less density than middle gray.*

Take a reading off the darkest important shadow in the subject where
you want to render detail — for example, black hair might call for
1/60 at f 4. If you use the indicated exposure, the negative will render
gray on a print. The negative is overexposed — too much shadow
density. Therefore, expose for two stops less to place the minimum
shadow density: 1/60 at f 8, or 1/125 at f 5.6, or 1/250 at f 4. Once the
shadow density is correctly placed, the highlights will naturally fall
in place, rendering as greater densities on the negative according to
their relative reflectance values.

In most lighting situations, assuming minimum shadow density,
normal development will produce a good, printable negative. If the
subject brightness range is particularly high, the negative can be
underdeveloped or simply printed on a #1 paper grade; if the subject
contrast is particularly low, the negative can be overdeveloped or
printed on a #4, #5, or #6 paper grade. However, you may choose to
alter both the exposure and development to adjust the contrast of the
negative, particularly in extremely high- or low-contrast lighting
conditions.

Changing Exposure and Development

To alter the negative contrast, you can change the film's exposure
index and development time. Manufacturers assume average lighting
conditions (five-stop subject brightness range) when rating film speed
and development time. On an average day, expose and develop nor-
mally; on other days, follow these rules:

To reduce contrast: reduce both the exposure index and the de-
velopment time — in other words, overexpose and underdevelop.

To increase contrast: increase both the exposure index and the de-
velopment time — in other words, underexpose and overdevelop.

Reducing Contrast. A high-contrast day has a subject brightness
range of more than five stops. The highlights are particularly bright
and the shadows particularly dark, so there is a danger of losing
detail in either extreme area. The shadow areas in a normally ex-
posed and normally developed negative will be too thin, since they
will render extremely black, possibly lacking detail. Exposure con-

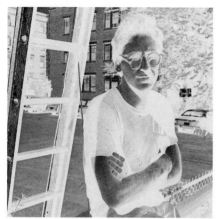

A negative exposed correctly, 1/250 at f 16, and developed normally, for ten minutes, on a high-contrast day

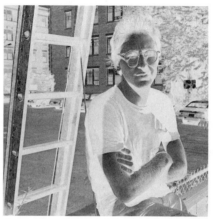

A negative taken with the same lighting conditions, overexposed by one stop, 1/250 at f 11, and underdeveloped 20 percent less, for eight minutes

A high-contrast print from that negative

A print from that negative has less contrast

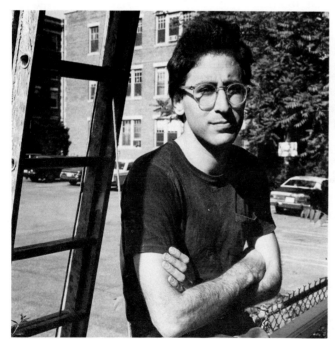

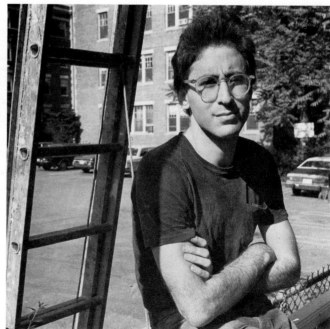

trols shadow density, so increase the meter's indicated exposure to guarantee adequate shadow density in the negative. Of course, increased exposure will also raise the highlight density. Since development controls highlights, underdevelop the negative to lower the highlight density.

By overexposing, you are effectively assigning a lower exposure index to the film. If the indicated exposure is 1/250 at f 16 for 400 A.S.A. film, overexposing by one stop means a corrected exposure of 1/250 at f 11, or 1/125 at f 16. You are treating the film as if it were less sensitive and needed twice as much exposure — the equivalent of rating the film at E.I. 200. Overexposing inevitably means less depth of field (due to a wider aperture) and/or more image movement (due to a slower shutter speed).

Once the film is overexposed, follow these general guidelines for development:

subject brightness range	increase exposure by	comparable exposure index (based on film speed of 400 A.S.A.)	decrease development by
6 stops	1 stop	E.I. 200	20% (if normal development is 10 minutes, use 8 minutes instead)
7 stops	2 stops	E.I. 100	40% (if normal development is 10 minutes, use 6 minutes instead)

These recommendations vary according to many different factors, including the types of film and developer used. To gauge times with your film/developer combination, you should run tests or refer to the contrast indexes provided by the manufacturer (see pages 43–45 and Appendix 1).

Overexposing and underdeveloping guarantees shadow detail, lowers contrast, and will reduce negative graininess by reducing the density in the highlights. Some people like to rate their film more slowly and underdevelop, even under normal conditions, since the results will be softer and less grainy and, if the negative is too flat, they can always print it on a higher grade of paper.

Increasing Contrast. A low-contrast day presents the opposite problem — a subject brightness range of less than five stops. Both highlights and shadows tend to be gray, rather than bright and dark. There is little danger of losing detail, but the print will lack bright whites and solid blacks.

In a normally exposed and normally developed negative, taken on a low-contrast day, the shadow areas are too dense since they render as gray not black. Exposure controls the shadows, so decrease the indicated exposure to lower the shadow density, and the shadows will print darker. Of course, decreased exposure will also lower highlight density. Since development controls highlights, overdevelop the negative to raise the highlight density.

By underexposing, you are effectively assigning a higher exposure index to the film. If the indicated exposure is 1/60 at f 8 for 400 A.S.A. film, underexposing by one stop means 1/60 at f 11, or 1/125 at f 8. You are treating the film as if it were more sensitive and needed half as much exposure — the equivalent of rating the film at E.I. 800. Under-exposing means increased depth of field (due to a smaller aperture) and/or less movement (due to a faster shutter speed). Because increased development raises highlight density, it will increase the negative's graininess.

Once the film is underexposed, follow these general guidelines for development:

subject brightness range	decrease exposure by	comparable exposure index (based on a film speed of 400 A.S.A.)	increase development by
4 stops	1 stop	E.I. 800	50% (if normal development is 10 minutes, use 15 minutes instead)
3 stops	2 stops	E.I. 1600	100% (if normal development is 10 minutes, use 20 minutes instead)

Underexposing and overdeveloping is also used to produce a print-

A negative exposed correctly, 1/60 at f 8, and developed normally, for ten minutes, on a low-contrast day

A negative taken with the same lighting conditions, underexposed by one stop (1/60 at f 11), and overdeveloped 50 percent more, for fifteen minutes

A low-contrast print from that negative

A print from that negative has more contrast

able negative from a low-light situation. This use is referred to as *pushing film*. See pages 93–95 for details.

The Zone System

The *Zone System* is a complete method of exposing, developing, printing, and even viewing photographs, based on careful previsualization of the subject. *Previsualization* means viewing the subject as it would appear in a final print before making the exposure; and then gearing the exposing, developing, and printing processes toward reproducing the previsualized tones.

Ideally, large format cameras and sheet film are required for Zone System work, since individual development of each exposure is implicit. If roll film is used, the principles of Zone System exposure are still valid, but the rules of development should be modified (see pages 34–35).

The Zone System is based on the same film response to exposure and development as of any other system. It is merely more complex and precise. The Zone System is not the only accurate method of producing a good negative, but it is the most controlled method. In fact, some critics argue that it is more controlled than is necessary. But even if you have no intention of using the Zone System, it is instructive in its explanation and interpretation of the film exposure/development relationship.

For strict use of the Zone System, exposure and development should be carefully tested and calibrated to conform to your equipment, materials, and processing techniques. The following serves as an introduction to the Zone System, not a definitive treatment, so no testing or calibration methods are included. For appropriate tests, refer to the sources listed at the end of the chapter.

The Gray Scale. The Zone System uses a gray scale representing ten possible *zones*, or tonal values, ranging from the darkest possible black to the brightest possible white that can be reproduced in a print. The zones are numbered beginning with zero and then in Roman numerals through IX. The higher the number, the lighter the tone (in the print) and the greater the density (in the negative).

The zones are defined by exposure differences of one stop; for example, Zone V represents a tonal value that is one stop brighter

than (or twice as reflective as) Zone IV; Zone VI represents a tonal value that is one stop darker than (or half as reflective as) Zone VII.

The grays in the scale do not change consistently from zone to zone. The shadow values (Zones 0–III) change little despite one-stop exposure differences between zones. The same one-stop change creates much greater visible differences in the middle values (Zones IV–VII). The highlights (Zones VIII and IX) again show little tonal change.

The most important zones are III, V, and VII:

Zone III represents the darkest shadow area with full detail, comparable to minimum shadow density, which is two stops less negative exposure than Zone V.

Zone V is *middle gray* — a tonal value with a reflectance of 18 percent — representing the gray for which meters are calibrated.

Zone VII is the brightest highlight area with full textured detail, representing two stops more negative exposure than Zone V.

The five-stop subject brightness range is represented by the range between, and inclusive of, Zones III through VII. All the important detail in a print is rendered in these five zones. Zones 0, I, and II represent the darkest shadow areas, and Zones VIII and IX the brightest highlights in the print. These dark and bright zones are important for the overall feeling of the print; without them there would be only shades of gray with no strong blacks or whites. But the important information, or detail, is in Zones III–VII. Here are descriptions of each zone:

Zone 0: the maximum possible black. It varies with the brand of printing paper used. You can determine Zone 0 with any paper by exposing it for several seconds, developing it fully, then fixing and washing it.

Zone I: the first, barely perceptible change from Zone 0. It may not be noticeable in the print.

Zone II: the first slight sign of shadow detail or texture.

Zone III: the deepest shadow area where full detail and texture are rendered. Some examples are dark clothes, black hair, and dark mahogany furniture.

Zone IV: a medium dark value, such as brown hair, dark clothes, new blue jeans, shadows under trees, dark stones, and average dark foliage.

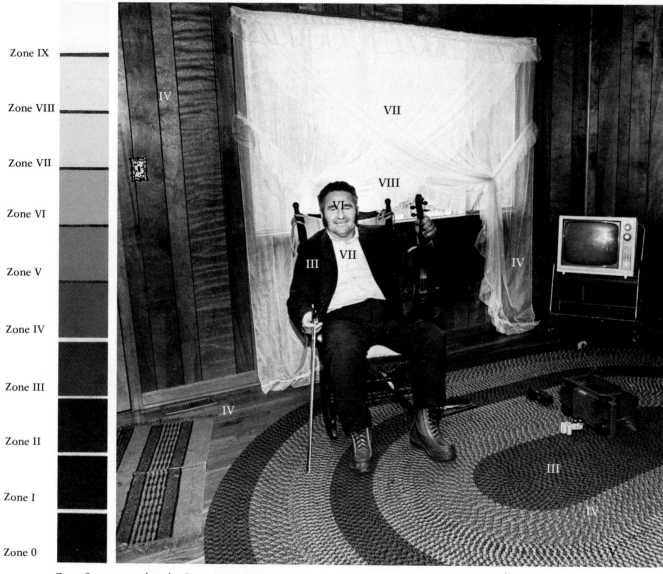

Zone IX

Zone VIII

Zone VII

Zone VI

Zone V

Zone IV

Zone III

Zone II

Zone I

Zone 0

Zone System tonal scale: Representing ten zones, or tonal values, ranging from the darkest possible black to the brightest possible white that can be reproduced in a print. (Reproduced by courtesy of Minor White from *The New Zone System Manual,* by White, Zakia, Lorenz, 1976.)

A print with approximate zone equivalents

Zone V: a middle gray value, such as dark skin, average grass, lighter foliage, average stone, and a gray card.

Zone VI: the darkest highlight value, such as Caucasian skin, light hair, average concrete, and snow or sand in shadow.

Zone VII: bright, textured detail, such as average snow or sand, white clothes, and light concrete.

Zone VIII: the last zone with some remnants of texture, such as direct sunlight on white clothes, snow or sand.

Zone IX: approaches the pure white of the paper base; it can be determined by fixing and washing an unexposed sheet of paper.

Zone System Exposure. Zone System exposure is similar to minimum density exposure. After previsualizing the tonal values, place the darkest shadow on the negative where you want full texture or detail at Zone III (or minimum density). Imagine you are metering black hair and the indicated exposure is 1/60 at f 8. If you expose accordingly, the hair will render as middle gray, or Zone V. So place the hair value at a lower negative density (Zone III) by reducing the exposure two stops: 1/60 at f 16, or 1/125 at f 11, or 1/250 at f 8.

Occasionally, you may choose to place values other than Zone III. If no deep shadow is prominent, expose for Zone IV. For example, a reading off brown hair might indicate 1/125 at f 8. Expose one stop less to place the hair at Zone IV: 1/125 at f 11, or 1/250 at f 8.

In theory, you could choose to expose for a highlight value and place it at Zone VI or Zone VII density; but you risk losing shadow detail, especially on a high-contrast day, since you are not guaranteeing the minimum negative density of Zone III. Reading for Caucasian skin, if the indicated exposure is 1/60 at f 5.6, the skin will render middle gray; so correct the exposure by adding one stop of negative density, therefore placing the skin at Zone VI: 1/60 at f 4, or 1/30 at f 5.6.

Zone System Development. The Zone System offers three development plans:

> *N,* which is normal development;
> *N minus,* which is reduced (or *contracted*) development;
> and *N plus,* which is increased (or *expanded*) development.

Before exposing the film, take a reading for Zone VII off the brightest textured highlight of the subject. The Zone VII indicated exposure, along with the Zone III indicated exposure, provides the subject brightness range. If the range is five stops, use an N development; if it is more than five stops, use an N minus development; if it is less than five stops, use an N plus development:

subject brightness range	development plan
3 stops	N plus 2
4 stops	N plus 1
5 stops	N
6 stops	N minus 1
7 stops	N minus 2

Once again, development times should be calibrated to fit your particular equipment, film, and processing. Otherwise, use this chart as a general guideline:

For N, use manufacturer's recommended times
For N minus 1, reduce N time by 20 percent
For N minus 2, reduce N time by 40 percent
For N plus 1, increase N time by 50 percent
For N plus 2, increase N time by 100 percent

Note that these suggestions are similar to those for under-exposure/overdevelopment and overexposure/underdevelopment. After all, both systems rely on the same general rules of film response to exposure and development.

Minus developments can create problems. Although shadow density does not vary significantly with development, it is affected slightly. With extreme underdevelopment, shadow density may be reduced enough to affect print detail. So, when using minus development, you may need to increase exposure slightly to compensate, perhaps one-half stop for N minus 1 and one stop for N minus 2.

For Example. Follow these steps to use the Zone System:

1. Previsualize the subject according to the tonal values you want on the final print.

2. Meter the deepest shadow where you want detail; for example, black hair might indicate an exposure of 1/60 at f 4.

3. Meter the brightest highlight where you want detail; for example, a white shirt might indicate 1/60 at f 11.

4. Note that the subject brightness range is 4 stops, and, therefore, the appropriate development plan is N plus 1.

5. Place the shadow value (the black hair) at Zone III by exposing for two stops less than the indicated exposure off the hair: 1/60 at f 8, or 1/125 at f 5.6, or 1/250 at f 4.

6a. With sheet film, develop the film according to the appropriate development plan. If normal developing time is ten minutes, N plus 1 development is approximately 50 percent greater, or fifteen minutes. For more accuracy, use the results from your own tests and calibrations.

6b. With roll film, use an N development, and alter the contrast when printing by using different graded papers. Or, if the entire roll conforms to the same developing plan, increase or decrease development accordingly.

In Conclusion

Some exposure/development methods are more precise than others. The Zone System in particular, with its zone designations and development plans, is aimed at total control of the final image. But any of the systems can work well, if used intelligently and with an understanding of the basic principles involved.

All methods aim at the same end — a printable negative. And all are based on the same principles of film response to exposure and development. After all, the materials (film and chemistry) are the same; only the approach to the materials varies.

Some systems are more applicable to certain situations and certain photographers than others. The Zone System is especially suited to large-format, technique-oriented photographers; it takes time and

patience to meter different parts of the subject and to note a development plan. On the other hand, a general reading suits quick, candid photographers who have no time to spare.

You do not need to choose a particular system to produce good photographs. If you understand exposure and development, you can use parts of any of the methods to their best advantage.

Basic Sensitometry

Sensitometry is the science of measuring film response to exposure and development. It allows accurate prediction and control of that response. (The same applies to printing paper, but film will be emphasized in this chapter.) Many photographers shy away from this science, claiming it is too confusing, unnecessary, and boring. Actually, most photographers need little or no direct knowledge of sensitometry, because manufacturers do the testing and calculations, and pass on the information in the form of film speeds, development times, and other ratings. But an understanding of the science is helpful in using and controlling this information.

The Graph

The sensitometric graph indicates the exposure/density relationship of a particular film in a logarithmic scale, but you do not have to understand logarithms to use the graph. Consider the log numbers only as indicators of units of exposure and density.

Exposure is plotted on the x-axis (the horizontal axis). The numbers, such as −3.00, −2.00, −1.00, are logarithmic expressions of small amounts of light (fractions of a second); each 0.30 represents one stop, or a halving or doubling of exposure: −2.70 is twice as much exposure as −3.00; −1.20 is half as much exposure as −0.90.

Density is plotted on the y-axis (the vertical axis). The density figures, such as 0.40, 0.60, and 0.80, are logarithmic expressions of the opacity of the film. *Opacity* describes the ability of the film to hold back light. The greater the density of the film, the greater its opacity. Each 0.30 decrease or increase in density represents a halving or

A sensitometric graph. Exposure is plotted on the x-axis; density on the y-axis.

A typical characteristic curve. Density increases with exposure. At the low and the high points on the curve, increases in exposure have little effect on density.

doubling of opacity; a density of 0.60 is half as opaque as a density of 0.90; 1.50 is twice as opaque as 1.20.

Parts of the Characteristic Curve

The *characteristic curve* (also called the *H + D curve)* is the plotted representation of the exposure and density relationship. Predictably, density increases with exposure. But equal units of exposure change do not always produce equal units of density change. At the low points and the high points on the curve, increases in exposure have little effect on density. Here are the parts of a typical characteristic curve:

37

Parts of the curve (designated by bold lines)

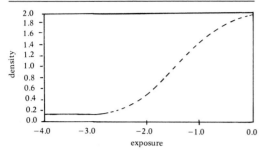

Film base plus fog density. Even unexposed film has some density. Small amounts of light have no effect on that density.

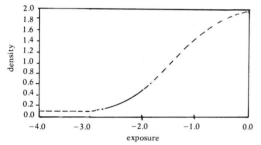

The toe. The part of the curve where small amounts of exposure first affect negative density.

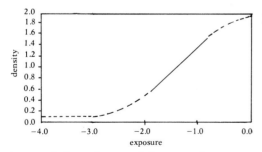

The straight line. The part of the curve where exposure and density increase proportionately.

Film Base Plus Fog Density

The curve starts slightly above 0 density, since even an unexposed developed piece of film will have a little density from the base of the film and the development process (which always fogs film slightly — that is, develops some unexposed silver). The film base plus fog portion begins at no exposure (represented as less than −3.00 units) and travels in a direct horizontal path, which indicates that small amounts of light have no effect on negative density. The actual density of this part of the curve varies with the type of film used; Kodak Tri-X 35 mm film has a denser film base plus fog (0.30) than Kodak Tri-X sheet film (0.10).

The Toe

The toe is the area where small amounts of exposure first register as density increases. Shadow areas in a negative should be located on the toe of the curve since it represents the minimum negative density required to render detail in a print.

The Straight Line

After the toe, the curve travels up in a straight line, indicating that exposure and density increase in direct proportion; one unit of exposure change creates an equivalent change in density all along the straight line. Most parts of an average negative will be located along this portion of the curve — this includes all the gray values and even the highlights. The constantly changing densities in the straight line region account for the separations and subtleties of tone so important to a good negative and a fine print.

The Shoulder

The curve levels off after the straight line, indicating that past a certain point, increases in exposure no longer produce increases in density. In a negative, the shoulder represents overexposed highlight areas. Since the density does not vary, highlights landing on the shoulder will be flat and lacking in tonal subtleties.

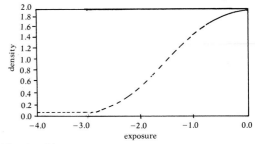

The shoulder. Past a certain point, increases in exposure no longer produce significant increases in density.

Reading the Curve

The shape of the characteristic curve provides specific information about film speed, latitude, and contrast.

Film Speed

Film speed refers to the sensitivity of the emulsion to light. It is measured by the film's ability to record density at low levels of exposure, and is indicated on the toe of the characteristic curve — the area where minimum exposure first produces negative density. Fast films record density at shorter exposures than slow films. The top illustration on page 41 shows the curves of Kodak Tri-X (a fast film) and Kodak Panatomic-X (a slow film). The curve of Tri-X begins to slope upward at a log exposure of approximately −2.25, while the curve of Panatomic begins to slope upward at a log exposure of approximately −1.75. Therefore, Panatomic-X requires a longer exposure to record minimum shadow density, and is less sensitive to light than Tri-X.

Latitude

Latitude is the tolerance for error of the film — how much the exposure can be off and still produce a good negative. It is described on the characteristic curve as the difference between the exposure range of the film and the subject brightness range.

The *exposure range* for each film is the area from the toe up through the straight line, ending at the shoulder of the curve. All useful detail in a negative will fall somewhere along the exposure range. Below the toe, the negative is too thin to render detail; and above the straight

39

line, the negative is too dense to render detail. So, as long as the film exposure places the subject somewhere along the exposure range, you should have no trouble making a good print from the negative.

An average subject brightness range should be located within the exposure range, with the shadows on the toe (at a density of approximately 0.45), and the highlights up on the straight line of the curve (at a density of approximately 1.10). If the film is underexposed, the shadows of the brightness range will fall along the fog base density and render no detail; if the film is overexposed, the shadows will fall along the straight line and the highlights might fall up on the shoulder of the curve and print flat and textureless.

The exposure latitude of a film is the difference between the exposure range and the subject brightness range. A careful reading of the curve indicates these important conclusions about latitude:

The higher the subject contrast, the smaller the latitude.

On a high-contrast day, the brightness range uses up more of the curve than on a low-contrast day. Also:

Overexposure allows more latitude than underexposure.

If the film is overexposed, the shadows land on the straight line of the curve and the highlights, especially on a low-contrast day, may still land on the straight line (though they would be more dense than with normal exposure). Assuming the brightness range is along the straight line, the negative will print with full detail. If the film is underexposed, the shadows land below the toe, thus rendering no printable shadow density. So, as stated earlier, if in doubt, overexpose.

Contrast

The characteristic curve describes the contrast of the film emulsion as follows:

The steeper the curve, the higher the contrast of the film.

The term *gamma* is a measurement of film contrast that uses the slope (or incline) of the straight line of the curve:

The steeper the slope, the higher the gamma and the greater the contrast.

Film speed

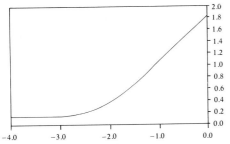

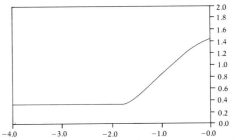

Characteristic curve of Kodak Tri-X film. Note that the curve begins to slope upward at a log exposure of approximately −2.25.

Characteristic curve of Kodak Panatomic-X film. Note that the curve begins to slope upward at a longer exposure, approximately −1.75, indicating that Panatomic-X is less sensitive to light than Tri-X.

Exposure latitude

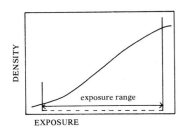

The exposure range for each film is the area extending from the toe to the shoulder of the curve. All useful detail in a negative falls along the exposure range.

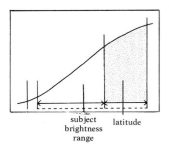

The latitude of a film — how much the exposure can be off and still produce a good negative — is the difference between the exposure range and the subject brightness range. On a high-contrast day, the subject brightness range takes up most of the curve, so there is little latitude.

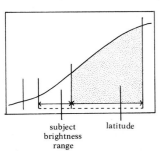

On a low-contrast day, the subject brightness range uses up less of the curve, so there is more latitude

41

The steeper the curve, the higher the contrast of the film; so curve A indicates a film with more contrast than curve B

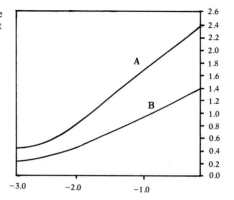

Gamma. A measurement of film contrast, using the slope of the straight line of the curve.

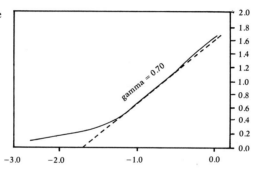

Contrast index. A measurement of film contrast, using the slope of a line drawn between the most useful shadow density and the most useful high-light density of the curve.

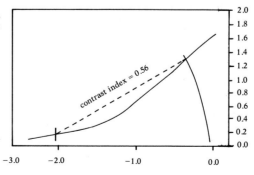

To calculate gamma, extend the straight line portion of the curve to meet the x-axis of the graph. The tangent of the angle formed with the axis is gamma. Mathematically:

$$\text{gamma} = \frac{\text{density change}}{\text{exposure change}}$$

For example, if an increase of 0.60 exposure produces an increase of 0.60 density, then:

$$\text{gamma} = \frac{0.60}{0.60} = 1.00$$

Average-contrast films have a gamma of approximately 0.80.

Contrast index is a better measurement of contrast than gamma, since gamma measures only the slope of the straight line of the curve and ignores the toe area. The length of the toe of different films varies enough so that curves of equal gamma may produce negatives of much different contrasts.

Contrast index is a measurement of the slope of a line drawn between the most useful shadow density and the most useful highlight density of the negative.* Once the line is determined, the slope of the line is measured the same way as gamma:

$$\text{contrast index} = \frac{\text{density change}}{\text{exposure change}}$$

A film with a density change of 0.5 for an exposure change of 1.0 has a contrast index of:

$$\frac{0.5}{1.0} \text{ or } .50$$

*The most useful shadow is defined as the point on the curve where the density measures 0.10 above the film base plus fog density. An arc, with this point as the center, is made with a radius the equivalent of a distance of 2.00 on the exposure axis. The point where the arc intersects the curve is defined as the most useful highlight density. A straight line drawn between the two points is measured, and the slope of that line is the contrast index.

And it follows that:

The higher the contrast index, the higher the contrast.

An average contrast index — for a negative that will print normally on #2 or #3 paper — is approximately 0.50 to 0.60. This varies depending upon whether a diffusion or a condensor enlarger is used. A diffusion enlarger produces a lower-contrast print, so requires a negative with a higher-contrast index (approximately 0.60) to produce the same contrast print as a condensor enlarger (closer to 0.50).

Contrast is also dependent on the amount of development and the subject brightness range, as well as the inherent characteristics of the emulsion. Since:

The wider the subject brightness range, the higher the contrast,

a range of five stops, assuming proper exposure and normal development, will produce a negative of a contrast index of approximately 0.55. If the range is less than five stops, normal exposure and development will produce a lower-contrast index (perhaps 0.45); if the range is more than five stops, normal exposure and development will produce a higher-contrast index (perhaps 0.75). Since:

The greater the development, the higher the contrast,

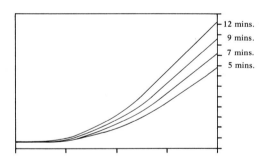

12 mins.
9 mins.
7 mins.
5 mins.

A family of curves. Different amounts of development affect the characteristic curve of a film. Note: The greater the development, the higher the contrast.

some graphs provide a *family of curves* that describes the exposure/density response of a film with different amounts of development.

Contrast index curves are separate graphs designed to relate development directly to the contrast index. These curves provide specific information about the effect of adjusted development upon the contrast index of a well-exposed negative. For increased contrast, develop the film to a higher-contrast index, for example 0.70; for decreased contrast, develop the film to a lower-contrast index, for example 0.45.

Contrast index curves relate development to contrast index

1. Panatomic-X 35 mm

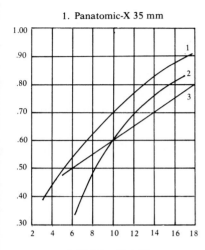

1. D76 (undiluted)
2. D76 (1:1)
3. Microdol X

2. Tri-X pan film rolls and 35 mm

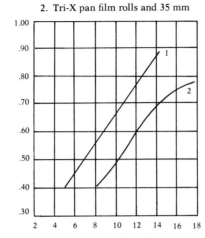

1. D76 (undiluted)
2. Microdol X and D76 (1:1)

3. Ilford FP-4 rolls and 35 mm

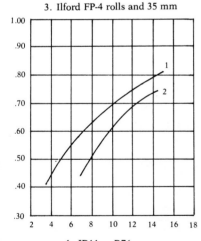

1. ID11 or D76
2. ID11 or D76 (1:1)

4. Ilford HP-4 roll film

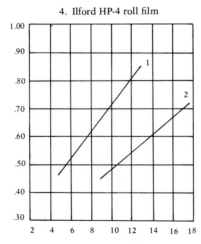

1. ID11 or D76
2. ID11 or D76 (1:1)

1. Contrast index curve for Kodak Panatomic-X film

2. Contrast index curve for Kodak Tri-X film

3. Contrast index curve for Ilford FP-4 film

4. Contrast index curve for Ilford HP-4 film

The parts of a negative can be measured with a *densitometer* to determine actual density measurements. If you meter a gray card, and expose and develop the film normally, the gray card on the negative will measure a density of 0.75. If you expose the gray card one stop less than gray, the density will be 0.60. One stop more density measures approximately 0.95. The densities vary slightly according to the type of film used.

An average negative, with a five-stop brightness range, will have densities ranging from approximately:

0.45, representing the minimum density, still retaining full shadow detail

0.60, representing a shadow area, slightly denser than minimum density

0.75, representing a middle gray, the tonal value for which meters are calibrated

0.95, representing the darkest highlight area, such as Caucasian skin

1.10, representing the maximum textured highlight density

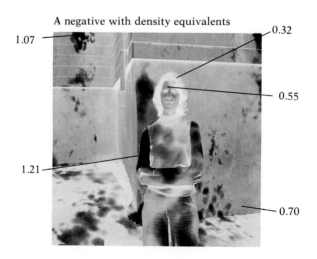

A negative with density equivalents

Here is a chart of relative negative densities with corresponding Zone System equivalents:

zone	sheet film	size 120 film	35 mm film
0	0.10	0.10	0.30
I	0.20	0.15	0.33
II	0.25	0.30	0.37
III	0.40	0.45	0.45
IV	0.60	0.60	0.60
V	0.75	0.75	0.75
VI	0.95	0.95	0.90
VII	1.15	1.10	1.05
VIII	1.35	1.30	1.20
IX	1.50	1.50	1.30
X	1.60	1.65	1.40

Additional Considerations

Reciprocity Failure

Reciprocity refers to the interdependent relationship between light intensity (f-stop) and time (shutter speed): 1/60 at f 8 produces the same negative exposure as 1/125 at f 5.6.

Reciprocity failure (or *reciprocity departure*) — the breakdown of reciprocity — happens at fast and slow exposure times. Most black-and-white films suffer reciprocity failure at speeds of 1/1,000 of a second or faster, and of one second or slower. To compensate for reciprocity failure, you must add light to the indicated exposure (and possibly change the film development time); otherwise the negative will be underexposed. Here is a general chart for compensation with most black-and-white films:

indicated exposure	additional exposure	development change needed
1/10,000 of a second	½ stop	15% more
1/1,000 of a second	none	10% more
1 second	1 stop (or use 2 seconds instead)	10% less
10 seconds	2 stops (or use 50 seconds instead)	20% less
100 seconds	3 stops (or use 1,200 seconds instead)	30% less

Write to the film manufacturer for reciprocity failure information for specific films.

Reciprocity failure is linked only to time, not to intensity, so when possible, compensate by increasing the f-stop. If you compensate by lengthening the shutter speed, reciprocity failure will be compounded.

Times of faster than 1/1,000 generally refer to electronic flash use, when the time factor is the duration of the flash (not the shutter speed). Most electronic flash units have a duration of less than 1/1,000 of a second.

The simplest way to circumvent problems of reciprocity failure is to avoid using fast and long exposures. If the meter reads one second at f 4, use instead ½ at f 2.8, and you will not need to compensate.

Close-up Photography

When focusing for a close-up shot of the subject, the indicated meter reading must be increased or the negative will be underexposed. F-stops are calculated with the lens focused at infinity. As the lens focuses more closely, the distance the light travels through the lens increases, so the amount of light reaching the film decreases. The rule is:

Increase the indicated exposure when the distance to the sub-ject is closer than eight times the focal length of the lens.

With a 50 mm (two-inch) lens, increase exposure when focusing closer than 400 mm (fourteen inches) from the subject; with a 150 mm (six-inch) lens, increase exposure when focusing closer than 1,200 mm (four feet) from the subject.

If you use a through-the-lens meter, the indicated exposure is al-ready corrected for (the meter reads the light that travels through the lens). Otherwise, to compensate for decreased light, use the *exposure factor* applicable to the conditions at hand. This factor indicates the necessary corrected exposure. In the chart below, 4× means an in-crease of four times as much light (two stops). Here are typical factors and compensations:

if the factor is	increase exposure by
1½×	½ stop
2×	1 stop
3×	1½ stops
4×	2 stops
5×, or 6×	2½ stops
7×, 8×, or 9×	3 stops

To compensate, when using extension tubes or close-up lenses, use the exposure factor indicated by the manufacturer. If the conditions are a metered exposure of 1/30 at f 8, and an exposure factor of 4×, use a corrected exposure of 1/30 at f 4; or 1/15 at f 5.6; or 1/8 at f 8.

To compensate when using a camera with a bellows, use the follow-ing formula to determine the exposure factor:

$$\frac{(\text{bellows length})^2}{(\text{focal length})^2} = \text{exposure factor}$$

If the conditions are a bellows length of four inches, a focal length of two inches (50 mm), and an indicated exposure of 1/30 at f 8, plug the figures into the formula:

$$\frac{(4)^2}{(2)^2} = 4$$

The exposure factor is 4×, so the corrected exposure is 1/30 at f 4; or 1/15 at f 5.6; or 1/8 at f 8.

Be sure to keep reciprocity failure in mind. If the corrected exposure is one second or slower, increase the exposure once again, using the chart for reciprocity failure.

Filter Factors

The use of most filters on the lens cuts down the amount of light reaching the film, so the indicated exposure will need correction. Each filter has a *filter factor* to indicate the necessary additional exposure. Filter factors work like exposure factors with close-up photography; 2 × means an increase of one stop; 8 × means an increase of three stops. If you use a through-the-lens light meter, the filtered light will be measured, so no exposure correction is necessary.

Filter factors are indicated either on the edge of the rim of the filter, or in the filter instruction sheets. These factors are intended only as guides to corrected exposure, since a filter's effect varies with the light conditions and type of film. If in doubt, bracket exposures, starting with the corrected exposure.

Neutral density filters (available as Wratten Filters #96) reduce the amount of light reaching the film without affecting the tones or color of the photograph. Usually a neutral density filter is used to permit a slower shutter speed (for a greater feeling of movement), or a larger aperture (for less depth of field). Neutral density filters are numbered logarithmically:

neutral density filter number	filter factor	increase exposure by
0.30	2×	1 stop
0.60	4×	2 stops
0.90	8×	3 stops

50

Further Reading

Adams, Ansel. *The Negative* (Basic Photo Series). Boston: New York Graphic Society, 1977.

Dowdell, John J., III, and Richard D. Zakia. *Zone Systemizer for Creative Photographic Control.* Dobbs Ferry, New York: Morgan and Morgan, 1973.

Dunn, J. F., and G. L. Wakefield. *Exposure Manual.* Dobbs Ferry, New York: Morgan and Morgan, 1975.

Eastman Kodak Company. *Basic Photographic Sensitometry Workbook.* Rochester, New York: Kodak Publication Z-22-ED, 1971.

———. *Kodak Professional Black-and-White Films.* Rochester, New York: Kodak Publication F-5, 1969.

Gassan, Arnold. *Handbook for Contemporary Photography.* Athens, Ohio: Handbook Publishing Company, 1974.

Haverman, Josepha. *Workbook in Creative Photography.* Dobbs Ferry, New York: Morgan and Morgan, 1976.

Picker, Fred. *Zone VI Workshop.* Garden City, New York: Amphoto, 1974.

Todd, Hollis N., and Richard D. Zakia. *Photographic Sensitometry.* Dobbs Ferry, New York: Morgan and Morgan, 1974.

White, Minor, Richard D. Zakia, and Peter Lorenz. *The New Zone System Manual.* Dobbs Ferry, New York: Morgan and Morgan, 1976.

Photographic Chemistry

You need no knowledge of chemistry for basic negative and print processing since common chemical formulas are available in packaged form, complete with instructions for dilution and use. Beyond the basic level, however, chemical knowledge is helpful to improve control over processing.

If you understand what chemicals do to film and paper, you will be able to work out more intelligent and efficient processing techniques. Also, if you choose, you will be able to mix your own formulas from scratch, many of which are unavailable in packaged form. Or, you will be able to modify packaged formulas with simple additives to produce different results.

How Each Chemical Works

Developer

The developer reacts with the exposed silver halide crystals in film

and paper emulsions, and reduces them to metallic silver. Developer formulas contain several different components:

The *developing agent* (or *reducing agent*) is the primary chemical in the developer formula. Different developing agents vary in many ways, including their effect on negative and print contrast, color, and graininess. The most common developing agents are hydroquinone, Metol, and phenidone.

Developing agents, on their own, are not efficient enough to develop the exposed silver crystals. Their chief deficiency is their low activity level. Most developing agents simply do not work fast enough, so additional chemicals are needed.

The *accelerator* (also called *alkali* or *activator*) activates the developing agent. A developer formula with strong acceleration generally causes quicker development and produces higher contrast, but may lead to excessive fog, overly soft emulsions, coarse grain, or shortened developer life. Some common accelerators, in order of strength (strongest first), are: sodium (or potassium) hydroxide, sodium carbonate, Kodalk, borax, and sodium sulfite.

A *restrainer* is added to minimize *chemical fog* — the tendency of developing agents to develop unexposed silver halide crystals. The restrainer slows down development action, particularly in the areas receiving the least exposure. Therefore, great amounts of restrainer will increase contrast in the negative by lowering shadow density in relation to highlight density, and in the print by lowering highlight density in relation to shadow density. Also, the type of restrainer used affects the warmness or the coldness of the image color; this factor is particularly important in print processing. Potassium bromide is the most commonly used restrainer, although benzotriazole is occasionally used.

A *preservative* is added to prevent the deterioration of developing agents, which react easily with oxygen in the air and oxidize. Sodium sulfite is the most common preservative.

Stop Bath

The *stop bath* is a mild acid rinse that neutralizes the development action, thereby permitting maximum control of development times. Sometimes a water rinse is used in lieu of a stop bath. But water will

slow down the development action, not stop it. If water is used, the fixer is then forced to stop the development, and quickly becomes exhausted. The fixer is much more expensive than the stop bath, so it is worth saving. Furthermore, the stop bath acts to reduce the tendency of the emulsion to swell and soften.

Most stop baths consist solely of extremely dilute acetic acid. Occasionally, some other additives are used:

A *hardener* usually is used in the fixer, but can be used in the stop bath or in lieu of a stop bath. Its purpose is to protect the emulsion from damage while it is wet. It reduces the swelling tendency of the gelatin in the film, and is therefore particularly useful in high temperature solutions and where film development is carried out in hot climates. This swelling can lead to increased graininess and even *reticulation* (cracks in the emulsion surface). Potassium chrome alum is usually used in hardened stop baths.

A *color indicator* is sometimes added for a visual check of the usefulness of the stop bath.

Fixer

The *fixer* (also called *hypo*) dissolves the unexposed (and, therefore, undeveloped) silver halide crystals from the emulsion. If these crystals are not removed, they will eventually darken and ruin the image. Fixers generally contain several different components:

A *fixing agent* does most of the work in removing the unexposed silver halide crystals, but without additional ingredients it would quickly become contaminated. Either sodium thiosulfate or ammonium thiosulfate is used as a fixing agent.

An *acid*, usually acetic acid, neutralizes the developing action, especially when the stop bath is weak or nonexistent. However, on its own, the acid works to cause the disintegration of the fixer solution.

A *preservative*, sodium sulfite, prevents the disintegration of the fixer by the acid.

A *hardener* is commonly used in fixers to prevent excessive swelling and softening of the film or the paper during the washing process; it protects both the wet and the dry emulsions from damage. Potassium alum is a common fixer hardener.

A *buffer*, usually boric acid, must be used with hardened fixers to maintain the acidity of the fixer. If the acidity is not kept at a certain level, the hardener does not function to its maximum ability.

Wash

A thorough water wash is needed to remove the remaining soluble fixer and silver compounds, which, if left in the negative or print, would eventually cause staining or fading. Therefore, the main purpose of the wash is to make the photographic image permanent.

A *washing aid* (such as Edwal Hypo Eliminator, Kodak Hypo Clearing Agent, Perma Wash, or Sprint Fixer Remover) should be used to effect a quicker and more efficient wash than is possible with plain water. The washing aid is then removed from the film or paper with a final water wash. Sometimes treatment in the washing aid is preceded by an initial water rinse.

A *wetting agent* (such as Ecco 121, Edwal Kwik-Wet, FR Wetting Agent, or Kodak Photo-Flo) is recommended for use after the final wash. It reduces the surface tension of the water to facilitate rapid and uniform drying.

A Guide to Common Photographic Chemicals

Here is a list of common photographic chemicals with their most important uses and, where relevant, their special characteristics.

acetic acid: the most common chemical stop bath; also used as an acid in fixing baths

amidol: a developing agent; produces excellent quality neutral-black print tones, but does not keep well; also expensive

ammonium thiosulfate: a rapid-acting fixing agent; has greater capacity and is easier to wash out of negatives and prints than sodium thiosulfate, the other common fixing agent

benzotriazole: a developer restrainer; not as commonly used as

potassium bromide; produces neutral-black print tones; available commercially as DuPont B-B Developer Additive, Edwal Liquid Orthazite, and Kodak Anti-Fog #1

borax: a mild developer accelerator; produces a developer that is low in activity and used widely in fine-grain film developers; also a buffer in some hardened fixing baths

boric acid: a buffer commonly used in hardened fixing baths

chlorquinol: (also called *adurol* and *chlorhydroquinone*); a developing agent, somewhat similar to hydroquinone; used to produce warm-tone prints

Elon: Kodak trade name for p-Methylaminophenol sulfate; a very common developing agent (also called Metol, Rhodol, etc.)

formaldehyde: occasionally used as a supplementary hardener

glycin: a developing agent; produces fine-grain negatives and warm-tone prints; keeps very well

gold chloride: used primarily in gold toners

hydroquinone: a very common and versatile developing agent for both negatives and prints; a high-contrast agent that works primarily on heavily exposed areas (highlights with negatives and shadows with prints); usually used in combination with a low-contrast agent, such as Metol or phenidone, to make up the M and Q (Metol and hydroquinone) and P and Q (phenidone and hydroquinone) group of developer formulas; changing the relative amounts of hydroquinone to Metol and hydroquinone to phenidone in a formula can effect very different developer characteristics; on its own, hydroquinone works very slowly, so requires strong acceleration

Kodalk: (also called *Kodak Balanced Alkalai*); a mild accelerator used primarily in film developers; also a buffer in some hardened fixing baths

p-Methylaminophenol sulfate: (also called variously Elon, Metol, Rhodol, etc.); a very common and versatile developing agent for negatives and prints; a low-contrast agent that works primarily in lightly exposed areas (shadows with negatives and highlights with prints); usually used in combination with hydroquinone, a high-contrast agent, to make up the M and Q (Metol and hydroquinone) group of developer formulas;

some people are allergic to this agent and should consider using a formula with phenidone instead; in this text, p-Methylaminophenol sulfate will be referred to as Metol or Elon — its most common trade names

Metol: Agfa, Ansco, and other companies' trade name for p-Methylaminophenol sulfate; (also called Elon, Rhodol, etc.)

orthophenylene diamine: an extra fine-grain developing agent; requires extra film exposure

paraphenylene diamine: similar to orthophenylene diamine

paraminophenol hydrochloride: a negative and print developing agent; similar in many respects to Metol, though less active and less toxic; keeps exceptionally well, and is commonly used in highly concentrated liquid developers

phenidone: a popular developing agent most commonly used in Ilford formulas; like Metol, a low-contrast agent usually used in combination with hydroquinone; developer formulas that contain phenidone and hydroquinone belong to the P and Q group of developers; phenidone is considered nontoxic, so is safe for those allergic to Metol, Rhodol, Elon, etc., to use

potassium alum: (or just *alum*); a common hardener used in fixing baths; does not harden quite as effectively as potassium chrome alum, but keeps for a much longer time

potassium bromide: the most common developer restrainer; with prints, tends to produce a warm image color

potassium chrome alum: (or just *chrome alum*); occasionally used as a hardener; does not keep well

potassium dichromate: a very toxic chemical used in chromium intensifiers and some other bleaches

potassium ferricyanide: a bleach used in Farmer's reducer and in some toners

potassium hydroxide: a very strong developer accelerator; produces extremely active film developers that must be mixed just before using and thrown out after one use

potassium metabisulfate: occasionally used as a developer or fixer preservative; with some fixing baths, serves as both a preservative and an acid; also sometimes used in place of acetic acid as a stop bath

pyrogallol: (or *pyro*); one of the earliest known developing agents; used rarely these days; stains easily and does not keep well

Rhodol: DuPont trade name for p-Methylaminophenol sulfate — a very common developing agent (also called Elon, Metol, etc.)

sodium bisulfite: same uses as potassium metabisulfate

sodium carbonate: a strong developer accelerator commonly used with print developers

sodium hydroxide: same uses as potassium hydroxide

sodium metabisulfate: same uses as potassium metabisulfate

sodium sulfate: used in warm processing solutions to reduce gelatin swelling

sodium sulfite: by far the most common preservative in developer and fixer baths; also acts as a mild accelerator in some developer formulas; when great amounts are added to developer formulas, acts as a silver solvent and produces finer-grain negatives

sodium thiosulfate: (or plain *hypo*); the most common fixing agent; also used in Farmer's reducer

Once you know what chemicals do and which chemicals do what, you should be able to look at a formula and determine its approximate characteristics.

For example, Kodak D-8 developer contains:

> sodium sulfite
> hydroquinone
> sodium hydroxide
> potassium bromide

This formula indicates a fast-acting, high-contrast developer (sodium hydroxide as the accelerator, combined with hydroquinone as the developing agent).

Kodak D-23 developer contains only:

> Elon
> sodium sulfite

This formula indicates a slower working, lower-contrast developer. (Elon is a low-contrast developing agent, mildly activated by sodium sulfite.)

Kodak D-76 developer contains:

> Elon
> sodium sulfite
> hydroquinone
> borax

This formula indicates a more general-use developer with average contrast and average acceleration (Elon and hydroquinone in combination with borax as the accelerator).

However, these characteristics are approximate because factors other than the formulas (such as working strength, time of development, temperature of developer, and agitation technique) affect the results.

As you can see, not all developers require all the possible developer chemicals. In some cases (for example, Kodak D-23), one chemical serves more than one function. In other cases, mild accelerators (such as borax) obviate the need for a restrainer.

Mixing Your Own Formulas

Store-bought, packaged formulas work well for most purposes. However, many useful formulas are not commercially available. Besides, you can learn a lot about the nature and the potential of film and print processing by mixing your own formulas.

What You Need

The mixing process is simple and inexpensive, but an initial investment is necessary. You will need the following:

A *scale*, as chemical formulas are usually listed in metric weight (though this text will also list formulas cookbook-style, in ta-

blespoons and teaspoons). The scale should measure a range of approximately 0.1 grams to 500 grams. An ideal type is a triple-beam balance that uses a counterbalance. Other types of scales require a separate set of weights.

A full set of *measuring spoons*, plastic or stainless steel, if you intend to use the cookbook method of mixing chemicals.

A supply of *chemicals* to suit the formulas you intend to make.

Several *mixing bowls* of different sizes.

Small and large size *graduates*, with maximum capacities ranging from ten milliliters to four liters.

Stirring rods.

Some *storage bottles* of various capacities.

Spoons to transfer the dry chemicals from their containers to the scale.

A *thermometer.*

Funnels to transfer the solutions to thin-necked bottles.

In general, chemical formulas should be mixed with, handled, and stored in containers and equipment made of stainless steel, glass, or chemically resistant polyethylene. Other materials, such as aluminum, zinc, and tin, will react with and contaminate the chemicals.

How to Buy Chemicals

Form

Chemicals are sold in various forms or compositions, such as:

anhydrous: all water has been removed from the chemical
desiccated: most of the water has been removed; for mixing purposes, anhydrous and desiccated are equivalent forms
crystalline: much water remains in the chemical
monohydrated: a crystalline form, one part water

Most formulas specify the required form, for example, sodium sulfite (anhydrous).

The more water removed from a chemical, the more potent it is. For example, one hundred parts of sodium carbonate (crystalline) is equal to thirty-seven parts of sodium carbonate (anhydrous). How-

ever, substitutions of one form for another must be made with care since different chemicals require different substitutions. If the form is specified in the formula, the simplest procedure is to use that form.

Purity

Chemicals are available in various grades of purity, such as:

photo: specially made for photographic purposes

USP (U.S. Pharmacopoeia): consistently high purity

A.R. (formerly *C.P.*): analytical grade — the purest and most expensive form

technical (or *commercial*): low purity

The formula will note if a special grade is required. In general, use photo grade whenever possible, although most grades, except for technical grade, are suitable for photographic use.

Where to Buy Chemicals

The major sources of supply for photographic chemicals are:

Camera stores: these are ideal since they carry most of the relevant chemicals in their appropriate form and purity. Smaller camera stores may not stock photographic chemicals, but probably can special-order them for you.

Chemical laboratory supply houses: these carry all the chemicals you normally need. Since these houses cater to all kinds of demands, you must be careful to request the appropriate form and purity. Some houses will not sell small quantities to individuals. Most universities have internal lab supply houses, some of which sell to outsiders.

Drugstores: these carry some chemicals, but again be sure to request the proper form and purity.

Mail-order houses: these service both photographic and general customers; most firms will supply a catalogue upon request; see Appendix 2 for a partial list of suppliers.

General Guidelines

Follow common sense rules of safety. Label and handle all chemicals with care.

Some chemicals are dangerous; they should be marked accordingly, and stored below eye level. Read the cautionary information on packages before using any chemicals. Mix only in a room with adequate ventilation, preferably an exhaust fan. Be careful of splashing chemicals. Protective equipment (such as rubber gloves, aprons, and goggles) is recommended, especially when handling toxic chemicals. See Appendix 3 for further information on health hazards with photographic chemicals. If in doubt, write to the manufacturer of the product for safety information (Appendix 2 includes names and addresses of major manufacturers).

Keep the mixing area and equipment clean and dry to avoid contamination.

Follow mixing instructions carefully, in particular:

> *Start with the quantity and temperature of water as stated at the start of the formula. And always mix the chemicals in the order given by the formula.*

Many chemicals do not dissolve properly when mixed at the wrong temperature or in the wrong order.

Drinkable tap water is adequate for nearly all photographic purposes. Some people insist on using distilled water, especially in developer formulas. However, distilled water is necessary only when the formula specifically requires it; or when the tap water is of poor quality (either hard, rusty, or bad smelling).

Be sure the chemical is completely dissolved before adding other ingredients to the solution.

Measure with care, by bringing the thermometer or measuring cup up to eye level for viewing.

When measuring weight, place the chemical on a clean scrap of paper on the scale. For each chemical, use new paper to avoid contamination. Be sure to compensate for the weight of the paper in measurement.

"Water to Make"

In most formulas, the last ingredient called for is "water to make . . . " Since dry chemicals add volume to a solution, you usually start with a quantity of water less than (approximately three-quarters of) the total amount required. Dissolve the chemicals first, and then pour in the rest of the water to make up the total quantity of the solution.

Some dry chemicals dissolve only in hot water, so the formula will state a temperature for the initial quantity of water. In such cases, the "water to make" should be cold water to lower the temperature of the stock solution.

About the Metric System

As of this writing, the United States is in the process of switching from the avoirdupois to the metric system of weights and measures. The metric system is recommended for use in mixing chemical formulas. If you are unfamiliar with the metric system, refer to a measures and weights conversion chart; you can find such a chart in any good dictionary. For photographic purposes, the following *approximate* measurements are most relevant ("a" stands for avoirdupois; "m" for metric):

volume

1 ounce (a)	30 milliliters (m)
32 ounces (a)	1 quart (a)
1000 milliliters (m)	1 liter (m)
34 ounces (a)	1 liter (m)

weight

1 ounce (a)	28 grams (m)

temperature

68° Fahrenheit (a)	20° Celsius (m)
125° Fahrenheit (a)	52° Celsius (m)

length

1 inch (a)	25 millimeters (m)

A Percentage Solution

When only a small quantity of a chemical is needed, the formula may specify a *percentage solution*. To make a percentage solution, dissolve the cited percentage amount in grams into seventy-five milliliters of water, then add water to make one hundred milliliters.

For example, to make a 5 percent solution:

 water 75 milliliters
 chemical in dry form ... 5 grams
 water to make 100 milliliters

To make a 10 percent solution:

 water 75 milliliters
 chemical in dry form ... 10 grams
 water to make 100 milliliters

Because 100 milliliters is a small quantity, and therefore difficult to measure, percentage solutions are usually mixed in larger quantities, such as one liter (one thousand milliliters). Simply multiply all the quantities by ten; for a 10 percent solution, mix:

 water 750 milliliters
 chemical in dry form ... 100 grams
 water to make 1 liter

This text includes several formulas. If you with to experiment further, there are many other possible sources. Many other textbooks include formulas, but the most comprehensive source is *The Photo Lab Index* edited by Ernest M. Pittaro. A good, inexpensive alternative is *Amphoto Black-and-White Processing Book* by John Carroll. Also, Kodak publishes its own formulas in *Processing Chemicals and Formulas for Black-and-White Photography*, Kodak Publication J-1.

The Cookbook Method of Mixing Formulas

Dry chemicals can be measured cookbook-style — in tablespoons and teaspoons — if you know their correct weight equivalents. This method is not quite as precise as measuring by weight; however, it is sufficiently accurate for most photographic formulas. Most formulas in this text are given in both metric weight and cookbook equivalents. (With the cookbook formulas, measurements of volume are given in ounces and quarts, although milliliters and liters can also be used; in a given formula, substitute thirty milliliters for each ounce and one liter for each quart.) These equivalents were worked out by Zone V, Incorporated, a mail-order chemical supply house.

The accompanying chart relates gram weights to their equivalents in level tablespoons and teaspoons for the most common photographic chemicals in their most common form. If you find a formula not included in this text, you can use this chart for easy, cookbook-style mixing. For example, if a formula calls for nine grams of hydroquinone, use one tablespoon of hydroquinone. When the equivalents do not work out exactly, measure as closely as you can.

Measure the dry chemicals as you would any cooking ingredient, with a level teaspoon or tablespoon. Use a set of plastic or stainless steel measuring spoons. Be sure to wash and dry each spoon immediately after each use.

To level the chemical, use the back of a clean, dry measuring spoon. Or, place a wide piece of tape across part of the opening of the bottle containing the chemical; while removing a heaping spoonful, skim the excess chemical with the underside of the tape.

In many sets of measuring spoons, the smallest is a one-quarter teaspoon, in which case, if the formula calls for one-eighth of a teaspoon or less, you have two options. Either estimate the measurement by using one-half of the one-quarter teaspoon; or, double all the ingredients, and use a full one-quarter teaspoon.

Weight Equivalents in Grams

	1 tablespoon	½ tablespoon	1 teaspoon	½ teaspoon	¼ teaspoon	⅛ teaspoon
amidol	7.0	3.5	2.3	1.2	0.7	0.4
benzotriazole	6.0	3.0	2.1	1.0	0.5	0.25
borax	15.0	7.5	5.0	2.5	1.3	0.7
boric acid	12.0	6.0	4.1	2.0	1.0	0.5
chlorquinol	9.7	5.0	3.4	1.7	0.8	0.45
glycin	4.1	2.1	1.4	0.7	0.35	0.2
hydroquinone	9.0	4.5	3.0	1.5	0.75	0.4
Kodalk	14.5	7.2	4.8	2.4	1.2	0.6
Metol (or Elon)	10.5	5.25	3.5	1.75	0.85	0.45
phenidone	6.0	3.0	2.0	1.0	0.5	0.25
potassium alum	16.8	8.4	5.6	2.8	1.5	0.8
potassium bromide	19.5	10.0	6.5	3.2	1.6	0.8
potassium dichromate	22.0	11.5	7.9	4.1	2.2	1.1
potassium ferricyanide	15.5	8.0	5.5	2.8	1.5	0.8
silver nitrate	41.0	20.7	13.8	7.0	3.6	1.8
sodium bisulfate	22.9	11.5	7.7	4.0	2.0	1.0
sodium bisulfite	18.0	9.0	6.0	3.0	1.5	0.75
sodium carbonate	18.0	9.0	6.0	3.0	1.5	0.75
sodium sulfate	22.5	11.4	7.7	3.8	2.0	1.0
sodium sulfite	22.8	11.4	7.6	3.8	1.9	1.0
sodium thiosulfate	18.0	9.0	6.0	3.0	1.5	0.75

Formula Storage and Capacity

Storage

Chemicals, in particular developers, may react unfavorably to light, oxygen, moisture, or heat. The best storage rooms are dark, dry,

and cool. The best containers are dark glass bottles, although chemically resistant plastic bottles are also adequate. The bottle should have a good sealing capacity, usually a screw-on cap, to help protect the contents from oxidizing.

Avoid partly filled storage bottles since trapped oxygen will expedite chemical deterioration. Transfer small quantities of chemicals from large to smaller bottles; or if the bottle is plastic, carefully squeeze the air out of it.

A *cubitainer* is a safe, plastic storage container, packaged in a cardboard box. It has a spigot for draining solution, and it collapses as its capacity dwindles, thereby preventing air from entering. Cubitainers are used with premixed formulas by some companies (such as Kodak Ektaflo Chemicals). Empty cubitainers are sold by some camera stores and some mail-order houses (see Appendix 2 for sources).

A few chemicals are poisonous or give off fumes. Their packaging will be marked with appropriate warnings. They should be handled with great care, stored away from film and paper, and used only in a well-ventilated room.

Storage life is dependent upon the type and brand of chemical as well as the storage conditions. Manufacturers will provide estimates for their products. For example, Kodak suggests:

chemical	stock solution in stoppered bottle	working solution in tray
developer	2 to 6 months*	12 to 24 hours
stop bath	indefinite	3 days
fixer	2 months	1 week
washing aid	3 months	24 hours

*This depends upon how full the bottle is.

Capacity

Fresh chemicals are important for good, consistent results. Overused developer will produce weak print tones and may cause stain-

A cubitainer is a plastic storage container that collapses as its capacity dwindles, thereby preventing air from entering

ing. Exhausted stop bath will not effectively neutralize development and will overtax the fixer. Overused fixer will produce weak print tones, improperly fix the image, and be difficult to wash out of the film or print, eventually causing fading or staining.

The simplest way to test chemicals for exhaustion is to refer to capacity charts provided by the manufacturer. The charts are necessarily estimates, due to the many uncertainties of storage and use. Here are some general guidelines, based upon one liter of working solution (the solution after dilution with water for use):

chemical	film (number of 36-exposure, 35 mm rolls)	prints (number of 8″ × 10″ prints)
developer	4 rolls	25 prints
stop bath	15 rolls	15 prints
fixer	25 rolls	25 prints
washing aid — with preliminary wash	40 rolls	50 prints
washing aid — without preliminary wash	12 rolls	20 prints

The following amount of film is approximately equal to one thirty-six-exposure, 35 mm roll of film:

2 20-exposure, 35 mm rolls
1 size 120 or 620 roll
4 4″ × 5″ sheets
2 size 127 rolls
7 12-exposure, size 110 rolls

Another way to judge chemical exhaustion is by a visual test. Developers usually darken when used up. Some packaged formulas include indicators that change color when the solution is depleted. Other visual testing methods are commercially available for stop baths and fixers, such as Braun Hyp-a-Test, Edwal Hypo-Check, and Kodak Testing Outfit for Print Stop Baths and Fixing Baths.

In general, fixers should clear film or paper in half the recommended fixing time. Put a piece of blank film into a tank or a tray of used fixer. Agitate the film intermittently. If the manufacturer recommends a five-minute fixing time, the film should clear in approximately two and one-half minutes or less. Otherwise, the fixer is exhausted and should be replaced.

A more accurate fixer test is available with a simple homemade formula.

Mix:

Kodak Rapid Selenium Toner ... 10 milliliters
Water to make 100 milliliters

Follow these directions:

1. Use a piece of film or a print that has been processed in the suspected fixer.

2. Place a drop of the diluted solution on a squeegeed, clear part of the film or on the white margin of the print.

3. Wait three minutes; then wipe off the drop with a clean blotter or cloth. If the test leaves any discoloration other than a slight cream tint, the fixer is exhausted.

There are other tests that can be used, but if in doubt always mix new solutions. The extra cost of fresh chemicals is always worth avoiding the risk of ruining important work.

Some Useful Formulas*

If a formula is available in packaged form, there is little if any advantage in mixing your own. However, it is worthwhile to examine the packaged formulas to determine their characteristics. Some of the following standard formulas are commercially available, and some are not.

Kodak D-76
(a film developer)

water at 125° F (or 52° C)	750 milliliters	24 ounces
Elon	2 grams	½ teaspoon
sodium sulfite, anhydrous	100 grams	4 tablespoons plus 1 teaspoon
hydroquinone	5 grams	1½ teaspoons
borax, granular	2 grams	½ teaspoon
water to make	1 liter	1 quart

Dilute for use: Either use undiluted and replenish; or use one part D-76 with one part water and throw out after one use.

*Note: When mixing formulas, Elon and Metol are the same chemical and can be used interchangeably.

Note: This formula is similar to DuPont 6-D and Ilford ID-11 film developers.
To use: Here are recommended developing times for the following films at 68° F:

film type	undiluted	diluted one-to-one
Kodak Panatomic-X	7 minutes	9 minutes
Kodak Plus-X	not recommended	8 minutes
Kodak Tri-X	8 minutes	11 minutes
Ilford Pan F	6 minutes	9 minutes
Ilford FP4	6½ minutes	9 minutes
Ilford HP4	7 minutes	12 minutes

Kodak D-72
(a print developer)

water at 125° F (or 52° C)	500 milliliters	16 ounces
Elon	3 grams	1 teaspoon
sodium sulfite, anhydrous	45 grams	2 tablespoons
hydroquinone	12 grams	1 tablespoon plus 1 teaspoon
sodium carbonate, monohydrated	80 grams	4 tablespoons plus 1¼ teaspoons
potassium bromide, anhydrous	2 grams	½ teaspoon
water to make	1 liter	1 quart

Dilute for use: Standard dilutions are one part D-72 to two parts or three parts water.
Note: D-72 is similar to the packaged Kodak Dektol, and to DuPont 53-D and GAF 125 print developers.
To use: Develop for two to three minutes, with constant agitation.

Kodak SB-1
(a universal stop bath)

| water | 1 liter | 1 quart |
| 28% acetic acid* | 48 milliliters | 1½ ounces |

*Acetic acid can be bought in 28 percent, or glacial, strength. To make a 28 percent solution from glacial acetic acid, mix three parts glacial acetic acid with eight parts water.

Capacity: Fifteen to twenty 8″ × 10″ prints; or fifteen to twenty 35 mm (36-exposure) rolls of film per liter; or the equivalent.
Note: This formula is similar to many others, including Agfa 200, DuPont 1-S, and GAF 210.
To use: Treat for ten to fifteen seconds, with constant agitation.

Kodak SB-3
(a hardening stop bath)

| water | 1 liter | 1 quart |
| potassium chrome alum | 30 grams | 2 tablespoons |

Capacity: An indicator is built into this formula; when the bath turns yellow-green, it is exhausted.
Note: This formula is similar to GAF 216. It is recommended for processing films in hot weather to reduce gelatin swelling.
To use: 1. After development, soak film in SB-3 solution for three minutes. Agitation is necessary only for the first thirty seconds.
 2. Follow this treatment with a hardened fixer.

Ilford IF-2
(a nonhardening acid fixer)

water at 125° F (or 52° C)	750 milliliters	24 ounces
sodium thiosulfate	200 grams	11 tablespoons
potassium metabisulfite*	12.5 grams	2 teaspoons
cold water to make	1 liter	1 quart

*Sodium bisulfite may be substituted.

Dilute for use: One part IF-2 to one part water.

Note: This formula is similar to Agfa 300 and DuPont 8-F. It is recommended for fixing prints that do not need hardening. The advantages are easier and more efficient washing and toning. Do not use with prints to be heat dried or with film. Also, do not wash prints fixed in IF-2 at warm temperatures.

To use: Fix for five to ten minutes, with intermittent agitation.

Kodak F-6
(a hardening acid fixer)

water at 125° F (or 52° C)	600 milliliters	20 ounces
sodium thio-sulfate	240 grams	13 tablespoons
sodium sulfite, anhydrous	15 grams	2 teaspoons
28% acetic acid	48 milliliters	1½ ounces
Kodalk	15 grams	1 tablespoon
potassium alum	15 grams	2½ teaspoons
water to make	1 liter	1 quart

Note: This formula is similar to GAF 204. It has a minimal odor. It does not harden as well as some fixers, though well enough for most purposes. It washes out of films and papers more readily than most hardened fixers.

To use: Fix for five to ten minutes, with intermittent agitation.

Further Reading

Carroll, John. *Amphoto Black-and-White Processing Data Book.* Garden City, New York: Amphoto, 1975.

Dignan Newsletter. Available from Dignan Photographic, 12304 Erwin Street, North Hollywood, California 91606.

Eastman Kodak Company. *Basic Chemistry of Photographic Processing* (in two parts). Rochester, New York: Kodak Publication Z-23-ED, 1971.

————. *Practical Processing in Black-and-White Photography.* Rochester, New York: Kodak Publication P-229, 1970.

_____. *Processing Chemicals and Formulas.* Rochester, New York: Kodak Publication J-1, 1973.

Eaton, George. *Photographic Chemistry in Black-and-White and Color Photography.* Dobbs Ferry, New York: Morgan and Morgan, 1965.

McCann, Michael. *Health Hazards Manual for Artists.* Available from Foundation for the Community of Artists, 32 Union Square East, Room 816, New York, New York 10003.

Photophile. A newsletter, available from Photophile, 57 West Hillcrest Avenue, Havertown, Pennsylvania 19083.

Pittaro, Ernest M., ed. *The Photo Lab Index.* Dobbs Ferry, New York: Morgan and Morgan, 1976.

Zone V, Incorporated. *The Z/7 Photochemical Instruction Manual.* Available from Zone V, Incorporated, Box 811, Brookline, Massachusetts 02146.

CHAPTER THREE

Archival Processing and Storing

Many photographers are too casual about their methods of processing and storing negatives and prints. Poorly cared for materials will stain or fade with time. Sometimes deterioration takes dozens of years, but it can happen within a few months. Proper handling requires a little extra work and expense, but will produce better quality and more permanent results.

Archival care means special processing and storing of negatives and prints to ensure their maximum permanence. Archives, libraries, and museums have long been concerned with preserving records, books, and artwork, but photographers have only recently taken a similar interest.

Arguments can be made against archival care. It requires extra work and expense and, frankly, most photographs are not worth preserving. Besides, some photographers have a strange sense of priority; they would sooner see a permanent print than a good photograph.

However, the basic tenets of archival care are sound. Processing and storing are important, not only to the long-range permanence of the image, but to the day-to-day quality of your work. For most purposes, you do not need to adhere rigorously to archival standards.

However, an awareness of these standards should encourage a more careful attitude toward your processing and storing methods. After all, most photographers do have their own archives of sorts — either a record of their past photographic achievements (and disappointments) or a record of their own lives.

Reasons for Staining and Fading

The most common causes of staining and fading are poor fixing and washing techniques. If the fixing time is too short, some unexposed silver halides will remain in the negative or print and eventually cause discoloration. If the fixing time is too long or the fixer is exhausted, the negative or print will be extremely difficult to wash properly. In turn, poorly washed materials will retain great amounts of fixer that will slowly react with the silver image to produce sulfur stains, or with compounds in the air to cause fading.

Other causes of staining and fading include high temperatures, high humidity, excessive pollution, and impure storage containers. Furthermore, some emulsions are inherently freer from deterioration than others; fine-grain films and warm-tone papers, for example, will suffer more damage from poor processing techniques than coarse-grain films and cold-tone papers.

Good Fixing Technique

The following considerations are important for good fixing technique:

Do not use exhausted fixer. Refer to the sections on storage and capacities on pages 67–71 to judge the usefulness of a fixer bath.

Fix for the prescribed period of time; over- and underfixing are both harmful. Take special care with ammonium thiosulfate (rapid) fixers, which can easily lead to overfixing due to their rapid activity; however:

Ammonium thiosulfate fixers wash out of negatives and prints more easily than sodium thiosulfate fixers.

Agitate for at least half the time for which the film or the paper remains in the fixer, particularly when tray-processing several sheets of film or paper at the same time.

Hardener retards proper washing, so whenever possible reduce or eliminate the amount of hardener in the fixing bath. Prints that are not to be heat-dried need little or no hardener; negatives should always be hardened.

For maximum print permanence, use a two-bath fixer system, treating each print for approximately half the required time in each bath. Here is an easy two-bath system:

1. Set up only one fixer bath during the printing session. Keep each print in that bath for one-half the recommended fixing time. Agitate at least half the time for which the print remains in the bath.

2. Place the half-fixed print in a tray of water. Change the water every fifteen to thirty minutes during the printing session.

3. After the printing session is over, mix up a fresh fixer bath (preferably without hardener) and shuffle the prints through this bath for the second half of the required time.

4. Wash normally.

If you are processing a lot of prints, throw out the first bath after the printing session, and save the second bath for reuse later as a first bath. If you are processing only a few prints, you can save both baths.

Good Washing Technique

Negatives and prints can never be completely rid of unwanted fixer and silver compounds, but a thorough wash will reduce these contaminants to a minimum. The following considerations are important for good washing technique:

Be sure the wash water is constantly changing; fixer that is removed from negatives or prints ends up in the wash water, and fixer-laden water will not effect a proper wash. A good rule is to use a washing system that will create a complete change of water every five

minutes. Ideally, the water should enter at the bottom and drain at the top of the washing apparatus.

Separate and agitate negatives and prints while washing to guarantee an efficient rinse. Special archival washers (see Appendix 2 for sources of supply) provide separate slots for individual sheets of negatives and prints. Otherwise, you must agitate by hand. Roll film should be kept on the reel during the entire wash; sheet film should be washed a few sheets at a time in a tray, or washed while on film hangers in a tank.

Always use a washing aid for both negatives and prints to shorten the wash time, and to effect a more thorough wash. A plain water rinse will never wash as thoroughly as a washing aid followed by a water rinse.

RC papers (resin-coated) should be handled differently than regular papers. They should be washed (for approximately five minutes) immediately after they are fixed. A washing aid is not necessary. Also, they should be dried immediately after they are washed.

You can mix a formula to test the efficiency of your negative or print washing procedure. The following solution will react with the fixer remaining in the negative or print to leave a stain; the deeper the stain, the more fixer remains, and the less efficient the washing procedure.

Kodak HT-2

water	750 milliliters	24 ounces
acetic acid (28% solution)*	125 milliliters	125 milliliters
silver nitrate	7.5 grams	½ teaspoon
water to make	1 liter	1 quart

*To prepare a 28 percent solution, mix three parts of glacial acetic acid with eight parts of water.

Storage: Store HT-2 away from light, in a tightly stoppered, dark bottle.
Note: Mix in low light, preferably darkness.
Take care: HT-2 will cause staining, so do not touch or spill it. Also, if possible, use distilled water for this formula, even when mixing the 28 percent acetic acid solution.
To use: 1. Wash the negative or print thoroughly, making careful note of the times in the washing aid and in the final wash.

2. Apply one drop of HT-2 to a clear (unexposed) edge of a dried negative, or to a white (unexposed) margin of a wet print (first wiping off the excess water).

3. Cover the drop with an inverted roll-film tank (or any dark container) to prevent light from influencing the test.

4. Wait two minutes (the timing is important), and wipe off the drop with a clean cloth or tissue.

5. If discoloration occurs, a more thorough wash is needed. Wash for a longer period of time and test again. The lighter the discoloration, the more efficient the wash. Properly processed negatives or prints should show little, if any, discoloration.

6. Repeat the test on other parts and on the other side of the negative or the print. Washing is usually more efficient on one section than on another. In particular, an edge section tends to wash more rapidly than a center section.

Drying Prints

The normal print-drying methods — blotters and electric dryers — are easily contaminated if not used with extreme care. Poorly fixed or washed prints will stain the blotter paper or the cloth apron, and contaminate or stain all succeeding prints.

Air drying is the preferable method of drying. It can take several hours, depending upon the type of paper used and the temperature and humidity of the room; but it is safe, efficient, and inexpensive. There are two common ways to air dry prints.

You can simply hang the prints up on a clothesline:

1. Remove the excess water from each print by gently squeegeeing it on both sides.

2. Put two prints together, back to back, with their emulsions facing out.

3. Hang the prints from a clothesline (or piece of twine) using four spring-type clothespins, one on each corner of the print.

Or you can build or buy (see Appendix 2 for suppliers) fiberglass drying screens, and lay the prints on the screens until they are dry. Use only fiberglass screens because they clean easily and do not rust. Air will flow through the screens, effecting fast and efficient drying. Here are instructions for building a very simple drying screen to

Nail or hammer the wood together to make a rectangular frame

Stretch fiberglass screening along the frame, stapling or tacking it to the wood

To dry: After squeegeeing the prints, lay them on the screens, emulsion side down (emulsion side up with RC papers)

accommodate up to eight 8″ × 10″ prints (several screens of this type can be stacked for easy storage):

1. Make a frame for the screening. 1″ × 1″ wood is a good size, although similar sizes will work as well. Cut the wood into two two-foot lengths, and two three-foot lengths.

2. Nail or hammer the wood together into a rectangular frame with the ends of the three-foot lengths butted up against the sides of the two-foot lengths. It is a good idea, though not required, to treat the wood with two coats of glossy polyurethane.

3. Buy fiberglass screening material, available from any hardware store, 38″ × 24″, for each frame. Stretch the screening along the frame, stapling or tacking it to the wood.

Before using the drying screens, scrub them with soap and water and rinse them thoroughly. The screens should also be cleaned periodically in the same manner.

To screen dry:

1. Remove the excess water from each print by gently squeegeeing it on both sides.

2. Lay prints to dry, emulsion side down (with RC papers, emulsion side up), on the screens.

A common problem with air drying is that the prints do not always lie flat. Print-flattening solutions help somewhat, but they are damaging to print permanence. The best ways to ensure print flatness are:

Reduce or eliminate the amount of hardener in the fixer.

Use double-weight printing papers.

Place a heavy book on top of the prints immediately after drying.

Best of all, place the dried prints, one at a time, in a dry-mount press at approximately 225 degrees for thirty seconds, and place a heavy book on them until they cool off. Be sure the surface of the prints is protected from the heated plate of the press by a clean piece of heavy paper or cardboard.

RC papers should dry flat without these precautions.

Mounting Prints

Most mounting boards contain harmful sulfur or acid compounds that slowly attack and stain prints. For maximum print permanence, use acid-free boards. Several types are available, most commonly 100 percent *rag* (made of cotton fiber) board. Most rag boards, such as Museum Board (made by Bainbridge, Process Materials, and Strathmore) are acid-free, but are also expensive. Process Materials makes a good, nonrag, but acid-free, alternative called Conservation Board. Mounting board is available at all art supply stores and through mail-order firms (see Appendix 2 for suppliers).

Some people mount their prints back to back on a piece of unexposed, but archivally processed, double-weight photographic paper. This paper provides a safe and inexpensive backing that also minimizes the curling tendency of prints.

Dry mounting and overmatting are the best ways to mount prints. Spray and liquid adhesives are damaging to print permanence.

Negative and Print Storing

Many storage containers — even conventional items, like glassine negative envelopes — contain impurities that will eventually contaminate negatives and prints. The following materials are safe for storage:

> Aluminum
> Cellulose acetate
> Glass or porcelain
> Hard rubber
> Metals coated with baked enamel
> 100% rag content, acid-free paper or storage boxes
> Polyethylene
> Stainless steel

For maximum permanence, negatives should be protected by polyethylene or acid-free envelopes, such as Print File negative preservatives; and prints should be protected by acid-free paper and boxes. (Appendix 2 lists some mail-order suppliers of envelopes and boxes for negative and print storage.)

Special Techniques for Archival Care of Prints

Hypo Eliminator

The use of hypo eliminator (not to be confused with Hypo Clearing Agent or Hypo Neutralizer, which are washing aids) provides a final step that transforms most of the remaining fixer in the print into sodium sulfate — a substance that is not harmful to silver and is soluble in the final wash. The term "hypo eliminator" is a misnomer; it does not completely eliminate fixer, but it does reduce the fixer to a minimum.

Kodak Hypo Eliminator
(HE-1)

water	500 milliliters	16 ounces
hydrogen peroxide (3% solution)	125 milliliters	4 ounces
ammonia solution*	100 milliliters	3½ ounces
water to make	1 liter	1 quart

*To make, mix one part of concentrated ammonia (28 percent solution) to nine parts of water.

Storage: Never store HE-1.
Dilute for use: Use undiluted.
Capacity: Fifteen 8″ × 10″ prints per liter.
Note: Hydrogen peroxide and ammonia are unavailable in camera stores but are available in drugstores and chemical supply houses.
Take care: Do not put HE-1 in a stoppered bottle; the gases in the solution could break the bottle.
To use: 1. Wash prints thoroughly, using a washing aid.

2. Transfer prints directly to a tray of HE-1 for six minutes. Agitate constantly.

3. Wash prints for fifteen more minutes in running water, and air dry as usual.

Sprint Systems, a chemical company in Pawtucket, Rhode Island, recommends this alternate hypo eliminator formula:

Sprint Hypo Eliminator

water	750 milliliters	24 ounces
formaldehyde	15 milliliters	½ ounce
baking soda	1 gram	¼ teaspoon
water to make	1 liter	1 quart

To use: 1. Wash prints normally, but halfway through the final water rinse, transfer them into a tray of hypo eliminator.

2. Keep prints in hypo eliminator for three to five minutes with constant agitation.

3. Continue the final wash to completion. Air dry as usual.

Toning for Protection

Certain print-toning formulas provide excellent protection against print deterioration. Kodak Blue Toner and, especially, two-bath sepia toners provide the most protection; however, both these formulas produce an obvious color change that may be undesirable. Selenium toning provides protection against certain types of deterioration, but is useless and possibly detrimental to print permanence in other ways; however, selenium toning does produce a minimum change in image color. Pages 123–126 provide more information on these toning formulas.

Certain gold-toning formulas are quite protective, and produce little, if any, color change. However, the cost of gold toning is high (approximately thirty cents for an 8″ × 10″ print, as of this writing). Also, you must buy a minimum of one gram of gold chloride from a supplier (one gram will tone approximately eighty 8″ × 10″ prints). When mixed, the toning solution does not keep, so use it efficiently; if

you decide on gold toning, set aside several prints to be toned at one time.

<div align="center">

Kodak Gold Protective Solution
(GP-1)

</div>

water	750 milliliters	24 ounces
gold chloride (1% stock solution)*	10 milliliters	⅓ ounce
sodium thiocyanate (liquid)	15.2 milliliters	½ ounce
water to make	1 liter	1 quart

*To make a 1 percent solution, mix one gram of gold chloride into one hundred milliliters of water.

Storage: The 1 percent gold chloride solution can be stored; the mixed GP-1 solution must be used, then thrown out after use.
Capacity: Eight 8″ × 10″ prints per liter.
Note: Special mixing instructions: first, add the 1 percent gold chloride solution to the 750 milliliters of water; then mix the sodium thiocyanate separately into 125 milliliters of water; combine the two solutions just before use, with rapid, smooth stirring. Then add water to make one liter, and stir again.
To use: 1. Wash prints thoroughly, using both a washing aid (between water rinses) and a hypo eliminator bath.

2. Transfer the prints directly to the toning bath for ten minutes (at 68 degrees) or until a slight color change (to blue-black) is evident. Agitate constantly.

3. Wash prints for fifteen minutes in running water; then air dry.

Further Reading

East Street Gallery. *Procedures for Processing and Storing Black and White Photographs for Maximum Possible Permanence.* Grinnell, Iowa: East Street Gallery, 1970.

Eastman Kodak Company. *B/W Processing for Permanence.* Rochester, New York: Kodak Publication J-19, 1973.

Time-Life Books. *Caring for Photographs: Display, Storage, and Restoration.* New York: Life Library of Photography, 1972.

Wilhelm, Henry. *Preservation of Contemporary Photographic Materials.* Grinnell, Iowa: East Street Gallery, 1977.

Processing Controls

This chapter is a mixture of observations, techniques, and chemical formulas designed to improve control over film and print processing. Some are important to know, and some are simply interesting to know about. Do not assume that all these formulas and techniques are necessary for each and every negative and print you make. Instead, read over the chapter, adopting the information that you can immediately use, while filing the rest away for future reference.

Different films, papers, and chemicals have different characteristics. Also, manufacturers are constantly changing their products to provide better or different results. Therefore, the instructions and observations in this chapter may need modification for some products. If in doubt, refer to the manufacturer's published instructions, or write the manufacturer directly. Most are quite willing to help out. Addresses of major film, paper, and chemical manufacturers are listed in Appendix 2.

Film Processing

Development Controls

Grain

Film developers convert the exposed silver halide crystals of the film emulsion into clumps of metallic silver that make up the photographic image. These clumps of silver are referred to as *grain*, and are usually visible in the print. A negative with large clumps of silver has *coarse grain;* a negative with small clumps of silver has *fine grain.* Coarse grain is occasionally wanted to create a special effect; but fine grain is usually more desirable.

Printing paper, when developed, also displays coarse- or fine-grain characteristics. However, the appearance of paper grain is most noticeable in its rendition of print color or print tone (see pages 114–117).

The grain characteristics of a negative are dependent on several factors, many of which are unrelated to the developing process:

Film speed: The slower the speed of the film, the finer the grain; the faster the speed of the film, the coarser the grain.

Film exposure: An overexposed negative will have coarser grain than a correctly exposed negative.

Film development: An overdeveloped negative will have coarser grain than a normally developed negative.

Film developers also have an effect on negative graininess, though this effect is sometimes overrated. Most developer formulas rightfully claim fine-grain characteristics, but some will produce finer grain than others. Several factors related to developer formulas affect the grain characteristics of the negative:

Developing agent: Most film developers use a combination of Metol or phenidone combined with hydroquinone as developing agents. Both combinations provide good, fine-grain characteristics. Those formulas using either orthophenylene diamine or paraphenylene diamine as developing agents provide even finer grain, but at a loss of one or two stops of film speed. In fact, most extrafine-grain developers, regardless of the developing agent used, are linked with a loss of

film speed. For example, when using developers such as Kodak Microdol X and Ilford Perceptol, plan to increase film exposure by approximately one stop.

Accelerator: Fine-grain developers use mild developer accelerators, such as borax or Kodalk.

Sodium sulfite: Sodium sulfite is the preservative used in most developer formulas, but it also plays a role in reducing negative graininess. Sodium sulfite acts as a mild accelerator; in fact, some fine-grain formulas (such as Kodak D-23, see page 92) use only sodium sulfite as both the accelerator and the preservative.

Also, a large amount of sodium sulfite acts as a mild silver halide solvent, actually dissolving parts of the silver and making the grain less apparent. Therefore, developer formulas with large amounts of sodium sulfite display finer-grain characteristics. However, too much sodium sulfite tends to soften the grain pattern and reduce the sharpness of the image.

Some film developers can be modified to produce finer-grain negatives by adding extra amounts of sodium sulfite. For example, Agfa Rodinal is an extremely concentrated liquid that is not a particularly fine-grain developer; however, it does produce exceptionally sharp negatives. To produce finer-grain results, add approximately forty-five grams (or two tablespoons) of sodium sulfite to each liter (or quart) of diluted Rodinal. Try diluting Rodinal one-to-one-hundred with water, adding the sodium sulfite, and developing Kodak Plus-X (or Ilford FP-4) for eleven and one-half minutes at 68 degrees. Or try diluting Rodinal one-to-seventy-five with water, adding the sodium sulfite, and developing Kodak Tri-X (or Ilford HP-4) for fourteen and one-half minutes at 68 degrees.

Edwal FG-7 is a somewhat less concentrated liquid that produces fine-grain and low-contrast negatives. To produce even finer grain, add approximately ninety grams (or four tablespoons) of sodium sulfite to each liter (or quart) of diluted FG-7. Try diluting FG-7 one-to-fifteen with water, adding the sodium sulfite, and developing Kodak Plus-X for five minutes, Ilford FP-4 for six minutes, Kodak Tri-X for six minutes, and Ilford HP-4 for seven minutes (all at 70 degrees).

Contrast

Negative contrast is also a result of several factors:

Subject contrast: The higher the contrast of the subject, the higher the negative contrast.

Negative exposure: Both an underexposed and an overexposed negative will affect negative contrast — usually reducing it.

Type of film: Some films have inherently more contrast than others. Kodak High-Contrast Copy film, for example, produces much higher contrast negatives than Ilford HP4 film.

Amount of development: Increased development produces more contrast than normal or decreased development. Increased development is achieved through longer developing times, stronger developer concentrations, warmer developer temperatures, or more vigorous agitation.

Developer formulas also affect negative contrast, though rarely as dramatically as the aforementioned factors.

Developing agent: Hydroquinone is a high-contrast developing agent; Metol and phenidone are low-contrast developing agents.

Accelerator: When a strong accelerator, such as sodium hydroxide, is used, the result is higher negative contrast; when a mild accelerator, such as sodium sulfite or borax is used, the result is lower negative contrast.

Kodak D-23 is an excellent, all-purpose film developer that resembles Kodak D-76, but produces lower-contrast negatives. It uses only two chemicals: Metol, as the developing agent, and sodium sulfite, as both the preservative and the accelerator. D-23 is commercially unavailable, but easy to mix.

Kodak D-23

water at 125° F (or 52° C)	750 milliliters	24 ounces
Elon	7.5 grams	2½ teaspoons
sodium sulfite, desiccated	100 grams	4 tablespoons plus 1 teaspoon
water to make	1 liter	1 quart

Dilute for use: Use undiluted.

To use: For approximately 10 percent less time than for Kodak D-76, such as:

Kodak Tri-X	7 minutes at 68° F
Kodak Panatomic-X	6¼ minutes at 68° F
Ilford HP4	6¼ minutes at 68° F
Ilford FP4	5½ minutes at 68° F

Pushing Film

Pushing film refers to underexposing and overdeveloping film to produce a printable negative from a low-light situation (see pages 28–30 for a review of underexposing and overdeveloping). By underexposing, you are assigning a higher exposure index to your film. It is as if the film had increased sensitivity, a factor badly needed in low light to permit a small enough aperture or a fast enough shutter speed to capture the image. By overdeveloping, you are increasing contrast for a more printable negative.

For example, assume you are using 400 A.S.A. film. If the indicated exposure is 1/15 at f 2, you may rate your film at E.I. 800 and expose for one stop less, either 1/30 at f 2, or 1/15 at f 2.8. Or, you may rate your film at E.I. 1600 and expose for two stops less, either 1/60 at f 2, 1/30 at f 2.8, or 1/15 at f 4. Your choice is dependent upon whether you require a faster shutter speed or a smaller aperture.

One problem with pushing film is that the film's actual sensitivity never changes. Four hundred A.S.A. film remains 400 A.S.A.; you are simply assigning it a different exposure index. Outdoors, in flat light, there is little danger that slight underexposure will eliminate shadow detail, since the shadows have plenty of density when normally exposed. However, indoors, in low light, there is great danger of losing shadow detail, since the shadows may be thin even when normally exposed; under low light, shadow areas are darker than they are outdoors in flat light.

After the film has been underexposed, it must be overdeveloped to create enough negative contrast for an acceptable print. The amount of development varies widely with the type of film, the type of developer, and the dilution of the developer. Here are general guidelines for pushing film; note that they are the same as for underexposing and overdeveloping:

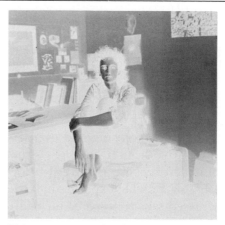

The indicated exposure at 400 A.S.A. was ⅛ at f 2.8. The film was rated at 1600 A.S.A. and shot at 1/30 at f 2.8, to prevent the subject from blurring. The result with normal development is an underexposed negative.

This negative was also shot at 1600 A.S.A., 1/30 at f 2.8, but with "pushed" development. The developer that was used claimed to produce an effective film speed of 1600 A.S.A. The shadows are still thin, though slightly denser than they would have been with normal development. The highlights are much denser, providing a negative with more contrast. The effect is similar to underexposure and overdevelopment.

A print from that negative. Note: Pushing film generally yields prints with greater contrast and more graininess (the graininess is not so evident in this example).

A print from that negative

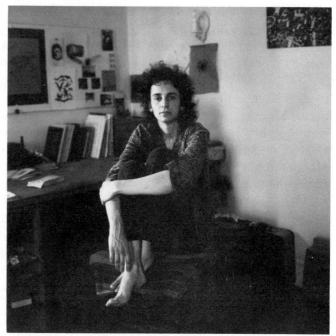

for film speed of *	underexpose by	overdevelop by
400 A.S.A.	normal exposure	normal development
E.I. 800	one stop	50 percent
E.I. 1600	two stops	100 percent

*For film speeds with an A.S.A. other than 400, simply double the rating for each stop of underexposure; for example, 125 A.S.A. can be rated at E.I. 250, underexposed by one stop, then overdeveloped by 50 percent.

The best results when pushing film are usually accomplished with special "high-energy" developers, such as Acufine, Besseler FD3, Edwal Super-12, and Ethol UFG. The manufacturers of these products sometimes make optimistic claims about their ability to increase film speed without losing shadow detail. For example, be wary of the developer that claims to produce a four-stop speed increase. However, many "high-energy" developers will produce a little more shadow detail; and most will increase the contrast of the negative enough to produce acceptable prints.

There are several disadvantages to pushing film, regardless of claims made by the manufacturers:

Shadow detail will be minimal: Regardless of the developer's ability to render shadow detail, in low light an underexposed negative will have little if any detail.

Graininess will be increased: Pushing film is similar to overdeveloping film; negative density will be increased, especially in the highlights; therefore, graininess will be increased.

Contrast will be increased: Pushing film is like overdeveloping film; the highlight density increases while shadow density is barely affected, causing an increase in negative contrast.

Incidentally, pushing film and intensifying negatives are quite similar. See pages 109–112 for information on intensification.

Two-Bath Development

Developers can be divided into two parts for simple, almost automatic, negative-making. The resulting negatives have excellent shadow detail and relatively low contrast. There are several variations, but all two-bath formulas work on the same principle. The first bath contains a normal developer formula, except there is little or no

accelerator added; in this bath, the film soaks up the solution, but does not darken significantly because developers are largely inactive without an accelerator. The second bath contains only the accelerator (in some versions, sodium sulfite is also added to the second bath to prolong its working life); in this bath, the developer that has been soaked into the film is activated, and full development is achieved.

Two-bath development is almost automatic. The time the film is in (and the temperature of) either bath is relatively unimportant. The first bath simply soaks into the film; it does not develop it. The second bath merely activates the developer which has soaked into the film; beyond that, it has a limited impact upon the results. Furthermore, the type of film used is not important; Kodak Tri-X and Kodak Panatomic-X can be developed in the same tank for the same amount of time in each bath. In each case, full development is reached at the end of the second bath. (However, note that two-bath development is most effective with thick-emulsion films like Tri-X.)

Two-bath developers act in a *compensating* manner — that is, compared to single-solution developers, they develop the shadows more fully than they develop the highlights. Because the highlights represent heavily exposed areas, the developing agents become quickly exhausted when they react with the second bath, and development stops short. In the shadows, because they are more lightly exposed, development continues more slowly and, therefore, more completely. As a result, negatives developed in two-bath solutions have fuller shadow detail and less contrast than negatives developed in comparable single-solution developers.

Contrast control is very limited with two-bath development. However, an increase in the time of the first bath will increase contrast slightly.

Some two-bath formulas actually increase the effective speed of, or "push," the film. Diafine is a commercially available example; its makers claim a speed increase of approximately two and one-half stops. Edwal offers a two-bath alternative with its standard FG-7 developer; they claim an increase of almost two stops greater film speed. These claims may be somewhat optimistic, but an increase of one or two stops can be reasonably expected.

You can buy a two-bath formula, like Diafine, or mix your own.

Kodak D-23 can be used as a first bath, for a short period of time, and then a mild borax (or Kodalk) bath is used to complete development.

Two-Bath Variation
of Kodak D-23

First Bath:

water at 125° F (or 52° C)	750 milliliters	24 ounces
Elon (or Metol)	7.5 grams	2 teaspoons
sodium sulfite, desiccated	100 grams	4 tablespoons plus one teaspoon
water to make	1 liter	1 quart

Second Bath:

water	750 milliliters	24 ounces
borax (or Kodalk)	15 grams	1 tablespoon
water to make	1 liter	1 quart

Storage: Keep the first bath in a tightly stoppered bottle for six months, then discard it. Unused second bath can be stored for the same period of time in the same manner.

Dilute for use: Use undiluted.

To use: 1. Soak the film in the first bath for four minutes, agitating normally, at approximately 68 to 70 degrees.

2. Pour out the first bath and add the second bath for three minutes, at approximately the same temperature.

Do not use a water rinse between the first and second baths. Agitation in the second bath should be minimal and gentle, or else streaking may occur. Try agitating for less than the normal time, approximately five seconds out of every minute. If streaking becomes a problem with roll film, you may need to invert the film by hand. After thirty seconds of the second bath, shut off the room light and remove the film reel from its tank. Invert the reel and return it to the tank. One minute later, invert it again.

3. Stop, fix, wash, and dry in the normal manner. For increased contrast, use a five- or six-minute first bath.

Kodak D-76 can be modified and split up into two parts for effective two-bath development:

Two-Bath Variation
of Kodak D-76

First Bath:

water at 125° F (or 52° C)	750 milliliters	24 ounces
Elon (or Metol)	2 grams	½ teaspoon
sodium sulfite, desiccated	100 grams	4 tablespoons plus 1 teaspoon
hydroquinone	6 grams	2 teaspoons
potassium bromide	1 gram	⅛ teaspoon
water to make	1 liter	1 quart

Second Bath:

water	750 milliliters	24 ounces
borax (or Kodalk)	30 grams	2 tablespoons
water to make	1 liter	1 quart

Capacity: The first bath can be used and reused for dozens of rolls of film without replenishment. The second bath should be used for a very few (about four) rolls, and then discarded.

Storage: The same as for two-bath D-23.

To use: The same way and for the same lengths of time as two-bath D-23.

Replenishing Developers

A *replenisher* is a solution that is added to used film developer to give it new life. Some developers are made to be used once and then discarded; others can be used, chemically replenished, and then reused several times.

Replenishers are similar in composition to developers, except they generally contain no additional bromide (for a restrainer). The development process deposits bromide from the film into the used developer solution, so the replenisher needs no bromide.

The advantages of replenishment relate to expense and waste. It is much cheaper to replenish used developer than to mix new solutions; and it is less wasteful to reuse chemicals than to throw them out.

The disadvantages of replenishment relate to control. Development times may change as the replenished solution ages, and that change is difficult to measure. For most purposes, the change is minimal, a case of slight over- or underdevelopment, which in turn leads to a little

more or a little less than normal contrast. Generally, too little replenisher is preferable to too much replenisher, since, after development, it is easier to build up the negative contrast (with a higher grade of printing paper) than to reduce it.

Replenishment procedures vary with different developers. Here are some general guidelines:

add the following amount of replenisher . . .	for each of the following amounts of film developed
15 milliliters (or ½ ounce)	35 mm (20 exposures)
22 milliliters (or ¾ ounce)	35 mm (36 exposures)
22 milliliters (or ¾ ounce)	120 or 620 size
15 milliliters (or ½ ounce)	127 size
22 milliliters (or ¾ ounce)	4 4″ × 5″ (sheets)

The recommended procedure is:

1. After each use of the developer, pour the required amount of replenisher into an empty graduate.

2. Then pour the used developer into the graduate to fill it up to the original volume.

3. Discard any extra used developer beyond that volume.

Throw out the replenished developer when (1) sludge or dirt forms in the solution; (2) the processed film shows staining or fogging; (3) the following amounts of film have been processed per gallon of replenished developer:

> 200 rolls of 35 mm (20 exposures each)
> 100 rolls of 35 mm (36 exposures each)
> 120 rolls of 120 or 620 size
> 220 rolls of 127 size
> 480 sheets of 4″ × 5″ size

Replenishers for many common developers are available in packaged form in camera stores. Kodak D-23 developer is replenished by the following formula:

Kodak DK-25R

water at 125° F (or 52° C)	750 milliliters	24 ounces
Elon	10 grams	1 tablespoon
sodium sulfite, desiccated	100 grams	4 tablespoons plus 1 teaspoon
Kodalk	20 grams	1 tablespoon plus 1 teaspoon
cold water to make	1 liter	1 quart

Dilute for use: Use undiluted.
Note: Double the normal replenishment rate to forty-four milliliters per 35 mm (36-exposure) roll for the first thirteen rolls per gallon of DK-25R used.

Developing by Inspection

Film can be inspected during development to ensure negatives of desired density. This technique obviates time and temperature calculations, and is especially useful when you are uncertain about film exposure.

For the best results, *desensitize* the film before starting development. Generally, sheet film is used, but even roll film can be developed by inspection if desensitized first.

A dim, green safelight is used for viewing the negatives. Kodak recommends a #3 safelight with a 15-watt bulb, but this combination provides a very low level of illumination. A brighter light (such as a #3 safelight with a 75-watt bulb or a #7 safelight with a 15-watt bulb) can be used safely.

Kodak Desensitizer is the primary available formula. It is expensive, but lasts for a very long time.

Kodak Desensitizer

Mix:	
water at 125° F (or 52° C)	1 liter
Kodak Desensitizer	1 gram

Storage: Away from bright light.
Dilute for use: One part of stock solution to fifty parts of water.
Capacity: Sixteen 4″ × 5″ sheets of film, four 35 mm (36-exposure) rolls, or the equivalent, per liter of diluted solution.

Usually reserved for sheet film processing, but can be used for roll film as well. After desensitizing the film, periodically hold it up close to the safelight to watch the development progress.

Do not try to look directly through the film

Instead, view the emulsion side at a slight angle to the safelight, so the light bounces off the film, reflecting the developing image

To use: 1. Prewet the film in water for approximately one minute (optional).

2. In total darkness, soak the film for two to three minutes in a working solution of desensitizer. Agitate for one or two minutes.

3. Rinse the film for fifteen seconds in running water.

4. Place the film in the developer and agitate normally.

5. Turn on the safelight at any time after desensitization. It may remain on during the entire development time.

6. The film may be inspected at will, viewed close to the safelight (right up against the safelight, if necessary). Kodak is somewhat conservative in suggesting that you keep the film at least twelve inches from the safelight, and view it for only five seconds once every thirty seconds. If you follow Kodak's suggestions you will barely be able to see the film. For inspection, do not try to look directly through the film, since it has a milky coating and will not transmit much light. Instead, view the emulsion side at a slight angle to the safelight, so the light bounces off the film, reflecting the developing image.

7. When development is complete, soak the film in the stop bath, and finish the process in the normal manner.

101

To determine when development is complete, watch the progress of the highlights. Remember, exposure controls shadows and development controls highlights. When the highlights reach their desired density, the development is complete.

Potentially, the desensitizer can cause the following problems:

Fogging. With proper desensitization, the danger of fogging is much reduced. If your film does fog, use a dimmer safelight or view the film for less time and at a greater distance from the safelight.

Film staining. Staining will occur if the working solution of the desensitizer is too concentrated, or if sheets of film are stacked together without proper agitation (with sheet film, develop only a few sheets at a time to avoid stacking them).

A loss of effective film speed, or a slowdown in the development process. These are common complaints, but they are exaggerated. Neither of these problems is likely to happen with the Kodak Desensitizer. But, if your negatives do lack shadow detail after inspection development, lower your effective film speed rating by one stop (use E.I. 200 rather than 400 A.S.A.). A slowdown in development, should it happen, is no problem since you should continue development until the negative looks good, regardless of the recommended development time.

The Importance of Temperature

The temperature of the solutions affects the processing times. The higher the temperature, the faster the solution works, so the shorter the required processing time; the lower the temperature, the slower the solution works, so the longer the required processing time.

The ideal temperature for processing black-and-white films is 68 degrees. However, other temperatures can be used. Some manufacturers provide a *time-temperature chart* to offer alternate times for film development. In general, below 65 degrees, solutions will not work efficiently; above 80 degrees, solutions will work rapidly but may cause reticulation.

Reticulation is the appearance of small wrinkle patterns (sometimes mistaken for grain) on the negative emulsion. The prime cause of reticulation is excessive swelling of the gelatin in the film due to extreme processing temperatures. If you develop film at 70 degrees,

and then use a 90-degree stop bath, the gelatin will expand and possibly crack. A common misconception is that temperature control is only important with color processing. Actually, for best results with black-and-white film, the processing temperature must be consistent throughout — from developer to drying — preferably at 68 degrees. Here are some suggestions for maintaining constant temperature throughout the processing:

1. Use chemicals that must be diluted for use. A one-to-nine dilution with water, for example, allows for the use of hot or cold water to compensate for cold or hot storage conditions.

2. Premix the developer, stop bath, fixer, washing aid, and wetting aid in separate containers. Then place the containers in a tray filled with 68-degree water, until they all reach a common temperature.

3. Carefully monitor the temperature of running-water washes. In some cases, it is impossible to maintain a constant temperature (such as when someone in the house flushes the toilet), so use a pail of 68-degree water to effect the wash. Pour water from the pail into the film tank; agitate the tank for thirty seconds; then throw out the water and repeat. A washing aid plus ten changes of water will effect a complete wash.

4. Hang the negatives to dry in an area where the temperature approximates the processing temperature. Do not heat-dry negatives.

In warm or hot temperatures, gelatin swelling is a very serious problem. In extreme heat, the gelatin may even melt and come off the film base. Here are some ways to reduce the effect of high or changing temperatures on gelatin swelling.

1. Do not use highly active (fast-acting) developers, as they contain greater amounts of accelerator that tend to soften the gelatin. Besides, at high temperatures, developing time is greatly reduced (the rule of thumb is: for every 15-degree rise in temperature, the recommended development time must be halved); so low-energy (slow-acting) developers are necessary to obviate very short developing times.

2. Add a quantity of sodium sulfate (*not* sodium sulfite) to the normal developer formula. This chemical acts to cut down the amount of water that the gelatin absorbs, thus reducing swelling. Use as follows:

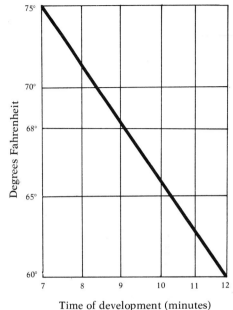

A time-temperature chart providing equivalent developing times for different developer temperatures

if temperature of developer is . . .	add the following quantity of sodium sulfate per liter of working developer solution
75° to 80° F	50 grams (or 2 tablespoons plus ½ teaspoon)
80° to 85° F	75 grams (or 3 tablespoons plus 1 teaspoon)
85° to 90° F	100 grams (or 4 tablespoons plus 1 teaspoon)

The sodium sulfate acts to slow the developing action, so that normal (68-degree) developing times can be used in lieu of the decreased times usually required for warm developer solutions.

3. Use a hardening stop bath, such as Kodak SB-3 (see page 73), in place of a regular stop bath.

4. Use a good hardening fixer, such as Kodak F-6 (see page 74).

5. Use a prehardener before development, such as:

Kodak Prehardener SH-5

Stock solution:		
water	900 milliliters	28 ounces
0.5% solution of Kodak Anti-Fog #2*	40 milliliters	1⅓ ounces
sodium sulfate, desiccated	50 grams	2 tablespoons plus ½ teaspoon
sodium carbonate, monohydrated	12 grams	2 teaspoons
cold water to make	1 liter	1 quart

Just before using add and mix thoroughly:		
formaldehyde	5 milliliters	¹/₈ ounce

*To make, dissolve one gram of Kodak Anti-Fog #2 into two hundred milliliters of water, preferably distilled.

Storage: SH-5 does not keep; throw it out after use.
Note: Formaldehyde is poisonous and should be used with care.
To use: 1. Soak the exposed film in SH-5 for ten minutes with intermittent agitation; then discard.

2. Rinse the film with water for thirty seconds.

3. Develop with the following adjusted times:

temperature	adjusted time
75°	use time recommended by manufacturer for 68°
80°	85% of 68° time
85°	70% of 68° time
90°	60% of 68° time
95°	50% of 68° time

4. A plain water rinse can replace the stop bath. Then fix in a hardening fixer. Wash and dry normally.

The Importance of Agitation

Film (and paper, too) must be agitated during processing to ensure even development. Proper agitation is required throughout the process — developer through wash — but the effects of poor agitation are most immediately evident in the development step. Both under-agitation and overagitation can cause problems. Underagitation may result in low-contrast, streaky negatives, or mottled tonalities; over-agitation may result in high contrast or excessive density on the edges of the negative.

There are dozens of acceptable ways to agitate. The best rule is: stick with whatever works for you. Here are some general guidelines:

Be consistent. Figure out a good method of agitating, and repeat it every time you process.

Inverting the tank is an important part of agitating roll films. If you invert certain types of tanks, the chemical will pour out. Either buy a tank that retains the chemical when inverted, or invert the reel by hand, approximately every two minutes. To invert the reel by hand, shut off the room lights, take the loaded reel out of the tank, turn it upside down, then place it back in the tank.

Rotating the tank is also important. While inversion provides vertical agitation for the film, rotation provides horizontal agitation.

Prewetting the film can ease agitation problems. Before pouring in the developer, fill the tank with water (at the same temperature as the developer). Leave the film soaking in the water for one minute. Pour

out the water and develop as usual. The prewetting will soften up the emulsion and allow the developer to soak in more quickly and more evenly. Prewetting is particularly recommended when working with a fast-acting developer.

Start agitating as soon as the developer is poured into the tank. The first few seconds are important for even development.

Every film/developer combination can create different agitation problems. However, most of the time, one method will work for all types of films and developers.

Here is a simple agitation method that works well for most purposes:

1. Prewet the film for one minute.

2. Pour the developer into the tank as rapidly as possible.

3. Rap the tank two or three times lightly against a counter to dislodge air bubbles.

4. Put the cap on the top of the tank and agitate for thirty seconds in the following manner: rotate the tank around twice, invert it twice, again rotate it twice, invert it twice, and repeat until the thirty seconds are up. The agitation movement should be moderate but constant. Do not violently shake the tank, and do not agitate it in slow motion.

5. After thirty seconds, stop agitating and put the tank down to rest.

6. Wait thirty seconds, then agitate for five seconds in the same manner: rotate the tank twice, invert it twice, and so forth.

7. Stop agitating and put the tank down to rest. Repeat the five-second agitation every thirty seconds — no more and no less.

Agitation is also important while the film is in the stop bath, the fixer, and the washing aid. In the development stage, the image is forming, so the agitation technique is critical to the appearance of the negatives. With the other steps the image has already formed, so the main purpose is to ensure even and efficient processing. During these steps, agitate regularly — for at least one-half the recommended processing time.

Reversal (or *direct positive*) *processing* refers to developing film to produce a positive rather than a negative image, such as with movie film and with color slides. Black-and-white reversal processing is sometimes used for original slides, but more commonly when making slides from existing photographs or other work to be copied. Almost any film can be processed to produce a positive, but certain films are preferable for this purpose, such as Kodak Direct Positive Film (available only in bulk) and Kodak Panatomic-X.

Exposure is especially critical when you are planning for reversal processing, since there is little control in the development process (and, of course, no control in printing). The film should be rated at a film speed of approximately one and one-half stops over the manufacturer's index (for example, rate Panatomic-X at E.I. 80, rather than 32 A.S.A.).

You can mix your own formulas for reversal processing, but packaged formulas are much easier to use. Kodak makes a Direct Positive Processing Kit incorporating all the chemicals; Sprint Systems offers a cheaper and quicker alternative.

The basic development procedure is as follows (times vary with chemistry and type of film, so follow the manufacturer's instructions):

1. *First developer.* The film is developed as a negative in a modified film developer. As with normal development, the exposed silver crystals darken relative to the amount of exposure.

2. *Short water rinse.*

3. *Bleach.* The film is bleached to remove the silver built up in the first developer. After bleaching, only unexposed (and undeveloped) silver remains on the film. The silver removal is proportional to the original exposure. Where the film received a lot of exposure (in the highlights), the bleach leaves little silver; where the film received minimum exposure (in the shadows), the bleach leaves much silver.

4. *Short water rinse (optional).*

5. *Clearing bath.* The bleaching process leaves a stain on the film, and the clearing bath removes that stain. After this point, the film is

A black-and-white slide

107

almost perfectly clear. The exposed (and developed) silver is gone, and only the unexposed (and undeveloped) silver remains.

6. *Reexposure.* The film is reexposed fully to white light. The amount of exposure is not critical; the aim is simply to darken whatever silver remains. The Kodak and Sprint processing methods obviate this step, since their redeveloper — the next step — includes a foggant that chemically simulates reexposure.

7. *Redeveloper.* The film is redeveloped to darken the parts of the film left untouched by the bleach that were either reexposed or chemically fogged. The reversal effect is now complete; the bleach removed most of the highlight density, so the reversed highlights will be appropriately thin; the bleach removed little of the shadow density, so the reversed shadows will be correspondingly dark.

8. *Fix.* Reversal processing uses up virtually all the silver in the film; the exposed silver is bleached out, and the remaining silver is exposed and developed. Since the fixer primarily acts to remove unexposed silver, and no unexposed silver is left, fixing is theoretically unnecessary. However, a brief fix is recommended to harden the film and to remove extraneous bits of silver that might remain.

9. *Wash.* The film is washed normally, preferably with a washing aid.

10. *Optional toning.* A selenium toning bath added to any washing aid (such as Kodak Hypo Clearing Agent) can be used to enrich the image tones. Mix the following solution:

Kodak Rapid Selenium Toner (or GAF Flemish Toner)	15–30 milliliters	1 ounce
Washing aid (working solution)	1 liter	1 quart

and use it after the fixer for thirty seconds to one minute. Then, wash and dry normally.

Contrast control, with reversal processing, is minimal. Altering the exposure and the first developer times will affect contrast somewhat; underexposing and overdeveloping will increase contrast, and overexposing and underdeveloping will decrease contrast. However, these alterations are difficult to control; therefore, normal exposure

(using a gray card or an incident light-meter reading) and normal development are highly recommended.

Negative Repair

Poorly exposed or developed negatives can be repaired to produce better quality prints. *Intensification* will increase the density of a thin negative; *reduction* will decrease the density of a dense negative. Neither technique is difficult or expensive, but both take extra time and can create problems. Always aim at a correctly exposed and developed negative. But keep the following techniques in mind, just in case.

Intensification

Thin negatives — underexposed, underdeveloped, or both — can be intensified for increased density. The process works to deposit a metal (such as chromium, mercury, or silver) onto the existing silver of the negative.

Intensification resembles increased (or pushed) development, since it works primarily on the highlights and barely on the shadows. Thin areas of a negative, such as underexposed shadows, cannot be effectively intensified, since they have little density for the intensifier to build upon. Relatively dense areas, such as highlights, are easily intensified. The net effect is increased negative contrast to allow easier printing. A less desirable side effect is increased graininess.

Negatives must be properly fixed and washed before intensification, or they will stain. If in doubt, refix and rewash. Also, negatives must be well hardened, or the intensifier may damage the image. Be sure to use a hardened fix for the prescribed period of time. If in doubt, soak the film in a plain hardening solution before proceeding, such as:

Kodak Supplementary Hardener SH-1

water	500 milliliters	16 ounces
formaldehyde*	10 milliliters	⅓ ounce
sodium carbonate, monohydrated	6 grams	1 teaspoon
water to make	1 liter	1 quart

*Formaldehyde is poisonous and should be used with care.

An underexposed negative

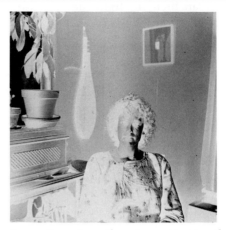

A negative given the same exposure, then treated with a chromium intensifier. Notice that the shadow density is not affected since there is little density for the intensifier to build upon; however, the highlights are much more dense.

A print from that negative lacks contrast

A print from the intensified negative has much more contrast

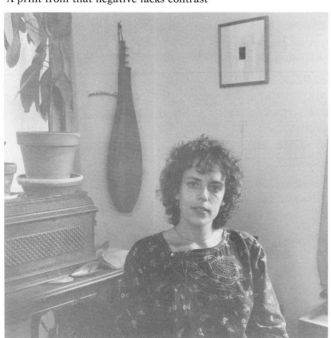

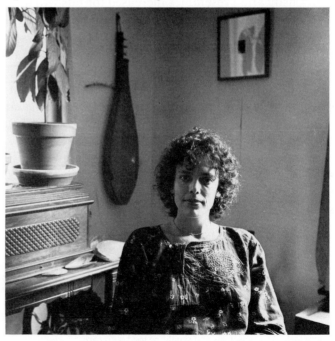

To use: 1. Soak the dry or wet negative in the SH-1 solution for three minutes with intermittent agitation.

 2. Rinse with running water for one minute.

 3. Fix in a hardened or nonhardened fixer bath.

 4. Proceed to repair the negative.

All containers used in the process must be clean; any contamination can cause staining. Also, avoid touching the intensifier since it can irritate skin. Handle the negatives with rubber gloves or print tongs; if contact is necessary, wash your hands immediately afterward.

Intensification is easiest when treating one negative at a time. If using roll film, cut the negative from the roll, and intensify it in trays containing the solutions. The trays should be white to provide a good background for viewing the process.

Packaged intensifiers — almost always chromium formulas — are recommended since they are safer to mix and cheaper to use than those you mix yourself. The chief chemical in chromium intensifiers is potassium dichromate, which is extremely malodorous and unhealthy, especially in its dry form. Mix it with water for use in a well-ventilated room (not necessarily a darkroom; a room with a window open or outdoors is best). As with all formulas, use the intensifier in a well-ventilated darkroom.

The packaged Kodak Chromium Intensifier consists of two parts — an intensifier and a clearing bath. Some formulas leave out the clearing bath, replacing it with a water rinse. Room lights should remain on during the entire intensification process. Here are general instructions:

 1. Soak the wet negative (if negative is dry, presoak it in water for a few minutes) in the intensifier (part A of the Kodak packaged formula) for three to five minutes, with constant agitation. The image will lighten, seemingly disappearing, except for a yellowish stain.

 2. Rinse the negative in running water for approximately one minute.

 3. Soak the negative in the clearing bath (part B) for approximately two minutes, with constant agitation, until the yellowish

stain has largely disappeared; or, wash the negative until the stain disappears.

4. If a clearing bath is used, wash the negative in running water for approximately one minute.

5. Redevelop the negative, agitating constantly, with a diluted paper developer (such as Kodak Dektol, diluted one-to-three with water; DuPont 53-D, diluted one-to-three; or Sprint Quicksilver, diluted one-to-nine). Most film developers are not suitable for redevelopment because their high sulfite content tends to dissolve the image before fully redeveloping it.

6. When the negative reaches the desired density, stop the redevelopment. Fixing is unnecessary. Rinse for fifteen seconds in a stop bath to neutralize development, and then wash normally. The process can be repeated for a second or third time if the initial intensification is inadequate.

Reduction

Dense negatives — either overexposed or overdeveloped — can be reduced for decreased density, most commonly with a solution containing potassium ferricyanide and sodium thiosulfate (plain fixer). This treatment will allow for shorter print exposure times and, when necessary, will correct the contrast of the negative.

Reduction, like intensification, requires well-fixed, hardened, and washed negatives to prevent stains and emulsion damage. Refer to the precautions mentioned for intensifying negatives. Reducers should be used like intensifiers, under room light, with individual negatives treated in white trays.

There are three types of reducer formulas:

1. *Cutting* (or *subtractive*) *reducers* remove density equally in all parts of the negative. Therefore, the reducing effect is most noticeable in the shadows, which have the least density to begin with. The result is thinner shadow areas, most useful when reducing overexposed negatives (remember, exposure controls shadow density).

2. *Proportional reducers* remove density in proportion to the amounts of silver built up on the negative. Therefore, the reducing effect is most noticeable in the highlights, which have the most den-

Reduction

An overexposed negative

A negative given the same exposure after treatment with a Farmer's reducer

112

sity to begin with. The result is thinner highlight areas, most useful when reducing overdeveloped negatives (remember, development controls highlight density).

3. *Superproportional reducers* have the same basic effect as proportional reducers, except they remove even more highlight density and little, if any, shadow density.

The most common use of reducers is for a cutting effect — to correct overexposed negatives. The most common cutting reducer is called Farmer's reducer. It is available in packaged form, or you can mix your own formula. Here is a typical Farmer's reducer:

Kodak Farmer's Reducer (R-4a)

Stock Solution A		
potassium ferri- cyanide, anhydrous	37.5 grams	2 tablespoons plus 1 teaspoon
water to make	500 milliliters	16 ounces
Stock Solution B		
sodium thiosulfate	480 grams	26 tablespoons
water to make	2 liters	2 quarts

Storage: Store each solution separately. They will keep for several months in tightly stoppered bottles, but after being mixed they should be used immediately and thrown out.

Dilute for use: Mix 30 milliliters of solution A with 120 milliliters of solution B; add water to make one liter of working solution.

To use: 1. Put the negative in a tray of diluted solution. Agitate constantly. Reduction usually takes place within thirty seconds to one minute.

2. Pull the negative from the solution and rinse until the light yellow stain left by the reducer is removed.

3. Examine the results. Repeat steps one and two if more reduction is required.

4. Fix, wash, and dry normally.

Print Processing

Development Controls

Paper developers exert an influence over both print color and print contrast. *Color* refers to the tone of the print; *warm* tones are brownish and *cold* tones are neutral black. *Contrast* refers to the difference between the highlights and the shadows of a print; low-contrast (or *soft*) prints are gray with few solid whites or blacks, and high-contrast (or *hard*) prints are white and black with few grays.

Printing papers provide the most important control of color and contrast. The effect of developers is more subtle, and valuable mostly for slight changes that the paper alone cannot provide.

Color

Prints, like negatives, have grains of silver crystals. Print grain is not visible as sandlike texture, but it is an important factor in print color.

The finer the grain, the warmer the print color.

The grain of the paper emulsion provides the key to the eventual print color. Some papers are inherently warm (fine-grain) and some are inherently cold (coarse-grain). Some examples are:

Warm-tone papers:
Agfa Portriga Rapid
GAF Allura
GAF Cykora
Kodak Ektalure
Kodak Medalist
Kodak Polycontrast

Cold-tone papers:
Agfa Brovira
DuPont Varigam
GAF Vee Cee Rapid

Ilford Ilfobrom
Kodak Azo
Kodak Kodabromide

These catagories are relative. Kodak Polycontrast, for example, is a warm-tone paper, but not nearly as warm as Agfa Portriga Rapid.

Development exerts a more subtle but still important control over print tone. A warm-tone developer will produce a warmer color in a print than a cold-tone developer will produce in the same print. The inherent characteristics of the paper generally remain dominant; a warm-tone paper will be browner than a cold-tone paper. But most types of paper vary greatly in tone depending upon the developer used. In general, the color characteristic of a developer is dependent on its activity:

The greater the developer activity, the colder the print color;
the milder the developer activity, the warmer the print color.

The activity, in turn, is affected by several factors. In general:
For warmer tones: Use a warm-tone packaged developer, such as Kodak Selectol Soft or Edwal Super III. Or mix your own formula, such as:

GAF 135

water (125° F or 52° C)	750 milliliters	24 ounces
Metol	1.6 grams	½ teaspoon
sodium sulfite, desiccated	24 grams	1 tablespoon
hydroquinone	6.6 grams	2 teaspoons
sodium carbonate, monohydrated	24 grams	1 tablespoon plus 1 teaspoon
potassium bromide	2.8 grams	½ teaspoon
cold water to make	1 liter	1 quart

Dilute for use: One part stock solution with one part water.
To use: For approximately one and one-half to two minutes.

Or: Increase the dilution of the working solution of developer. If

115

the manufacturer recommends one part of stock developer to three parts water, try one-to-four or one-to-five instead.

Or: Overexpose and underdevelop the print. If normal exposure and development is ten seconds at two minutes, try instead: twelve seconds at one and one-half minutes, or fifteen seconds at one minute. Exact times vary with the conditions, so experimentation is necessary.

For colder tones: Use a cold-tone packaged developer, such as Kodak Dektol, Printofine, or Sprint Quicksilver. Or mix your own formula, such as:

GAF 103

water at 125° F (or 52° C)	750 milliliters	24 ounces
Metol	3.5 grams	1 teaspoon
sodium sulfite, desiccated	45 grams	2 tablespoons
hydroquinone	11.5 grams	1 tablespoon plus ¾ teaspoon
sodium carbonate, monohydrated	75 grams	4 tablespoons plus ½ teaspoon
potassium bromide	1.2 grams	¼ teaspoon
cold water to make	1 liter	1 quart

Dilute for use: One part stock solution with one part water.
To use: For approximately one to one and one-half minutes.

Or: try the following formula using amidol — an expensive but excellent cold-tone developing agent:

GAF 113

water	750 milliliters	24 ounces
amidol	6.6 grams	1 tablespoon
sodium sulfite, desiccated	44 grams	2 tablespoons
potassium bromide	0.5 grams	⅛ teaspoon
water to make	1 liter	1 quart

Storage: Mix just before use, then throw out after printing session or when capacity is reached. Amidol developers are very short-lived.

Dilute for use: Use without dilution.
Note: If hot water is used for mixing, dissolve the sodium sulfite and the potassium bromide first. Then add the amidol after the solution cools off.
To use: For one to two minutes.

Or: Decrease the dilution of the working solution of the developer. If the manufacturer recommends one part of stock developer to three parts of water, try one-to-one or use undiluted instead.

Or: Underexpose and overdevelop the print. If normal exposure and development is ten seconds at two minutes, try instead eight seconds at three minutes, or six seconds at five minutes.

The rules above are generally true but not always useful. For example, a short development time will produce warmer tones than a long development time but may produce ugly warm tones or uneven, streaky development. Also, different developer formulas react differently to changes in activity. The surest way to control print color is to vary the type of paper or type of developer used.

Contrast

Differently graded (or polycontrast) papers produce the most significant changes in print contrast; the higher the grade of paper, the greater the contrast. Paper development exerts a more subtle control. Some developers will naturally produce more or less contrast than others. In general:

> *The greater the print developer activity the greater the print contrast; the milder the activity, the lower the print contrast.*

So, print color and print contrast are somewhat related. Development that produces warm tones usually produces low contrast; development that produces cold tones usually produces high contrast. There are exceptions to this rule; for example, large amounts of potassium bromide, a restrainer, produce higher contrast and warmer tones than smaller amounts (see discussion of developer additives, pages 121–122).

For lower contrast: Use a low-contrast packaged developer, such as those suggested as warm-tone developers, or:

This print was developed in Kodak Dektol

This print was made from the same negative, and developed in GAF 120; note the decreased contrast. A similar effect can be achieved by using a lower-contrast grade of paper.

GAF 120

water at 125° F (or 52° C)	750 milliliters	24 ounces
Metol	12.3 grams	1 tablespoon plus ½ teaspoon
sodium sulfite, desiccated	36 grams	4¾ teaspoons
sodium carbonate, monohydrated	36 grams	2 tablespoons
potassium bromide	1.8 grams	¼ teaspoon
cold water to make	1 liter	1 quart

Dilute to use: One part stock solution with one part water.
To use: For approximately one and one-half to three minutes.

Or: Increase the dilution of the working solution of developer.
Or: Overexpose and underdevelop the print.

For higher contrast: Use a high-contrast packaged developer, such as those suggested as cold-tone developers.
Or: Decrease the dilution of the working solution of the developer.
Or: Underexpose and overdevelop the print.

Beer's Developer

Beer's developer is a traditional two-solution formula that can be combined in different concentrations to yield different print contrasts. Part A uses only Metol as the developing agent and therefore produces low contrast; part B uses only hydroquinone as the developing agent and produces higher contrast.

Beer's developers can provide a range that is the equivalent of approximately three paper grades. You can, of course, simply change paper grades and achieve similar results. However, Beer's does provide a means for more precise contrast control; for example, you can simulate a #3½ or even a #3¼ paper grade.

A Beer's Developer Formula

Part A

water at 125° F (or 52° C)	750 milliliters	24 ounces
Metol	8 grams	2¼ teaspoons
sodium sulfite	23 grams	1 tablespoon
sodium carbonate, monohydrated	23 grams	1 tablespoon plus ¾ teaspoon
potassium bromide	1.5 grams	¼ teaspoon
cold water to make	1 liter	1 quart

Part B

water at 125° F (or 52° C)	750 milliliters	24 ounces
hydroquinone	8 grams	1 tablespoon
sodium sulfite	23 grams	1 tablespoon
sodium carbonate, monohydrated	32 grams	1 tablespoon plus 2 teaspoons
potassium bromide	2 grams	⅜ teaspoon
cold water to make	1 liter	1 quart

Storage: Solution A keeps well, but solution B should be thrown out after a maximum of two weeks.

To use: Mix parts A and B together as follows for one liter of working solution:

For normal contrast:

part A	300 milliliters	10 ounces
part B	200 milliliters	6 ounces
water	500 milliliters	16 ounces

For high contrast:

part A	125 milliliters	3 ounces
part B	875 milliliters	29 ounces

For low contrast:

part A	500 milliliters	16 ounces
water	500 milliliters	16 ounces

You can work out your own mixtures, along these lines, for intermediate higher- or lower-contrast results.

A Beer's formula can be simulated by combining a packaged low-contrast developer (such as Kodak Selectol Soft) and a packaged high-contrast developer (such as Kodak Dektol). Simply call the stock solution of low-contrast developer "part A," and call the stock solu-

tion of high-contrast developer "part B." The results are good, almost as dramatic as with the Beer's formula.

Developer Additives

Packaged developers can be modified by the addition of other chemicals to alter print color or the print contrast. These changes are usually quite subtle.

A convenient way to store and to use additives is in a weak solution, for example, 10 percent (see page 65 for instructions on mixing a percentage solution). Different packaged formulas (and papers) react differently to developer additives, so consider these instructions as general guidelines that may need alteration, depending upon the specific conditions.

1. Sodium carbonate
Purpose: To make the print color colder.
Use: Try adding four hundred milliliters of a 10 percent solution to one liter of working solution of developer.
Note: Too much sodium carbonate will fog the print.

2. Hydroquinone
Purpose: To increase the print contrast.
Use: Try adding one hundred milliliters of 10 percent solution poured into one liter of working solution of developer. If you plan to store this solution, mix it with forty grams (two tablespoons) of sodium sulfite to prevent spoilage.

3. Potassium bromide
Purpose: To increase the print contrast and to make the print color warmer. Also to salvage outdated printing papers.
Use: Try adding fifty milliliters of 10 percent solution to one liter of working solution of developer.
Note: Additional potassium bromide retards the development action, and so requires longer developing times. Also, potassium bromide turns the print color warmer, but too much produces a greenish tinge.

4. Metol (or Elon)

Purpose: To reduce the print contrast.

Use: Try adding fifty milliliters of a 10 percent solution to one liter of working solution of developer.

5. Benzotriazole (commercially available as DuPont B-B Developer Additive, Edwal Liquid Orthazite, or Kodak Anti-Fog #1)

Purpose: To increase the print contrast and to make the print color colder. Also to salvage outdated printing papers.

Use: Try adding sixty milliliters of 10 percent solution to one liter of working solution of developer. Edwal Liquid Orthazite is a liquid benzotriazole solution; for use, follow the directions on the package.

Two-Bath Print Development

Two-bath developers can be used for easy and inexpensive print processing. The idea is the same as with two-bath film developers; solution A contains the developing agents, preservative, and restrainer, while solution B contains the accelerator. In solution A, the print soaks up the developing agents but does not darken; in solution B, the development is activated. Note the similarity of two-bath development to stabilization processing (see pages 131–132). Here is a typical two-bath formula:

Solution A		
water (at 125° F or 52° C)	750 milliliters	24 ounces
Metol	7 grams	2 teaspoons
sodium sulfite	38 grams	1 tablespoon plus 2 teaspoons
hydroquinone	3 grams	1 teaspoon
potassium bromide	3 grams	½ teaspoon
cold water to make	1 liter	1 quart
Solution B		
water	750 milliliters	24 ounces
sodium carbonate	100 grams	5½ tablespoons
cold water to make	1 liter	1 quart

Storage: Solution A can be kept for approximately six months, assuming it is stored in a tightly stoppered bottle. Solution B should be mixed fresh just before use and discarded when the printing session is over (it is inexpensive and dissolves easily in water).

Capacity: Solution A can be used indefinitely with replenishment; solution B

can be used for approximately forty 8″ × 10″ prints at one printing session. *Note:* The color and contrast characteristics of this formula can be modified by altering the relative amounts of hydroquinone, Metol, potassium bromide, and/or sodium carbonate. Refer to the previous sections for guidance (for example, more hydroquinone and less Metol will increase the contrast of the print).

To use: 1. Place the print in solution A for approximately one minute with constant agitation.

2. Drain the print and then place it in solution B for approximately one minute.

Water-Bath Development

A water bath — used alternately with the developer — can be used to reduce the contrast of a print. The water acts to restrain the shadow areas while allowing near-normal highlight development. Proceed as follows:

1. Use a tray of print developer and a tray of water, side by side. The developer should be heavily diluted with water to allow a long developing time (for example, Kodak Dektol should be diluted at least one-to-three or one-to-four with water).

2. Agitate the print in the developer for ten seconds.

3. Transfer the print to the water bath. Soak the print in water for approximately one minute. Do not agitate.

4. Transfer the print back to the developer for five seconds. Agitate normally.

5. Return it to the water for one minute, without agitation. Continue the cycle with a five-second development, until the print is developed to your needs.

6. Stop, fix, and wash the print normally.

Toning

Print color (or tone) can be changed by varying the type of paper or the type of developer used, but it can also be changed with a toning bath after the processing is complete. *Toners* combine with the silver image to form new compounds that produce a print of different color. Sometimes the change is subtle, perhaps a slight color shift from warm to cold; and sometimes it is obvious, perhaps a change from

black-and-white to blue-and-white. Here are some general guidelines for toning:

Do not tone unless it will improve the photograph. Color will not miraculously turn a poor photograph into a good photograph.

Mix and use toners with care — only in a room with good ventilation. Many toning formulas smell bad or contain toxic compounds.

Reduce or eliminate the hardener used in the processing, since hardener retards toning action. Use a nonhardened fixer, such as Ilford IF-2 (see pages 73–74 for mixing instructions) or a packaged rapid fixer without hardener. Or, if some hardening is required, use a two-bath fixer with hardener in the first bath and no hardener in the second.

Keep an extra copy of the print, soaking in a water tray, next to the toning bath. As the toning action progresses, compare the results with the original, especially with formulas that produce subtle results, such as selenium toners. Besides, the extra print may be needed if the results of the toning are not satisfactory.

Direct Toners

Direct toners are single-toner solutions. Many direct toners produce different results with different dilutions and at different times and temperatures. Kodak Polytoner, for example, is a packaged formula that produces progressively warmer tones as its concentration is diluted with water.

Selenium toners (such as Kodak Rapid Selenium Toner and GAF Flemish Toner) have a mild tendency to increase print permanence, but are primarily used to effect a slight change in print color. A mild selenium bath deepens the print's blacks; a longer or more concentrated selenium bath produces progressively warmer, and even purple, tones. Selenium toning is usually recommended for warm-tone printing papers, but it will also work on cold-tone papers. A convenient method is to add the toner directly to the washing aid (such as Kodak Hypo Clearing Agent, Perma Wash, or Sprint Fixer Remover), as follows:

Selenium Toning Bath

selenium toner*	25 to 50 milliliters	¾ to 1½ ounces
working solution of washing aid	1 liter	1 quart
Kodalk (optional)	20 grams	1 tablespoon plus 1 teaspoon

*Use either Kodak Rapid Selenium Toner or GAF Flemish Toner. The amount varies with the type of paper used and the results desired (if you use more toner the color change will be more dramatic).

Note: Tone the prints immediately after the fixing bath. The best method is to use a two-bath fixer.

To use: 1. Fix the prints in the second fixer bath for the required time.

2. Transfer the prints directly from the second fixer into the toning bath. Do not rinse between baths. If the print to be toned is dry, soak it briefly in a fresh fixer bath, and then transfer it into the toning bath.

3. The time in the toning bath varies, depending on the desired results; approximately five minutes (at 68 degrees) is sufficient.

4. When the toned print looks good, remove it from the toning bath and wash it normally — a brief wash, a fresh solution of washing aid (with no toner), and a longer, final wash.

Other direct toners are available in packaged form or can be homemade. Brown or sepia toners are the most popular. Kodak Blue Toner produces a blue print, but will produce a red print if preceded by a brown or sepia toning bath.

Two-Bath Toners

Two-bath toners consist of a bleach and a redeveloper. The bleach converts the silver of the image to a virtually invisible silver bromide compound. The redeveloper converts the silver bromide to a brown or sepia silver sulfide, producing a highly permanent image. Two-bath toners are generally recommended for use with cold-tone papers.

Packaged two-bath toners are available commercially, such as Kodak Sepia Toner, and homemade formulas are available. Here are typical instructions:

1. Be sure the print is fixed and washed properly.

2. In room light, place the print in the tray of bleach bath, and

125

agitate it constantly for approximately one minute; the blacks in the shadows will disappear.

3. Wash the print in running water for approximately two minutes.

4. Place the print in a tray of redeveloper bath for approximately thirty seconds to one minute, until the desired effect is achieved.

Bleaching Prints

An entire print (or part of a print) can be lightened by treatment in a weak solution of potassium ferricyanide, in combination with sodium thiosulfate (plain fixer). This process, called *bleaching*, or *reducing*, resembles negative reduction (see pages 112–113), in that it works to dissolve the metallic silver of the print. Note that Farmer's reducer, used in negative reduction, is also a combination of potassium ferricyanide and sodium thiosulfate.

Bleaching an entire print lightens it, but it also increases the print contrast. The effect of the bleach is cutting — that is, more density is removed from the lightly exposed areas (the highlights of the print) than from the heavily exposed areas (the shadows). Therefore, bleaching can be used both to lighten an overexposed print, or to increase the contrast of a print. A low-contrast negative can be deliberately printed too dark, developed normally, and then bleached for increased contrast.

For best results, bleach only a fully or overdeveloped print. If the print is underdeveloped, then bleached, the tonalities of the print will likely be mottled. Occasionally, a print is exposed and developed normally, then bleached for special effect.

To bleach an entire print, proceed as follows:

1. Soak the print in a tray of plain sodium thiosulfate solution, mixed as follows:

water	750 milliliters	24 ounces
sodium thiosulfate	200 grams	11 tablespoons
water to make	1 liter	1 quart

2. Transfer the print directly from this solution to a tray of potassium ferricyanide, mixed as follows:

water	750 milliliters	24 ounces
potassium ferricyanide	3 grams	½ teaspoon
water to make	1 liter	1 quart

3. Agitate the print constantly in the potassium ferricyanide solution for fifteen seconds.

4. Drain the print, and return it to the tray of fixer.

5. After a few seconds in the fixer, examine the print to see if the bleaching action is sufficient. If more bleaching is necessary, return the print to the potassium ferricyanide solution for fifteen more seconds. Keep repeating the process until the results are satisfactory.

6. Fix, wash, and dry the print in the normal manner.

Small parts of the print can be bleached for emphasis or to remove unwanted dark spots, wrinkles, and so forth. This process is known as *local bleaching*, or *local reducing*. Proceed as follows:

1. Fill a small container with a solution of potassium ferricyanide, mixed as follows:

water	75 milliliters	2½ ounces
potassium ferricyanide	1½ grams	¼ teaspoon
water to make	100 milliliters	4 ounces

2. Presoak the dry or wet print in a tray of plain fixer.

3. Drain the print, and place it in a dry, empty tray, near a good light source.

4. Wipe off the area of the print to be bleached with a clean sponge, cloth or paper towel.

5. Apply the ferricyanide solution with a cotton swab or a small, pointed brush for a very short period of time. Try five seconds. The metal ferrule (the part that holds the bristles and handle together in most brushes) will react with the ferricyanide, and cause print staining, so either use a bamboo brush (that has no metal ferrule), or coat the ferrule with shellac or clear nail polish.

6. Immediately after applying the bleach, blot the area with a clean sponge, cloth or paper towel. The bleaching action will continue after the ferricyanide has been used, so take care. Apply the bleach for a very short time, and blot after each application.

7. Place the print in the tray of plain fixer for approximately thirty

An overexposed print

The same print, bleached, is lighter and has more contrast

seconds. Then examine the results. Repeat the procedure if more bleaching is required.

8. Fix, wash, and dry the print in the normal manner.

The main danger in the bleaching process, whether treating the entire print or only a part of it, is overbleaching. To obviate this problem, use a weaker solution of potassium ferricyanide and/or shorten the time for which the print is bleached. Above all, work carefully and patiently, repeating the bleaching process several times if necessary.

Flashing

Flashing is a method of reducing print contrast by deliberately fogging the printing paper. It is especially useful for adding gray tone or detail to a very bright area that might be difficult to burn in. The paper is exposed normally in the enlarger; then the negative is removed, and the paper is exposed very briefly to white light. The white light exposure primarily affects the print highlights, barely altering the shadows, and thereby reducing the overall print contrast.

Here is the procedure:

1. Expose printing paper normally.

2. Remove the negative from the enlarger.

3. Reduce the enlarger illumination by lifting the enlarger head to its maximum height, and closing down the lens to its minimum aperture.

4. Reexpose the paper briefly to plain white light from the enlarger. The time of exposure varies with the enlarger and the circumstances, but try five seconds. If the highlights are too dark, reduce the flashing time; if the highlights are too light, increase the flashing time.

5. Develop the print normally.

The primary disadvantage of flashing is that all highlights are darkened; as a result, the entire print may lose brightness.

Local flashing is a method of selectively darkening extremely bright highlights, without altering the other parts of the print. It is particularly effective as a substitute for burning in when the bright areas are either out of focus or contain no important detail.

A print before flashing

A print after a brief overall flashing. Note the decreased contrast, and the increased detail in the highlights (the background).

The best tool for local flashing is a small penlight. Wrap a piece of black paper around the front of the penlight, making a shade to direct the light. You may also have to reduce the penlight illumination by taping pieces of tissue paper over the bulb. Here is the procedure:

1. Expose the printing paper normally.

2. Place a red filter under the enlarging lens. Most enlargers have such filters that allow for turning on the enlarger light without exposing the printing paper.

3. Turn on the enlarger. The image will be projected through the red filter onto the printing paper. Now you can see the highlight areas that need flashing.

4. Briefly expose the bright highlights with the penlight. Move the

Local flashing

A method of selectively darkening extremely bright highlights, without altering the other parts of the print

Expose the printing paper normally

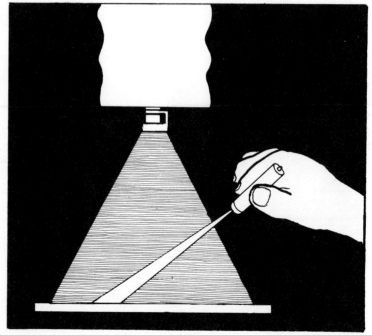

Place a red filter under the enlarging lens, and project the negative through the filter. With a shaded penlight, briefly expose the bright highlights, moving the beam of light slightly during the flashing time.

beam of light slightly during the flashing to allow the tones to merge with the areas surrounding the flashed areas. Once again, the time of exposure varies. Try two or three seconds; if the highlights are too dark, reduce the flashing time; if they are too light, increase the flashing time.

5. Develop the print normally.

Stabilization Processing

Stabilization processing is a method of developing and fixing prints by machine, rather than in trays. Its major advantages are speed (prints are completely processed in approximately fifteen seconds) and convenience (the machines use little space and no running water is required). It is ideal for contact prints and work prints (see page 133). Its major disadvantages are expense (the machine is at least as expensive as most enlargers; and special printing paper and chemicals are required), and lack of stability (stabilized prints will stain and fade after several months, unless fixed and washed normally, as in tray processing).

Stabilization machines contain a series of soft rollers that absorb two chemicals — an activator and a stabilizer — from two trays located underneath. The paper is exposed normally, then fed into the roller system. Stabilization papers contain dry developing agents (without accelerator). The *activator* acts as a strong accelerator to the dry developing agents and darkens the exposed parts of the paper (this process simulates two-bath development where the paper soaks in solution A — the developing agent — and darkens in solution B — the accelerator). The *stabilizer* converts the unexposed silver into relatively stable and colorless compounds, allowing the print to be viewed under white light. These new compounds remain in the print, eventually causing image staining or fading. With normal tray processing, the fixer dissolves the unexposed silver out of the print.

Stabilized prints are generally considered inferior to tray-processed prints. However, stabilized print quality can be excellent, assuming fresh chemicals are used and the machine is kept clean. Stabilization papers are made by several companies in a variety of surfaces, contrasts, sizes, speeds, and thicknesses.

Several models of stabilization processors are available at widely

Feed the paper into the stabilization processor. The rollers automatically carry the print through the brief activator and stabilizer baths.

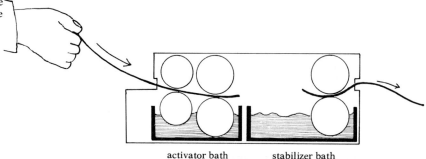

activator bath stabilizer bath

varying prices — from approximately one hundred fifty dollars up. Most are used in the following manner:

1. Expose the special stabilization paper just as you would normal photographic paper.

2. Feed the paper into the stabilization processor, emulsion side down. Take care to put the paper straight in, so it does not bump against the sides of the machine. If the print is smaller than 8″ × 10″, you may have to feed it into the rollers at an angle.

3. The rollers automatically carry the print through brief activator and stabilizer baths. When it comes out of the machine, the print will be slightly sticky. Put it aside until dry (approximately fifteen to thirty minutes).

Stabilized prints, even when dry, will contaminate whatever they touch, since the chemicals are never washed out of the paper. Therefore, dry and store stabilized prints carefully. To dry, place the sticky prints, emulsion side up, on newspapers laid out over a counter space. When the prints are dry, store them in separate boxes, containing only other stabilized prints.

For maximum permanence, stabilized prints can be fixed and washed as follows:

1. Use a stop bath for fifteen seconds.

2. Fix in hardened fixer bath for the recommended period of time.

3. Wash and dry normally, using a washing aid. After this treatment, stabilized prints will not be quite as lasting as tray-processed prints, archivally treated, but they are safe and enduring enough for most purposes.

Work prints provide a useful means to evaluate your negatives while reducing your overall processing time. Upon spotting promising negatives, you may be tempted to work hard to make the best possible prints. Instead, make quick work prints, and spend a few days looking them over, before deciding which ones are worth printing well. Follow this procedure:

1. Contact-print all your negatives.

2. Pick out the negatives that look at all interesting (including some you might not have bothered with normally), and make a quick print of each. To save money and time, use inexpensive, small-size paper (out-of-date paper often can be purchased cheaply) and quick processing techniques (stabilization processing is perfect for work printing, as are RC papers that develop, fix, wash and dry more quickly than normal papers). Do not aim at exact exposure and contrast. Aim instead at quickness and quantity. If the negatives are reasonably well exposed, you should have no trouble making readable prints after one or two tries.

3. Tack the dry prints on a wall (a 4' × 8' sheet of homosote, painted white, makes an excellent viewing board; homosote is cheap and available from any lumber yard).

4. Keep the work prints on the wall for a few days, before deciding which ones you really like and want to work on. Imagine different cropping possibilities, and various ways of printing (dark, light, high- or low-contrast).

5. Finally, print those photographs that stand the test of time.

Work printing can save a lot of time, money, and effort, especially if you are a fussy printer. You may even discover some worthwhile photographs that you otherwise would never have considered printing.

A Black Border

Some people like to make prints with thin black borders by printing the clear edge of the film, surrounding the negative image. If the cutout section of a negative carrier is enlarged, the clear edge will print through.

The neatest way to enlarge the negative carrier is to have it done at a machine shop. Bring along a sample negative so it can be measured exactly. Or you can put the carrier in a vise to hold it steady and gently file all four sides. Be sure to smooth out all rough spots; otherwise the carrier may scratch the negative.

Once the carrier is enlarged, insert the negative so that the clear edges show in the cutout. Adjust the easel size to include the edges. If you want a 6″ × 9″ image, set the easel for 6⅛″ × 9⅛″. The clear edge of the negative will then print as a $^1/_{16}$″ black border.

A print with a black border

Many people print poorly because they do not understand what a good print looks like. The best way to learn about printing is to look at good, original prints — in galleries, museums, or wherever possible. When making your own prints, follow this rule:

> *Exposure controls the highlights, and contrast controls the shadows.*

Exposure, in turn, is controlled by time and aperture. Contrast is controlled by paper grade, developer used, dilution of developer, and time of development (see pages 117–119).

Here is a simple printing system that will help you make a good print:

1. Make a test strip.
2. Look at the important bright highlight areas (ignoring extremely bright areas that can be burned in or flashed). These bright highlights should have just enough darkness to show detail, yet still retain brightness. If the highlights are too light, give the print more exposure; if they are too dark, give the print less exposure. When judging exposure, ignore the shadow tones.
3. Once the exposure is correct, examine the important dark shadows (ignoring extremely dark areas that can be dodged or even reduced). Assuming proper exposure (it is difficult to make a reasonable judgment about the shadows if the highlights are too dark or too light), these shadows should be dark — almost black — but still retain detail. If the shadows are too light, increase the print contrast; if the shadows are too dark, decrease the contrast.
4. Make sure, after a contrast change, that the important highlights have not become too bright or too dark. In adjusting print contrast, the exposure may have to be altered (for example, to compensate for the exposure speeds of different contrast papers).
5. Once the highlights and shadows are set, burn, flash, dodge, or reduce the extremely bright or extremely dark areas as needed.

This first print with a #2 paper is properly exposed since the important bright highlights (the engineer's shirt, the rims of the wheels, and the connecting rod) look right. However, it needs more contrast since the shadows (the detail above the wheels) are too light. Ignore the extremely bright highlights (the hat and the bottom corners) since they can be burned in later.

The second print. A #4 paper was used to darken the shadows. However, the exposure of this print is wrong; the highlights are too light.

136

The third print. A #4 paper was used with more exposure. The exposure is correct; the highlights are much the same as the highlights in the first print. However, the shadows are much too dark, so the contrast must be reduced.

The fourth print. A #3 paper was used to lighten the shadows. However, the exposure of this print is wrong; the highlights are too dark.

137

The fifth print. A #3 paper was used with less exposure. The exposure is now correct; the highlights are much the same as those in the first and the third prints. And the shadows are finally correct; they are dark, but retain detail. However, the cap and the bottom corners are still too bright.

The final print. The same exposure and contrast as the fifth print, but with the cap and the bottom corners burned in.

Further Reading

Adams, Ansel. *The Print* (Basic Photo Series). Boston: New York Graphic Society, 1977.

Eastman Kodak Company. *Creative Darkroom Techniques.* Rochester, New York: Kodak Publication AG-18, 1973.

_____. *Kodak Darkroom Data-Guide.* Rochester, New York: Kodak Publication R-20, 1975.

Gassan, Arnold. *Handbook for Contemporary Photography.* Athens, Ohio: Handbook Publishing Company, 1974.

Jacobson, C. I. *Developing: The Technique of the Negative.* Garden City, New York: Amphoto, 1972.

Jacobson, C. I., and L. A. Mannheim. *Enlarging: The Technique of the Positive.* Garden City, New York: Amphoto, 1972.

Lootens, J. Ghislain. *Lootens on Photographic Enlarging and Print Quality.* Garden City, New York: Amphoto, 1975.

Vestal, David. *The Craft of Photography.* New York: Harper and Row, 1975.

Zakia, Richard D., and Hollis N. Todd. *101 Experiments in Photography.* Dobbs Ferry, New York: Morgan and Morgan, 1969.

CHAPTER FIVE

Lighting

Most photographers prefer natural light — either direct or reflected sunlight — for their photographs. However, natural light is usually uncontrollable; it cannot be moved, and it is subject to the whims of weather. Also, natural light is not always available, such as indoors or at night. Sometimes, you must choose between adding an artificial light source, or not taking the desired picture at all.

This chapter suggests ways to use artificial light for maximum control of the final image. The rules for working with artificial light are based largely on those governing natural light. Therefore, some preliminary observations about natural light are necessary.

Natural Light

Quality of Light

The quality of sunlight is variable. Sometimes, on clear, bright days, the sun's rays travel in a direct path — uninterrupted by cloud cover or haze. The dominant light quality on such days is said to be *specular* — meaning harsh, crisp, and producing high contrast with hard lines and edges.

Cloud cover or haze interrupts and redirects the path of the sun's rays. The dominant light quality under these conditions is *diffuse* — meaning soft and producing low contrast with less distinct lines and edges. Even shadows on clear, bright days (when the dominant light quality is specular) have a diffuse quality, since they are not lit by direct sunlight, but rather by redirected or reflected sunlight off the sky and the landscape.

Location of Light

The sun is almost always above and at an angle to the subject. With specular light, the location of the sun is conspicuous and important; when it is located behind the camera, the photographic result is very different from when the sun is shining toward the lens. But with diffuse light, the location is less important; the light is evenly spread out with no definite direction.

Controlling Natural Light

You can exert very little control over the quality or the direction of sunlight; however, the subject's position or location can be varied to effect different results. When the subject faces the sun, the result is very different from when the subject's back faces the sun; when the

Specular light. The sun's rays travel in a direct path — uninterrupted by cloud cover or haze.

Diffuse light. Cloud cover or haze interrupts and redirects the path of the sun's rays.

Diffuse light. Shadows on clear, bright days are lit by sunlight reflected off the sky and the landscape.

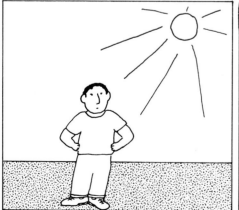
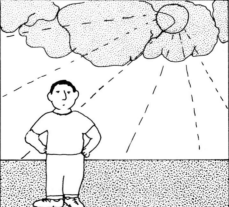
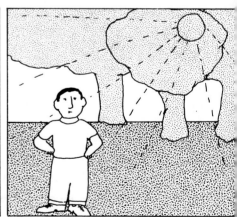

subject sits in the shade, the result is very different from when the subject sits in the direct path of the sun. Naturally, these controls are limited, since the subject cannot always be turned around or relocated. However, under certain conditions the quality of light can be modified.

Diffuse light

Specular light

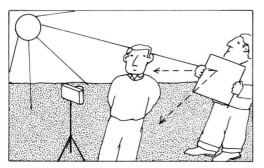

A reflector panel redirects sunlight. Position it on the side of the subject opposite the sun, using it to reflect the sunlight toward the shadows.

Specular lighting can be modified by using a *reflector panel* to redirect sunlight. Any flat, white surface — even a bed sheet or the side of a white house — can serve as a reflector panel. Or, you can make a portable panel with a piece of white mounting board. Cover one side of the board with a crumpled piece of aluminum foil. The white side of the panel will reflect light with a diffuse quality; the foil side will reflect greater amounts of light with a more specular quality. Position the panel on the opposite side of the subject from the sun, using it to reflect the sunlight toward the shadows. The reflected light will open up the shadows, thereby reducing the contrast of the lighting.

Learning about Light

The best way to learn about light is to observe it. A day with bright sun and intermittent cloud cover is ideal. Watch the lighting change from specular to diffuse, as the clouds move in and out of the path of the sun. In direct light, the shadows will darken and the highlights will brighten; in diffuse light, the opposite will occur.

The effect of the sun's location can be best observed with the help of a friend. Turn him or her around and notice the effect of the light striking from the front, side, and back. Fronting the sun, the subject's face will be well lit; turned away from the sun, the face will be in shadow.

Understanding natural light, you should be able to use artificial light. Most of the rules are the same. The main difference is that artificial light allows more control.

Artificial Light

Choosing methods of lighting is an intuitive process and highly dependent upon taste. Some general guidelines exist, and will be offered for consideration. However, the best way to learn about artificial light is to use it; try different setups, and carefully observe the results.

All light sources, except when extremely diffuse, cast shadows that affect the appearance of the subject. A photograph is a flat, two-dimensional surface. Shadows add a feeling of form, or three-dimensionality, to that surface. Imagine a face, directly lit by a single light source; the entire face will be evenly illuminated and seem flat. Now imagine a face, lit at an angle by a single light source; one side of the face will be in shadow, clearly differentiated from the lit side, giving the face an added (third) dimension.

The shadows are controlled by varying the angle at which the dominant light source strikes the subject. This angle will help determine the emphasis of the lighting. Often the form (or the three-dimensionality) of the subject is most emphasized. But lighting can also be used to add texture detail to the surface of the subject, or to emphasize the outline or shape of the subject.

Lighting with One Light Source

Most effective lighting setups require more than one light source, but much can be learned by noting the effect of one source positioned at different angles to the subject. Ask a friend to sit for you. Set up a camera, preferably on a tripod, and turn off the room lights. Place a single light source, such as a floodlight, at several angles to the subject, and observe the results while looking through the camera.

Front Lighting

When the light shines directly at, and on a level with, the subject, the face is evenly illuminated. It lacks surface detail and appears flat and formless, because of the absence of shadows. To some extent, the shape of the face is emphasized, as the subject is usually tonally different (and, therefore, separate) from the background.

As the light is lifted up and shined down at an angle to the subject, shadows are created, adding a suggestion of form or volume. This light angle simulates natural light, since the sun always shines down on a subject. However, the overall impression is still that of flatness; also, in portraits the shadows will fall directly under the subject's nose and chin, creating an undesirable effect.

145

 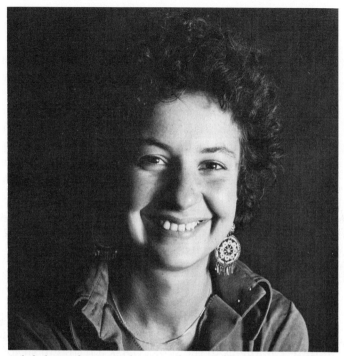

Front lighting: Her face is evenly illuminated, emphasizing its shape

Side lighting, from a 45-degree angle: Part of her face is in shadow. This light position is called *modeling light*, and best suggests the three-dimensionality, or form, of the subject.

Front lighting

Side lighting (45-degree angle)

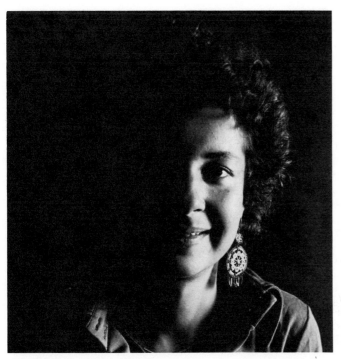

Side lighting, directly from the side: The entire left side of her face is in shadow. This light position is called *skim light*, and best suggests surface texture and detail.

Back lighting: The face falls into shadow and becomes a silhouette, suggesting only the shape of the subject. This light position is called *rim lighting*.

Side lighting

Back lighting

A rug lit with a single light source, placed in the front position.

The same rug lit with a single light source skimmed along its surface. The result is much more texture detail.

Side Lighting

When the light shines from the side of the subject, the lit side of the face is bright and the other side is in shadow. The shadows suggest the form or the three-dimensionality of the subject. The side position most commonly used is called *modeling lighting*, when the light source is placed between the front and the side positions, or between the back and the side positions, at approximately a 45-degree angle to the subject; it is then lifted up above the camera position and pointed down at the subject, simulating natural light.

Side lighting pointed directly along the surface of the subject emphasizes the detail or texture of that surface. Such lighting is called *skim lighting*, because the light skims along the subject plane, illuminating the surface's high points and casting shadows in its valleys.

Back Lighting

When the light shines on the back of the subject, the face falls into shadow and becomes a silhouette — a dark shape outlined by a halo of light. This effect is called *rim lighting* and provides no modeling or texture detail, only a suggestion of shape. This light position should be used carefully. Keep the light directly in back of the subject so it will not shine into the camera lens.

Top Lighting

When a light source is placed directly above and pointing down at the subject, it may emphasize surface detail, just like side lighting. However, top lighting is an unusual sun position, so it is rarely used.

Bottom Lighting

When a light source is placed below and pointing directly up at the subject, it produces an eerie effect. This position is also rarely used, since similar natural lighting conditions are impossible.

The Main Lighting Functions

Most lighting setups benefit from the use of more than one light source. Here are common light functions:

The *key* light is the dominant source, comparable to the sun in

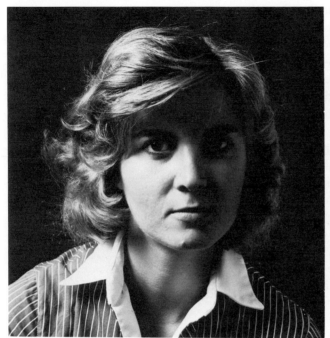

The key light is the dominant source

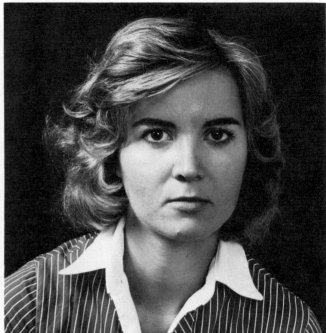

The fill light adds illumination to the shadows created by the key

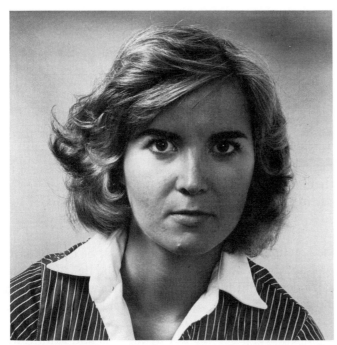

The background light adds illumination to the area in back of
the subject

natural light. It provides the bulk of the illumination in most lighting
setups; and its position determines whether the lighting will most
emphasize the form, the texture, or the shape of the subject.

The *fill* light adds illumination to the shadows created by the key, to
provide detail to the darkness, thereby reducing the subject contrast.
In harsh, natural light, the fill is provided by reflected sunlight (from
the sky and landscape). Also, reflector panels can act as fill light
sources. The fill must always produce less illumination than the key.
If it is as strong as the key, it will even out the lighting; if it is
stronger, it will dominate the lighting.

The *background* light adds illumination to the area in back of the
main subject. It should act tonally to separate the subject and the
background; if the illumination on both is equally intense, the light-
ing effect will be two-dimensional.

151

A Typical Lighting Setup

Effective lighting setups are best thought out in advance. The placement of each light source must accomplish a useful purpose. Overlighting a scene is as pointless as underlighting it. So ask yourself: What is the purpose of the lighting? Do I simply want to illuminate a room? Or do I want to light a subject? Should I emphasize depth and form? Texture? Shape?

Place the lights one at a time. After each placement, look through the camera to see what has been accomplished. Here are some general guidelines for a conventional portrait setup; but the same rules can apply when lighting most any subject.

1. Start out in relative darkness. Shut off all bright room lights, unless they are part of the setup, since they may adversely affect the lighting.

2. Place the key light in position. The key must be dominant both in illumination and in setting the emphasis of the lighting.

To emphasize depth and form, place the key source two or three feet above the camera position and off to the side of the subject, at approximately a 45-degree angle to the subject.

To emphasize texture, place the key at the side and skim it along the surface of the subject.

To emphasize outline, place the key to the rear of the subject.

3. The key light will cast shadows, so place the fill in position to add illumination to the darkness. Generally the fill is located on the opposite side of the camera from the key, but near the camera position. It should provide enough illumination to open up the shadows to render detail, but it should never be as dominant as or more dominant than the key. Take care that the fill does not create a new set of shadows — a situation that is impossible in natural light, and must be avoided in all artificial lighting setups.

4. Now add background lighting if necessary. The background light can be located on either side of, or directly in back of, the subject, pointed away from the subject, toward the background. Remember that the subject should stand out from the background, so avoid equal light intensities on both.

The key light placed in a modeling position — to emphasize form — above the camera position and off to the side of the subject at approximately a 45-degree angle

The fill light adds illumination to the shadows created by the key. It is placed at the opposite side of the camera from the key, but near the camera position.

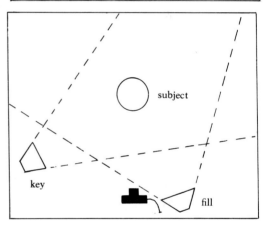

The background lights add illumination to the back of the subject. Here two lights are used, one on each side, pointed in toward the background.

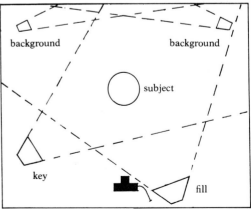

A Light Source Is Not Always a Light

Bounced, window, and ambient light can serve as effective light sources. *Bounced light* is reflected or redirected light from one particular source. Most studio photographers have a variety of different-size reflector panels, though any reflective surface is a potential source for bounced light. Also, special *umbrella* units, with highly reflective inner surfaces, are sometimes used as bounced light sources.

Bounced light

The subject was lit by a direct quartz light placed to the right of the camera position. Note the high contrast and harsh shadows.

Bounced light can be used for almost any lighting function. For a diffuse key source, place a strong light so it bounces off a reflector panel (or an umbrella), which is aimed back toward the subject. For a fill or background light source, place the bounced light in position to reflect illumination into the shadows or background.

Window light can be used along with artificial sources in certain lighting setups. Sometimes this type of light is strong enough to act as a key, in which case other sources are used to provide fill or background illumination. More commonly, window light is weaker and better suited for fill or background light.

Bounced light

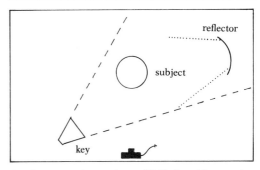

A reflector can be used as a fill if placed in a position to reflect illumination from the key into the shadows

Here the light came from the same position, but was first bounced into an umbrella, creating a softer, more diffuse lighting

155

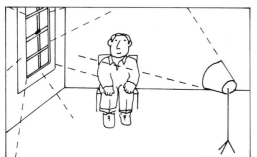

The ambient or window light in a room can be mixed with artificial light sources and used as a fill or background light source

In a room with strong natural light, place your subject next to the window. Set the key on the side opposite the window. Be sure the key provides the most illumination. The window light will serve as either fill or background light, depending upon the exact placement of the subject.

Ambient light is the surrounding or existing light in a room. Since it usually provides a low level of illumination, ambient light is used, along with a strong key, as either fill or background light.

Exposure with Artificial Light

Artificial light exposure is similar to natural light exposure, except the light (and, therefore, the exposure) is more controllable. The *lighting ratio* is a measurement of the relative brightness provided the subject by the key and the fill light sources. A four-to-one ratio, for example, indicates that the light falling on the subject's highlight side (lit primarily by the key) is four times as strong as the light falling on the subject's shadow side (lit primarily by the fill).

To determine the lighting ratio, turn on both the key and the fill lights. Use an incident light meter, held close to the subject's highlight side, pointing directly at the key light source. Assume the indicated exposure is 1/60 at f 11. Now hold the incident meter in front of the subject's shadow side, pointing directly at the fill light source. If the indicated exposure is 1/60 at f 5.6, the relative brightness of the highlight and the shadow sides is two stops, or four times, as great, so the lighting ratio is four-to-one.

If you do not own an incident light meter, take a reading off an 18 percent gray card, placed close to the subject in front of the highlight side. Then take a reading off the gray card, placed close to the subject in front of the shadow side. Compare the two indicated exposures, in the same manner as with incident readings, for the lighting ratio.

The higher the lighting ratio, the greater the subject contrast. A lighting ratio of one-to-one indicates flat, even lighting. A moderate ratio — five-to-one for black-and-white, or three-to-one for color — is

recommended to suggest the form and three-dimensionality of the subject, while retaining good highlight and shadow detail. Extremely high ratios (approximately eight-to-one or higher) will cause "blocked up" highlights and overly dark shadows. A high ratio with a black-and-white negative can be reduced (if there is enough negative detail) by decreasing the paper contrast. However, a high ratio with a color negative is a problem, since contrast control is limited in color printing.

Lighting ratios

A three-to-one lighting ratio

An eight-to-one lighting ratio

Controlling Illumination

Lighting ratios are determined by the amount of illumination provided by the key and the fill light sources. In turn, the amount of illumination is governed by quantity, directness, and distance.

Quantity is the amount of light that the source produces. A 500-watt bulb gives off much more light than a 250-watt bulb.

Directness alludes to the path of the illumination. A light that travels in an uninterrupted path will illuminate the subject more than one that is bounced or diffused before reaching the subject.

Distance is measured from the light source to the subject. A 500-watt bulb located ten feet from the subject will provide more illumination than the same bulb located twenty feet from the subject. According to the *inverse square law*, the intensity of light is related inversely to the square of the distance from the light to the subject, or:

$$\text{change in intensity} = \frac{1}{(\text{change in light-subject distance})^2}$$

If the light starts out at ten feet away from the subject and is moved back to twenty feet, the amount of change in the light source distance is two times (ten to twenty feet), so:

$$\frac{1}{2^2} = 1/4$$

(the intensity of the light is reduced to one-quarter).

By controlling the illumination, you can set and control the lighting ratio. Changing distance is the most common method of control. If you have two 500-watt light sources, place the key five feet from the subject and the fill ten feet from the subject. The key will produce four times as much light, so the lighting ratio will be approximately four-to-one.

Lighting Equipment

Types

Photofloods (also called *floods*) are similar to everyday light bulbs, except they are larger, brighter, and usually frosted. These bulbs have

The amount of illumination is reduced as the distance increases. Here the subject is properly illuminated, but the light falls off in back of the subject as the distance the light travels increases.

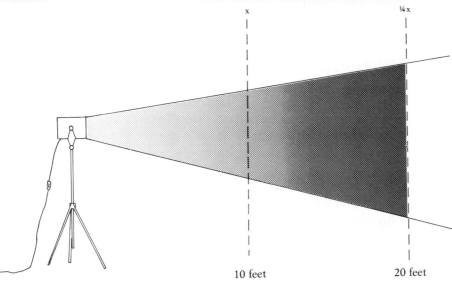

x ¼x

10 feet 20 feet

159

A side view of a photoflood housed in a reflector unit

A spotlight. The light is focused by varying the distance between the bulb and the condensor.

tungsten filaments, and come in different sizes (such as 250, 500, or 1,000 watts) for varying the light intensity. Floods are commonly used as key, fill, or background lighting.

Most floods are housed in a curved reflector unit to direct light toward the subject. The rays from the center of the bulb travel directly toward the subject, while the rays from the side and bottom of the bulb bounce off the reflector and then travel toward the subject. So a bulb in a reflector produces a combination of specular and diffuse light — harsh in the middle and soft on the edges.

Quartz-halogen (also called *quartz*) lights are long, thin bulbs of varying intensities that fit into a special receptacle, surrounded by a reflector unit. Quartz lights are more expensive, but more stable and longer lasting than floods, and are especially good for color use. They serve the same functions as floods — for key, fill, or background lighting.

Spotlights (also called *spots*) are special units that project a beam of light through a condenser. The light is focused by varying the distance between the bulb and the condenser. The result is direct, concentrated, specular light. Spots are used as key or background light sources.

Flash light produces a lot of illumination for a short period of time. It is a versatile light source that can function as key, fill, or background light. A separate section on flash follows.

Color Temperature

Color temperature is a measurement in degrees Kelvin of the precise color of the light emanating from a particular source. Sources with a low color temperature tend to be red or orange; sources with a high color temperature tend to be more bluish. The color differences may not be obvious to the human eye, but they are to the film. Color films are made to balance with (or match) specific color temperatures.

Here are the color temperatures of some common light sources:

household incandescent bulbs — 2,800° K
quartz-halogen bulbs — available in both 3,200° K and 3,400° K
floodlights — available in both 3,200° K and 3,400° K
clear flashbulbs — 3,800° K
blue flashbulbs — 6,000° K

electronic flashtubes — 6,000° K
daylight — approximately 6,000° K

The color temperature of daylight varies greatly according to the time of day, the season, and the location. For example:

Average direct sunlight (10 A.M. to 3 P.M.) — approximately 6,000° K
Average light from overcast sky — approximately 7,500° K
Average light from clear, blue sky — 10,000° K or higher

If the color film is not balanced with the color temperature of the light source, the color rendition will be inaccurate. Here are the types of color film that are available, with the color temperatures for which they are balanced:

film type	balanced for a color temperature of
type A tungsten	3,400° K
type B tungsten	3,200° K
daylight	6,000° K

So if you use a 3,400° K floodlight, use type A film for accurate color rendition.

Gelatin filters can be used in front of the light source — or glass or gelatin filters in front of the camera lens — to match up film types with light sources of different color temperature. Filters cut down on the amount of light reaching the film, so an increase in exposure is necessary. Here is a partial list of filters with their exposure factors:

light	film	Kodak Wratten filter #	increase in exposure
daylight	type A	85	⅔ stop
daylight	type B	85B	⅔ stop

light	film	Kodak Wratten filter #	increase in exposure
3,200° K	daylight	80A	2 stops
3,200° K	type A	82A	⅓ stop
3,400° K	daylight	80B	1 stop
3,400° K	type B	81A	⅓ stop
electronic flash	daylight	none	none

So, if you are shooting outdoors with type A film in your camera, add a Wratten filter #85 to the lens. If you are shooting indoors with a 3,200° K photoflood source and outdoor film, place an #80A filter in front of the lens or in front of the photoflood.

Here are some general rules governing the use of color temperature:

Do not mix light sources of differing color temperatures unless you want unbalanced color for special effect.

Some light sources (such as 3,200° K floods) require a warm-up time of several minutes to reach their rated color temperature.

Quartz lights maintain a more consistent color temperature than floods.

A change in the voltage of the electricity reaching the light source will alter its color temperature. For critical color work, a voltage regulator should be used on the electrical line to guarantee constant voltage.

Care with Lighting Equipment

Take care when using more than one light unit, since it is possible to overload a normal household circuit. To determine the capacity of your electrical line, multiply the voltage of the line by the amperage rating of its fuse:

$$volts \times amps = watts$$

Most household circuits are 110 volts; a common amp rating is 15, in which case:

162

$$110 \times 15 = 1,650$$

Therefore, this circuit will accommodate up to 1,650 watts. Three 500-watt photofloods, totaling 1,500 watts (or any combination totaling less than 1,650 watts) will work safely, assuming no large power-drawing electrical appliances (such as an air conditioner) are running at the same time.

Lighting Accessories

The following are commonly used lighting accessories:

Barn doors: Adjustable black metal flaps attached directly to the front of the light source to control the angle of the projected light. They are especially useful if the light must be directed into a limited area.

Boom: A pole that sits on a light stand; it has a light source on one end and a counterbalance on the other. It allows the light source to be lifted, dropped, and moved around at will, while keeping the light stand out of the picture area.

Clamp: Literally a spring-type clamp used to place a light source — usually a flood — in locations where a light stand cannot be used conveniently. One end of the clamp holds the light source; the other end grips onto a stationary object, such as a table, shelf, or pole.

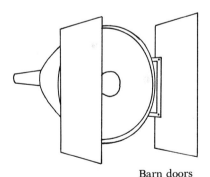

Barn doors

A boom

163

Control box: A portable, electrical device incorporating several outlets, so that more than one light source can be plugged in at a single location. The box should have a long cable to provide maximum movability. The cable is plugged into a wall outlet, and the light sources are plugged into the box.

Diffusers: Any material placed between the light source and the subject to soften the quality of the light. A popular, inexpensive type of diffuser is a milky-colored, plastic disk that attaches directly to the front of a reflector unit.

Light stand: A tripod used for holding the light source. Some stands are light for portable use; others are heavy for studio use.

Reflector panel: Any white panel used for bouncing or reflecting light.

Seamless: Wide, long rolls of different-color paper used for background in studio lighting setups.

Snoot: A black metal tube placed directly in front of the light source — usually with spotlights — to limit the direction and the size of the projected light.

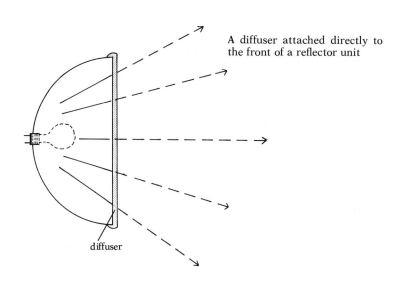

A diffuser attached directly to the front of a reflector unit

diffuser

Umbrella: Literally an umbrella with a highly reflective inner surface used for reflecting or bouncing light. The light source is aimed at the umbrella, which, in turn, is aimed at the area to be illuminated, thereby softening the quality of the light.

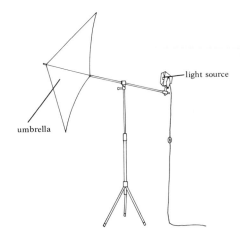

A light source aimed into an umbrella unit

Flash

Flash is the most common artificial light source. Flashbulbs were once the main type of flash light, but their use is now largely limited to simple, automatic cameras. *Electronic flash* (also called *strobe*) is more commonly used at present. Most of the following information relates to using both bulb and electronic flash, but the latter is emphasized.

There are several advantages to using a flash unit over other sources of artificial light. It is portable, unobstrusive, and produces a large amount of illumination in a short period of time with a constant color temperature. It is ideal for situations requiring stopped movement. Some flash units (such as the more bulky studio strobes) actually produce far more illumination than most other artificial light sources. Also, flash light is much cooler and, therefore, more comfortable for both the subject and the photographer.

A major disadvantage of flash light is that you cannot see the results of the lighting ahead of time, and must guess at its effect. Some studio strobes do contain *modeling lights* that can be switched on to check the lighting before using the flash; but these units are expensive and practical only for professional studio use. Many photographers use Polaroid film to check the lighting, and then switch to regular film; but Polaroid film and film holders are expensive and not adaptable to all cameras.

The most common use of flash is one unit, located on or near the camera position, functioning as a key light. But flash units can also be used together with other units or other types of light (artificial or natural) to perform every light function — key, fill, and background. The main differences between flash and other artificial sources is in their mechanical use and the exposure calculations.

165

Mechanical Use of Flash

Unlike other light sources, the flash duration must *synchronize* with the opening of the camera shutter. The means of synchronization varies with the type of shutter. Leaf shutters synchronize at any speed, since they include a mechanism that ensures that the flash does not fire until the shutter blades are wide open. Focal plane shutters synchronize only at slow speeds — usually 1/60 or slower — since at fast speeds, only a section of the shutter will be open when the flash fires, exposing at most only a part of the film. At slow speeds, the shutter will be fully open when the flash fires, exposing the entire piece of film.

The synchronization mechanism is built into the shutter. There are electrical contacts on the shutter or on the camera body that connect to the flash unit. Many modern cameras have a *hot shoe* that holds the flash unit and has a built-in electrical connection to the shutter. The most common way to connect the flash to the shutter is with a *pc* (or *synch*) *cord*, which is an insulated wire with metal contacts on each end. One end of the cord fits onto the flash unit; the other end fits into the "x" contact on the shutter or on the camera body (some shutters have "m" and/or "fp" contacts for synchronization with flashbulbs).

Most flash units have a self-contained source of electrical energy — usually a replaceable or rechargeable battery. Some more sophisticated strobe units have separate battery packs for greater power and more flashes, and use a *power cord* to connect the battery to the strobe. Also, many strobe units can be adapted to work off household current.

Studio strobes use a large power pack that plugs into the house circuit. These packs usually weigh several pounds each so they are not easily portable; but they provide enough current so that several flash units can be attached to a single pack, allowing for multiple flash work for key, fill, or background light functions.

Most portable strobes can be adapted with a *slave,* a tiny photoelectrical unit that plugs into an auxiliary strobe and sets off the auxiliary when the main strobe fires. The slave must be positioned in view of the main flash (usually no farther than thirty to forty feet away). Several slaves and auxiliary strobes can be used at the same

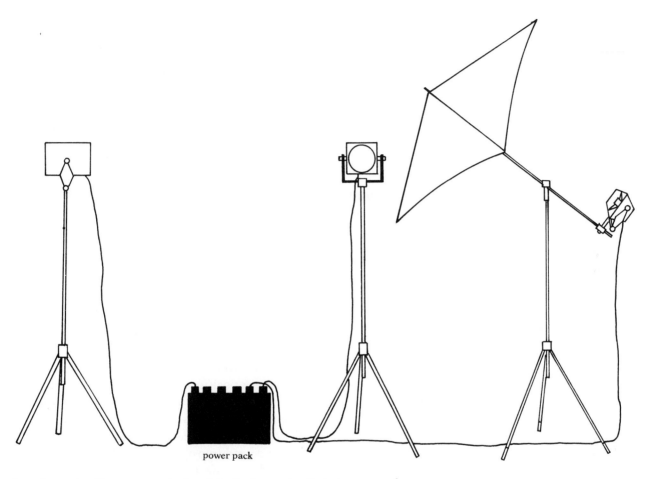

A studio strobe. The power pack plugs into the house circuit; in turn, several lights can feed off the power pack.

power pack

time, but be sure that each strobe unit is turned on and contains its own slave.

Flash Exposure

Flash as the Primary Light Source

The inverse square law affects all artificial light sources, therefore:

The intensity of flash light is reduced as the distance between the flash and the subject increases.

With natural light, floods, and spots, exposure is figured with a light meter. With flash, exposure is figured with the help of the inverse square law.

The important factors with flash exposure are distance and aperture:

As the distance between the flash source and the subject increases, the aperture must be opened to accept more light.

If you use f 16 at five feet, then you must use f 8 at ten feet.

Remember that distance refers to the distance that the light travels to the subject, not the distance from the camera to the subject. When the flash is used at the camera position, pointing directly at the subject, these distances are the same; but if the flash is away from the camera position, or bounced, the distances will be different.

Shutter speed is of little consequence with flash exposure. Most strobes fire for a very brief period (most fire for 1/1,000 of a second or less). The exposure is made during that brief flash, and therefore the extra time that the shutter stays open adds very little exposure to the film (although there are situations, to be discussed, where this extra exposure can be useful). The duration of the flash is usually fixed and uncontrollable, so it is not a factor you need to reckon with. (On some flash units, the duration varies for "automatic" exposure, but you have no control over this variance.)

Every flash unit has a *guide number* that represents the effective light output of the unit, and that is used to figure flash exposure. The guide number is always quoted in relation to a particular film speed, usually 25 A.S.A. Assume the guide number of a unit is 64 for 25

A.S.A. The number can be fitted into the following formula to determine the correct f-stop:

$$\frac{\text{guide number}}{\text{distance in feet}} = \text{f-stop}$$

The formula is based on the inverse square law — illumination is sharply reduced as distance is increased. If the flash travels sixteen feet to the subject:

$$\frac{64}{16} = \text{f } 4$$

With a guide number of 64 (at 25 A.S.A.), use f 4 at sixteen feet. When using a different speed film, you must make a conversion. If the film speed is:

50 A.S.A. — reduce exposure by one stop
100 A.S.A. — reduce exposure by two stops
400 A.S.A. — reduce exposure by four stops

If needed, the guide number of the flash for different film speeds can be worked out by figuring the exposure at the appropriate speed and using the formula. For the same flash unit at sixteen feet, you must close down four stops for 400 A.S.A. film to f 16. So plug f 16 into the formula:

$$\frac{\text{guide number}}{16} = \text{f } 16$$

guide number = 256 (at 400 A.S.A.)

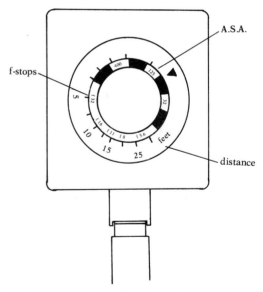

A guide-number dial on the back of a flash unit. Set the A.S.A. of the film; the required f-stop setting will be located opposite the distance setting.

Most strobe units have a dial that uses the guide number to quickly calculate the exposure. First, set the A.S.A. of the film; then note the distance. There is a mark on the dial, usually opposite the distance setting, that indicates the appropriate f-stop.

You can figure the guide number of the unit (if you do not know it

169

already) by using the dial. Set the dial at 25 A.S.A., and read the f-stop opposite ten feet — for example, f 4:

$$\frac{\text{guide number}}{10} = \text{f } 4$$

Therefore, the guide number of the unit is 40 for 25 A.S.A. film.

The guide number is only a guide. You may need to adjust your flash's guide number if you get consistently underexposed or overexposed negatives. Also, under some circumstances, the guide number's indicated exposure must be adjusted. Here are some general rules:

If the flash unit is used outdoors at night or in a large room, increase the indicated flash exposure by one or two stops.

If the flash unit is used in a small room, or in a white room, decrease the indicated flash exposure by one stop.

If the flash unit is used off the camera to the side of the subject, increase the indicated flash exposure by one stop.

If the flash unit is used off the camera in back of the subject, increase the indicated flash exposure by two stops.

Newer, portable strobes usually offer *automatic exposure.* Light travels at 186,000 miles per second, compared to which the flash duration is quite long; the first burst of flash light actually bounces off the subject and reaches the film while the flash is continuing its output. A sensor device on the flash unit (or on the camera) measures the light as it is reaching the film. Once the sensor registers the return of an adequate amount of light, it cuts short the flash duration. Usually the f-stop and the A.S.A. must be preset on the flash unit for the sensor to react to how much light is traveling through the lens.

Automatic exposure flash may seem like an ideal solution to flash exposure, but it has important drawbacks. Like any automatic device, it limits control. Many people use automatic flash without thinking, therefore never really learning the nature of flash exposure. Also, "automatic" implies infallible, but machines do make mistakes. If the room is very bright and the subject very dark, the sensor may register the light from the bright walls, and cut off the flash before allowing in adequate light to render detail in the subject. Furthermore, the sensor can misjudge which subject to concentrate on. Assume the main subject is ten feet away from the flash. If there is a bright object five feet away, the sensor may pick up the light from the

foreground and cut short the flash, causing an underexposed main subject.

Most automatic exposure units have a nonautomatic (or a manual) setting. If you use this setting and figure exposure with the guide number (or dial), you will learn a great deal about the nature of flash exposure, and should end up with more consistent results.

Multiple Flash

When you are using more than one flash unit, the exposure is always dependent upon the unit serving as the key light. So ignore the fill and the background units when computing multiple flash exposure. For example, set up the key and the fill units. Compute the exposure for each unit separately. If the key unit calls for f 8, and the fill unit calls for f 4, use f 8. The lighting ratio will be the difference between the key and the fill, which is two stops, or four-to-one.

If more than one flash unit is used for key lighting, the exposure must be decreased by one stop for each unit providing equal amounts of intensity, since the amount of light reaching the subject will be doubled. For example, if you use two flash units, each equal in power and distance from the subject, and the exposure for each calls for f 8, use instead f 11.

Flash with Ambient Light

Photographs taken with a single flash source often have a harsh, two-dimensional quality that can sometimes be countered with the use of ambient light in the exposure. The flash always serves as a key in low light levels, but window light or room light can add fill or background illumination to produce a more natural lighting effect.

Figuring exposure when using ambient light requires some juggling. The simplest approach is:

> *Use the f-stop required for a correct flash exposure; and set the shutter speed according to how much ambient light you want to capture.*

The indicated flash exposure is required since the flash serves as the key light. However, with flash the shutter speed is chosen primarily to allow synchronization with the duration of the flash (with indoor, low-light work, the shutter speed will usually be at 1/60 of a second or

This subject was photographed using a single flash unit at the camera position. The shutter speed was set slow enough to capture some of the ambient light provided from overhead and the windows.

slower, so synchronization with either focal plane or leaf shutters is rarely a problem). The flash fires once, and produces the bulk of the exposure; the remaining time for which the shutter stays open produces the additional ambient light exposure.

First, determine the flash exposure by the normal method — either using the unit dial or dividing the guide number by the distance. Let's say the flash exposure is f 8. Now measure the ambient light, such as general room light or window light. Let's say the ambient light measures 1/15 at f 4. Adjust the f-stop from the indicated ambient light exposure to match the f-stop from the indicated flash exposure: 1/4 at f 8.

If you use this exposure, the film will be equally affected by the flash and the ambient light. The resultant lighting will be flat and even. Since the flash is almost always the key light, it should be more

dominant than the ambient light, which acts as fill or background lighting. This difference produces the tonal separations that suggest the three-dimensionality of the image.

The solution is to use a shorter camera exposure to capture less ambient light than flash light. To do so, adjust the shutter speed of the indicated ambient light exposure; do not make changes in the f-stop since these will affect the flash exposure. If 1/4 at f 8 produces an evenly illuminated image, then 1/8 at f 8 will produce an image with half as much ambient light, and, therefore, some tonal separation. And 1/15 at f 8 will produce an image with one-fourth as much ambient light, and even more tonal separation. Be sure to use a tripod when shooting at slow shutter speeds to avoid a blurred image.

Outdoor Fill Flash

A flash can be used outdoors on a bright sunny day as a fill to add illumination to dark shadow areas. Outdoors, the sun is the key light, so exposure is based solely on the light meter reading. The flash simply adds a little more illumination to the shadows.

Take a light–meter reading off the subject, and assume the reading is 1/250 at f 8. Now you must juggle the flash and the camera exposures. With most cameras that have a focal plane shutter, your setting must be at 1/60 or slower for synchronization (with some cameras, you can use 1/125 or slower), so change the indicated exposure to 1/60 at f 16, and use that exposure. If you have a leaf shutter, there is no need to change the camera exposure, since the shutter will synchronize at all speeds. Focal plane shutters, since they are less flexible, are difficult to use in some situations (such as a bright day with 400 A.S.A. film).

Calculate the flash exposure with either the unit dial or the guide number. Assume the flash exposure is f 8 at ten feet. So at ten feet from the subject the flash will produce two stops less illumination than the sun (f 8 as opposed to f 16), and soften up the subject by producing a little more detail in the shadows (creating a lighting ratio of four-to-one between the highlights and the shadows of the subject).

Occasionally, the flash illumination is as strong as (or stronger than) the sun's illumination. In the above example, if the flash output were two stops stronger, the flash exposure would be f 16 at ten feet. If

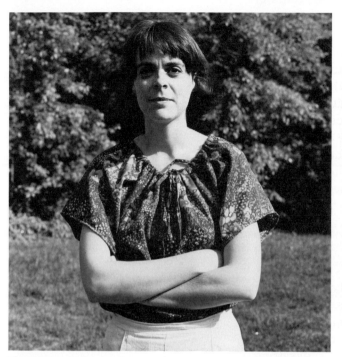

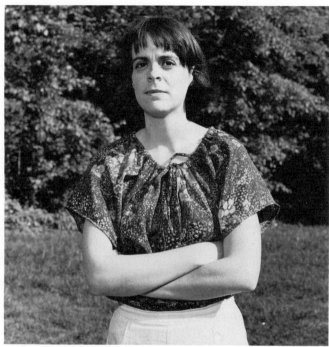

This photograph was taken on a bright sunny day. Note the dark shadows on the subject's face.

Here a flash was used as a fill to add illumination to the shadows

you use f 16, the flash and the sun will equally affect the subject, and the results will be flat and even. So reduce the flash illumination by increasing the flash-to-subject distance, or by diffusing the flash light (for example, by covering it with a handkerchief); or by reducing the aperture opening and adjusting the shutter speed to 1/30 at f 22, instead of 1/60 at f 16.

Flash Meters

Flash meters are similar to regular light meters, except they measure flash intensity. They are very accurate, so are worth owning if you regularly use flash light.

Different brands of flash meters work differently. Some use a long cord that plugs into the flash unit and contains a button that sets off the flash and measures the illumination; others work without a cord and measure illumination as the flash is set off. With all units, the meter is placed at the subject position and aimed toward the key flash unit. When the flash fires, the meter registers the light and suggests the appropriate f-stop.

Lighting ratios can be easily figured with a flash meter. Position the meter close to the subject and measure the light output from the key flash unit. Assume the indicated exposure is f 11. Now position the meter close to the subject and measure the output from the fill flash unit. Assume the indicated exposure is f 5.6. The difference is two stops, so the lighting ratio is four-to-one.

Bare Bulb

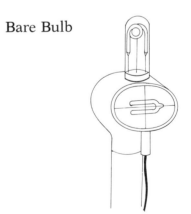

Bare bulb refers to the use of flash — either bulb or electronic — without a reflector to soften the quality of the lighting. With a reflector, the light is harsh and travels in a direct path to the subject; without a reflector, the light is soft, reflecting off walls and ceiling, thereby simulating a more natural light.

Since the light of bare-bulb flash scatters all over the room — in back, to the side, above and below the subject — expect to increase your film exposure. A good rule is to increase exposure two stops. In a small, bright room, one stop may be sufficient; outdoors at night, three stops may be necessary.

A limited number of flash units can be adapted to bare-bulb use.

Bare bulb. A regular flash unit converted to accept an additional bare-bulb flashtube.

A bare-bulb flash is a soft, reflected light source

Some bulb-type units have removable reflectors. Some electronic flash units can accept (or be converted by the manufacturer to accept) an additional bare-bulb flashtube. A very few electronic flash units accept only bare-bulb flash.

Open Flash

Open flash is a manual synchronization method where the shutter is mechanically opened, and the flash is independently fired. Very low light conditions are necessary for open flash use. Since the shutter is open, any ambient light will strike the film, and that quantity must be minimized.

Open flash can be used to increase the intensity of the light source. With a stationary subject, open the shutter and fire the strobe several times. This is particularly useful if you need greater illumination to shoot at a small aperture for increased depth of field. Also, you can simulate multiple flash with a single source, by moving the flash around from key to fill to background position.

Open flash can also be used to make a multiple image. Place the subject against a dark background, open the shutter, and fire the flash. Now move the subject and fire again. Due to the dark background, the flash will expose only the subject; since the subject moves, it will appear simultaneously in different locations on the film.

To open the shutter:

Use the "t" *(time)* setting, cock the shutter, and press the shutter button. The shutter will close when the button is pressed a second time.

Or, use the "b" *(bulb)* setting and press the shutter button. When the button is released, the shutter will close. A locking cable-release will keep the shutter locked open at the "b" setting; the shutter will close when the release is unlocked.

Further Reading

Adams, Ansel. *Artificial Light Photography* (Basic Photo Series). Boston: New York Graphic Society, 1977.

————. *Natural Light Photography* (Basic Photo Series). Boston: New York Graphic Society, 1977.

Bomback, Edward S. *Manual of Photographic Lighting.* Dobbs Ferry, New York: Morgan and Morgan, 1973.

Eastman Kodak Company. *Professional Portrait Techniques.* Rochester, New York: Kodak Publication 0-4, 1973.

Helprin, Ben, and the Editors of Photographic Magazine. *Photo Lighting Techniques.* Los Angeles: Petersen Publishing Company, 1973.

Time-Life Books. *Studio.* New York: Life Library of Photography, 1971.

The View Camera

Introducing the View Camera

View cameras are used mostly by professional photographers, but also by many serious amateurs for ultimate control over image quality. They produce large negatives that print with maximum sharpness and minimum graininess; and they provide means for control over the perspective and the focus of the image. A view camera does not guarantee a good photograph, and in many situations it is an impractical tool, but it is an important photographic option that you should know about and consider using.

Should You Use a View Camera?

The advantages of a view camera are: It accommodates individual sheets of large-size film; it allows for interchangeable lenses; and it has a bellows and ground-glass viewing.

Film size: View cameras are made for various film sizes, such as 2¼″ × 3¼″, 4″ × 5″, 5″ × 7″, and 8″ × 10″. The relatively large size of

the film means better-quality negatives and prints — less graininess, more overall sharpness, smaller scratch and dust spots, and generally greater tolerance for error. After all, large negatives need less enlargement than small negatives to produce equivalent-size prints.

Furthermore, contact prints from large negatives are easy to view. Some photographers use direct contact printing rather than enlarging for final prints, particularly when using 5″ × 7″ and larger negatives, because the quality of a contact print is superior to the quality of an enlargement.

Sheet film: View cameras use flat, individual pieces of sheet (or *cut*) film. Each sheet can be developed individually for increased or decreased development, thereby allowing for maximum control over the final negative contrast. Also, because it is primarily produced for professional use, sheet film is available in a greater variety of emulsion types than roll film.

Image control: The front and back parts of the view camera can be moved independently in many directions to effect changes in the relative positions of the lens and the film. These camera movements are used to maximize control over the perspective and the focus of the image, as well as over the position of the image in relation to the film.

Interchangeable lenses: A great variety of lens types and focal lengths is available. Most lenses are easily interchangeable from camera to camera when mounted on the correct-size lens board.

Long bellows: View cameras use a collapsible bellows that allows great flexibility in focusing, particularly useful for close-up photography requiring a long distance between lens and film.

Ground-glass viewing: A ground glass — exactly the size of the negative — for through-the-lens viewing, composing, and focusing the image is used in the view camera. Because you see exactly what the film will record, photographing is more precise and controlled.

The major disadvantages of the view camera are its size and its expense.

Size: View cameras are large and slow to operate. Size is not a serious problem in a studio; but lugging a view camera in the field with case, tripod, and accessories can be a chore. Also, view cameras must be used on a tripod, so are not suited to quick or candid shooting situations.

Expense: View cameras and accessories are expensive. Also, sheet

film and its processing are more costly per exposure than roll film. On the other hand, it is possible to spend a great deal on any type of camera with accessories. View-camera users do work carefully, so they tend to shoot less film than most roll-film users.

<div align="right">View-Camera Parts</div>

The view camera is a simple instrument despite its complex appearance. There are variations among brands, but all view cameras include the following: camera bed, lens standard, back standard, and bellows.

The *camera bed* is a base that holds the rest of the camera body, and provides a connection to a tripod. Most modern view cameras use a *monorail* (or single rail), though some cameras use double-rail and flatbed bases. A *clamp* connects the monorail to the tripod, and is movable for positioning and balancing the lens and back standards.

The *lens standard* (also called the *front standard*) is the assembly that holds the lens board (which, in turn, holds the lens). It permits lens movement up and down, side to side, and back and forth for maximum image control. The lens standard has *positioning knobs* that control and lock all the movements.

The *back standard* (also called the *rear standard*) is the assembly that holds the *camera back*, which, in turn, contains the *ground glass* and holds the film. Most back standards permit film movement in much the same manner as the lens standard permits lens movement. The back standard also has positioning knobs that control and lock all the movements.

The *bellows* is a light-tight, collapsible cloth or leather tube that connects the lens and back standards. It facilitates focusing by permitting easy expansion and contraction of the distance between the standards. For close-up focusing, the standards are far apart; for focusing at a distance, the standards are closer together.

<div align="right">Film and Film Holders</div>

View cameras can accommodate several types of film, depending upon the film holder used.

Sheet film is the most popular and is usually loaded into a *double-*

<div align="right">183</div>

The parts of a view camera

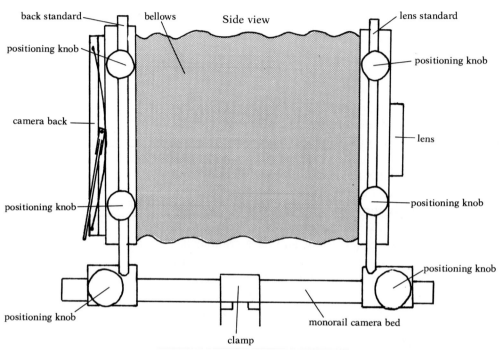

Side view

- back standard
- bellows
- lens standard
- positioning knob
- positioning knob
- camera back
- lens
- positioning knob
- positioning knob
- positioning knob
- positioning knob
- monorail camera bed
- clamp

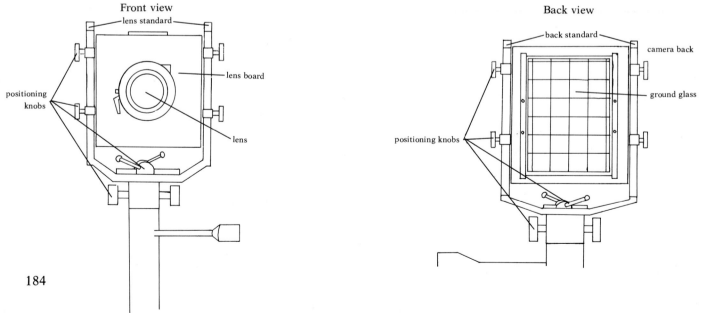

Front view

- lens standard
- lens board
- positioning knobs
- lens

Back view

- back standard
- camera back
- ground glass
- positioning knobs

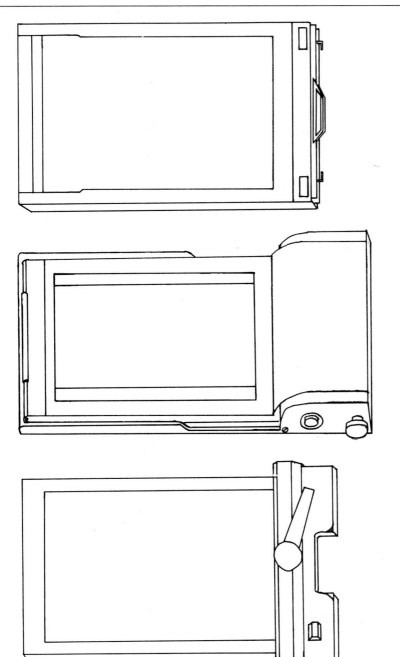

A double-sheet film holder

A roll-film holder

A Polaroid holder

sheet film holder that provides space for two sheets of film — one on each side of the holder. Since each holder allows for only two exposures, you must have several holders for a full day of shooting. *Grafmatic film holders* store up to six sheets of film in a single unit, but they are no longer manufactured.

Roll film is usable with many view cameras when loaded into special roll-film holders. Some roll-film holders slide directly into the camera back, and some completely replace the back. Not all types of roll-film holders are compatible with all types of cameras. If you use roll film, you must mark off the ground glass to indicate the reduced image size.

Polaroid film can be used with 4″ × 5″ view cameras when loaded into Polaroid holders. One type of holder accepts regular Polaroid pack film, and the other type accepts Polaroid sheet film (special professional films that differ from Polaroid amateur films). The image produced is slightly smaller than 4″ × 5″, so you must mark off the ground glass to indicate the reduced image size.

Film packs contain sixteen 3¼″ × 4¼″ or 4″ × 5″ sheets in a compact package. Film-pack holders are no longer produced, but the film is still available, though often only on special order.

View-Camera Lenses

A view-camera lens on a lens board

View cameras can accept a great variety of different lenses. Each lens must be mounted on its own board that attaches to the lens standard. Various brands of view cameras use different-size lens boards.

Most view-camera lenses have built-in leaf shutters, although lens and shutter can be purchased separately. A few have built-in focal plane shutters.

Focal Length and Angle of View

Focal length, angle of view, and negative size are closely related. The *angle of view* refers to the amount of area that the lens takes in or "sees." But this angle is dependent upon the negative size. Any 90 mm lens — regardless of the brand — sees the same area. However, when that area is projected back to different-size negatives, the angle of view changes. For example, a 90 mm lens takes in a 27-degree

This photograph was taken with a 90 mm lens onto 4″ × 5″ film; the angle of view is 63 degrees

This photograph was also taken with a 90 mm lens, but onto 35 mm film, at the same distance from the subject; the angle of view is narrower — 27 degrees

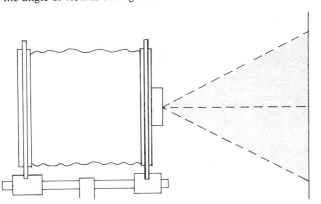

diagonal angle with a 35 mm negative, but a 63-degree diagonal angle with a 4″ × 5″ negative.

Therefore, a single lens can act as a normal, a wide-angle, or a telephoto lens when used with different negative sizes. A 150 mm lens is normal for a 4″ × 5″ negative, short (or wide-angle) for an 8″ × 10″ negative, long (or telephoto) for a 2¼″ × 2¼″ negative. Here is a chart of focal lengths and comparable angles of view for different negative sizes:

Negative Size	Diagonal angle of view					
	wide-angle			normal	telephoto	
	88 °	75 °	63 °	46 °	29 °	18 °
35 mm	21 mm	28 mm	35 mm	50 mm	85 mm	135 mm
2¼″ × 2¼″	40 mm	50 mm	65 mm	80 mm	150 mm	250 mm
4″ × 5″	60 mm	80 mm	90 mm	150 mm	240 mm	360 mm
5″ × 7″	90 mm	121 mm	130 mm	220 mm	360 mm	540 mm
8″ × 10″	120 mm	165 mm	180 mm	330 mm	480 mm	720 mm

(Note: These comparisons are approximate, since commonly available focal lengths vary slightly with different negative sizes. Also, 25.4 mm equals 1 inch, so a 50 mm lens is commonly referred to as a 2-inch lens; a 100 mm lens as a 4-inch lens; a 150 mm lens as a 6-inch lens; and so forth.)

Covering Power

The *covering power* of a lens is a measurement of the amount of even illumination and even sharpness it can project. All lenses actually project two concentric circles of light back to the film. The *circle of good definition* provides an even distribution of sharpness; it falls within the *circle of illumination* that provides an even distribution of light. A lens must project a large enough circle of good definition to properly cover the film size, or the edges of the negative will lack sharpness and/or density.

The covering power of a lens varies with several factors:

1. *Lens design:* Different lenses are designed differently. Generally

The covering power of a lens is dependent upon several factors: design, focal length, f-stop, and focus distance

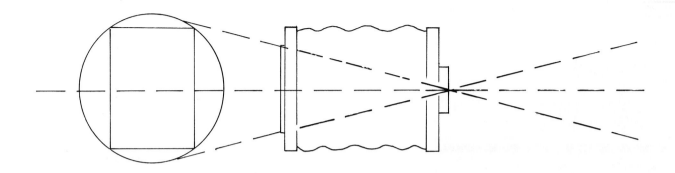

This lens has barely enough covering power for the negative size used

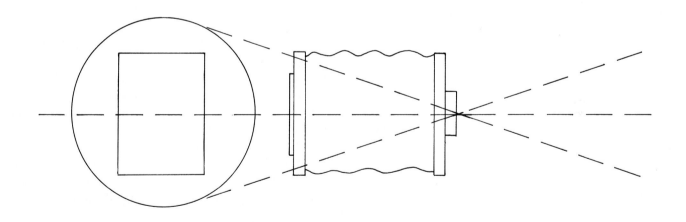

This lens has excess covering power

This photograph was taken with a 75 mm lens (of regular design) onto 4″ × 5″ film. The lens does not cover that negative size; there is a reduction of both sharpness and illumination at the edges of the image.

the better (and more expensive) designs have greater covering power; two differently designed 150 mm lenses could provide greatly different coverage.

2. *Focal length:* With lenses of similar design, the longer the focal length, the greater the covering power; a 135 mm lens of a particular design will provide less coverage than a 210 mm lens of the same design. In fact, short-focal-length lenses often will not cover large negative sizes. A 75 mm lens will rarely cover a 4″ × 5″ negative, while a 240 mm lens will always cover that size.

3. *Aperture:* The smaller the aperture, the larger the covering power of a lens. A lens stopped down to f 22 will cover a larger area than the same lens at f 8.

4. *Focus distance:* The greater the distance at which the lens is focused, the smaller the covering power of that lens. When focused at an object eight feet away, the lens will cover a larger area than when focused at an object twenty-five feet away.

Most normal, and even slightly short, lenses will cover adequately when used with a minimum of camera movements. However, as the lens and back standards are moved around, the film may end up outside the lens's covering power. This factor will be discussed in more depth later, but for now, remember that a lens of excess covering power is necessary when using camera movements.

Wide-Field and Telephoto Designs

Wide-field and *telephoto* designed lenses are special types that differ from lenses of regular design. A wide-field lens provides more covering power than a regular lens of the same focal length; a telephoto lens focuses using a smaller bellows extension than that of a regular

lens of the same focal length at the same distance. The design of these two lenses does not affect the angle of view; a wide-field, 90 mm lens sees the same area as a regular 90 mm lens.

Wide-field lenses are necessary because regular, short-focal-length lenses have little covering power. But a wide-field lens does not always show a wide-angle view. A 100 mm wide-field lens, for example, provides a wide-angle view for a 4″ × 5″ negative, but a normal view for 2¼″ × 3¼″ negative. Some popular wide-field lenses are Schneider Super-Angulon, Rodenstock Grandagon, and Kodak Wide-Field Ektar (no longer in production).

Telephoto lenses are desirable because regular, longer-focal-length lenses require a longer bellows extension, sometimes longer than the camera can provide. In addition, long extensions can also mean sagging bellows or a loss of illumination to the film. Sagging bellows will interfere with the ability of light to reach the film; and loss of illumination will produce an underexposed negative. A 300 mm telephoto lens requires a much shorter bellows extension than a regular 300 mm lens, when focused at the same object distance. But do not confuse telephoto design with so-called telephoto, or long, lenses. A 300 mm telephoto lens will provide a small angle of view for a 4″ × 5″ negative, but a normal view for an 8″ × 10″ negative. However, telephoto designed lenses are used only when necessary, since they provide less covering power than regular lenses of the same focal length. Some popular telephoto design lenses are Schneider Tele-Arton and Rodenstock Rotelar.

The advantage of a lens with a telephoto design is that it requires a shorter bellows extension than does a regular lens of the same focal length

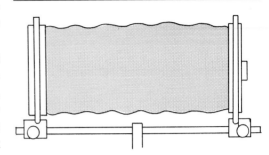

This regular-design 300 mm lens must be greatly extended to focus; it provides a 24-degree angle of view with a 4″ × 5″ negative

This telephoto-design 300 mm lens requires much less extension to focus on an object at the same distance; it provides the same 24-degree angle of view with a 4″ × 5″ negative. However, it does project less covering power than a regular-design 300 mm lens.

A List of Accessories

The *film holder* used depends on the type of film used — sheet film, roll film, Polaroid, or film pack.

Extra lenses are useful, though expensive.

Lens boards are used to fit the lens onto the lens standard of the view camera. Each lens should have its own board for easy changing. When focusing with a wide-angle lens, note that the lens and back standards are close together, and the bellows may not compress enough. A *recessed lens board* allows the lens to sit in behind the lens standard,

closer to the film, so the lens and back standards can be positioned farther apart, particularly helpful when using camera movements that require maximum bellows flexibility.

A *tripod* must be rugged, heavy, and sturdy to hold a view camera steady.

A *hand-held light meter* is a necessity, particularly if you are concerned enough about quality to bother using a view camera.

A *focusing cloth* is a piece of black material that is used for blocking out extraneous light from around the ground glass, to facilitate viewing and focusing. Generally, there is a clip on the rear standard to hold the cloth, though wire frames are sometimes available for this purpose. You can buy focusing cloths in a camera store, but these are flimsy and difficult to hold in place in windy weather. You can easily make your own cloth by double-lining a heavy piece of black material (approximately three by four feet or larger). Some cameras can be fitted with a collapsible, metal *focusing hood* that fits around the camera back in place of a focusing cloth.

A *cable release* is needed to trip the shutter gently and thus prevent camera motion, particularly during long exposures.

A *lens shade* blocks unwanted light from reaching the lens. Several types of shades are available for view-camera lenses. *Tube shades* attach directly to the front of the lens. A *compendium bellows* is an adjustable unit that attaches directly to the lens standard to act as a lens shade (and a filter holder). The adjustment is useful since different lenses require different amounts of shading.

A *lupe magnifier* is a small magnifying glass (usually with an 8x or 12x magnification), placed directly on the ground glass to allow for critical focusing.

Filters are used with black-and-white films for controlling sky tones and manipulating contrast, and with color films for guaranteeing color balance. The most practical type is a square gelatin filter that fits either in front or in the back of all size lenses. Filter holders (such as compendium bellows) are used to keep the gelatins in place, but some photographers simply tape the gelatin to the front or to the rear of the lens. Screw-type and series glass filters are also available to fit view-camera lenses.

A roomy *case* is useful to carry and protect camera and accessories.

A *bag* (or *wide-angle*) *bellows* is a cloth pouch that replaces the

A compendium bellows is an adjustable lens shade which also serves to hold filters

A bag (or wide-angle) bellows replaces the regular bellows on some cameras to allow greater flexibility in focusing and movement

bellows unit on some view cameras. It allows the lens and the back standard to move very close together for flexibility in focusing and movement, and is especially useful with wide-angle lenses.

Extension rails and extralong bellows are used in situations that require greatly expanded bellows, such as extreme close-ups or focusing with long-focal-length lenses. The normal view-camera rail and bellows extension is approximately sixteen inches, but some cameras have longer extensions, and some have optional, add-on lengths.

Reducing backs are provided on some cameras to handle different film sizes.

There are, of course, endless other accessories, most with specialized or limited functions. For shooting in the field, bring along some small tools, a gray card, tape, scissors, paper, pencil, and perhaps some lunch.

How to Use the View Camera

Loading Sheet Film

A double-sheet film holder accommodates two pieces of film, one on each side. Each piece is covered by a stiff, thin *dark slide* that slips easily in and out of the holder. Each dark slide has one metal edge — one side of which is black and smooth, the other side of which is light (or silver) and ridged. Convention dictates that when the black edge is facing out, the holder contains exposed film; when the light edge is facing out, the holder contains unexposed film.

An end flap on each side of the holder folds out to facilitate loading, and folds in to secure the dark slide. Also, thin metal guides in each film compartment hold the sheet film flat in its proper position.

Here are the steps for loading:

1. The holder must be cleaned thoroughly to prevent dust and grit from accumulating and scratching or dirtying the film. Remove both dark slides completely. Use a soft brush (about two inches wide), a rubber air syringe, or canned air to clear dust and grit from both the

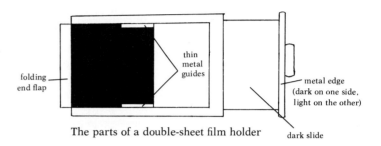

The parts of a double-sheet film holder

The notched code for Kodak Plus-X film. The emulsion side is facing you when the film is held vertically, and the notched code is at the lower-left or upper-right corner.

The notched code for Kodak Tri-X film

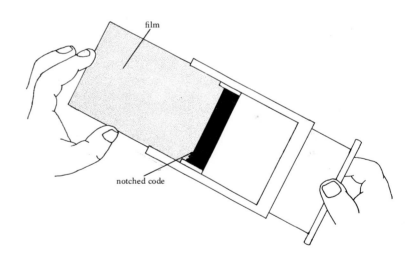

Sliding the film, emulsion side facing out, under the thin metal guides with the dark slide kept halfway in the holder

holder and the dark slides. Tap the holders lightly against a counter to dislodge any accumulation from inside corners and edges.

2. Before shutting off the room lights, prepare the area by laying everything out on a counter. You should have all the film holders (with dark slides) as well as a box of film within easy reach. Sometimes the dark slides are taken completely out of the holders, but it is easier to keep the slides halfway in for ease in reassembling the holder in total darkness. If you do leave the slides in the holders, be sure that the light edges are facing out to indicate unexposed film.

3. Shut off all the lights.

4. Take out the film, which is protected by a three-section box and a foil (or paper) wrapping. Be very careful when unpacking and handling the film. Sheet film is tougher than roll film, but it still scratches easily. Handle the film only by its edges. Each sheet has a notched code for easy identification in the dark. The shape of the notch varies with the type of emulsion, but the location is always on a short edge of the film, next to a corner (4″ × 5″ film is notched on a 4″ edge). The emulsion is facing you when you hold the film vertically with the notch at the lower left or upper right corner.

5. Load the film in the holder with the emulsion facing out of, not into, the holder. Fold out the end flap and slip the film carefully under the thin metal guides. Refold the end flap once the film is in place. Push the dark slide across the loaded film, until it locks securely into the end flap. Turn over the holder, and load another sheet of film.

6. When all the holders are loaded, wrap up the film and return it to the box. Save the empty film boxes for future storage of film or negatives.

Loading sheet film is not difficult, but you should practice before wasting film and time. Use a practice sheet. Look at the coded notches, and learn to identify the emulsion side. Practice slipping the film under the guides, and moving the dark slide in and out. Make sure that the slide fits snugly into the end flap. Practice first in room light, and then in total darkness.

Zero position is the neutral setting where the view camera operates
without lens or film movement, like any regular camera. You should
first set up at zero position, and then make movements only after
looking through the ground glass to see what needs adjusting.

1. Place the camera securely on the tripod.

2. Spread the lens and back standard apart, arbitrarily positioning
and locking the lens standard in place about halfway between the
front and center of the camera bed.

3. Set the camera at zero position by putting the lens and back
standards parallel to each other and perpendicular to the camera
bed. Also, be sure the center of the lens is directly in line with the
center of the ground glass.

Zero position

The neutral camera setting. Lens and back stan-
dard are parallel to each other and perpendicular
to the camera bed; the center of the lens is directly
in line with the center of the ground glass.

Side view of view camera in zero position

Top view of view camera in zero position

Viewing and Focusing the Image

1. Open the shutter to view and focus the image. Different shutters open differently. With some, you simply push a button located on the shutter casing; with others, you must first cock the shutter, then push the appropriate button. Occasionally you must set the shutter at T, then cock and release it.

2. Open the aperture to its widest f-stop for maximum illumination, to permit easier viewing and focusing on the ground glass.

3. View the image with a dark cloth tightly wrapped around the ground glass and your head, to block out extraneous light. The image will appear upside-down on the ground glass. If necessary, rotate the camera back to accommodate a vertical or horizontal image. Most backs revolve, though some must be removed, rotated, and then replaced.

4. Focus carefully by moving the back standard back and forth until the image is in focus. If you run out of room on the camera bed, adjust the lens standard position. Use a lupe magnifier flat against the ground glass for critical focusing. When the image is properly composed and focused, lock the positioning knobs in place.

5. Take a light-meter reading, and set the appropriate shutter speed and f-stop.

6. View and focus once more, since the focus of many lenses changes slightly at different apertures. Unfortunately, at small apertures or under low-light conditions, there is little illumination, so viewing and focusing may be difficult.

Taking the Picture

1. Close the shutter.

2. Cock the shutter by pressing the cocking lever on the shutter casing.

3. Carefully insert a film holder into the camera back by pulling the ground-glass screen. Make sure that the holder fits securely in place. Also, take care not to move the camera while loading the holder.

4. Remove the dark slide that is closest to the lens.

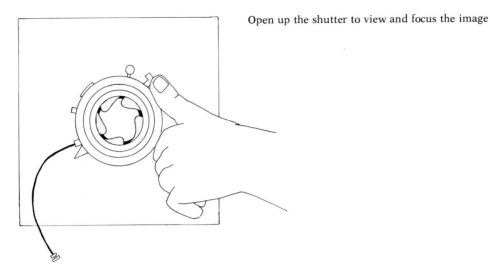

Open up the shutter to view and focus the image

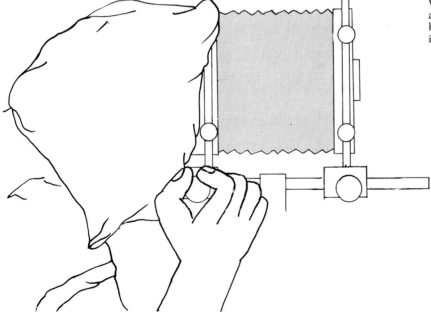

View the image with a dark cloth tightly wrapped around both the ground glass and your head to block out extraneous light. Focus carefully by moving the back standard back and forth.

Carefully insert a film holder into the camera back

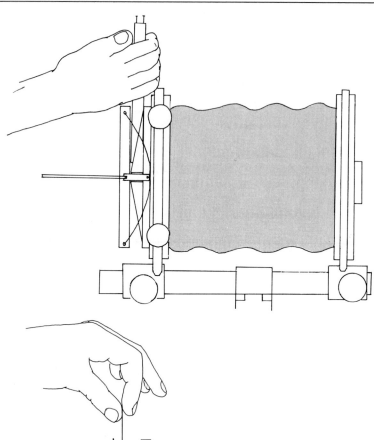

Remove the dark slide that is closest to the lens

5. Use a cable release to discharge the shutter, thereby exposing the film.

6. Replace the dark slide with its black metal edge facing out to indicate exposed film.

7. Pull back the ground glass and remove the film holder.

Camera Movements

Camera movements are adjustments in the relative positions of the lens or film, used to control focus, perspective, and the position of the image in relation to the film. The actual movement procedure varies from camera to camera. Sometimes the entire standard moves, and sometimes only the lens board or the back moves. Generally there are positioning knobs that loosen and lock the movements in place. Most view cameras allow for a lot of lens movement, but some have limited back movement. On many cameras there are click-stops or degree scales to help measure the exact amount of movement.

This section describes the effects of camera movements upon the image. However, it is important to understand that controlling the movements means far more than simply following a few rules. Every situation is slightly different, but you can always depend upon the accuracy of ground-glass viewing. After each movement, check the ground glass to see the results. If necessary, keep adjusting the camera until the desired effect is achieved.

The Rise, Drop, and Shift Movements

The rise, drop, and shift movements control the position of the image in relation to the film:

A *raised lens* has an effect similar to lifting the camera straight up; it moves the lens's projected image down on the ground glass (and, therefore, on the film) and reveals more of the top and less of the bottom of the subject (since the image is inverted).

A *dropped lens* has an effect similar to lowering the camera directly down; it moves the lens's projected image up on the ground glass and,

A camera in zero position; the lens projects the image, represented by the dotted rectangular frame, back to the ground glass

top view

side view

therefore, reveals less of the top and more of the bottom of the subject.

A *raised back* effects the same basic change as a dropped lens.

A *dropped back* effects the same basic change as a raised lens.

The shifting movements are horizontal versions of raising and dropping the lens and the back.

A *lens shift* to the left has an effect similar to moving the entire camera to the left; it slides the lens's projected image to the right on the ground glass. A lens shift to the right has the same effect as moving the camera to the right; it slides the lens's projected image to the left on the ground glass.

A *back shift* to the left effects the same basic change as a lens shift to the right; a back shift to the right has basically the same effect as a lens shift to the left.

When the lens is raised, dropped, or shifted, there is also a minor change in the viewpoint of the image. Imagine the lens is first aimed straight at the subject. If the lens is then raised, the point of view will be from a slightly higher position. When the camera back is moved, the point of view does not change. The difference is small and may be insignificant (certainly smaller than the effect of moving the entire

A camera with the lens raised (or the back dropped) reveals more of the top and less of the bottom of the subject

side view

A camera with the lens dropped (or the back raised) reveals less of the top and more of the bottom of the subject

side view

A camera with the lens shifted to the left (or the back shifted to the right) reveals more of the left side and less of the right side of the subject

top view

A camera with the lens shifted to the right (or the back shifted to the left) reveals more of the right side and less of the left side of the subject

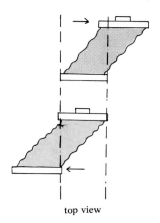

204

top view

camera). But you may choose to raise, lower, or shift the back instead of the lens to avoid this viewpoint change.

Sometimes the rise, drop, and shift movements are used for minor changes. For example, you may set up the camera in zero position, view the image, and decide to include a little more of the top of the subject. Rather than raising the entire camera (by raising the tripod) or pointing the camera up (which would alter the shape of the image — see the next section), you can simply raise the lens or drop the back.

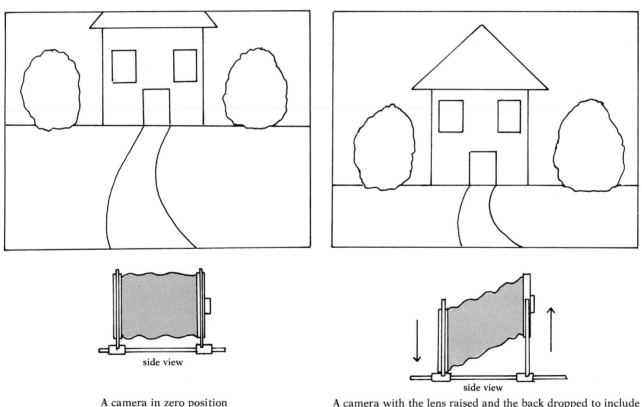

side view

A camera in zero position

side view

A camera with the lens raised and the back dropped to include much more of the top of the subject

A camera in zero position, photographing a wall straight on. The camera reflects in the mirror.

top view

To circumvent the reflection, the entire camera is moved to the right; then, the lens is shifted to the left, and the back is shifted to the right

top view

For more significant changes, you may choose to move both the lens and back. For example, you may want to photograph a building, but if you shoot it at zero position, the top of the building will not be included on the ground glass. Raising the lens will include more of the top, but possibly not enough. So raise the lens and drop the back to effect a greater movement.

Also, you can circumvent interfering elements by moving the entire camera, and then using the rise, drop, or shift movements. For example, imagine you want to photograph a wall, straight on, with a mirror in the center. If you set the camera at zero position, pointing directly at the wall, the mirror will reflect the camera. So, move the entire camera to the right, out of the view of the mirror, and shift the lens to the left and the back to the right to circumvent the reflection.

The Tilt and Swing Movements

The lens or back can be tilted or swung toward or away from the subject. Imagine horizontal and vertical axes crossing through both the lens and the back. *Tilting* refers to rotating the lens or the back about its horizontal axis; *swinging* refers to rotating the lens or the back about its vertical axis.

The tilt and swing movements are the most difficult to understand and control. With the rise, drop, and shift movements, the lens and back always remain parallel to each other. However, with a tilt or swing, the lens and back are no longer parallel, thereby causing important changes in the shape and focus of the image.

side view

The tilt movement: a camera with its lens tilted downward along its horizontal axis

top view

The swing movement: a camera with its lens swung to the right along its vertical axis

The Back Controls Shape (or Perspective)

The shape (or perspective) of an object can be changed by tilting or swinging the camera back. Imagine pointing a camera straight up at a tall, rectangular building. Because of perspective (the size of an object diminishes with distance), the top of the building seems smaller than the bottom. The building's vertical lines converge, and its shape resembles a trapezoid rather than a rectangle. The amount of convergence is dependent upon the angle of the camera back to the object. When the camera is pointing up, the back is at an angle to the

207

building. As you increase that angle, the convergence becomes more pronounced; as you decrease that angle, the convergence becomes less pronounced.

One of the most common uses of camera movements is to eliminate convergence by tilting or swinging the camera back, so the object and the back are parallel. When the camera is pointing up at a building, tilt the back forward to straighten out the converging vertical lines. Or, imagine photographing a horizontal building, located at an oblique angle to the camera. The top and bottom lines of the building

Controlling shape, or perspective, of vertical converging lines: tilting the camera back

side view

side view

Point a camera in zero position straight on at a tall building. The camera back is parallel to the building, so the building's vertical lines are parallel; they do not converge. However, the top of the building is not included.

Point the camera up to include the entire building. However, the camera back is now at an angle to the building. As a result, the building's vertical lines begin to converge; the shape of the building changes from a rectangle to a trapezoid.

converge horizontally. To correct this convergence, swing the camera back so it is parallel to the building.

Tilting or swinging the back will alter the image's focus, due to the change in the relative film-to-lens positions. To put the image back into focus, tilt and/or swing the lens in the same manner as you moved the back, so that the lens and the back are again parallel.

Or, you can alter the lens to conform to the *Scheimpflüg Principle*, explained on pages 211–212. Notice, in the illustration below, that when the back is tilted at a greater angle to the building to increase convergence, the entire building, despite the tilt, is in focus.

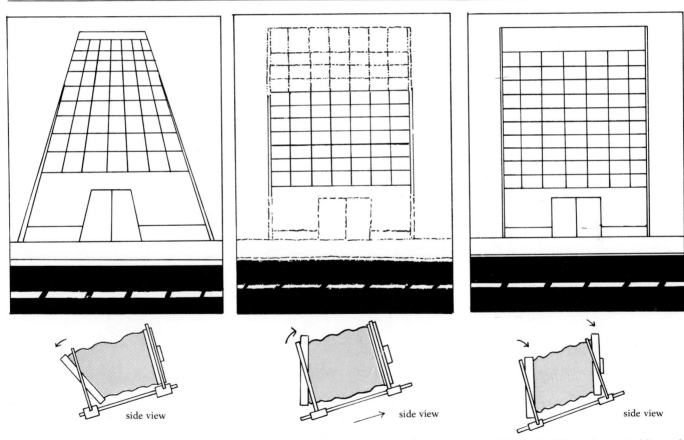

side view side view side view

If the camera back is tilted backward, the angle between the camera back and the building is increased, and the convergence is more pronounced

If the camera back is tilted forward to make it parallel to the building, the vertical lines of the building become parallel. However, the top and bottom of the image are out of focus (represented by dotted lines), so tilt the lens forward, in the same direction as the back. The lens and the back are again parallel; the building's vertical lines are parallel; and the image is in focus.

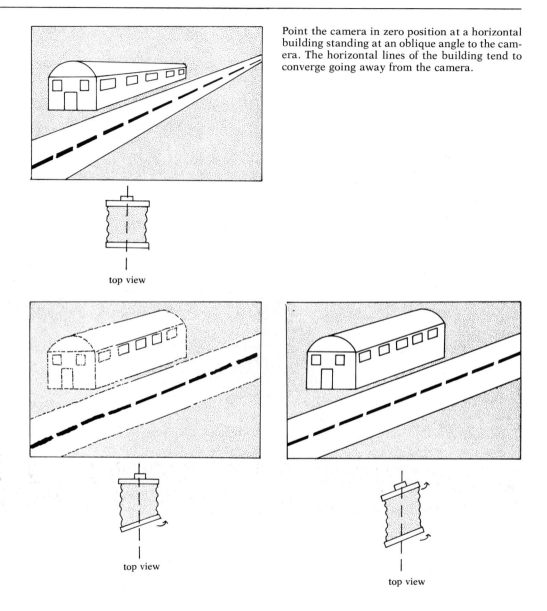

Point the camera in zero position at a horizontal building standing at an oblique angle to the camera. The horizontal lines of the building tend to converge going away from the camera.

top view

top view

top view

Swing the camera back to the left to make it parallel to the horizontal lines of the building. However, the image is partly out of focus, so swing the lens to the left — in the same direction as the back. The lens and the back are again parallel; the horizontal lines of the building are parallel; and the image is in focus.

210

The Lens Controls Focus

The apparent focus of an object can be controlled by tilting or swinging the lens. The *plane of sharpest focus* of an object is the plane that travels through the focal point (on that object), parallel to the lens standard. Imagine a camera in zero position, focused on a wall that is parallel to both the lens and the back. The wall represents the plane of sharpest focus; the entire wall will be equally in focus. The depth of field will extend in front and in back of the surface of the wall, parallel to the plane of sharpest focus. However, if the wall is located at an angle, rather than parallel to the lens and back, to guarantee maximum focus you must change the plane of sharpest focus by swinging the lens in the same direction as the wall. This phenomenon is based on the Scheimpflüg Principle, which states:

When the planes of the lens, the film, and the subject are extended and meet at a common point, the subject will appear in maximum focus.

Controlling the plane of sharpest focus: tilting or swinging the lens

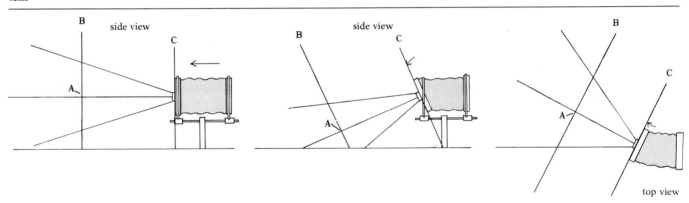

With the camera at zero position, focused on point A, line B represents the plane of sharpest focus; all points along that plane will be equally in focus. The plane of sharpest focus is parallel to the lens plane (line C).

Tilting the lens downward changes the plane of sharpest focus. The lens plane (line C) moves downward, as does the plane of sharpest focus (line B), parallel to the lens plane.

Swinging the lens to the right also changes the plane of sharpest focus. The lens plane (line C) moves to the right, so the plane of sharpest focus (line B) also moves to the right, parallel to the lens plane.

211

When the extended planes of the lens (line Y), the film (line X), and the subject (line Z) meet at a common point, the subject will be in maximum focus.

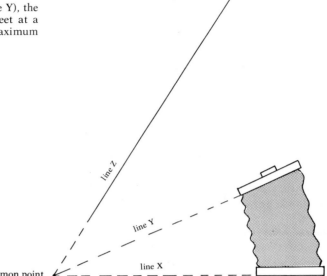

line Z

line Y

line X

common point

Generally, to increase focus, you tilt or swing the front. But tilting or swinging the back may also mean the planes of the lens, the film, and the subject will all meet at a common point (see the illustration above). However, tilting or swinging the back also creates a change in the object's shape, so unless that change is desired, always tilt or swing the front to increase the focus.

In Summary

The rules of tilting and swinging the camera back and lens can be confusing. Here are the main points to remember:

1. Tilting and swinging the camera back controls the shape or perspective of the object. When the back is parallel to the object, there is no apparent convergence; when the back is tilted or swung away from the object, the vertical or horizontal lines of that object seem to converge; the greater the angle between the back and the object, the greater the convergence.

2. Tilting or swinging the lens controls the apparent focus of the photograph. Maximum focus is achieved when the planes of the lens, the film, and the object are all parallel to one another; or when the planes of the lens, the film, and the object — when extended — all meet at a common point.

Increasing focus: swinging the lens

A camera in zero position, viewing a fence straight on. The center of the fence is in focus, but there is not enough depth of field, so the front and back of the fence are out of focus (represented by dotted lines).

top view

To increase the focus, swing the lens to the right, in the direction of the fence

top view

A camera in zero position, pointing at railroad tracks. The center of the tracks is in focus, but the front and back are out of focus.

side view

To increase apparent focus, tilt the lens down, in the direction of the tracks

side view

At zero position, the center of the film is located directly in back of the center of the lens (and presumably within the center of the lens's covering power). Any adjustment (except possibly tilting or swinging the back) could cause the film to move outside the covering power of the lens. Furthermore, with extreme camera movement the bellows may actually block the light traveling to the film. Either way, the result will be a negative lacking in sharpness or density at its edges.

You can identify poor coverage or bellows interference by a careful inspection of the corners of the ground glass. On some cameras, the corners of the ground glass are clipped off. You should be able to see a spot of light coming through each corner. If any corner is dark, the light is blocked off because of inadequate lens coverage or bellows interference.

View-Camera Exposure

Film exposure with a view camera is the same as that of any other camera, except that the bellows extension (the distance from the center of the lens to the film) and reciprocity failure more often need consideration. As the bellows extension increases, the intensity of the light reaching the film decreases. The formula, as explained on pages 49–50, is as follows:

$$\frac{(\text{bellows length})^2}{(\text{focal length})^2} = \text{exposure factor}$$

Assume that the focal length is six inches (150 mm), and the bellows extension is twelve inches. Therefore:

$$\frac{12^2}{6^2} = 4x$$

The exposure factor is 4x (or two stops), so if the indicated exposure is

side view

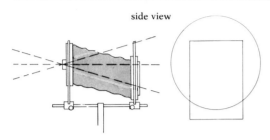

A lens with excess covering power is needed to allow flexibility in camera movements. Almost any movement (here it was a raised lens) could cause the film to end up outside the covering power of the lens. Note the reduced illumination at the top of the image.

1/250 at f 8, use a corrected exposure of 1/60 at f 8, or 1/125 at f 5.6, or 1/250 at f 4.

A simpler way to figure the needed correction is the 50 percent rule:

For every 50 percent increase of bellows extension over focal length, increase exposure by one stop.

In other words, if you are using a six-inch lens, and the bellows extension is nine inches (50 percent more), increase the indicated exposure by one stop. If the bellows extension is twelve inches (100 percent more), increase the indicated exposure by two stops. If you are using an eight-inch lens, and the bellows extension is twelve inches (50 percent more), increase the indicated exposure by one stop. If the bellows extension is sixteen inches (100 percent more), increase the indicated exposure by two stops.

Reciprocity failure is also common with view-camera work, since long exposures are frequently necessary to increase depth of field or to compensate for reduced illumination due to bellows extension. See pages 47–48 for details on reciprocity failure.

Processing Sheet Film

The most common methods of processing sheet film are with trays or with tanks and hangers. There are daylight processing tanks available for sheet film, like those available for roll film, but they are awkward to use and difficult to agitate correctly.

Tray Processing

The simplest and least expensive processing method is in trays, using the same basic techniques as with prints. The film must be handled very carefully since there is little protection from scratching. Also, only a few sheets (perhaps a maximum of six) can be safely processed at a time. Here are the instructions:

1. Set up five trays (8″ × 10″ for 4″ × 5″ film) in this order: water, developer, stop bath, fixer, and water.
2. Turn off the lights and remove up to six sheets of film from the

217

holders. Stack the sheets carefully, handling them at the edges with your fingertips.

3. Presoak the film by dropping the sheets, emulsion side up, one at a time, into the first tray of water for one minute. Gently push each sheet under the water. This presoak acts to prevent the sheets from sticking together, thus guaranteeing even development.

4. Remove the sheets from the presoak, and place them one at a time in the developer.

5. When all the sheets are in the developer, stack them to prevent the corners from gouging the film emulsion. Agitate constantly by gently holding down the top sheet, removing the bottom sheet from the developer, and placing it on top of the stack. Keep shuffling the sheets — bottom to top — until the time is up.

6. Stop and fix the film with the same type of agitation. The final tray is a holding bath for the wash.

7. Use a washing aid to cut down the wash time. The final wash should be in slow-running water with constant agitation. Take care, since running water causes movement and could damage the film. Or, you can safely wash film by changing the water in the tray every thirty seconds, with constant agitation between changes.

8. Soak the film in a tray of wetting agent.

9. Hang the film to dry by a corner with a spring-type clothespin.

Tank and Hanger Processing

Another method of sheet-film processing is with deep tanks and film hangers. The hangers hold one, two, or four sheets, depending on the model and size. There is less risk of scratching film with this method since the hangers separate the sheets, though you must be careful not to gouge the film with the corners of the hangers. Also, it is easier to process larger quantities of film at a single time with tanks and hangers. Here are the instructions:

1. Set up four tanks in this order: developer, stop bath, fixer, and water. A presoak is optional.

2. Prepare the hangers for loading, in room light, by folding back the top of the loading compartment.

3. Turn out the lights and remove the film from the holders. Load the hangers by slipping one sheet of film into the channels of each

channels

Slipping a sheet of film into the channels of a hanger

folding top

A loaded hanger, with the top folded over to keep the film from sliding out

tank

Dropping the holder into a developing tank

Lifting the holder out of the tank to agitate

holder. When the film is in the holder, fold back the top of the loading compartment to keep the film from sliding out.

4. Hold all the loaded hangers together by their handles, and drop them into the developing tank. Agitate by slowly lifting all the hangers out of the tank, and tilting them to one side. Rap the holders lightly against the top of the tank, and return them to the developer. Then, repeat the agitation process, tilting the holders to the opposite side. The agitation should be gentle, but constant for the first thirty seconds of development, then for ten seconds of each succeeding minute, until development is complete.

5. Transfer the hangers to the stop bath and fixer, agitating constantly.

6. Wash the film (still on hangers) in a tank, using either running water or ten changes of water (with constant agitation).

7. Place the film (on hangers) in a tank of wetting agent.

8. Remove the film from the hangers, and hang each sheet to dry by a corner with a spring-type clothespin.

Further Reading

Adams, Ansel. *Camera and Lens* (Basic Photo Series). Boston: New York Graphic Society, 1976.

Eastman Kodak Company. *Photography with Large-Format Cameras.* Rochester, New York: Kodak Publication 0–18, 1973.

Foldes, Joseph. *Large-Format Camera Practices.* Garden City, New York: Amphoto, 1969.

Stroebel, Leslie. *View Camera Techniques.* New York: Hastings House, 1972.

Time-Life Books. *Studio.* New York: Life Library of Photography, 1971.

A Simple Film-Speed Test

Film manufacturers use elaborate methods to rate the speed of their products. However, cameras, lenses, meters, and processing techniques vary from photographer to photographer. For best results, you should make film-speed tests to determine the exposure index most suited to your particular needs.

Film speed is a measure of the ability of a film to render minimum density in the shadows — the areas receiving the least exposure. The following test determines the minimum exposure at which the film will render density. In turn, that minimum exposure reflects the exposure index you should use. The test may seem long and complicated but, in fact, it takes only about two hours and is quite simple. To perform this test, you will need the following equipment:

tripod
18% gray card
Wratten Neutral Density Filter #96, with a density of 0.10 (available in
 most camera stores or on special order in 2″ and 3″ gelatin squares)
camera (with built-in or separate light meter)
roll of 20-exposure film

Follow these steps:
1. Set up to photograph an 18 percent gray card. Place the card in even

light (outdoors on a bright, overcast day is best). Put the camera on a tripod, close to the gray card, so that the entire viewfinder is filled up with the image of the gray card. Focus the lens at infinity to obviate close-up exposure problems. The card is used only as a reference point, so it does not have to be in focus. Be sure that the camera does not cast a shadow onto the card.

2. Take a light-meter reading of the gray card. Be sure to meter only the card.

3. Reduce the indicated exposure by four stops for the first exposure on the roll of film. Try to use a fast shutter speed, but avoid 1/1,000 of a second. Also, use an f-stop somewhere in the middle of the lens's f-stop range — not f 16 or f 2. Sometimes, with fast films, there is too much light: For example, Kodak Tri-X (400 A.S.A.) may require an indicated exposure of 1/250 at f 11. Four stops underexposure means 1/1,000 at f 16. To counter this problem make the test under dimmer light, either later in the day or indoors with bright window light; or put a neutral density filter on the lens to cut down the light reaching the film, and permit a slower shutter speed and/or a wider f-stop (for example, a 0.90 neutral density filter will require an additional three stops of exposure).

4. Advance the film and take the second exposure so that it leaves a blank frame on the film. To do so, cover the lens with the lens cap and cover the capped lens with something (like a coat or towel) to prevent any light from entering the camera.

5. Uncover the lens. Now, advance the film and take another exposure with one-half stop less exposure than in step 3.

6. Now expose for another blank frame; then underexpose by one stop less exposure than in step 3. Continue this procedure, alternating a gray-card exposure and a blank exposure in half-stop increments, two stops underexposed and two stops overexposed from the gray-card reading. Adjust the f-stop, not the shutter speed, in the different exposures, since the variation from one shutter speed to another will be greater than the variation from one f-stop to another, producing more chances for error in the test. For example, if the gray-card reading is 1/250 at f 8, the exposures will be as follows:

exposure number	expose for	if the gray-card reading is 1/250 at f 8, use
1	the indicated gray-card reading	1/250 at f 8
2	a blank frame	—

exposure number	expose for	if the gray-card reading is 1/250 at f 8, use
3	½ stop less than #1	1/250 at between f 8 and f 11
4	a blank frame	—
5	1 stop less than #1	1/250 at f 11
6	a blank frame	—
7	1½ stops less than #1	1/250 at between f 11 and f 16
8	a blank frame	—
9	2 stops less than #1	1/250 at f 16
10	a blank frame	—
11	½ stop more than #1	1/250 at between f 5.6 and f 8
12	a blank frame	—
13	1 stop more than #1	1/250 at f 5.6
14	a blank frame	—
15	1½ stops more than #1	1/250 at between f 4 and f 5.6
16	a blank frame	—
17	2 stops more than #1	1/250 at f 4

7. Develop the film normally, according to the manufacturer's suggested times.

8. Examine the results carefully on a light table or against a windowpane. Parts of the film will have various densities, separated by blank frames; parts of the film will be completely blank. Place the neutral density filter (0.10

density) onto the various blank frames, and compare it with the various negative densities. The negative exposure that matches the density created by the blank frame plus the neutral density filter represents the effective film speed for your purposes. To interpret the results, use the following chart (if you use a film with a different film speed from those listed, entrapolate the results; for example, exposure 5 represents an exposure index of double the manufacturer's rating):

If this exposure number matches the density created by the blank frame plus the neutral density filter	Then use this adjusted exposure index based upon manufacturer's rating of:		
	32 A.S.A.	125 A.S.A.	400 A.S.A.
1	32	125	400
3	50	180	600
5	64	250	800
7	100	375	1,200
9	125	500	1,600
11	25	100	300
13	16	64	200
15	12	50	150
17	8	32	100

Film speed is determined by discovering the threshold exposure point of the film — that amount of exposure that produces a density, on most films, of 0.10 above the film base, plus fog. In this test, film base plus fog is represented by the blank frames, and 0.10 density above the film base plus fog is represented by the neutral density filter added to the blank frame. Reread Chapter One, particularly page 38, for more background.

(Some people prefer to base their effective film speed on a threshold density of greater than 0.10 above film base, plus fog, in order to produce negatives with a more easily printable minimum density. In effect, they are opting to overexpose their film by reducing their effective film speed number.

You can test this method by using a darker neutral density filter of 0.20, or by cutting a 0.10 filter in half and placing the two halves on top of each other, and performing the same test. If you choose to use this method, you are adding exposure to your film, so you should underdevelop, by approximately 20 to 30 percent, in relation to the manufacturer's recommendations.)

If you own more than one camera, lens, or meter, you should test each possible combination because of the variation among pieces of equipment. With 400 A.S.A. film, you may need to use E.I. 600 with one camera and E.I. 300 with another.

Also, for testing view cameras, either use a roll-film back, or shoot and develop one sheet of film for each exposure. Instead of shooting alternate blank frames, develop one unexposed sheet of film and use it, along with the neutral density filter, for comparison with the exposed sheets.

Resources

Book Sales

These companies distribute a wide range of new photographic books:

Laurel Photographic Books, Incorporated
Post Office Box 956
Melville, New York 11746

Light Impressions
Box 3012
Rochester, New York 14614

Porter's Camera Store, Incorporated
Post Office Box 628
Cedar Falls, Iowa 50613

Kodak has published dozens of useful publications. Write to the following address for their free *Index to Kodak Information* (Kodak Publication L-5):

Eastman Kodak Company
Department 454
343 State Street
Rochester, New York 14650

Also, some publishers mail order their own books, in particular:

Amphoto
American Photographic Book Publishing Company
Garden City, New York 11530

Morgan and Morgan, Incorporated
145 Palisade Street
Dobbs Ferry, New York 10522

Chemical Sales

These companies sell photographic chemicals:

Dignan Photographic, Incorporated
12304 Erwin Street
North Hollywood, California 91606
 (some chemicals, but mostly an in-
 formation source; publishers of the
 Dignan Newsletter)

Eastman Organic Chemicals
Eastman Kodak Company
Rochester, New York 14650
($25 minimum order)

Lander Chemical
350 Peninsula Avenue
San Mateo, California 94401

The Photogroup
Post Office Box 419
719 Washington Street
Huntington, Pennsylvania 16652
 (a photographic cooperative that sells
 some chemicals, as well as film,
 paper, and other products)

Porter's Camera Store, Incorporated
Post Office Box 628
Cedar Falls, Iowa 50613
 (some chemicals, as well as much
 other photographic equipment and
 materials)

Zone V, Incorporated
Box 811
Brookline, Massachusetts 02146
 (chemicals and other supplies; in-
 struction material based heavily
 upon the cookbook method of mixing
 chemicals)

These companies are general chemical mail-order suppliers:

Aldrich Chemical Company, Incorporated
940 West Saint Paul Avenue
Milwaukee, Wisconsin 53233

Fisher Scientific Company
Chemical Manufacturing Division
Fair Lawn, New Jersey 07410

D. F. Goldsmith
909 Pitner Avenue
Evanston, Illinois 60202
 (a source for gold chloride and silver nitrate)

Pfaltz and Bauer
375 Fairfield Avenue
Stamford, Connecticut 06902

Manufacturers: Film, Paper, and Chemicals

Most film, paper, and chemical manufacturers are willing to answer your technical questions, no matter how specific. Also, many offer free pamphlets and information that naturally emphasize their own products, but often contain useful general information. Here are some important addresses:

Acufine, Incorporated
439 East Illinois Street
Chicago, Illinois 60611

Agfa-Gevaert, Incorporated
275 North Street
Teterboro, New Jersey 07608

E. I. DuPont de Nemours and Company
1007 Market Street
Wilmington, Delaware 19898

Eastman Kodak Company
343 State Street
Rochester, New York 14650

Edwal Scientific Products Corporation
12120 South Peoria Street
Chicago, Illinois 60643

Ethol Chemicals, Incorporated
1808 North Damen Avenue
Chicago, Illinois 60647

FR, Division of Photomagnetics, Incorporated
Chemical Division
16 Gordon Place
Yonkers, New York 10703

Fuji Photo Film U.S.A., Incorporated
350 Fifth Avenue
New York, New York 10001

GAF Corporation
Binghamton, New York 13902

The H and W Company
Box 332
Saint Johnsbury, Vermont 05819

Heico, Incorporated
Delaware Water Gap, Pennsylvania 18327

Hustler Photo Products
Post Office Box 14
Saint Joseph, Missouri 64502

Ilford, Incorporated
West 70 Century Road
Post Office Box 288
Paramus, New Jersey 07652

Luminos Photo Corporation
25 Wolffe Street
Yonkers, New York 10705

Polaroid Corporation
730 Main Street
Cambridge, Massachusetts 02139

Spiratone, Incorporated
135–06 Northern Boulevard
Flushing, New York 11354

Sprint Systems of Photography
100 Dexter Street
Pawtucket, Rhode Island 02860

Supreme Photo Products
543 West 43rd Street
New York, New York 10036

TKO Chemical Company
303 South 5th Street
Saint Joseph, Missouri 64501

Unicolor Division Photo Systems, Incorporated
Post Office Box 306
Detroit, Michigan 48130

Manufacturers: Special Products

These companies mail order various useful products, many of which are unavailable through normal retail outlets. The following specialize in products for archival care:

Archival Products
300 North Quidnessett Road
North Kingston, Rhode Island 02852
 (custom-made print cases, mounting
 board, negative envelopes, and re-
 lated products)

Depth of Field
Box 141
Madison, Wisconsin 53701
 (air-drying screens)

East Street Gallery
723 State Street
Grinnell, Iowa 50112
 (archival print and film washers, as
 well as air-drying screens)

Hollinger Corporation
Post Office Box 6037
3810 South Four Mile Run Drive
Arlington, Virginia 22206
 (mounting board, negative envelopes,
 storage boxes, and related products)

Light Impressions
Box 3012
Rochester, New York 14614
 (mounting board, storage boxes,
 framing services, and related products)

Photo Plastic Products, Incorporated
Post Office Box 507
Fairfax, Virginia 22030
 (negative envelopes)

Print File
Box 100
Schenectady, New York 12304
 (negative envelopes)

TALAS, Division of Technical Library
 Service
104 Fifth Avenue
New York, New York 10011
 (large catalogue of archival products,
 including mounting board and stor-
 age containers)

Zone VI Studios, Incorporated
Putney, Vermont 05346
 (print and film washers and related
 products and services)

The following companies are general interest suppliers, dealing in various types of merchandise:

Edmund Scientific
100 Edscorp Building
Barrington, New Jersey 08007
 (many types of scientific products,
 some with photographic applica-
 tions)

Freestyle Sales Company
Post Office Box 27924
Hollywood, California 90027
 (various brands of film, paper, chemi-
 cals, and other products, often at low
 prices)

The Nega-File Company
Furlong, Pennsylvania 18925
 (negative and slide storage systems)

The Photogroup
 (see listing under "Chemical Sales")

Porter's Camera Store, Incorporated
 (see listing under "Chemical Sales")

Spiratone, Incorporated
135–06 North Boulevard
Flushing, New York 11354
 (various name brand and Spiratone
 brand products)

Zone V, Incorporated
 (see listing under "Chemical Sales")

Health Hazards with Photographic Chemicals

When handled carelessly, photographic chemicals, whether homemade or store-bought, can create serious health hazards. In recent years, there has been increasing concern over such hazards. Information on this subject is still scarce. By law, manufacturers must provide safety warnings on the labels of their products. Many manufacturers also publish safety data sheets which they will provide upon request.

A very helpful source for information in this area is: *Health Hazards Manual for Artists* by Michael McCann.* This booklet contains a short section on photographic health hazards, as well as useful information about ventilation and personal protection. The section on photography is reprinted here in full with the permission of the author:

Many of the chemicals used in photographic processing can cause severe skin problems, and, in some cases, lung problems through inhalation of dusts

*This booklet is available by mail from:
 Foundation for the Community of Artists
 32 Union Square East
 Room 816
 New York, New York 10003

At the time of this writing McCann was working on a complete book about health hazards of artists' materials, scheduled to be published by Watson-Guptil.

and vapors. The greatest hazard occurs during the preparation and handling of concentrated stock solutions of the various chemicals. During these steps in particular, it is essential to wear protective gloves and goggles (to protect against splashes). Special care should be taken to avoid skin contact with powders and to avoid stirring up dusts which can be inhaled. Good ventilation is important to get rid of vapors, especially from the fixer.

Black-and-white processing includes developing, stop bath, fixing and rinsing steps. The developer usually consists of hydroquinone and Metol (monomethyl p-aminophenol sulfate), both of which cause severe skin irritation and allergic reactions. These are dissolved in an alkaline solution containing sodium sulfite and sodium carbonate or sodium hydroxide. These chemicals can cause skin irritation and even burns. Hands should never be put into the developer. If skin contact does occur, the skin should be washed copiously with water and then with an acid-type skin cleanser.

The stop bath consists of a weak solution of acetic acid. The concentrated acid can cause burns, and inhalation of the vapors can irritate the breathing passages and throat. Potassium chrome alum, sometimes used as a stop hardener, contains chromium and can cause ulcerations especially in cuts and nasal membranes.

The fixer usually contains sodium sulfite, acetic acid, and sodium thiosulfate (hypo), boric acid and potassium alum. The mixture of sodium sulfite and acetic acid produces sulfur dioxide which is extremely corrosive to the lungs. Potassium alum, a hardener, is a weak sensitizer and may cause skin dermatitis.

Many intensifiers (bleaches) can be very dangerous. The common two-component chrome intensifiers contain potassium dichromate and hydrochloric acid. The separate components can cause burns, and the mixture produces chromic acid. Its vapors are very corrosive and may cause lung cancer. Handling of the powder of another intensifier, mercuric chloride, is very hazardous because of possible inhalation of the dusts and resultant mercury poisoning.

The commonest reducer contains potassium ferricyanide. If it comes into contact with heat or concentrated acids, the extremely poisonous hydrogen cyanide gas may be released.

Hardeners and stabilizers often contain formaldehyde which is very poisonous, extremely irritating to the eyes, throat and breathing passages, and can cause dermatitis, severe allergies and asthma. Some of the solutions used to clean negatives contain harmful chlorinated hydrocarbons.

Color processing involves many of the same chemicals used in black-and-white processing. Developers also contain dye couplers, which can cause severe skin problems, and some solutions contain toxic organic solvents.

The above concerns are well stated, although the situation is probably not as bleak as it sounds. Different people will react in various ways to different chemicals. For example, not everyone's skin is sensitive to Metol; besides, many developers contain phenidone, rather than Metol. Furthermore, as manufacturers become more aware of the health hazards of their products, additional safety precautions and refinements are likely to be made.

However, the possibility of health hazards should be taken seriously. The best safeguards are an awareness of the problems and the use of common sense. Here are some specific suggestions:

Be sure your darkroom is well ventilated (McCann's booklet contains some good suggestions for types of exhaust fans). In particular, avoid small, unventilated closets when mixing chemicals and processing negatives and prints.

Read the safety warnings on the labels of all packages before proceeding to mix and use the chemicals.

Take special care when mixing dry chemicals. If you are using a badly ventilated darkroom, mix dry chemicals outside or near an open window. During the mixing process, keep your eyes, mouth and nose turned away from the chemicals.

Use concentrated liquid chemicals instead of dry chemicals whenever possible. The liquid chemicals are usually more expensive, but they are safer to handle.

Wear protective rubber gloves when handling chemicals and developing film, and use tongs when processing prints. If you do soak your hands in the solutions, be sure to wash them off immediately after each soaking.

Index

Page numbers in italics indicate illustrations.

CONTENTS

AP 2 only

AP 2 only

AP 2 only
AP 2 only
AP 2 only

AP 2 only

AP 2 only

AP 2 only

PRACTICE TESTS

Appendix

As you review the content in this book to work toward earning that **5** on your AP Physics 1 exam, here are five things that you **MUST** know above everything else.

Know your kinematics:

- Know the difference between velocity and speed, displacement and distance.
- Know to use equations of motion only for problems involving constant acceleration and to otherwise use graphical methods to analyze the kinematics.
- Find hidden information within the problem (initial or final speeds of zero, accelerations of 9.8 m/s$^2$).
- Keep your *x*- and *y*-motions separate: the only connecting variable is time.

Know your dynamics:

- Start all analyses with a free-body diagram.
- Align your coordinate system with the direction of acceleration (if known).
- Be alert for situations that require a net force but no corresponding change in speed (centripetal forces).
- Do not add additional forces in an ad hoc manner. Decide on the number of forces based on the object's interactions, not its motion.

Know your conservation laws:

- If all the masses and motions of interacting particles are specified, conserve the net values of energy, momentum, and angular momentum.
- If the object in question is interacting with an object whose masses and motions are unspecified, then use the interactions to calculate changes in "conserved" quantities.
- When using conservation of energy, be alert to work done by nonconservative forces.
- When using conservation of momenta, remember that both linear and angular momenta are vector quantities.

Look for cross-cutting questions:

- This exam is designed to probe for your understanding of the connections between the various topics covered in a first year physics class. It is not enough to be able to solve the "classic" problem types. You must be able to solve multi-tiered problems (e.g., apply conservation of angular momentum and dynamics at the same time within one problem).

Understand the underlying concepts:

- Many of the questions are concept-focused. Be sure to understand how to explain the why's, not just to calculate a numerical solution.

As you review the content in this book to work toward earning that **5** on your AP Physics 2 exam, here are five things that you **MUST** know above everything else.

Barron's Essential (AP Physics 2)

1 **Master the Essential 5 listed for the AP Physics 1 Exam.** These provide the essential knowledge base for the material in this second-year course.

2 **Understand fields:**

- Be able to visualize, draw, and interpret the major fields: gravitation, electric, and magnetic.
- Be able to make analogies between electric and gravitational fields.
- Understand the difference between the field strengths and the actual force exerted on an object in that field.
- Understand the differences between field potentials and the actual potential energy present when an object is in the field.

3 **Know how and when to use the various models for light:**

- Model light and all electromagnetic radiation as a wave for interactions such as diffraction and interference, and when describing it in terms of amplitude and wavelength.
- Model light as a series of wave-front rays for problems in optics (reflection, refraction, mirrors, and lenses).
- Model light as individual particles (photons) in atomic and modern physics.

4 **Understand the limiting cases for capacitors in simple and complex circuits:**

- Although detailed questions about the exponential nature of charging and discharging capacitors will not be asked, you must understand their behavior and purpose when fully charged or fully discharged in circuits.

5 **Understand the energy conservation roots of thermodynamics and fluid dynamics:**

- Understand the specialized vocabulary of thermodynamics and be able to connect all operations to energy transfers and transformations.
- Be able to go back and forth between the macroscopic descriptions of fluids with their microscopic behavior.

PREFACE

In this review book, you will find all the material needed to review and prepare for two different AP Physics exams: AP Physics 1 (a first-year precalculus course in physics) and AP Physics 2 (a second year of precalculus physics). Each chapter has review questions that vary in style and level of difficulty. These are intended to test your level of understanding of the review material. Some of these chapter questions may be easier, harder, or of a slightly different style from the actual AP exam as they are limited to the content of that particular chapter. The tests, on the other hand, are broad in scope and draw from several different content areas at once. At the end of this book are several full-length practice tests that mirror the actual AP exams in style, content, and difficulty. All questions have full solutions and explanations provided.

Before the review chapters are two diagnostic exams (one each for AP Physics 1 and AP Physics 2). They can be used for practice or to guide you specifically to certain content areas you may need to review before the test. Additional problem-solving strategies are provided throughout the book.

The majority of the review content of this book is drawn from the existing book by Jonathan Wolf written for the (now-retired) AP Physics B exam. With all of the changes in scope, sequence, focus, and style, I am grateful to both him and our editor at Barron's Educational Series, Linda Turner, for the opportunity to assist in this overhaul and transformation of the AP Physics B materials into this new AP Physics 1 and 2 book. Most important, I want to thank my wife, Irene, for her support throughout this project.

Ken Rideout
Wayland, Massachusetts
July 2014

Introduction

STRUCTURE AND SCOPE OF THE AP PHYSICS EXAMS

The College Board has replaced its traditional AP Physics B exam. Although many changes have occurred, the most basic is that the exam is now being reissued as two exams. The AP Physics 1 exam corresponds to a first-year course, and the AP Physics 2 exam corresponds to a second-year course. Both exams are algebra based (as opposed to the calculus-based AP Physics C exams). Both will focus on conceptual underpinnings and basic scientific reasoning alongside the traditional problem-solving aspects of physics. In addition, both exams have questions that require experiential lab understanding. Both exams are based on the same "Seven Big Ideas" in physics. Although the exams do concentrate on different topics, some overlap occurs between the two exams, enabling this one book to cover all topics required for both exams.

AP Physics 1 focuses on mechanics (including rotational mechanics), the conservation laws (energy as well as both linear and angular momentum), introductory circuits, and mechanical waves (including sound). AP Physics 2 focuses on electrostatics, electromagnetism (including light as a wave), fluid mechanics, thermodynamics, optics, and modern physics. Both exams include multiple-choice questions as well as free-response questions.

ORGANIZATION OF THIS BOOK

This introduction serves as general background information that the student will find useful for either exam. The next section contains two separate diagnostic exams (one for AP Physics 1 and the other for AP Physics 2) that will help students determine their weaknesses and target the specific chapters in this book that will be most beneficial to them.

With chapter 1, the physics content begins. Each subsequent chapter has practice problems at the end along with complete solutions. Generally speaking, the content for AP Physics 1 is in the earlier chapters while the content for AP Physics 2 is in the later chapters. A complete breakdown of chapter sections is shown in the table that follows. Each topic is identified as being for AP Physics 1 (1), AP Physics 2 (2), or both exams (B). In addition, each section of

the book is identified by a "1" (material appearing on the AP 1 Physics Exam), a "2" (material appearing on the AP 2 Physics Exam), or a "B" (material covered in both exams). The final chapter contains two full-length exams (one for AP Physics 1 and the other for AP Physics 2). Some concepts are not strictly covered in AP Physics 2, such as mechanical energy conservation. Since AP Physics 2 is designed as a second-year course, though, many students would be well served to review those chapter sections as well.

Chapter/Section	Topic	In Exam (1) or (2) or Both (B)
Introduction	AP Physics Exams 1 & 2 General Tips for AP Physics	B
	AP Physics 1 Diagnostic	1
	AP Physics 2 Diagnostic	2
1	Overview of the AP Physics Concepts	B
1.3	Fundamental Particles	2
2	Vectors and Scalars	B
3	Kinematics	1
4	Forces	B
5	Energy	1
6	Oscillations	1
7	Sound as a Wave	1
8	Gravity	1
9	Linear Momentum	1
9.5	Center of Mass Calculations	2
10	Rotational Motion	1
11	Electrostatics	B
12	Simple Circuits	B
12.5	Capacitors	2
12.7	Electrical Energy	2
13	Magnetism and Electromagnetism	2
14	Physical Optics	2
15	Geometrical Optics	2
16	Fluids	2
17	Thermodynamics	2
18	Topics in Twentieth-Century Physics	2

UNITS

Preparing for an AP exam takes time and planning. In fact, your preparation should begin in September when you start the class. If you are using this review book during the year, the content review chapters should parallel what you are covering in class. If you are using this review book a few weeks prior to the exam in May, your strategy needs to change. The review material should help you refresh your memory as you work on the practice exams. In either case, you should have a plan.

In this chapter, we will look at study skills and tips for helping you do well on the Physics 1 and 2 exams. One of the most important things to remember is that most physical quantities have units associated with them. You must memorize units since you can be asked questions about them in the multiple-choice section. In the free-response questions, you must include all units when using equations, making substitutions, and writing final answers.

A list of standard fundamental (SI) units as well as a list of some derived units are shown in the following two tables. As you work through the different chapters, make a note (on index cards, for example) of each unit.

TIP

Make sure you set up a review schedule.

TIP

Make sure you memorize all units. Be sure to include them with all calculations and final answers.

TABLE 1

Fundamental SI Units Used in Physics

Quantity	Unit Name	Abbreviation
Length	Meter	m
Mass	Kilogram	kg
Time	Second	s
Electric current	Ampere	A
Temperature	Kelvin	K
Amount of substance	Mole	mol

TABLE 2

Some Derived SI Units Used in Physics

Quantity	Unit Name	Abbreviation	Expression in Other SI Units
Area			m^2
Linear velocity			m/s
Linear acceleration			m/s^2
Force	Newton	N	$kg \cdot m/s^2$
Momentum			$kg \cdot m/s$
Impulse			$N \cdot s = kg \cdot m/s$
Angular velocity			rad/s
Angular acceleration			rad/s^2
Torque			Nm
Angular momentum			$kg \cdot m^2/s$
Moment of inertia			$kg \cdot m^2$
Spring constant		N/m	kg/s^2
Frequency	Hertz	Hz	s^{-1}
Pressure	Pascal	Pa	$N/m^2 = kg/(m \cdot s^2)$
Work, energy	Joule	J	$N \cdot m = kg \cdot m^2/s^2$
Power	Watt	W	$J/s = kg \cdot m^2/s^3$
Electric charge	Coulomb	C	$A \cdot s$
Electric field		N/C	$kg \cdot m/(A \cdot s^3)$
Electric potential	Volt	V	$J/C = kg \cdot m^2/(A \cdot s^3)$
Resistance	Ohm	Ω	$V/A = kg \cdot m^2/(A^2 \cdot s^3)$
Capacitance	Farad	F	$C/V = A^2 \cdot s^4/(kg \cdot m^2)$
Magnetic flux	Weber	Wb	$V \cdot s = kg \cdot m^2/(A \cdot s^2)$
Magnetic flux density	Tesla	T	$Wb/m^2 = N/(A \cdot m) = kg/(A \cdot s^2)$
Inductance	Henry	H	$Wb/A = kg \cdot m^2/(A^2 \cdot s^2)$

RELATIONSHIPS AND REVIEW OF MATHEMATICS

Since AP Physics 1 and 2 are algebra-based courses, the Appendix reviews some essential aspects of algebra. In physics, we often discuss how quantities vary using proportional relationships. Four special relationships are commonly used. You can review them in more detail by referring to Appendix A. You should memorize these relationships.

- Direct relationship—This is usually represented by the algebraic formula $y = kx$, where k is a constant. This is the equation of a straight line, starting from the origin. An example of this relationship is Newton's Second Law of Motion, $\mathbf{a} = \dfrac{\mathbf{F}_{net}}{m}$, which states that the acceleration of a body is directly proportional to the net force applied (see Chapter 4).

- Inverse relationship—This is usually represented by the algebraic formula $y = \dfrac{k}{x}$. This is the equation of a hyperbola. An example of this relationship can be seen in a different version of Newton's Second Law, $\mathbf{F}_{net} = m\mathbf{a}$. In this version, if a constant net force is applied to a body, the mass and acceleration are inversely proportional to each other. Some special relationships, such as gravitation and static electrical forces, are known as inverse square law relationships. The forces are inversely proportional to the square of the distances between the two bodies (see Chapters 8 and 11).

- Squared (quadratic) relationship—This is usually represented by the algebraic formula $y = kx^2$ and is the equation of a parabola starting from the origin. An example of this relationship can be seen in the relationship between the displacement and uniform acceleration of a mass from rest $\mathbf{d} = \frac{1}{2} \mathbf{a}t^2$ (see Chapter 3).

- Square root relationship—This is usually represented by the algebraic formula $y = k\sqrt{x}$ and is the equation of a "sideways" parabola. This relationship can be seen in the relationship between the period of a simple pendulum and its length, $T = 2\pi\sqrt{L/g}$ (see Chapter 6).

- As you review your material, you should know each of these relationships and their associated graphs (see Appendix A for more details).

TIPS FOR ANSWERING MULTIPLE-CHOICE QUESTIONS

Without a doubt, multiple-choice questions can be tricky. The AP Physics 1 and 2 exams each ask 50–55 multiple-choice questions. These can range from a simple recall of information to questions about units, graphs, proportional relationships, formula manipulations, and simple calculations (without a calculator). The questions cover all areas of the course.

One tip to remember is that there is no penalty for wrong answers. This means that you may want to try to answer all questions. Instead of randomly guessing, however, you can improve your chances of getting a correct answer if you can eliminate at least two answer choices. Guess intelligently. For the Physics 1 and 2 exams, all multiple-choice questions will have four answer choices. A new question type has also been added, the "multiple-correct items" question. These questions, which ask you to mark two correct responses, will be clearly indicated on the exam and are introduced in this book.

When you read a multiple-choice question, try to get to the essential aspects. You have 90 minutes for this part, so do not waste too much time per question. Try to eliminate two

or three choices. If a formula is needed, you may try to use approximations (or simple multiplication and division). For example, the magnitude of the acceleration due to gravity (**g**) can be approximated as 10 m/s². You can also use estimations or order of magnitude approximations to see if answers make sense.

Remember, no formulas or calculators are allowed for this part. However, you are supplied with a table of information. As you work on the multiple-choice questions in the practice exams, look for distractors. These are choices that may look reasonable but are incorrect. For example, if the question is expecting you to divide to get an answer, the distractor may be an answer obtained by multiplying. Watch out for quadratics (such as centripetal force) or inverse squares (such as gravitation).

If you cannot recall some information, perhaps another similar question will cue you as to what you need to know. (You may work on only one part of the exam at a time.) When you read the question, try to link it to the overall general topic, such as kinematics, dynamics, electricity. Then narrow down the specific area and the associated formula. Finally, you must know which quantities are vectors and which quantities are scalars (see Chapter 2).

Each multiple-choice question in the practice exams is cross-indexed with the general topic area of physics to guide you on your review. As you work on the exams and check your answers, you can easily go back to the topic area to review. At the start of your review, you may want to work on the multiple-choice questions untimed for the diagnostic and first practice exam. A few days before the exam (see the timeline schedule later in this chapter), you should do the last practice exam timed (90 minutes).

TIPS FOR SOLVING FREE-RESPONSE QUESTIONS

The AP Physics 1 and 2 exams include 4–5 free-response questions. You have 90 minutes for this section. You may use an approved calculator. (Check the College Board's website for details.) A formula sheet is provided. One of the first things you may notice is that you are not given every formula you ever learned. Some teachers may let you use a formula sheet on their classroom exams, and some teachers may require you to memorize formulas. Even if you get to use a formula sheet on a classroom exam, you should memorize derivations and variations of formulas.

Each exam has its own specific breakdown of free-response questions. Physics 1 has a total of 5 free-response questions, and Physics 2 has 4. Physics 1 has 1 experimental design question, 1 qualitative/quantitative translation problem, and 3 short-answer questions. Physics 2 has 1 experimental design question, 1 qualitative/quantitative translation problem, and 2 short-answer questions (one of which will require a paragraph-long argument).

Qualitative/quantitative translation problems emphasize proportional and symbolic reasoning skills. These problems also provide an opportunity for students to demonstrate their ability to translate between multiple representations of the same problem. Every exam has questions that require students to "justify your response." There is an expectation that students will be able to write paragraph-long coherent argument answers involving multiple concepts in physics. Students are expected to be able to read critically and write precise and coherent responses. Experimental design questions are addressed in the next section. All 3 free-response question types are used in this book.

Since you are not given specific formulas for some concepts, you should begin learning how these formulas are derived starting at the beginning of the year. For example, you are

not given the specific formulas for projectile motion problems since these are easily derived from the standard kinematics equations. If you begin reviewing a few weeks before the AP exam, you may want to make index cards of formulas to help you to memorize them.

For the free-response questions, each question may be worth a different amount. In fact, each subsection may be worth a different amount. However, each part of the exam is worth 50 percent of your grade to determine your "raw score." Keep in mind that the curve for the exam changes from year to year.

You must read the entire question carefully before you begin. Make sure you know where the formulas and constants can be found on the supplied tables. Also, make sure that you have a working calculator with extra batteries.

As you begin to solve the problem, make sure that you write down the general concept being used, for example, conservation of mechanical energy or conservation of energy. Then, you must write down the equations you are using. For example, if the problem requires you to use conservation of mechanical energy (potential and kinetic energies), write out those equations:

Initial total mechanical energy = Final total mechanical energy

$$mgh_i + \frac{1}{2}mv^2_i = mgh_f + \frac{1}{2}mv^2_f$$

When you are making substitutions, you must include the units! For example, if you are calculating net forces on a mass (such as a 2 kg mass that has an acceleration of 4 m/s$^2$), you must write as neatly as possible:

$$\Sigma \mathbf{F} = \mathbf{F}_{net} = m\mathbf{a} = (2\,kg)(4\,m/s^2) = 8\,N$$

Include all relevant information. Communicate with the grader by showing him/her that you understand what the question is asking. You may want to make a few sketches or write down your thoughts in an attempt to find the correct solution path. If a written response is requested, make sure that you write neatly and answer the question in full sentences.

Sometimes the question refers to a lab experiment typically performed in class or simulated data is given. In that case, you may be asked to make a graph (refer to Appendix A). Make sure the graph is labeled correctly (with axes labeled and units clearly marked), points plotted as accurately as possible, and best-fit lines or curves used. Do not connect the dots. Always use the best-fit line for calculating slopes. Make sure you include your units when calculating slopes. Always show all of your work.

If you are drawing vectors, make sure the arrowheads are clearly visible. For angles, there is some room for variation.

Since angles are measured in degrees, be sure your calculator is in the correct mode. If scientific notion is used, make sure you know how to input the numbers into your calculator correctly. Remember, each calculator is different.

If you are asked to draw a free-body diagram (see Chapter 4), make sure you include only actual applied forces. Do not include component forces. Centripetal force is not an applied force and should not be included on a free-body diagram.

What do you do if you are not sure how to solve a problem? Follow these 11 tips.

1. Make sure you understand the general concepts involved, and write them down.
2. Write down all appropriate equations.

Make sure you show all of your work on Part II. Include all formulas, substitutions with units, and general concepts used. Remember to label all diagrams. Communicate with the grader!

Make sure you have pencils, pens, a calculator, extra batteries, and a metric ruler with you for the exam!

3. Try to see how this problem may be similar to one you may have solved before.
4. Make sure you know which information is relevant and which information is irrelevant to what is being asked.
5. Rephrase the question in your mind. Maybe the question is worded in a way that is different from what you are used to.
6. Draw a sketch of the situation if one is not provided.
7. Write out what you think is the best way to solve the problem. This sometimes triggers or cues a solution.
8. Use numbers or estimations if the solution is strictly algebraic manipulation, such as deriving a formula in terms of given quantities or constants.
9. Relax. Sometimes if you move on to another problem, take a deep breath, close your eyes, and just relax for a moment, the tension and anxiety may go away and allow you to continue.
10. Do not leave anything out. Unlike on the multiple-choice questions, you need to show all of your work to earn credit.
11. Understand what you are being asked to do. The Physics 1 and Physics 2 exams want you to respond in specific ways to certain key words.
 - "Justify" or "Explain": Support your answer with words, equations, calculations, diagrams, or graphs.
 - "Calculate": Provide numerical and algebraic work leading to the final answer.
 - "What is" or "Determine": Although showing work is always desirable, it is not necessary for these questions—you may simply state your answer.
 - "Derive": Starting with a fundamental equation (such as those given on the formula sheet), mathematically manipulate it to the desired form.
 - "Sketch": Without numerical scaling or specific data points, draw a graph that captures the key trend in the relationship (curvature, asymptotes, and so on).
 - "Plot": Specific data points should be placed onto a scaled grid. Do not connect the dots (although trends, especially linear ones, may be superimposed on the graph).

EXPERIMENTAL DESIGN QUESTIONS

According to the College Board, there are seven "Science Practices" that students should be familiar with when taking the exam. Although students need to know these practices throughout the exam, pay special attention to these when answering the experimental design question.

1. Appropriate use of representations and models: Use diagrams, graphs, and equations when explaining the problem.
2. Appropriate use of mathematics: Define your variables, show algebraic manipulations clearly, and plug in only specific data at the very end of the problem. Do not use more significant digits in your answer than you have in the raw data.
3. Scientific questioning: All proposals must be testable and easy to understand. Phrase proposals in terms of specific relationships, such as "y will vary inversely with increasing x-values."

4. Planning and implementing data collection strategies: Systematic testing of one possible factor at a time while holding other factors constant is the key here.
5. Data analysis and evaluations: Graph the data when possible, and explicitly address whether or not the data are correlated (one variable has an effect on the other). Is there a linear trend? What is the line of best fit?
6. Work with scientific explanations and theories.
7. Connect and relate knowledge from various concepts, scales, and representations.

Fold your existing knowledge of physics in to your experimental design. Can you make analogies to other areas of physics? ("Like force causes linear acceleration; the torques here will cause angular accelerations.")

GRAPHS, FITS, AND THE LINEARIZATION OF DATA

Graphs that are linear in nature are much easier to analyze, especially by hand, than graphs of any other nature. Trends, slopes, intercepts, and correlations of experimental results to theoretical predications are readily obtained. For this reason if you are asked to graph your data, it will almost always be advantageous to linearize it first. Specifically if the relationship is not linear to start, use a change of variable to make the relationship linear.

For example, if asked to determine the spring constant K of a system based on a collection of elastic potential energies for various extensions of the spring, the relevant equation is

$$EPE = \frac{1}{2}Kx^2$$

This is a quadratic relationship, not a linear one. Before graphing, make the following change of variable:

$$z = x^2$$

So the relationship is now:

$$EPE = \frac{1}{2}Kz$$

Now when graphed and a line of best fit is applied, the slope of the straight line will be ½K.

How can a line of best fit be generated by hand? If need be, you can use a straightedge and draw one straight line that has as many data points above the line as below it. Once this line is drawn, all subsequent calculations should be based on the slope and intercept of this best line fit rather than on the original data. The idea here is that the fit of the data is an average of the raw data and is inherently better than any one particular point because the random variations in data have been smoothed out by the fit. When asked to analyze a graph of data, always use the fitted line or curve rather than the individual data points for this same reason.

Determine K by graphing the following data provided by another student.

EPE (J)	x (cm)
0.058	2.5
0.196	4.6
1.117	11.0
2.081	15.1

Solution

Since the relationship between these variables is quadratic, begin by squaring the given values for x. Also change to the standard MKS units of meters as well.

x (cm)	z (m²)
2.5	0.000625
4.6	0.002116
11.0	0.0121
15.1	0.022801

Energy of extension vs. stretch squared

Approximate slope = $\Delta y / \Delta x = 2/0.02 = 100$ J/m² or 100 N/m (since J = N · m)

Note the labels (with units) on the x- and y-axes as well as the title for the graph.

UNCERTAINTY AND PERCENT ERROR

In addition to respecting the number of significant digits in measured or recorded data, you can also determine the corresponding uncertainty in derived quantities. For example, if the radius of a circle is measured and recorded as 3.5 cm, there are only 2 significant digits in this number. Therefore, the area of the circle (πr^2) should be truncated from the calculator result to 2 significant digits. The area is 38 cm$^2$. The rest of the digits are not significant as they imply a precision in the radius that we do not have.

To take this analysis one step further, a percent error can be associated with a measurement. For example, one could write down the uncertainty in radius explicitly as $r = 4.5$ +/− 0.05 cm. This implies that the true value is most likely between 4.45 and 4.55 cm. This is a percent error of 1.1%.

$$\frac{0.05}{4.5} \times 100 = 1.1\%$$

$$100 * \text{Uncertainty} / \text{Value} = \text{Percent error}$$

Percent errors are an easier way of comparing the relative precision of different measurements. For example, a measurement of 128 +/− 2 mm has a percent error of 1.6% and is thus less precise than our original measurement that has an error of 1.1%.

STUDY SKILLS AND SCHEDULING YOUR REVIEW

Preparing for any Advanced Placement exam takes practice and time. Effective studying involves managing your time so that you efficiently review the material. Do not cram a few days before the exam. Getting a good night's sleep before the exam and having a good breakfast the day of the exam is a better use of your time than "pulling an all-nighter." Working in a study group is a good idea. Using index cards to make your own flash cards of key concepts, units, and formulas can also be helpful.

When you study, try to work in a well-lighted, quiet environment, when you are well rested. Studying late at night when you are exhausted is not an effective use of your time. Although some memorization may be necessary, physics is best learned (and studied) by actively solving problems. Remember, if you are using this book during the year, working through the chapter problems as you cover each topic in class, memorizing the units, and familiarizing yourself with the formulas at that time will make your studying easier in the days before the exam.

If you are using this book in the weeks before the exam, make sure you are already familiar with most (if not all) of the units, equations, and topics to be covered. You can either use the chapter review for a quick overview and practice or dive right in to the diagnostic exam. You do not need to take the diagnostic test under timed conditions. See how you do, and then review the concepts for those questions that you got wrong. You can use the end-of-chapter questions (some of which may be more difficult than the actual AP exam) to test your grasp of specific topics and then work on the remaining practice exams.

Setting up a workable study schedule is also vital to success. Each person's needs are different. The following schedule is just one example of an effective plan.

TABLE 3

Test Prep Schedule

September 1–April 15	As the year progresses, make sure you memorize units and are comfortable with formulas. If you are using this book during the year, do end-of-chapter problems as they are covered in class. Make sure you register for the exam, following school procedures, and refer to the College Board's website for details: *www.collegeboard.com*
Four weeks before the exam	Most topics should be covered by now in class. If you are using this book for the first time, begin reviewing concepts and doing the end-of-chapter problems. Begin reviewing units and formulas. Devote at least 30 minutes each day to studying.
Three weeks before the exam	Start working on the diagnostic exam. Go back and review topics that you are unsure of or feel that you answered incorrectly.
Two weeks before the exam	Begin working on practice exams. The CD-ROM edition of this book has two additional practice exams. Continue to review old concepts.
One week before the exam	Do the remaining practice exams timed. Make sure you are comfortable with the exam format and know what to expect. Review any remaining topics and units.
The day before the exam	Pack up your registration materials, pens, pencils, calculator, extra batteries, and metric ruler. Put them by the door, ready to go. Get a good night's sleep.
The day of the exam	Have a good breakfast. Make sure you take all the items you prepared the night before. Relax!

SUMMARY

- Make sure you set up a manageable study schedule well in advance of the exam.
- Make sure you memorize all units and are familiar with the exam format.
- Multiple-choice questions do not have a penalty for wrong answers, so do not skip any. If you are unsure of the answer, try to eliminate as many choices as you can, and then guess!
- Do not leave any question out on the free-response part! Show all of your work. Write down all fundamental concepts, write all equations used, and include units for all substitutions and in your final answer.
- Read each question carefully. Write your answers clearly. On the multiple-choice questions, make sure you have a #2 pencil and bubble in all information carefully. Write out short-answer questions in full sentences. Clearly label graphs with units and use best-fit lines or curves.
- Try to relax and do all of the practice exams. Work on the chapter questions to review concepts as needed.
- Get a good night's sleep before the exam.
- On the day of the exam, bring all registration materials with you, as well as pens, pencils, calculators, extra batteries, and a metric ruler.

Relax and Good Luck!

Diagnostic Tests

This section contains two diagnostic tests, one for the AP Physics 1 exam and one for the AP Physics 2 exam. The purpose of these diagnostic exams is for you to identify those conceptual areas most in need of review. The relevant sections of the book (indicated in the answer keys) should be reviewed thoroughly before attempting one of the full-length practice exams at the end of this book.

Diagnostic Test

AP Physics 1

SECTION I: MULTIPLE-CHOICE

> **DIRECTIONS:** Select the best answer (or two best answers when indicated) on each of the following 26 multiple-choice questions as well as the 2 free-response questions. The detailed answer explanations will direct you to a specific chapter for further review on the specific subject matter in that question. You may use a calculator and make use of the formula sheet provided in the appendix.

1. A mass is suspended from the ceiling by one rope at an angle as indicated. The mass is held in place by a second, horizontal rope. Without knowing the exact angle from the ceiling, except that it is greater than 45 degrees, which statement best represents the possible value for tension in the horizontal line?

 (A) $T > mg$
 (B) $T = mg$
 (C) $T < mg$
 (D) $T = mg/\sqrt{2}$

2. Pushing on a mass of 15 kg with a sideways force of 120 N is not enough to get the mass to start sliding across the floor. Which of the following best describes the coefficient of static friction between the floor and the mass?

 (A) $\mu = 0.8$
 (B) $0.8 < \mu < 1.25$
 (C) $\mu < 0.8$
 (D) $\mu = 1.25$

3. While standing on an elevator and experiencing a downward acceleration of 4.9 m/s$^2$, what is the force between the floor and your feet?

(A) mg

(B) 0.5 mg

(C) 1.5 mg

(D) 4.9 mg

4. After throwing a ball at an upward angle, the reason the ball continues to go horizontally while falling due to gravity is that

(A) the ball's inertia keeps it going

(B) the force of the throw keeps it going

(C) the energy from gravitation potential energy keeps replenishing the lost energy

(D) air pressure keeps the ball from falling too quickly

5. Consider the situation in which your hand is pushing a book across a rough desktop with lots of friction. Of the many forces involved, consider only these two individual forces: the force on your hand from the book and the force the book is experiencing from your hand. While the book is accelerating from rest to its final velocity, which statement best compares the force experienced by your hand compared with that experienced by the book?

(A) Force on book > force on hand

(B) Force on hand > force on book

(C) Force on hand = force on book

(D) The relationship between these two forces depends on the frictional force

6. A puck comes to a stop in 20 meters after an initial speed of 10 m/s. What is the coefficient of kinetic friction between the puck and the floor?

(A) The mass is required to calculate this answer.

(B) 0.25

(C) 0.5

(D) 0.025

7. A rock is dropped from an extremely high cliff and experiences free-fall conditions. Which of the following statements is NOT true about the rock's velocity, acceleration, or displacement between the 3rd and 4th seconds of falling?

(A) The rock will fall an additional 4.9 meters.

(B) The rock will speed up by 9.8 m/s.

(C) The rock's acceleration will remain 9.8 m/s$^2$.

(D) The rock's displacement, velocity, and acceleration vectors are all directed downward.

8. When using the kinematics equation $x = x_0 + v_{x0}t + \frac{1}{2} a_x t^2$, which of the following is always assumed to be true?

(A) a_x = zero

(B) $x > x_0$

(C) V_{x0} is positive.

(D) a_x is constant.

9. Consider a projectile launched at 30 degrees above a flat surface. The projectile experiences no air resistance and lands at the same height from which it was launched. Compare the initial and final conditions of the following vector components:

$$V_x \quad V_y \quad a_x \quad a_y$$

(A) They are all the same at both instances.
(B) They are all different.
(C) V_x and V_y have changed, but $a_x\, a_y$ are constant.
(D) They are all the same except for V_y.

10. A physics teacher is swirling a bucket around in a vertical circle. If the bucket slips out of his hand when it is directly overhead, the bucket will

(A) fly upward initially
(B) drop straight down
(C) fly out horizontally initially
(D) fly out up and at an angle initially

11. If the Moon was twice as far from the center of Earth as it is currently, how would its orbital period change?

(A) The Moon's orbital period would double.
(B) The Moon's orbital period would increase by a factor of 4.
(C) The Moon's orbital period would increase by a factor of $2\sqrt{2}$.
(D) The Moon's orbital period would decrease by a factor of 2.

12. If you went to another planet, which of the following would be true?

(A) Your mass would be the same, but your weight would change.
(B) Your mass would change, but your weight would be the same.
(C) Your mass would be the same, and your weight would be the same.
(D) Your mass would change, and your weight would change.

13. You lift a heavy suitcase twice. Each time you lift it to the same height, but the second time you do it in half the time. Compare the work done to and power delivered to the suitcase.

(A) Same work, same power
(B) Twice the work, twice the power
(C) Twice the work, same power
(D) Same work, twice the power

14. A constant horizontal force of 12 N is applied for 5 meters to move an initially stationary mass of 5 kg. The friction between the floor and the mass does a total of −40 joules of work to the mass. The final speed (in m/s) of the object is

(A) $2(6)^{\frac{1}{2}}$
(B) $2(2)^{\frac{1}{2}}$
(C) $2(10)^{\frac{1}{2}}$
(D) 4

15. A skier begins a downhill run at a height of 9 meters and a speed of 2 m/s. If you ignore friction, what will be her speed when she is 3 meters from the bottom of the slope?

 (A) 6.0 m/s
 (B) 12.8 m/s
 (C) 11.1 m/s
 (D) 7.7 m/s

16. A rubber ball ($m = 0.250$ kg) strikes a wall horizontally at 3.50 m/s and rebounds elastically. What is the magnitude of impulse delivered to the wall in N · s?

 (A) 0.875
 (B) 1.75
 (C) 2.50
 (D) 8.75

17. A running back ($m = 85$ kg) running at 1.5 m/s is tackled from the side by another player ($m = 75$ kg) running perpendicularly to the running back's original heading at 1.75 m/s). What is the resulting speed of the two entangled players just after the tackle?

 (A) 2.2 m/s
 (B) 0.25 m/s
 (C) 1.6 m/s
 (D) 1.1 m/s

18. Which of the following ranks the torques applied by the three equal forces *A*, *B*, and *C* to the long thin rod about its fixed axis as indicated?

 (A) $\tau_C > \tau_B > \tau_A$
 (B) $\tau_A = \tau_B > \tau_C$
 (C) $\tau_B = \tau_C > \tau_A$
 (D) $\tau_B > \tau_A > \tau_C$

19. A large spherical cloud of dust in deep space that is spinning slowly collapses under its own gravitational force into a spherical cloud 10 times smaller in diameter. How does its rotational rate change?

 (A) The rotational rate does not change.
 (B) The rotational rate increases by a factor of 10.
 (C) The rotational rate decreases by a factor of 10.
 (D) The rotational rate increases by a factor of 100.

20. A single resistor attached to a constant voltage source has an additional, identical resistor inserted between one end of the resistor and the voltage supply. Which of these is the correct description of what will happen to the voltage drop across (V) and the current running through the original resistor (I) as a result?

 (A) I and V will remain unchanged.
 (B) I and V will both be halved.
 (C) I will be halved; V will remain unchanged.
 (D) V will be halved; I will remain unchanged.

21. A single resistor attached to a constant voltage source has an additional, identical resistor inserted beside it, forming its own connection across the voltage supply. Which of these is the correct description of what will happen to the voltage drop across (V) and the current running through the original resistor (I) as a result?

 (A) I and V will remain unchanged.
 (B) I and V will both be halved.
 (C) I will be halved; V will remain unchanged.
 (D) V will be halved; I will remain unchanged.

22. A simple circuit consisting of a battery, switch, and a lightbulb in series is constructed. Which is the best explanation of what happens when the switch is closed for the first time?

 (A) The lightbulb goes out immediately.
 (B) Electrons are allowed to flow through the switch from the battery. When they reach the bulb, it lights.
 (C) Electrons are allowed to flow through the switch. When those electrons already within the bulb move, the lightbulb lights.
 (D) Electrons on the negative side of the switch are allowed to first flow. When they reach the bulb, it lights.

23. As two sine waves run into each other on a single rope under tension, as shown above, what is the resulting sequence of events?

 (A) Initial constructive interference following by unchanged waves emerging on opposite sides
 (B) Initial constructive interference following by waves bouncing backward
 (C) Initial partial destructive interference followed by constructive interference followed by unchanged waves emerging on opposite sides
 (D) Initial partial destructive interference followed by constructive interference followed by waves bouncing backward

24. As you stand on the side of the road, an ambulance approaches your position at high speed. Which option best describes the sound of the siren as observed by you as compared with the driver's perception?

	Frequency	Wavelength	Wave Speed
(A)	Higher	Lower	Same
(B)	Higher	Same	Same
(C)	Higher	Same	Higher
(D)	Lower	Higher	Higher

35 MPH

45 MPH

25. Two cars approach an intersection at right angles, as pictured above. What is their relative speed to each other?

(A) 10 mph
(B) 45 mph
(C) 57 mph
(D) 80 mph

26. Which of the following statements are true regarding collisions? Select two answers.

(A) An elastic collision conserves both net momentum and net kinetic energy.
(B) An inelastic collision conserves mechanical energy but not net momentum.
(C) An elastic collision between two objects has equal but opposite impulses delivered.
(D) An inelastic collision between two objects is one in which both objects come to rest during the collision.

SECTION II: FREE-RESPONSE

1. A static, nonuniform wedge-shaped mass, *M*, (with center of mass *x* as indicated) with a base length of *L* (shown below) is supported at two points. The first support point is at the bottom left corner of the wedge. The second support point is located at a point ¾ of the length of the wedge away from that corner.

(a) Using as givens *M*, *L*, and *g* (the gravitational field strength), solve for the two unknown contact forces at the points of support (F_1 and F_2).

(b) Support #2 is removed. The wedge begins to fall by rotating around support #1 with an angular acceleration of 2 rad/s². If the mass of the wedge is 3.8 kg and *L* = 75 cm, determine the moment of inertia of the nonuniform wedge about the top of support #1.

(c) As the wedge continues to rotate clockwise but remains in contact with support #1:
 (i) Does the angular acceleration increase, decrease, or remain the same? Why?
 (ii) Does the moment of inertia of the wedge increase, decrease, or remain the same? Why?

2. An object of unknown mass is fired at an unknown angle with an initial speed of 25 m/s. Ignore frictional effects. If only 45 percent of its initial kinetic energy is still present as kinetic energy at the projectile's highest point, determine the time in flight for the projectile.

ANSWER KEY	Topic and Chapter to Reference
1. **(C)**	Statics problem, Chapter 4
2. **(B)**	Frictional dynamics, Chapter 4
3. **(B)**	Elevator problem, Chapter 4
4. **(A)**	Newton's first law, Chapter 4
5. **(C)**	Newton's third law, Chapter 4
6. **(B)**	Friction, Chapters 3 and 4
7. **(A)**	Friction, Chapters 3 and 4
8. **(D)**	Kinematics, Chapter 3
9. **(D)**	Projectile motion, Chapter 3
10. **(C)**	Circular motion, Chapter 4
11. **(C)**	Gravity, Chapter 8
12. **(A)**	Mass vs. weight, Chapter 4
13. **(D)**	Work and power, Chapter 5
14. **(B)**	Net work = ΔKE, Chapter 5
15. **(C)**	Net work = ΔKE, Chapter 5
16. **(B)**	Impulse and momentum, Chapter 9
17. **(D)**	Conservation of momentum, Chapter 9
18. **(D)**	Torque, Chapter 10
19. **(D)**	Conservation of angular momentum, Chapter 10
20. **(B)**	Series circuits, Chapter 12
21. **(A)**	Parallel circuits, Chapter 12
22. **(C)**	Open/closed circuit, Chapter 12
23. **(C)**	Open/closed circuit, Chapter 12
24. **(A)**	Sound waves, Chapter 7
25. **(C)**	Relative velocity, Chapter 3
26. **(A)** and **(C)**	Conservation of linear momentum, Chapter 9

ANSWERS EXPLAINED
Section I: Multiple-Choice

1. **(C)** $T < mg$. Since the mass is stationary, we conclude that the net force is zero. The upward tension of the angled rope must be mg in order to cancel out gravity. The free-body diagram on the hanging mass is:

 Since the angle θ is greater than 45 degrees, the vertical component of tension T_2 must be bigger than the horizontal component (To see this quickly, draw an extreme case like 85 degrees). Therefore, the horizontal component of tension must be less than mg. The horizontal rope T must cancel this horizontal component of T_2.

2. **(B)** $\mu > 0.8$. The normal force between the mass and the floor is 150 N. The needed sideways push to overcome static friction is **greater than** 120 N. Dividing these two forces would give us:

$$\mu_s = 120/150 = 0.8$$

 Since a greater force is needed, the coefficient of static friction must be greater than this value.

3. **(B)** $0.5\ mg$. The free-body diagram consists of only two forces.

 Newton's second law gives us $+N - mg = ma$. Let $a = -0.5\ g$, which is half the value of g and downward:

$$N - mg = -0.5\ mg$$

$$N = 0.5\ mg$$

4. **(A)** The ball's inertia keeps it going. Newton's first law says that a body's inertia maintains its current motion once in motion. After the force of the throw, the only force on the ball is the vertical force of gravity. This causes the ball to accelerate in the vertical direction while the ball's sideways velocity in maintained due to its inertia.

5. **(C)** Force on hand = force on book. Newton's third law of action-reaction states that the force pair of interaction between two objects is always equal and opposite. The acceleration of either object has no role in the third law. The acceleration comes about from the net force on a single object.

6. **(B)** 0.25. To find force, we must first find acceleration:

$$v_f^2 = v_i^2 + 2ad$$

$$(0)^2 = (10 \text{ m/s})^2 + (2a)(20 \text{ m})$$

$$a = -2.5 \text{ m/s}^2$$

The net force horizontally is the friction. There are no other horizontal forces:

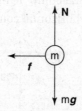

Newton's second law gives us:

$$f = ma = -m(2.5)$$

Our model for friction gives us:

$$f = -\mu N$$

This value is negative since it is to the left. Since the vertical forces cancel out, $N = mg$. Substituting for friction from above and mg for N:

$$-m(2.5) = -\mu mg$$

Note that mass cancels:

$$\mu = (2.5/g) = 0.25$$

7. **(A)** The rock will fall an additional 4.9 meters is NOT true. An object in free fall will accelerate by a constant 9.8 m/s². Since the rock is already moving downward, this leads to an increase in speed of 9.8 m/s in that 1-second interval. However, the rock will fall much farther than 4.9 m as it is already moving close to 30 m/s downward by the start of the 3rd second. It will fall an additional 35 meters in that 4th second. The rock does indeed fall 4.9 meters in the 1st second of the drop but falls an increasingly greater distance each second thereafter.

8. **(D)** a_x is constant. All the equations of motion are predicated on the assumption of constant acceleration. Any permutation of signs or values will work in any of the equations of motion. If the acceleration is not constant, one must use graphical methods or approximate the acceleration as constant over a narrow interval of time.

9. **(D)** They are all the same except for V_y. Projectile motion involves a constant vertical acceleration of $-g$ and no horizontal acceleration at all. Therefore, a_x and a_y are both constant throughout the flight. Since a_x is zero, there is no change in V_x. So V_x is also constant. V_y, however, is always changing. For a symmetric problem such as this one, the projectile lands with the same vertical speed as it had initially but in the opposite direction so that $V_{yf} = -V_{yi}$.

10. **(C)** The bucket will fly out horizontally initially. Objects executing circulation motion have velocity vectors tangent to their motion while experiencing an inward acceleration. If the inward force is released, Newton's first law dictates the object follow its velocity vector. Note that gravity will cause the object to fall after it is released, but the initial motion is horizontal.

11. **(C)** The Moon's orbital period would increase by a factor of $2\sqrt{2}$. Kepler's third law of orbital bodies states that their orbital periods squared are proportional to their orbital radius cubed:

$$T_{old}^2 / R_{old}^3 = T_{new}^2 / R_{new}^3$$

Substituting $R_{new} = 2R_{old}$:

$$T_{old}^2 / R_{old}^3 = T_{new}^2 / (2R_{old})^3$$

Cancel R and solve for T_{new}:

$$T_{new} = 8^{\frac{1}{2}} T_{old} = 2\sqrt{2} T_{old}$$

Note that you can also obtain this result by examining the equation for orbital speed from Newton ($v = (Gm/r)^{1/2}$). This shows that the orbital speed of the Moon must decrease by the square root of 2. Coupling this with the knowledge the new orbit is now twice as large, it will take $2(2^{1/2})$ or $2\sqrt{2}$ times as long to orbit once around Earth as it used to.

12. **(A)** Your mass would be the same, but your weight would change. Mass is a property of an object and measures the object's inertia regardless of location. Weight is a force due to gravity and depends both on the object's mass and on the planetary gravity the object is currently experiencing.

13. **(D)** Same work, twice the power.

$$\text{Work} = \text{force} \times \text{distance}$$

For lifting operations, the force is assumed to be equal to the weight of the object for most of the lift. (Briefly, at the beginning of the lift, the lifting force must be greater than the weight in order to get the object moving. This brief force must be different in the second case in order to get the suitcase moving faster. However, this initial force is generally ignored in these calculations as it does not happen over an appreciable distance, just as the decrease in lifting force at the end of the lift is likewise ignored.) The same force over the same distance yields the same work. If the details of the forces contributing to the work are troublesome, you may prefer to think about the energy gained by the suitcase ($W = \Delta E$). Since the suitcase has gained the same amount of energy in both cases by being lifted, the work done must likewise be the same:

$$\text{Power} = \text{work} / \text{time}$$

If the same work is done in half the time, twice the power must be supplied.

14. **(B)** $2(2)^{1/2}$ m/s. From the work-energy theorem:

$$W_{net} = \Delta KE$$

$$\text{Work done by the horizontal force} = (12 \text{ N})(5 \text{ m}) = 60 \text{ J}$$

$$\text{Word done by friction} = -40 \text{ J}$$

$$W_{net} = +60 - 40 = 20 \text{ J}$$

So the kinetic energy of the mass has gone up by 20 J. Initially, it had no KE since it was stationary. Therefore:

$$\frac{1}{2}mV_f^2 = 20$$

$$V_f^2 = 40/5 = 8$$

$$V_f = 2\left(2^{\frac{1}{2}}\right)$$

15. **(C)** 11.1 m/s. Mechanical energy is conserved since there are no nonconservative forces involved:

$$ME_i = ME_f$$

$$KE_i + PE_i = KE_f + PE_f$$

$$\frac{1}{2}m(2 \text{ m/s})^2 + mg(9 \text{ m}) = \frac{1}{2}mv_f^2 + mg(3 \text{ m})$$

Canceling mass in every term and solving for v_f yields:

$$v_f^2 = 2^2 + 2 \times (9g - 3g) = 4 + 12g = 124$$

$$v_f = 11.1 \text{ m/s}$$

16. **(B)** 1.75

$$\text{Impulse} = \Delta \text{momentum}$$

$$= m\mathbf{v}_f - m\mathbf{v}_i$$

Since the collision is elastic, no kinetic energy is lost. Assuming the wall remains stationary, the rubber ball must rebound with the same speed but in the opposite direction:

$$\mathbf{v}_f = -\mathbf{v}_i$$

Substituting for \mathbf{v}_f above:

$$\text{Impulse} = m(-\mathbf{v}_i) - m\mathbf{v}_i = -2 \ m\mathbf{v}_i = -2 \ (0.25 \ \text{kg})(3.5 \ \text{m/s}) = -1.75 \ \text{kg m/s}$$

Here the negative sign indicates that the impulse delivered to the ball is in the opposite direction from the ball's initial velocity. Note the ball and the wall receive equal and opposite impulses (from Newton's third law) and the problem asks for magnitude (absolute value).

Since $F\Delta t$ is also impulse, units of N · s must be the same as kg · m/s and is quickly shown:

$$\text{N} \cdot \text{s} = (\text{kg} \cdot \text{m/s}^2)\text{s} = \text{Kg} \cdot \text{m/s}$$

17. **(D)** 1.1 m/s. Total momentum must be conserved through the collision. So we need to find only the magnitude of the initial momentum of the system. Each player is originally running perpendicularly to the other. So their individual momentums are different components. Imagine one as an x-component and the other as a y-component. Therefore, the resulting magnitude is found using the Pythagorean theorem. Dividing by total mass yields the speed of the combined players after impact:

$$P_{1x} = 85 \ (1.5) = 127.5 \ \text{kg} \cdot \text{m/s}$$

$$P_{2y} = 75 \ (1.75) = 131.25 \ \text{kg} \cdot \text{m/s}$$

$$\text{Magnitude} = 183 \ \text{kg m/s}$$

$$\text{Net mass} = 160 \ \text{kg}$$

$$\text{Speed} = \text{magnitude} / \text{mass} = 1.14 \ \text{m/s}$$

18. **(D)** $\tau_B > \tau_A > \tau_C$.

$$\text{Torque} = (\text{force}) \ (\text{distance from axis of rotation}) \sin \ \theta$$

Force C is applied along the lever arm. So force C has an angle of 180°, resulting in no torque.

Force A has a much shorter lever arm than force B. Therefore the torque supplied by A is much less than the torque supplied by B.

19. **(D)** The rotational rate increases by a factor of 100. The moment of inertia (I) for a sphere is proportional to R^2. Since the shape of the cloud is not changing, we can determine that the moment of inertia has decreased by a factor of 10^2. Since angular momentum is conserved:

$$I_1\omega_1 = I_2\omega_2$$

The new angular velocity (ω_2) must be 100 times bigger:

$$I_1\omega_1 = I_2\omega_2 = (I_1/100)\,(100\,\omega_1)$$

20. **(B)** I and V both are halved. The effective resistance of the entire circuit is doubled, meaning the voltage supply will send out only half the current:

$$V = IR$$

$$V_{same}\,/\,R_{doubled} = I$$

The voltage used for the entire circuit must be shared between the two resistors. Since the two resistors are identical, the split will be 50/50.

21. **(A)** I and V will remain unchanged. The new resistor forms its own parallel path and therefore does not affect the voltage for original path. Since the original resistor has the same voltage and resistance, it will draw the same current. Note, however, that the voltage supply must now furnish twice the current with the second resistor in place.

22. **(C)** Electrons are allowed to flow through the switch. When those electrons already within the bulb move, the lightbulb lights. Closing a switch completes the path, allowing electrons to move around the circuit. All components within the circuit have electrons that respond to the voltage difference and begin to flow. This resulting movement of electrons already within the bulb causes the lightbulb to glow. Recall that the drift velocities of electrons in simple circuits that make up the current are only about 0.03 cm/s.

23. **(C)** Initial partial destructive interference followed by constructive interference followed by unchanged waves emerging on opposite sides. After the waves superpose, they emerge as they were before as if they had never met. As they begin to overlap, the leading trough of the wave on the left will superpose with leading peak of the wave on the right to interfere destructively. However, since the other halves of the waves are unaffected, this is only partial destruction. When the waves are completely superposed, trough will be on trough and peak on peak, leading to a constructive interference.

24. **(A)** Higher frequency, lower wavelength, same wave speed. Wave speed is determined by the medium, which is the air. So wave speed will not be observed to be different by either observer. Wavelength will appear to be shorter to the stationary observer as the crests are compressed by the ambulance moving toward you between peaks:

$$\text{Wavelength} \times \text{frequency} = \text{wave speed}$$

Since wavelength is shorter, the frequency must be higher in order to give the same speed. This higher frequency is the directly observable higher pitch that is known as the Doppler shift.

25. **(C)** 57 mph. Relative velocity is the difference in the velocity vectors. When the vectors are subtracted, the resultant is the hypotenuse of a right triangle:

$$\text{Relative velocity} = \left(35^2 + 45^2\right)^{\frac{1}{2}}$$

26. **(A)** and **(C)** An elastic collision conserves both net momentum and net kinetic energy. An elastic collision between two objects has equal but opposite impulses delivered. All collisions conserve net momentum. Elastic collisions also conserve kinetic energy. All collisions involve equal but opposite exchanges of momentums. Inelastic collisions simply indicate that kinetic energy is not conserved.

Section II: Free-Response

1. This is a statics problem (see Chapters 4 and 10 for more information).

(a) Both net force and net torque must add up to zero. Make a free-body diagram:

$$F_{NET} = F_1 + F_2 - Mg = Ma = 0$$

$$F_{net} = +F_1 + F_2 - Mg = ma = 0$$

$$F_1 + F_2 = Mg$$

We now have two unknowns but only one equation! For torque, we are free to choose any axis of rotation we want since the wedge is not actually moving. We should place the axis of rotation at either contact point in order to eliminate one variable. If we place our axis of rotation at the F_1 contact point and use minus for clockwise rotations and plus for counterclockwise rotations:

$$\text{Net torque} = F_1(0) - Mg\,(L/3) + F_2\,(3L/4) = I\alpha = 0$$

$$F_2(3L/4) = Mg\,(L/3)$$

$$F_2 = 4\ Mg/9$$

Combine this equation with the one found above.

$$F_1 = Mg - 4\ Mg/9 = 5\ Mg/9$$

(b)

$$\text{Torque} = I\alpha$$

Since F_2 is gone, the torque is supplied only by the mass of the object:

$$\text{Torque} = FR \sin\ \theta$$

$$\text{Torque} = Mg\,(L/3)\ (1)$$

Substituting into the above equation:

$$MgL/3 = I\alpha = I\ (2)$$

$$I = MgL/6 = (3.8)(9.8)(0.75)/6 = 4.7\ \text{kg} \cdot \text{m}^2$$

Note that I = mr² cannot be used as the object has mass spread out over many different r values.

(c) (i) As the object rotates, neither the lever arm nor the force (Mg) changes. However, the angle between the lever arm and force goes from 90° initially toward 0° at the lowest point of the downward swing. Since torque is proportional to sin θ, the torque (and thus the angular acceleration) will decrease.

 (ii) Since neither the distribution of mass nor the axis of rotation changes during the swing, the object's moment of inertia remains constant.

2. This is a projectile motion (Chapter 3) and energy conservation (Chapter 5) problem. Energy conservation tells us that the other 55 percent of the initial energy is in gravitational potential energy.

$$\text{GPE at top} = 55\% \text{ of initial KE} = 0.55\left(\frac{1}{2}m(25^2)\right)$$

$$mgh = 0.55\left(\frac{1}{2}m(25^2)\right)$$

Solve for height and note that mass cancels:

$$h = 17.5 \ \text{m}$$

Determine the time to fall from that height. Remember there is no vertical velocity at the highest point!

$$D_y = \frac{1}{2}at^2$$

$$17.5 = 4.9t^2$$

$$t = 1.89 \ \text{s}$$

Double this value to obtain time in flight: 3.8 seconds.

Diagnostic Test

AP Physics 2

SECTION I: MULTIPLE-CHOICE

> **DIRECTIONS:** Pick the best answer (or 2 best answers when indicated) on each of the following 26 multiple-choice questions as well as the two free-response questions. The detailed answer explanations will direct you to a specific chapter for further review on the specific subject matter in that question. You may use a calculator and make use of the formula sheet provided in the appendix.

1. Compare the two columns of water pictured below. They have the same height. Which of the following statements compares the total weight and the pressure at the bottom of the columns?

 (A) Weight and pressure are greater for the wider column.
 (B) Weight and pressure are the same for both.
 (C) Weight is greater for the wider column, while pressure is the same.
 (D) Weight is the same, while pressure is greater for the wider column.

2. The exact same boat will ride higher (have more volume exposed to the air) while floating on a fluid if

 (A) the fluid's density is raised
 (B) the fluid's temperature is raised
 (C) the boat's density is raised
 (D) the boat shifts its cargo to a lower deck

3. Fluid is poured into an open U-shaped tube as shown below. If a person blows across the top of the right hand side's opening, what will happen to the fluid in the tube?

(A) It will remain the same.
(B) It will rise on the right-hand side and lower on the left-hand side.
(C) It will rise on both sides.
(D) It will rise on the left-hand side and lower on the right-hand side.

4. The Sun's rays strike a black surface that is directly on top of a liquid. The liquid is then observed to swirl as it transfers the heat to the bottom layers of the liquid. The correct sequence of transfers in thermal energy in this story is

(A) Radiative → convective → conductive
(B) Radiative → conductive → convective
(C) Convective → conductive → convective
(D) Convective → conductive → radiative

5. Which of the following is the best explanation of the statement, "A roomful of neon gas has a lower average speed than 1 mole of helium gas at the same temperature and pressure."

(A) This is not a correct statement.
(B) There is more than 1 mole of neon gas in an average room.
(C) Helium atoms have more degrees of freedom than do neon atoms.
(D) Helium has a lower mass per particle than neon.

6. Consider the following process for a gas. Which of the following statements is true concerning this process?

(A) Path D (from point 4 to point 1) is isobaric.
(B) No work was done to or by the gas during path A (from point 1 to point 2).
(C) No net work was done to or by the gas during the entire cycle (from point 1 back to point 1 through A, B, C, D).
(D) No work was done to or by the gas during path B (from point 2 to point 3).

7. Two identical spheres originally in contact undergo induced charge separation. The two spheres are slowly separated until a gap of 12 cm is separating their surfaces. The net force of attraction between the two oppositely charged large spheres after they have been separated by 12 cm is measured. The entire experiment is then repeated with two smaller but otherwise similar spheres.

The force between the smaller spheres compared with the force between the larger spheres is best described as

(A) the same since the charges and separations are the same
(B) smaller since the charges on each small sphere are closer together
(C) bigger since the center of the spheres are closer
(D) the same since the average force felt by any one particular charge is the same in both cases

8. One large conducting sphere with a net charge of +8 microcoulombs is put into contact with a slightly smaller conducting sphere that initially has a charge of –6 microcoulombs. Which statement best describes the charge distribution after the two spheres are separated?

(A) They are both neutral.
(B) The larger sphere has +8 microcoulombs of charge, while the smaller retains –6 microcoulombs of charge.
(C) Both spheres have +1 microcoulomb of charge.
(D) The larger sphere has slightly more than +1 microcoulomb of charge, while the smaller sphere has slightly less than +1 microcoulomb of charge.

9. Which of the following pictures is an incorrect representation of the electric field near various charged conductors?

(A)

(B)

(C)

(D)

10. A standard RC (resistor-capacitor) circuit takes approximately 2 seconds to charge the capacitor fully. If the resistor is 100 ohms and the voltage across the RC combination is 12 volts, what is the current through the capacitor?

(A) One must know the capacitance of the capacitor in order to answer this question.

(B) 0.12 A

(C) 0.06 A

(D) 0 A

11. If each of the batteries in the circuit below supplies a voltage *V* and if each resistor has resistance *R*, what will be the reading on the meter pictured?

(A) 0

(B) *V*/3

(C) 2*V*/3

(D) 2*V*/3*R*

12. The primary difference between a permanent magnet (an object with identifiable north and south poles) and magnetic material that does not have identifiable north and south poles is

(A) electron configuration

(B) magnetic domain alignment

(C) magnetic materials have no poles at all

(D) magnetic materials are lacking one of the two poles

13. A very long wire carries a steady current. What is the magnetic field at a distance of *R* from the wire?

(A) The magnetic field is zero.

(B) The magnetic field loops around the wire and gets weaker proportional to $1/R^2$ as one moves to larger *R* values.

(C) The magnetic field loops around the wire and gets weaker proportional to $1/R$ as one moves to larger *R* values.

(D) The magnetic field extends radially outward and gets weaker proportional to $1/R^2$ as one moves to larger *R* values.

14. Two parallel wires carrying current near each other exert magnetic forces on each other. If the direction and magnitude of the current in both wires is reversed and doubled, what will happen to the magnetic forces?

(A) They will reverse directions and double in magnitude.

(B) They will reverse directions and quadruple in magnitude.

(C) They will remain in the same directions and double in magnitude.

(D) They will remain in the same directions and quadruple in magnitude.

15. A conducting loop of wire is held steady parallel to the ground within a strong magnetic field directed upward. The setup is viewed from above. As the loop of wire is quickly pulled out of a magnetic field, what will the loop experience?

 (A) A temporary clockwise current that dies out soon after the loop is out of the field
 (B) A temporary counterclockwise current that dies out soon after the loop is out of the field
 (C) A temporary clockwise current that dies out as soon as the loop is out of the field
 (D) A temporary counterclockwise current that dies out as soon as the loop is out of the field

16. A charge is accelerated by an electric field. While the charge is accelerating, which of the following is occurring?

 (A) A static magnetic field is created.
 (B) A new, static electric field is created.
 (C) Only a varying magnetic field is created.
 (D) An electromagnetic wave is created.

17. A light beam is traveling in a vacuum and then strikes the boundary of another optically dense material. If the light comes to the interface at an angle of incidence of 30 degrees on the vacuum side. It will emerge with an angle of refraction

 (A) equal to 30 degrees
 (B) less than 30 degrees
 (C) greater than 30 degrees
 (D) the relative indices of refraction must be known in order to find the solution

18. A beam of light incident at 50 degrees travels from a medium with an index of refraction of 2.5 into one with an index of refraction of 1.1. The refracted angle of light that emerges is

 (A) 20 degrees
 (B) 50 degrees
 (C) 90 degrees
 (D) there is no solution

19. A radio telescope uses a curved reflecting material to focus radio signals from orbiting satellites or distance objects in space onto a detector. Which of the following would be the biggest problem with designing a radio telescope with a convex reflecting dish?

 (A) The image produced is virtual.
 (B) The image produced is inverted.
 (C) The detection equipment would have to be placed in the line of sight.
 (D) There is no real problem with designing a convex reflecting dish for radio waves.

20. When examining a two-slit diffraction pattern, which of the following would you notice as the slits were brought closer together?

(A) The interference pattern would contain more maximums. They would be more closely spaced.

(B) The location of the central interference peak would shift.

(C) The interference pattern would spread out.

(D) The interference peaks themselves would each become sharper (narrower).

21. A convergent lens can produce which of the following from a single object in front of the lens? Select two answers.

(A) Real and upright image

(B) Virtual and upright image

(C) Real and inverted image

(D) Virtual and inverted image

22. A radioactive isotope undergoes gamma decay. Afterward, the nucleus

(A) contains fewer nucleons

(B) has the same number of nucleons but a different ratio of protons/neutrons

(C) has the same mass number but a lower mass

(D) undergoes beta decay

23. When examining the spectrum for a specific element, a bright spectral line with the highest frequency represents

(A) an electron excited to the atom's highest energy state

(B) an electron falling from the highest energy state in the atom to the next to highest state

(C) an electron excited from its ground state to the next to lowest energy state

(D) an electron falling from a higher energy state to a much lower energy state

24. Some objects can be made to exhibit an interference pattern with the two-slit experiment, and some objects cannot. What is the difference between those that can and those that cannot?

(A) Objects are either fundamentally a wave or fundamentally a particle.

(B) All objects can exhibit either wavelike properties or particle-like properties depending on the situation.

(C) Whether an interference pattern can be observed depends on the object's de Broglie wavelength.

(D) All objects can be made to exhibit an interference pattern under the right circumstances.

25. For an RC circuit, which of the following is the correct analogy for the instantaneous current behavior in a pathway containing a capacitor? Choose the option that would give the correct instantaneous current values in the capacitor's path.

	Uncharged Capacitor	Fully Charged Capacitor
(A)	Closed switch	Open switch
(B)	Open switch	Closed switch
(C)	Closed switch	Closed switch
(D)	Open switch	Open switch

26. Which of the following statements are true concerning isolated fundamental particles? Select two answers.

(A) An isolated, fundamental particle cannot have charge.

(B) An isolated, fundamental particle cannot have potential energy.

(C) An isolated, fundamental particle cannot have internal energy.

(D) An isolated, fundamental particle cannot have mass.

SECTION II: FREE-RESPONSE

1. Use the following circuit to answer the questions below.

(a) When the battery is first attached to the circuit and the capacitor is still uncharged, how much current is being supplied by the battery? Explain your reasoning.

(b) After the capacitor has been fully charged, how much current is being supplied by the battery? Explain your reasoning.

(c) After the capacitor has been fully charged, the battery is removed, leaving an open circuit where the battery was currently located. Determine the direction of current through the 10-ohm resistor and

 (i) The total amount of charge that passes through the 10-ohm resistor
 (ii) The initial instantaneous current after the battery has been removed
 (iii) The approximate time for the capacitor to be half discharged

2. A student is provided with a solenoid attached to an ammeter and with a bar magnet. The student monitors the ammeter as she performs the following sequence of events. Describe qualitatively her observation of the ammeter (comparing current sign and magnitude) at each step of her procedure.

(a) The student slowly inserts the north pole of the bar magnet into the solenoid.

(b) She holds the magnet steady at this location.

(c) The student withdraws the magnet quickly from the solenoid.

(d) She repeats the steps but uses the south pole of the magnet.
 What factors about this procedure and the equipment affect the magnitude of current observed?

ANSWER KEY	TOPIC AND CHAPTER TO REFERENCE
1. **(C)**	Pressure, Chapter 16
2. **(A)**	Archimedes, Chapter 16
3. **(B)**	Bernoulli, Chapter 16
4. **(B)**	Thermal energy, Chapter 17
5. **(D)**	Kinetic-molecular theory, Chapter 17
6. **(D)**	P-V diagram, Chapter 17
7. **(C)**	Coulomb's law, Chapter 11
8. **(D)**	Charge transfer, Chapter 11
9. **(C)**	Electric fields near a conductor, Chapter 11
10. **(D)**	RC circuits, Chapter 12
11. **(B)**	Kirchoff's rules, Chapter 12
12. **(B)**	Magnetic materials, Chapter 13
13. **(C)**	Magnetic fields, Chapter 13
14. **(D)**	Magnetic forces, Chapter 13
15. **(D)**	Lenz's law, Chapter 13
16. **(D)**	Electromagnetic induction, Chapter 13
17. **(B)**	Snell's law, Chapter 15
18. **(D)**	Total internal reflection, Chapter 15
19. **(A)**	Reflection/mirrors, Chapter 15
20. **(C)**	Diffraction patterns, Chapter 14
21. **(B)** and **(C)**	Lens and image, Chapter 15
22. **(C)**	Nuclear reactions, Chapter 18
23. **(D)**	Light/matter interactions, Chapter 18
24. **(C)**	Wave-particle duality, Chapter 18
25. **(A)**	Capacitors, Chapter 12
26. **(B)** and **(C)**	Fundamental particles, Chapter 1

ANSWERS EXPLAINED

Section I: Multiple-Choice

1. **(C)** Weight is greater for the wider column, while pressure is the same. Although the wider column has a greater volume of water and therefore more mass, the fact that the height remains constant means any unit area on the bottom of the column will experience the same force/area (pressure).

2. **(A)** The fluid's density is raised. The buoyancy force that lifts the boat upward is proportional to the weight of the fluid displaced. The boat will rise or sink until the buoyant force and the boat's weight cancel. Raising the fluid's temperature will usually make the fluid less dense, requiring a greater displacement of water (i.e., the boat will ride lower). Raising the boat's density will increase its weight, requiring a greater displacement of water. Finally, shifting the cargo around will have no effect as the weight and shape of the boat remain unaffected.

3. **(B)** It will rise on the right-hand side and lower on the left-hand side. Blowing over the right-hand side will lower the pressure at that height:

$$\frac{1}{2}\rho v^2 + \rho g h + P = \text{constant}$$

 Remember that h remains the same while v is raised, forcing P lower. This causes an imbalance in pressure between the right-hand side (lower pressure) and left-hand side (higher pressure). This difference in pressure causes a net force pushing the fluid upward on the right and downward on the left.

4. **(B)** Radiative → conductive → convective. Radiative transfer is the transfer of energy via electromagnetic radiation (such as sunlight). Conductive transfer is the transfer of thermal energy via direct contact (such as a floating object in contact with the water). Convective transfer is the transfer of thermal energy due to the movement of a fluid (like currents in the water).

5. **(D)** Helium has a lower mass per particle than neon. Average kinetic energy is directly related to temperature. Since both gases are at STP (standard temperature and pressure), their average kinetic energies are the same. However, since helium has a lower mass, it must have a higher velocity to obtain the same kinetic energy ($\frac{1}{2}mv^2$).

6. **(D)** No work was done to or by the gas during path B (from point 2 to point 3). The term *isobaric* indicates constant pressure, so choice (A) is false. During path B, the gas expands and therefore does work to its surroundings. So choice (B) is false. Over the entire process, the area of the enclosed area is the work done by the gas. Since this area does not equal zero, choice (C) is false. Process D involves an expansion or contraction (displacement) of the gas. Therefore no work is done during the part of the process.

7. **(C)** Bigger since the center of the spheres are closer. Remember $kq_1 q_2/r^2$.

 The charges (q_1 and q_2) are the same, and k is a constant. So the only variation in the two situations is the average r between the spheres. In the case of the 2 smaller spheres, the average distance (represented by the center of the spheres) is actually closer. Therefore the force is stronger in that case.

8. **(D)** The larger sphere has slightly more than +1 microcoulomb of charge, while the smaller sphere has slightly less than +1 microcoulomb of charge. When the spheres contact each other, electrons move off of the smaller sphere to the larger sphere and attempt to neutralize both spheres. Since this is a net +2 microcoulombs of charge, the electrons distribute themselves over both surface areas of the spheres, keeping the positive charges as far from each other as possible. Since the larger sphere has more surface area, it captures a greater portion of the excess charge than does the smaller sphere.

9. **(C)** Field lines should point away from the positive and toward the negative, which all the pictures show. Field lines should never cross, and none of these diagrams has that. Field lines should also be perpendicular to the surface of conductors. Picture (C) violates this principle.

10. **(D)** A fully charged capacitor cannot accept any more charge; therefore, the current going into it is zero.

11. **(B)** $V/3$. The meter pictured is a voltmeter. The voltage supplied by the battery will be split evenly among the three identical resistors. Having the additional battery in parallel does not affect the potential difference. The current drawn from each battery will be half of the current flowing through each resistor.

12. **(B)** Magnetic domain alignment. Electron configuration is the difference between a non-magnetic and a magnetic material. Any magnetic material can be made to have overall north and south poles by lining up all of the individual magnetic domains within the material. (Each domain has its own north and south poles.) Magnetic poles do not exist in isolation as all magnetic field lines loop back on themselves.

13. **(C)** The magnetic field loops around the wire and gets weaker proportional to $1/R$ as one moves to larger R values. The moving charges in the wire create loops of magnetic field around them. As R increases, the field strength decreases proportional to $1/R$ rather than $1/R^2$ because the source of the field is a line rather than a point.

14. **(D)** They will remain in the same directions and quadruple in magnitude. Reversing the direction of one current will switch the direction of its magnetic field. However, when using the right-hand rule and since the direction of the moving charges within the reversed field is also reversed, the same direction of force is found. Doubling the source current will double the field strength, which then is acting on twice as much current and creating 4 times the force.

$$B \propto I_1$$

$$F \propto I_2 B$$

$$F \propto I_1 I_2$$

15. **(D)** A temporary counterclockwise current that dies out as soon as the loop is out of the field. Only while the flux of the field through the loop is changing will there be an induced emf causing the current. The induced current will be such that its magnetic field will oppose the change. Since the magnetic field flux upward through the loop is getting smaller as the loop is pulled out, the induced current will create an additional upward magnetic field. The right-hand rule for current indicates a counterclockwise current is needed.

16. **(D)** An electromagnetic wave is created. When a charge is accelerating, the changing velocity of the charge creates a changing magnetic field. The changing magnetic field induces a changing electric field. This dual oscillation is self-perpetuating and is known as electromagnetic radiation (or light when the frequency of oscillation lies within the visible range).

17. **(B)** Less than 30 degrees. Since the second medium is slower, it will have a larger n value, thereby requiring a smaller $\sin\theta$ value. So a smaller angle is needed:

$$n_1 \sin\theta_1 = n_2 \sin\theta_2$$

18. **(D)** There is no solution. This is a situation of total internal reflection. Since 50 degrees is beyond the critical angle for this pair of materials, all of the light will be reflected and none will be refracted. Remember that a 90-degree "refraction" happens right at the critical angle.

19. **(A)** The image is virtual. Convex mirrors are diverging. This means the real, reflected rays do not come to an actual focus. The focus is virtual and located behind the mirror. So any detection equipment placed at the focus would not actually receive a signal!

20. **(C)** The interference pattern would spread out.

$$D \sin\theta = m\lambda$$

Wavelength does not change. So as D get smaller, $\sin\theta$ must increase. Therefore, the location of the bright, constructive interference fringes (integer m's) are found at greater angles.

21. **(B)** and **(C)** The image is virtual and upright, or it is inverted and real. If the distance of the object is less than 1 focal length from the convergent lens, the image is virtual and upright. If the distance of the object is more than 1 focal length from the convergent lens, the image is inverted and real.

22. **(C)** The nucleus has the same mass number but a lower mass. Since the nucleus has emitted a photon of electromagnetic energy, the net charge on the nucleus must remain the same. Since energy left the nucleus, the mass of the nucleus as a whole must be decreased by E/c^2.

23. **(D)** An electron falling from a higher energy state to a much lower energy state. Light is emitted (bright spectral line) when an electron falls from an excited state to a lower energy state. The greater the energy *difference* is (as opposed to the starting energy state), the higher the frequency of light emitted ($E = hf$).

24. **(C)** Whether an interference pattern can be observed depends on the object's de Broglie wavelength. The de Broglie wavelength is the connection between classically particle-like objects and their wavelike properties. Interference patterns have been successfully shown for many particles. Macroscopic objects, however, have such large masses that their de Broglie wavelengths make observing a diffraction pattern impossible:

$$\lambda = h/p$$

25. **(A)** Uncharged capacitor—closed switch; fully charged capacitor—open switch. An uncharged capacitor will initially appear to be a simple wire as the first charge to hit one side of the capacitor draws its opposite on the other side. On the other hand, a fully charged capacitor accepts no additional charges and blocks any current from entering its pathway. These two states are connected by an exponential function:

$$I = (V/R)\, e^{-t/RC}$$

Remember to compare $t = 0$ to $t \gg RC$.

26. **(B)** and **(C)** An isolated, fundamental particle cannot have potential energy. An isolated, fundamental particle cannot have mass. Potential energies are energies of relationship and therefore cannot belong to an isolated particle with no internal structure. Likewise, internal energy refers to energies (both kinetic and potential) carried by the various internal constituents of nonfundamental particles.

Section II: Free-Response

1. This is an electric circuit problem (see Chapter 12 for more information).

 (a) Initially the top path acts as a simple 5-ohm resistor because the capacitor is uncharged and will act as if current is passing right through it. The 10-ohm resistor is in parallel with the capacitor, resulting in an equivalent resistance of 10/3 ohms:

$$1/5 + 1/10 = 1/R$$
$$2/10 + 1/10 = 1/R$$
$$3/10 = 1/R$$
$$R = 3\,\Omega$$

 Ohm's law gives us a 3-amp current coming from the battery:

$$V = IR$$
$$10 = I\,(10/3)$$
$$I = 3\,\text{A}$$

 (b) After the capacitor has been fully charged, it will act as an open circuit, no longer allowing charge to flow through the upper path. Equivalent resistance for the circuit will now be 10 ohms

$$V = IR$$
$$10\,\text{V} = I\,(10\,\Omega)$$
$$I = 1\,\text{A}$$

(c) The direction of current is constant throughout the problem, from right to left, whether it is being supplied by the battery or by the capacitor.

(i)

$$C = Q/V$$

$$5\,\mu F = Q/10\,V$$

The entire 10 V is on the capacitor at the end because the 5-ohm resistor is not using any voltage ($I = 0$):

$$Q = 50\,\mu C$$

(ii) Initially, the 10 volts of the capacitor will be driving current through an equivalent resistance of 15 ohms (5 + 10 in series):

$$V = IR$$

$$10 \text{ volts} = I\,(15 \text{ ohms})$$

$$I = 0.67 \text{ amps}$$

Note that right away, the voltage will begin to decrease across the capacitor as it discharges, therefore driving increasingly smaller currents through the resistors.

(iii) As an exponential decreasing function, the time constant of RC provides an approximate time for losing about half the charge:

$$RC = (15\,\text{ohms})(5\,\text{microfarads})$$
$$= 75\,\text{microseconds}$$

2. This is a magnetism and electromagnetism problem (see Chapter 13 for more information).

(a) The student will see a modest current in one direction as the bar magnet enters the solenoid. Note that without knowing the actual orientation of the loops, the magnet, and the ammeter, the actual sign of the current cannot be determined.

(b) She will observe no current while the magnet is being held still.

(c) The student will observe a current in the opposite direction as it is withdrawn. The magnitude of this current will be larger as the change in magnetic flux is happening quicker.

(d) The same as described above but with opposite signs for the current. The number of coils, the total resistance of the coils, the strength of the magnet, the speed at which the magnet is moved, and possibly the orientation of the magnet relative to the cross-sectional area of the solenoid all affect the magnitude of the observed current.

Review and Practice

Overview of AP Physics Concepts

1

KEY CONCEPTS

→ **THE SEVEN BIG IDEAS**

→ **OBJECTS VS. SYSTEMS**

→ **FUNDAMENTAL PARTICLES (AP PHYSICS 2 ONLY)**

THE SEVEN BIG IDEAS

The College Board has identified seven "Big Idea" strands that serve as the central organizing structure for both exams. Although the tests have different content, they both attempt to reinforce these central ideas in ways that are appropriate to the subject matter.

- Big Idea 1: "Objects and systems have properties such as mass and charge. Systems may have internal structure."
- Big Idea 2: "Fields existing in space can be used to explain interactions."
- Big Idea 3: "The interactions of an object with other objects can be described by forces."
- Big Idea 4: "Interactions between systems can result in changes in those systems."
- Big Idea 5: "Changes that occur as a result of interactions are constrained by conservation laws."
- Big Idea 6: "Waves can transfer energy and momentum from one location to another without the permanent transfer of mass and serve as a mathematical model for the description of other phenomena."
- Big Idea 7: "Probability can be used to describe quantum systems."

Use these big idea strands as a guide when studying for the tests. They indicate what conceptual questions may appear on the exam.

OBJECTS VS. SYSTEMS

An **object** is thought of as an isolated mass that is being acted upon by outside forces. Any internal structure of the object is ignored. The object is defined by its properties (e.g., mass, charge). Strictly speaking, for a single object being analyzed, it does not make sense to make use of potential energy, Newton's third law, thermal energy, or the conserved quantities. Instead when discussing a single object, use the following relationships from mechanics:

$$\mathbf{F}_{net} = m\mathbf{a}$$

$$T = I\alpha$$

$$F\Delta t = m\Delta v$$

$$F\Delta d = \Delta KE$$

A **system**, in contrast, is made up of objects that may interact. It is within isolated systems that the conserved quantities, canceling Newton's third law forces (internal forces), the heat capacity of the constituent parts, and the potential energy of relationship between interacting objects are useful concepts. Within systems, conserved quantities become the most useful lens through which to view the situation:

$$p_i = p_f$$

$$L_i = L_f$$

$$ME_i = ME_f$$

AP 2 only

FUNDAMENTAL PARTICLES

A fundamental particle is a true object. In other words, if an object is found to have no internal structure (i.e., it cannot be broken into smaller pieces), then it is a fundamental particle. Electrons and photons are fundamental particles, whereas protons and neutrons are not. Electrons and photons can be converted into energy but cannot be broken into smaller pieces. Neutrons and protons, however, can be broken into their constituent parts (quarks and gluons, which are fundamental particles themselves). Einstein's famous $m = E/c^2$ is the course for the majority of mass contained within systems. (The binding energies between the fundamental particles provide the energy.) The search for mass belonging to some fundamental particles themselves (rather than arising from the energy contained within) culminated in the 2013 Nobel prize in physics being awarded to two physicists who first proposed a mechanism by which fundamental particles themselves acquire mass (the Higgs field).

Modern theoretical physics (the standard model) is predicated on this notion of a limited number of fundamental particles combining in various ways to give rise to all matter. These fundamental particles influence each other by exchanging other fundamental particles of interaction. Just as all molecules are made up of a limited number of elements in the periodic table, so is everything in the universe made up of limited number of types of interactions among a limited number of fundamental particles.

SUMMARY

- Know the "7 Big Ideas" of physics as defined by the College Board; they are helpful clues as to what key concepts are emphasized on the exams.
- An object can be represented a single mass. When exposed to external forces, it is best modeled as experiencing changes in speed and/or direction.
- A system is a group of objects which, if isolated, is best modeled with conservation laws.
- A fundamental particle has no internal structure.

Vectors

<div style="text-align: right;">2</div>

KEY CONCEPTS

→ **COORDINATE SYSTEMS AND FRAMES OF REFERENCE**
→ **VECTORS**
→ **ADDITION OF VECTORS**
→ **SUBTRACTION OF VECTORS**
→ **ADDITION METHODS USING THE COMPONENTS OF VECTORS**

COORDINATE SYSTEMS AND FRAMES OF REFERENCE

We begin our review of physics with the idea that all observations and measurements are made relative to a suitably chosen frame of reference. In other words, when observations are made that will be the basis of future predictions, we must be careful to note from what point of view those observations are being made. For example, if you are standing on the street and see a car driving by, you observe the car and all of its occupants moving relative to you. However, to the driver and other occupants of the car, the situation is different: they may not appear to be in motion relative to themselves; rather, you appear to be moving backward relative to them.

If you were to get into your car, drive out to meet the other car, and travel at the same speed in the same direction, right next to the first car, there would be no relative motion between the two cars. These different points of view are known as **frames of reference**, and they are very important aspects of physics.

A coordinate system within a frame of reference is defined to be a set of reference lines that intersect at an arbitrarily chosen fixed point called the **origin**. In the Cartesian coordinate system, the reference lines are three mutually perpendicular lines designated x, y, and z (see Figure 2.1). The coordinate system must provide a set of rules for locating objects within that frame of reference. In the three-dimensional Cartesian system, if we define a plane containing the x- and y-coordinates (let's say a horizontal plane), then the z-axis specifies direction up or down.

It is often useful to compare observations made in two different frames of reference. In the example above, the motion of the occupants of the car was reduced to zero if we transformed our coordinate system to the car moving at constant velocity. In this case we say that the car is an **inertial frame of reference**. In such a frame, it is impossible to observe whether or not the reference frame is in motion if the observers are moving with it.

> **REMEMBER**
>
> A **frame of reference** represents an observer's viewpoint and requires a coordinate system to set the origin. A frame of reference moving with a constant velocity relative to the origin is called an **inertial frame of reference**.

Figure 2.1

VECTORS

Another way of locating the position of an object in the Cartesian system is with a directed line segment, or **vector**. If you draw an arrow, starting from the origin, to a point in space (see Figure 2.2), you have defined a position vector **R** whose magnitude is given by |**R**| and is equal to the linear distance between the origin and the point (x, y). The direction of the vector is given by the angle, identified by the Greek letter θ, that the arrow makes with the positive x-axis. Any quantity that has both magnitude and direction is called a **vector quantity**. Any quantity that has only magnitude is a **scalar quantity**. Examples of vector quantities are force, velocity, weight, and displacement. Examples of scalar quantities are mass, distance, speed, and energy.

TIP

Vectors have both magnitude (size) and direction. Scalars have only magnitude.

Figure 2.2

If we designate the magnitude of the vector **R** as r, and the direction angle is given by θ, then we have an alternative coordinate system called the **polar coordinate** system. In two dimensions, to locate the point in the Cartesian system (x, y) involves going x units horizontally and y units vertically. Additionally, we can show that (see Figure 2.2)

$$x = r \cos\theta \quad \text{and} \quad y = r \sin\theta$$

Having established this polar form for vectors, we can easily show that r and θ can be expressed in terms of x and y as follows:

$$r^2 = x^2 + y^2$$

$$\tan\theta = \frac{y}{x}$$

The magnitude of **R** is then given by

$$|\mathbf{R}| = r = \sqrt{x^2 + y^2}$$

and the direction angle θ is given by

$$\theta = \tan^{-1}\frac{y}{x}$$

ADDITION OF VECTORS
Geometric Considerations

The ability to combine vectors is a very important tool of physics. From a geometric standpoint, the "addition" of two vectors is not the same as the addition of two numbers. When we state that, given two vectors **A** and **B**, we wish to form the third vector **C** such that **A** + **B** = **C**, we must be careful to preserve the directions of the vectors relative to our chosen frame of reference.

One way to do this "addition" is by the construction of what is called a **vector diagram**. Vectors are identified geometrically by a directed arrow that has a "head" and a "tail." We will consider a series of examples.

> **REMEMBER**
> Vectors add constructively from head to tail. The vector sum is called the **resultant**. Vectors that act at the same place and at the same time are called **concurrent vectors**.

EXAMPLE 1

First, suppose a girl is walking from her house a distance of five blocks east and then an additional two blocks east. How can we represent these displacements vectorially? First, we must choose a suitable scale to represent the magnitude lengths of the vectors. In this case, let us just call the scale "one vector unit" or just "one unit," to be equal to one block of distance. Let us also agree that "east" is to the right (and hence "north" is directed up). A vector diagram for this set of displacements is given in Figure 2.3. Note that the resultant has both magnitude and direction as it, too, is a vector.

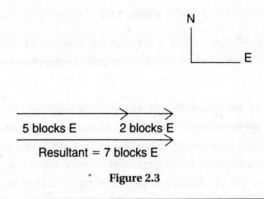

Figure 2.3

EXAMPLE 2

Now, for our second example, suppose the girl walks five blocks east and then two blocks northeast (that is, 45 degrees north of east). As before, we draw our vector diagram, using the same scale as before, so that the two vectors are connected "head to tail" or "tip to tail." The vector diagram will look like Figure 2.4. The resultant is drawn from the tail of the first vector to the head of the second, forming a triangle (some texts use the "parallelogram" method of construction, which is equivalent). The direction of the resultant is measured from the horizontal axis as usual.

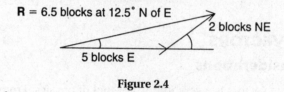

R = 6.5 blocks at 12.5° N of E

2 blocks NE

5 blocks E

Figure 2.4

EXAMPLE 3

For our third example, suppose the girl walks five blocks east and then two blocks north. Figure 2.5 shows the vector diagram for this set of displacements.

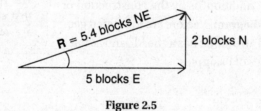

R = 5.4 blocks NE

2 blocks N

5 blocks E

Figure 2.5

EXAMPLE 4

Finally, for our fourth example, suppose the girl walks five blocks east and then two blocks west. Her final displacement will be three blocks east of the starting point as shown in Figure 2.6.

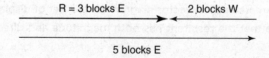

R = 3 blocks E 2 blocks W

5 blocks E

Figure 2.6

In our four examples (Figures 2.3, 2.4, 2.5, and 2.6) the two vectors of magnitudes 5 and 2 could add to any value between 7 and 3, depending on their relative orientation.

From these examples, we conclude that, as the angle between two vectors increases, the magnitude of their resultant decreases. Also, the magnitude of the resultant between two vectors is a maximum when the vectors are in the same direction (at a relative angle of 0 degree), and a minimum when they are in the opposite direction (at a relative angle of 180 degrees). It is important to remember that the vectors must be constructed head to tail and a suitable scale chosen for the system.

Algebraic Considerations

In the above examples, the resultant between two vectors was constructed using a vector diagram. The magnitude of the resultant was the measured length of the vector drawn from the tail of the first vector to the head of the second. If we sketch such a situation, we form a triangle whose sides are related by the **law of cosines** and whose angles are related by the **law of sines**.

Consider the vector triangle in Figure 2.7 with arbitrary sides a, b, and c and corresponding angles A, B, and C.

Figure 2.7

The law of cosines states that

$$c^2 = a^2 + b^2 - 2ab\cos C$$

The law of sines states that

$$\frac{a}{\sin A} = \frac{b}{\sin B} = \frac{c}{\sin C}$$

If we use the information given in our second example above, we see that in Figure 2.8 the vectors have the following magnitudes and directions:

Figure 2.8

Using the law of cosines, we obtain the magnitude of the resultant in "blocks":

$$c = \sqrt{(2)^2 + (5)^2 - 2(2)(5)\cos 135} = 6.56$$

Using the law of sines, we find that the direction of the resultant is angle A:

$$\frac{6.56}{\sin 135} = \frac{2}{\sin A}$$

Angle A turns out to be equal to 12.45 degrees north of east.

Addition of Multiple Vectors

As long as the vectors are constructed head to tail, multiple vectors can be added in any order. If the resultant is zero, the diagram constructed will be a closed geometric figure. This can be shown in the case of three vectors forming a closed triangle, as in Figure 2.9.

$$\mathbf{a} + \mathbf{b} + \mathbf{c} = 0$$

Figure 2.9

Thus, if the girl walks five blocks east, two blocks north, and five blocks west, the vector diagram will look like Figure 2.10, with the resultant displacement being equal to two blocks north.

Figure 2.10

SUBTRACTION OF VECTORS

Subtraction of vectors is best understood by rethinking the subtraction as the addition of a negative vector.

$$\mathbf{R}_2 - \mathbf{R}_1 = \mathbf{R}_2 + (-\mathbf{R}_1)$$

A negative vector is simply one of the same magnitude but directed opposite (i.e., a 180-degree rotation). Note that the result of this operation is the same here as in the example that follows since the resultant has the same magnitude and direction. See Figures 2.11 and 2.12. This difference between the two vectors is sometimes called $\Delta\mathbf{R}$, so that $\Delta\mathbf{R} = \mathbf{R}_2 - \mathbf{R}_1$.

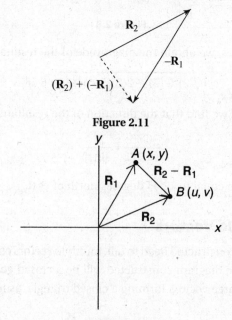

Figure 2.11

Figure 2.12

From our understanding of vector diagrams, we can see that \mathbf{R}_1 and $\Delta\mathbf{R}$ are connected head to tail, and thus that $\mathbf{R}_1 + \Delta\mathbf{R} = \mathbf{R}_2$!

ADDITION METHODS USING THE COMPONENTS OF VECTORS

Any single vector in space can be **resolved** into two perpendicular components in a suitably chosen coordinate system. The methods of vector resolution were discussed in Section 2.2, but we can review them here. Given a vector (sketched in Figure 2.13) representing a displacement of 100 meters northeast (that is, making a 45-degree angle with the positive x-axis), we can observe that it is composed of an x- and a y- (a horizontal and a vertical) component that can be geometrically or algebraically determined.

Figure 2.13

Geometrically, if we were to draw the 100-meter vector to scale at the correct angle, then projecting a perpendicular line down from the head of the given vector to the x-axis would construct the two perpendicular components. Algebraically, we see that if we have a given vector \mathbf{R}, then, in the x-direction, we have

$$\mathbf{R}_x = R\cos\theta \quad \text{and} \quad \mathbf{R}_y = R\sin\theta$$

where the magnitude of \mathbf{R} is R. The magnitude of R may also be written as $|\mathbf{R}|$.

This method of vector resolution can be useful when adding two or more vectors. Since all vectors in the same direction add up numerically, and all vectors in opposite directions subtract numerically, therefore, if we are given two vectors, the resultant between them will be found from the addition and subtraction of the respective components. In other words, if vector \mathbf{A} has components A_x and A_y, and if vector \mathbf{B} has components B_x and B_y, the resultant vector \mathbf{C} will have components C_x and C_y such that

if $\mathbf{C} = \mathbf{A} + \mathbf{B}$, then $C_x = A_x + B_x$ and $C_y = A_y + B_y$

An example of this method is shown in Figure 2.14. Suppose we have two vectors, \mathbf{A} and \mathbf{B}, that represent tensions in two ropes applied at the origin of the coordinate system (let's say it's a box). The resultant force between these tensions (which are vector quantities) can be found by determining the respective x- and y-components of the given vectors.

Figure 2.14

From the diagram, we see that

$$A_x = 5\cos 25 = 4.53\text{ N} \qquad \text{and} \qquad A_y = 5\sin 25 = 2.11\text{ N}$$

For the second vector, we have

$$B_x = -10\cos 45 = 10\cos 135 = -7.07\text{ N (Negative since it is pointing left)}$$

$$B_y = 10\sin 45 = 10\sin 135 = 7.07\text{ N (Positive since it is pointing right)}$$

Therefore,

$$C_x = 4.53\text{ N} - 7.07\text{ N} = -2.54\text{ N} \qquad \text{and} \qquad C_y = 2.11\text{ N} + 7.07\text{ N} = 9.18\text{ N}$$

The magnitude of the resultant vector, **C**, is given by

$$|\mathbf{C}| = \sqrt{(-2.54)^2 + (9.18)^2} = 9.52\text{ N}$$

The angle that vector **C** makes with the positive x-axis is about 105°.

"Tip-to-Tail" method:

SUMMARY

- Vectors are quantities that have both magnitude (size) and direction.
- Vectors can be resolved into components that represent the magnitude and direction of a vector along a particular axis.
- Scalars are quantities that have only magnitude.
- Force, displacement, and velocity are examples of vectors.
- Distance, speed, and mass are examples of scalars.
- Vectors can be "added" geometrically by the "tip to tail" method.
- The resultant of two vectors is equal to the vector obtained by "adding" them.

- If two vectors are in the same direction, their resultant is equal to the sum of their magnitudes.
- If two vectors are in the opposite direction, their resultant is equal to the difference of their magnitudes.

Problem-Solving Strategies for Vectors

When solving a vector problem, be sure to:

1. Understand the frame of reference for the situation.
2. Select an appropriate coordinate system for the situation. Cartesian systems do not necessarily have to be vertical and horizontal (a mass sliding down an inclined plane is an example of a rotated system with the "x-axis" parallel to the incline).
3. Pick an appropriate scale for starting your vector diagram. For example, in a problem with displacement, a scale of 1 cm = 1 m might be appropriate.
4. Recognize the given orientation of the vectors as they correspond to geographical directions (N, E, S, W). Be sure to maintain the same directions as you draw your vector triangle.
5. Connect vectors head to tail, and connect the resultant from the tail of the first vector to the head of the last vector.
6. Identify and determine the components of the vectors. In most cases, vector problems can be simplified using components.

PRACTICE EXERCISES

Multiple-Choice

1. A vector is given by its components, $A_x = 2.5$ and $A_y = 7.5$. What angle does vector **A** make with the positive x-axis?

 (A) 72°
 (B) 18°
 (C) 25°
 (D) 50°

2. Which pair of vectors could produce a resultant of 35?

 (A) 15 and 15
 (B) 20 and 20
 (C) 30 and 70
 (D) 20 and 60

3. A vector has a magnitude of 17 units and makes an angle of 20° with the positive x-axis. The magnitude of the horizontal component of this vector is

 (A) 16 units
 (B) 4.1 units
 (C) 5.8 units
 (D) 50 units

4. As the angle between a given vector and the horizontal axis increases from 0° to 90°, the magnitude of the vertical component of this vector

(A) decreases
(B) increases and then decreases
(C) decreases and then increases
(D) increases

5. Vector **A** has a magnitude of 10 units and makes an angle of 30° with the horizontal *x*-axis. Vector **B** has a magnitude of 25 units and makes an angle of 50° with the negative *x*-axis. What is the magnitude of the resultant between these two vectors?

(A) 20
(B) 35
(C) 15
(D) 25

6. Two concurrent vectors have magnitudes of 3 units and 8 units. The difference between these vectors is 8 units. The angle between these two vectors is

(A) 34°
(B) 56°
(C) 79°
(D) 113°

7. Which of the following sets of displacements have equal resultants when performed in the order given?

 I: 6 m east, 9 m north, 12 m west
 II: 6 m north, 9 m west, 12 m east
 III: 6 m east, 12 m west, 9 m north
 IV: 9 m north, 6 m east, 12 m west

(A) I and IV
(B) I and II
(C) I, III, and IV
(D) I, II, IV

8. Which vector represents the direction of the two concurrent vectors shown below?

9. Three forces act concurrently on a point *P* as shown below. Which vector represents the direction of the resultant force on point *P*?

(A) (B) (C) (D)

10. On a baseball field, first base is about 30 m away from home plate. A batter gets a "hit" and runs toward first base. She runs 3 m past the base and then runs back to stand on it. The magnitude of her final displacement from home plate is

(A) 27 m
(B) 30 m
(C) 33 m
(D) 36 m

Free-Response

1. Find the magnitude and direction of the two concurrent forces shown below using the algebraic method of components.

Note: Figure is not drawn to scale.

2. Two vectors, **A** and **B**, are concurrent and attached at the tails with an angle θ between them. Given that each vector has components A_x, A_y and B_x, B_y, respectively, use the law of cosines to show that

$$\cos\theta = \frac{A_x B_x + A_y B_y}{|\mathbf{A}||\mathbf{B}|}$$

3. Give a geometric explanation for the following statement: "Three vectors that add up to zero must be coplanar (that is, they must all lie in the same plane)."

4. (a) Is it necessary to specify a coordinate system when adding to vectors?

 (b) Is it necessary to specify a coordinate system when forming the components of a vector?

5. Can a vector have zero magnitude if one of its components is nonzero?

ANSWERS EXPLAINED

Multiple-Choice Problems

1. **(A)** The angle for the vector to the positive x-axis is given by

$$\tan\theta = \frac{A_y}{A_x} = \frac{7.5}{2.5}$$

Thus $\tan\theta = 3$ and $\theta = 71.5°$ or, rounded off, 72°.

2. **(B)** Two vectors have a maximum resultant, whose magnitude is equal to the numerical sum of the vector magnitudes, when the angle between vectors is 0°. The resultant is a minimum at 180°, and the magnitude is equal to the numerical difference between the magnitudes. When this logic is used, only pair (20, 20) produce a maximum and minimum set that could include the given value of 35 if the angle were specified. All the others have maximum and minimum resultants that do not include 35 in their range.

3. **(A)** The formula for the horizontal component of a vector **A** is $A_x = |\mathbf{A}|\cos\theta$, where $|\mathbf{A}|$ is the magnitude of **A**. When the known values are used, values $A_x = 17\cos 20 = 15.9$ units.

4. **(D)** The vertical component of a vector is proportional to the sine of the angle, which increases to a maximum at 90°.

5. **(D)** Form the components of each vector and then add these components, remembering the sign conventions; right and up are positive values. Thus, we have $A_x = 10\cos 30 = 8.66$ and $A_y = 10\sin 30 = 5$, $B_x = -25\cos 50 = -16.06$ and $B_y = 25\sin 50 = 19.15$.

The components of the resultant are $C_x = A_x + B_x = 8.66 - 16.06$, so $C_x = -7.4$ units and $C_y = A_y + B_y = 5 + 19.15 = 24.15$. The magnitude of this resultant vector is given by

$$|\mathbf{C}| = \sqrt{C_x^2 + C_y^2} = \sqrt{(7.4)^2 + (24.15)^2}$$

implying that **C** = 25 units.

6. **(C)** Use the law of cosines where $a = 3$, $b = 8$, and $c = 8$, and solve for $\cos\theta$:

$$(8)^2 = (3)^2 + (8)^2 - 2(3)(8)\cos\theta$$

Solving gives $\cos\theta = 0.1875$ and $\theta = 79°$.

7. **(C)** Vectors can be added in any order. The only requirement is that the vectors have the same magnitude and direction as they are shuffled. A look at the four sets of displacements indicates that I, III, and IV consist of the same vectors listed in different orders. These three sets will produce the same resultant.

8. **(C)** Sketch the vectors head to tail as if forming a vector triangle in construction. The resultant is drawn from the tail of the first vector to the head of the second. Choose the horizontal vector as the first one; then choice C is the general direction of the resultant.

9. **(B)** Sketch the vectors in any order, as shown below. Draw the resultant from the tail of the first vector to the head of the last.

10. **(B)** The displacement is in the direction of first base and is equal in magnitude to the straight-line distance between home plate and first base (30 m).

Free-Response Problems

1. Let $\mathbf{A} = 10$ N force and $\mathbf{B} = 20$ N force

 We declare left to be negative and up to be positive.

 From the diagram, the components are:

 $$A_x = 10\text{ N}\cos 30° = 8.66\text{ N} \qquad B_x = -20\text{ N}\cos 60° = -10\text{ N}$$

 $$A_y = 10\text{ N}\sin 30° = 5\text{ N} \qquad B_y = 20\text{ N}\sin 60° = 17.32\text{ N}$$

 The components of the resultant are now given by the following equations. Watch your signs!

 $$R_x = A_x + B_x = 8.66\text{ N} + (-10\text{ N}) = -1.34\text{ N}$$

 $$R_y = A_y + B_y = 5\text{ N} + 17.32\text{ N} = 22.32\text{ N}$$

 Use the Pythagorean theorem to find the magnitude of the resultant:

 $$|\mathbf{R}|^2 = (-1.34\text{ N})^2 + (22.32\text{ N})^2$$

 $$|\mathbf{R}| = 22.36\text{ N}$$

To find the direction, notice that the resultant will lie in the second quadrant since R_x is negative and R_y is positive:

$$\tan\theta = \frac{22.32 \text{ N}}{-1.34 \text{ N}} = -16.66$$

$$\theta = 86.6° \text{ (relative to the } x\text{-axis)}$$

2. The situation is shown below. The "third" side of the vector triangle is $\mathbf{A} - \mathbf{B}$.

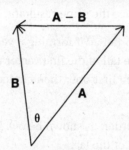

From the rules for vector subtraction, the components of $\mathbf{A} - \mathbf{B}$ are $(A_x - B_y)$ and $(A_y - B_y)$. The law of cosines states that, for the given triangle,

$$|\mathbf{A} - \mathbf{B}|^2 = |\mathbf{A}|^2 + |\mathbf{B}|^2 - 2|\mathbf{A}||\mathbf{B}|\cos\theta$$

Using our definitions of magnitudes and components, we have

$$(A_x - B_x)^2 = (A_y - B_y)^2 = A_x^2 + A_y^2 + B_x^2 + B_y^2 - 2|\mathbf{A}||\mathbf{B}|\cos\theta$$

Expanding the left side and canceling like terms on both sides, we are left with

$$-2A_x B_x - 2A_y B_y = -2|\mathbf{A}||\mathbf{B}|\cos\theta$$

Again, canceling like terms on both sides leaves us with the final expression as we solve for $\cos\theta$:

$$\cos\theta = \frac{A_x B_x + A_y B_y}{|\mathbf{A}||\mathbf{B}|}$$

3. Any two vectors can be added geometrically using the parallelogram method of construction. A parallelogram is a plane figure. The resultant of two vectors is represented by the diagonal of this parallelogram. In order for three vectors to add up to zero, the third remaining vector must be equal in magnitude, but opposite in direction, to the resultant of the remaining two vectors. Hence, all three must lie in the same plane to achieve this result.

4. (a) Using the logic of problem 3, any two vectors can be added by simply constructing a parallelogram from them. They can be in any orientation and in any plane. Hence, no coordinate system is necessary.

 (b) The components of a vector, by definition, lie along the axes of a chosen coordinate system (such as the x- or y-axis). Hence, to form these components, a coordinate system must be specified.

5. The magnitude of a vector is a number obtained by taking the square root of the sum of the squares of the magnitudes of its components. If one of the components is nonzero, the magnitude of the whole vector must, by definition, be nonzero as well.

Kinematics

<div style="text-align: right;">**3**</div>

KEY CONCEPTS
→ **AVERAGE AND INSTANTANEOUS MOTION**
→ **ACCELERATION**
→ **ACCELERATED MOTION DUE TO GRAVITY**
→ **GRAPHICAL ANALYSIS OF MOTION**
→ **RELATIVE MOTION**
→ **HORIZONTALLY LAUNCHED PROJECTILES**
→ **PROJECTILES LAUNCHED AT AN ANGLE**
→ **UNIFORM CIRCULAR MOTION**

Motion involves the change in position of an object over time. When we observe an object moving, it is always with respect to a frame of reference. Since descriptions of motion have both magnitude *and* direction, there is a vector nature to motion that must be taken into account when we want to analyze how something moves.

In this chapter, we shall confine our discussions to motion in one dimension only. In physics, the study of motion is called **kinematics**. Kinematics is a completely descriptive study of *how* something moves.

AVERAGE AND INSTANTANEOUS MOTION

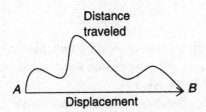

Figure 3.1

TIP
Distance is a scalar quantity, while displacement is a vector quantity.

If, in Figure 3.1, we consider the actual distance traveled by the object along some arbitrary path, we are dealing with a scalar quantity. The **displacement vector AB**, however, is directed along the line connecting points *A* and *B* (whether or not this is the actual route taken). Thus, when a baseball player hits a home run and runs around the bases, he or she may have traveled a distance of 360 feet (the bases are 90 feet apart), but the player's final displacement is zero (having started and ended up at the same place)!

If we are given the displacement vector of an object for a period of time Δt, we define the **average velocity**, \bar{v}, to be equal to

$$\bar{v} = \frac{\Delta x}{\Delta t}$$

This is a vector quantity since directions are specified. Numerically, we think of the average speed as being the ratio of the total distance traveled to the total elapsed time. The units of velocity are meters per second (m/s).

If we are interested in the velocity at any instant in time, we can define the **instantaneous velocity** to be the velocity, **v**, as determined at any precise instant in time. In a car, the speedometer registers instantaneous speed, which can become velocity if we take into account the direction of motion. If the velocity is constant, the average and instantaneous velocities are equal, and we can write simply

$$x = v\Delta t$$

Note that if we were to graph time on the x-axis and displacement on the y-axis, the slope would be velocity!

TIP

Speed is a scalar quantity while velocity is a vector quantity.

Figure 3.2

If an object is moving with a constant velocity such that its position is taken to be zero when it is first observed, a graph of the expression $x = vt$ would represent a direct relationship between position and time (see Figure 3.2).

Since the line is straight, the constant slope (in which $v = \Delta x/\Delta t$) indicates that the velocity is constant throughout the time interval. If we were to plot velocity versus time for this motion, the graph might look like Figure 3.3.

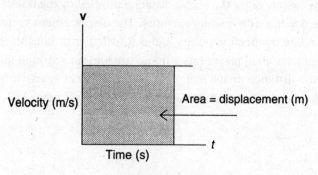

Figure 3.3

Notice that, for any time interval t, the area under the graph equals the displacement during that interval.

ACCELERATION

Velocity will change if either speed or direction changes. In any case, if the velocity is changing, we say that the object is **accelerating**. If the velocity is changing uniformly, the object has uniform acceleration. In this case, a graph of velocity versus time would look like Figure 3.4. Note that in Figure 3.3, the slope of the graph is zero. This makes sense since if the velocity is constant, acceleration is zero.

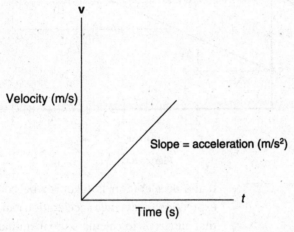

Figure 3.4

The displacement from $t = 0$ to any other time is equal to the area of the triangle formed. However, between any two intermediary times, the resulting figure is a trapezoid. If we make several measurements, the displacement versus time graph for uniformly accelerated motion is a parabola starting from the origin (if we make the initial conditions that, when $t = 0$, $x = 0$, and $\mathbf{v} = 0$; see Figure 3.5).

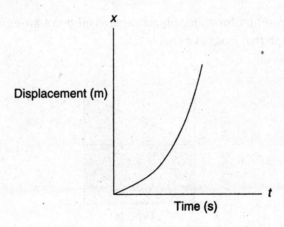

Figure 3.5

The slope of the velocity versus time graph is defined to be the average acceleration in units of meters per second squared (m/s²). We can now write, for the average acceleration (Figure 3.6)

$$\bar{a} = \frac{\Delta v}{\Delta t}$$

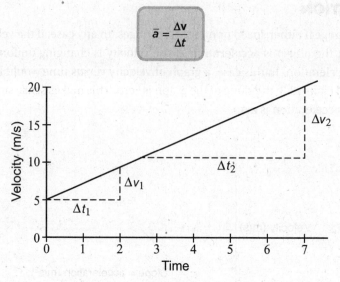

Figure 3.6

If the acceleration is taken to be constant in time, our expression for average acceleration can be written in a form that allows us to calculate the instantaneous final velocity after a period of acceleration has taken place. In other words, $\Delta v = at$ (if we start our time interval from zero). If we define Δv to be equal to the difference between an initial and a final velocity, we can arrive at the fact that

$$v_f = v_i + at$$

If we plot velocity versus time for uniformly accelerated motion starting with a nonzero initial velocity, we get a graph that looks like Figure 3.7.

Figure 3.7

The displacement during any period of time will be equal to the total area under the graph. In this case, the total area will be the sum of two areas, one a triangle and the other a rectangle. The area of the rectangle, for some time t, is just $v_i t$. The area of the triangle is one-half the base times the height. The "base" in this case is the time period, t, the "height" is the change in velocity, Δv. Therefore, the area of the triangle is $(1/2)\Delta vt$. If we recall the definition of Δv and the fact that $v_f = v_i + at$, we obtain the following formula for the displacement during uniformly accelerated motion starting with an initial velocity:

$$x = v_i t + \frac{1}{2}at^2$$

This analysis suggests an alternative method of determining the average velocity of an object during uniformly accelerated motion. The area under the flat line halfway between v_i and v_f will be the same as in Figure 3.7.

Therefore, we can simply write

$$\bar{v} = \frac{v_i + v_f}{2} = v_{average}$$

Since the above equation relates the average velocity to the initial and final velocities (for uniformly accelerated motion), we can write our displacement formula as

$$x = \frac{v_i + v_f}{2}t = \left(v_{average}\right)t$$

Occasionally, a problem in kinematics does not explicitly mention the time involved. For this reason it would be nice to have a formula for velocity that does not involve the time factor. We can derive one from all the other formulas.

Now, since $v_f = v_i + at$, we can express the time as $t = (v_f - v_i)/a$. Therefore

$$x = \left(\frac{v_i + v_f}{2}\right)\left(\frac{v_f - v_i}{a}\right)$$

$$x = \left(\frac{v_f^2 - v_i^2}{2a}\right)$$

A particle accelerates from rest at a uniform rate of 3 m/s² for a distance of 200 m. How fast is the particle going at that time? How long did it take for the particle to reach that velocity?

Solution

We use the formula

$$v_f^2 - v_i^2 = 2ax$$

Since the particle begins from rest, the initial velocity is equal to zero and

$$v_f^2 = 2(3 \text{ m/s}^2)(200 \text{ m})$$

$$v_f = 34.64 \text{ m/s}$$

To find the time, we use $v = at$

$$t = \frac{34.64 \text{ m/s}}{3 \text{ m/s}^2} = 11.55 \text{ s}$$

ACCELERATED MOTION DUE TO GRAVITY

Since velocity and acceleration are vector quantities, we need to consider the algebraic conventions accepted for dealing with various directions. For example, we usually agree to consider motion up or to the right as positive, and motion down or to the left as negative. Note that negative velocity means motion to the left (or down) and does not imply the object is slowing down. Likewise, negative acceleration means velocity is changing in the negative direction and does not imply the object is slowing down. When people say an object is decelerating, they do mean the object is slowing down. That can happen in two different ways. First, an object with positive velocity can slow down with a negative acceleration. Second, an object with a negative velocity can slow down with a positive acceleration. The general rule is that if the velocity and acceleration are pointed in the same direction, the object speeds up. However, if they are in opposite directions, the object slows down. (Acceleration at a right angle to velocity makes an object change direction.)

"Slowing down" "Speeding up" "Turning"

Gravity provides a constant downward acceleration. The value of gravity on Earth is commonly represented by the symbol **g** to stand in for 9.8 m/s/s. Note that an object going upward will be slowed down by gravity, while a downward moving object is sped up by gravity. A sideways-moving object will turn toward the ground! An object undergoing acceleration due to gravity and gravity alone (with no other forces) is referred to as being in "free fall." This is true regardless of whether the object is moving vertically up or down. Free fall is also called "projectile motion" if the object is also moving sideways while under the influence of gravity.

Choosing up as positive and down as negative for all three kinematic vectors (displacement, velocity, and acceleration) will provide consistent results for vertical velocities and vertical displacements:

> Students often forget that there is still gravitational acceleration even at the top of a projectile's path! The acceleration vector never changes during free fall.

$$V_f = v_i + at \quad \text{becomes} \quad v_f = v_i - gt \quad \text{since } a = -g$$

Using Δy to represent the vertical displacement:

$$\Delta y = v_i + \frac{1}{2}at^2 \quad \text{becomes} \quad \Delta y = v_i - \frac{1}{2}gt^2$$

Note that if an object is dropped or falls, $v_i = 0$. All subsequent displacements and velocities are negative since all motion is downward in those cases. If an object is thrown upward, v_i is positive. If an object is thrown downward, v_i is negative.

A projectile is fired vertically upward at an initial velocity of +98 m/s. How high will it rise? How long will it take the projectile to reach that height?

Solution

We use $a = -9.8$ m/s$^2$ (recall gravity's direction is downward) and note that $v_{fy} = 0$ at the highest point:

$$v_{fy}^2 - v_{iy}^2 = 2ay$$

$$-(98 \text{ m/s})^2 = -2(9.8 \text{ m/s}^2)y_{max}$$

$$y_{max} = 490 \text{ m}$$

To find the time, we use

$$v = at$$

$$t = \frac{-98 \text{ m/s}}{-9.8 \text{ m/s}^2} = 10 \text{ s}$$

GRAPHICAL ANALYSIS OF MOTION

We have seen that much information can be obtained if we consider the graphical analysis of motion. If complex changes in motion are taking place, visualization may provide a better understanding of the physics involved than algebra. The techniques of graphical analysis are as simple as slopes and areas. For example, we already know that, for uniformly accelerated motion, the graph of distance versus time is a parabola. Since the slope is changing, the instantaneous velocity can be approximated at a point **P** by finding the slope of a tangent line drawn to a given point on the curve (see Figure 3.8).

Figure 3.8

What would happen if an object accelerated from rest maintained a constant velocity for a while, and then slowed down to a stop? Using what we know about graphs of velocity and acceleration in displacement versus time, we might represent the motion as shown in Figure 3.9.

Figure 3.9

We can apply many instances of motion to graphs. In the case of changing velocity, consider the graph of velocity versus time for an object thrown upward into the air, reaching its highest point, changing direction, and then accelerating downward. This motion has a constant downward acceleration that, at first, acts to slow the object down, but later acts to speed it up. A graph of this motion is seen in Figure 3.10.

Figure 3.10

Figure 3.10a shows the parabolic nature of $\Delta y = v_i t - \frac{1}{2}gt^2$.

Figure 3.10b shows the linear nature of $v_f = v_i - gt$.

A ball is thrown straight up into the air and, after being in the air for 9 s, is caught by a person 5 m above the ground. To what maximum height did the ball go?

Solution

The equation

$$y = v_i t - \frac{1}{2} g t^2$$

represents the vertical position of the ball above the ground for any time t. Since the ball is thrown upward, the initial velocity is positive, while the acceleration of gravity is always directed downward (and hence is algebraically negative). Thus, we can use the above equation to find the initial velocity when $y = 5$ m and $t = 9$ s. Substituting these values, as well as the magnitude of g (9.8 m/s²) in the equation, we get $v_i = 44.65$ m/s.

Now, to find the maximum height, we note that, when the ball rises to its maximum, its speed becomes zero since its velocity is changing direction. Since we do not know how long the ball takes to rise to its maximum height (we could determine this value if desired), we can use the formula

$$v_f^2 - v_i^2 = -2gy$$

When the final velocity equals zero, the value of y is equal to the maximum height. Using our answer for the initial velocity and the known value of g, we find that $y_{max} = 101.7$ m.

RELATIVE MOTION

All measurements are relative. Specifically, all measurements, including velocity, are made with respect to some reference point or object. Just as vectors are all relative to a specific coordinate system, all velocities are too. When we describe a car as moving at 55 mph, what we really mean is 55 mph relative to Earth's surface. The rules of vector addition provide us with a means by which to translate one relative velocity to another.

An example of this type of motion can be seen when a boat trying to cross a river or an airplane meeting a crosswind is considered. In the case of the boat, its velocity, relative to the river, is based on the properties of the engine and is measured by the speedometer on board. However, to a person on the shore, its **relative velocity** (or effective velocity) is different from what the speedometer in the boat may report. In Figure 3.11, we see such a situation with the river moving to the right at 4 meters per second and the boat moving relative to the water at 10 meters per second. If you like, we can call to the right "eastward" and up the page "northward."

Figure 3.11

By vector methods, the resultant velocity relative to the shore is given by the Pythagorean theorem. The direction is found by means of a simple sketch (Figure 3.12) connecting the vectors head to tail to preserve the proper orientation. Numerically, we can use trigonometry.

Figure 3.12

The resultant velocity is 10.5 meters per second at an angle of 22 degrees east of north.

HORIZONTALLY LAUNCHED PROJECTILES

If you roll a ball off a smooth table, you will observe that it does not fall straight down. With trial and error, you might observe that how far it falls will depend on how fast it is moving forward. Initially, however, the ball has no vertical velocity. The ability to "fall" is given by gravity, and the acceleration due to gravity is –9.8 meters per second squared. Since gravity acts vertically and the initial velocity is horizontal, the two motions are simultaneous and independent. Galileo demonstrated that the trajectory characterized by constant horizontal velocity and constant vertical acceleration is a parabola.

We know that the distance fallen by a mass dropped from rest is given by the equation

$$\Delta y = v_{iy}t + \frac{1}{2}a_y t^2 = \frac{1}{2}gt^2$$

since $v_{iy} = 0$ and $a_y = g$

Since the ball that rolled off the table is moving horizontally, with some initial constant velocity, it covers a distance, x, called the **range**:

$$\Delta x = v_{ix}t + \frac{1}{2}a_x t^2 = v_{ix}t$$

Since the time is the same for both motions, we can first solve for the time, using the x equation, and then substitute it into the y equation. In other words, y as a function of x is easily shown to be

$$\Delta y = \frac{1}{2}gt^2 = \frac{1}{2}g\left(\Delta x/v_{ix}\right)^2 = g\Delta x^2/\left(2v_{ix}^2\right)$$

since $a_x = 0$

which is of course the equation of a parabola. This equation of y in terms of x is called the **trajectory** of the projectile, while the two separate equations for x and y as functions of time are called **parametric equations**. Figure 3.13 illustrates this trajectory as well as a position vector **R**, which locates a point at any given time in space.

Figure 3.13

If the height from which a projectile is launched is known, the time to fall can be calculated from the equation for free fall. For example, if the height is 49 m, the time to fall is 3.16 s. If the horizontal velocity is 10 m/s, the maximum range will be 31.6 m.

$$\Delta y = \frac{1}{2}gt^2$$

$$49 = \frac{1}{2}(9.8)t^2$$

$$t = 3.2 \text{ s}$$

$$\Delta x = v_{ix}t = 10(3.2) = 32 \text{ m}$$

A projectile is launched horizontally from a height of 25 m, and it is observed to land 50 m from the base. What was the launch velocity?

Solution

We know that the vertical motion is independent of the horizontal motion. Thus, we can find the time that the projectile is in the air using:

$$d = \frac{1}{2}at^2$$

solving for t we get

$$t = 2.26 \text{ s}$$

Now, since $x = v_x t$, we see that $v_x = \dfrac{50 \text{ m}}{2.26 \text{ s}} = 22.12 \text{ m/s}$

PROJECTILES LAUNCHED AT AN ANGLE

Suppose that a rocket on the ground is launched with some initial velocity at some angle θ. The vector nature of velocity allows us to immediately write the equations for the horizontal and vertical components of initial velocity:

$$\mathbf{v}_{ix} = v \cos θ \text{ and } \mathbf{v}_{iy} = v \sin θ$$

Since each motion is independent, we can consider the fact that, in the absence of friction, the horizontal velocity will be constant while the y velocity will decrease as the rocket rises. When the rocket reaches its maximum height, its vertical velocity will be zero; then gravity will accelerate the rocket back down. It will continue to move forward at a constant rate. How long will the rocket take to reach its maximum height? From the definition of acceleration and the equations in Chapter 3, we know that this will be the time needed for gravity to decelerate the vertical velocity to zero, that is,

$$v_y = v_{iy} + at$$

$$0 = v_{iy} - gt_{up}$$

$$t_{up} = \frac{v_{iy}}{g}$$

The total time of flight will be just twice this time. Therefore, the range is the product of the initial horizontal velocity (which is constant) and the total time. In other words,

$R = \text{Range} = v_{ix}(2t_{up}) = 2v \cos θ t_{up} = 2v \cos θ (v \sin θ/g)$
$= 2v^2 \cos θ \sin θ/g$

REMEMBER

When a projectile is launched at an angle, the vertical velocity component is equal to zero at the maximum height. Additionally, for a given launch velocity, the maximum range occurs when the launch angle is equal to 45°.

Since the vertical motion is independent of the horizontal motion, the changes in vertical height are given one dimensionally as

$$\Delta y = v_{iy}t - \frac{1}{2}gt^2$$

If we want to know the maximum height achieved, we simply use the value for the time to reach the highest point. The trajectory is seen in Figure 3.14 for a baseball being hit.

Figure 3.14

As an example, if a projectile is launched with an initial velocity of 100 m/s at an angle of 30°, the maximum range will be equal to 883.7 m. To find the maximum height, we could first find the time required to reach that height, but a little algebra will give us a formula for the maximum height independent of time. The maximum height can also be expressed as

$$\Delta y = v_{iy}t + \frac{1}{2}at^2$$

$$\Delta y_{max} = v_{iy}t_{up} - \frac{1}{2}g(t_{up})^2$$

$$= \frac{1}{2}\frac{v_{iy}^2}{g}$$

Using the known numbers, we find that the maximum height reached is 127.55 m.

SAMPLE PROBLEM

A projectile is launched from the ground at a 40° angle with a velocity of 150 m/s. Calculate the maximum height of the projectile.

Solution

From trigonometry, we know that $v_{iy} = v_o \sin\theta$. Thus,

$$v_{iy} = (150 \text{ m/s}) \sin(40°) = 96 \text{ m/s}$$

Now, at the maximum height, the vertical velocity is equal to zero, and the acceleration is g:

$$v_{fy}^2 - v_{iy}^2 = -2gy$$

$$y_{max} = \frac{v_{iy}^2}{2g} = \frac{96 \text{ m}^2/\text{s}^2}{19.6 \text{ m/s}^2} = 474 \text{ m}$$

UNIFORM CIRCULAR MOTION

Velocity is a vector. To change a velocity's direction simply requires an acceleration since change in direction is a change in the vector. An acceleration directed perpendicularly to the velocity will change the direction of the velocity in the direction of the acceleration. When the direction is the only quantity changing, as the result of a centrally directed deflecting force, the result is uniform circular motion. We consider here an object already undergoing periodic, uniform circular motion. By this description we mean that the object maintains a constant speed as it revolves around a circle of radius R, in a period of time T. The number of revolutions per second is called the **frequency**, f. This is illustrated in Figure 3.15.

Figure 3.15

The direction of the acceleration is toward the center and is called the **centripetal acceleration**. The magnitude of the centripetal acceleration is given by two formulas:

$$a_c = \frac{v^2}{r}$$

Recalling that the circumference of a circle is $2\pi r$, the speed must be:

$$V = \frac{2\pi r}{T} \text{ for uniform circular motion}$$

$$T = \frac{1}{f}$$

$$a_c = \frac{4\pi^2 r}{T^2}$$

A 5-kg mass is undergoing uniform circular motion with a constant speed of 10 m/s in a circle of radius 2 m. Calculate the centripetal acceleration of the mass.

Solution

We use the formula

$$a_c = \frac{v^2}{R} = \frac{(10 \text{ m/s})^2}{2 \text{ m}} = 50 \text{ m/s}^2$$

SUMMARY

- Displacement, velocity, and acceleration are all vectors.
- Distance, speed, and time are scalars.
- Kinematics is a description of motion.
- Velocity is defined to be equal to the rate of change of displacement.
- Acceleration is defined to be equal to the rate of change of velocity.
- Velocity is the slope of a displacement versus time graph.
- Acceleration is the slope of a velocity versus time graph.
- The displacement can be obtained from a velocity versus time graph by taking the area under the graph.
- The acceleration due to gravity, near the surface of Earth, is equal to $g = 9.8 \text{ m/s}^2$ and is directed downward. This is the only acceleration in free fall and projectile motion problems.
- The relative velocity can be found by vector addition of the individual velocity vectors.
- When a projectile is launched, in the absence of air resistance, the horizontal motion is independent of the vertical motion.
- The vertical and horizontal components of the launch velocity can be obtained using trigonometry. The regular kinematics equations can then be used for each direction.
- If an object is moving in a circle, then the object has an acceleration acting toward the center called the centripetal acceleration.

Problem-Solving Strategies for Motion Problems

Since all motion is relative, it is very important to always ask yourself the following question: "From what frame of reference am I viewing the situation?" Also, whenever you solve a physics problem, be sure to consider the assumptions being made, explicitly or implicitly, about the moving object or objects. In this way, your ability to keep track of what is relevant for your solution path will be maintained. In addition, it is suggested that you:

1. Identify all the goals and givens in the problem. Recall from the Introduction that the goals may be explicit or implicit. If a question is based on a decision or prediction, be sure to understand the algebraic requirements necessary to reach an answer.

2. Consider the "meaningfulness" of your solution or process. Does your answer or methodology make sense?

3. Choose a proper coordinate system and remember the sign conventions for algebraically treating vector quantities. In addition, make sure you understand the nature of the concepts being discussed (for example, whether they are vectors or scalars).

4. Use proper SI units throughout your calculations, and make sure that correct units are included in your final answer. Try "dimensional analysis" to see whether the answer makes sense. Perhaps it looks too large or too small because it is expressed in the wrong units.

5. Make a sketch of the situation if one is not provided.

6. If you are interpreting a graph, be sure you understand the interrelationships among all the kinematic variables discussed (slopes, areas, etc.).

7. If you are constructing a graph, label both axes completely, choose a proper scale for each axis, and draw neatly and clearly.

8. Try different problem-solving heuristics if you get stuck on a difficult problem.

9. Remember to break vectors into components first if the problem is two dimensional.

PRACTICE EXERCISES

Multiple-Choice

1. A ball is thrown upward with an initial velocity of 20 m/s. How long will the ball take to reach its maximum height?

 (A) 19.6 s
 (B) 9.8 s
 (C) 6.3 s
 (D) 2.04 s

2. An airplane lands on a runway with a velocity of 150 m/s. How far will it travel until it stops if its rate of deceleration is constant at -3 m/s$^2$?

 (A) 525 m
 (B) 3,750 m
 (C) 6,235 m
 (D) 9,813 m

3. A ball is thrown downward from the top of a roof with a speed of 25 m/s. After 2 s, its velocity will be

 (A) 19.6 m/s
 (B) -5.4 m/s
 (C) -44.6 m/s
 (D) 44.6 m/s

4. A rocket is propelled upward with an acceleration of 25 m/s² for 5 s. After that time, the engine is shut off, and the rocket continues to move upward. The maximum height, in meters, that the rocket will reach is

(A) 900

(B) 1,000

(C) 1,100

(D) 1,200

Questions 5–7 refer to the velocity versus time graph shown below.

5. The total distance traveled by the object during the indicated 14 s is

(A) 7.5 m

(B) 25 m

(C) 62.5 m

(D) 77.5 m

6. The total displacement of the object during the 14 s indicated is

(A) 7.5 m

(B) 25 m

(C) 62.5 m

(D) 77.5 m

7. The average velocity, in meters per second, of the object is

(A) 0

(B) 0.5

(C) 2.5

(D) 4.5

8. What is the total change in velocity for the object whose acceleration versus time graph is given below?

(A) 40 m/s

(B) −40 m/s

(C) 80 m/s

(D) −80 m/s

9. An object has an initial velocity of 15 m/s. How long must it accelerate at a constant rate of 3 m/s$^2$ before its average velocity is equal to twice its initial velocity?

(A) 5 s

(B) 10 s

(C) 15 s

(D) 20 s

10. A projectile is launched at an angle of 45° with a velocity of 250 m/s. If air resistance is neglected, the magnitude of the horizontal velocity of the projectile at the time it reaches maximum altitude is equal to

(A) 0 m/s

(B) 175 m/s

(C) 200 m/s

(D) 250 m/s

11. A projectile is launched horizontally with a velocity of 25 m/s from the top of a 75-m height. How many seconds will the projectile take to reach the bottom?

(A) 15.5

(B) 9.75

(C) 6.31

(D) 3.91

12. At a launch angle of 45°, the range of a launched projectile is given by

(A) $\dfrac{v_i^2}{g}$

(B) $\dfrac{2v_i^2}{g}$

(C) $\dfrac{v_i^2}{2g}$

(D) $\sqrt{\dfrac{v_i^2}{2g}}$

13. A projectile is launched at a certain angle. After 4 s, it hits the top of a building 500 m away. The height of the building is 50 m. The projectile was launched at an angle of

(A) 14°
(B) 21°
(C) 37°
(D) 76°

14. The operator of a boat wishes to cross a 5-km-wide river that is flowing to the east at 10 m/s. He wishes to reach the exact point on the opposite shore 15 min after starting. With what speed and in what direction should the boat travel?

(A) 11.2 m/s at 26.6° E of N
(B) 8.66 m/s at 63.4° W of N
(C) 11.4 m/s at 60.9° W of N
(D) 8.66 m/s at 26.6° E of N

Free-Response

1. A particle has the acceleration versus time graph shown below:

If the particle begins its motion at $t = 0$, with $v = 0$ and $x = 0$, make a graph of velocity versus time.

2. A stone is dropped from a 75-m-high building. When this stone has dropped 15 m, a second stone is thrown downward with an initial velocity such that the two stones hit the ground at the same time. What was the initial velocity of the second stone?

3. A particle is moving in one dimension along the x-axis. The position of the particle is given, for any time, by the following position function:

$$x(t) = 3t^2 + 2$$

(a) Evaluate the average velocity of the particle starting at $t = 2$ s for $\Delta t = 1, 0.5, 0.2, 0.1, 0.01, 0.001$ second.
(b) Interpret the physical meaning of your results for part (a).

4. A stone is dropped from a height h and falls the last half of its distance in 4 seconds. (a) What was the total time of fall? (b) From what height was the stone dropped?

5. If the average velocity of an object is nonzero, does this mean that the instantaneous velocity of the object can never be zero? Explain.

6. A girl standing on top of a roof throws a stone into the air with a velocity $+\mathbf{v}$. She then throws a similar stone directly downward with a velocity $-\mathbf{v}$. Compare the velocities of both stones when they reach the ground.

7. Explain how it is possible for an object to have zero average velocity and still have nonzero average speed.

8. A mass attached to a string is twirled overhead in a horizontal circle of radius R every 0.3 s. The path is directly 0.5 m above the ground. When released, the mass lands 2.6 m away. What was the velocity of the mass when it was released and what was the radius of the circular path?

9. A football quarterback throws a pass to a receiver at an angle of 25 degrees to the horizontal and at an initial velocity of 25 m/s. The receiver is initially at rest 30 m from the quarterback. The instant the ball is thrown, the receiver runs at a constant velocity to catch the pass. In what direction and at what speed should he run?

10. A car is moving in a straight line with velocity \mathbf{v}. Raindrops are falling vertically downward with a constant terminal velocity \mathbf{u}. At what angle does the driver think the drops are hitting the car's windshield? Explain.

ANSWERS EXPLAINED
Multiple-Choice Problems

1. (**D**) Given the initial velocity of 20 m/s, we know that the ball is decelerated by gravity at a rate of 9.8 m/s$^2$. Therefore, we need to know how long gravity will take to decelerate the ball to zero velocity. Clearly, from the definition of acceleration, dividing 20 m/s by 9.8 m/s$^2$ gives the answer: 2.04 s.

2. (**B**) We do not know the time needed to stop, but we do know that the final velocity is zero. If we use the formula

$$\mathbf{v}_f^2 - \mathbf{v}_t^2 = 2\mathbf{a}x$$

and substitute 150 m/s for the initial velocity and -3 m/s$^2$ for the deceleration, we get the answer: 3,750 m.

3. (**C**) The initial velocity is -25 m/s downward, so $\mathbf{v} = -(25) - (9.8)(2) = -44.6$ m/s.

4. **(C)** The rocket accelerates from rest, so the first distance traveled in 5 s is given by

$$y_1 = \frac{1}{2}at^2$$

Substituting the values for time (5 s) and acceleration (25 m/s²) gives $y_1 = 312.5$ m. After 5 s of accelerating, the rocket has a velocity of 125 m/s. After this time, the engine stops and the rocket is decelerated by gravity as it continues to move upward. The time to decelerate to zero is found by dividing 125 m/s by the acceleration of gravity. Thus 125/9.8 = 12.76 s.

The distance traveled during that time is added to the first accelerated distance. The second distance is given by

$$y_2 = 125(12.76) - 4.9(12.76)^2 = 796.6 \text{ m}$$

The total distance traveled is therefore equal to 1,108 m or, rounded off, 1,100 m.

5. **(C)** The total distance traveled by the object in 14 s is equal to the total area under the graph. Breaking the figure up into triangles and rectangles, we find that their areas add up to 62.5 m (recall that distance is a scalar).

6. **(A)** The total displacement for the object is the sum of the positive (forward) and negative (backward) areas representing the fact that the object moves away from the origin and then back (as indicated by the velocity vs. time graph) going below the x-axis. Adding and subtracting the proper areas: 35 − 2.5 − 20 − 5 = 7.5 m for the final displacement.

7. **(B)** Average velocity is the change in displacement for the object over the change in time (not distance). Since from question 6 we know the displacement change to be 7.5 m in 14 s, the average velocity is therefore 0.53 m/s.

8. **(A)** The change in velocity for the object is equal to the area under the graph, which is equal to 1/2 (+8)(10) = +40 m/s.

9. **(B)** For uniformly accelerated motion, the average velocity is

$$\bar{\mathbf{v}} = \frac{\mathbf{v}_f + \mathbf{v}_i}{2}$$

The question requires that the average velocity be equal to twice the initial velocity; thus, if the average velocity is 30 m/s, the final velocity attained must be 45 m/s. Now the question is, how long must the object accelerate from 15 m/s to achieve a speed of 45 m/s? A change in velocity of 30 m/s at a rate of 3 m/s² for 10 s is implied.

10. **(B)** The horizontal component of velocity remains constant in the absence of resistive forces and is equal to $\mathbf{v}_i \cos \theta$. Substituting the known numbers, we get $\mathbf{v}_x = (250)(0.7) = 175$ m/s.

11. **(D)** The time to fall is given by the free-fall formula:

$$t = \sqrt{\frac{2y}{g}}$$

If we substitute the known numbers, we get 3.91 s for the time.

12. **(A)** From the formula for range, we see that, at 45°, $\sin 2\theta = 1$, and so

$$R = \frac{v_i^2}{g}$$

13. **(A)** We know that, after 4 s, the projectile has traveled horizontally 500 m. Therefore, the horizontal velocity was a constant 125 m/s and is equal to $\mathbf{V}_i \cos \theta$. We also know that, after 4 s, the *y*-position of the projectile is 50 m. Thus we can write:

$$50 = 4v_i \sin \theta - 4.9(4)^2 = 4\, v_i \sin \theta - 78.4$$

Therefore, $v_i \cos \theta = 125$, $v_i \sin \theta = 32.1$, and $\tan \theta = 0.2568$, so $\theta = 14.4°$.

14. **(C)** The river is flowing at 10 m/s to the right (east) and the resultant desired velocity is 5.55 m/s up (north). Therefore, the actual velocity, relative to the river, is heading W of N. By the Pythagorean theorem, the velocity of the boat must be 11.4 m/s. The angle is given by the tangent function. In the diagram below, not drawn to scale but correct for orientation, $\tan/\theta = \dfrac{10}{5.55} = 1.8$. Therefore, $\theta = 60.9°$ W of N.

River velocity = 10 m/s
(velocity of water with respect to land)

Direction

Velocity of boat
(with respect to water)

θ

Resultant velocity of boat = 5.55 m/s
(with respect to land)

Free-Response Problems

1. The acceleration graph given in the problem indicates constant acceleration from $t = 1$ to $t = 3$. Therefore, the area represents a constant change in velocity from 0 to 9 m/s. The second region corresponds to negative acceleration, which slows the object down and turns it around. We know this since the area is −12 m/s. This brings the graph from 9 m/s to −3 m/s (a change in direction). The last area is a change of 3 m/s which brings the velocity to 0 m/s. A graph of this motion is shown below, as desired:

2. In this problem, we know that the first stone will be dropped from a height of 75 m, and it will be in free fall because of gravity. Therefore the time to fall is given by

$$t = \sqrt{\frac{2y}{g}} = 3.9 \, \text{s}$$

Since the first stone is to fall 15 m before the second stone is dropped, we can likewise determine that $t = 1.75$ s to fall that distance. Thus, since the two stones must reach the ground at the same time, we know that the second stone must reach the ground after the first one has traveled for 3.9 s. Since the second stone is thrown when the distance fallen by the first stone is 15 m, we subtract 1.75 s from the total time of 3.9 s to get the second stone's duration of fall. That time is equal to 2.15 s. Since the second stone is thrown downward, it has a negative displacement, and so we can write

$$-75 = -\mathbf{v}_i(2.15) - \frac{1}{2}(9.8)(2.15)^2$$

This gives us a downward initial velocity of 24.34 m/s for the second stone.

3. (a) Using the position function, we know that when $t = 2$ s, $x = 14$ m. The average velocity is given by $\Delta x / \Delta t$. For $\Delta t = 1$ s, we find that at $t = 3$ s, $x = 29$ m. Thus $\Delta x = 15$ m and the average velocity is equal to 15 m/s. If $\Delta t = 0.5$ s, then at $t = 2.5$ s, $x = 20.75$ m and the new average velocity is equal to 13.5 m/s (6.75 m/0.5 s). We continue this procedure. For $\Delta t = 0.2$ s, the average velocity is 12.6 m/s. For $\Delta t = 0.1$ s, the average velocity is 12.3 m/s. For $\Delta t = 0.01$ s, the average velocity is 12.03 m/s. Finally, for $\Delta t = 0.001$ s, the average velocity is 12.003 m/s.

 (b) It appears that as the time interval gets smaller and smaller, the average velocity approaches 12 m/s as a limit. We can say that at t = 2 s, the "instantaneous" velocity is approximately equal to 12 m/s.

4. Let $T =$ the total time to fall the distance h. In free fall, this is given by

$$h = \frac{1}{2}gT^2$$

Now we know that the stone falls the last half of its distance in 4 seconds.
This means

$$\frac{h}{2} = \frac{1}{2}g(T-4)^2$$

$$\frac{1}{4}gT^2 = \frac{1}{2}g(T-4)^2$$

$$T^2 = 2(T-4)^2$$

$$T = \sqrt{2}(T-4)^2$$

Solving for the total time yields $T = 13.7$ seconds, and thus $h = 915$ meters.

5. The average velocity is the ratio of the change in the displacement to the change in the time. It is possible that the object stops for a while and then continues. Thus it is possible for a nonzero average velocity to have a zero instantaneous velocity.

6. The two stones will have the same velocity when they reach the ground. As the first stone rises, gravity decelerates it until it stops, and then it begins to fall back down. When it passes its starting point, it has the same speed but in the opposite direction. This is the same starting velocity as that of the second stone. Both stones are then accelerated through the same displacement, giving them both the same final velocity.

7. The average velocity is the total displacement divided by the total time and is a vector quantity. The average speed is equal to the total distance divided by the total time and is a scalar quantity. If an object is undergoing periodic motion, it can return to its starting point and have zero displacement in one period. This gives it zero average velocity. However, since it traveled a distance, it has a nonzero average speed.

8. The mass is undergoing uniform circular motion. Therefore, it has a constant speed. The velocity when it is released can be determined from the height of the mass and the horizontal range.

 We know it falls vertically 0.5 m in 0.32 s. During this time, it moves horizontally 2.6 m. Thus, the magnitude of the horizontal initial velocity was

 $$v = \frac{2.6\,\text{m}}{0.32\,\text{s}} = 8.125\,\text{m/s}$$

 In circular motion, the constant velocity found above is equal to the ratio of the circumference of the circular path and the period:

 $$v = \frac{2\pi R}{T}$$

 Substituting for the velocity and the period of 0.3 s, we find that R = 0.388 m.

9. The first quantity we can calculate is the football's theoretical range:

 $$R = \frac{v_i^2 \sin 2\theta}{g} = \frac{(25)^2 (\sin 50)}{g} = 48.85\,\text{m}$$

 The receiver needs to travel 18.85 m away from the quarterback to catch the ball. To determine how fast the receiver must run, we need to know how long it takes the ball to travel 48.85 m horizontally. This is equal to the range divided by the horizontal velocity:

 $$t = \frac{48.85\,\text{m}}{v_i \cos 25} = 2.16\,\text{s}$$

 Therefore, to travel 18.85 m in 2.16 s, the receiver must run at 8.73 m/s.

10. From the diagram below, we can see that, to the driver, tan θ = **u/v**.

Forces and Newton's Laws of Motion

4

From our discussion in Chapter 2 of frames of reference, you should be able to convince yourself that, if two objects have the same velocity, the relative velocity between them is zero, and therefore one object looks as though it is at rest with respect to the other. In fact, it would be impossible to decide whether or not such an "**inertial**" observer was moving! Therefore, accepting this fact, we state that an object that appears to be at rest in the Earth frame of reference will simply be stated to be "at rest" relative to us (the observers).

FORCES

An object does not change its velocity (accelerate) on its own. Rather, an interaction is required between that object and another object. This interaction can be direct as in the case of **contact force**, or it may take place via an action at a distance. Gravitational, electrical, and magnetic forces are all examples of forces that act at a distance (no direct contact is required). Friction and normal forces are examples of contact forces. If there is a net unbalanced force (the forces on an object do not add up to zero), then there will be an acceleration. This acceleration can be a change in either speed or direction of motion of the object, or it can be both. If there is no change in speed or direction, the object is not accelerating and the net force must be zero.

Unless an object is in deep space, far from the influence of any other objects, objects experience a net force of zero because two or more forces are in opposition to each other, canceling out each other. These objects experiencing a net force of zero are in a force equilibrium. If the object is at rest, it is in **static equilibrium**. Note that an object can be in motion while experiencing a net force of zero; it may be experiencing a constant velocity.

The following is a complete list of all common forces used on the AP Physics 1 and AP Physics 2 exams.

TIP

Forces are vector quantities.

Types of Forces

Force	When Force Is Present	Rule for Direction
Weight / gravity	Always	Drawn straight toward the center of Earth
Normal	When object is in contact with another object	Drawn straight away from the surface (perpendicular)
Tension	When an object is being pulled by a rope, string, or chain	Drawn in the direction the rope is attached
Push or pull	When a person or an active agent is interacting with the object	Made clear by the situation
Spring / restorative	When a spring or an elastic material is compressed or extended	Opposite the extension or compression
Friction	Surface friction: When two surfaces are sliding (or trying to slide) past each other Fluid friction: When an object is moving through a gas or liquid	Opposes the motion (velocity vector) or the likely motion if stationary
Electric	Whenever two or more net charges are present	Opposite charges attract (center toward center) and similar charges repel (directly away from each other)
Magnetic	Whenever a charge is in motion in a magnetic field	Direction is given by the right-hand rule (see Chapter 13)

Of these forces, weight (or the force due to gravity when on the surface of a planet) is the most ubiquitous and has its own formula:

$$F_g = mg$$

In this equation, g is the strength of the gravity field at the location of the mass (9.8 N/kg at Earth's surface). Note that weight is a vector force and depends on an object's location in the universe. In contrast, mass is a scalar measure of an object's inertia, which belongs to the object independent of location. This g identified here as the gravitation field strength is the same g used in kinematics as the acceleration due to gravity in free fall and projectile motion.

If all the forces acting on an object produce no net change, the object is in a state of **equilibrium**. If the object is moving relative to us, we say that it is in a state of **dynamic equilibrium**. If the object is at rest relative to us, we say that it is in a state of **static equilibrium**. Figure 4.1 illustrates these ideas.

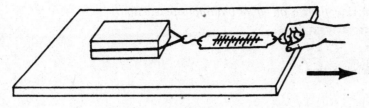

Figure 4.1

NEWTON'S LAWS OF MOTION

In 1687, at the urging of his friend Edmund Halley, Isaac Newton published his greatest work. It was titled the *Mathematical Principles of Natural Philosophy*, but is more widely known by a shortened version, *Principia*. In this book, Isaac Newton revolutionized the rational study of mechanics by the introduction of mathematical principles that all of nature was considered to obey. Using his newly developed ideas, Newton set out to explain the observations and analyses of Galileo Galilei and Johannes Kepler.

The ability of an object to resist a change in its state of motion is called **inertia**. This concept is the key to Newton's first law of motion:

Every body continues in its state of rest, or of uniform motion in a straight line, unless it is compelled to change that state by forces acting on it.

In other words, an object at rest will tend to stay at rest, and an object in motion will tend to stay in motion, unless acted upon by an external force. By "rest," we of course mean the observed state of rest in a particular frame of reference. As stated above, the concept of "inertia" is taken to mean the ability of an object to resist a force attempting to change its state of motion. As we will subsequently see, this concept is covered under the new concept of **mass** (a scalar, as opposed to **weight**, a vector force).

If a mass has an unbalanced force incident upon it, the velocity of the mass is observed to change. The magnitude of this velocity change depends inversely on the amount of mass. In other words, a force directed along the direction of motion will cause a smaller mass to accelerate more than a larger mass. Newton's second law of motion expresses these observations as follows:

The change of motion is proportional to the net applied force, and is in the direction which that force acts.

The acceleration produced by the force is in the same direction as the force. The second law is sometimes expressed as: $\mathbf{F} = m\mathbf{a}$.

However, to preserve the vector nature of the forces, and the fact that by "force" we mean "net force," we write the second law as:

$$\mathbf{F_{net}} = \sum \mathbf{F} = m\mathbf{a}$$

The units of force are **newtons**; 1 newton (N) is defined as the force needed to give a 1-kilogram mass an acceleration of 1 meter per second squared. Thus 1 newton equals 1 kilogram-meter per second squared.

Newton's third law of motion is crucial for understanding the conservation laws we will discuss later. It stresses the fact that forces are the result of mutual interactions and are thus produced in pairs. The third law is usually stated as follows (Figure 4.2):

For every action, there is an equal but opposite reaction.

THINK ABOUT IT

Can you think of some other action-reaction pairs?

Objects *A* and *B* are in contact or colliding.

They exert equal and opposite forces on each other:

Force of *B* on *A* Force of *A* on *B*

(a)

Objects *C* and *D* are attracted to each other.

Force of *D* on *C* Force of *C* on *D*

(b)

Figure 4.2

Remember these tips for Newton's third law action-reaction pairs.

- There are no unpaired forces in the universe. Recall that all forces arise from an interaction between two objects.
- Action and reaction forces are applied to two different objects. The pair of forces do not cancel each other for this reason.
- One force does not cause the other. Which force is the action and which is the reaction is a matter of perspective. They happen simultaneously.
- Action-reaction force pairs are the same type of force. In other words, the reaction to a normal force must be another normal force, in the opposite direction, on the other surface. For example, a normal force would never be the reaction force to a gravitational force.

SAMPLE PROBLEM

A 2-kg mass is accelerated by a net force of 20 N. What is the acceleration of the mass?

Solution

We use Newton's second law:

$$\mathbf{F_{net}} = ma$$

Thus,

$$a = \frac{20 \text{ N}}{2 \text{ kg}} = 10 \text{ N/kg} = 10 \text{ m/s}^2$$

How much does a 2-kg mass weigh on the surface of Earth?

Solution

We use the formula for weight:

$$F_g = mg$$

$$F_g = (2 \text{ kg})(-9.8 \text{ m/s}^2) = -19.6 \text{ N (downward)}$$

Notice in both problems that the units for acceleration can be written as both N/kg or m/s². They are equivalent, and we can think of the acceleration due to gravity in terms of the force per unit mass (which is referred to as a field strength).

STATIC APPLICATIONS OF NEWTON'S LAWS

If we look more closely at Newton's second law of motion, we see an interesting implication. If the net force acting on an object is zero, the acceleration of the object will likewise be zero. Notice, however, that kinematically, zero acceleration does not imply zero motion! It simply indicates that the velocity of the object is not changing. If the object is in a state of rest and remains at rest (because of zero net forces), the object is in static equilibrium. Some interesting problems in engineering deal with the static stability of structures. Let's look at a simple example.

Place this book on a table. You will observe that it is not moving relative to you. Its state of rest is provided by the zero net force between the downward force of gravity and the upward reactive force of the table (pushing on the floor, which in turn pushes up on the table, etc.). Figure 4.3 shows this setup. The upward reactive force of the table, sometimes called the **normal force**, always acts perpendicular to the surface.

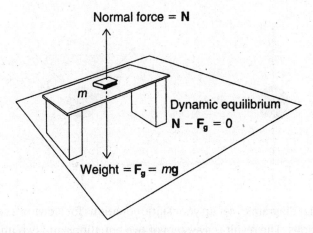

Figure 4.3

Remember: the second law is a vector equation, and so we must treat the sum of all vector forces in each direction separately! In this case, we have:

$$\sum F_y = N - F_g = 0$$

In this example, the normal force is equal to the object's weight.

There are no forces in the x-directions to be "analyzed."

A slightly more complex problem would concern a mass suspended by two strings. The tensions in the strings support the mass and are thus vector forces acting at angles. In the problem illustrated in Figure 4.4, a 10-kilogram mass is suspended by two strings, making angles of 30 and 60 degrees, respectively, to the horizontal. The question is, "What are the tensions in the two strings?"

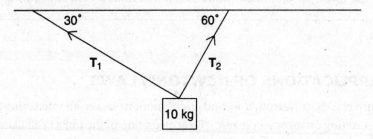

Figure 4.4

A useful heuristic for solving these types of problems is to construct what is called a "free-body diagram." In such a diagram, you "free" the body of its realistic constraints and redraw it, indicating the directions of all applied forces.

You must understand that the College Board has very specific expectations for free-body diagrams. The central object experiencing the forces should be represented by a big round dot. All forces experienced by the object should be represented by one arrow coming out from that dot with no stacking and no components indicated. The net force, acceleration, and velocity vector are *not* part of the free-body diagram. For example, free-body diagrams for Figures 4.3 and 4.4 would be

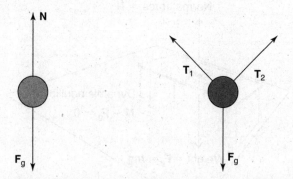

You then use that diagram to set up your static equations for Newton's second law in both the x- and y-directions. The result is a system of two equations and two unknowns. The two representations of the free-body diagram in Figure 4.5 are useful in identifying the horizontal and vertical components of the forces involved for Figure 4.4. However, these pictures of the components should not be mistaken for an actual free-body diagram.

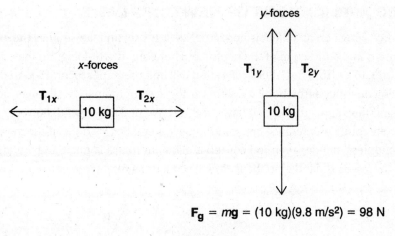

$$\mathbf{F_g} = m\mathbf{g} = (10 \text{ kg})(9.8 \text{ m/s}^2) = 98 \text{ N}$$

Figure 4.5

We can now set up our equations for Newton's second law, using the techniques of vector analysis reviewed in Chapter 2. We thus determine the x- and y-components of the tensions, which are given by $T_{1x} = -T_1 \cos 30$ and $T_{2x} = T_2 \cos 60$. The negative sign is used since T_{1x} is to the left. Thus, in the x-direction we write $\sum F_x = ma_x = 0$ since there is no horizontal acceleration.

$$\sum F_x = 0 = T_2 \cos 60 - T_1 \cos 30 = 0.5 T_2 - 0.866 T_1$$

Likewise, for the y-direction, we see that the 10-kg mass weighs 98 N. The downward pull of gravity is compensated for by the upward pull of the two vertical components of the tensions. In other words, we can write for the y-direction $\sum F_y = ma_y = 0$ since there is no vertical acceleration.

$$\sum F_y = 0 = T_1 \sin 30 + T_2 \sin 60 - F_g = 0.5 T_1 + 0.866 T_2 - 98$$

The two simultaneous equations can then be solved for T_1 and T_2. Performing the algebra, we find that $T_1 = 49$ N and $T_2 = 85$ N.

Another static situation occurs when a mass is hung from an elastic spring. It is observed that, when the mass is attached vertically to a spring that has a certain natural length, the amount of stretching, or elongation, is directly proportional to the applied weight. This relationship, known as **Hooke's law**, supplies a technique for measuring static forces. Mathematically, Hooke's law is given as

$$\mathbf{F} = -k\mathbf{x}$$

where k is the spring constant in units of newtons per meter (N/m), and \mathbf{x} is the elongation beyond the natural length. The negative is used to indicate that the applied force is restorative so that, if allowed, the spring will accelerate back in the opposite direction. As a static situation, a given spring can be calibrated for known weights or masses, and thus used as a "scale" for indicating weight or other applied forces.

DYNAMIC APPLICATIONS OF NEWTON'S LAWS

If the net force acting on an object is not zero, Newton's second law implies the existence of an acceleration in the direction of the net force. Therefore, if a 10-kilogram mass is acted on by a 10-newton force from rest, the acceleration will be 1 meter per second squared. Heuristically, we can construct a free-body diagram for the system to analyze all forces acting in all directions and then apply the second law of motion. We must be careful, however, to choose an appropriate frame of reference and coordinate system. For example, if the mass is sliding down a frictionless incline, a natural coordinate system to use is one that is rotated in such a way that the x-axis is parallel to the incline (see Figure 4.6).

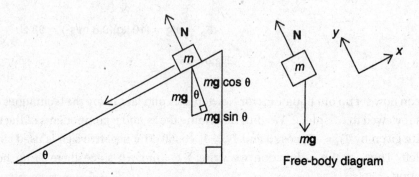

Figure 4.6

Therefore, in order to resolve the force of gravity into components parallel and perpendicular to the incline, we must first identify the relevant angle in the geometry. This is outlined in Figure 4.6, and we can see that the component of weight along the incline is given by $-mg\sin\theta$, where θ is the angle of the incline. The magnitude of the normal force, perpendicular to the incline, is therefore given by $|\mathbf{N}| = |mg\cos\theta|$ since it is canceling the other component of weight.

If, for example, the mass was 10 kg, the weight would be 98 N. If $\theta = 30°$, we would write for the x-forces:

$$\sum F_x = ma = -mg\sin\theta = -98\sin 30 = -49\,\text{N}$$

giving us an acceleration of 4.01 m/s$^2$ down the incline. Since there is no acceleration in the y-direction, we would have:

$$\sum F_y = 0 = N - mg\cos\theta = N - 98\cos 30 = N - 84.9$$

Thus the normal force is equal to 85 N.

CENTRAL FORCES

Consider a point mass moving around a circle, supported by a string making a 45-degree angle to a vertical post (the so-called **conical pendulum**). Let's analyze this situation, which is shown in Figure 4.7.

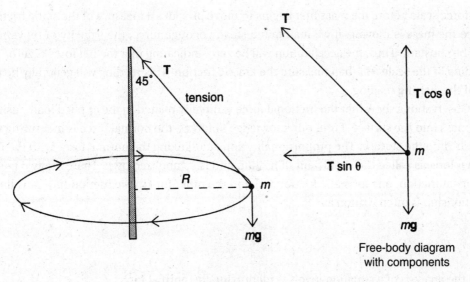

Figure 4.7

In this case, the magnitude of the weight, mg, is balanced by the upward component of the tension in the string, given by $T\cos\theta$. The inward component of tension, $T\sin\theta$, is responsible for providing a **centripetal force**. Note that the centripetal force is *not* an additional force. It is just a description of existing force(s).

If we specify that the radius is 1.5 m and the velocity of the mass is unknown, we see that, vertically, $T\cos 45 = mg$. This implies that, if $mg = 98$ N, then $T = 138.6$ N.

Horizontally, we see that

$$\sum F_x = ma_x$$

$$T\sin 45 = ma_c$$

where a_c denotes a centripetal acceleration.

$$a_c = \frac{v^2}{R}$$

Therefore, the general expression for centripetal force is given by

$$F_c = \frac{mv^2}{R}$$

using the logic of $\mathbf{F} = m\mathbf{a}$. Using our known information, we solve for velocity and find that $\mathbf{v} = 3.8$ m/s. It is important to remember that the components of forces must be resolved along the principal axes of the chosen coordinate system.

FRICTION

Friction is a contact force between two surfaces that is responsible for opposing sliding motion. Even the smoothest surfaces are microscopically rough, with peaks and valleys like a mountain range. If a spring balance is attached to a mass and then pulled, the reading of

the force scale before the mass first begins to move provides a measure of the static friction. Once the mass is moving, if we maintain a steady enough force, the velocity of movement will be constant. Thus, the acceleration will be zero, indicating that the net force is zero. The reading of the scale will then measure the kinetic friction. This reading will generally be less than the starting reading.

Observations show that the frictional force is directly related to the applied load pushing the mass into the surface. From our knowledge of forces, the normal force is measuring this "push" into the surface. The proportionality constant linking the normal force with the frictional force is called the coefficient of friction and is symbolized by μ. There are two coefficients of friction, one for static friction (μ_s) and the other for kinetic friction (μ_k). This linear relationship is often written as

$$f_k = \mu_k N$$

and the analysis of a situation involves identifying the normal force.

For example, in Figure 4.8 a mass is being pulled along a horizontal surface by a string, making an angle θ.

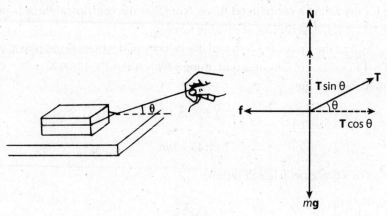

Figure 4.8

$$\Sigma F_y = ma_y = 0$$

$$+ N + T\sin\theta - mg = 0$$

$$N = mg - T\sin\theta$$

and the force of kinetic friction, given a coefficient of kinetic friction, μ_k, is written as:

$$f = \mu_k N = \mu_k(mg - T\sin\theta)$$

Newton's second law in the vertical direction gives us:

$$\Sigma F_y = ma_y = 0 \quad \text{(no vertical acceleration)}$$

$$N + T\sin\theta - mg = 0$$

Solving for N:

$$N = mg - T\sin\theta$$

Note that the normal force is less than the weight of the mass by precisely the upward component of the tension. Newton's second law in the horizontal direction gives us:

$$\sum F_x = ma_x$$

$$T\cos\theta - f = ma_x$$

Using our model for friction and substituting our expression for the normal force found above:

$$f = \mu_k N = \mu_k(mg - T\sin\theta)$$

With this expression for friction, we can substitute into our horizontal force equation to find the general solution:

$$T\cos\theta - \mu_k(mg - T\sin\theta) = ma_x$$

These types of problems will usually either give all the parameters (T, m, θ, μ_k) and ask for the resulting acceleration or will state the mass is being pulled with constant velocity ($a_x = 0$), allowing you to solve for a different unknown (typically μ_k).

SAMPLE PROBLEM

A 2-kg mass is held at rest at the top of an incline that makes a 40° angle with the ground. The incline is 1.5 m long and the coefficient of kinetic friction μ_k = 0.2. When the mass is released, it slides down the incline with uniform acceleration.

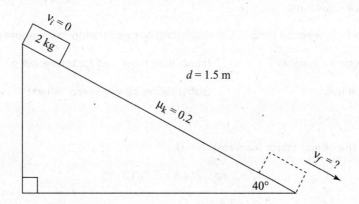

(a) Calculate the acceleration of the mass.
(b) Calculate the speed of the mass when it reaches the bottom of the incline.

Solution

(a)

From the geometry, we see that $F_{\parallel} = mg\sin\theta$ and $F_{\perp} = mg\cos\theta$.

We also know that $F_f = \mu_k F_N$.

Taking y to be perpendicular to the plane and x to be down along the plane:

$$\sum F_y = ma_y$$

$$+N - mg\cos\theta = 0 \text{ (since } a_y = 0)$$

$$N = mg\cos\theta$$

$$\sum F_x = ma_x$$

$$mg\sin\theta - F_f = ma_x$$

$$mg\sin\theta - \mu_k N = ma_x$$

$$mg\sin\theta - \mu_k mg\cos\theta = ma_x \qquad \text{(substituting our expression for } N \text{ above)}$$

$$a_x = g(\sin\theta - \mu_k\cos\theta) \qquad \text{(cancelling mass and factoring out } g)$$

$$a_x = 4.8 \text{ m/s}^2 \qquad \text{(substituting all our given values)}$$

(b) $v_f^2 = v_i^2 + 2ad$

Since the object starts from rest, $v_i = 0$.

$$v_f^2 = 2ad = 2(4.8 \text{ m/s}^2)(1.5 \text{ m})$$

$$v_f = 3.8 \text{ m/s}$$

SUMMARY

- Forces are pushes and pulls that can be represented by vectors.
- Inertia is the tendency of a mass to resist a force changing its state of motion in a given frame of reference.
- The normal force is a force acting perpendicular to, and away from, a surface.
- Friction is a force that opposes motion.
- Newton's three laws help us to understand dynamics, the actions of forces on masses:
 i. In the absence of an external net force, an object maintains constant velocity (law of inertia).
 ii. If a net force is acting on a mass, then the acceleration is directly proportional to the net force ($F_{net} = m\mathbf{a}$).
 iii. For every action force, there is an equal but opposite reaction force.
- Weight is a force caused by the pull of Earth's gravity on a mass and is directed downward.
- An inertial frame of reference is a frame of reference moving at a constant velocity.
- Free-body diagrams assist in the analysis of forces by identifying and labeling all forces acting on a mass freed from the confines of the illustrated situation.
- In circular motion, the net force is directed inward toward the center and is referred to as the centripetal force. A centrifugal force is a ficticious or psuedo-force identified in an accelerated frame of reference attached to a mass undergoing circular motion.

Problem-Solving Strategies for Forces and Newton's Laws of Motion

The key to solving force problems, whether static or dynamic, is to construct the proper free-body diagram. Remember that Newton's laws operate on vectors, and so you must be sure to resolve all forces into components once a frame of reference and a coordinate system have been chosen. Therefore, you should:

1. Choose a coordinate system.
2. Make a sketch of the situation if one is not provided.
3. Construct a free-body diagram for the situation.
4. Resolve all forces into perpendicular components based on the chosen coordinate system.
5. Write Newton's second law as the sum of all forces in a given direction. If the problem involves a static situation, set the summation equal to zero. If the situation is dynamic, set the summation equal to $m\mathbf{a}$. Be sure to include only applied forces in the diagram.
6. Find the normal force. It is always perpendicular to the surface.
7. Remember that the centripetal force is always directed inward toward the circular path and parallel to the plane of the circle. Gravity is always directed vertically downward.
8. Carefully solve your algebraic equations, using the techniques for simultaneous equations.

Be careful about the changing roles of the forces in vertical circular motion! Radially inward forces are positive and outward ones are negative. Compare the expressions for net force (centripetal force) at the top and bottoms of a roller coaster loop.

$$F_{net} = F_c = N - F_g \qquad F_{net} = F_c = F_g + N$$

Multiple-Choice

1. In the situation shown below, what is the tension in string 1?

 (A) 69.3 N
 (B) 98 N
 (C) 138.6 N
 (D) 147.6 N

2. Two masses, M and m, are hung over a massless, frictionless pulley as shown below. If $M > m$, what is the downward acceleration of mass M?

 (A) \mathbf{g}

 (B) $\dfrac{(M-m)\mathbf{g}}{M+m}$

 (C) $\left(\dfrac{M}{m}\right)\mathbf{g}$

 (D) $\dfrac{Mm\mathbf{g}}{M+m}$

3. A 0.25-kg mass is attached to a string and swung in a vertical circle whose radius is 0.75 m. At the bottom of the circle, the mass is observed to have a speed of 10 m/s. What is the magnitude of the tension in the string at that point?

(A) 2.45 N
(B) 5.78 N
(C) 22.6 N
(D) 35.7 N

4. A car and driver have a combined mass of 1,000 kg. The car passes over the top of a hill that has a radius of curvature equal to 10 m. The speed of the car at that instant is 5 m/s. What is the force of the hill on the car as it passes over the top?

(A) 7,300 N up
(B) 7,300 N down
(C) 12,300 N up
(D) 12,300 N down

5. A hockey puck with a mass of 0.3 kg is sliding along ice that can be considered frictionless. The puck's velocity is 20 m/s. The puck now crosses over onto a floor that has a coefficient of kinetic friction equal to 0.35. How far will the puck travel across the floor before it stops?

(A) 3 m
(B) 87 m
(C) 48 m
(D) 58 m

6. A spring with a stiffness constant $k = 50$ N/m has a natural length of 0.45 m. It is attached to the top of an incline that makes a 30° angle with the horizontal. The incline is 2.4 m long. A mass of 2 kg is attached to the spring, causing it to be stretched down the incline. How far down the incline does the end of the spring rest?

(A) 0.196 m
(B) 0.45 m
(C) 0.646 m
(D) 0.835 m

7. A 20-N force is pushing two blocks horizontally along a frictionless floor as shown below.

What is the force that the 8-kg mass exerts on the 2-kg mass?

(A) 4 N
(B) 8 N
(C) 16 N
(D) 20 N

8. A force of 20 N acts horizontally on a mass of 10 kg being pushed along a frictionless incline that makes a 30° angle with the horizontal, as shown below.

The magnitude of the acceleration of the mass up the incline is equal to

(A) 1.9 m/s²

(B) 2.2 m/s²

(C) 3.17 m/s²

(D) 3.87 m/s²

9. According to the diagram below, what is the tension in the connecting string if the table is frictionless?

(A) 6.4 N

(B) 13 N

(C) 19.7 N

(D) 25 N

10. A mass, *M*, is released from rest on an incline that makes a 42° angle with the horizontal. In 3 s, the mass is observed to have gone a distance of 3 m. What is the coefficient of kinetic friction between the mass and the surface of the incline?

(A) 0.8

(B) 0.7

(C) 0.6

(D) 0.5

Free-Response

1. A 3-kg block is placed on top of a 7-kg block as shown below.

The coefficient of kinetic friction between the 7-kg block and the surface is 0.35. A horizontal force F acts on the 7-kg block.

(a) Draw a free-body diagram for each block.

(b) Calculate the magnitude of the applied force \mathbf{F} necessary to maintain an acceleration of 5 m/s².

(c) Find the minimum coefficient of static friction necessary to prevent the 3-kg block from slipping.

2. A curved road is banked at an angle θ, such that friction is not necessary for a car to stay on the road. A 2,500-kg car is traveling at a speed of 25 m/s, and the road has a radius of curvature equal to 40 m.

(a) Draw a free-body diagram for the situation described above.

(b) Find angle θ.

(c) Calculate the magnitude of the force that the road exerts on the car.

3. The "rotor" is an amusement park ride that can be modeled as a rotating cylinder, with radius R. A person inside the rotor is held motionless against the sides of the ride as it rotates with a certain velocity. The coefficient of static friction between a person and the sides is μ.

(a) Derive a formula for the period of rotation T, in terms of R, g, and μ.

(b) If $R = 5$ m and μ = 0.5, calculate the value of the period T in seconds.

(c) Using the answer to part (b), calculate the angular velocity ω in radians per second.

4. How does the rotation of Earth affect the apparent weight of a 1-kg mass at the equator?

5. If you overwax a floor, you can actually increase the coefficient of kinetic friction instead of lowering it. Explain how this might happen.

6. If forces occur in action-reaction pairs that are equal and opposite, how is it possible for any one force to cause an object to move?

ANSWERS EXPLAINED

Multiple-Choice Problems

1. **(A)** We need to apply the second law for static equilibrium. This means that we must resolve the tensions into their *x*- and *y*-components. For T_1, we have $T_1 \cos 45$ and $T_1 \sin 45$. In equilibrium, the sum of all the *x* forces must equal zero. This means that $T_1 \cos 45 = T_2$ (since T_2 is entirely horizontal). The *y*-component of T_1 must balance the weight $= mg = 49$ N. Thus, $T_1 \sin 45 = 49$ N and $T_1 = 69.3$ N.

2. **(B)** The free-body diagrams for both masses, *M* and *m*, look like this:

 The large mass is accelerating downward, while the small mass is accelerating upward. The tension in the string is directed upward, while gravity, given by the weight, is directed downward. Using the second law for accelerated motion, we must show that for each mass, $\sum F_y = ma$. Thus we have

$$T - Mg = -Ma \quad \text{and} \quad T - mg = ma$$

 Eliminating the tension *T* and solving for *a* gives us $(M - m)g/(M + m)$.

3. **(D)** A sketch of the situation is shown below:

 At the lowest point, the downward force of gravity is opposed by the upward tension in the string. Thus we can write

$$\mathbf{T} - mg = \frac{m\mathbf{v}^2}{R}$$

 Substituting in the given values and solving for **T** gives us 35.7 N.

4. **(A)** As the car goes over the hill, the force that the hill exerts on the car is the normal force, **N**. This is opposed, however, by the downward force of gravity. The combination produces (as in question 3) the centripetal force \mathbf{F}_c. Thus, we can write

$$N - mg = \frac{-mv^2}{R}$$

The centripetal force, in this case, is directed downward, and hence is written as negative. A sketch is shown below. Substituting in the given values and solving for **N** gives 7,300 N upward.

5. **(D)** With horizontal motion, the normal force is equal to the force of gravity. When the puck is moving with constant velocity, no net force is acting on it. Thus, when friction acts to slow the puck down, the friction is the only net force. Therefore, we write

$$f = \mu N = \mu mg = -ma$$

(since the puck is decelerating). Substituting the known numbers gives a deceleration of -3.43 m/s$^2$. Now, the final velocity will be zero; and since the time to stop is unknown, we use the following kinematic expression to solve for the stopping distance:

$$-v_i^2 = 2ax$$

Substituting the known numbers, we obtain approximately 58 m as the distance the puck will travel before stopping.

6. **(C)** A sketch of the situation is given below. The spring constant is $k = 50$ N/m.

According to Hooke's law, $\mathbf{F} = k\mathbf{x}$, where **x** is the elongation in excess of the spring's natural length (here 0.45 m). The force, in this case, is provided by the component of weight parallel to the incline, which is given by $mg\sin\theta$. Substituting the known numbers gives us an elongation of $\mathbf{x} = 0.196$ m. Since this must be in excess of the spring's natural length, the answer is 0.646 m.

7. **(C)** The 20-N force is pushing on a total mass of 10 kg. Thus, using $\mathbf{F} = m\mathbf{a}$, we have the acceleration of both blocks equal to 2 m/s². We draw a free-body diagram for the 2-kg mass as shown below.

Let **P** represent the force that the 8-kg mass exerts on the 2-kg mass. Writing the second law of motion, we get $\mathbf{F} - \mathbf{P} = m\mathbf{a}$. To find **P**, we substitute the known numbers; $20 - \mathbf{P} = (2)(2) = 4$. Thus, $\mathbf{P} = 16$ N.

8. **(C)** The component of gravity down the incline is always given by $m\mathbf{g}\sin\theta$. Resolving the given force into a component parallel to the incline and a component perpendicular to the incline, we find that the force up the incline is, at the same angle, $\mathbf{F}\cos\theta$. Thus, in general we would write:

$$\mathbf{F}\cos\theta - m\mathbf{g}\sin\theta = m\mathbf{a}$$

Substituting the known numbers gives $\mathbf{a} = -3.17$ m/s².

Note that the negative sign denotes an acceleration down the ramp, but the question asks for magnitude only.

9. **(C)** From the given diagram, we see that the 4-kg mass is accelerating to the right and the 2-kg mass is accelerating up. Thus we write that the sum of all forces, in each direction, equals $m\mathbf{a}$. In the x-direction we have (since the tension in the string will try to pull left), $-\mathbf{T} + 20 = 4\mathbf{a}$. In the y-direction, the tension pulls up against gravity. We therefore write $\mathbf{T} - 19.6 = 2\mathbf{a}$. Solving for **T** by eliminating **a**, we get $\mathbf{T} = 19.7$ N.

10. **(A)** We know that the mass accelerates from rest uniformly in 3 s and goes a distance of 3 m. Thus, we can say that

$$d = \frac{1}{2}\mathbf{a}t^2$$

Substituting the known number gives us an acceleration of 0.67 m/s². On an incline, the normal force is given by $m\mathbf{g}\cos\theta$, and so friction can be expressed as $f = \mu m\mathbf{g}\cos\theta$. Once again, this force opposes the downward force of gravity parallel to the incline, given by $-m\mathbf{g}\sin\theta$. In the downward direction, these two forces are added together and set equal to $-m\mathbf{a}$. Thus we write for this case

$$\mu(M)(9.8)\cos 42 - (M)(9.8)\sin 42 = -(M)(0.67)$$

The masses all cancel out, and solving for μ gives 0.8 as the coefficient of kinetic friction.

Free-Response Problems

1. (a) A free-body diagram for each of the two blocks is given below:

 (b) The force of static friction between the two blocks is the force responsible for accelerating the 3-kg block to the right (hence the direction of friction in the free-body diagram). On the other hand, kinetic friction opposes the applied force, **F**, acting on the 7-kg block. Even so, the force **F** must accelerate both blocks combined. Thus, in the horizontal direction we can write that, for the second law of motion,

$$F - f = Ma$$

 Also, since $f = \mu N$, we can write (since we have horizontal motion, the normal force is equal to the combined weights) $F - (0.35)(10)(9.8) = (10)(5)$. Solving for F, we get $F = 84.3$ N.

 (c) Now, for the two blocks together, we know that static friction provides the force needed for the 3-kg block to accelerate at 5 m/s². The normal force on the "surface" is just the weight of the 3-kg block, as seen in the free-body diagram drawn in part (a). Thus $\mu(3)(9.8) = (3)(5)$. From this we get $\mu = 0.51$.

2. (a) A sketch of the situation and the free-body diagram are given below:

 (b) In the coordinates chosen, the component of the normal force parallel to the plane of the curved road provides the centripetal acceleration. Thus we can write, in the absence of friction,

$$N \sin\theta = \frac{m\mathbf{v}^2}{r}$$

We can also see that $\mathbf{N}\cos\theta = m\mathbf{g}$. Thus, eliminating \mathbf{N} from both equations gives us

$$\tan\theta = \frac{\mathbf{v}^2}{r\mathbf{g}}$$

Substituting the known numbers, we find that $\tan\theta = 1.59$ and $\theta = 57.8°$ (rather steep).

(c) Substituting our known value for the angle into the force equation above:

$$N\sin(57.8) = \frac{mv^2}{R}$$

$$N\,(0.846) = \frac{2,500(25)^2}{40}$$

$$N = 46,000 \text{ N}$$

3. (a) A diagram of the rotor is seen below. Here, the normal force is perpendicular to the person and supplies the inward centripetal force. Friction acts along the walls against gravity, $m\mathbf{g}$, tending to slide the person down. Thus, the key to stability is to be fast enough to maintain equilibrium.

Since $\mathbf{F} = m\mathbf{a}$ and $F_c = m\dfrac{v^2}{R}$,

$$N = \frac{4M\pi^2 r}{T^2}$$

In the vertical direction $f = Mg$; thus

$$f = \mu N = \frac{\mu M 4\pi^2 r}{T^2} = Mg$$

Solving for T, we get

$$T = \sqrt{\frac{\mu 4\pi^2 r}{g}}$$

This makes sense, since if the coefficient of friction is high, the rotation rate can be small, and thus a larger period!

(b) Substituting the known numbers gives $T = 10$ s.

(c) $\omega = \dfrac{2\pi}{T} = \dfrac{6.28}{10} = 0.628 \text{ rad/s}$.

4. In the frame of reference of the mass, there is an apparent upward force that tends to reduce the apparent weight of the mass at the equator. This effect is very small, and only very sensitive scales can measure it.

5. Initially, the wax fills in the ridges and furrows of the floor on a microscopic level. This reduces the coefficient of kinetic friction and makes it easier for objects to slide. However, each successive wax buildup can actually overfill the ridges and then cause a sticky layer of material that increases the coefficient of kinetic friction.

6. This is a classic question and is very tricky. The answer is that the action and reaction pairs act on different objects. Thus, the applied force, if it is (or results in) a net force, can cause an object to move in a given frame of reference.

Energy

<div style="text-align: right; font-size: large;">5</div>

KEY CONCEPTS

→ **WORK**

→ **POWER**

→ **KINETIC ENERGY AND THE WORK-ENERGY THEOREM**

→ **POTENTIAL ENERGY AND CONSERVATIVE FORCES**

→ **CONSERVATION OF ENERGY AND SYSTEMS**

WORK

When a force is applied to an object over a displacement, **work** is done to the object. The simplest type of work problem involves a single mass m and a constant force F that causes a displacement d. The angle is between the force and displacement vectors. Work is measured in joules and is a scalar; 1 joule = 1 newton · meter:

$$W = Fd \cos \theta$$

SAMPLE PROBLEM 1

In each scenario below, a force F is applied to a box of mass m that is pushed a distance d horizontally across a frictionless table. If the box is displaced by 20 m, calculate the work W done by the 10 N force indicated.

Solutions

(a) The force and displacement are in the same direction, so all of the force is effective. We use equation $W = Fd$.

$$W = Fd$$

$$W = (10 \text{ N})(20 \text{ m})$$

$$W = 200 \text{ J}$$

Note that $W = Fd$ is a simplified version of $W = (F\cos\theta)d$. The angle is determined by placing both arrows at the origin and measuring the smallest angle between them. If the force and displacement are in the same direction, then $\theta = 0°$. Thus:

$$W = (F\cos\theta)d$$

$$W = (10 \text{ N})(\cos 0°)(20 \text{ m})$$

$$W = (10 \text{ N})(1)(20 \text{ m})$$

$$W = 200 \text{ J}$$

We get the same answer.

(b) The force is not in the same direction as the displacement, so not all of the force is effective. (In fact, none of the force is effective.) We use equation $W = (F\cos\theta)d$. The force is pushing at right angles to the displacement, so $\theta = 90°$:

$$W = (F\cos\theta)d$$

$$W = (10 \text{ N})(\cos 90°)(20 \text{ m})$$

$$W = (10 \text{ N})(0)(20 \text{ m})$$

$$W = 0 \text{ J}$$

(c) Again, the force is not in the same direction as the displacement, so not all of the force is effective. We use equation $W = (F\cos\theta)d$. The force is applied at a 60° angle from the direction of displacement, so $\theta = 60°$:

$$W = (F\cos\theta)d$$

$$W = (10 \text{ N})(\cos 60°)(20 \text{ m})$$

$$W = (10 \text{ N})(0.5)(20 \text{ m})$$

$$W = 100 \text{ J}$$

(d) Again, the force is not in the same direction as the displacement, so we use the equation $W = (F\cos\theta)d$. The force is applied in entirely the opposite direction as the displacement, so $\theta = 180°$:

$$W = (F\cos\theta)d$$

$$W = (10 \text{ N})(\cos 180°)(20 \text{ m})$$

$$W = (10 \text{ N})(-1)(20 \text{ m})$$

$$W = -200 \text{ J}$$

> **TIP**
>
> **When calculating work, the mass m of the object being displaced is irrelevant.**

In Sample Problem 1, cases (b) and (d) are the most troublesome. In case (b), no work is done by that particular force. This seems counterintuitive because the box does experience a displacement. Remember that work is not simply "effort" on the part of the force. It is effort that results in a displacement of the object *in the direction of the force*. If the object is unchanged *in the direction of the force*, no energy was transferred to the object *from that particular force*. The source of the force may be expending energy. Think of yourself holding up a heavy weight at a constant height above the floor. If there is no vertical movement, that energy is not being transferred to the object. Therefore, no work is being done on the object.

In case (d), what does it mean to have negative work? The negative sign tells us that the flow of energy is reversed. Energy is being transferred *from* the mass *to* the source of the force. For example, frictional forces often do negative work, meaning that the mass is losing energy.

SAMPLE PROBLEM 2

Calculate the **total work (or net work)** done on object M by the four forces indicated.

$F_1 = 50$ N
$76°$
$F_3 = 1$ N \leftarrow M \rightarrow $F_2 = 7$ N
$\leftarrow d = 2$ m \rightarrow
$F_4 = 20$ N

Solution

Total, or net, work is the sum of the individual works done by each of the individual forces.

$$W_{total} = W_1 + W_2 + W_3 + W_4$$

$$W = (F\cos\theta)d$$

$$W_1 = (50 \text{ N})(\cos 104°)(2 \text{ m})$$

$$W_1 = (10 \text{ N})(-0.24)(2 \text{ m})$$

$$W_1 = -24 \text{ J}$$

$$W_2 = (7 \text{ N})(2 \text{ m})$$

$$W_2 = 14 \text{ J}$$

$$W_3 = (1 \text{ N})(\cos 180°)(2 \text{ m})$$

$$W_3 = (1 \text{ N})(-1)(2)$$

$$W_3 = -2 \text{ J}$$

$$W_4 = (20 \text{ N})(\cos 90°)(2 \text{ m})$$

$$W_4 = (20 \text{ N})(0)(2 \text{ m})$$

$$W_4 = 0$$

$$W_{total} = (-24 \text{ J}) + (14 \text{ J}) + (-2 \text{ J}) + (0 \text{ J})$$

$$W_{total} = -12 \text{ J}$$

> **REMEMBER**
>
> θ is measured relative to the direction of displacement.

In sample problem 2, can we compute the net force and then do one work calculation? Try it, and see that you get the same answer. The work done by the net force is equal to the work done by all the individual forces *when you assume that all forces are acting on the center of mass*. Note that this assumption applies in translational motion only but not in rotational motion or deformations of the object.

POWER

When work is done over some amount of time, we can measure the **power**, or the rate at which the work is performed. Power is a scalar with units of Watts; 1 Watt = 1 Joule/sec:

$$P = \frac{W}{t}$$

$$P = \frac{\Delta E}{t}$$

> **REMEMBER**
>
> When a constant force *F* is applied to an object moving at constant velocity *v*, the power *P* is the product of the two values: *P = Fv*.

SAMPLE PROBLEM 3

If the 2-meter displacement in Sample Problem 2 occurred in 4 seconds, how much power was delivered to the object?

Solution:

We use equation $P = \dfrac{W}{t}$.

$$P = \frac{W}{t}$$

$$P = \frac{-12 \text{ J}}{4 \text{ s}}$$

$P = -3$ W (The negative sign indicates that the object is losing energy rather than gaining it.)

KINETIC ENERGY AND THE WORK-ENERGY THEOREM

If work is a measure of energy transferred, what does a gain, or loss, of energy mean? One way energy can be easily seen is through an object's motion. This energy of motion is called **kinetic energy**, *KE*:

$$KE = \frac{1}{2}mv^2$$

A 16 kg object starts at rest and gains 2 J of kinetic energy. Determine the final speed of the object.

Solution

Since the object started at rest, the change in kinetic energy is exactly the kinetic energy of the moving object:

$$KE = \frac{1}{2}mv^2$$

$$2\,J = \frac{1}{2}(16\,kg)v^2$$

$$\frac{1}{4} = v^2$$

$$0.5\,m/s = v$$

If we are calculating the net work done by all external forces, the gain or loss of energy W is seen as a change in the speed of the object, which is incorporated in the object's kinetic energy KE. This is the **work-energy theorem**:

$$W_{total} = \Delta KE$$

A 5 kg object is sliding across a floor at 10 m/s. How much work is done by friction to bring it to a stop?

Solution

The change in kinetic energy is the only calculation we can make:

$$KE_i = \text{initial kinetic energy}$$

$$KE_f = \text{final kinetic energy}$$

$$v_i = \text{initial velocity}$$

$$v_f = \text{final velocity}$$

We are told that $v_i = 10$ m/s. Since the object comes to a stop, we know that $v_f = 0$ m/s:

$$W_{total} = \Delta KE = KE_f - KE_i$$

$$W_{total} = \frac{1}{2}mv_f^2 - \frac{1}{2}mv_i^2$$

$$W_{total} = \frac{1}{2}(16\,kg)(0\,m/s)^2 - \frac{1}{2}(16\,kg)(10\,m/s)^2$$

$$W_{total} = 0 - 250\,J$$

$$W_{total} = -250\,J$$

> The object has lost 250 joules of movement energy as it slowed down. This is the work done by friction: −250 J.
>
> Note that if we knew the distance, we could calculate the force required to bring the object to a stop.

POTENTIAL ENERGY AND CONSERVATIVE FORCES

Potential energy, *PE*, refers to energy stored within a system (between particles that are bound by certain types of forces). The forces that are related to potential energy are called **conservative forces.** There are many forms of potential energy. For the purposes of the AP tests, we are concerned with only three: gravitational, elastic (springs), and electrical. Treat all other forces as nonconservative. Generally speaking, we are concerned only with changes in potential energies

Gravity: The farther two masses are separated, the greater the potential energy stored in the system. The mass that is interacting with Earth close to the planet's surface may change the relationship by changing its height: $PE_{gravity} = mgh$.

Elastics (e.g., springs): The more a spring is compressed or stretched away from its equilibrium point, the greater the potential energy stored in the system. The stretched or compressed spring has stored potential energy: $PE_{elastic} = \frac{1}{2}kx^2$. For examples, see Chapter 6.

Electrical: The closer two similar charges are held, or the farther apart two opposite charges are held, the greater the potential energy. Electrical potential energy is given by the equation $PE_{electrical} = q\Delta V$. For examples, see Chapter 11.

CONSERVATION OF ENERGY AND SYSTEMS

If only conservative forces are present, the **mechanical energy** (kinetic energy *KE* plus potential energy *PE*) is conserved. The **law of conservation of energy** states that the initial mechanical energy must equal the final mechanical energy.

Initial Mechanical Energy = Final Mechanical Energy

$$KE_i + PE_i = KE_f + PE_f$$

SAMPLE PROBLEM 6

A rock falls from a height of 20 meters in a vacuum. How fast is the rock traveling when it reaches the bottom?

Solution

In this problem, we are dealing with the potential energy due to gravity. So $PE = mgh$.

Since there are no nonconservative forces in this problem, we use the law of conservation of energy: $KE_i + PE_i = KE_f + PE_f$.

From the information given, we know that:

$h_i = 20$ m

$v_i = 0$ m/s

$h_f = 0$ m

$$KE_i + PE_i = KE_f + PE_f$$

$$\frac{1}{2}mv_i^2 + mgh_i = \frac{1}{2}mv_f^2 + mgh_f$$

$$\frac{1}{2}(0 \text{ m/s})^2 + (10 \text{ m/s}^2)(20 \text{ m}) = \frac{1}{2}v_f^2 + (10 \text{ m/s}^2)(0 \text{ m})$$

$$200 \text{ m}^2/\text{s}^2 = \frac{1}{2}v_f^2$$

$$400 \text{ m}^2/\text{s}^2 = v_f^2$$

$$20 \text{ m/s} = v_f$$

Note that the direction of v_f is downward. Also note that the mass m canceled out completely at the start of the problem solving.

SAMPLE PROBLEM 7

An arrow is shot from the roof of a building 30 meters high at 5 m/s and at an angle of 45 degrees. How fast will the arrow be going when it hits the ground?

Solution

From the information given, we know that:

$h_i = 30$ m
$v_i = 5$ m/s
$h_f = 0$ m

$$KE_i + PE_i = KE_f + PE_f$$

$$\frac{1}{2}mv_i^2 + mgh_i = \frac{1}{2}mv_f^2 + mgh_f$$

$$\frac{1}{2}v_i^2 + gh_i = \frac{1}{2}v_f^2 + gh_f$$

$$\frac{1}{2}v_i^2 + gh_i = \frac{1}{2}v_f^2 + g(0 \text{ m})$$

$$\frac{1}{2}v_i^2 + gh_i = \frac{1}{2}v_f^2$$

$$v_f^2 = v_i^2 + 2gh_i$$

$$v_f^2 = (5 \text{ m/s})^2 + (2)(10 \text{ m/s}^2)(30 \text{ m})$$

$$v_f^2 = 25 \text{ m}^2/\text{s}^2 + 600 \text{ m}^2/\text{s}^2$$

$$v_f^2 = 625 \text{ m}^2/\text{s}^2$$

$$v_f = 25 \text{ m/s}$$

A 2 kg mass sliding along a frictionless floor at 3 m/s hits a spring (with $k = 200$ N/m), compresses it, and bounces back. What is the maximum compression of the spring?

Solution

In this problem, we are dealing with the potential energy of a spring. So $PE = \frac{1}{2}kx^2$.

Note that the final state refers to the spring at maximum compression. From the information given, we know:

$m = 2$ kg

$x_i = 0$ m

$v_i = 3$ m/s

$v_f = 0$ m/s

REMEMBER

Velocity is 0 m/s when the spring is at maximum compression ($v = 0$ during any turnaround).

$$KE_i + PE_i = KE_f + PE_f$$

$$\frac{1}{2}mv_i^2 + \frac{1}{2}kx_i^2 = \frac{1}{2}mv_f^2 + \frac{1}{2}kx_f^2$$

$$\frac{1}{2}mv_i^2 + \frac{1}{2}k(0 \text{ m})^2 = \frac{1}{2}m(0 \text{ m/s})^2 + \frac{1}{2}kx_f^2$$

$$\frac{1}{2}mv_i^2 = \frac{1}{2}kx_f^2$$

$$mv_i^2 = kx_f^2$$

$$(2 \text{ kg})(3 \text{ m/s})^2 = (200 \text{ N/m}) \, x_f^2$$

$$x_f^2 = \frac{9}{100} \text{ m}$$

$$x_f = \frac{3}{10} = 0.3 \text{ m}$$

If **nonconservative forces** are present (e.g., friction), the work done by those forces must be accounted for when calculating the final kinetic and potential energies. If W_{NC} is the work done by nonconservative forces, the energies must be balanced in the following manner:

$$KE_i + PE_i + W_{NC} = KE_f + PE_f$$

A 2 kg rock falls from a cliff 20 m above the ground. The air friction does –39 J of work during the fall. What is the final speed of the rock?

Solution

Since nonconservative forces are involved, we use equation

$$KE_i + PE_i + W_{NC} = KE_f + PE_f$$

From the information given, we know:

$m = 2$ kg
$h_i = 20$ m
$v_i = 0$ m/s
$h_f = 0$ m

$$KE_i + PE_i + W_{NC} = KE_f + PE_f$$

$$\frac{1}{2}mv_i^2 + mgh_i + (-39 \text{ J}) = \frac{1}{2}mv_f^2 + mgh_f$$

$$\frac{1}{2}(2\text{ kg})(0\text{ m/s})^2 + (2\text{ kg})(10\text{ m/s}^2)(20\text{ m}) - (39\text{ J}) = \frac{1}{2}(2\text{ kg})v_f^2 + (2\text{ kg})(10\text{ m/s}^2)(0)$$

$$0 \text{ J} + 400 \text{ J} - 39 \text{ J} = v_f^2 + 0 \text{ J}$$

$$361 \text{ J} = v_f^2$$

$$19 \text{ m/s} = v_f$$

SUMMARY

- Work (measured in joules) is both a force over a distance and a transfer of energy.
- Power (measured in watts) is the rate at which work is done.
- Net work done by all forces to an object is equal to the change in kinetic energy of that object.
- Work done by conservative forces is path independent.
- Potential energy is stored energy within a system due to internal conservative forces. If you take into account only the work done by nonconservative forces to a system, the work-energy theorem becomes:

$$W_{NC} = \Delta KE + \Delta PE$$

- If there are only conservative forces, then the total mechanical energy ($KE + PE$) is conserved.
- If mechanical energy is not conserved in an isolated system, the "missing" energy can be found in the form of internal energies (thermal energy, etc.).

Often a problem can be solved either through kinematics or energy. Usually energy is the quicker, more powerful tool. However, time permitting, you can double-check your answer with simple kinematics.

PRACTICE EXERCISES

Multiple-Choice

1. W™hich of the following are the units for the spring constant, k?
 (A) $kg \cdot m^2/s^2$
 (B) $kg \cdot s^2$
 (C) $kg \cdot m/s$
 (D) kg/s^2

2. Which of the following is an expression for mechanical power?
 (A) $\mathbf{F}t/m$
 (B) $\mathbf{F}^2 m/\mathbf{a}$
 (C) $\mathbf{F}m^2/t$
 (D) $\mathbf{F}^2 t/m$

3. A pendulum consisting of a mass m attached to a light string of length ℓ, is displaced from its rest position, making an angle θ with the vertical. It is then released and allowed to swing freely. Which of the following expressions represents the velocity of the mass when it reaches its lowest position?

(A) $\sqrt{2g\ell(1-\cos\theta)}$
(B) $\sqrt{2g\ell(\tan\theta)}$
(C) $\sqrt{2g\ell(\cos\theta)}$
(D) $\sqrt{2g\ell(1-\sin\theta)}$

4. An engine maintains constant power on a conveyor belt machine. If the belt's velocity is doubled, the magnitude of its average acceleration

(A) is doubled
(B) is quartered
(C) is halved
(D) is quadrupled

5. A mass m is moving horizontally along a nearly frictionless floor with velocity **v**. The mass now encounters a part of the floor that has a coefficient of kinetic friction given by μ. The total distance traveled by the mass before it is slowed by friction to a stop is given by

(A) $2v^2/\mu g$
(B) $v^2/2\mu g$
(C) $2\mu g v^2$
(D) $\mu v^2/2g$

6. Two unequal masses are dropped simultaneously from the same height. The two masses will experience the same change in

(A) acceleration
(B) kinetic energy
(C) potential energy
(D) velocity

7. A pendulum that consists of a 2-kg mass swings to a maximum vertical displacement of 17 cm above its rest position. At its lowest point, the kinetic energy of the mass is equal to

(A) 0.33 J
(B) 3.33 J
(C) 33.3 J
(D) 333 J

8. A 0.3-kg mass rests on top of a spring that has been compressed by 0.04 m. Neglect any frictional effects, and consider the spring to be massless. Then, if the spring has a constant k equal to 2000 N/m, to what height will the mass rise when the system is released?

 (A) 1.24 m
 (B) 0.75 m
 (C) 0.54 m
 (D) 1.04 m

9. A box is pulled along a smooth floor by a force F, making an angle θ with the horizontal. As θ increases, the amount of work done to pull the box the same distance, d,

 (A) increases
 (B) increases and then decreases
 (C) remains the same
 (D) decreases

10. As the time needed to run up a flight of stairs decreases, the amount of work done against gravity

 (A) increases
 (B) decreases
 (C) remains the same
 (D) increases and then decreases

Free-Response

1. A 0.75-kg sphere is dropped through a tall column of liquid. When the sphere has fallen a distance of 2.0 m, it is observed to have a velocity of 5 m/s.

 (a) How much work was done by the frictional "viscosity" of the liquid?
 (b) What is the average force of friction during the placement of 2.0 m?

2. A 15-kg mass is attached to a massless spring by a light string that passes over a frictionless pulley as shown below. The spring has a force constant of 500 N/m and is unstretched when the mass is released. What is the velocity of the mass when it has fallen a distance of 0.3 m?

$k = 500$ N/m m 15 kg

3. A 1.5-kg block is placed on an incline. The mass is connected to a massless spring by means of a light string passed over a frictionless pulley, as shown below. The spring has a force constant k equal to 100 N/m. The block is released from rest, and the spring is initially unstretched. The block moves down a distance of 16 cm before coming to rest. What is the coefficient of kinetic friction between the block and the surface of the incline?

4. Explain how it might be possible for a moving object to possess, and simultaneously not possess, kinetic energy?

5. When you hold up a 10-kg mass with your arms outstretched, you get tired. However, according to physics, you have not done any work! Explain how this is possible.

ANSWERS EXPLAINED
Multiple-Choice Problems

1. **(D)** The units for the spring or force constant are provided by Hooke's law, $\mathbf{F} = kx$, and are newtons per meter. Recall that $1 \text{ N} = 1 \text{ kg} \cdot \text{m/s}^2$, so dividing by m gives kg/s^2.

2. **(D)** Power is equal to work done divided by time. Therefore,

$$P = \frac{W}{t} = \frac{\mathbf{Fd}}{t}$$

Using some algebra and kinematics, we see that

$$P = \frac{\mathbf{Fd}}{t} = \mathbf{Fv} = \mathbf{Fa}t = \mathbf{F}\left(\frac{\mathbf{F}}{m}\right)t = \frac{\mathbf{F}^2 t}{m}$$

You could also get the answer by verifying which expression has units of joules per second.

3. **(A)** Consider the sketch below of the situation:

From the geometry of the sketch, note that

$$h = \ell - \ell \cos\theta = \ell\,(1 - \cos\theta)$$

If it is assumed that there is no friction, gravity is the only conservative force acting to do work. Therefore, $\Delta KE = \Delta PE$, and so, at the bottom,

$$\mathbf{v} = \sqrt{2\mathbf{g}h} = \sqrt{2\mathbf{g}\ell(1-\cos\theta)}$$

4. **(C)** Power is equal to the product of the average force applied times the velocity. If the velocity is doubled, and the power is constant, the average force must be halved. Since $\mathbf{F} = m\mathbf{a}$, the average acceleration of the belt must be halved as well.

5. **(B)** The only applied force is friction, which is doing work to stop the mass. This work is being taken from the initial kinetic energy. For friction, we know that $\mathbf{f} = \mu\mathbf{N}$, and since the motion is horizontal, $\mathbf{N} = m\mathbf{g}$. Let x be the distance traveled while stopping; therefore, we can write that $W_f = KE$ and:

$$\frac{1}{2}m\mathbf{v}^2 = \mu m\mathbf{g}x$$

Solving for x, we get:

$$x = \frac{\mathbf{v}^2}{2\mu\mathbf{g}}$$

6. **(D)** Objects dropped simultaneously from the same height have the same constant acceleration, which is the change in velocity. The unequal masses will provide for different energies, but the velocity changes will be the same.

7. **(B)** Since we have a conservative system,

$$\Delta KE = \Delta PE = (2)(9.8)(0.17) = 3.33 \text{ J}$$

Remember to change 17 cm to 0.17 m!

8. **(C)** We are dealing with a conservative system, so the initial starting energy is just the potential energy of the compressed spring. This energy supplies the work needed to raise the mass a height h, which is a gain in gravitational potential energy. Thus we equate these two expressions and solve for the height:

$$\frac{1}{2}(2000)(0.4)^2 = (0.3)(9.8)h$$

Thus $h = 0.54$ m.

9. **(D)** The component of the applied force in the horizontal direction depends on the cosine of the angle. This value decreases with increasing angle. Thus the work decreases as well.

10. **(C)** The work done is independent of the time or path taken since gravity is a conservative force. The power generated is affected by time, but the work done to run up the stairs remains the same as long as the same mass is raised to the same height.

Free-Response Problems

1. (a) The change in potential energy is a measure of the initial energy and equals (0.75)(9.8)(2) = 14.7 J. After the sphere has fallen 2 m, its velocity is 5 m/s, so the kinetic energy is given by

$$KE = \left(\frac{1}{2}\right)(0.75)(5)^2 = 9.375\,J$$

The work done by friction is due to a nonconservative force that is equal to the difference between the final and initial energies:

$$E_f - E_i = 9.375\,J - 14.7\,J = -5.325\,J$$

Therefore, $W_f = -5.325$ J.

(b) The average frictional force is equal to the work done divided by the displacement of 2 m. Thus

$$\mathbf{f} = -2.67\ N$$

which of course is negative since it opposes the motion.

2. The loss of potential energy is balanced by a gain in elastic potential energy for the spring and in kinetic energy for the falling mass if we assume that the starting energy for the system is zero relative to the starting point for the mass. In the absence of friction, the displacement of the mass is equal to the elongation of the spring. Thus we can equate our energies and write:

$$0 = -mgh + \frac{1}{2}kx^2 + \frac{1}{2}mv^2$$

If we substitute the known numbers, we get

$$0 = -(15)(9.8)(0.3) + \left(\frac{1}{2}\right)(500)(0.3)^2 + \left(\frac{1}{2}\right)(15)(\mathbf{v}^2)$$

Solving for velocity \mathbf{v} gives $\mathbf{v} = 1.7$ m/s.

3. In this problem, the work done by gravity down the incline is affected by the work done by friction. Together, the net work is applied to stretching the spring by an amount equal to the displacement of the mass. Thus we can say

$$W_g - W_f = W_s$$

where W_g is the work done by gravity, W_f is the work done by friction, and W_s is the work done to the spring. Hence:

$$mg \sin\theta\, d - \mu\, mg \cos\theta\, d = \frac{1}{2}kx^2$$

Substituting the known numbers, we get:

$$(1.5)(9.8)(0.16)\sin 35 - \mu(1.5)(9.8)(0.16)\cos 35 = \frac{1}{2}(100)(0.16)^2$$

Solving for the coefficient of friction gives $\mu = 0.036$.

4. The motion of an object is always relative to a given frame of reference. If an object is moving relative to one frame, we can envision a second frame, moving with the object, in which it appears to be at rest. Thus, in one frame, the object possesses kinetic energy because of its relative motion. In the second frame, with the object appearing to be at rest, it does not possess kinetic energy.

5. When you hold up a mass, your arm muscles strain against the force of gravity. This requires energy from your body, which makes you feel tired.

Oscillatory Motion

6

KEY CONCEPTS

→ **SIMPLE HARMONIC MOTION: A MASS ON A SPRING**

→ **SIMPLE HARMONIC MOTION: A SIMPLE PENDULUM**

→ **THE DYNAMICS OF SIMPLE HARMONIC MOTION**

SIMPLE HARMONIC MOTION: A MASS ON A SPRING

From Hooke's law in Chapter 4, we know that a spring will become elongated by an amount directly proportional to the force applied. The force constant, k, relates to the specific amount of force (in newtons) needed to stretch or compress the spring by 1 meter:

$$F = -k\mathbf{x}$$

The negative sign indicates that the force is restorative. One could easily use Hooke's law without the negative sign in the proper context.

Suppose we have a spring with a mass attached to it horizontally in such a way that the mass rests on a flat frictionless surface as shown in Figure 6.1.

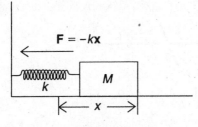

Figure 6.1

> **REMEMBER**
>
> A spring will produce a restoring force if it is stretched or compressed.

If the mass M is pulled a displacement \mathbf{x}, a restoring force of $F = -k\mathbf{x}$ will act on it when released. However, as the mass accelerates past its equilibrium position, its momentum will cause it to keep going, thus compressing the spring. This action will slow the mass down until the same displacement, \mathbf{x}, is reached in compression. The same restoring force will then accelerate the mass back and forth, creating oscillatory motion with a certain period T (in seconds) and frequency f (in hertz or cycles per second). The SI unit for frequency is reciprocal seconds (s^{-1}).

Now, according to Newton's second law of motion, $\mathbf{F} = m\mathbf{a}$, so when the mass was originally extended, the restoring force $F = -k\mathbf{x}$ would also produce an instantaneous acceleration,

given by $\mathbf{F} = m\mathbf{a}$. In other words, $\mathbf{a} = -(k/m)\mathbf{x}$. The fact that the acceleration is directly proportional to the displacement (but in the opposite direction) is characteristic of a special kind of oscillatory motion called **simple harmonic motion**. From this expression, it can be shown that the acceleration is zero at the equilibrium point (where $x = 0$).

We can build up a qualitative picture of this type of motion by considering a displacement versus time graph for this mass-spring system. Suppose we have the system at rest so that the spring is unstretched. We now pull the mass to the right a distance A (called the **amplitude**) and release the mass. This action creates a restoring force that will pull the mass to the left toward the equilibrium point. The velocity will become greater and greater, reaching a maximum as the mass passes through the equilibrium point (at which $\mathbf{a} = 0$). The mass will then move toward the left, slowing down as it compresses the spring (since the acceleration is in the opposite direction). The mass stops momentarily when $x = -A$ (because of conservation of energy) and then accelerates again to maintain simple harmonic motion (in the absence of friction).

A graph of displacement versus time (see Chapter 3) would look like a graph of the **cosine** function since the mass is beginning at some distance from the origin. We could consider the motion in progress from the point of view of the origin, in which case the graph would be of the **sine** function (some textbooks use this format). Figure 6.2 shows the characteristics of acceleration and deceleration as the mass oscillates in a period T with a frequency f (for arbitrary units of displacement and time).

From Chapter 5, we know that the maximum energy of a compressed (or stretched) spring is given by $E = (1/2)kA^2$, for $x = A$ as in our example. Thus the constraining points $X = \pm A$ define the limits of oscillation for the mass.

Figure 6.2

A graph of velocity versus time can be built up qualitatively in much the same way. Recall that the slope of the displacement versus time graph represents the instantaneous velocity. From Figure 6.2, you can see that, at $t = 0$, the graph is horizontal, indicating that $v = 0$. The increasingly negative slope shows that the mass is accelerating "backward" until, at $t = 1$, the line is momentarily straight, indicating maximum velocity when $x = 0$. The slope now gradually approaches zero at $t = 2$, indicating that the mass is slowing down as it approaches $x = -A$. The cycle then repeats itself, producing a graph similar to Figure 6.3.

Finally, analyzing the velocity graph with slopes, we produce an acceleration versus time graph. When $t = 0$, the line is momentarily straight with a negative slope indicating a maximum negative acceleration. When the mass crosses the equilibrium point, velocity is maximum but acceleration is momentarily zero. The acceleration (proportional to displacement) reaches a maximum once again when $x = -A$. The cycle repeats itself, producing Figure 6.4.

Notice that the acceleration graph is approximately shaped like the negative of the displacement graph, as expected!

Figure 6.3

Figure 6.4

To derive the period of oscillation for the mass-spring system, we can consider another form of periodic motion already discussed: uniform circular motion. If a mass is attached to a rotating turntable and then turned onto its side, a projected shadow of the rotating mass simulates simple harmonic motion (Figure 6.5).

Figure 6.5

In this simulation, the radius r acts like the amplitude A, and the frequency and period of the rotation can be adjusted so that, when the shadow appears next to a real oscillating system, it is difficult to decide which one is actually rotating.

$$\omega = 2\pi f = \frac{2\pi}{T}$$

From our understanding of uniform circular motion, we know that the magnitude of the centripetal acceleration is given by

$$\mathbf{a}_c = \frac{4\pi^2 r}{T^2} = \frac{v^2}{r}$$

Since the projected sideways view of this motion appears to approximate simple harmonic motion, we can let the radius r be approximated by the linear displacement x and write

$$\mathbf{a}_x = \frac{4\pi^2 x}{T^2}$$

Since $\mathbf{a} = (k/m)\mathbf{x}$ in simple harmonic motion, we can now write

$$\left(\frac{k}{m}\right)x = \frac{4\pi^2 x}{T^2}$$

$$T = 2\pi\sqrt{\frac{m}{k}}$$

TIP

The period of a mass on a spring is independent of the acceleration due to gravity.

This is the equation for the period of an oscillating mass-spring system in seconds. To find the frequency of oscillation, recall that $f = 1/T$. Also, the angular frequency (velocity) is expressed as $\omega = 2\pi/T$, which implies that $\omega = \sqrt{k/m}$. The units of angular frequency are radians per second. Note there is no dependence on amplitude.

SAMPLE PROBLEM

A 0.5-kg mass is attached to a massless, elastic spring. The system is set into oscillation along a smooth horizontal surface. If the observed period is 0.5 s, what is the value of the force constant k?

Solution

The formula for the period is

$$T = 2\pi\sqrt{\frac{m}{k}}$$

Thus,

$$k = \frac{4\pi^2 m}{T^2}$$

$$k = \frac{(4\pi^2)(0.5 \text{ kg})}{(0.5 \text{ s})^2} = 79 \text{ N/m}$$

SIMPLE HARMONIC MOTION: A SIMPLE PENDULUM

Imagine a pendulum consisting of a mass M (called a bob) and a string of length ℓ that is considered massless (Figure 6.6). The pendulum is displaced through an angle θ that is much less than 1 radian (about 57 degrees). Under these conditions, the pendulum approximates simple harmonic motion and the period of oscillation is independent of amplitude.

Figure 6.6

When the pendulum swings through an arc of length s, it appears to be following a straight path for a suitably chosen small period of time or small section of the arc. In this approximation, we can imagine the pendulum as being accelerated down an incline. The oscillations occur because gravity accelerates the pendulum back to its lowest position. Its momentum maintains the motion through that point, and then the constraining action of the string (providing a centripetal force) causes the pendulum to swing in an upward arc. Conservation of energy will bring the pendulum to the same vertical displacement (or cause it to swing through the same arc length) and then momentarily stop until gravity begins to pull it down again.

If we imagine that an incline of set angle θ is causing the acceleration, then, from our discussions of kinematics, we know that $a = -g\sin\theta$ (where the angle is measured in radians). Now, if θ is sufficiently less than 1 radian, we can write that $\sin\theta \approx \theta$ and therefore that

$$a = -g\sin\theta \approx -g\theta \approx \frac{gs}{\ell}$$

In the above equation we used the known relationship from trigonometry that, in radian measure, if s is the arc length and ℓ corresponds to the effective "radius" of swing, then $s = \ell\theta$.

It should be remembered that these are only approximations, but for angles of less than 20 degrees the approximations are fairly accurate. Since the pendulum now approximates simple harmonic motion, we know that we can find a suitable rotational motion that, when viewed in projection (as well as the pendulum swing being viewed in projection), simulates our simple harmonic motion. Therefore, in a similar fashion to that in the first section of this chapter, we can write

$$a = \frac{4\pi^2 s}{T^2} = \frac{gs}{\ell}$$

where the arc length s is the amplitude of swing in this case.

If we solve for the period T, we finally get

$$T = 2\pi\sqrt{\frac{\ell}{g}}$$

 TIP

The period of a simple pendulum is independent of the mass.

Notice that period is independent of mass but is very sensitive to the local acceleration of gravity. This becomes an excellent way to independently measure the value of **g** in various locations.

SAMPLE PROBLEM

A simple pendulum consists of a string 0.4 m long and a 0.3 kg mass. On an unknown planet, the pendulum is set into oscillation and the observed period is 0.8 s. What is the value of **g** on this planet?

Solution

The period of a simple pendulum is independent of the mass and is given by

$$T = 2\pi\sqrt{\frac{L}{g}}$$

Thus,

$$g = \frac{4\pi^2 L}{T^2} = \frac{(4\pi^2)(0.4 \text{ m})}{(0.8 \text{ s})^2} = 25 \text{ m/s}^2$$

REMEMBER

The period of a system oscillating with simple harmonic motion is independent of the amplitude. In simple harmonic motion, the acceleration is proportional to the *negative* of the displacement!

THE DYNAMICS OF SIMPLE HARMONIC MOTION

From Chapter 5 we know that the work done to compress a spring is also equal to the potential energy stored in the spring. This value is expressed as $(1/2)kx^2$. If the system is set into oscillation by stretching the spring by an amount $x = A$, the maximum energy possessed by the oscillating system is given by $U = (1/2)kA^2$. As the mass oscillates, it reaches maximum velocity when it passes through $x = 0$. At that point, the potential energy of the spring is zero; and since we are treating the cases without friction, the loss of potential energy is balanced by this gain in kinetic energy:

$$KE_{max} = \frac{1}{2}m\mathbf{v}_{max}^2 = \frac{1}{2}kA^2$$

If we want to treat cases in which the mass is between the two extremes of $x = 0$ and $x = \pm A$, we note that the spring will still possess some elastic potential energy (no gravitational potential energy is involved since the mass is oscillating horizontally). This implies that

$$\frac{1}{2}kA^2 = \frac{1}{2}m\mathbf{v}^2 + \frac{1}{2}kx^2$$

If we solve for velocity, we get

$$\mathbf{v} = \pm\sqrt{\frac{k}{m}(A^2 - x^2)}$$

PRACTICE EXERCISES

Multiple-Choice

1. What is the length of a pendulum whose period, at the Equator, is 1 s?

 (A) 0.15 m
 (B) 0.25 m
 (C) 0.30 m
 (D) 0.45 m

2. On a planet, an astronaut determines the acceleration of gravity by means of a pendulum. She observes that the 1-m-long pendulum has a period of 1.5 s. The acceleration of gravity, in meters per second squared, on the planet is

 (A) 7.5
 (B) 15.2
 (C) 10.2
 (D) 17.5

3. When a 0.05-kg mass is attached to a vertical spring, it is observed that the spring stretches 0.03 m. The system is then placed horizontally on a frictionless surface and set into simple harmonic motion. What is the period of the oscillations?

(A) 0.75 s

(B) 0.12 s

(C) 0.35 s

(D) 1.3 s

4. A mass of 0.5 kg is connected to a massless spring with a force constant k of 50 N/m. The system is oscillating on a frictionless horizontal surface. If the amplitude of the oscillations is 2 cm, the total energy of the system is

(A) 0.01 J

(B) 0.1 J

(C) 0.5 J

(D) 0.3 J

5. A mass of 0.3 kg is connected to a massless spring with a force constant k of 20 N/m. The system oscillates horizontally on a frictionless surface with an amplitude of 4 cm. What is the velocity of the mass when it is 2 cm from its equilibrium position?

(A) 0.28 m/s

(B) 0.08 m/s

(C) 0.52 m/s

(D) 0.15 m/s

6. If the length of a simple pendulum is doubled, its period will

(A) decrease by 2

(B) increase by 2

(C) decrease by $\sqrt{2}$

(D) increase by $\sqrt{2}$

7. The pendulums of two grandfather clocks have the same length. One clock (A) runs faster than the other clock (B). Which of the following statements is true?

(A) Pendulum A is more massive.

(B) Pendulum B is more massive.

(C) Pendulum A is located at a higher altitude.

(D) Pendulum B is located at a higher altitude.

8. A 2-kg mass is oscillating horizontally on a frictionless surface when attached to a spring. The total energy of the system is observed to be 10 J. If the mass is replaced by a 4-kg mass, but the amplitude of oscillations and the spring remain the same, the total energy of the system will be

(A) 10 J

(B) 5 J

(C) 20 J

(D) 3.3 J

Free-Response

1. A mass M is attached to two springs with force constants k_1 and k_2, respectively. The mass can slide horizontally over a frictionless surface. Two arrangements, (a) and (b), for the mass and springs are shown below.

 (a) Show that the period of oscillation for situation (a) is given by

 $$T = 2\pi\sqrt{\frac{m(k_1 + k_2)}{k_1 k_2}}$$

 (b) Show that the period of oscillation for situation (b) is given by

 $$T = 2\pi\sqrt{\frac{m}{k_1 + k_2}}$$

 (c) Explain whether the effective spring constant for the system has increased or decreased.

(a)

(b)

2. A mass M is attached to two light elastic strings both having length ℓ and both made of the same material. The mass is displaced vertically upward by a small displacement $\Delta \mathbf{y}$ such that equal tensions \mathbf{T} exist in the two strings, as shown below. The mass is released and begins to oscillate up and down. Assume that the displacement is small enough so that the tensions do not change appreciably. (Ignore gravitational effects.)

 (a) Show that the restoring force on the mass can be given by (for small angles)

 $$F = \frac{-2T\,\Delta y}{\ell}$$

 (b) Derive an expression for the frequency of oscillation.

3. Explain why a simple pendulum undergoes only approximately simple harmonic motion.

4. Explain how the mass of an object can be determined in a free-fall orbit using the concept of simple harmonic motion.

5. Explain why soldiers are ordered to "break step" as they march over a bridge.

ANSWERS EXPLAINED

Multiple-Choice Problems

1. **(B)** If we use the formula for the period of a pendulum, $T = 2\pi\sqrt{\ell/g}$, and square both sides, we can solve for the length:

$$\ell = T^2 \frac{g}{4\pi^2}$$

Using the values given in the question, we find that $\ell = 0.25$ m.

2. **(D)** Again using the formula for the period of a pendulum, this time we solve for the magnitude of the acceleration of gravity:

$$g = \frac{4\pi\ell}{T^2}$$

Using the values given in the question, we find that $\mathbf{g} = 17.5$ m/s².

3. **(C)** We first find the spring constant. From $\mathbf{F} = k\mathbf{x}$, we see that

$$\mathbf{F} = mg\,(0.05)(9.8) = 0.49 \text{ N}$$

Thus

$$k = \frac{F}{x} = \frac{0.49}{0.03} = 16.3 \text{ N/m}$$

Now the period is given by the formula $T = 2\pi\sqrt{m/k}$. Using the values given in the question, we find that $T = 0.35$ s.

4. **(A)** The formula for total energy is $E = (1/2)kA^2$. Using the values given in the question, we get $E = 0.01$ J.

5. **(A)** The formula for any intermediary velocity is $\mathbf{v} = \sqrt{(k/m)(A^2 - x^2)}$. Before substituting the known values, we must change centimeters to meters: 4 cm = 0.04 m and 2 cm = 0.02 m. Then, using these values for amplitude and position, we find that $\mathbf{v} = 0.28$ m/s.

6. **(D)** Since the period of a pendulum varies directly as the square root of the length, if the length is doubled, the period increases by $\sqrt{2}$.

7. **(D)** If clock A runs faster, its period is shorter and therefore must be experiencing a slightly larger value for gravity (see page 139). At higher altitudes, gravity is slightly weaker so clock A must be a lower altitude.

8. **(A)** The maximum energy in the mass-spring system can be expressed independently of the mass; it depends on the force constant and the square of the amplitude. Thus, if the spring and the amplitude of oscillations remain the same, so will the total energy of the system (10 J).

Free-Response Problems

1. (a) When mass M is stretched a distance x, spring k_1 is stretched distance x_1 and spring k_2 is stretched distance x_2. At the point of connection, Newton's third law states that the forces must be equal and opposite. Thus we can write

$$k_1 x_1 = k_2 x_2$$

Since $x = x_1 + x_2$, we have $x_2 = x - x_1$, and so

$$k_1 x_1 = k_2 (x - x_1)$$

$$= k_2 x - k_2 x_1$$

$$k_1 x_1 + k_2 x_1 = k_2 x$$

$$k_2 x = (k_1 + k_2) x_1$$

$$x_1 = \left(\frac{k_2}{k_1 + k_2} \right) x$$

is the expression for the displacement of k_1.

Now, for any spring, let's say spring **1**:

$$\mathbf{F}_1 = k_1 \mathbf{x}_1 = \left(\frac{k_1 k_2}{k_1 + k_2} \right) \mathbf{x}$$

Let's call $(k_1 k_2 / k_1 + k_2) = k'$, so

$$\mathbf{F}_1 = k' \mathbf{x}$$

This is in the form of the equation for simple harmonic motion and therefore is equal to $m\mathbf{a}$ by Newton's second law:

$$m\mathbf{a} = k' \mathbf{x}$$

Thus

$$T = 2\pi \sqrt{\frac{m}{k'}} = 2\pi \sqrt{\frac{m(k_1 + k_2)}{k_1 k_2}}$$

This is the period of oscillation for arrangement (a).

(b) In this case, each spring is displaced the same distance as the mass, since the springs are on either side of the mass. Thus we can write

$$\mathbf{F} = -(k_1 + k_2)\mathbf{x}_1$$

and set $k' = k_1 + k_2$. We therefore have the equation for the period of oscillation

$$T = 2\pi \sqrt{\frac{m}{k_1 + k_2}}$$

for arrangement (b).

(c) Situation (a) suggests that when the springs are connected in series, the effective spring constant decreases. Situation (b) suggests that when the springs are connected in parallel, the effective spring constant increases.

2. (a) In the diagram, we can see that, since Δy is small, $\theta = \Delta y / \ell$. Now, since θ (in radians) is small, $\theta \approx \sin\theta \approx \Delta y / \ell$. From the geometry, we see that the net restoring force is given by

$$\mathbf{\Sigma F} = -2T\sin\theta = \frac{-2T\,\Delta y}{\ell}$$

(b) Since this situation is approximating simple harmonic motion, we can write

$$\mathbf{F} = -k\mathbf{y}$$

$$-2T\frac{\Delta y}{\ell} = -k\,\Delta y$$

$$k = \frac{2T}{\ell}$$

so we must then have

$$f = \frac{1}{2\pi}\sqrt{\frac{2T}{\ell m}}$$

3. A pendulum represents only approximately simple harmonic motion since only for small angles is the acceleration proportional to the displacement (angular displacement in this case).

4. Since the period of a horizontally oscillating mass on a spring is independent of the acceleration due to gravity, the object's mass can be determined using springs and horizontal oscillations.

5. The rhythmic marching of soldiers can set up resonance in a bridge where the frequency of the march matches the natural vibrating frequency of the bridge. If amplified, these resonant vibrations can cause damage to the bridge.

Waves and Sound

7

KEY CONCEPTS

→ PULSES
→ WAVE MOTION
→ TYPES OF WAVES
→ STANDING WAVES AND RESONANCE
→ SOUND
→ THE DOPPLER EFFECT

PULSES

A pulse is a single vibratory disturbance in a medium. An example of a pulse is seen in Figure 7.1. If a string fixed at both ends and made taut, under a tension T (in newtons), is given a quick up and down snap, an upwardly pointing pulse is directed from the left to the right. The pulse appears to travel with a velocity **v** down the string. In actuality, the energy transferred to the string causes segments to vibrate up and down successively. This effect produces the illusion of a continuous pulse. Only energy is transferred by the pulse, and because the vibration is perpendicular to the apparent direction of motion, the pulse is said to be **transverse**. The **amplitude** of the pulse is the displacement of the disturbance above the level of the string.

Transverse pulse

Figure 7.1

If the tension in the string is increased, the velocity of the pulse increases. If a heavier string is used (greater mass per unit length), the pulse appears to move slower. Careful measurements of these observations leads to the following equation for the velocity of the pulse:

$$\mathbf{v} = \sqrt{\frac{T}{M/\ell}}$$

where T is the tension in newtons, M is the mass in kilograms, and ℓ is the length of the string in meters. In general, the velocity of pulses and waves is dependent on the **medium**. The medium is the material through which the waves and pulses are traveling.

When the pulse reaches one boundary, the energy transferred is directed upward against the wall, creating an upward force. Since the wall is rigid, the reaction to this action is a downward force. The string responds by being displaced downward and is reflected back. The result of this boundary interaction, illustrated in Figure 7.2, is observed as an inversion of the pulse upon reflection. Some energy is lost in the interaction, but most is reflected back with the pulse. This is known as "phase inversion."

TIP

Waves transfer only energy.

(a) Incidence

(b) Reflection

Figure 7.2

At a nonrigid boundary, say between two strings of different masses (but equal tensions), a different effect occurs. When the pulse reaches the nonrigid boundary, the upward displacement causes the second string to also be displaced upward. The magnitude of the second displacement depends on the mass density and tension in the second string. Thus, the transmitted pulse has an upward orientation and may travel with a larger or smaller velocity, depending, in this case, on the mass density.

The reflected pulse will be upward in orientation since no inversion takes place with a nonrigid boundary unless the difference between the two media (as measured by the second string's inertia) is large enough to behave as a semirigid boundary. As an example, consider a light string attached to a heavy rope, with the pulse traveling from the string to the rope. Figure 7.3 illustrates both cases.

Case I: Rigid reflection

Case II: Nonrigid reflection

Figure 7.3

Since pulses transmit only energy, when two pulses interact, they obey a different set of physical laws than when two pieces of matter interact. Pulses are governed by the **principle of superposition**, which states that, when two pulses interact at the same point and at the same time, the interaction produces a single pulse whose amplitude displacement is equal to the sum of the displacements of the original two pulses. After the interaction, however,

both pulses continue in their original directions of motion, unaffected by the interaction. Sometimes, this interaction is called **interference**.

When a pulse with an upward displacement interacts with another pulse with an upward displacement, the resulting pulse has a displacement larger than that of either original pulse (equal to the numerical sum of these pulses). This interaction is called **constructive interference**.

When a pulse with an upward displacement interacts with a pulse that has a downward displacement, the interaction is called **destructive interference**, and the resulting pulse has a smaller displacement than either original pulse (equal to the numerical difference of these pulses). Figure 7.4 illustrates these two types of interferences; a and b designate the two original amplitudes and p is a point on the string.

(a) Constructive interference (b) Destructive interference

Figure 7.4

In the destructive interference case, it is possible, if the amplitudes are equal, that the interaction will momentarily cancel out both pulses. In any case, the orientation of the resulting pulse depends on the magnitude of each amplitude.

WAVE MOTION

If a continuous up and down vibration is given to the string in Figure 7.1, the resulting set of transverse pulses is called a **wave train** or just a **series of waves**. Whereas the pulse was just an upward- or downward-oriented, transverse disturbance, a wave consists of a complete up and down segment. Waves are thus periodic disturbances in a medium. The number of waves per second is called the **frequency**, designated by the letter f and expressed in units of reciprocal seconds (s$^{-1}$) or **Hertz** (Hz). The time required to complete one wave cycle is called the **period**, designated by the capital letter T and expressed in seconds. The frequency and period of a wave are reciprocals of each other, so that $f = 1/T$.

Like pulses, waves transmit only energy. The particles in the medium vibrate only up and down as the transverse waves approach and pass a given point. Since there is a contiuous series of waves, many points in the medium will be moving up or down in unison. The **phase** of a wave is defined to be the relative position of a point on a wave with respect to another point on the same wave.

The distance between any two successive points in phase is a measure of the **wavelength**, designated by the Greek letter λ (lambda) and measured in meters. The peaks of the wave are called **crests**; the valleys, **troughs**. Thus, one wavelength can also be measured as the distance between any two successive crests or troughs. The **amplitude**, A, of the wave is the

distance, measured in meters, of the maximum displacement, up or down, above the normal rest position (equilibrium level). Figure 7.5 illustrates a typical transverse wave.

Figure 7.5 Transverse Wave

The sinusoidal nature of the wave is similar to the graph of displacement versus time for a mass on a spring undergoing simple harmonic motion. We recall from Chapter 6 that the maximum energy in a simple harmonic motion system is directly proportional to the square of the amplitude. This is indeed the case with a simple wave motion like the one described in Figure 7.5. In this illustration we can identify points A and A′ as all in phase. Points B and B′ are also in phase, and the distance from B to B′ can also be used to measure the wavelength. Finally, the velocity of the transverse wave is given by the equation $\mathbf{v} = f\lambda$.

Since each wave carries energy, it should not be surprising that the frequency is also proportional to the energy of a wave. The amplitude is related to what we might consider the wave's **intensity**. In sound, this property might be called **volume**. The frequency, however, measures the **pitch** of the wave. Waves of higher frequency transmit, at the same amplitude, more energy per second than waves of lower frequency.

There are many different kinds of frequencies that interact with human senses. It is worthwhile, therefore, to recall that the prefix *kilo-* represents 10^3, the prefix *mega-* represents 10^6, and the prefix *giga-* represents 10^9.

TYPES OF WAVES

In physics we usually deal with two types of waves, mechanical and electromagnetic. Waves that result from the vibration of a physical medium (a drum, a string, water, etc.) are called **mechanical waves**. Waves that result from electromagnetic interactions (light, X rays, radio waves, etc.) are called **electromagnetic waves**. These electromagnetic waves are special since they do not require a physical medium to carry them. Also, all electromagnetic waves are transverse in nature.

Another way to set up periodic disturbances in the spring is to pull the spring back and forth along its longitudinal axis. The resulting disturbances consist of regions of compressions and expansions that appear to travel parallel to the disturbances themselves. These waves are called **longitudinal** (Figure 7.6) or **compressional** waves. Sound is an example of a longitudinal wave. The vibrations of an object in the air create pressure differences that alternately expand and contract the air and that, when impacted on our ears, create that phenomenon known as **sound**.

> **REMINDER**
>
> Make sure you know the differences between **transverse** and **longitudinal waves**. You should also know the differences between **mechanical** and **electromagnetic waves**.

Figure 7.6 Longitudinal Wave

In a transverse wave, the vibrations must be perpendicular to the direction of apparent motion. However, if we cut a plane containing the directions of vibration, we find that there are many possible three-dimensional orientations in which the vibrations can still be considered perpendicular to the direction of travel. Thus, we can select one or more planes containing our chosen vibrational orientation. For example, a sideways vibration is just as "transverse" as an up and down or diagonal vibration. This selection process, known as **polarization** (see Figure 7.7), applies only to transverse waves.

In a longitudinal wave, there is only one way to make the vibrations parallel to the direction of travel. Special devices have been developed to test for polarization in mechanical and electromagnetic waves. Since all electromagnetic waves can be polarized, physicists conclude that they must be transverse waves. Since sound cannot be polarized, physicists conclude that sound waves are longitudinal.

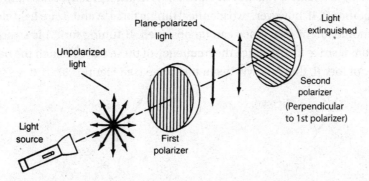

Figure 7.7 Used with permission of Prentice Hall, Needham, MA.

STANDING WAVES AND RESONANCE

Consider Figure 7.1 again. There are several ways in which we can make the taut string vibrate transversely. One way is make the entire string move up and down as a single unit. This is the easiest frequency mode of vibration possible and is called the **fundamental mode**. If we increase the frequency, something interesting happens. The waves reaching a boundary reflect off it inverted and match perfectly, in amplitude and frequency, the remaining incoming waves. In this situation, the apparent horizontal motion of the wave stops and we have a **standing wave**, which appears to be segmented by **nodal points**. These nodal points correspond to points where no appreciable displacement takes place.

Figure 7.8 shows a standing wave in various vibrational modes. Figure 7.8a illustrates the fundamental mode. In Figure 7.8b we see the second mode, in which one nodal point appears. This nodal point occurs at the one-half wavelength mark, so that, for a string of length ℓ, $\lambda = \ell$ (at this frequency). In the fundamental mode of Figure 7.8a, $\lambda = 2\ell$. In Figure 7.8c, there are two nodal points and $\lambda = 2\ell/3$.

This standing-wave pattern is a form of interference, and with sound the nodal points would be determined by a significant drop in intensity. With light, we would observe a darker region relative to the surrounding area. With a string, we would see the characteristic segmented pattern shown in Figure 7.8. Note that each segment is half a wavelength, bounded by 2 nodes with an antinode in the middle.

$$a \quad \ell = \frac{\lambda}{2}$$

$$b \quad \ell = \lambda$$

$$c \quad \ell = \frac{3}{2}\lambda$$

$$d \quad \ell = 2\lambda$$

Figure 7.8

Standing waves can be manipulated so that the maximum points continuously reinforce themselves. This buildup of wave energy due to the constructive interference of standing waves is called **resonance**. Resonance can also be induced by an external agent.

All objects have a natural vibrating frequency. When a glass or bell is struck, only one fundamental characteristic frequency of vibration is heard (actually, the sound is a complex mixture of vibrations). If, however, two identical tuning forks, *A* and *B*, are held close together, then the phenomenon of resonance can be observed. If tuning fork *A* is struck, the waves emanating from it strike fork *B*. Since the frequency of these waves match the natural vibrating frequency of fork *B*, that fork will begin to vibrate (see Figure 7.9).

A B

Figure 7.9 Resonance in Two Identical Tuning Forks

Resonance also explains how an opera singer can shatter a crystal wine glass. More important, it explains why soldiers are ordered to "break march" when crossing a bridge. The rhythmic marching can set up a resonance vibration and perhaps collapse the bridge. In November 1940, a resonance vibration caused by a light gale wind generated catastrophic torsional vibrations in the Tacoma Narrows Bridge in Washington State. The violent convulsions were photographed and are shown as a classic illustration of the principle of resonance. Nicknamed "Galloping Gertie," the bridge has become a testament to the need for engineers to be very careful when considering the possible effects of resonance.

SOUND

Sound is a longitudinal mechanical wave. Air molecules are alternately compressed and spaced out (rarefied) as pressure differences move through the air. When lightning occurs, the expansion of air due to the very high temperature of the lightning bolt creates the violent sound known as thunder.

Since sound is "carried" by air molecules, it is temperature dependent. At 0 degree Celsius, the velocity of sound in air is 331 meters per second. For each 1-degree rise in temperature, the velocity of sound increases by 0.6 meter per second. The study of sound is called **acoustics**, and longitudinal waves in matter are sometimes termed **acoustical waves**.

The ability of sound waves to pass through matter depends on the structure of the matter involved. Thus, sound travels slower in a gas, in which the molecules have more random motion, than in a liquid or a solid, which has a more "rigid" structure. In Table 7.1 the velocities of sound in selected substances are listed.

Human hearing can detect sound in a range from 20 to 20,000 hertz. Sound waves exceeding a frequency of 20,000 hertz are called **ultrasonic** waves. The amplitude of the sound wave is the intensity of **loudness** of the wave, while the frequency relates to the **pitch**. When two sound waves interfere, the regions of constructive and destructive interference produce the

> **THINK ABOUT IT**
>
> Since sound is a longitudinal wave, it cannot be polarized. Polarization can be used to test whether a wave has a transverse nature. For example, since light exhibits the properties of interference and polarization, it contains transverse electromagnetic waves.

Table 7.1

Velocities of Sound in Selected Substances	
Substance	Velocity (m/s)
Gases (0°C)	
Carbon dioxide	259
Air	331
Helium	965
Liquids (25°C)	
Ethyl alcohol	1207
Water, pure	1498
Water, sea	1531
Solids	
Lead	1200
Wood	~4300
Iron and steel	~5000
Aluminum	5100
Glass (Pyrex)	5170

phenomena known as **beats**. The number of beats per second is equal to the frequency difference.

Interference, for any kind of wave, is dependent on what is called the **path-length difference**. Consider two point sources of sound, A and B, and a receiver some distance away. If the distance from source A to the receiver is ℓ_A and the distance from source B to the receiver is ℓ_B, the receiver will be at a point of constructive interference if the path-length difference, $\ell_A - \ell_B$, is equal to a whole multiple of the wavelength, $n\lambda$. Destructive interference will occur if the path-length difference is equal to an odd multiple of the half-wavelengths, $(n + 1/2)\lambda$.

Another phenomenon associated with interference is **diffraction**. When a wave encounters a boundary, the wave appears to bend around the corners of the boundary. This effect, known as **diffraction**, occurs because at the corners the wave behaves like a point source and creates circular waves. These waves, because of their shape, reach behind the corners, and this continuous effect gives the illusion of wave bending. In Figure 7.10a, we observe a series of straight waves, made in a water tank, and the resulting diffraction at a corner. Figure 7.10b shows the diffraction of waves as they pass through a narrow opening. "Narrow" is relative to the wavelength of wave present. Waves do not show significant diffraction through openings much larger than their wavelength.

(a) Diffraction around a corner

(b) Diffraction through a narrow opening

Figure 7.10

THE DOPPLER EFFECT

Almost everyone has had the experience of hearing a siren pass by. Even though the siren is emitting a sound at a single frequency, the changing position of the siren, relative to the hearer, produces an apparent change in the frequency. As the siren approaches, the pitch is increased; as the siren passes, the pitch is decreased. This phenomenon is called the **Doppler effect**.

Resonance, interference, diffraction, and the Doppler shift are phenomena associated with **ALL** waves!

In Figure 7.11 the source is moving; let's say toward point A. Then, for each period of time T between waves, the circular waves will not be concentric. In other words, the spacing between each two successive waves will be reduced by an amount equal to the distance traveled by the source in time T. Thus, an apparent increase in frequency is experienced at point A, while at point B there is an apparent decrease in frequency.

Figure 7.11

This Doppler shift, as it is known, is the result of the relative motion between the source of the wave and the receiver or observer. This can be accomplished by any combination of source and observer movement. As long as the two are approaching, the received frequency will be higher. When the two are getting farther apart, the received frequency will be lower. The amount of the shift in frequency is related to the relative velocity of the two compared with the velocity of the wave itself.

SUMMARY

- Mechanical waves are periodic vibratory disturbances in a medium.
- A pulse is a single vibratory disturbance.
- A pulse or wave is transverse if its vibrations are perpendicular to the direction of propagation.
- A pulse or wave is longitudinal if its vibrations are parallel to the direction of motion.
- Transverse waves can be polarized. This means that we can select the preferred orientation of vibrations relative to the direction of propagation. Longitudinal waves cannot be polarized.
- Waves transmit only energy. The principle of superposition states that waves can be added together.
- The amplitude of a wave is its maximum displacement from its equilibrium position.
- The frequency of a wave is the number of cycles per second.
- The period of a wave is the time that it takes to complete one cycle and is equal to the reciprocal of the frequency.
- Particles in a medium that display the same state of motion, simultaneously, are said to be in phase.
- The "wavelength" of a wave is the distance between any two successive points in phase.
- The wave velocity is equal to the product of the frequency times the wavelength.
- A standing wave is a wave in which incident and reflected waves combine to produce a wave that appears to be "standing" in one place.
- Standing wave nodes are points where there is no appreciable displacement. Nodes occur every half-wavelength.
- Resonance is the maximum transfer of energy from one body to another that shares the same natural vibrating frequency.
- Reflection is the returning of a wave in the opposite direction due to a difference in media at a boundary.
- Refraction is the bending of a wave as it enters a new medium, at an oblique angle, with different propagation speed.
- Diffraction is the bending of waves around obstacles in a given medium or the outward speed as the wave passes through small openings.
- Interference is the superposition of two waves of identical or opposite phase to produce constructive or destructive interference, respectively.
- Sound is a longitudinal mechanical wave.
- The Doppler effect states that when a source is moving relatively toward an observer, there is an apparent increase in frequency. If the relative motion is away from source or observer, there is an apparent decrease in frequency.

Problem-Solving Strategies for Waves and Sound

Solving wave motion problems involves remembering the basic physical concepts involved. For transverse waves, the only particle motion in the medium will be up and down. If a series of waves is presented, you must resist the temptation of viewing labeled

points as beads on a wire. As a wave approaches a point, it will first go up and then go down. Points that are in phase are either going up at the same time or going down at the same time.

Transverse waves can be polarized, meaning that you can select a preferred axis to contain the vibrations and have them remain perpendicular to the direction of apparent wave motion. Longitudinal waves cannot be polarized, and the vibrations remain parallel to the apparent direction of wave motion.

Sound waves travel through a medium, and their speed is determined by the molecular structure of the matter involved. In air, the speed of sound increases with increasing temperature. Sound wave interference is manifested by the beat pulsations heard when two frequencies are experienced simultaneously.

PRACTICE EXERCISES

Multiple-Choice

1. A stretched string has a length of 1.5 m and a mass of 0.25 kg. What must be the tension in the string in order for pulses in the string to have a velocity of 5 m/s?

 (A) 2.45 N
 (B) 12.5 N
 (C) 4.2 N
 (D) 150 N

2. A stretched string is vibrated in such a way that a standing wave with two nodes appears. The distance between the nodes is 0.2 m. What is the wavelength of the standing wave?

 (A) 0.4 m
 (B) 0.3 m
 (C) 0.2 m
 (D) 0.6 m

3. What is the wavelength of sound produced at a frequency of 300 Hz when the air temperature is 20°C?

 (A) 1.10 m
 (B) 1.30 m
 (C) 0.80 m
 (D) 1.14 m

4. Two tuning forks are vibrating simultaneously. One fork has a frequency of 256 Hz; the other, a frequency of 280 Hz. The number of pulsational beats per second heard will be

(A) 256
(B) 536
(C) 1.1
(D) 24

5. In a stretched string with a constant tension T, as the frequency of the waves increases, the wavelength

(A) increases
(B) decreases
(C) remains the same
(D) increases, then decreases

6. What is the period of a wave that has a frequency of 12,000 Hz?

(A) 36.25 s
(B) 0.000083 s
(C) 0.0275 s
(D) 12,000 s

7. Sound waves travel fastest in

(A) a vacuum
(B) air
(C) water
(D) wood

8. The amplitude of a sound wave is related to its

(A) pitch
(B) loudness
(C) frequency
(D) resonance

9. At 25°C, a sound wave takes 3 s to reach a receiver. How far away is the receiver from the source?

(A) 1038 m
(B) 993 m
(C) 1215 m
(D) 1068 m

Free-Response

1. What must be the tension in a 0.25-m string with a mass of 0.30 kg so that its fundamental frequency mode is 400 Hz?

2. Why should people not march in unison when crossing over a bridge?

3. Apartment dwellers are used to hearing the "boom-boom" sound of bass tones when neighbors play their stereos too loudly. What can account for this phenomenon?

4. People who live near airports claim that they hear planes that are on the ground more during the summer. Explain why this might occur.

ANSWERS EXPLAINED

Multiple-Choice Problems

1. **(C)** The formula for wave velocity in a string is

$$v = \sqrt{\frac{T}{M/\ell}}$$

Using the given information and solving for tension leads to **T** = 4.2 N.

2. **(A)** Standing-wave nodes occur at half-wavelength intervals. Thus,

$$\lambda = 2(0.2) = 0.4 \text{ m}$$

3. **(D)** At 20°C, the speed of sound is 330 + (0.6)(20) = 343 m/s. Since **v** = fλ, we get a wavelength of λ = 1.14 m.

4. **(D)** The number of beats per second is equal to the frequency difference: 280 − 256 = 24.

5. **(B)** Since **v** = fλ and since, for constant tension, the velocity is constant, as the frequency increases, the wavelength decreases.

6. **(B)** Frequency and period are reciprocals of each other. Thus

$$T = \frac{1}{12,000} = 0.000083 \text{ s}$$

7. **(D)** Because of molecular arrangement, sound travels faster in solids than in liquids or gases.

8. **(B)** Amplitude is related to the intensity of a wave. In sound, wave intensity is perceived as loudness.

9. **(A)** At 25°C, the speed of sound is 331 + (0.6)(25) = 346 m/s. Since **x** = **v**t,

$$x = (346)(3) = 1038 \text{ m}$$

Free-Response Problems

1. At fundamental frequency, we have

$$\lambda = 2\ell = (2)(0.25) = 0.5 \text{ m}$$

Now, $\mathbf{v} = f\lambda$, which means that

$$\mathbf{v} = (400)(0.5) = 200 \text{ m/s}$$

We can now use the formula for the velocity in a fixed string:

$$\mathbf{v} = \sqrt{\frac{\mathbf{T}}{M/\ell}}$$

Solving for the tension gives $\mathbf{T} = 48{,}000$ N.

2. People should not march in unison when crossing over a bridge because the uniform vibrations may induce resonance, which can be "destructive."

3. The resonant frequency of apartment building walls is quite low, and so low-frequency bass tones resonate through the walls as the "boom-boom" sound so familiar to apartment building dwellers.

4. Since the velocity of sound increases with temperature, the hot summer air carries the sound waves farther.

Gravitation

KEY CONCEPTS
→ NEWTON'S LAW OF UNIVERSAL GRAVITATION
→ GRAVITATIONAL ENERGY

NEWTON'S LAW OF UNIVERSAL GRAVITATION

We already know that all objects falling near the surface of Earth have the same acceleration, given by $\mathbf{g} = 9.8$ m/s$^2$. The value of this constant can be determined from the independence of the period of a pendulum on the mass of the bob. This "empirical" verification is independent of any "theory" of gravity.

The weight of an object on Earth is given by $\mathbf{F_g} = m\mathbf{g}$, which represents the magnitude of the force of gravity due to Earth that is acting on the object. From our discussion in Chapter 3, we know that gravity causes a projectile to assume a parabolic path. Isaac Newton, in his book *Principia*, extended the idea of projectile motion to an imaginary situation in which the velocity of the projectile was so great that the object would fall and fall, but the curvature of the earth would bend away and leave the projectile in "orbit." Newton conjectured that this might be the reason why the Moon orbits Earth. This is shown in Figure 8.1.

Figure 8.1

To answer this question, Newton first had to determine the centripetal acceleration of the Moon based on observations from astronomy. He knew the relationship between centripetal acceleration and period. We have written that relationship as

$$\mathbf{a}_c = \frac{4\pi^2 R}{T^2}$$

where R is the distance to the Moon (in meters) and T is the orbital period (in seconds). From astronomy we know that $R = 3.8 \times 10^8$ m, and since the Moon orbits Earth in 27.3 days, we have $T = 2.3 \times 10^6$ s. Using these values, we find that the magnitude of $a_c = 2.8 \times 10^{-3}$ m/s$^2$. Newton realized that some kind of universal gravity was acting as the centripetal force on the Moon.

Using his third law of motion, Newton realized that the force that Earth exerts on the Moon should be exactly equal, but opposite, to the force that the Moon exerts on Earth (observed as tides). This relationship implied that the force should be dependent on the mass of Earth, and this mutual interaction implied that the force of gravity should be proportional to the product of both masses. In other words, Newton's law of gravity could be expressed as

$$F_g = \frac{GM_1M_2}{R^2}$$

where R is measured from center to center. This is a vector equation in which the force of gravity is directed inward toward the center of mass for the system (in this case, near the center of Earth). Since Earth is many times more massive than the Moon, the Moon orbits Earth, and not vice versa.

The value of G, called the universal gravitational constant, was experimentally determined by Henry Cavendish in 1795. In modern units $G = 6.67 \times 10^{-11}$ N \cdot m$^2$/kg$^2$. If we recognize that $\mathbf{F} = m\mathbf{a}$, and then if we consider M_1 to equal the mass of an object of mass m, and M_2 equal to the mass of Earth, M_E, the acceleration of a mass m near the surface of Earth is given by

$$F_g = ma$$

$$a = \frac{GM_E}{R_E^2}$$

where R_E is the radius of Earth in meters. Using known values for these quantities, we discover that $\mathbf{a} = 9.8$ m/s$^2 = \mathbf{g}$!

Thus we have a theory that accounts for the value of the known acceleration due to gravity. In fact, if we replace the mass of Earth by the mass of any other planet, and the radius of Earth by the corresponding radius of the other planet, the above formula allows us to determine the value of \mathbf{g} on any planet or astronomical object in the universe! For example, the value of \mathbf{g} on the Moon is approximately 1.6 meters per second squared, or about one-sixth the value on Earth. Thus, objects on the Moon weigh one-sixth as much as they do on Earth. This formula also allows us to solve for the acceleration due to gravity at any distance above Earth's surface. Replace R_E with any R greater than R_E.

TIP

Newton's law of universal gravitation is referred to as an inverse square law. For example, if the distance between the masses is doubled, the force between them is one-fourth.

TIP

Notice that the acceleration due to gravity does not depend on the mass of the falling object. This is consistent with Galileo's observations of falling bodies and the period of a pendulum.

Calculate the gravitational force of attraction between a 2,000-kg car and a 12,000-kg truck, separated by 0.5 m.

Solution

We use Newton's law of gravitation:

$$F_g = \frac{GM_1M_2}{R^2}$$

$$F_g = \frac{(6.67 \times 10^{-11} \text{ N} \cdot \text{m}^2/\text{kg}^2)(2{,}000 \text{ kg})(12{,}000 \text{ kg})}{(0.5 \text{ m})^2} = 6.4 \times 10^{-3} \text{ N}$$

GRAVITATIONAL ENERGY

In Chapter 5 we saw that the amount of work done (by or against gravity) when vertically displacing a mass is given by the change in the gravitational potential energy:

$$\Delta \text{PE} = \Delta m\mathbf{g}b$$

This formula is good only for h values that are small when compared to R_E and only at the surface of Earth.

We now know that the value of \mathbf{g} is not constant but varies inversely with the square of the distance from the center of Earth. Also, since we want the potential energy to become smaller the closer we get to Earth, we can use the results of the previous section to rewrite the potential energy formula as

$$\text{PE} = \frac{-GM_0M_E}{R_E}$$

The "escape velocity" from the gravitational force of Earth can be determined by considering the situation where an object has just reached infinity, with zero final velocity, given some initial velocity at any direction away from the surface of Earth. We designate that escape velocity as \mathbf{v}_{esc}, and state that, when the final velocity is zero (at infinity), the total energy must be zero, which implies

$$\frac{1}{2}M_0\mathbf{v}_{esc}{}^2 = \frac{GM_0M_E}{R_E}$$

The mass of the object can be eliminated from the relationship, leaving

$$\mathbf{v}_{esc} = \sqrt{\frac{2GM_E}{R_E}}$$

An object can leave the surface of Earth with any velocity. There is, however, one minimum velocity at which, if the spacecraft coasted, it would not fall back to Earth because of gravity.

THINK ABOUT IT

Notice that both the **escape velocity** and the **orbital velocity** depend on the mass of Earth and not on the mass of the object.

The orbital velocity can be determined by assuming that we have an approximately circular orbit (see Chapter 3). In this case, we can set the centripetal force equal to the gravitational force:

$$\frac{GM_0 M_E}{R_E{}^2} = \frac{M_0 \mathbf{v}_0{}^2}{R_E}$$

Eliminating the mass of the object from the equation leaves

$$\mathbf{v}_{orbit} = \sqrt{\frac{GM_E}{R_E}}$$

By comparing the two expressions for escape velocity and orbital velocity, we see that

$$\mathbf{v}_{esc} = \sqrt{2}\,\mathbf{v}_{orbit}$$

Of course, we could repeat our derivation of orbital speed for any planet of arbitrary mass M and any arbitrary orbital radius R:

$$\mathbf{v}_{orbit} = \sqrt{\frac{GM}{R}}$$

By assuming the orbit is circular, we can substitute in $2\pi R/T$ for \mathbf{v}_{orbit}. Simplifying and collecting like terms gives the relationship first made famous by Kepler in 1619 for all orbiting objects (orbiting around the same central mass):

$$\frac{T^2}{R^3} = \frac{4\pi^2}{GM} = \text{Constant}$$

SAMPLE PROBLEM

(a) What is the magnitude of the acceleration due to gravity at an altitude of 400 km above the surface of Earth?

(b) What percentage loss in the weight of an object results?

Solution

(a) The formula for the acceleration due to gravity above Earth's surface is

$$g = \frac{GM_E}{(R_E + h)^2}$$

We have $M_E = 5.98 \times 10^{24}$ kg, $R_E = 6.38 \times 10^6$ m, $h = 400$ km $= 0.4 \times 10^6$ m. Substituting these values, as well as the known value for G, given in Section 12.1, we get $g = 8.67$ m/s$^2$.

(b) The fractional change in weight is found by comparing the value of g at 400 km to its value at Earth's surface: $8.67/9.8 = 0.885$. Thus, there is an 11.5% loss of weight at that height.

Three uniform spheres of masses 1 kg, 2 kg, and 4 kg are placed at the corners of a right triangle as shown below. The positions relative to the coordinate system indicated are also shown. What is the magnitude of the resultant gravitational force on the 4-kg mass if we consider that mass to be fixed?

Solution

In this problem, we have to determine separately the force of gravitational attraction between each of the smaller masses and the 4-kg mass. Then we must do a vector sum of these forces.

We begin by calculating the force between the 1-kg mass and the 4-kg mass:

$$F_{1-4} = \frac{(6.67 \times 10^{-11})(1)(4)}{2^2} = 6.67 \times 10^{-11} \text{ N}$$

The direction is to the right and is therefore considered positive.

For the 2-kg mass and the 4-kg mass, the downward direction is taken as negative:

$$F_{2-4} = \frac{(6.67 \times 10^{-11})(2)(4)}{3^2} = 5.93 \times 10^{-11} \text{ N}$$

The magnitude of the resultant force is given by the Pythagorean theorem, since F_{1-4} is horizontal and F_{2-4} is vertical.

$$F = \sqrt{(6.67 \times 10^{-11})^2 + (5.93 \times 10^{-11})^2} = 8.92 \times 10^{-11} \text{ N}$$

PRACTICE EXERCISES

Multiple-Choice

1. What is the value of **g** at a height above Earth's surface that is equal to the radius of Earth?

 (A) 9.8 N/kg
 (B) 4.9 N/kg
 (C) 6.93 N/kg
 (D) 2.45 N/kg

2. A planet has half the mass of Earth and half the radius. Compared to the acceleration due to gravity near the surface of Earth, the acceleration of gravity near the surface of this other planet is

 (A) twice as much
 (B) one-fourth as much
 (C) half as much
 (D) the same

3. Which of the following is an expression for the acceleration of gravity with uniform density and radius R?

 (A) $G(4\pi\rho/3R^2)$
 (B) $G(4\pi\rho R^2/3)$
 (C) $G(4\pi\rho/3R)$
 (D) $G(4\pi R\rho/3)$

4. What is the orbital velocity of a satellite at a height of 300 km above the surface of Earth? (The mass of Earth is approximately 6×10^{24} kg, and its radius is 6.4×10^6 m.)

 (A) 5.42×10^1 m/s
 (B) 1.15×10^6 m/s
 (C) 7.7×10^3 m/s
 (D) 6×10^6 m/s

5. What is the escape velocity from the Moon, given that the mass of the Moon is 7.2×10^{22} kg and its radius is 1.778×10^6 m?

 (A) 1.64×10^3 m/s
 (B) 2.32×10^3 m/s
 (C) 2.69×10^6 m/s
 (D) 5.38×10^6 m/s

6. A "black hole" theoretically has an escape velocity that is greater than or equal to the velocity of light (3×10^8 m/s). If the effective mass of the black hole is equal to the mass of the Sun (2×10^{30} kg), what is the effective "radius" (called the "Schwarzchild radius") of the black hole?

 (A) 3×10^3 m
 (B) 1.5×10^3 m
 (C) 8.9×10^6 m
 (D) 4.45×10^6 m

7. What is the gravitational force of attraction between two trucks, each of mass 20,000 kg, separated by a distance of 2 m?

 (A) 0.057 N
 (B) 0.013 N
 (C) 0.0067 N
 (D) 1.20 N

8. The gravitational force between two masses is 36 N. If the distance between masses is tripled, the force of gravity will be

 (A) the same
 (B) 18 N
 (C) 9 N
 (D) 4 N

Free-Response

1. Find the magnitude of the gravitational field strength **g** at a point P along the perpendicular bisector between two equal masses, M and M, that are separated by a distance $2b$ as shown below:

2. Explain why a heavier object near the surface of Earth does not fall faster than a lighter object (neglect air resistance).

3. Show that the units for **g** in N/kg are equivalent to m/s². Why is **g** referred to as the "gravitational field strength"?

4. Explain why objects in orbit appear to be "weightless."

ANSWERS EXPLAINED

Multiple-Choice Problems

1. **(D)** The value of **g** varies inversely with the square of the distance from the center of Earth; therefore, if we double the distance from the center (as in this case), the value of **g** decreases by one-fourth: 1/4(9.8) = 2.45. Since **g** = **F**/m, alternative units are newtons per kilogram.

2. **(A)** If, using the formula for **g**, we take half the mass, the value decreases by one-half. If we decrease the radius by half, the value will increase by four times. Combining both effects results in an overall increase of two times.

3. **(D)** The formula for **g** is **g** = GM/R^2. The planet is essentially a sphere of mass M, radius R, and density ρ (with $M = V_\rho$; where V is the volume). The volume of the planet is given by $V = 4/3\pi R^3$. Making the substitutions yields:

$$\mathbf{g} = G\frac{4\pi R_\rho}{3}$$

4. **(C)** The formula for orbital velocity is

$$\mathbf{v}_{\text{orbit}} = \sqrt{\frac{GM}{R}}$$

where R is the distance from the center of Earth. In this case we must add 300 km = 300,000 m to the radius of Earth. Thus, $R = 6.7 \times 10^6$ m. Substituting the given values yields $\mathbf{v}_{\text{orbit}} = 7,728$ or 7.7×10^3 m/s.

5. **(B)** The formula for escape velocity is

$$v_{esc} = \sqrt{\frac{2GM_{Moon}}{R_{Moon}}}$$

Substituting the given values yields $v_{esc} = 2{,}324$ or 2.32×10^3 m/s.

6. **(A)** From question 6, we know that the escape velocity is given by $v_{esc} = \sqrt{2GM/R}$. To find R, we need to square both sides, and then solve for the radius. This yields $R = 2GM/v^2$. Substituting the given values yields $R = 3{,}000$ or 3×10^3 m. (This is only a "theoretical" size for the black hole. As an interesting exercise, try calculating the value of **g** on such an object!)

7. **(C)** We use the formula for gravitational force:

$$F = \frac{GM_1 M_2}{R^2}$$

Substituting the given values (don't forget to square the distance!) yields $F = 0.0067$ N.

8. **(D)** The force of gravity is an inverse-square-law relationship. This means that, as the distance is tripled, the force is decreased by one-ninth. One-ninth of 36 N is 4 N.

Free-Response Problems

1. Let's designate as g_1 the field strength at P caused by the top mass and designate as g_2 the field strength at point P due to the bottom mass. Both of these field strengths are accelerations and therefore vectors. The distance from point P to the line connecting the masses is r, and the midpoint distance connecting the masses is b. Therefore, the distance from point P to each mass is given by the Pythagorean theorem and is equal to $\sqrt{r^2 + b^2}$.

The direction of each acceleration **g** is directed toward each mass from point P. Since each mass is identical and the distance to each mass is the same, the angles formed by the vectors to the x-axis are the same. Let's call each angle θ such that $\tan\theta = b/r$ in magnitude.

From the above analysis we can conclude that

$$g_1 = g_2 = \frac{GM}{r^2 + b^2}$$

The vector components of each field strength result in a symmetrical cancellation of the y-components. This is true since the direction of g_1 is toward the upper left, and thus its x-component is directed to the left and its y-component is directed upward. Field strength g_2 has an x-component that is also directed to the left and equal in magnitude to the x-component of g_1. The y-component of g_2 is directed downward and is also equal in magnitude to the y-component of g_1. Since these two vectors are equal and opposite, they will sum to zero and will not contribute to the net resultant field (which is just directed horizontally to the left).

What remains to be done is to determine the expression for the x-component of \mathbf{g}_1 or \mathbf{g}_2 and then multiply by 2. Since $\mathbf{g}_{1x} = \mathbf{g}_1 \cos\theta$, we can see from the geometry that

$$\cos\theta = \frac{r}{\sqrt{r^2 + b^2}}$$

Combining results gives

$$\mathbf{g}_{net} = \frac{2GMr}{\left(r^2 + b^2\right)^{3/2}}$$

2. The acceleration due to gravity near the surface of Earth is given by

$$\mathbf{g} = \frac{GM_E}{R^2}$$

Hence, this acceleration is independent of the mass of an object.

3. We know that $\mathbf{F} = m\mathbf{a}$, and for gravity, $\mathbf{F} = m\mathbf{g}$. Hence,

$$\mathbf{g} = \frac{\mathbf{F}}{m} = \text{N/kg}$$

But we also know that $\text{N} = \text{kg} \cdot \text{m/s}^2$. Thus, in units,

$$\text{N/kg} = \text{m/s}^2$$

A gravitational field measures the amount of force per unit mass. Thus, \mathbf{g} is referred to as the gravitational field strength since $\mathbf{g} = \mathbf{F}/m$.

4. Objects in orbit are in free fall. Thus, all objects fall together and appear to be weightless. A person in free fall therefore does not experience any contact forces and does not feel his or her own weight.

Impacts and Linear Momentum

<div style="text-align: right; font-size: 3em;">9</div>

KEY CONCEPTS

→ **INTERNAL AND EXTERNAL FORCES**

→ **IMPACT FORCES AND MOMENTUM CHANGES**

→ **THE LAW OF CONSERVATION OF LINEAR MOMENTUM**

→ **ELASTIC AND INELASTIC COLLISIONS**

→ **CENTER OF MASS**

INTERNAL AND EXTERNAL FORCES

Consider a system of two blocks with masses m and M ($M > m$). If the blocks were to collide, the forces of impact would be equal and opposite. However, because of the different masses, the response to these forces (i.e., the changes in velocity) would not be equal. In the absence of any outside or external forces acting on the objects (such as friction or gravity), we say that the impact forces are internal.

To Newton, the "quantity of motion" discussed in his book *Principia* was the product of an object's mass and velocity. This quantity, called **linear momentum** or just **momentum**, is a vector quantity having units of kilogram · meters per second (kg · m/s). Algebraically, momentum is designated by the letter **p**, such that **p** = m**v**.

To understand Newton's rationale, consider the action of trying to change the motion of a moving object. Do not confuse this with the inertia of the object; here, both the mass and the velocity are important. Consider, for example, that a truck moving at a slow 1 meter per second can still inflict a large amount of damage because of its mass. Also, a small bullet, having a mass of perhaps 1 gram or less, does incredible damage because of its high velocity. In each case (see Figure 9.1) the damage is the result of a force of impact when the object is intercepted by something else. Let's now consider the nature of impact forces.

TIP

Momentum and impulse are both vector quantities.

Figure 9.1 Comparison of the Momentum of a Truck with That of a Bullet

IMPACT FORCES AND MOMENTUM CHANGES

Consider a mass m moving with a velocity \mathbf{v} in some frame of reference. If the mass is subjected to some external forces, then, by Newton's second law of motion, we can write that $\Sigma\mathbf{F} = m\mathbf{a}$. The vector sum of all the forces, referred to as the **net force**, is responsible for changing the velocity of the motion (in magnitude and/or direction).

If we recall the definition of acceleration as the rate of change or velocity, we can rewrite the second law of motion as

$$\mathbf{F}_{net} = m\left(\frac{\Delta \mathbf{v}}{\Delta t}\right)$$

This expression is also a vector equation and is equivalent to the second law of motion. If we make the assumption that the mass of the object is not changing, we can again rewrite the second law in the form

$$\mathbf{F}_{net} = \frac{\Delta m\mathbf{v}}{\Delta t} = \frac{\Delta \mathbf{p}}{\Delta t}$$

This expression means that the net external force acting on an object is equal to the rate of change of momentum of the object and is another alternative form of Newton's second law of motion. This **change in momentum** is a vector quantity in the same direction as the net force applied. Since the time interval is just a scalar quantity, we can multiply both sides by Δt to get

$$\mathbf{F}_{net}\,\Delta t = \Delta \mathbf{p} = m\,\Delta \mathbf{v} = m\mathbf{v}_f - m\mathbf{v}_i$$

The quantity, $\mathbf{F}_{net}\Delta t$, called the **impulse**, represents the effect of a force acting on a mass during a time interval Δt, and is likewise a vector quantity. From this expression, it can be stated that the impulse applied to an object is equal to the change in momentum of the object.

Another way to consider impulse is to look at a graph of force versus time for a continuously varying force (see Figure 9.2).

The area under this curve is a measure of the impulse in units of newton · seconds (N · s). Another way to view this concept is to identify the average force, $\bar{\mathbf{F}}$, such that the area of the rectangle formed by the average force is equal in area to the entire curve. This is more manageable algebraically, and we can write

$$\bar{\mathbf{F}}\Delta t = \Delta \mathbf{p}$$

A 2,000-kg car is traveling at 20 m/s and stops moving over a 10-s period. What was the magnitude of the average braking force?

Solution

We know that

$$F = \frac{m\Delta v}{\Delta t}$$

Substituting, we obtain

$$F = \frac{(2,000 \text{ kg})(20 \text{ m/s})}{10 \text{ s}} = 4,000 \text{ N}$$

Figure 9.2

> How do airbags work? After all, the same impulse must be supplied to the car's occupants during the crash. The air bag lengthens the time interval over which the force is applied. The area under the curve is the same. However, it is wider and not as high (lower force).

THE LAW OF CONSERVATION OF LINEAR MOMENTUM

Newton's third law of motion states that for every action there is an equal but opposite reaction. This reaction force is present whenever we have an interaction between two objects in the universe. Suppose we have two masses, m_1 and m_2, that are approaching each other along a horizontal frictionless surface. Let \mathbf{F}_{12} be the force that m_1 exerts on m_2, and let \mathbf{F}_{21} be the force that m_2 exerts on m_1. According to Newton's law, these forces must be equal and opposite; that is, $\mathbf{F}_{12} = -\mathbf{F}_{21}$.

Rewriting this expression as $\mathbf{F}_{12} + \mathbf{F}_{21} = 0$ leads to an interesting implication. Since each force is a measure of the rate of change of momentum for that object, we can write

$$\mathbf{F}_{12} = \frac{\Delta \mathbf{p}_1}{\Delta t} \quad \text{and} \quad \mathbf{F}_{21} = \frac{\Delta \mathbf{p}_2}{\Delta t}$$

Therefore:

$$\frac{\Delta \mathbf{p}_1}{\Delta t} + \frac{\Delta \mathbf{p}_2}{\Delta t} = 0 \quad \text{and} \quad \frac{\Delta (\mathbf{p}_1 + \mathbf{p}_2)}{\Delta t} = 0$$

The change in the sum of the momenta is therefore zero, implying that the sum of the total momentum for the system ($\mathbf{p}_1 + \mathbf{p}_2$) is a constant all the time. This conclusion is called the **law of conservation of linear momentum**, and we say simply that the momentum is conserved.

Here is another way of writing this conservation statement in a general form for any two masses (after separating all initial and final terms):

$$m_1\mathbf{v}_{1i} + m_2\mathbf{v}_{2i} = m_1\mathbf{v}_{1f} + m_2\mathbf{v}_{2f}$$

Extension of the law of conservation of momentum to two or three dimensions involves the recognition that momentum is a vector quantity. Given two masses moving in a plane relative to a coordinate system, conservation of momentum must hold simultaneously in both the horizontal and vertical directions. These vector components of momentum can be calculated using the standard techniques of vector analysis used to resolve forces in components.

ELASTIC AND INELASTIC COLLISIONS

During any collision between two pieces of matter, momentum is always conserved. This statement is not, however, necessarily true about kinetic energy. If two masses stick together after a collision, it is observed that the kinetic energy before the collision is not equal to the kinetic energy after it. If the kinetic energy is conserved as well as the momentum, the collision is described as **elastic**. If the kinetic energy is not conserved after the collision (e.g., energy being lost to heat or friction), the collision is described as **inelastic**.

As an example, suppose that a mass m has a velocity \mathbf{v} while mass M is at rest along a horizontal frictionless surface. The two masses collide and stick together. What is the final velocity, \mathbf{u}, of the system? According to the law of conservation of momentum, the total momentum before the collision ($m\mathbf{v}$), must be equal to the total momentum after. Since the two masses are combining, the new mass of the system is $M + m$, and the new momentum is given by $(m + M)\mathbf{u}$. Thus, we find that:

$$\mathbf{u} = \frac{m\mathbf{v}}{m + M}$$

The initial kinetic energy is $(1/2)m\mathbf{v}^2$. The final kinetic energy is given by

$$KE_f = \frac{1}{2}(m + M)\mathbf{u}^2 = \frac{1}{2}\left(\frac{m^2\mathbf{v}^2}{m + M}\right)$$

which is of course not equal to the initial kinetic energy.

If we have an elastic collision, we write both conservation laws to get two equations involving the velocities of the masses before and after the collision:

$$m_1\mathbf{v}_{1i} + m_2\mathbf{v}_{2i} = m_1\mathbf{v}_{1f} + m_2\mathbf{v}_{2f}$$

$$\frac{1}{2}m_1\mathbf{v}_{1i}^2 + \frac{1}{2}m_1\mathbf{v}_{2i}^2 = \frac{1}{2}m_1\mathbf{v}_{1f}^2 + \frac{1}{2}m_2\mathbf{v}_{2f}^2$$

If we cancel out the factor (1/2) in the second equation, and collect the expressions for each mass on each side, we can rewrite the two equations as

$$m_1(\mathbf{v}_{1i} - \mathbf{v}_{1f}) = m_2(\mathbf{v}_{2f} - \mathbf{v}_{2i})$$

$$m_1(\mathbf{v}_{1i}^2 - \mathbf{v}_{1f}^2) = m_2(\mathbf{v}_{2f}^2 - \mathbf{v}_{2i}^2)$$

The second equation is factorable and so can be simplified. Again rewriting the expressions, we get

$$m_1(\mathbf{v}_{1i} - \mathbf{v}_{1f}) = m_2(\mathbf{v}_{2f} - \mathbf{v}_{2i})$$

$$m_1(\mathbf{v}_{1i} + \mathbf{v}_{1f})(\mathbf{v}_{1i} - \mathbf{v}_{1f}) = m_2(\mathbf{v}_{2f} + \mathbf{v}_{2i})(\mathbf{v}_{2f} - \mathbf{v}_{2i})$$

If we take the ratio of the two expressions, we arrive at an interesting result after collecting terms:

$$\mathbf{v}_{1i} - \mathbf{v}_{2i} = -(\mathbf{v}_{1f} - \mathbf{v}_{2f})$$

This expression states that the relative velocity between the masses before the elastic collision is equal and opposite to the relative velocity between the masses after the elastic collision! Thus, there exists the characteristic "rebounding" observed during elastic collisions.

SAMPLE PROBLEM

A mass of 2 kg is moving at a speed of 10 m/s along a horizontal, frictionless surface. It collides, and sticks, with a 3-kg mass moving in the same direction at 5 m/s.

(a) What is the final velocity of the system after the collision?
(b) What percentage of kinetic energy was lost in the collision?

Solution

(a) Using conservation of momentum, we see that

$$m_1\mathbf{v}_1 + m_2\mathbf{v}_2 = (m_1 + m_2)\mathbf{v}_f$$

$$(2\,\text{kg})(10\,\text{m/s}) + (3\,\text{kg})(5\,\text{m/s}) = (5\,\text{kg})\mathbf{v}_f$$

$$35\,\text{kg}\cdot\text{m/s} = (5\,\text{kg})\mathbf{v}_f$$

$$\mathbf{v}_f = 7\,\text{m/s}$$

(b) The initial kinetic energy is given by

$$\frac{1}{2}m_1\mathbf{v}_1^2 + \frac{1}{2}m_2\mathbf{v}_2^2 = KE_i$$

$$\frac{1}{2}(2\,\text{kg})(10\,\text{m/s})^2 + \frac{1}{2}(3\,\text{kg})(5\,\text{m/s})^2 = 137.5\,\text{J}$$

The final kinetic energy is given by

$$\frac{1}{2}(m_1 + m_2)\mathbf{v}_f^2 = KE_f$$

$$\frac{1}{2}(5\,\text{kg})(7\,\text{m/s})^2 = 122.5\,\text{J}$$

We now take the ratio of the final kinetic energy and the initial kinetic energy:

$$(122.5\,\text{J}) / (137.5\,\text{J}) = 0.89 \rightarrow 89\% \text{ left over KE}$$

Therefore, 11% of the initial kinetic energy was lost in the collision.

CENTER OF MASS

The center of mass of a system is a very useful concept. Conceptually, the center of mass is the point in a system about which all the mass is balanced. It is found by taking the weighted average of all points of mass along each axis. For example, along the *x*-axis:

$$x_{cm} = \sum m_i x_i / \sum m_i$$

It is the center of mass of an object to which we apply our forces in our free-body diagrams. The center of mass of an object is actually located at the positions specified in all our physics problems. For example, a real-world, unsymmetrical object may not appear to travel in a parabola when undergoing projectile motion as it twists and turns during its flight. However, its center of mass is following the parabolic path.

When thinking of the momentum of a system of interacting particles, the overall momentum of the system obeys all of Newton's law relative to external forces. For example, a mass of gas consisting of many moving and interacting molecules can be modeled as being attracted gravitationally to Earth by placing the total mass of the gas cloud at its center of mass.

Consider the following snapshot of two different types of cars parked on the deck of a ferry. One car type ($2m$) has twice the mass of the other (m). The top two points have mass m, while the bottom two (farthest to the left and right) have mass $2m$. Where is the center of mass for this system located?

Solution

For the x-position of the center of mass:

$$x_{cm} = (m(2) + m(1) + 2m(3) + 2m(-3))/(m + m + 2m + 2m)$$

$$x_{cm} = (3m/6m) = 0.5$$

For the y-position of the center of mass:

$$y_{cm} = (m(1) + m(2) + 2m(-1) + 2m(-2))/(m + m + 2m + 2m)$$

$$y_{cm} = (-3m/6m) = -0.5$$

The center of mass of the system of mass $6m$ is at point (0.5, −0.5).

SUMMARY

- Momentum is a vector quantity equal to mv.
- The impulse ($F\Delta t$) is found by taking the area under a graph of force versus time.
- Impulse is equal to the change in momentum ($F\Delta t = m\Delta v$).
- Force is equal to the rate of change of momentum.
- In an isolated system, the total momentum is conserved.
- In an elastic collision, the kinetic energy of the system is conserved.
- In an inelastic collision (typically, but not necessarily) where masses stick together, kinetic energy is lost (this energy loss typically transforms into heat).

Problem-Solving Strategies for Impacts and Linear Momentum

In any matter interaction, momentum is always conserved. Therefore, when you read a problem that does not state explicitly that momentum is involved, you can safely assume, in the case of collision or an impact, that momentum is conserved, and you should write the equations for the conservation of momentum. The kinetic energy, however, is not necessarily conserved unless the collision is elastic. In summary, you should:

1. Decide whether an impact or a collision is involved. If there is a collision, observe whether it is elastic or inelastic.
2. Remember that, if the collision is inelastic, masses will usually stick together, so be sure to determine the new combined mass.
3. If the collision is elastic, write the equations for the conservation of both momentum and kinetic energy.
4. Remember that the impulse given to a mass is equal to its change in momentum. The change in momentum is a vector quantity in the same direction as the impulse or net force.
5. Be sure to take into account algebraically any reversal of directions, and remember the sign conventions for left, right, up, and down motions.
6. Keep in mind that motions may be simpler if studied in the center-of-mass frame of reference. In such a frame, one considers the motion of the center of mass, as well as the motions of mass particles relative to the center of mass.
7. Remember that in two dimensions the center of mass will follow a smooth path after an internal explosion since the forces involved were internal and the initial momentum in that frame was zero. For example, for a projectile launched at an angle and then exploded the center of mass still follows the regular parabolic trajectory.

Multiple-Choice

1. Which of the following expressions, where **p** represents the linear momentum of the particle, is equivalent to the kinetic energy of a moving particle?

 (A) $m\mathbf{p}^2$
 (B) $m^2/2\mathbf{p}$
 (C) $2\mathbf{p}/m$
 (D) $\mathbf{p}^2/2m$

2. Two carts having masses 1.5 kg and 0.7 kg, respectively, are initially at rest and are held together by a compressed massless spring. When released, the 1.5-kg cart moves to the left with a velocity of 7 m/s. What is the velocity and direction of the 0.7-kg cart?

 (A) 15 m/s right
 (B) 15 m/s left
 (C) 7 m/s left
 (D) 7 m/s right

3. The product of an object's instantaneous momentum and its acceleration is equal to its

 (A) applied force
 (B) kinetic energy
 (C) power output
 (D) net force

4. A ball with a mass of 0.15 kg has a velocity of 5 m/s. It strikes a wall perpendicularly and bounces off straight back with a velocity of 3 m/s. The ball underwent a change in momentum equal to

 (A) 0.30 kg · m/s
 (B) 1.20 kg · m/s
 (C) 0.15 kg · m/s
 (D) 5 kg · m/s

5. What braking force is supplied to a 3,000-kg car traveling with a velocity of 35 m/s that is stopped in 12 s?

 (A) 29,400 N
 (B) 3,000 N
 (C) 8,750 N
 (D) 105,000 N

6. A 0.1-kg baseball is thrown with a velocity of 35 m/s. The batter hits it straight back with a velocity of 60 m/s. What is the magnitude of the average impulse exerted on the ball by the bat?

(A) 3.5 N · s

(B) 2.5 N · s

(C) 7.5 N · s

(D) 9.5 N · s

7. A 1-kg object is moving with a velocity of 6 m/s to the right. It collides and sticks to a 2-kg object moving with a velocity of 3 m/s in the same direction. How much kinetic energy was lost in the collision?

(A) 1.5 J

(B) 2 J

(C) 2.5 J

(D) 3 J

8. A 2-kg mass moving with a velocity of 7 m/s collides elastically with a 4-kg mass moving in the opposite direction at 4 m/s. The 2-kg mass reverses direction after the collision and has a new velocity of 3 m/s. What is the new velocity of the 4-kg mass?

(A) −1 m/s

(B) 1 m/s

(C) 6 m/s

(D) 4 m/s

9. A mass m is attached to a massless spring with a force constant k. The mass rests on a horizontal frictionless surface. The system is compressed a distance x from the spring's initial position and then released. The momentum of the mass when the spring passes its equilibrium position is given by

(A) $x\sqrt{mk}$

(B) $x\sqrt{k/m}$

(C) $x\sqrt{m/k}$

(D) $x\sqrt{k^2m}$

10. During an inelastic collision between two balls, which of the following statements is correct?

(A) Both momentum and kinetic energy are conserved.

(B) Momentum is conserved, but kinetic energy is not conserved.

(C) Momentum is not conserved, but kinetic energy is conserved.

(D) Neither momentum nor kinetic energy is conserved.

Free-Response

1. Two blocks with masses 1 kg and 4 kg, respectively, are moving on a horizontal frictionless surface. The 1-kg block has a velocity of 12 m/s, and the 4-kg block is ahead of it, moving at 4 m/s, as shown in the diagram below. The 4-kg block has a massless spring attached to the end facing the 1-kg block. The spring has a force constant k equal to 1,000 N/m.

(a) What is the maximum compression of the spring after the collision?
(b) What are the final velocities of the blocks after the collision has taken place?

2. A 0.4-kg disk is initially at rest on a frictionless horizontal surface. It is hit by a 0.1-kg disk moving horizontally with a velocity of 4 m/s. After the collision, the 0.1-kg disk has a velocity of 2 m/s at an angle of 43° to the positive x-axis.

(a) Determine the velocity and direction of the 0.4-kg disk after the collision.
(b) Determine the amount of kinetic energy lost in the collision.

3. A 50-kg girl stands on a platform with wheels on a frictionless horizontal surface as shown below. The platform has a total mass of 1,000 kg and is attached to a massless spring with a force constant k equal to 1,000 N/m. The girl throws a 1-kg ball with an initial velocity of 35 m/s at an angle of 30° to the horizontal.

(a) What is the recoil velocity of the platform-girl system?
(b) What is the elongation of the spring?

4. (a) Can an object have energy without having momentum? Explain.

(b) Can an object have momentum without having energy? Explain.

5. Explain why there is more danger when you fall and bounce as opposed to falling without bouncing.

6. A cart of mass M is moving with a constant velocity \mathbf{v} to the right. A mass m is dropped vertically onto it, and it is observed that the new velocity is less than the original velocity. Explain what has happened in terms of energy, forces, and conservation of momentum (as viewed from different frames of reference).

ANSWERS EXPLAINED

Multiple-Choice Problems

1. **(D)** If we multiply the formula for kinetic energy by the ratio m/m, we see that the formula for kinetic energy becomes

$$\text{KE} = \left(\frac{1}{2m}\right)(m^2)(\mathbf{v}^2) = \frac{\mathbf{p}^2}{2m}$$

2. **(A)** Momentum is conserved, so $(1.5)(7) = 0.7\mathbf{v}$. Thus $\mathbf{v} = 15$ m/s. The direction is to the right since in a recoil the masses go in opposite directions.

3. **(C)** An object's instantaneous momentum times its acceleration will equal its power output in units of joules per second or watts.

4. **(B)** The change in momentum is a vector quantity. The rebound velocity is in the opposite direction, so $\Delta\mathbf{v} = 5 - (-3) = 8$ m/s. The change in momentum is

$$\Delta\mathbf{p} = (0.15)(8) = 1.20 \text{ kg} \cdot \text{m/s}$$

5. **(C)** The formula is $\mathbf{F}\Delta t = m\Delta\mathbf{v}$. Solving for the force, we get

$$\mathbf{F} = \frac{(3,000)(35)}{12} = 8,750 \text{ N}$$

6. **(D)** Impulse is equal to the change in momentum, which is

$$\Delta\mathbf{p} = |\, 0.1\, [-60 - 35]\,| = 9.5 \text{ N} \cdot \text{s}$$

because of the change in direction of the ball.

7. **(D)** First, we find the final velocity of this inelastic collision. Momentum is conserved, so we can write $(1)(6) + (2)(3) = (3)\mathbf{v}'$ since both objects are moving in the same direction. Thus $\mathbf{v}' = 4$ m/s. The initial kinetic energy of the 1-kg object is 18 J, while the initial kinetic energy of the 2-kg mass is 9 J. Thus the total initial kinetic energy is 27 J. After the collision, the combined 3-kg object has a velocity of 4 m/s and a final kinetic energy of 24 J. Thus, 3 J of kinetic energy has been lost.

8. **(B)** Momentum is conserved in this elastic collision but the directions are opposite, so we must be careful with negative signs. We therefore write $(2)(7) - (4)(4) = -(2)(3) + 4\mathbf{v}'$ and get $\mathbf{v}' = 1$ m/s.

9. **(A)** We set the two energy equations equal to solve for the velocity at the equilibrium position. Thus

$$\frac{1}{2}kx^2 = \frac{1}{2}m\mathbf{v}^2$$

since no gravitational potential energy is involved, and we write that the velocity is $\mathbf{v} = x\sqrt{k/m}$. Now momentum $\mathbf{p} = m\mathbf{v}$, so we multiply by m and factor the "mass" back under the radical sign, where it is squared so that we get $\mathbf{p} = x\sqrt{mk}$.

10. **(B)** Momentum is always conserved in an inelastic collision, and kinetic energy is not conserved because the objects stick together.

Free-Response Problems

1. (a) Upon impact, the spring becomes compressed, but both blocks are still in motion. Therefore, for an instant, we have an inelastic collision, and momentum is of course conserved. Thus we can write for the moment of impact

$$m_1\mathbf{v}_{1i} + m_2\mathbf{v}_{2i} = (m_1 + m_2)\mathbf{v}_f$$

Solving for the final velocity, we get $\mathbf{v}_f = 5.6$ m/s. Using the initial values for the velocities, we find that the initial kinetic energies are 72 J and 32 J for the 1-kg and 4-kg blocks, respectively. Thus the total initial kinetic energy is 104 J. Using the final velocity of 5.6 m/s and the combined mass of 5 kg, we get a final kinetic energy of 78.4 J. The difference in kinetic energy of 25.6 J is used to compress the spring in this inelastic collision. Using the formula for the work done against a spring, $(1/2)kx^2$, we get $x = 0.05$ m for the maximum compression of the spring after the collision.

(b) After the collision has taken place, the two blocks again separate. If we treat the situation as elastic, since we assume that the work done to compress the spring will be used by the spring in rebounding, we can use the initial velocities as a "before" condition for momentum and kinetic energy, and seek to solve for the two final velocities of the blocks after the rebound has taken place. To find both velocities, we need two equations, and we use the conservation of kinetic energy in this case to assist us. Thus we write

$$m_1\mathbf{v}_{1i} + m_2\mathbf{v}_{2i} = m_1\mathbf{v}_{1f} + m_2\mathbf{v}_{2f}$$

and for the kinetic energy

$$\frac{1}{2}m_1\mathbf{v}_{1i}^2 + \frac{1}{2}m_2\mathbf{v}_{2i}^2 = \frac{1}{2}m_1\mathbf{v}_{1f}^2 + \frac{1}{2}m_2\mathbf{v}_{2f}^2$$

Substituting the known numbers, we obtain for the momentum $28 = \mathbf{v}_{1f} + 4\mathbf{v}_{2f}$, and for the kinetic energy we get $208 = \mathbf{v}_{1f}^2 + 4\mathbf{v}_{2f}^2$.

If we solve for \mathbf{v}_{1f} from the momentum equation, square the result, and substitute into the kinetic energy equation, we obtain a factorable quadratic equation for \mathbf{v}_{2f}:

$$\mathbf{v}_{2f}^2 - 11.2\mathbf{v}_{2f} + 28.2 = (\mathbf{v}_{2f} - 7.2)(\mathbf{v}_{2f} - 4) = 0$$

Of the two choices for the second final velocity, only one provides a physically meaningful set of solutions. This is so because the first mass must rebound, and hence its final velocity must be negative. Our final answers are therefore $\mathbf{v}_{2f} = 7.2$ m/s and $\mathbf{v}_{1f} = -0.8$ m/s.

2. (a) This is a two-dimensional collision, and we consider the conservation of momentum in each direction, before and after. In the x-direction, we have only the initial momentum of the 0.1-kg disk with a velocity of 4 m/s. After the collision, the 0.1-kg disk has an x-component of momentum given by $(0.1)(2)\cos 43$.

The 0.4-kg disk had initially zero momentum and now has some unknown velocity at some unknown angle, θ, to the x-axis. Let us assume that the angle is below the x-axis, so that the x-component will be positive and the y-component negative. If

our assumption is correct, we will get a positive answer for θ. A negative answer will let us know that the assumption is incorrect. The x-component of final momentum for the 0.4-kg disk is given by $(0.4)\mathbf{v}_{2f}\cos θ$, and the y-component by $-(0.4)\mathbf{v}_{2f}\sin θ$. We can therefore write for the x-direction:

$$(0.1)(4) + 0 \doteq (0.1)(2)\cos 43 + (0.4)\mathbf{v}_{2f}\cos θ$$

and for the y-direction:

$$0 = (0.1)(2)\sin 43 - (0.4)\mathbf{v}_{2f}\sin θ$$

Solving for the angles and velocities in each we get the following two equations:

$$\mathbf{v}_{2f}\sin θ = 0.34 \text{ and } \mathbf{v}_{2f}\cos θ = 0.635$$

Taking the ratio gives $\tan θ = 0.535$ and $θ = 28°$. Substituting this angle gives us the final velocity for the 0.4-kg disk: 0.72 m/s.

(b) To find the loss of kinetic energy, we calculate the total initial and final kinetic energies. Using the given data, we find that the initial kinetic energy is 0.8 J. Using our final data, we get a total final kinetic energy of 0.3 J. Thus 0.5 J of kinetic energy has been lost.

3. (a) In this problem, the x-component of the velocity provides the impulse to elongate the spring using recoil. Thus we have that the velocity of the ball is $35\cos 30 = 30.31$ m/s. Using conservation of momentum, we state that $(1)(30.31) = (1{,}050)\mathbf{v}'$. Thus $\mathbf{v}' = 0.0289$ m/s in the negative x-direction, so the recoil velocity of the platform-girl system can be expressed as $\mathbf{v}' = -0.0289$ m/s.

$$\left(\frac{1}{2}\right)(1{,}050)(0.0289)^2 = \left(\frac{1}{2}\right)(1{,}000)x^2$$

(b) Solving for x gives $x = 0.0296$ m for the elongation of the spring.

4. (a) In a given frame of reference, an object can appear to be at rest and possess potential energy. In this frame, the object has zero velocity and hence its momentum is zero.

(b) If an object has nonzero momentum, it must have nonzero velocity, which means it must have kinetic energy.

5. When an object bounces, an additional upward force (impulse) is given to it. This extra force, which provides for an additional change in momentum, can be dangerous if it is large enough.

6. First, if the mass is placed vertically onto the object, the increase in mass appears to lower the velocity since no force was acting in the direction of motion. We can also state that since the object did not have any horizontal motion, the friction between the new mass and the object must act to accelerate the mass m, and this energy comes from the moving object. From the mass M frame of reference, it appears as though the mass m is coming toward it, providing a backward force which will slow down the object.

Rotational Motion

10

In Chapter 9, we discussed the fact that, if a single force is directed toward the center of mass of an extended object, the result is a linear or translational acceleration in the same direction as the force. If, however, the force is not directed through the center of mass, then the result is a rotation about the center of mass. In addition, if the object is constrained by a fixed pivot point, the rotation will take place about that pivot (e.g., a hinge). These observations are summarized in Figure 10.1.

TIP

Torque produces rotation.

Figure 10.1

PARALLEL FORCES AND MOMENTS

If two forces are used, it is possible to prevent the rotation if these forces are parallel and are of suitable magnitudes. If the object is free to move in space, translational motion may result (see Figure 10.2).

a translation

\mathbf{F}_1

\mathbf{F}_2

parallel forces

Figure 10.2

As an example of parallel forces, consider two people on a seesaw, as shown in Figure 10.3. The two people have weights \mathbf{F}_{g1} and \mathbf{F}_{g2}, respectively, and are sitting distances d_1 and d_2 from the fixed pivot point (called the **fulcrum**). From our discussion about forces, we see that the tendency of each force (provided by gravity), is to cause the seesaw to rotate about the fulcrum. Force \mathbf{F}_{g1} will tend to cause a counterclockwise rotation; force \mathbf{F}_{g2}, a clockwise rotation. Arbitrarily, we state that a clockwise rotation is taken as being a negative, while counterclockwise is taken as positive. What factors will influence the ability of the two people to remain in "balance"; that is, what conditions must be met so that the system remains in rotational equilibrium (it is already in a state of translational equilibrium and constrained to remain that way)?

> **REMEMBER**
>
> In **static equilibrium**, the net torque on a system is equal to zero. In other words, the sum of the clockwise torques must be equal to the sum of the counterclockwise torques.

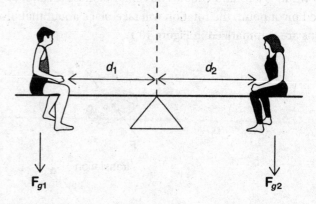

Figure 10.3

Through experiments, you can show that distances d_1 and d_2 (called **moment arm distances**) play a crucial role since we take the weights as being constant. If the two weights were equal, it should not be a surprise to learn that $d_1 = d_2$. In these examples, the weight of the seesaw is taken to be negligible (this is not a realistic scenario).

It turns out that, if \mathbf{F}_{g2} is greater, that person must sit closer to the fulcrum. If equilibrium is to be maintained, the following condition must hold:

$$(\mathbf{F}_{g1})(d_1) = (\mathbf{F}_{g2})(d_2)$$

These are force and distance products, but they do not represent work in the translational sense because the force vectors are not causing a displacement. In rotational motion, the product of a force and a perpendicular moment arm distance (relative to a fulcrum) is called **torque**. Let us now consider some more examples of torques and equilibrium.

A 45-kg girl and a 65-kg boy are sitting on a see-saw in equilibrium. If the boy is sitting 0.7 m from the fulcrum, where is the girl sitting?

Solution

In equilibrium,

$$F_{g1}d_1 = F_{g2}d_2$$

$$(65\,kg)(9.8\,m/s^2)(0.7\,m) = (45\,kg)(9.8\,m/s^2)d_2$$

$$d_2 = 1.01\,m$$

TORQUE

When you tighten a bolt with a wrench, you apply a force to create a rotation or twist. This twisting action, called torque in physics, is represented by the Greek letter τ. Even though its units are newton · meters (N · m), you must not confuse it with translational work. In static equilibrium, the two conditions met are that the vector sum of all forces acting on the object equals zero and that the vector sum of all torques equals zero:

$$\Sigma F = 0 \quad \text{and} \quad \Sigma \tau = 0$$

When we say that $\tau = Fd$, d is the moment arm distance from the center of mass, or the pivot point, and F is the force perpendicular to the vector displacement. If the force is applied at some angle θ to the object, as seen in Figure 10.4, the component of the force, perpendicular to the vector displacement out from the pivot, is taken as the force used. Algebraically this is stated as $F_\perp = F \sin\theta$

REMEMBER

Torque is a vector quantity, but **work** is not! The direction of the torque is taken as either positive or negative, depending on whether the rotation is counterclockwise or clockwise.

Figure 10.4

$$\tau = Fd \sin\theta$$

Consider a light string wound around a frictionless and massless wheel, as shown in Figure 10.5. The free end of the string is attached to a 1.2-kg mass that is allowed to fall freely. The wheel has a radius of 0.25 m. What torque is produced?

Figure 10.5

Solution

The force acting at right angles to the center of the wheel is the weight of the mass, given by

$$\mathbf{F_g} = mg = (1.2)(9.8) = 11.76 \text{ N}$$

The radius serves as the moment arm distance, $d = 0.25$ m, so we can write

$$\tau = -Fd \, (11.76)(0.25) = -2.94 \text{ N} \cdot \text{m}$$

The torque is negative since the falling weight induces a clockwise rotation in this example.

MORE STATIC EQUILIBRIUM PROBLEMS USING FORCES AND TORQUES

In the following example (see Figure 10.6), a hinged rod of mass M is attached to a wall with a string (and, of course, by the hinge). The string is considered massless, and makes an angle θ with the horizontal. A mass m is attached to the end of the rod, whose length is ℓ. What is the tension \mathbf{T} in the string?

Since the system is in static equilibrium, we must write that the sum of all forces and the sum of all torques equal zero. If we choose to focus on the pivot, then all forces acting through that point do not contribute any torques since the moment arm d would be zero. The reaction force \mathbf{R} is the response of the wall to the rod and acts at some unknown angle ϕ. Thus we state that

$$\Sigma \tau = 0 \quad \text{and} \quad \Sigma \mathbf{F} = 0$$

Situation

Free-body diagram for rod M

Figure 10.6

Since this is a static problem, both the net force and the net torques must be zero. By inspection of the diagram for hanging mass m, $T_2 = mg$. Thus the equilibrium statement for vertical force on the rod becomes:

$$\Sigma F_x = R_x - T \cos \theta = 0$$

$$\Sigma F_y = R_y + T \sin \theta - Mg - mg = 0$$

The rod is assumed to be uniform. Therefore its weight force is applied at the halfway point ($L/2$). By taking the left-hand side of the rod as our axis of rotation, the torque from force R is zero, leaving us with the following equilibrium statement for torques. The axis for a static problem can be taken anywhere you choose. By choosing the location where an unknown force is being applied, though, that unknown can be eliminated:

$$\Sigma \tau = (T \sin \theta)(L) - Mg(L/2) - mg(L) = 0$$

Note the clockwise torques are negative while the counterclockwise torque is positive. Without additional information, the two force statements cannot be further simplified. However, the length of rod L can be eliminated from the torque equation. This allows us to solve for T in terms of the two masses:

$$T = ((M/2 + m)g)/\sin \theta$$

Usually, problems of this type will either give you the angle theta or let you determine the angle by the geometry of the situation. Once the tension **T** is known, one can determine the components of the unknown force **R** from the two force equations.

For example, if $M = 1$ kg, $m = 10$ kg, and $\theta = 30°$:

$$T = 205.8 \text{ N}$$

$$R_x = T \cos \theta = 178.2 \text{ N}$$

$$R_y = (M + m)g - T \sin \theta = 4.9 \text{ N}$$

Note that the **R** force from the wall is almost entirely horizontal!

It should be noted that the rod is considered to have mass and that the torque produced by the rod is its weight taken from the center of mass ($\ell/2$ in this case) and is always clockwise (negative).

MOMENT OF INERTIA

Rotational inertia is slightly more complicated than linear inertia. However, like linear inertia, rotational inertia (or an object's moment of inertia) measures an object's tendency to resist changes to its motion, which is angular motion in this case. Linear inertia is simply the total mass of an object that we imagine as being located at the object's center of mass. Rotational inertia depends not only on the mass but on how that mass is distributed. Specifically, for a distribution of pointlike masses (or objects where the individual center of masses are known), the moment of inertia (I) (i.e., the rotational inertia) of the entire object is given by:

$$I = \Sigma m_i R_i^2$$

where R is the distance from the rotational axis. The units are $kg \cdot m^2$. The result depends not only on the shape and mass distribution of the object but also about which axis the object is being rotated. On the AP exam if a solid object is being used, the general moment of inertia for that object will be given or easily obtained through other relationship (see below). For example, the moment of inertia of a solid rod of length L is different when rotating the object about one end of the rod as opposed to rotating it around its midpoint (see Figure 10.7).

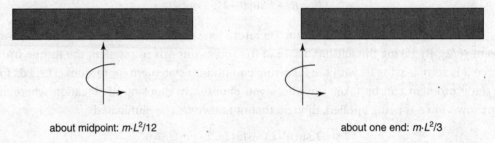

about midpoint: $m \cdot L^2/12$ about one end: $m \cdot L^2/3$

Figure 10.7

Try oscillating a ruler between your fingers while holding it at its midpoint. Then oscillate it while holding one end. You will quickly see that rotating the ruler about its midpoint is much easier and, hence, has a smaller moment of inertia.

ANGULAR KINEMATICS

Rotational inertia takes the place of mass in all of the linear formulas in physics. An object's position in rotational motion is represented by its angular position (θ). Note that all angular values are measured in radians. (Recall the conversion 360 degrees = 2π radians = approximately 6.283 radians.) An object's angular velocity is defined analogously to linear velocity:

$$\omega = \frac{\Delta\theta}{\Delta t}(rad/sec) \quad \text{direction is either clockwise (CW) or counterclockwise (CCW)}$$

Likewise, angular acceleration (caused by torques) is defined kinematically by

$$\alpha = \frac{\Delta\omega}{\Delta t}(rad/s^2)$$

Having defined the basic angular quantities of torque, moment of inertia, and the kinematic variables, we can complete the analogy between the physics of linear motion and that of rotational motion. Simply rewrite any of our linear physics relationships through substitution.

Comparison of Linear and Angular/Rotational Motion

Linear	Angular/Rotational
x: position (m)	θ: angle (radians)
v: velocity (m/s)	ω: angular speed (rad/sec)
a: acceleration (m/s$^2$)	α: angular acceleration (rad/s$^2$)
$\Delta x = v_o t + \frac{1}{2} at^2$	$\Delta\theta = \omega_o t + \frac{1}{2} \alpha t^2$
F = force (push or pull) (Newtons)	τ = torque = R × F (N · m)
F = ma (for constant m)	$\tau = I\alpha$ (for constant I)
p = mv = momentum	L = $I\omega$ = angular momentum = R × p
F = Δp/Δt	$\tau = \Delta$L/Δt
Linear KE = $\frac{1}{2}mv^2$	Rotational KE = $\frac{1}{2}I\omega^2$
Work = F · D	Work = $\tau \cdot \theta$

ANGULAR MOMENTUM

Just as forces cause changes in linear momentum over time, torques cause changes in angular momentum over time. In addition, an isolated system angular momentum is conserved just as a linear momentum is. Whereas it is relatively rare for an isolated system's mass to change, changing the moment of inertia of an isolated object is not that difficult. If the momentum of inertia changes due to internal forces, the rotational velocity must also change in order to conserve angular momentum. Observe a spinning ice skater drawing in her arms, thereby decreasing the R values in her moment of inertia calculation. You will see her rotational speed increase (see Figure 10.8).

I_1 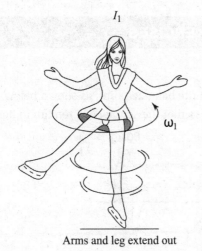 ω_1 I_2 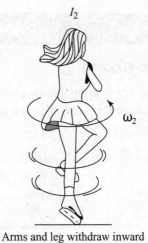 ω_2

Arms and leg extend out Arms and leg withdraw inward

Figure 10.8

$$I_1\omega_1 = I_2\omega_2$$

SUMMARY

- Torque is vector quantity equal to the product of (force × lever arm).
- The force and lever arm are perpendicular to each other.
- In equilibrium, the sum of the clockwise torques must be equal to the sum of the counterclockwise torques.
- Newton's laws apply in rotating systems just as they do in linear systems.
- The units for torque are $N \cdot m$, but they should *not* be confused with the scalar energy unit for joules, which can also be expressed as $N \cdot m$.

Problem-Solving Strategies for Torque

Solving torque problems is similar to solving static equilibrium problems with Newton's laws. In fact, Newton's laws provide the first condition for static equilibrium (the vector sum of all forces equals zero). This fact means that you should once again draw a free-body diagram of the situation.

In rotational static equilibrium, the vector sum of all torques must equal zero. Remember that torque is a vector even though its units are newton · meters. We take clockwise torques as negative and counterclockwise torques as positive. Any force going through the chosen pivot point (or fulcrum) does not contribute any torques. Therefore, it is wise to choose a point that eliminates the greatest number of forces. Also, remember that only the components of forces that are perpendicular to the direction of a radius displacement from the pivot (called the moment arm) are responsible, a situation that usually involves the sine of the force's orientation angle.

Problem-Solving Strategies for Rotational Motion

Translating a rotational problem first into the more comfortable language of linear physics can be helpful. The only major difference is that whereas changes of an object's mass in the middle of a problem are rare in linear problems, changes in moment of inertia are common in rotational problems.

PRACTICE EXERCISES

Multiple-Choice

1. A 45-kg girl is sitting on a seesaw 0.6 m from the balance point, as shown below. How far, on the other side, should a 60-kg boy sit so that the seesaw will remain in balance?

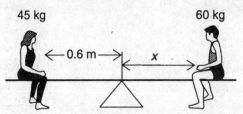

(A) 0.30 m
(B) 0.35 m
(C) 0.40 m
(D) 0.45 m

2. A balanced stick is shown below. The distance from the fulcrum is shown for each mass except the 10-g mass. What is the approximate position of the 10-g mass, based on the diagram?

(A) 7 cm

(B) 9 cm

(C) 10 cm

(D) 15 cm

3. A solid cylinder consisting of an outer radius R_1 and an inner radius R_2 is pivoted on a frictionless axle as shown below. A string is wound around the outer radius and is pulled to the right with a force $\mathbf{F}_1 = 3$ N. A second string is wound around the inner radius and is pulled down with a force $\mathbf{F}_2 = 5$ N. If $R_1 = 0.75$ m and $R_2 = 0.35$ m, what is the net torque acting on the cylinder?

(A) 2.25 N · m

(B) −2.25 N · m

(C) 0.5 N · m

(D) −0.5 N · m

Answer questions 4 and 5 based on the following diagram. The rod is considered massless.

4. What is the net torque about an axis through point A?

 (A) 16.8 N · m
 (B) 15.2 N · m
 (C) –5.5 N · m
 (D) –7.8 N · m

5. What is the net torque about an axis through point C?

 (A) 3.5 N · m
 (B) 7.5 N · m
 (C) –15.2 N · m
 (D) 5.9 N · m

6. Compute the average angular acceleration and the angular displacement during the 2 seconds a rotating object speeds up from 0.5 rad/s to 0.7 rad/s.

 (A) $\alpha = 0.1$ rad/s² $\Delta\theta = 0.3$ radians
 (B) $\alpha = 0.2$ rad/s² $\Delta\theta = 0.5$ radians
 (C) $\alpha = 0.1$ rad/s² $\Delta\theta = 1.2$ radians
 (D) $\alpha = 0.2$ rad/s² $\Delta\theta = 1.2$ radians

7. An object with a moment of inertia **I** experiences a net torque of **T**. If the object is initially at rest, what is its angular speed after 3 seconds of this torque?

 (A) **3IT**
 (B) **9IT**
 (C) **3I/T**
 (D) **3T/I**

8. If a spinning ball of clay on top of a freely turning frictionless tabletop increases its rotational inertia by 50 percent by bulging outward, what will happen to the rotational speed of the clay and tabletop?

 (A) It will be half as fast.
 (B) It will be 1.5 times faster.
 (C) It will be 4 times slower.
 (D) It will be slower by a factor of 2/3.

Free-Response

1. A 500-N person stands 2.5 m from a wall against which a horizontal beam is attached. The beam is 6 m long and weighs 200 N (see diagram below). A cable attached to the free end of the beam makes an angle of 45° to the horizontal and is attached to the wall.

(a) Draw a free-body diagram of the beam.

(b) Determine the magnitude of the tension in the cable.

(c) Determine the reaction force that the wall exerts on the beam.

2. A uniform ladder of length ℓ and weight 100 N rests against a smooth vertical wall. The coefficient of static friction between the bottom of the ladder and the floor is 0.5.

(a) Draw a free-body diagram of this situation.

(b) Find the minimum angle, θ, that the ladder can make with the floor so that the ladder will not slip.

ANSWERS EXPLAINED
Multiple-Choice Problems

1. **(D)** To remain in balance, the two torques must be equal. The force on each side is given by the weight, $m\mathbf{g}$. The moment arm distances are 0.6 m and x. Since the factor \mathbf{g} will appear on both sides of the torque balance equation, we can eliminate it and write

$$(45)(0.6) = (60)x \quad \text{implies} \quad x = 0.45 \text{ m}$$

2. **(C)** In this problem, again, the sum of the torques on the left must equal the sum of the torques on the right. We could convert all masses to kilograms and all distances to meters, but in the balance equation the same factors appear on both sides. Therefore, for simplicity and time efficiency, we can simply write

$$(30)(40)+(40)(20)+(20)(5)=(10)x+(50)(40)$$

$$x = 10 \text{ cm}$$

3. **(D)** The net torque is given by the vector sum of all torques. F_2 provides a counterclockwise positive torque, while F_1 provides a clockwise negative torque. Each radius is the necessary moment arm distance. Thus we have

$$\tau_{net} = (5)(0.35) - (3)(0.75) = -0.5 \text{ N} \cdot \text{m}$$

4. **(A)** In this problem, the net torque about point A implies that the force passing through point A does not contribute to the net torque. Also, we need the components of the remaining forces perpendicular to the beam. From the diagram, we see that the 30-N force acts counterclockwise (positive), while the 10-N force acts clockwise (negative). Thus:

$$\tau_{net} = (30)(\cos 45)(1.5) - (10)(\sin 30)(3) = 16.8 \text{ N} \cdot \text{m}$$

5. **(B)** In this problem, since the pivot is now set at point C, we can eliminate the 30-N force passing through point C as a contributor to the torque. Again, we see that the 20-N force will act in a counterclockwise direction, while the 10-N force will act clockwise. Each force is 1.5 m from the pivot. We also need the component of each force perpendicular to the beam. Thus:

$$\tau_{net} = (20)(\sin 30)(1.5) - (10)(\sin 30)(1.5) = 7.5 \text{ N} \cdot \text{m}$$

6. **(C)** $\alpha = \dfrac{\Delta \omega}{\Delta t} = \dfrac{0.7 - 0.5}{2} = 0.1 \text{ rad/s/s} = 0.1 \text{ rad/s}^2$

$$\Delta \theta = \omega_0 t + \frac{1}{2}\alpha t^2 = 0.5(2) + \frac{1}{2}(0.1)(2)^2 = 1 + 0.2 = 1.2 \text{ radians}$$

7. **(D)** Since $\tau = I\alpha$ and $\alpha = \dfrac{\Delta \omega}{\Delta t}$, we can combine and solve for $\Delta \omega$:

$$\Delta \omega = (\mathbf{T}/\mathbf{I})\Delta t = 3\mathbf{T}/\mathbf{I}$$

8. **(D)** Angular momentum is conserved:

$$\mathbf{I}_i\omega_i = \mathbf{I}_f\omega_f \qquad \mathbf{I}_f = (3/2)\mathbf{I}_i$$

$$\mathbf{I}_i\omega_i = ((3/2)\mathbf{I}_i)\omega_f$$

$$\omega_f = 2/3\omega_i$$

Free-Response Problems

1. (a) The free-body diagram for this situation appears below:

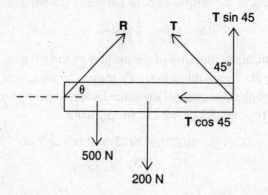

(b) The reaction force acts at some unknown angle, θ. We use our two conditions for equilibrium:

1. The sum of all forces in the x- and y-directions must equal zero:

$$0 = \mathbf{R}\cos\theta - \mathbf{T}\cos 45 \quad \text{and} \quad 0 = \mathbf{R}\sin\theta + \mathbf{T}\sin 45 - 500\ \text{N} - 200\ \text{N}$$

2. The sum of all torques through contact point O must be zero, thus eliminating the reaction force \mathbf{R}:

$$0 = -(500)(2.5) - (200)(3) + \mathbf{T}\sin 45(6)$$

Both weights produce clockwise torques! Solving for \mathbf{T} in the last equation, we get $\mathbf{T} = 436.05$ N.

(c) Using the result from part (b), we can rewrite the first two equations as:

$$\mathbf{R}\cos\theta = (436.05)\cos 45 = 308.33\ \text{N} \quad \text{and} \quad \mathbf{R}\sin\theta = 391.67\ \text{N}$$

Taking the ratio of these two equations gives us $\tan\theta = 1.27$; therefore $\theta = 51.8°$. Since we know the angle at which the reaction force acts, we can simply write

$$\mathbf{R}\cos 51.8 = 308.33 \quad \text{implies} \quad \mathbf{R} = 498.6\ \text{N}$$

2. (a) A sketch of the situation and its free-body diagram are given below:

Situation

Free-body diagram

(b) The reaction force \mathbf{R} is the vector resultant of the normal force \mathbf{N} (from the floor) and the frictional force \mathbf{f} that opposes slippage. The force \mathbf{P} is the normal force of the vertical wall; there is no friction on the vertical wall. The weight $\mathbf{F_g}$ acts from the center of mass, $\ell/2$, and initiates a clockwise torque. Since we have equilibrium at this angle, we can write our equations for the conditions of static equilibrium.

1. The sum of all x- and y-forces must be equal to zero. Horizontally, friction is an opposing force, as well as the reaction force, P: $0 = f - P$. Vertically, we can write $0 = N - F_g$. Since $\mathbf{F_g} = 100$ N, then $N = 100$ N. Now, for no slippage, $f \leq \mu N$, thus $f = (0.5)(100) = 50\ \text{N} = P$.

2. The sum of the torques must be zero. We need the component of **P** perpendicular to the ladder. From the geometry, we see that this is $P \sin\theta$. Also, the component of weight perpendicular to the ladder is $F_g \cos\theta$. Thus, for the sum of all torques equals zero, we write:

$$0 = P\ell \sin\theta - F_g\left(\frac{\ell}{2}\right)\cos\theta$$

The length of the ladder is therefore irrelevant and can be canceled out. Since we know that $P = 50$ N and $F_g = 100$ N, we find that $\tan\theta = F_g/2P = 1.0$. Therefore $\theta = 45°$.

Electrostatics

KEY CONCEPTS

→ **THE NATURE OF ELECTRIC CHARGES**

→ **THE DETECTION AND MEASUREMENT OF ELECTRIC CHARGES**

→ **COULOMB'S LAW**

→ **THE ELECTRIC FIELD**

→ **ELECTRIC POTENTIAL**

→ **CAPACITANCE**

THE NATURE OF ELECTRIC CHARGES

The ancient Greeks used to rub pieces of amber on wool or fur. The amber was then able to pick up small objects that were not made of metal. The Greek word for amber was *elektron* (ελεκτρον)—hence the term *electric*. The pieces of amber would retain their attractive property for some time, so the effect appears to have been **static**. The amber acted differently from magnetic ores (lodestones), naturally occurring rocks that attract only metallic objects.

In modern times, hard rubber, such as ebonite, is used with cloth or fur to dramatically demonstrate the properties of electrostatic force. If you rub an ebonite rod with cloth (charging by fiction) and then bring it near a small cork sphere painted silver (called a "pith ball") and suspended on a thin thread, the pith ball will be attracted to the rod. When the ball and rod touch each other, the pith ball will be repelled. If a glass rod that has been rubbed with silk is then brought near the pith ball, the ball will be attracted to the rod. If you touch the pith ball with your hand, the pith ball will return to its normal state. This is illustrated in Figure 11.1.

Figure 11.1

In the nineteenth century, chemical experiments to explain these effects showed the presence of molecules called **ions** in solution. These ions possessed similar affinities for certain objects, such as carbon or metals, placed in the solution. These objects are called **electrodes**. The experiments confirmed the existence of two types of ions, **positive** and **negative**. The effects they produce are similar to the two types of effects produced when ebonite and glass are rubbed. Even though both substances attract small objects, these objects become **charged** oppositely when rubbed, as indicated by the behavior of the pith ball. Further, chemical experiments coupled with an atomic theory demonstrated that in solids it is the negative charges that are transferred. Additional experiments by Michael Faraday in England during the first half of the nineteenth century suggested the existence of a single, fundamental carrier of negative **electric charge**, which was later named the **electron**. The corresponding carrier of positive charge was termed the **proton**.

AP 2 only

THE DETECTION AND MEASUREMENT OF ELECTRIC CHARGES

When ebonite is rubbed with cloth, only the part of the rod in contact with the cloth becomes charged. The charge remains localized for some time (hence the name *static*). For this reason, among others, rubber, along with plastic and glass, is called an **insulator**. A metal rod held in your hand cannot be charged statically for two reasons. First, metals are **conductors**; that is, they allow electric charges to flow through them. Second, your body is a conductor, and any charges placed in the metal rod are conducted out through you (and into the earth). This effect is called **grounding**. The silver-coated pith balls mentioned in the first section of this chapter can become statically charged because they are suspended by thread, which is an insulator. They can be used to detect the presence and sign of an electric charge, but they are not very helpful in obtaining a qualitative measurement of the magnitude of charge they possess.

An instrument that is often used for qualitative measurement is the **electroscope**. One form of electroscope consists of two "leaves" made of gold foil (Figure 11.2a). The leaves are vertical when the electroscope is uncharged. As a negatively charged rod is brought near, the leaves diverge. If we recall the hypothesis that only negative charges move in solids, we can understand that the electrons in the knob of the electroscope are repelled down to the leaves through the conducting stem. The knob becomes positively charged, as can be verified with a charged pith ball, as long as the rod is near but not touching (Figure 11.2b). If you take the rod away, the leaves will collapse as the electroscope is still neutral overall.

Upon contact, electrons are directly transferred to the knob, stem, and leaves. The whole electroscope then becomes negatively charged (Figure 11.2c). The extent to which the leaves are spread apart is an indication of how much charge is present (but only qualitatively). If you touch the electroscope, you will ground it and the leaves will collapse together.

Repulsion

Contact

Uncharged
(leaves hanging)

(a)

Induced
charge separation
(leaves diverge)

(b)

Conduction:
Charging by contact
(leaves remain diverged)

(c)

Figure 11.2

The electroscope can also be charged by **induction**. If you touch the electroscope shown in Figure 11.2b with your finger when the electroscope is brought near (see Figure 11.3a), the repelled electrons will be forced out into your body. If you remove your finger, keeping the rod near, the electroscope will be left with an overall positive charge by induction (Figure 11.3b).

Electrons out

(a)

(b)

Figure 11.3

Finally, we can state that electric charges, in any distribution, obey a conservation law. When we transfer charge, we always maintain a balanced accounting. Suppose we have two charged metal spheres. Sphere *A* has +5 elementary charges, and sphere *B* has a +1 elementary charge (thus both are positively charged). The two spheres are brought into contact. Which way will charges flow? Excess charges are always spaced out as far apart as possible since they repel each other. When charges are allowed to flow, electrons do the moving even if the net charge on both objects is positive. Note that the vast majority of charge is not moving! If the two spheres are of equal size, they will each have a +3 charge after enough electrons move from the +1 sphere to the +3 sphere in this case. If one object is bigger than the other, the larger object will wind up with more of the net excess charge after those excess charges have all spread out as evenly as possible around the outer surfaces of the combined object.

COULOMB'S LAW

From the first two sections of this chapter, we can conclude that like charges repel each other while unlike charges attract (see Figure 11.4). The electrostatic force between two charged objects can act through space and even a vacuum. This property makes electrostatic force similar to the force of gravity.

Figure 11.4

In the SI system of units, charge is measured in **coulombs** (C). In the late eighteenth century, the nature of the electrostatic force was studied by French scientist Charles Coulomb. He discovered that the force between two point charges (designated as q_1 and q_2), separated by a distance r, experienced a mutual force along a line connecting the charges that varied directly as the product of the charges and inversely as the square of the distance between them. This law, known as **Coulomb's law**, is, like the law of gravity, an inverse square law acting on matter at a distance. Mathematically, Coulomb's law can be written as

$$F = \frac{kq_1q_2}{r^2}$$

The constant k has the value $8.9875 \times 10^9 \approx 9 \times 10^9$ N · m²/C².

An alternative form of Coulomb's law is

$$F = \left(\frac{1}{4\pi\varepsilon_0}\right)\frac{q_1q_2}{r^2}$$

The new constant, ε_0, is called the **permittivity of free space** or **permittivity of the vacuum** and has a value of 8.8542×10^{-12} C²/N · m². In the SI system, one elementary charge is designated as e and has a magnitude of 1.6×10^{-19} C.

Coulomb's law, like Newton's law of universal gravitation, is a vector equation. The direction of the force is along a radial vector connecting the two point sources. It should be noted that Coulomb's law applies only to one pair of point sources (or to sources that can be treated as point sources, such as charged spheres). If we have a distribution of point charges, the net force on one charge is the vector sum of all the other electrostatic forces. This aspect of force addition is sometimes termed **superposition**.

Calculate the static electric force between a $+6.0 \times 10^{-6}$ C charge and a -3.0×10^{-6} C charge separated by 0.1 m. Is this an attractive or repulsive force?

Solution

We use Coulomb's law:

$$F = \frac{kq_1q_2}{R^2}$$

$$F = \frac{(9 \times 10^9 \text{ N}\cdot\text{m}^2/\text{C}^2)(+6.0 \times 10^{-6} \text{ C})(-3.0 \times 10^{-6} \text{ C})}{(0.1\text{ m})^2} = -16.2\text{ N}$$

The negative sign (opposite charges) indicates that the force is attractive.

THE ELECTRIC FIELD

AP 2 only

Another way to consider the force between two point charges is to recall that the force can act through free space. If a charged sphere has charge $+Q$, and a small test charge $+q$ is brought near it, the test charge will be repelled according to Coulomb's law. Everywhere, the test charge will be repelled along a radial vector out from charge $+Q$. We can state that, even if charge $+Q$ is too small to be visible, the influence of the electrostatic force can be observed and measured (since charges have mass and $\mathbf{F} = m\mathbf{a}$ as usual).

In this way, charge $+Q$ is said to set up an electric field, which pervades the space surrounding the charge and produces a force on any other charge that enters the field (just as a gravitational field does). The strength of the electric field, \mathbf{E}, is defined to be the measure of the force per unit charge experienced at a particular location. In other words,

$$E = \frac{F}{q}$$

and the units are newtons per coulomb (N/C). The electric field strength \mathbf{E} is a vector quantity since it is derived from the force (a vector) and the charge (a scalar).

TIP

Compare this formula for the electric field to the formula for the gravitational field strength $g = F/m$.

An illustration of this situation is given in Figure 11.5. Charge $+Q$ is represented by a charged sphere drawn as a circle. A small positive test charge, $+q$, is brought near and repelled along a radial vector \mathbf{r} drawn outward from charge $+Q$. In fact, anywhere in the vicinity of charge $+Q$, the test charge will be repelled along an outward radial vector. We therefore draw these **force field lines** as radial vectors coming out from charge $+Q$.

By convention, we always consider the test charge to be positive. Since the force varies according to Coulomb's law, the electric field strength \mathbf{E} will also vary, depending on the location of the test charge. Thus, we can write for a point charge or outside a spherically symmetric charge:

$$E = \frac{F}{q} = \frac{kQ}{r^2} = \left(\frac{1}{4\pi\varepsilon_0}\right)\frac{Q}{r^2}$$

Figure 11.5

We can also interpret field strength by observing the density of field lines per square meter. With point charges, the radial nature of their construction causes the field lines to converge near the surface of the charge, Q, indicating a relative increase in field strength. In the next section, we will encounter a configuration in which the field strength remains constant throughout.

There are several other configurations of electric field lines that we can consider. In Figure 11.6, the field between two point charges, with different arrangements of signs, is illustrated. Notice that the field lines are always perpendicular to the "surface" of the source and that they never cross each other. This fact can be extended to the idea that the electric field inside a hollow conducting sphere is zero, and all of the charges reside on the surface of the sphere.

The arrows on the field lines always indicate the direction in which a positive test charge would move.

Figure 11.6

$\boxed{\text{SAMPLE PROBLEM}}$

What is the force acting on an electron placed in an external electric field **E** = 100 N/C?

Solution

We know that **E** = F/q

Thus,

$$F = Eq = (100 \text{ N/C})(-1.6 \times 10^{-19} \text{ C}) = -1.6 \times 10^{-17} \text{ N}$$

ELECTRIC POTENTIAL

AP 2 only

In Chapter 4, we reviewed the fact that gravity is a conservative force. Any work done by or against gravity is independent of the path taken. In Chapter 8, the work done was measured as a change in the gravitational potential energy. Recall that work is equal to the magnitude of force times displacement, $W = \mathbf{F}\,\Delta x$. Suppose that the force is acting on a charge q in an electric field \mathbf{E}. The work done by or against the electric field, which is also a conservative field, is given by

$$W = \mathbf{E}q\,\Delta r \text{ (in the direction of } \mathbf{E}\text{)}$$

Since the electrostatic force is conservative, the work done should be equal to the change in the electrical potential energy between two points, A and B.

Many points can have the same electrical potential energy. Consider the original electric field diagram in Figure 11.5. If test charge $+q$ is a distance r from source charge $+Q$, it will experience a certain radial force whose magnitude is given by Coulomb's law. At any position around the source, at a fixed distance r, we can observe that the test charge will experience the same force. The localized potential energy will be the same as well. The set of all such positions defines a circle of radius r (actually a sphere in three dimensions), called an **equipotential surface**.

Figure 11.7 shows a series of equipotential "curves" of varying radii. Since the electric field is conservative, work is done by or against the field only when a charge is moved from one equipotential surface to another. To better understand this effect, we define a quantity called the **electric potential**, which is a measure of the magnitude of electrical potential energy per unit charge at a particular location in the field. Thus, the work done per unit charge, in moving from equipotential surface A to equipotential surface B, is a measure of what is called the **potential difference** or **voltage**.

Figure 11.7

We thus define electric potential difference (V or ΔV) to be the potential difference between two points ($V_B - V_A$). Note that voltage or emf (electromotive force) are sometimes used as synonyms for "electric potential difference." Since electric potential difference is the work per charge, the units of potential difference are joules/coulomb or volts:

$$\text{Units of electric field potential} = \text{volt} = \text{V} = \text{J/C} = \text{N} \cdot \text{m/C}$$

> **TIP**
>
> Try not to confuse electric potential with electric potential energy. Additionally, the ratio of volts per meter (V/m) is often referred to as a gradient.

> **AP PHYSICS 1**
>
> You **must** know the definition of **voltage**.

Sometimes it is convenient to speak of the potential at a point. This implies that a zero-volt point has already been chosen and all the other electric potential differences are relative to that point. Frequently, zero voltage is taken at infinity. At other times, it is taken to be at the closest grounding point or the negative terminal of a battery in a simple circuit.

If there exists a constant, uniform electric field (see below), then rearranging the definition of electric potential difference shown above yields the following relationship between electric field (a proxy for electric force) and potential difference (a proxy for electrical potential energy):

$$\text{Units of electric field} = N/C = V/m$$

Therefore, if we have a uniform electric field, the electric potential difference between two points is simply the electric field times the distance between the two points in the direction of the field. One way to produce such a uniform electric field is between two charged parallel plates that are separated by a distance d. If each side is oppositely charged (see Figure 11.8), the electric field will be uniform. Therefore, a test charge within this field would feel the same force at any point in between the plates. Compare this to the gravitational field g near Earth's surface. A test mass in the location experiences the same force mg anywhere in this area. Note in Figure 11.8 that the electric field loses its uniformity near the edges of the plates. This phenomenon is known as the **fringe effect**. It is due to the fact that the charge distribution is no longer uniform at the edges.

Figure 11.8

Recall that work done by a conservative force is the negative of the change in potential energy. By combining our definition of electric potential difference with our work relationship to potential energy:

$$W = q\Delta V = -\Delta PE$$

If the moving charge is positive, a positive ΔV results in negative work (the charge is losing energy). However if the moving charge is negative, a positive ΔV results in positive work (the charge is gaining energy). Just as positive and negative charges will experience opposite forces when placed into the same electric field, so one will gain energy when the other loses energy. Generally speaking, positive charges move from high electric potential difference to low electric potential difference, whereas negative charges move from low electric potential differences to high ones. Going back to our gravitational analogy, negative mass (if it existed) would experience an upward force. By moving up, it would lower its gravitational potential energy by raising its gravitational potential. In this analogy, height is electric potential difference while the ground is the negative plate. The negative mass is certainly gaining height (greater electric potential difference) by responding to the upward force. Since its mass is negative, its gravitational potential energy is decreasing.

Similarities in Uniform Gravitational and Electric Fields

	Gravitational	Electrical
Forces	mg	qE
Potential Energy Differences	$mg\Delta h$	$qE\Delta D$

Another convenient unit of electrical energy is the **electron volt** (eV). By definition, if one elementary charge experiences a potential difference of 1 volt, its energy (or the work done to transfer the charge) is equal to 1 electron volt. Consequently, we can state that 1 electron volt = 1.6×10^{-19} joule.

SAMPLE PROBLEM

Given that the charge on a proton is $+1.6 \times 10^{-19}$ C,

(a) Calculate the electric potential at a point 2.12×10^{-10} m from the proton.

(b) If an electron (and no other charges) is placed at that point, what will be its electric potential energy. Assume that the potential energy at infinity is equal to zero.

Solution

(a) For the proton, we use

$$V = \frac{kQ}{r}$$

$$V = \frac{(9 \times 10^9 \text{ N} \cdot \text{m}^2/\text{C}^2)(1.6 \times 10^{-19} \text{ C})}{2.12 \times 10^{-10} \text{ m}} = 6.79 \text{ V}$$

(b) For the electron, the potential energy

$$U = qV = (-1.6 \times 10^{-19} \text{ C})(6.79 \text{ V}) = -1.09 \times 10^{-18} \text{ J}$$

CAPACITANCE

AP 2 only

When there are two charged parallel metal plates in a configuration called a **capacitor**, there is a proportional relationship between the potential difference and the total charge. The capacitance, C, of a capacitor is defined to be the ratio of the charge on either conductor and the potential difference between the conductors:

$$C = \frac{Q}{V}$$

This is a positive scalar quantity that is essentially a measure of the capacitor's ability to store charge. The reason is that, for a given capacitor, the ratio Q/V is a constant since potential difference increases as the charge on either capacitor increases.

The SI unit of capacitance is the **farad** (F). The types of capacitors typically used in electronic devices have capacitances that range from microfarads to picofarads.

The capacitance of a given object is a property of the materials used and the geometry of the two surfaces upon which the two oppositely charged distributions will be induced when a voltage is supplied. For simple parallel plate capacitors, it can be shown that

$$C = Q/V = \varepsilon_0 A/d$$

where A is the cross-sectional area of the plates and d is the separation between them. Note that the capacitance is not affected by either the amount of charge or the voltage, but, instead, is fixed by its construction.

The parallel plate capacitor is one of the simplest ways to achieve a uniform electric field. In Figure 11.9 below, note the regularly spaced parallel lines of the electric field pointing from the positive plate to the negative one. The equipotential surfaces are indicated by the vertical lines. Any charge will have the same electrical potential energy on one of the surfaces.

Figure 11.9

Note that the fields are uniform only near the center. Near the edges, the fields become nonuniform, known as the fringe effect.

The energy stored in a capacitor can be studied by recognizing that the definition of capacitance can be written as $Q = CV$. This direct relationship between plate charge and voltage will produce a diagonal straight line if we plot a graph of charge versus voltage (see Figure 11.10).

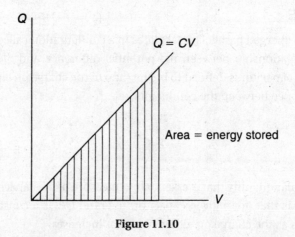

Figure 11.10

Notice that the units of QV are joules (the units of work). The area under the diagonal line is equal to the amount of energy stored in the capacitor. This energy is given by $E = (\frac{1}{2})CV^2$.

A point charge $+Q$ is fixed at the origin of a coordinate system. A second charge $-q$ is uniformly distributed over a spherical mass m and orbits around the origin at a radius r and with a period T. Derive an expression for the radius.

Solution

If we neglect gravity and other external forces, the orbit is due to the electrostatic force between the charges. This sets up a centripetal force for the mass m.

Thus, we can write

$$\frac{1}{4\pi\varepsilon_0}\left(\frac{Qq}{r^2}\right) = \frac{m4\pi^2 r}{T^2}$$

and

$$r = \left(\frac{T^2 Qq}{m\varepsilon_0 16\pi^3}\right)^{1/3}$$

SUMMARY

- There are two kinds of electric charges: positive and negative.
- Electrons are the fundamental carriers of negative charge.
- Protons carry a positive charge equal in magnitude to that of the electron.
- Like charges repel, while unlike charges attract.
- An electroscope can be used to detect the presence of static charges.
- Objects become charged through the transfer of electrons.
- Coulomb's law describes the nature of the force between two static charges. It states that the force of either attraction (–) or repulsion (+) is proportional to the product of the charges and inversely proportional to the square of the distance between them. This is similar to Newton's law of gravitation (see Chapter 8).
- The electrical potential difference is defined to be equal to the work done per unit charge (in units of joules per coulomb or volts).
- A capacitor is a device that can store charge and energy. The capacitance of a capacitor is defined as the amount of charge stored per unit volt ($C = Q/V$). **AP 2 only**
- Electric field lines indicate the direction of electric force on positive charges. They come out of positive source charges and go into negative source charges. They never cross, and their relative spacing indicates the strength of the field.
- Equipotential lines indicate regions of constant electrical potential. The lines (surfaces, actually) intersect the electric field lines at right angles and have their highest values near positive source charges and their lowest values near negative source charges.

AP 2 only

Problem-Solving Strategies for Electrostatics

The preceding sample problem reminds us that we are dealing with vector quantities when the electrostatic force and field are involved. Drawing a sketch of the situation and using our techniques from vector constructions and algebra were most effective in solving the problem.

Be sure to keep track of units. If a problem involves potential or capacitance, remember to maintain the standard SI system of units, which are summarized in the appendices.

Remember that electric field lines are drawn as though they followed a "positive" test charge and that Coulomb's law applies only to point charges. The law of superposition allows you to combine the effects of many forces (or fields) using vector addition. Additionally, symmetry may allow you to work with a reduced situation that can be simply doubled or quadrupled. In this aspect, a careful look at the geometry of the situation is called for.

If the electric field is uniform, the charges in motion will experience a uniform acceleration that will allow you to use Newtonian kinematics to analyze the motion. Electrons in oscilloscopes are an example of this kind of application.

Potential and potential difference (voltage) are scalar quantities usually measured relative to the point at infinity in which the localized potential is taken to be zero. In a practical sense, it is the change in potential that is electrically significant, not the potential itself.

PRACTICE EXERCISES

Multiple-Choice

1. An insulated metal sphere, A, is charged to a value of $+Q$ elementary charges. It is then touched and separated from an identical but neutral insulated metal sphere, B. This second sphere is then touched to a third identical and neutral insulated metal sphere C. Finally, spheres A and C are touched and then separated. Which of the following represents the distribution of charge on each sphere, respectively, after the above process has been completed?

 (A) $Q/3, Q/3, Q/3$
 (B) $Q/4, Q/2, Q/4$
 (C) $3Q/8, Q/4, 3Q/8$
 (D) $3Q/8, Q/2, Q/4$

2. Electrical appliances are usually grounded in order to

 (A) maintain a balanced charge distribution
 (B) prevent the buildup of heat on them
 (C) run properly using household electricity
 (D) prevent the buildup of static charges on their surfaces

3. Two point charges experience a force of repulsion equal to 3×10^{-4} N when separated by 0.4 m. If one of the charges is 5×10^{-4} C, what is the magnitude of the other charge?

 (A) 1.07×10^{-11} C
 (B) 2.7×10^{-11} C
 (C) 3.2×10^{-9} C
 (D) 5×10^{-4} C

AP 1 only

4. A parallel-plate capacitor has a capacitance of C. If the area of the plates is doubled, while the separation between the plates is halved, the new capacitance will be

AP 2 only

(A) $2CF$

(B) $4CF$

(C) $C/2$ F

(D) CF

5. What is the capacitance of a parallel-plate capacitor made of two aluminum plates, 4 cm in length on a side and separated by 5 mm?

AP 2 only

(A) 2.832×10^{-11} F

(B) 2.832×10^{-10} F

(C) 2.832×10^{-12} F

(D) 2.832×10^{-9} F

6. If 10 J of work is required to move 2 C of charge in a uniform electric field, the potential difference present is equal to

AP 1 only

(A) 20 V

(B) 12 V

(C) 8 V

(D) 5 V

7. Which of the following diagrams represents the equipotential curves in the region between a positive point charge and a negatively charged parallel plate?

AP 2 only

(A)

(B)

(C)

(D)

AP 2 only

8. An electron is placed between two charged parallel plates as shown below. Which of the following statements is true?

I. The electrostatic force is greater at *A* than at *B*.

II. The work done from *A* to *B* to *C* is the same as the work done from *A* to *C*.

III. The electrostatic force is the same at points *A* and *C*.

IV. The electric field strength decreases as the electron is repelled upward.

(A) I and II

(B) I and III

(C) II and III

(D) II and IV

9. How much kinetic energy is given to a doubly ionized helium atom due to a potential difference of 1,000 V?

(A) 3.2×10^{-16} eV

(B) 1,000 eV

(C) 2,000 eV

(D) 3.2×10^{-19} eV

AP 2 only

10. Which of the following is equivalent to 1 F of capacitance?

(A) $\dfrac{C^2 \cdot s^2}{kg \cdot m^2}$

(B) $\dfrac{kg \cdot m^2}{C^2 \cdot s^2}$

(C) $\dfrac{C}{kg \cdot s}$

(D) $\dfrac{C \cdot m}{kg^2 \cdot s}$

Free-Response

AP 2 only

1. An electron enters a uniform electric field between two parallel plates vertically separated with **E** = 400 N/C. The electron enters with an initial velocity of 4×10^7 m/s. The length of each plate is 0.15 m.

(a) What is the acceleration of the electron?

(b) How long does the electron travel through the electric field?

(c) If it is assumed that the electron enters the field level with the top plate, which is negatively charged, what is the vertical displacement of the electron during that time?

(d) What is the magnitude of the velocity of the electron as it exits the field?

2. A 1-g cork sphere on a string is coated with silver paint. It is in equilibrium, making a 10° angle in a uniform electric field of 100 N/C as shown below. What is the charge on the sphere?

3. Four identical point charges ($Q = +3$ μC) are arranged in the form of a rectangle as shown below. What are the magnitude and the direction of the net electric force on the charge in the lower left corner due to the other three charges?

4. An electrostatically charged rod attracts a small, suspended sphere. What conclusions can you make about the charge on the suspended sphere?

5. Why is it safe to be inside a car during a lightning storm?

6. Why are most electrical appliances grounded?

ANSWERS EXPLAINED
Multiple-Choice Problems

1. **(C)** We use the conservation of charge to determine the answer. Sphere A has $+Q$ charge, and B has zero. When these spheres are touched and separated, each will have one-half of the total charge, which was $+Q$. Thus, each now has $+Q/2$.

 When B is touched with C, which also has zero charge, we again distribute the charge evenly by averaging. Thus, B and C will now each have $+Q/4$, while A still has $+Q/2$.

 Finally, when A and C are touched, we take the average of $+Q/4$ and $+Q/2$, which is $+3Q/8$.

 The final distribution is therefore $3Q/8$, $Q/4$, $3Q/8$.

2. **(D)** Electrical appliances are grounded to prevent the buildup of static charges on their surfaces.

3. **(A)** We use Coulomb's law to calculate the answer. Everything is given except one charge. The working equation therefore looks like this:

$$3 \times 10^{-4} = \frac{(9 \times 10^9)(5 \times 10^{-4})q}{(0.4)^2}$$

$$q = 1.07 \times 10^{-11} \, C$$

4. **(B)** The formula for the capacitance of a parallel-plate capacitor is $C = \varepsilon_0 A / d$. Therefore, if the area is doubled and the separation distance halved, the capacitance increases by four times and is equal to $4CF$.

5. **(C)** We use the formula from question 4, but first all measurements must be in meters or square meters. Converting the given lengths yields 4 cm = 0.04 m and 5 mm = 0.005 m. Then $A = (0.04)(0.04) = 0.0016 \, m^2$ and $d = 0.005$ m. Using the formula and the value for the permittivity of free space given in the chapter, we get $C = 2.832 \times 10^{-12}$ F.

6. **(D)** Potential difference is the work done per unit charge. Thus

$$V = \frac{W}{q} = \frac{10}{2} = 5 \, V$$

7. **(C)** The equipotential curves around a point charge are concentric circles. The equipotential curves between two parallel plates are parallel lines (since the electric field is uniform). The combination of these two produces the diagram shown in choice C.

8. **(C)** The electric field is the same at all points between two parallel plates since it is uniform. Thus the force on an electron is the same everywhere. Also, we stated in the chapter that the electric field, like gravity, is a conservative field. This means that work done to or by the field is independent of the path taken. Thus both statements II and III are true.

9. **(C)** One electron volt is defined to be the energy given to one elementary charge through 1 V of potential difference. A doubly ionized helium atom has +2 elementary charges. Since the potential difference is 1,000 V, the kinetic energy is 2,000 eV. When using electron-volt units, we eliminate the need for the small numbers associated with actual charges of particles.

10. **(A)** One farad is defined to be 1 C/V. One volt is 1 J/C. One joule is 1 kg · m²/s². The combination results in

$$\frac{C^2 \cdot s^2}{kg \cdot m^2}$$

Free-Response Problems

1. (a) Since the electron is in a uniform electric field, the kinematics of the electron follows the standard kinematics of mechanics. Since $\mathbf{F} = m\mathbf{a}$ and $\mathbf{F} = -e\mathbf{E}$, $\mathbf{a} = -e\mathbf{E}/m$ (the negative sign is needed since an electron is negatively charged). Using the information given in the problem and the values for the charge and mass of the electron from the Appendix, we get

$$\mathbf{a} = \frac{-(1.6 \times 10^{-19})(400)}{9.1 \times 10^{-31}} = -7.03 \times 10^{13} \, m/s^2$$

(b) The electron is subject to a uniform acceleration in the downward direction. The path will therefore be a parabola, and the electron will be a projectile in the field. The initial horizontal velocity remains constant, and therefore the time is given by the expression

$$t = \frac{\ell}{\mathbf{v}_0} = \frac{0.15}{4 \times 10^7} = 3.75 \times 10^{-9} \text{ s}$$

(c) If we take the initial entry level as zero in the vertical direction, the electron has initially zero velocity in that direction. Thus, the vertical displacement is given by $\mathbf{y} = (1/2)\mathbf{a}t^2$. Using the information from parts (a) and (b), we get

$$\mathbf{y} = -(1/2)(7.03 \times 10^{13})(3.75 \times 10^{-9})^2 = -4.94 \times 10^{-4} \text{ m}$$

(d) The magnitude of the velocity as the electron exits the field, after time t has elapsed, is given by the vector nature of two-dimensional motion. The horizontal velocity is the same throughout the encounter and is equal to 4×10^7 m/s. The vertical velocity is given by $\mathbf{v}_y = -\mathbf{a}t$ since there is no initial vertical velocity. Using the information from the previous parts, we find that

$$\mathbf{v}_y = -(7.03 \times 10^{13})(3.75 \times 10^{-9}) = -2.6 \times 10^5 \text{ m/s}$$

Now the magnitude of the velocity is given by the Pythagorean theorem since the velocity is the vector sum of these two component velocities:

$$\mathbf{v} = \sqrt{(4 \times 10^7)^2 + (2.6 \times 10^5)^2} = 40{,}000{,}845 \text{ m/s} \approx 4 \times 10^7 \text{ m/s}$$

The result is not a significant change in the magnitude of the initial velocity. There is of course a significant change in direction. The angle of this change can be determined by the tangent function if desired.

2. If the sphere is in equilibrium, the vector sum of all forces acting on it must equal zero. There are several forces involved. Mechanically, gravity acts to create a tension in the string. This tension has an upward component that directly balances the force of gravity ($m\mathbf{g}$) acting on the sphere. A second horizontal component acts to the left and counters the horizontal electrical force established by the field and the charge on the sphere. A free-body diagram looks like this:

From the diagram, we see that $\mathbf{T}\cos\theta = m\mathbf{g}$, where $\theta = 10°$ and m = 1 g = 0.001 kg. Thus, $\mathbf{T} = 0.00995$ N, using our known value for the acceleration due to gravity, \mathbf{g}. Now, in the

horizontal direction, $\mathbf{T}\sin\theta = \mathbf{E}_q$ and $E = 100$ N/C. Using all known values given and derived, we arrive at

$$q = 1.75 \times 10^{-5}\ \text{C}$$

3. Since all the charges are positive, the lower-left-corner charge will experience mutual repulsions from the other three. A diagram showing these forces appears below:

The magnitude of each force is given by Coulomb's law. The diagonal distance was determined using the Pythagorean theorem. The three force magnitudes are therefore calculated to be:

$$\mathbf{F}_1 = \frac{(9\times10^9)(3\times10^{-6})(3\times10^{-6})}{(0.07)^2} = 16.53\ \text{N}$$

$$\mathbf{F}_2 = \frac{(9\times10^9)(3\times10^{-6})(3\times10^{-6})}{(0.086)^2} = 10.95\ \text{N}$$

$$\mathbf{F}_3 = \frac{(9\times10^9)(3\times10^{-6})(3\times10^{-6})}{(0.05)^2} = 32.4\ \text{N}$$

Now, \mathbf{F}_1 acts to the left and \mathbf{F}_3 acts downward, so no further vector reductions are necessary. However, \mathbf{F}_2 acts at some angle toward the lower left, given by θ. To find the angle, we recall that $\tan\theta = 5/7$, which implies that $\theta = 35.53°$. Both components of \mathbf{F}_2 will be negative by our sign convention of Chapter 2.

We can now write

$$\mathbf{F}_{2x} = \pm10.95 \cos 35.53 = \pm8.91\ \text{N}$$

and

$$\mathbf{F}_{2y} = \pm10.95 \sin 35.53 = \pm6.36\ \text{N}$$

The resultant or net force acting on the lower-left-corner charge is the vector sum of these charges. We can find the components of this force by simply adding up the forces in the same directions:

$$\mathbf{F}_x = -16.53 - 8.91 = -25.44\ \text{N}$$

$$\mathbf{F}_y = -32.40 - 6.36 = -38.76\ \text{N}$$

The magnitude of the net force \mathbf{F} is given by the Pythagorean theorem and is equal to 46.3 N. The direction of this force is given by

$$\tan\phi = \frac{\mathbf{F}_y}{\mathbf{F}_x} = \frac{38.76}{25.44} = 1.5$$

This implies that $\phi = 56.7°$ relative to the negative x-axis.

4. The only conclusion you can make is that the sphere is either "neutral" or oppositely charged compared to the rod.

5. If your car is hit by lightning, the charges are distributed around the outside and then dissipated away. In a sense, this acts like an electrostatic shield.

6. Appliances are grounded to prevent the buildup of static charges on their outside surfaces.

Electric Circuits

<div style="text-align: right;">

12

</div>

KEY CONCEPTS
→ CURRENT AND ELECTRICITY
→ ELECTRIC RESISTANCE
→ ELECTRIC POWER AND ENERGY
→ SERIES AND PARALLEL CIRCUITS
→ NETWORKS AND COMBINATION CIRCUITS
→ COMBINATION CIRCUITS
→ CAPACITORS IN CIRCUITS
→ ELECTRICAL ENERGY IS POTENTIAL ENERGY

CURRENT AND ELECTRICITY

In Chapter 11, we observed that, if two points have a potential difference between them, and they are connected with a conductor, negative charges will flow from a higher concentration to a lower one. This aspect of charge flow is very similar to the flow of water in a pipe due to a pressure difference.

Moving electric charges are referred to as electric **current**, which measures the amount of charge passing a given point every second. The units of measurement are coulombs per second (C/s). These are defined as an ampere or "amp." Algebraically, we designate current by the capital letter I and state that

$$I = \frac{\Delta Q}{\Delta t}$$

In electricity, it is the battery that supplies the potential difference needed to maintain a continuous flow of charge. In the nineteenth century, physicists thought that this potential difference was an electric force, called the **electromotive force** (emf), that pushed an electric fluid through a conductor. Today, we know that an emf is not a force, but rather a potential difference measured in volts. Do not be confused by the designation emf in the course of reviewing or of solving problems!

From chemistry, recall that a battery uses the action of acids and bases on different metals to free electrons and maintain a potential difference. In the process, two terminals, designated positive and negative, are created. When a conducting wire is attached and looped around to the other end, a complete circle of wire (a **circuit**) is produced, allowing for the continuous flow of charge. The battery acts like an elevator, raising electrons from the positive side up to the negative side using chemical reactions (see Figure 12.1). These electrons can then do work by transforming their electric potential energy into other forms of energy. This work is the electricity with which we have become so familiar in our modern world.

Figure 12.1

The diagram in Figure 12.1 shows a simple electric circuit. The direction of the conventional current, like electric fields, is from the positive terminal. To maintain a universal acceptance of concepts and ideas (recall our earlier discussions of concepts and labels), schematic representations for electrical devices were developed and accepted by physicists and electricians worldwide. These schematics are used when drawing or diagramming an electric circuit, and it is important that you be able to interpret and draw them to fully understand this topic. In Figure 12.2, schematics for some of the most frequently encountered electrical devices are presented.

Figure 12.2 Electrical Schematic Diagrams

The simple circuit shown in Figure 12.1 can now be diagrammed schematically as in Figure 12.3.

Figure 12.3

A switch has been added to the schematic; of course the charge would not flow unless the switch was closed. An open switch stops the flow by breaking the circuit.

In Figure 12.2, three schematics appear that we have not yet discussed. A **resistor** is a device whose function is to use up voltage. We will investigate resistors in more detail in the next section.

An **ammeter** is a device that measures the current. You can locate the water meter in your house or apartment building and notice that it is placed within the flow line. The reason is that the meter must measure the flow of water per second through a given point. An ammeter

is placed within an electric circuit in much the same way. This is referred to as a "series connection," and it maintains the singular nature of the circuit. In practical terms, you can imagine cutting a wire in Figure 12.3, and hooking up the bare leads to the two terminals of the ammeter. Ammeters have very low resistance.

A **voltmeter** is a device that measures the potential difference, or voltage, between two points. Unlike an ammeter, the voltmeter cannot be placed within the circuit since it will effectively be connected to only one point. A voltmeter is therefore attached in a "parallel connection," creating a second circuit through which only a small amount of current flows to operate the voltmeter. In Figure 12.4, the simple circuit is redrawn with the ammeter and voltmeter placed. Voltmeters have very high resistance.

Figure 12.4

For simple circuits, there will be no observable difference in readings if the ammeter and voltmeter are moved to different locations. However, there is a slight difference in the emf across the terminals of the battery when the switch is closed versus when it is open. The first emf reflects the work done by the battery not only to move charge through the circuit but also to move charge across the terminals of the battery. This is sometimes referred to as the **terminal emf** or **internal emf**.

ELECTRIC RESISTANCE

In Figure 12.4, a simple electric circuit is illustrated with measuring devices for voltage and current. If a light bulb is left on for a long time, two observations can be made. First, the bulb gets hot because of the action of the electricity in the filament. The light produced by the bulb is caused by the heat of the filament. Second, the current in the ammeter will begin to decrease.

These two observations are linked to the idea of electrical resistance. The interaction of flowing electrons and the molecules of a wire (or bulb filament) creates an electrical **resistance**. This resistance is temperature dependent since, from the kinetic theory, an increase in temperature will increase the molecular activity and therefore interfere to a greater extent with the flow of current. Electrical potential energy is being converted to thermal energy.

In the case of a light bulb, it is this resistance that is desired in order for the bulb to do its job. Resistance along a wire or in a battery, however, is unwanted and must be minimized. In more complicated circuits, a change in current flow is required to protect devices, and so special resistors are manufactured that are small enough to easily fit into a circuit. While resistance is the opposite of conductance, we do not want to use insulators as resistors since insulators will stop the flow altogether. Therefore, a range of materials, indexed by "resistivity," is catalogued in electrical handbooks to assist scientists and electricians in choosing the proper resistor for a given situation.

If the temperature can be maintained at a constant level, a simple relationship between the voltage and the current in a circuit is revealed: as the voltage is increased, a greater flow of current is observed. This direct relationship was investigated theoretically by a German physicist named Georg Ohm and is called **Ohm's law** (see Figure 12.5).

Figure 12.5 Ohm's law

Ohm's law states that in a circuit at constant temperature the ratio of the voltage to the current remains constant. The slope of the line in Figure 12.5 represents the resistance of the circuit, which is measured in units of ohms (Ω). Algebraically, we can write Ohm's law as

$$R = \frac{V}{I} \quad \text{or} \quad V = IR$$

Not all conductors obey Ohm's law. Lightbulbs, semiconductors, and liquid conductors, for example, do not.

Other factors also affect the resistance of a conductor. We have already discussed the effects of temperature and material type (resistivity). Resistivity is designated by the Greek letter ρ (rho). In a wire, electrons try to move through, interacting with the molecules that make up the wire. If the wire has a small cross-sectional area, the chances of interacting with a bound molecule increase and thus the resistance of the wire increases. If the length of the wire is increased, the greater duration of interaction time will also increase the resistance of the wire. In summary, these resistance factors all contribute to the overall resistance of the circuit.

Algebraically, we may write these relationships (at constant temperature) in the following form:

$$R = \frac{\rho L}{A}$$

where L is the length in meters and A is the cross-sectional area in units of m^2. The resistivity (ρ) is measured in units of ohm \cdot meters ($\Omega \cdot m$) and is usually rated at 20 degrees Celsius.

In Table 12.1, the resistivities of various materials are presented. Since the ohm is a standard (SI) unit, be sure that all lengths are in meters and areas are in square meters.

Table 12.1

Resistivities of Selected Materials at 20°C	
Substance	Resistivity, ρ ($\Omega \cdot$ m)
Aluminum	2.83×10^{-8}
Carbon	3.5×10^{-5}
Copper	1.69×10^{-8}
Gold	2.44×10^{-8}
Nichrome	100×10^{-8}
Platinum	10.4×10^{-8}
Silver	1.59×10^{-8}
Tungsten	5.33×10^{-8}

SAMPLE PROBLEM

Copper wire is being used in a circuit. The wire is 1.2 m long and has a cross-sectional area of 1.2×10^{-8} m$^2$ at a constant temperature of 20°C.

(a) Calculate the resistance of the wire.

(b) If the wire is connected to a 10-V battery, what current will flow through it?

Solution

(a) We use

$$R = \rho L / A \text{ where in this case, } \rho \text{ is the resistivity at 20°C}$$

$$R = \frac{(1.69 \times 10^{-8} \, \Omega \cdot \text{m})(1.2 \text{ m})}{1.2 \times 10^{-8} \text{ m}^2} = 1.69 \, \Omega$$

(b) Now, we use Ohm's law

$$I = \frac{V}{R} = \frac{10 \text{ V}}{1.69 \, \Omega} = 5.9 \text{ A}$$

ELECTRIC POWER AND ENERGY

Electrical energy can be used to produce light and heat. Electricity can do work to turn a motor. Having measured the voltage and current in a circuit, we can determine the amount of power and energy being produced in the following way. The units of voltage (potential difference) are joules per coulomb (J/C) and are a measure of the energy supplied to each coulomb of charge flowing in the circuit. The current, I, measures the total number of coulombs per second flowing at any given time. The product of the voltage and the current (VI)

Unit analysis

$$\left(\frac{J}{C}\right) \times \left(\frac{C}{s}\right) = \frac{J}{s} = \text{watt}$$

Derivation

$$P = \frac{\text{work}}{\text{time}}$$
$$= \frac{qV}{t}$$
$$= \left(\frac{q}{t}\right)V$$
$$= IV$$

is therefore a measure of the total power produced since the units will be joules per second (watts):

$$P = VI$$

The electrical energy expended in a given time t (in seconds) is simply the product of the power and the time:

$$\text{Energy} = Pt = VIt$$

SAMPLE PROBLEM

How much energy is used by a 10-Ω resistor connected to a 24-V battery for 30 minutes?

Solution

We know that the energy is given by $E = VIt = (V^2/R)t$, where t must be in seconds.

Thus,

$$E = \frac{(24\,\text{V})^2(1{,}800\,\text{s})}{10\,\Omega} = 1{,}036{,}800\,\text{J}$$

SERIES AND PARALLEL CIRCUITS

Two very important conservation laws underlie all of the circuit analysis that this chapter is about to explore: conservation of charge and conservation of energy. Gustav Kirchhoff first applied these to circuits and gave us the following rules for circuits.

1. **The junction rule:** The total current coming into a junction must equal the total current leaving the junction. (Charge must be conserved.)
2. **The loop rule:** The total voltage drops and gains must total to zero as you travel around any closed loop of a circuit. (Energy must be conserved.) Traveling across a resistor with the current is a voltage drop, against the current a gain. Traveling across a battery from negative to positive is a voltage gain and from positive to negative is a voltage drop.

What is the current in the top path of the following section of a circuit?

Solution

Since the current coming into the junction on the left is 9 amps, a total of 9 amps must be leaving. Since the other two branches are carrying away 8 amps total, 1 amp is left for the missing pathway.

How much voltage is being used by the resistor in this picture?

Solution

If we trace a loop starting at the bottom right-hand corner and go counterclockwise, we encounter the following voltage changes, which must sum to zero:

$$+9 \text{ V} + R1 - 5 \text{ V} + 2 \text{ V} = 0$$

Solving for R1 gives us −6 V. This means current is going from right to left in this resistor as we traced through this resistor from right to left to obtain the decrease in voltage result. (Recall that current goes from high voltage to low voltage.)

Series Circuits

A series circuit consists of two or more resistors sequentially placed within one circuit. More generally, elements on the same path within a more complicated circuit are "in series with each other." An example is seen in Figure 12.6.

Figure 12.6 Series Circuit

We need to ask two questions. First, what is the effect of adding more resistors in series to the overall resistance in the circuit? Second, what effect does adding the resistors in series have on the current flowing in the circuit?

One way to think about this circuit is to imagine a series of doors, one after the other. As people exit through one door, they must wait to open another. The result is to drain energy out of the system and decrease the number of people per second leaving the room. In an electric circuit, adding more resistors in series decreases the current (with the same voltage) by increasing the resistance of the circuit.

Algebraically, all of these observations can be summarized as follows. In resistors R_1, R_2, and R_3, we have currents I_1, I_2, and I_3. Each of these three currents is equal to each other current and to the circuit current I:

$$I = I_1 = I_2 = I_3$$

However, the voltage across each of these resistors is less than the source voltage V. If all three resistors were equal, each voltage would be equal to one-third of the total source voltage. In any case, we have

$$V = V_1 + V_2 + V_3$$

Using Ohm's law ($V = IR$), we can rewrite this expression as

$$IR = I_1R_1 + I_2R_2 + I_3R_3$$

However, the three currents are equal, so they can be canceled out of the expression. This leaves us with

$$R = R_1 + R_2 + R_3$$

In other words, when resistors are added in series, the total resistance of the circuit increases as the sum of all the resistances. This fact explains why the current decreases as more resistors are added. In our example, the total resistance of the circuit is

$$1\ \Omega + 2\ \Omega + 3\ \Omega = 6\ \Omega$$

Since the source voltage is 12 V, Ohm's law provides for a circuit current of 12/6 = 2 A. The voltage across each resistor can now be determined from Ohm's law since each gets the same current of 2 A. Thus,

$$V_1 = (1)(2) = 2 \text{ V}; \quad V_2 = (2)(2) = 4 \text{ V}; \quad V_3 = (3)(2) = 6 \text{ V}$$

The voltages in a series circuit add up to the total, and not unexpectedly we have

$$2 \text{ V} + 4 \text{ V} + 6 \text{ V} = 12 \text{ V}$$

It should be noted that, when batteries are connected in series (positive to negative), the effective voltage increases additively as well.

Parallel Circuits

A parallel circuit consists of multiple pathways connected from one point to another, all experiencing the same potential difference. An example of a parallel circuit is seen in Figure 12.7.

Figure 12.7 Parallel Circuit

In this circuit, a branch point is reached in which the current I is split into I_1 and I_2. Since each resistor is connected to a common potential point, experiments verify that the voltage across each resistor equals the source voltage V. Thus, in this circuit it is the current that is shared; the voltage is the same. Another feature of the parallel circuit is the availability of alternative paths. If one part of the circuit is broken, current can flow through the other path. While each branch current is less than the total circuit current I, the effect of adding resistors in parallel is to increase the effective circuit current by decreasing the circuit resistance R.

To understand this effect further, imagine a set of doors placed next to each other along a wall in a room. Unlike the series connection (in which the doors are placed one after the other), the parallel-circuit analogy involves placing the doors next to each other. Even though each door will have fewer people per second going through it at any given time, the overall effect is to allow, in total, more people to exit from the room. This is analogous to reducing the circuit resistance and increasing the circuit current (at the same voltage).

Algebraically, we can express these observations as follows. We have two resistors, R_1 and R_2, with currents I_1 and I_2. Voltmeters placed across the two resistors would indicate voltages V_1 and V_2, which would be essentially equal to the source voltage V; that is, in this example,

$$V = V_1 = V_2$$

Ammeters placed in the circuit would reveal that the circuit current I is equal to the sum of the branch currents I_1 and I_2; that is,

$$I = I_1 + I_2$$

Using Ohm's law, we see that

$$\frac{V}{R} = \frac{V_1}{R_1} + \frac{V_2}{R_2}$$

Since all voltages are equal, they can be canceled from the expression, leaving us with the following expression for resistors in parallel:

$$\frac{1}{R} = \frac{1}{R_1} + \frac{1}{R_2}$$

This expression indicates that the total resistance is determined "reciprocally," which in effect reduces the total resistance of the circuit as more resistors are added in parallel. If, for example, $R_1 = 10$ Ω and $R_2 = 10$ Ω, the total resistance is $R = 5$ Ω (in parallel)! It should be noted that connecting batteries in parallel (positive to positive and negative to negative) has no effect on the overall voltage of the combination.

SAMPLE PROBLEM

A 20-Ω resistor and a 5-Ω resistor are connected in parallel. If a 16-V battery is used, calculate the equivalent resistance of the circuit, the circuit current, and the amount of current flowing through each resistor.

Solution

We know that the equivalent resistance is given by

$$\frac{1}{R_{eq}} = \frac{1}{R_1} + \frac{1}{R_2} = \frac{1}{20\ \Omega} + \frac{1}{5\ \Omega}$$

In this case, it is easily seen that $R_{eq} = 4$ Ω.

Thus, using Ohm's law,

$$I = \frac{V}{R_{eq}} = \frac{16\ V}{4\ \Omega} = 4\ A$$

To find the current in each branch, we recall that the voltage drop across each resistor is the same as the source voltage. In this case:

$$I_{20} = \frac{16\ V}{20\ \Omega} = 0.8\ A$$

$$I_5 = \frac{16\ V}{5\ \Omega} = 3.2\ A$$

Notice that the total current is equal to 4 A as expected.

COMBINATION CIRCUITS

In Figure 12.8, a circuit that consists of resistors in series and parallel is presented. The key to reducing such a circuit is to decide whether it is, overall, a series or parallel circuit. In Figure 12.8, an 8-Ω resistor is placed in series with a parallel branch containing two 4-Ω resistors. The problem is to reduce the circuit to only one resistor and then to determine the circuit current, the voltage across the branch, and the current in each branch.

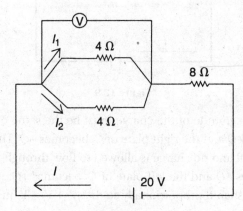

Figure 12.8

Solution

To reduce the circuit and find the circuit resistance R, we must first reduce the parallel branch. Thus, if R_e is the equivalent resistance in the branch, then

$$\frac{1}{R_e} = \frac{1}{4} + \frac{1}{4}$$

This implies that $R_e = 2\ \Omega$ of resistance. The circuit can now be thought of as a series circuit between a 2-Ω resistor and an 8-Ω resistor. Thus,

$$R = 2\ \Omega + 8\ \Omega = 10\ \Omega$$

Since the circuit voltage is 20 V, Ohm's law states that the circuit current is

$$I = \frac{V}{R} = \frac{20}{10} = 2\ A$$

In a series circuit, the voltage drop across each resistor is shared proportionally since the same current flows through each resistor. Thus, for the branch,

$$V = IR_e = (2)(2) = 4\ V$$

To find the current in each part of the parallel branch, we recall that in a parallel circuit the voltage is the same across each resistor. Thus, since the two resistors are equal, each will get half of the circuit current; thus each current is 1 A. Note how we used Kirchhoff's rule.

CAPACITORS IN CIRCUITS

Capacitors in Series

We know from Chapter 11 that the capacitance of a parallel-plate capacitor is given by $C = Q/V$. Suppose we have a series of capacitors connected to a potential difference V as shown in Figure 12.9.

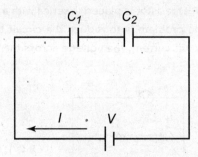

Figure 12.9

In this circuit, the magnitude of the charge must be the same on all plates because the left plate of C_1 becomes $+Q$ and the right plate of C_2 becomes $-Q$. This is because all capacitors are originally neutral and no charge is allowed to flow through them. By induction, the right plate of C_1 becomes $-Q$ and the left plate of C_2 becomes $+Q$. Additionally, the voltage across each capacitor is shared proportionally so that $V_1 + V_2 = V$ (just like the situation with resistors in series). Thus,

$$\frac{Q}{C_1} + \frac{Q}{C_2} = \frac{Q}{C}$$

and

$$\frac{1}{C_1} + \frac{1}{C_2} = \frac{1}{C} \quad \text{(for a series combination)}$$

Note that this is the opposite of the relationship for resistors in series. Be sure not to confuse them!

Capacitors in Parallel

A parallel combination of capacitors is shown in Figure 12.10.

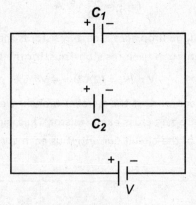

Figure 12.10

In this circuit, the current branches off, and so each capacitor is charged to a different total charge, Q_1 and Q_2. The equivalent total charge is $Q = Q_1 + Q_2$, and the voltage across each capacitor is the same as the source emf voltage. Thus,

$$CV = C_1V + C_2V$$

and

$$C = C_1 + C_2 \quad \text{(for a parallel combination)}$$

Note that this is the opposite of the relationship for resistors in parallel.

Capacitors and Resistors in a Circuit

If there is both a capacitor and resistor in a circuit, then there is a time-varying current as the capacitor "charges up" or "discharges." A typical RC circuit consists of a resistor and capacitor connected in series together with a switch and a battery (see Figure 12.11).

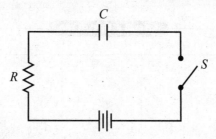

Figure 12.11

When the switch is closed, current flows through the resistor given by Ohm's law:

$$I = \frac{\text{emf}}{R}$$

As the capacitor (with capacitance C) becomes charged, a potential difference opposite to that of the battery appears across it given by

$$V = \frac{Q}{C}$$

The current begins to decrease as the potential difference across the capacitor increases. A graph of the increase in charge versus time for the capacitor is sketched in Figure 12.12:

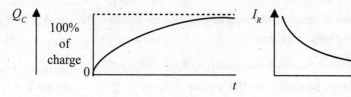

Figure 12.12

What is the equivalent capacitance of a 5-F capacitor and a 15-F capacitor connected in parallel?

Solution

We recall that in parallel, the total capacitance is equal to the sum of the individual capacitances:

$$C_T = C_1 + C_2 = 5\text{ F} + 15\text{ F} = 20\text{ F}$$

On the AP Physics 2 exam, students are required to solve steady-state RC circuits. So students must understand current and voltage everywhere once any charging or discharging of capacitors is complete. This simplifies matters considerably as a fully charged capacitor does not allow any current to flow through the pathway it is on as it can no longer accept any additional charges.

Given the values for the circuit components arranged as above, determine the steady-state solution for (a) charge on, (b) potential difference across, and (c) current through for each component.

DC power supply = 9 V R1 = 4.5 ohms C1 = C2 = 18 μF C3 = 9 μF

Solution

Once the capacitors are fully charged, no current will be flowing through the central wires to the capacitors, allowing us to solve part (c) quickly:

$$I \text{ (for any of the capacitors)} = 0\text{ A}$$

Since no current is flowing through any of the capacitors, the resistor and power supply are effectively in series.

$$I_{R1} = I_{\text{power supply}} = V/R = 9/4.5 = 2\text{ A}$$

Capacitor C1 is in parallel with the power supply, so C1 will receive the full 9 V (as does R1). Capacitors C2 and C3 must split the 9 volts between them.

$$V_{R1} = V_{C1} = V_{C2} + V_{C3} = 9\text{ V}$$

Resistors never accumulate charge, so $Q_{R1} = 0$.

Knowing the voltage across C1 allows us to solve for its charge quickly:

$$Q_{C1} = CV = (18\ \mu F)(9\ V) = 162\ \mu C$$

Recall that μ is simply the metric prefix *micro-*, which equals 10^{-6}. For C2 and C3, we must first determine their equivalent capacitance

$$\frac{1}{C_{equ}} = \frac{1}{C2} + \frac{1}{C3} = \frac{1}{18} + \frac{1}{9}$$

$$C_{equ} = 6\ \mu F$$

This equivalent capacitance would draw an amount of charge of:

$$Q = CV = (6\ \mu F)(9\ V) = 54\ \mu C$$

Since this is the amount of charge drawn into the pathway containing both C2 and C3, the top plate of C2 and the bottom plate of C3 must receive exactly this much charge, giving us:

$$Q_{C2} = Q_{C3} = 54\ \mu C$$

This result allows us to figure out how the 9 volts are distributed across C2 and C3:

$$V = Q/C$$

$$V_{C2} = 54\ \mu C/18\ \mu F = 3\ V$$

$$V_{C3} = 54\ \mu C/9\ \mu F = 6\ V$$

ELECTRICAL ENERGY IS POTENTIAL ENERGY

Many students of physics can get confused about the basic fact that the current going into a resistor is the same as the current coming out of the resistor. How can this be when the electrons have lost energy as the resistor heated up or gave off light? The conflict arises because many students are imagining the energy of the moving electrons as being kinetic energy. The energy in circuits, however, is electrical potential energy! The electrical potential energy is carried in the electric and magnetic fields associated with the moving charges. The electrons going into the resistor are spaced differently going into the resistor than they are when they are coming out. Even though the number of electrons passing per second, and hence their average speed (drift velocity), is the same before and after, the fields associated with their relative positions are completely different. Recall that all potential energies are energies of physical relationship between two or more interacting objects. Just as 5 fully extended rubber bands moving past you at 5 mph have more total energy than the same 5 slack rubber bands moving past you at the same speed, the slightly closer-spaced electrons before they enter the resistor have more energy than the slight farther apart electrons leaving the resistor.

The purest example of this field energy for electricity is in electromagnetic radiation (or light). The light travels without any charges (or mass for that matter). Yet the light is demonstrably carrying energy in its fields as it goes from one place to another. Parallels can be made with other potential energies. The gravitation potential of a rock held above the ground is not actually stored within the rock itself but, rather, in the gravitational field between the rock and Earth. The elastic energy of a stretched spring does not belong to the block at the end of the spring but is in the stretched or compressed spring itself. The nuclear energy released or absorbed in nuclear reactions is not contained in the individual nucleons but in the fields exchanged between them in the form of the strong nuclear forces binding them together.

SUMMARY

- Electric current is a measure of the flow of charge in units of amperes (1 A = 1 C/s).
- The conventional current is based on the direction of positive charge flow.
- Ohm's law states that at constant temperature the ratio of voltage and current is a constant in a conductor ($V/I = R$).
- Electrical resistance is based on the material used ("resistivity"), the length, and the cross-sectional area at constant temperature ($R = \rho L/A$).
- Ammeters measure current and are placed "in series" within the circuit.
- Voltmeters measure potential difference (voltage) and are placed in parallel (across segments of the circuit).
- A closed path and a source of potential difference are needed for a simple circuit.
- Resistors connected in series have an equivalent resistance equal to their numerical sum ($R_{eq} = R_1 + R_2$).
- Resistors connected in parallel have an equivalent resistance equal to their reciprocal sum [$1/R_{eq} = (1/R_1) + (1/R_2)$].

AP 2 only

- If capacitors are connected in series, then their equivalent capacitance is equal to their reciprocal sum (the opposite of resistors).
- If capacitors are connected in parallel, then their equivalent resistance is equal to their numerical sum (the opposite of resistors).
- In the steady state of being fully charged, capacitors act as an open circuit stopping current from flowing down their pathway.
- Kirchhoff's rules describe the flow of current in circuit branches and the changes in voltage around loops.

Problem-Solving Strategies for Electric Circuits

Several techniques for solving electric circuit problems have been discussed in this chapter. For resistances with one source of emf, we use the techniques of series and parallel circuits. Ohm's law plays a big role in measuring the potential drops across resistors and the determination of currents within the circuit.

When working with a combination circuit, try to reduce all subbranches first, as well as any series combinations. The goal is to be left with only one equivalent resistor and then use Ohm's law to identify the various missing quantities. Drawing a sketch of the circuit (if one is not already provided) is essential. Also, the direction of current is taken from the positive terminal of a battery. This is opposite to the way that electrons actually move!

Multiple-Choice

1. How many electrons are moving through a current of 2 A for 2 s?

 (A) 3.2×10^{-19}

 (B) 6.28×10^{18}

 (C) 4

 (D) 2.5×10^{19}

2. How much electrical energy is generated by a 100-W light bulb turned on for 5 min?

 (A) 20 J

 (B) 500 J

 (C) 3000 J

 (D) 30,000 J

3. What is the current in a 5-Ω resistor due to a potential difference of 20 V?

 (A) 25 A

 (B) 4 A

 (C) 0.20 A

 (D) 5 A

4. A 20-Ω resistor has 10 A of current in it. The power generated is

 (A) 2000 W

 (B) 2 W

 (C) 200 W

 (D) 4000 W

5. What is the value of resistor R in the circuit shown below?

 (A) 20 Ω

 (B) 2 Ω

 (C) 4 Ω

 (D) 12 Ω

6. What is the equivalent capacitance of the circuit shown below?

 (A) 2 F
 (B) 8 F
 (C) 5 F
 (D) 10 F

Answer questions 7 and 8 based on the circuit below:

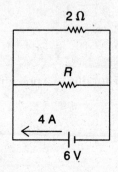

7. If the current in the circuit above is 4 A, then the power generated by resistor *R* is

 (A) 6 W
 (B) 18 W
 (C) 24 W
 (D) 7 W

8. What is the value of resistor *R* in the circuit above?

 (A) 4 Ω
 (B) 3 Ω
 (C) 5 Ω
 (D) 6 Ω

9. A 5-Ω and a 10-Ω resistor are connected in series with one source of emf of negligible internal resistance. If the energy produced in the 5-Ω resistor is *X*, then the energy produced in the 10-Ω resistor is

 (A) *X*
 (B) 2*X*
 (C) *X*/2
 (D) *X*/4

10. Four equivalent light bulbs are arranged in a circuit as shown below. Which bulb(s) will be the brightest?

(A) *A*
(B) *B*
(C) *C*
(D) *D*

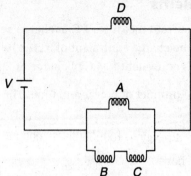

Free-Response

1. A 60-Ω resistor is made by winding platinum wire into a coil at 20°C. If the platinum wire has a diameter of 0.10 mm, what length of wire is needed?

2. Based on the circuit shown below:

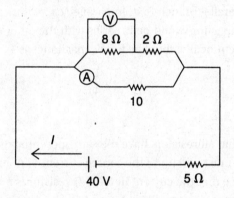

(a) Determine the equivalent resistance of the circuit.
(b) Determine the value of the circuit current *I*.
(c) Determine the value of the reading of ammeter A.
(d) Determine the value of the reading of voltmeter V.

3. Show that for two resistors in parallel, the equivalent resistance can be written as

$$R_{eq} = \frac{R_1 R_2}{R_1 + R_2}$$

4. Explain why connecting two batteries in parallel does not increase the effective emf.

5. You have five 2-Ω resistors. Explain how you can combine them in a circuit to have equivalent resistances of 1, 3, and 5 Ω.

6. A laboratory experiment is performed using lightbulbs as resistors. After a while, the current readings begin to decline. What can account for this?

ANSWERS EXPLAINED
Multiple-Choice Problems

1. **(D)** By definition, 1 A of current measures 1 C of charge passing through a circuit each second. One coulomb is the charge equivalent of 6.28×10^{18} electrons. In this question, we have 2 A for 2 s. This is equivalent to 4 C of charge or 2.5×10^{19} electrons.

2. **(D)** Energy is equal to the product of power and time. The time must be in seconds; 5 min = 300 s. Thus

$$\text{Energy} = (100)(300) = 30{,}000 \text{ J}$$

3. **(B)** Using Ohm's law, we have

$$I = \frac{V}{R} = \frac{20}{5} = 4 \text{ A}$$

4. **(A)** We know that $P = VI$, and using Ohm's law ($V = IR$), we get

$$P = I^2 R = (100)(20) = 2000 \text{ W}$$

5. **(C)** Using Ohm's law, we can determine the equivalent resistance of the circuit: $36/3 = 12 \ \Omega$. The two resistors are in series, so $12 = 8 + R$. Thus, $R = 4 \ \Omega$.

6. **(A)** We reduce the parallel branch first. In parallel, capacitors add up directly. Thus, $C_1 = 4$ F. Now, this capacitor would be in series with the other 4-F capacitor. In series, capacitors add up reciprocally; thus the final capacitance is

$$\frac{1}{C} = \frac{1}{4} + \frac{1}{4}$$

This implies that $C = 2$ F.

7. **(A)** In a parallel circuit, all resistors have the same potential difference across them. The branch currents must add up to the source current (4 A, in this case). Thus, using Ohm's law, we can see that the current in the 2-Ω resistor is $I = 6/2 = 3$ A. Thus, the current in resistor R must be equal to 1 A. Since $P = VI$, the power in resistor R is

$$P = (6)(1) = 6 \text{ W}$$

8. **(D)** Using Ohm's law, we have,

$$R = \frac{V}{I} = \frac{6}{1} = 6 \ \Omega$$

9. **(B)** In a series circuit, the two resistors have the same current but proportionally shared potential differences. Thus, since the 10-Ω resistor has twice the resistance of the 5-Ω resistor in series, it has twice the potential difference. Therefore, with the currents equal, the 10-Ω resistor will generate twice as much energy, that is, $2X$, when the circuit is on.

10. **(D)** The fact that all the resistors (bulbs) are equal means that the parallel branch will reduce to an equivalent resistance less than that of resistor D. The remaining series circuit will produce a greater potential difference across D than across that equivalent resistor. With the currents equal at that point, resistor D will generate more power than the equivalent resistance. Thus, with the current split for the actual parallel part, even less energy will be available for resistors A, B, and C. Bulb D will be the brightest.

Free-Response Problems

1. The formula we want to use is

$$R = \frac{\rho L}{A}$$

From Table 12.1, the resistivity of platinum at 20°C is equal to

$$\rho = 10.4 \times 10^{-8} \, \Omega \cdot m$$

The resistance needed is $R = 60 \, \Omega$. We need the cross-sectional area. The diameter of the wire is 0.10 mm, so the radius of the wire must be equal to

$$r = \frac{\text{diameter}}{2} = 0.05 \, mm = 0.00005 \, m$$

The cross-sectional area is

$$A = \pi r^2 = \pi (0.00005 \, m)^2 = 7.85 \times 10^{-9} \, m^2$$

The length of the wire is therefore

$$60 \, \Omega = \frac{(10.4 \times 10^{-8} \cdot \Omega \cdot m) L}{(7.85 \times 10^{-9} \, m^2)}$$

$$L = 4.53 \, m$$

2. (a) The first thing we need to do is to reduce the series portion of the parallel branch. The equivalent resistance there is $8 \, \Omega + 2 \, \Omega = 10 \, \Omega$. Now, this resistance is in parallel with the other 10-Ω resistor. The equivalent resistance is found to be 5 Ω for the entire parallel branch. This equivalent resistance is in series with the other 5-Ω resistor, making a total equivalent resistance of 10 Ω.

 (b) We can determine the circuit current using Ohm's law:

$$I = \frac{V}{R} = \frac{40}{10} = 4 \, A$$

 (c) To determine the reading of ammeter A, we must first understand that the potential drop across the 5-Ω resistor on the bottom is equal to 20 V since

$$V = IR = (4)(5) = 20$$

 Now, the equivalent resistance of the parallel branch is also 5 Ω, and therefore across the entire branch there is also a potential difference of 20 V (in a series circuit, the voltages must add up—in this case, to 40 V). In a parallel circuit, the potential difference is the same across each portion. Thus, the 10-Ω resistor has 20 V across it. Using Ohm's law, we find that this implies a current reading of 2 A for ammeter A.

 (d) If, from part (c), ammeter A reads 2 A, the top branch must be getting 2 A of current as well (since the source current is 4 A). Thus, using Ohm's law, we can find the voltage across the 8-Ω resistor:

$$V = IR = (2)(8) = 16 \, V$$

3. We start with the regular formula for two resistors in parallel and solve:

$$\frac{1}{R_{eq}} = \frac{1}{R_1} + \frac{1}{R_2}$$

$$\frac{1}{R_{eq}} = \frac{R_2}{R_2 R_1} + \frac{R_1}{R_1 R_2}$$

$$\frac{1}{R_{eq}} = \frac{R_1 + R_2}{R_1 R_2}$$

$$R_{eq} = \frac{R_1 R_2}{R_1 + R_2}$$

4. When two batteries are connected in parallel, the emf of the system is not changed. The storage capacity of the battery system, however, is increased since the parallel connection of the two batteries is similar to the parallel connection of two capacitors.

5. An equivalent resistance of 1 Ω can be achieved by connecting two 2-Ω resistors in parallel. An equivalent resistance of 3 Ω can be achieved by connecting two 2-Ω resistors in parallel and then connecting this system to one 2-Ω resistor in series. The addition of one more 2-Ω resistor in series to the combination above achieves an equivalent resistance of 5 Ω.

6. Lightbulbs produce their luminous energy by heating up the filament inside them. Thus, after a while, this increase in temperature reduces the current flowing through them since the resistance has increased.

Magnetism and Electromagnetism

13

AP 2 only
KEY CONCEPTS
(THIS CHAPTER IS FOR AP PHYSICS 2 ONLY)
→ MAGNETIC FIELDS AND FORCES
→ MAGNETIC FORCE ON A MOVING CHARGE
→ MAGNETIC FIELDS DUE TO CURRENTS IN WIRES
→ MAGNETIC FORCE ON A WIRE
→ MAGNETIC FORCE BETWEEN TWO WIRES
→ INDUCTION AND EMF IN A WIRE
→ FARADAY'S LAW OF INDUCTION

MAGNETIC FIELDS AND FORCES

When two statically charged point objects approach each other, each exerts a force on the other that varies inversely with the square of their separation distance. We can also state that one of the charges creates an electrostatic field around itself, and this field transmits the force through space.

When we have a wire carrying current, we no longer consider the effects of static fields. A simple demonstration reveals that, when we arrange two current-carrying wires parallel to each other so that the currents are in the same direction, the wires will be attracted to each other with a force that varies inversely with their separation distance and directly with the product of the currents in the two wires. If the currents are in opposite directions, the wires are repelled. Since this is not an electrostatic event, we must conclude that a different force is responsible.

The nature of this force can be further understood when we consider the fact that a statically charged object, such as an amber stone, cannot pick up small bits of metal. However, certain naturally occurring rocks called **lodestones** can attract metal objects. The lodestones are called **magnets** and can be used to **magnetize** metal objects (especially those made from iron or steel).

If a steel pin is stroked in one direction with a magnetic lodestone, the pin will become magnetized as well. If an iron rail is placed in the earth for many years, it will also become magnetized. If cooling steel is hammered while lying in a north-south line, it too will become magnetized (heating will eliminate the magnetic effect). If the magnetized pin is placed on a floating cork, the pin will align itself along a general north-south line. If the cork's orientation is shifted, the pin will oscillate around its original equilibrium direction and eventually settle down along this direction. Finally, if another magnet is brought near, the "compass" will realign itself toward the new magnet. This is illustrated in Figure 13.1.

Figure 13.1

Each of these experiences suggests the presence of a magnetic force, and we can therefore consider the actions of this force through the description of a magnetic field. If a magnet is made in the shape of a rectangular bar (see Figure 13.2), the orientation of a compass, moved around the magnet, demonstrates that the compass aligns itself tangentially to some imaginary field lines that were first discussed by English physicist Michael Faraday. In general, we label the north-seeking pole of the magnet as N and the south-seeking pole as S. We also observe that these two opposite poles behave in a similar way to opposite electric charges: like poles repel, while unlike poles attract.

A fundamental difference between these two effects is that magnet poles never appear in isolation. If a magnet is broken in two pieces, each new magnet has a pair of poles. This phenomenon continues even to the atomic level. There appear, at present, to be no magnetic monopoles naturally occurring in nature. (New atomic theories have postulated the existence of magnetic monopoles, but none has as yet been discovered.)

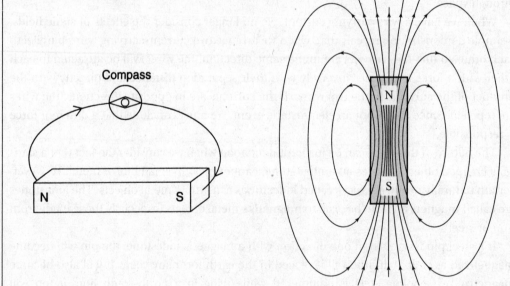

Figure 13.2

> **REMEMBER**
>
> A compass needle will align itself tangent to the external magnetic field.

Small pieces of iron (called "filings") can be used as miniature compasses to illustrate the characteristics of the magnetic field around magnets made of iron or similar alloys. The ability of a metal to be magnetized is called its **permeability**; substances such as iron, cobalt, and

nickel have among the highest permeabilities. These substances are sometimes called **ferromagnets**.

In Figure 13.3, several different magnetic field configurations are shown. By convention, the direction of the magnetic field is taken to be from the north pole of the magnet to the south pole. Note that magnetic field lines always form complete loups even if only the external fields are shown in pictures.

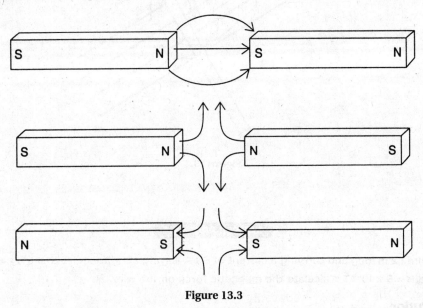

Figure 13.3

MAGNETIC FORCE ON A MOVING CHARGE

If a moving electric charge enters a magnetic field, it will experience a force that depends on its velocity, charge, and orientation with respect to the field. The force will also depend on the magnitude of the magnetic field strength (designated as **B** algebraically). This field strength is a vector quantity, just like the gravitational and electrical field strengths.

Experiments with moving charges in a magnetic field reveal that the resultant force is a maximum when the velocity, **v**, is perpendicular to the magnetic field and zero when the velocity is parallel to the field. With this varying angle of orientation θ and a given charge Q, we find that the magnitude of the magnetic force is given by:

$$F = BQv \sin\theta$$

For a current-carrying wire of length ℓ:

$$F = B I \ell, \sin\theta$$

Figure 13.4 illustrates the right-hand rule.

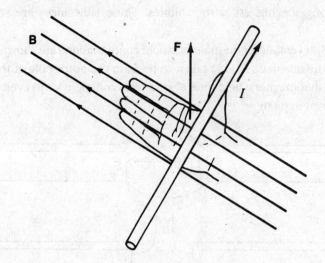

Figure 13.4

SAMPLE PROBLEM

A wire 1.2 m long and carrying a current of 60 A is lying at right angles to a magnetic field $B = 5 \times 10^{-4}$ T. Calculate the magnetic force on the wire.

Solution

We use

$$F_m = BIL = (5 \times 10^{-4} \text{ T})(60 \text{ A})(1.2 \text{ m}) = 0.036 \text{ N}$$

Since the units of force must be newtons, the units for the magnetic field strength **B** must be newton · seconds per coulomb · meter (N · s/C · m). Recall that the newton · second is the unit for an impulse. We can think of the magnetic field as a measure of the impulse given to 1 coulomb of charge moving a distance of 1 meter in a given direction. Additionally, if we have a beam of charges, we effectively have an electric current. The units (seconds per coulomb) can be interpreted as the reciprocal of amperes, and so the strength of the magnetic field in a current-carrying wire is given in units of newtons per ampere · meter (N/A · m).

In the SI system, this combination is called a **tesla**; 1 tesla is equal to 1 newton per ampere · meter. Thus, an electric current carries a magnetic field. This is consistent with the earliest experiments by Hans Oersted, who first showed that an electric current can influence a compass. Oersted's discovery, in 1819, established the new science of **electromagnetism**.

The direction of the magnetic force is given by a "**right-hand rule**" (Figure 13.5): *Open your right hand so that your fingers point in the direction of the magnetic field and your thumb points in the direction of the velocity of the charges (or the current if you have a wire). Your open palm will show the direction of the force.*

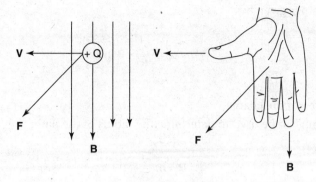

Figure 13.5

Figure 13.6 illustrates that, if the velocity and magnetic field are perpendicular to each other, the path of the charge in the field is a circle of radius R. The direction, provided by the right-hand rule, is the direction that a positive test charge would take. Thus, the direction for a negative charge would be opposite to what the right-hand rule predicted.

> The force vectors in Figure 13.5 are actually coming out of the page (straight toward the reader). It is hard to draw vectors unambiguously showing direction in this third direction. There is a convention to show arrows pointed straight out of the page and into the page:
>
> ⊙ means out of the page
> ⊗ means into the page
>
> In Figure 13.6, the magnetic field is out of the page (pointed toward the reader), as indicated by the field of dots.

Figure 13.6

The circular path arises because the induced force is always at right angles to the deflected path when the velocity is initially perpendicular to the magnetic field. This path is similar to the circular path of a stone being swung in an overhead horizontal circle while attached to a string. Magnetic forces, like other centripetal forces, can do no work because of their perpendicularity.

This relationship is given by:

$$F_c = ma_c = m\frac{v^2}{R} = BQv$$

where m is the mass of the charge.

This relationship can be used to determine the radius of the path:

$$R = m\frac{v}{QB}$$

We can use this expression to find the mass of the charge (as used in a mass spectrograph):

$$m = \frac{RQB}{v}$$

One way to determine the velocity of the charge, independently from the mass, is to pass the charge through both an electric and a magnetic field, as in a cathode ray tube. As shown in Figure 13.7, if the electric field is horizontal, the charges will be attracted or repelled along a horizontal line. If the magnetic field is vertical, the right-hand rule will force the charges along the same horizontal line. Careful adjustment of both fields (keeping the velocity perpendicular to the magnetic field) can lead to a situation where the effect of one field balances out the effect from the other and the charges remain undeflected. In that case, we can write that the magnitudes of the electric and magnetic forces are equal:

$Eq = Bqv$ which implies that the velocity $v = E/B$ (independent of mass)!

Figure 13.7

If the velocity is not perpendicular to the magnetic field when it first enters, the path will be a spiral because the velocity vector will have two components. One component will be perpendicular to the field (and create a magnetic force that will try to deflect the path into a circle), while the other component will be parallel to the field (producing no magnetic force and maintaining the original direction of motion). This situation is illustrated in Figure 13.8.

Figure 13.8

SAMPLE PROBLEM

An electron ($m = 9.1 \times 10^{-31}$ kg) enters a uniform magnetic field **B** = 0.4 T at right angles and with a velocity of 6×10^7 m/s.

(a) Calculate the magnitude of the magnetic force on the electron.

(b) Calculate the radius of the path followed.

Solution

(a) We use

$$F_m = Bqv$$

$$F_m = (0.4 \text{ T})(-1.6 \times 10^{-19} \text{ C})(6 \times 10^7 \text{ m/s}) = 3.8 \times 10^{-12} \text{ N}$$

(b) We use

$$r = \frac{(mv)}{(Bq)} = \frac{(9.1 \times 10^{-31} \text{ kg})(6 \times 10^7 \text{ m/s})}{(0.4 \text{ T})(-1.6 \times 10^{-19} \text{ C})} = 8.5 \times 10^{-4} \text{ m}$$

MAGNETIC FIELDS DUE TO CURRENTS IN WIRES
A Long, Straight Wire

If a compass is placed near a long, straight wire carrying current, the magnetic field produced by the current will cause the compass to align tangent to the field. Placing the compass at varying distances reveals that the strength of the field varies inversely with the distance from the wire and varies directly with the amount of current.

The shape of the magnetic field is a series of concentric circles (Figure 13.9) whose rotational direction is determined by a right-hand rule: *Grasp the wire with your right hand. If your thumb points in the direction of the current, your fingers will curl around the wire in the same direction as the magnetic field.*

Figure 13.9

The magnitude of the magnetic field strength at some distance r from the wire is given by

$$B = \frac{\mu I}{2\pi r}$$

where μ is the permeability of the material around the wire in units of newtons per square ampere (N/A^2). In air, the value of μ is approximately equal to the permeability of a vacuum:

$$\mu_0 = 4\pi \times 10^{-7} \frac{N}{A^2}$$

This equation is therefore usually written in the form

$$B = \frac{\mu_0 I}{2\pi r}$$

A Loop of Wire

Imagine a straight wire with current that has been bent into the shape of a loop with radius r. Each of the circular magnetic fields now interacts in the center of the loop. In Figure 13.10, we see that the sum or superpositioning of all these contributing magnetic fields produces one concentrated field, pointing inward or outward in the middle.

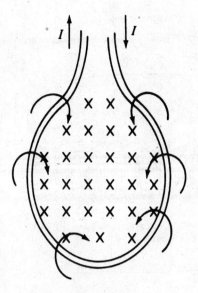

Figure 13.10

The general direction of the emergent magnetic field is given by a right-hand rule: *Grasp the loop in your right hand with your fingers curling around the loop in the same direction as the current. Your thumb will now show the direction of the magnetic field.*

If the loop consists of N turns of wire, the magnetic field strength will be increased N times. The magnitude of the field strength, at the center of the loop (of radius r), is given by

$$B = \frac{\mu NI}{2r}$$

The strength of the field can also be increased by changing the permeability of the core. If the wire is looped around iron, the field is stronger than if the wire were looped around cardboard. Also, if the loop's radius is smaller, the field is more concentrated at the center and thus stronger.

If the loop described in Section B is stretched out to a length L, in the form of a spiral, we have what is called a **solenoid** (Figure 13.11). This is the basic form for an electromagnet, in which wire is wrapped around an iron nail and then connected to a battery. The strength of the field will increase with the number of turns, the permeability of the core, and the amount of current in the wire. The field inside the solenoid is constant and given by:

$$B = \mu \frac{N}{L} I$$

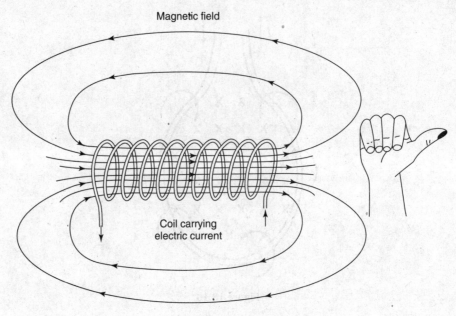

Magnetic field

Coil carrying
electric current

Figure 13.11

The direction of the magnetic field is given by another right-hand rule: *Grasp the solenoid with your right hand so that your fingers curl in the same direction as the current. Your thumb will point in the direction of the emergent magnetic field.*

What is the strength of the magnetic field at a point 0.05 m away from a straight wire carrying a current of 10 A?

Solution

We use

$$B = \frac{\mu_o I}{2\pi r} = \frac{(4\pi \times 10^{-7} \text{ N/A}^2)(10 \text{ A})}{(2\pi)(0.05 \text{ m})} = 4 \times 10^{-5} \text{ T}$$

MAGNETIC FORCE BETWEEN TWO WIRES

Imagine that you have two straight wires with currents going in the same direction (Figure 13.12). Each wire creates a circular magnetic field around itself so that, in the region between the wires, the net effect of each field is to weaken the other field relative to the other side. Although the resulting field around the two wires is found by adding the two magnetic fields produced by the two wires, each wire feels a force due to the other wire's magnetic field alone. Use the right-hand rule twice in a row to determine the force on each wire. The first time is to determine the direction of the magnetic field in which the wire is immersed. The second time is to determine the force the wire feels in response to that magnetic field. Note that the two wires form a Newton's third law pair and their mutual magnetic forces are equal and opposite.

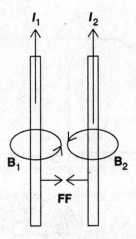

Figure 13.12

If the current in one wire is reversed, both forces will change directions and the wires will repel each other.

The magnitude of the force between the wires, at a distance r, can be determined if we consider the fact that one wire sets up the external field that acts on the other. If we want the magnetic force on wire 2 due to wire 1, we can write

$$B_1 = \frac{\mu_0 I_1}{2\pi r}$$

Since $\mathbf{F} = \mathbf{B}IL$, we can write

$$F_{12} = \frac{\mu_0 I_1 I_2 L}{2\pi r}$$

INDUCED MOTIONAL EMF IN A WIRE

We know from Oersted's experiments, mentioned previously, that a current in a wire generates a magnetic field. We also know that the field of a solenoid approximates that of an ordinary bar magnet. A third fact is that the magnetic property of a material (called its **permeability**) influences the strength of its magnetic field. Additionally, the interactions between fields lead to magnetic forces that can be used to operate an electric meter or motor.

A question can now be raised: Can a magnetic field be used to induce a current in a wire? The answer, investigated in the early nineteenth century by French scientist Andre Ampere, is yes. However, the procedure is not as simple as placing a wire in a magnetic field and having a current "magically" arise!

A simple experimental setup is shown in Figure 13.13. A horseshoe magnet is arranged with a conducting wire attached to a galvanometer. When the wire rests in the magnetic field, the galvanometer registers zero current. If the wire is then moved through the field in such a way that its motion "cuts across" the imaginary field lines, the galvanometer will register the presence of a small current. If, however, the wire is moved through the field in such a way that its motion remains parallel to the field, again no current is present. This experiment also reveals that a maximum current, for a given velocity, occurs when the wire moves perpendicularly through the field (which suggests a dependency on the sine of the orientation angle).

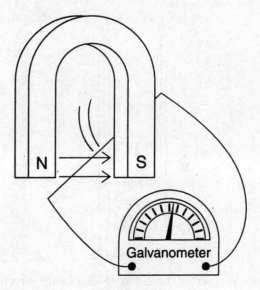

Figure 13.13

The phenomenon described above is known as **electromagnetic induction**. The source of the induced current is the establishment of a **motional emf** due to the change in something called the **magnetic flux**, which we will define shortly.

If the wire is moved up and down through the field in Figure 13.13, the galvanometer shows that the induced current alternates back and forth according to a right-hand rule. The fingers of the right hand point in the direction of the magnetic field; the thumb points in the direction of the velocity of the wire. Finally, the open palm indicates the direction of the induced current.

Now, since a parallel motion through the field implies no induced current, if the wire is moved at any other angle, only the perpendicular component contributes to the induction process. Recall that, if **v** is a perpendicular velocity component, $\mathbf{F} = \mathbf{B}q\mathbf{v}$ is the expression for the magnitude of the induced magnetic force on a charge q. Now, the wire in our situation contains charges that will experience a force **F** if we can get them to move through an external field. Physically moving the entire wire accomplishes this task. The direction of the induced force, determined by the right-hand rule, is along the length of the wire. If we let Q represent the total charge per second, we can write

$$\mathbf{F} = \mathbf{B}Q\mathbf{v} \tag{2}$$

The charges experience a force as long as they are in the magnetic field. This situation occurs for a length ℓ, and the work done by the force is given by $W = F\ell$. Thus

$$W = \mathbf{B}Q\mathbf{v}\ell \tag{3}$$

The induced potential difference (emf) is a measure of the work done per unit charge (W/Q), which gives us

$$\text{emf} = \mathbf{b}\ell\mathbf{v}$$

This emf is sometimes called a "motional emf," since it is due to the motion of a wire through a field.

An interesting fact about electromagnetic induction is that the velocity in the above expression is a relative velocity, that is, the induced emf can be produced whether the wire

moves through the field or the field changes over the wire! Additionally, an emf can be induced even if there is no relative velocity as long as the magnetic field is changing.

Figure 13.14 is a simple illustration of this effect.

Figure 13.14

In Figure 13.14, a bar magnet is thrust into and out of a coil in which there are N turns of wire. The number of coils is related to the overall length ℓ, in equation 1. The galvanometer registers the alternating current in the coil as the magnet is inserted and withdrawn. Varying the velocity affects the amount of current as predicted. Moving the magnet around the outside of the coils generates only a weak current. The concept of relative velocity is illustrated if the magnet is held constant and the coil is moved up and down over the magnet. In summary, an emf (or Δv) can be induced by any of the following:

$$\Delta B, \Delta \theta, \text{ or } \Delta \ell.$$

SAMPLE PROBLEM

What is the induced emf in a wire 0.5 m long, moving at right angles to a 0.04-T magnetic field with a velocity of 5 m/s?

Solution

We use

$$\text{emf} = B\ell v$$

$$\text{emf} = (0.04 \text{ T})(0.5 \text{ m})(5 \text{ m/s}) = 0.1 \text{ V}$$

MAGNETIC FLUX AND FARADAY'S LAW OF INDUCTION

In Figure 13.15, there is a circular region of cross-sectional area A. An external magnetic field **B** passes through the region at an angle θ to the region. The perpendicular component of the field is given by

$$\mathbf{B}_\perp = \mathbf{B} \cos \theta$$

Figure 13.15 Magnetic Flux

The magnetic flux, Φ, is defined as the product of the perpendicular component of the magnetic field and the cross-sectional area A:

$$\Phi = BA \cos \theta$$

The unit of magnetic flux is the **weber** (Wb); 1 weber equals 1 tesla per square meter.

On the basis of these ideas, the magnetic field strength is sometimes referred to as the **magnetic flux density** and can be expressed in units of webers per square meter (Wb/m^2).

English scientist Michael Faraday demonstrated that the induced motional emf was due to the rate of change of the magnetic flux. We now call this relationship **Faraday's law of electromagnetic induction** and express it in the following way:

$$\text{emf} = -\left(\frac{\Delta \Phi}{\Delta t}\right)$$

The negative sign is used because another relationship, known as **Lenz's law**, states that an induced current will always flow in a direction such that its magnetic field opposes the magnetic field that induced it. Lenz's law is just another way of expressing the law of conservation of energy. Consider the experiment in Figure 13.14. When the magnet is inserted through the coil, an induced current flows. This current, in turn, produces a magnetic field that is directed either into or out of the coil, along the same axis as the bar magnet.

If the current had a direction such that the "pole" of the coil attracted the pole of the bar magnet, more energy would be derived from the effect than is possible in nature. Thus, according to Lenz's law, the current in the coil will have a direction so that the new magnetic field will oppose the magnetic field of the bar magnet. The more one tries to overcome this effect, the greater it becomes. The opposition of fields in this way prevents violation of conservation of energy and can generate a large amount of heat in the process. If the flux is decreasing, the induced emf (voltage) will be such that its own magnetic field will add to the flux. If, on the other hand, the flux is increasing, the induced emf will be such that its own magnetic field will decrease the flux.

If there are N turns of wire in the coil, Faraday's law becomes:

$$\text{emf} = -N\left(\frac{\Delta \Phi}{\Delta t}\right)$$

A coil is made of 10 turns of wire and has a diameter of 5 cm. The coil is passing through the field in such a way that the axis of the coil is parallel to the field. The strength of the field is 0.5 T. What is the change in the magnetic flux? Also, if an average emf of 2 V is observed, for how long was the flux changing?

Solution

The change in the magnetic flux is given by

$$\Delta\Phi = -\mathbf{B}A = -B\pi r^2 = -(0.5)(3.14)(0.0025)^2 = -9.8 \times 10^{-4} \text{ Wb}$$

The time is therefore given by

$$\Delta t = N\left(\frac{\Delta\Phi}{\text{emf}}\right) = 10\left(\frac{9.8 \times 10^{-4}}{2}\right) = 4.9 \times 10^{-3} \text{ s}$$

SUMMARY

- Magnets consist of both north and south poles.
- Isolated magnetic poles do not exist (no monopoles of magnets).
- The ability of a metal to become magnetized is called permeability.
- Iron, cobalt, and nickel are metals with the highest permeabilities. Magnets made from these materials are called ferromagnets.
- Magnetic field lines go from north to south and loop back on themselves.
- An electric charge moving in an external magnetic field has a force induced on it. The direction of that force is determined by a right-hand rule.
- The path of a charged particle, traveling at right angles to an external magnetic field, is a circle.
- Metal wires carrying current generate magnetic fields. The magnetic field directions around wires can be found using a right-hand rule.
- Two wires carrying current can become attracted or repelled, depending on the directions of the currents.
- The forces induced on wires with currents can be used to make loops of wires spin in a motor or be controlled in an electric meter.
- A wire moving across an external magnetic field will have an emf induced in it.
- The induced emf will be a maximum if the wire cuts across the magnetic field at right angles to it.
- A wire moving parallel through an external magnetic field will not have an emf induced in it.
- Faraday's law states that the induced emf is equal to the rate of change of magnetic flux.
- Lenz's law states that an induced current will always flow in a direction such that its magnetic field opposes the change in magnetic flux that induced it.

Problem-Solving Strategies for Magnetism

The key to solving magnetic and electromagnetic field problems is remembering the right-hand rules. These heuristics have been shown to be useful in determining the directions of field interaction forces. Memorize each one, and become comfortable with its use. Some rules are familiar in their use of fingers, thumb, and open palm. Make sure, however, that you know the net result. Drawing a sketch always helps.

Keeping track of units is also useful. The tesla is an SI unit and as such requires lengths to be in meters and velocities to be in meters per second (forces are in newtons). Most force interactions are angle dependent and have maximum values when two quantities (usually velocity and field or current and field) are perpendicular. Be sure to read each problem carefully and to remember that magnetic field **B** is a vector quantity!

Problem-Solving Strategies for Electromagnetic Induction

When solving electromagnetic problems, keep in mind that vector quantities are involved. The directions of these vectors are usually determined by the right-hand rules. Additionally, remember Lenz's law: **An induced current will always flow in a direction such that its magnetic field opposes the change in magnetic flux that induced it,** which plays a role in many applications.

When solving problems in electromagnetic induction, it is important to remember the right-hand rules. Also, keep in mind that the induced emf is proportional to the change in the magnetic flux, not the magnetic field.

PRACTICE EXERCISES

Multiple-Choice

1. A charge moves in a circular orbit of radius R due to a uniform magnetic field. If the velocity of the charge is doubled, the orbital radius will become

 (A) $2R$
 (B) R
 (C) $R/2$
 (D) $4R$

2. Inside a solenoid, the magnetic field

 (A) is zero
 (B) decreases along the axis
 (C) increases along the axis
 (D) is uniform

3. An electron crosses a perpendicular magnetic field as shown below. The direction of the induced magnetic force is

(A) to the right
(B) to the left
(C) out of the page
(D) into the page

4. Three centimeters from a long, straight wire, the magnetic field produced by the current is determined to be equal to 3×10^{-5} T. The current in the wire must be

(A) 2.0 A
(B) 4.5 A
(C) 1.5 A
(D) 3 A

5. Magnetic field lines determine

(A) only the direction of the field
(B) the relative strength of the field
(C) both the relative strength and the direction of the field
(D) only the shape of the field

6. What is the direction of the magnetic field at point A above the wire carrying current?

(A) Out of the page
(B) Into the page
(C) Up the page
(D) Down the page

7. The back emf of a motor is at a maximum when

(A) the speed of the motor is constant
(B) the speed of the motor is at its maximum value
(C) the motor is first turned on
(D) the speed of the motor is increasing

8. A bar magnet is pushed through a flat coil of wire. The induced emf is greatest when

(A) the north pole is pushed through first
(B) the magnet is pushed through quickly
(C) the magnet is pushed through slowly
(D) the south pole is pushed through first

9. The magnetic flux through a wire loop is independent of

(A) the shape of the loop
(B) the area of the loop
(C) the strength of the magnetic flux
(D) the orientation of the magnetic field and the loop

10. A flat, 300-turn coil has a resistance of 3 Ω. The coil covers an area of 15 cm² in such a way that its axis is parallel to an external magnetic field. At what rate must the magnetic field change in order to induce a current of 0.75 A in the coil?

 (A) 0.0075 T/s
 (B) 2.5 T/s
 (C) 0.0005 T/s
 (D) 5 T/s

11. When a loop of wire is turned in a magnetic field, the direction of the induced emf changes every

 (A) one-quarter revolution
 (B) two revolutions
 (C) one revolution
 (D) one-half revolution

12. A wire of length 0.15 m is passed through a magnetic field with a strength of 0.2 T. What must be the velocity of the wire if an emf of 0.25 V is to be induced?

 (A) 8.3 m/s
 (B) 6.7 m/s
 (C) 0.0075 m/s
 (D) 0.12 m/s

Free-Response

1. An electron is accelerated by a potential difference of 12,000 V as shown in the following diagram. The electron enters a cathode ray tube that is 20 cm in length and the external magnetic field causes the path to deflect along a vertical screen for a distance y.

 (a) What is the kinetic energy of the electron as it enters the cathode ray tube?
 (b) What is the velocity of the electron as it enters the cathode ray tube?
 (c) If the external magnetic field has a strength of 4 × 10⁻⁵ T, what is the value of y? Assume that the field has a negligible effect on the horizontal velocity.

2. A straight conductor has a mass of 15 g and is 4 cm long. It is suspended from two parallel and identical springs as shown below. In this arrangement, the springs stretch a distance of 0.3 cm. The system is attached to a rigid source of potential difference equal to 15 V, and the overall resistance of the circuit is 5 Ω. When current flows through the conductor, an external magnetic field is turned on and it is observed that the springs stretch an additional 0.1 cm. What is the strength of the magnetic field?

3. Explain why a bar magnet loses its magnetic strength if it is struck too many times.

4. A horizontal conducting bar is free to slide along a pair of vertical bars, as shown below. The conductor has length ℓ and mass M. As it slides vertically downward under the influence of gravity, it passes through an outward-directed, uniform magnetic field. The resistance of the entire circuit is R. Find an expression for the terminal velocity of the conductor (neglect any frictional effects due to sliding).

5. A small cylindrical magnet is dropped into a long copper tube. The magnet takes longer to emerge than the predicted free-fall time. Give an explanation for this effect.

ANSWERS EXPLAINED
Multiple-Choice Problems

1. **(A)** The formula is

$$R = \frac{mv}{q\mathbf{B}}$$

If the velocity is doubled, so is the radius.

2. **(D)** Inside a solenoid, the effect of all the coils is to produce a long, uniform magnetic field.

3. **(D)** Using the right-hand rule, we place the fingers of the right hand along the line of the magnetic field and point the thumb in the direction of the velocity. The palm points outward. However, since the particle is an electron, and the right-hand rule is

designed for a positive charge, we must reverse the direction and say that the force is directed inward (into the page).

4. **(B)** The formula is

$$B = \frac{\mu_0 I}{2\pi r} = \frac{(2\times 10^{-7})I}{r}$$

Recalling that $r = 3$ cm $= 0.03$ m, we substitute all the given values to obtain $I = 4.5$ A.

5. **(C)** Magnetic field lines were introduced by Michael Faraday to determine both the direction of the field and its relative strength (a stronger field is indicated by a greater line density).

6. **(A)** Using the right-hand rule, we find that the circle surrounding the wire will have its field coming out of the page at point A.

7. **(B)** The back emf is proportional to the rate of change of magnetic flux and opposes the ability of the motor to turn. It is at its greatest value when the speed of the motor is at maximum.

8. **(B)** The motional emf is equal to $B\ell v$, where v is the velocity of the bar magnet. Thus, the induced emf is greatest when the magnet is pushed through quickly.

9. **(A)** The magnetic flux is independent of the shape of the wire loop.

10. **(D)** The formula for the rate of change of magnetic flux is emf $= -N(\Delta\Phi/\Delta t)$. Using the given values and Ohm's law, we get for the magnitude of the flux change

$$\left(\frac{\Delta\Phi}{\Delta t}\right) = \frac{(0.75)(3)}{300} = 0.0075 \text{ Wb/s}$$

Our question concerns the rate of change of the magnetic field. In a situation in which the axis of the coil is parallel to the magnetic field, $\Phi = BA$, where $A = 0.0015$ m$^2$. Thus $\Delta B/\Delta t = 5$ T/s.

11. **(D)** In an ac generator, the emf reverses direction every one-half revolution. The flux through the loop switches from getting bigger to getting smaller (Lenz's law).

12. **(A)** The motional emf is given by emf $= B\ell v$. Thus, using the given values, we find that $v = 8.3$ m/s.

Free-Response Problems

1. (a) The kinetic energy of the electron is the product of its charge and potential difference. Thus,

$$KE = (1.6 \times 10^{-19})\,(12{,}000) = 1.92 \times 10^{-15} \text{ J}$$

(b) The formula for the velocity, when the mass and kinetic energy are known, is

$$v = \sqrt{\frac{2KE}{m}} = \sqrt{\frac{(2)(1.92\times 10^{-15})}{9.1\times 10^{-31}}} = 6.5\times 10^7 \text{ m/s}$$

(c) The magnetic force will cause a downward uniform acceleration, which can be found from Newton's second law, $\mathbf{F} = m\mathbf{a}$. The force will be due to the magnetic force, $\mathbf{F} = qv\mathbf{B}$. Thus, $\mathbf{a} = qv\mathbf{B}/m$. Using our known values, we get

$$\mathbf{a} = 4.57 \times 10^{14} \text{ m/s}^2$$

Now, for linear motion downward (recall projectile motion), $\mathbf{y} = (1/2)\mathbf{a}t^2$. The time to drop y meters is the same time required to go 20 cm (0.20 m), assuming no change in horizontal velocity. Thus,

$$t = \frac{x}{\mathbf{v}} = \frac{0.20}{6.5 \times 10^7} = 3 \times 10^{-9} \text{ s}$$

This implies that, upon substitution, $y = 0.00205 \text{ m} = 2.05 \text{ mm}$.

2. The effect of the conductor is to stretch both springs. Since we have two parallel springs of equal force constant k, we know from our work on oscillatory motion (Chapter 6) that the effective spring constant is equal to $2k$. Thus:

$$\mathbf{F} = 2k\Delta x$$

where $\Delta x = 0.003$ m. Thus, the weight of the conductor is

$$\mathbf{W} = mg = (0.015)(9.8) = 0.147 \text{ N}$$

and $k = 24.5$ N/m. Now, the magnetic force, $\mathbf{F} = \mathbf{B}IL$, is responsible for another elongation, x. Since $\mathbf{F} = k\mathbf{x}$, we have (with both springs attached)

$$\mathbf{B}IL = (24.5)(24.5) = 0.0490 \text{ N}$$

The length of the conductor is 4 cm = 0.04 m; and using Ohm's law, we know that the current is $I = 15/5 = 3$ A. Thus, we find that

$$\mathbf{B} \,(3)(0.04) = 0.0490 \text{ implies } \mathbf{B} = 0.4 \text{ T}$$

3. Striking a bar magnet or even heating it disrupts the magnetic domains that have aligned to magnetize it, causing the magnet to lose its strength.

4. Initially, the bar is accelerated downward by the force of gravity, given by $\mathbf{F} = M\mathbf{g}$. The resistance R, in conjunction with the induced current I, produces an emf equal to IR and also to the product $\mathbf{B}\ell\mathbf{v}$. The magnetic force due to the current I is given by $\mathbf{B}I\ell$. Combining all these ideas, we get that at terminal velocity

$$M\mathbf{g} = I\ell\mathbf{B} \quad \text{and} \quad I = \frac{\mathbf{B}\ell\mathbf{v}}{R}$$

Thus

$$\mathbf{v}_t = \frac{M\mathbf{g}R}{\ell^2 \mathbf{B}^2}$$

5. Copper is not highly magnetic. However, because of Lenz's law, the currents set up in the tube produce magnetic field opposing the new field carried by the magnet. The result is to slow down the magnet's terminal velocity, as compared to the normal uniformly accelerated motion.

Physical Optics

AP 2 only

KEY CONCENTS

(THIS CHAPTER IS FOR AP PHYSICS 2 ONLY)

→ **ELECTROMAGNETIC WAVES**

→ **REFLECTION**

→ **REFRACTION**

→ **APPLICATIONS OF LIGHT REFRACTION**

→ **INTERFERENCE AND DIFFRACTION OF LIGHT**

ELECTROMAGNETIC WAVES

In Chapter 13, we reviewed aspects of electromagnetic induction. In one example, we observed how the changing magnetic flux in a solenoid can induce an electric field. This **mutual induction** involves the transfer of energy through space by means of an oscillating magnetic field. Experiments in the late nineteenth century by German physicist Heinrich Hertz confirmed what Scottish physicist James Clerk Maxwell had asserted theoretically in 1864: that oscillating electromagnetic fields travel through space as transverse waves and that they travel with the same speed as does light. See Figure 14.1.

TIP

Electromagnetic waves do not need a medium through which to propagate. All electromagnetic waves travel with the velocity of light in a vacuum.

Electric field Magnetic field

Figure 14.1

Light is just one form of electromagnetic radiation that travels in the form of transverse waves. We know that these waves are transverse because they can be polarized, as discussed in Chapter 7. The speed of light in a vacuum is approximately equal to 3×10^8 meters per second and is designated by the letter c.

Experiments by Sir Isaac Newton in the seventeenth century showed that "white light," when passed through a prism, contains the colors red, orange, yellow, green, blue, and violet (abbreviated as ROYGBV). Each color of light is characterized by a different wavelength and frequency. The wavelengths range from about 3.5×10^{-7} meter for violet light to about

7.0 × 10⁻⁷ meter for red. Small wavelengths are sometimes measured in **angstroms**, (Å); 1 angstrom is equal to 1×10^{-10} meter. In more modern textbooks, the units **nanometers** (nm) are used; 1 nanometer is equal to 1×10^{-9} meter.

Together with other electromagnetic waves, such as radio waves, X rays, and infrared waves, light occupies a special place in the so-called **electromagnetic spectrum** because we can "see" it. A sample electromagnetic spectrum is presented in Figure 14.2.

TIP

Make sure you know the correct order of the electromagnetic spectrum.

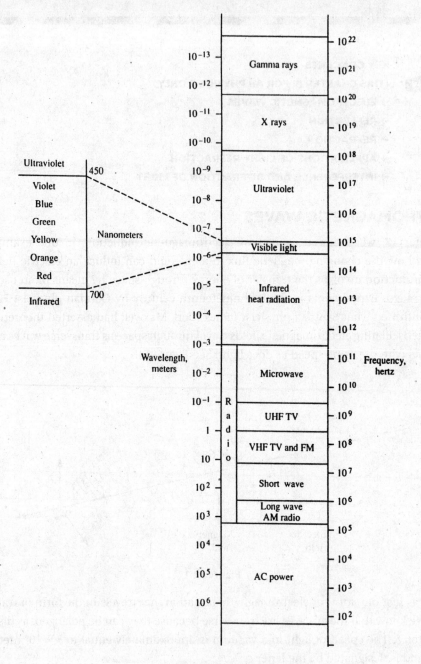

Figure 14.2 Electromagnetic Spectrum

Since electromagnetic waves are "waves," they all obey the relationship $c = f\lambda$, where c is the speed of light, discussed above. With this in mind, gamma rays have frequencies in the range of 10^{25} hertz and wavelengths in the range of 10^{-13} meter. These properties make gamma rays very small but very energetic.

REFLECTION

Reflection is the ability of light to seemingly bounce off a surface. There are two kinds of reflections: **specular** and **diffuse**. Specular reflections are reflections off of a smooth surface. They preserve the relative orientation of incoming light rays and are the primary type of reflection studied in physics. If the surface is rough and uneven, the reflection is said to be diffuse. The rays of incoming light are scattered in different directions. Note that each reflected light ray in a diffuse reflection is obeying the law of reflection. However, the overall effect is the light diffuses because of the microscopic variation in surface orientation. This phenomenon does not reveal the wave nature of light, and the notion of wavelength or frequency rarely enters into a discussion of reflection. If light is incident on a flat mirror, the angle of incidence is measured with respect to a line perpendicular to the surface of the mirror and called the **normal**.

In Figure 14.3 the **law of reflection**, which states that the angle of incidence equals the angle of reflection, is illustrated. Note that the angles of incidence and reflection and the normal are all coplanar.

> **REMEMBER**
>
> The law of reflection states that the angle of incidence is equal to the angle of reflection. Remember that the angles are measured relative to the normal line.

Figure 14.3

Reflection helps explain the colors of opaque objects. Ordinary light contains many different colors all blended together (so-called white light). A "blue" object looks blue because of the selective reflection of blue light due to the chemical dyes in the painted material. White paper assumes the color of the light incident on it because "white" reflects all colors. Black paper absorbs all colors (and of course nothing can be painted a "pure" color). If light of a single wavelength can be isolated (using a laser, for example), the light is said to be **monochromatic**. If all of the waves of light are moving in phase, the light is said to be **coherent**. The fact that laser light is both monochromatic and coherent contributes to its strength and energy. (The word *laser* is an acronym for *l*ight *a*mplification by the *s*timulated *e*mission of *r*adiation.)

REFRACTION

Place a pencil in a glass of water and look at the pencil from the side. The apparent bending of the pencil is due to refraction (Figure 14.4). As with all waves, wave speed depends on the medium. If light rays change speed as they pass from one medium to another medium, the light appears to bend toward or away from the normal. If there is no change in speed, as when light passes from benzene to Lucite, for example, there will be no refraction at any angle

(Figure 14.4). If the light is incident at an angle of zero degrees to the normal, there will again be no refraction, whether or not there is a change in speed (Figure 14.4) since the entire wave front speeds up or slows down at the same time.

(a) Refraction (b) No refraction (c) No refraction

(all angles coplanar)

Figure 14.4

TIP

When light refracts, its frequency does not change.

When light goes from one medium to another and slows down, at an oblique angle, the angle of refraction will be less than the angle of incidence, and we say that the light has been refracted **toward the normal**. Notice, in Figure 14.4a, that, when the light reemerges into the air, it will be parallel to its original direction, but slightly offset. This is due to the fact that the light is speeding up when it reenters the air. In that case, the angle of refraction will be larger than the angle of incidence, and we say that the light has been refracted **away from the normal**. Remember that, if the optical properties of the two media through which light passes are the same, no refraction occurs since there is no change in the speed of the light. In that case, the angle of incidence will be equal to the angle of refraction (no deviation).

The extent to which a medium is a good refracting medium is measured by how much change there is in the speed of light passing through it. This "physical" characteristic is manifested by a "geometric" characteristic, namely, the angle of refraction. The relationship between these quantities is expressed by **Snell's law**. With the angle of incidence designated as i and the angle of refraction as r, and with v_1 the velocity of light in medium 1 (equal to **c** if medium 1 or 2 is air) and v_2 the velocity of light in medium 2, Snell's law states that

$$\frac{\sin \theta_i}{\sin \theta_r} = \frac{v_1}{v_2} = \frac{n_2}{n_1}$$

The ratio n_2/n_1 is called the **relative index of refraction**. The absolute index of refraction, N, is more commonly used:

$$N = c/v$$

where v is the wave speed in medium N and c is the speed of light in a vacuum (3.0×10^8 m/s). This gives us the usual formula for Snell's law:

$$N_1 \sin \theta_1 = N_2 \sin \theta_2$$

Note that when a change in medium dictates a change in speed, the light's frequency remains unchanged. The frequencies of all waves are dictated by the source of the wave. The wave speed and wavelength are determined by the medium (see Table 14.1). The light's wavelength is what changes (to a new λ_N) to accommodate the new velocity and to keep the wave equation true:

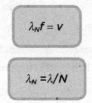

$$\lambda_N f = v$$

$$\lambda_N = \lambda/N$$

where λ is the wavelength in a vacuum.

Table 14.1

Absolute indices of Refraction of Selected Media

Substance	Index of Refraction
Air (vacuum)	1.00
Water	1.33
Alcohol	1.36
Quartz	1.46
Lucite	1.50
Benzene	1.50
Glass	
Crown	1.52
Flint	1.61
Diamond	2.42

The particular colors of visible light all have specific frequencies. When these colors are used in a refraction experiment, they produce angles of refraction since they travel at different speeds in media other than air (or a vacuum). Substances that allow the frequencies of light to travel at different speeds are called **dispersive media**. This aspect of refraction explains why a prism allows one to see a colored, "continuous" spectrum and, additionally, why red light (at the low-frequency end) emerges on top (see Figure 14.5).

White light

→ Red
→ Orange
→ Yellow
→ Green
→ Blue
→ Indigo
→ Violet

Figure 14.5 Prismatic Dispersion of Light

SAMPLE PROBLEM

A ray of light is incident from the air onto the surface of a diamond ($n = 2.42$) at a 30° angle to the normal.

(a) Calculate the angle of refraction in the diamond.

(b) Calculate the speed of light in the diamond.

Solution

(a) We use Snell's law:

$$n_1 \sin\theta_1 = n_2 \sin\theta_2$$

$$(1.00)\sin(30°) = (2.42)\sin\theta_2$$

$$\theta_2 = 12°$$

b) We use

$$v = \frac{c}{n}$$

$$v = \frac{3 \times 10^8 \text{ m/s}}{2.42} = 1.2 \times 10^8 \text{ m/s}$$

APPLICATIONS OF LIGHT REFRACTION

When light is refracted from a medium with a relatively large index of refraction to one with a low index of refraction, the angle of refraction can be quite large.

Figure 14.6 illustrates a situation in which the angle of incidence is at some critical value θ_c such that the angle of refraction equals 90 degrees (ray D). This can occur only when the relative index of refraction is less than 1.00, i.e., the light is moving from a slower to a faster medium.

If the angle of incidence exceeds this critical value, the angle of refraction will exceed 90 degrees and the light will be 100% internally reflected, a phenomenon aptly called **total internal reflection** (ray E). The ability of diamonds to sparkle in sunlight is due to total internal reflection and a relatively small critical angle of incidence (due to a diamond's high index of refraction). Fiber optics communication, in which information is processed along hair-thin glass fibers, works because of total internal reflection.

Figure 14.6

The critical angle can be determined from the relationship

$$\sin\theta_c = \frac{n_2}{n_1} \qquad (n_2 < n_1).$$

If $\theta > \theta_c$, the total internal reflection occurs.

SAMPLE PROBLEM

(a) Find the critical angle of incidence for a ray of light going from a diamond to air.

(b) Find the critical angle of incidence for a ray of light going from a diamond to water.

Solution

(a) We use

$$\sin\theta_c = \frac{n_2}{n_1}$$

$$\sin\theta_c = \frac{1.00}{2.42} = 0.4132$$

$$\theta_c = 24°$$

(b) We again use

$$\sin\theta_c = \frac{n_2}{n_1}$$

$$\sin\theta_c = \frac{1.33}{2.42} = 0.5496$$

$$\theta_c = 33°$$

INTERFERENCE AND DIFFRACTION OF LIGHT

The ability of light to diffract and exhibit an interference pattern is evidence of the wave nature of light. Light interference can be observed by using two or more narrow slits. Multiple-slit diffraction is achieved with a plastic "grating" onto which over 5,000 lines per centimeter are scratched.

Figure 14.7 shows that if white light is passed through the grating, a series of continuous spectra appears. Interestingly, this continuous spectrum is reversed from the way it appears in dispersion. The reason for this difference is that diffraction is wavelength dependent. Red, which has the longest wavelength has to travel farther in order to experience constructive interference.

Figure 14.7 Multiple-Slit Diffraction

With monochromatic light, an alternating pattern of bright and dark regions appears. If a laser is used, the pattern appears as a series of dots representing regions of constructive and destructive interference (see Figure 14.8). The dots are evenly spaced throughout.

Figure 14.8 Monochromatic Diffraction Pattern

The origin of this pattern can be understood if we consider a water-tank analogy. Suppose two point sources are vibrating in phase in a water tank. Each source produces circular waves that overlap in the region in front of the sources. Where crests meet crests, there is constructive interference; where crests meet troughs, destructive interference. This situation is illustrated in Figure 14.9.

Figure 14.9

Notice in Figure 14.9 a central maximum built up by a line of intersecting constructive interference points. This line lies along the perpendicular bisector of the line connecting sources S_1 and S_2. The symmetrical interference pattern consists of numbered "orders" that are evenly separated by a distance x. The distance from the sources to the screen along the perpendicular bisector is labeled L. The wavelength of each wave, measured by the spacing between each two concentric circles, is of course represented by λ, and the separation between the sources is designated as d.

In Young's double-slit experiment, the two explicit sources in the water tank are replaced by two narrow slits in front of a monochromatic ray of light. Each slit acts as a new point source of light that interferes with the waves from the other slit in much the same way as Figure 14.9 illustrates (this is known as **Huygen's principle**). The central maximum is called the "0-order maximum" because the **path length difference** from the two sources (slits) is zero at this point.

Each successive constructive interference point ($n = 0$, 1, 2 in Figure 14.9) is caused by the path length difference between the path from the higher slit (L_1) to that point of constructive interference and the path from the lower slit (L_2). Any time the difference in path is exactly 1 wavelength, the two waves arrive **in phase** and constructive interference occurs:

$$L_2 - L_1 = m\lambda$$

where m is an integer. This m value is precisely the number of the order in the diagram. Note that half-integer values give points of destructive interference (dark fringes) as the wave arrives at exactly half a wavelength or **out of phase**.

The relationship governing the variables discussed above is given by the equation

$$m\frac{\lambda}{d} = \frac{x}{L}$$

Don't forget that since light is a wave, it can also undergo Doppler shifts due to moving sources or receivers (see Chapter 4). However, since the speed of light is much larger than the speed of sound, Doppler shifts for light are not as common in our everyday lives. Speeds of cars and clouds, however, are frequently found via Doppler radar. (Radar is simply low-frequency light!)

where m represents the desired order.

If θ is an angle measured from the midpoint between the slits and a particular order, the ratio x/L is approximately equal to $\sin\theta$, and the diffraction formula becomes:

$$m\lambda = d\sin\theta$$

SAMPLE PROBLEM

A ray of monochromatic light is incident on a pair of double slits separated by 8×10^{-5} m. On a screen 1.2 m away, a set of dark and bright lines appear separated by 0.009 m. What is the wavelength of the light used?

Solution

We use

$$\lambda = \frac{dx}{L}$$

$$\lambda = \frac{(8 \times 10^{-5} \text{ m})(0.009 \text{ m})}{1.2 \text{ m}} = 6 \times 10^{-7} \text{ m}$$

SUMMARY

- Electromagnetic waves are produced by oscillating electromagnetic fields.
- Electromagnetic waves can travel through a vacuum and do not need a material medium for propagation.
- In a vacuum, all electromagnetic waves travel with the speed of light; $c = 3 \times 10^8$ m/s.
- Electromagnetic waves may be represented on a chart called the electromagnetic spectrum.
- Light waves are transverse since they can be polarized.
- Light rays travel in straight lines and produce shadows when incident on opaque objects.
- Luminous objects emit their own light. Opaque objects are seen by illumination; that is, they reflect light.
- The color of an opaque object is due to the selective reflection of certain colors.
- Light rays exhibit all wave characteristics such as reflection, refraction, diffraction, and interference.
- The law of reflection states that the angle of incidence is equal to the angle of reflection (as measured relative to a line normal to the surface).
- In optics, all angles are measured relative to the normal to a surface.
- Snell's law governs the refraction of light through transparent media.
- The ratio of the speed of light in air to the speed of light in a transparent medium is called the absolute index of refraction.
- The speed of light in a transparent medium can be obtained using Snell's law and is inversely proportional to the absolute index of refraction for the medium.

PRACTICE EXERCISES

Multiple-Choice

1. What is the frequency of a radio wave with a wavelength of 2.2 m?

 (A) 3×10^8 Hz
 (B) 1.36×10^8 Hz
 (C) 7.3×10^{-9} Hz
 (D) 2.2×10^8 Hz

2. A ray of light is incident from a layer of crown glass ($n = 1.52$) upon a layer of water ($n = 1.33$). The critical angle of incidence for this situation is equal to

 (A) 32°
 (B) 41°
 (C) 49°
 (D) 61°

3. The relative index of refraction between two media is 1.20. Compared to the velocity of light in medium 1, the velocity of light in medium 2 will be

 (A) greater by 1.2 times
 (B) reduced by 1.2 times
 (C) the same
 (D) The velocity will depend on the two media.

4. What is the approximate angle of refraction for a ray of light incident from air on a piece of quartz at a 37° angle?

(A) 24°

(B) 37°

(C) 42°

(D) 66°

5. What is the velocity of light in alcohol ($n = 1.36$)?

(A) 2.2×10^8 m/s

(B) 3×10^8 m/s

(C) 4.08×10^8 m/s

(D) 1.36×10^8 m/s

6. If the velocity of light in a medium depends on its frequency, the medium is said to be

(A) refractive

(B) resonant

(C) diffractive

(D) dispersive

7. If the intensity of a monochromatic ray of light is increased while the ray is incident on a pair of narrow slits, the spacing between maxima in the diffraction pattern will be

(A) increased

(B) decreased

(C) the same

(D) increased or decreased, depending on the frequency

8. In the diagram below, a source of light (*S*) sends a ray toward the boundary between two media in which the relative index of refraction is less than 1. The angle of incidence is indicated by *i*. Which ray best represents the path of the refracted light?

(A) *A*

(B) *B*

(C) *C*

(D) *D*

9. A coin is placed at the bottom of a clear trough filled with water ($n = 1.33$) as shown below. Which point best represents the approximate location of the coin as seen by someone looking into the water?

(A) A

(B) B

(C) C

(D) D

10. If, in question 9, the water is replaced by alcohol ($n = 1.36$), the coin will appear to be

(A) higher

(B) lower

(C) the same

(D) higher or lower, depending on the depth of the alcohol

Free-Response

1. (a) Light of wavelength 700 nm is directed onto a diffraction grating with 5,000 lines/cm. What are the angular deviations of the first- and second-order maxima from the central maxima?

(b) Explain why X rays, rather than visible light, are used to study crystal structure.

2. Light is incident on a piece of flint glass ($n = 1.66$) from the air in such a way that the angle of refraction is exactly half the angle of incidence. What are the values of the angles of incidence and the angle of refraction?

3. A ray of light passing through air is incident on a piece of quartz ($n = 1.46$) at an angle of 25°, as shown below. The quartz is 1.5 cm thick. Calculate the deviation d of the ray as it emerges back into the air.

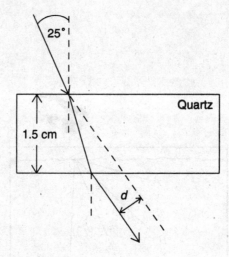

4. Immersion oil is a transparent liquid used in microscopy. It has an absolute index of refraction equal to 1.515. A glass rod attached to the cap of a bottle of immersion oil is practically invisible when viewed at certain angles (under normal lighting conditions). Explain how this might occur.

5. Explain why a diamond sparkles more than a piece of glass of similar size and shape.

6. Explain why total internal reflection occurs at boundaries between transparent media for which the relative index of refraction is less than 1.0.

ANSWERS EXPLAINED
Multiple-Choice Problems

1. **(B)** The velocity of light in air is given by the formula $c = f\lambda$. The wavelength is 2.2 m, and the velocity of light in air is 3×10^8 m/s. Substituting known values gives us

$$f = 1.36 \times 10^8 \, \text{Hz}$$

2. **(D)** The critical angle of incidence is given by the formula

$$\sin\theta_c = \frac{n_2}{n_1}$$

where $n_2 = 1.33$ and $n_1 = 1.52$. Substitution yields a value of 61° for the critical angle.

3. **(B)** The velocity relationship is given by the formula

$$\frac{v_1}{v_2} = n_2/n_1$$

Since the relative index of refraction is defined to be equal to the ratio n_2/n_1, we see that $v_1 = 1.2(v_2)$. Thus, compared to v_1, v_2 is reduced by 1.2 times.

4. **(A)** Snell's law in air is given by

$$\frac{\sin\theta i}{\sin\theta r} = n_2$$

The absolute index of refraction for quartz is 1.46. Substitution yields a value of 24° for the angle of refraction.

5. **(A)** Compared to the velocity of light in air, the velocity of light in any other transparent substance (here, alcohol) is given by the formula $\mathbf{v} = \mathbf{c}/n$. In this case, $n = 1.36$, and so the velocity of light is equal to $2.2 \times 108\,\text{m/s}$.

6. **(D)** By definition, a medium is said to be "dispersive" if the velocity of light is dependent on its frequency.

7. **(C)** The position and separation of interference maxima are independent of the intensity of the light.

8. **(A)** Since the relative index of refraction is less than 1, the light ray will speed up as it crosses the boundary between the two media and will therefore bend away from the normal, approximately along path A.

9. **(B)** The human eye traces a ray of light back to its apparent source as a straight line. If we follow the line from the eye straight back, we reach point B.

10. **(A)** Since alcohol has a higher absolute index of refraction, the light will be bent further away from the normal. Tracing that imaginary line straight back would imply that the image would appear closer to the surface (higher in the alcohol).

Free-Response Problems

1. (a) The general formula for diffraction is

$$n\lambda = d\sin\theta$$

where θ is the angle of deviation from the center. For the first-order maximum, $n = 1$, and d is equal to the reciprocal of the number of lines per meter. Thus, we must convert 5,000 lines/cm to 500,000 lines/m. Now,

$$\sin\theta = \frac{n\lambda}{d} = \frac{(1)(7\times10^{-7})}{500,000} = 0.35$$

and

$$\theta = 20.5°$$

For the second-order maximum, we have $n = 2$. Thus

$$\sin\theta = \frac{(2)(7\times10^{-7})}{500,000} = 0.7$$

and

$$\theta = 44.4°$$

(b) X rays are used to study crystal structure because of their very small wavelengths. These wavelengths are comparable to the spacings between lattices in a crystal and thus make it possible for the X rays to be diffracted from the different layers. Visible light has wavelengths that are much greater than these spacings and so are not affected by them. The use of X rays to probe crystals was one of the first diagnostic applications of these rays in atomic physics at the beginning of the twentieth century.

2. We want the angle of refraction to be equal to half the angle of incidence. This means that $i = 2r$. Now, since the light ray is initially in air ($n = 1.00$), Snell's law can be written:

$$\frac{\sin \theta i}{\sin \theta r} = n \text{ (glass)}$$

Substituting our requirement that $i = 2r$ gives

$$\frac{\sin 2r}{\sin r} = 1.66$$

Now, we recall the following trigonometric identity:

$$\sin 2\theta = 2 \sin \theta \cos \theta$$

Thus

$$\frac{2 \sin r \cos r}{\sin r} = 1.66$$

and

$$2 \cos r = 1.66$$

Therefore

$$\cos r = 0.83$$

and

$$r = 34°$$

which means that

$$i = 68°$$

3. The diagram from the problem has been redrawn as shown below. From our knowledge of refraction, we know that angle θ must be equal to 25°. Angle r is given by Snell's law:

$$\frac{\sin 25}{\sin r} = 1.46$$

$$\sin r = \frac{\sin 25}{1.46} = 0.2894$$

$$r = 16.8°$$

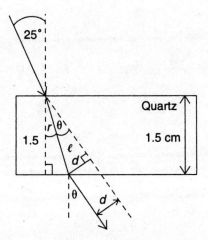

Now, angle θ is equal to the difference between the angle of incidence and the angle of refraction:

$$\theta = 25° - 16.8° = 8.2°$$

Since the quartz is 1.5 cm in thickness, the length of the light ray, in the quartz, at the angle of refraction, can be determined from $\cos r = 1.5 / \ell$. This implies that $\ell = 1.57$ cm. Now, since we know the length of the diagonal ℓ and the angle θ, the deviation d is just part of the right triangle in our diagram. Thus

$$\sin \theta = \frac{d}{\ell}$$

and

$$d = \ell \sin \theta = (1.57) \sin 8.2 = 0.224 \, \text{cm}$$

4. The index of refraction for the glass is very nearly equal to that for the immersion oil. When the applicator rod is filled with liquid, the light passes through both media without refracting and makes the glass rod appear invisible.

5. A diamond has a lower critical angle of incidence than glass. Therefore, when turned through various angles, the light passing through a diamond is internally reflected and then dispersed more easily than through glass. This creates the "sparkling" effect.

6. In order to produce total internal reflection, the angle of refraction must exceed 90 degrees. This is possible only when light passes from a high-index material to one with a low index of refraction. Under these conditions, the relative index of refraction for the two media is less than 1.0.

Geometrical Optics

15

AP 2 only

KEY CONCEPTS

(THIS CHAPTER IS FOR AP PHYSICS 2 ONLY)

→ **IMAGE FORMATION IN PLANE MIRRORS**

→ **IMAGE FORMATION IN CURVED MIRRORS**

→ **IMAGE FORMATION IN LENSES**

IMAGE FORMATION IN PLANE MIRRORS

When you look at yourself in a plane mirror, your image appears to be directly in front of you and on the other side of the mirror. Everything about your image is the same as you, the person, except for a left-right reversal. Since no light can be originating from the other side of the mirror, your image is termed **virtual**.

The formation of a virtual image in a plane mirror is illustrated in Figure 15.1. Using an imaginary point object, we construct two rays of light that emerge radially from the object because of ambient light from its environment. Each light ray is incident on the plane mirror at some arbitrary angle and is reflected off at the same angle (relative to the normal). Geometrically, we construct these lines using the law of reflection and a protractor. Since the rays diverge from the object, they continue to diverge after reflection. The human eye, however, perceives the rays as originating from a point on the other side of the mirror and in a direct line with the object.

Figure 15.1 Plane Mirror

IMAGE FORMATION IN CURVED MIRRORS

If a concave or convex mirror is used, the law of reflection still holds, but the curved shapes affect the direction of the reflected rays. Figure 15.2(a) shows that a concave mirror converges parallel rays of light to a **focal point** that is described as **real** since the light rays really cross. In Figure 15.2(b), we see that a convex mirror causes the parallel rays to diverge away from the mirror. If we extend the rays backward in imagination, they appear to originate from a point on the other side of the mirror. This point is called the **virtual focal point** since it is not real. The human eye will always trace a ray of light back to its source in a line. This deception of the eye is responsible for images in some mirrors appearing to be on the "other side" of the mirror (**virtual images**).

(a) Concave mirror

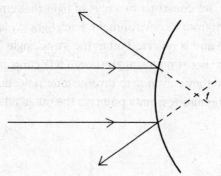

(b) Convex mirror

Figure 15.2

Concave Mirrors

In Figure 15.3, a typical concave mirror is illustrated. The shape of the bisecting axis, called the **principal axis**, should be parabolic in cross section. If the curvature of the mirror is too large, a defect known as **spherical aberration** occurs and distorts the images seen. The real images formed by concave mirrors can be projected onto a screen. The focal length can be determined by using parallel rays of light and observing the point at which they converge.

Figure 15.3 Concave Mirror

Another, more interesting method is to aim the mirror out the window at distant objects. Again, the images of those objects can be focused onto a screen. Since the objects are very far away, they are considered to be **at infinity**. Normally, at infinity, an object sends parallel rays of light and appears as a point. Since we are viewing extended objects, we project a smaller image of them, and the distance from the screen to the mirror is the focal length *F*.

The point along the principal axis labeled *C* on Figure 15.3 marks the **center of curvature** and is located at a distance 2*F*.

$$F = \frac{R}{2}$$

To illustrate how to construct an image formed by a concave mirror, we use an arrow as an imaginary object. Its location along the principal axis is measured relative to points *F* and *C*. The orientation of the arrow is of course determined by the way it points. We could choose an infinite number of light rays that come off the object because of ambient light from its environment. For simplicity, however, we choose two rays that emerge from the top of the arrow.

In Figure 15.4, we present several different concave-mirror constructions. The first light ray is drawn parallel to the principal axis and then reflected through the focal point *F*. The second light ray is drawn through the focal point and then reflected parallel to the principal axis. The point of intersection (below the principal axis in cases I, II, and III) indicates that the image appears inverted at the location marked in the diagram.

From cases I, II, and III in Figure 15.4, we can see that the real images are always inverted. Additionally, as the object is moved closer to the mirror, the image gets larger and appears to move farther away from the mirror. Notice that, when the object is at point *C*, as in case II, the image is also at point *C* and is the same size. When the object is at the focal point, as in case IV, no image can be seen since the light is reflected parallel from all points on the mirror. If the object is moved even closer, as in case V, we get an enlarged virtual image that is erect. In case IV, a light ray has been drawn toward the center of the mirror; by the law of reflection, it will reflect below the principal axis at the same angle of incidence.

Make sure you know these cases for both curved mirrors and lenses.

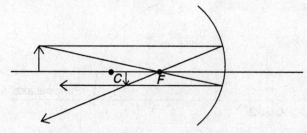

Case I—object beyond *C*; image is real, is between *F* and *C*, is smaller

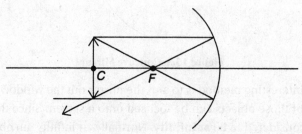

Case II—object at *C*; image is real, is at point *C*, is the same size

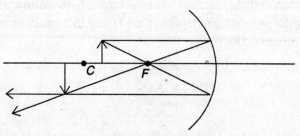

Case III—object between *F* and *C*; image is real, is beyond *C*, is larger

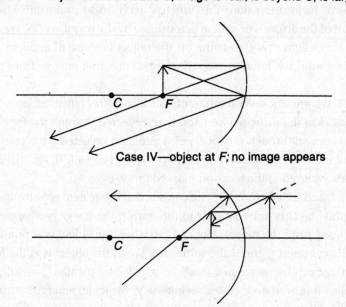

Case IV—object at *F*; no image appears

Case V—object between *F* and the mirror; image is virtual, is larger

Figure 15.4

Convex Mirrors

Convex mirrors are used in a variety of situations. In stores or elevators, for example, they have the ability to reveal images (although distorted) from around corners in aisles. An image in a convex mirror is always virtual and always smaller. This fact suggests that only one case construction, as opposed to five for concave mirrors, is necessary to understand image formation in these mirrors. In Figure 15.5, we show a sample construction and recall that convex mirrors diverge parallel rays. This divergence, however, is not at any arbitrary angle. The divergent ray is directed as though it originated from the virtual focal point.

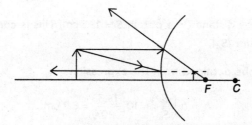

Image is virtual, erect, and smaller.

Figure 15.5 Convex Mirror

Algebraic Considerations

We can study the images formed in curved mirrors by means of an algebraic relationship. We let F represent the focal length (positive in a concave mirror; negative in a convex mirror), S_o represent the object distance, and S_i represent the image distance, then, for a curved mirror. If the image is virtual, S_i will be negative.

$$\frac{1}{f} = \frac{1}{S_o} + \frac{1}{S_i}$$

Also, if we let h_o represent the object size and h_i represent the image size, then

$$m = \frac{h_i}{h_o} = \frac{-S_i}{S_o}$$

The ratio of image size to object size is called the **magnification**. Negative magnification means the image is inverted (upside down).

A 10-cm-tall object is placed 20 cm in front of a concave mirror with a focal length of 8 cm. Where is the image located, and what is its size?

Solution

Using the first formula presented above, we can write

$$\frac{1}{8} = \frac{1}{20} + \frac{1}{S_i}$$

Solving for the image distance, we obtain S_i = 13.3 cm. This is consistent with case I as illustrated in Figure 15.4.

The image size can be obtained from the expression

$$h_i = h_o\left(\frac{S_i}{S_o}\right) = 10\left(\frac{13.3}{20}\right) = 6.7 \text{ cm}$$

IMAGE FORMATION IN LENSES

As a further example of light refraction, consider the refraction due to a lens. If monochromatic light is used, Figure 15.6a demonstrates what happens when two prisms are arranged base to base and two parallel rays of light are incident on them. We can observe that the light rays converge to a real focal point some distance away. This situation simulates the effect of refraction by a double convex lens, as shown in Figure 15.6b.

(a)

(b)

Figure 15.6

The focal length is dependent on the frequency of light used; red light will produce a greater focal length than violet light in a convex lens.

If the prisms are placed vertex to vertex, as in Figure 15.7a, the parallel rays of light will be diverged away from an apparent virtual focal point. This simulates, as shown in Figure 15.7b, the effect of a double concave lens.

(a)

(b)

Figure 15.7

Note that in Figure 15.6, the focal point is said to be real because the light rays actually do cross there. In Figure 15.7, the focal point is virtual.

Converging Lenses

When discussing the formation of images in lenses, we usually invoke what is called the **thin lens approximation**; that is, we consider that the light begins to refract from the center of the lens. As a result any curvature effects can be ignored. Since the top and the bottom of the lens are tapered like a prism, however, a defect known as **chromatic aberration** can sometimes occur. This defect causes the different colors of light to disperse in the lens and focus at different places because of their different frequencies and velocities in the lens material.

Figure 15.8 shows a series of cases in which a double convex lens is constructed as a straight line, using the thin lens approximation. The symmetry of the lens creates two real focal points, one on either side, and instead of considering the center of curvature (as in the curved mirror cases), we employ point 2*f* as an analogous location for reference. Our object is again an arrow drawn along the principal axis, which bisects the lens.

From Chapter 14, we know that a light ray parallel to the principal axis will refract through the focal point. Therefore, a light ray originating from the focal point will refract parallel to the principal axis. We will use these two light rays to construct most of our images.

Notice that in case IV no image is produced, and we had to draw a different light ray passing through the optical center of the lens. In case V an enlarged virtual image is produced on the same side as the object. This is an example of a simple magnifying glass.

Case I–object beyond 2F; image is between F and 2F, is real, is smaller, is inverted

Case II–object at 2F; image is at 2F, is real, is same size but inverted

Case III–object between F and 2F; image is beyond 2F, is real, is larger, is inverted

Case IV–object at F; no image is produced

Case V–object between F and the lens; image is behind object, is virtual, is larger but upright

Figure 15.8

Diverging Lenses

A concave lens will diverge parallel rays of light away from a virtual focal point. Figure 15.9 illustrates a typical ray construction for a diverging lens. Again, if we assume the thin lens approximation, we will draw the lens itself as a line for ease of construction. The context of the problem tells us that the drawing represents a concave, not a convex, lens.

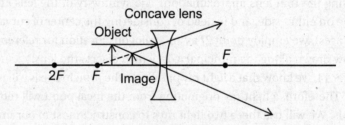

Figure 15.9

To construct the image, we have drawn a parallel light ray that then diverges away from the focal point. The second light ray is drawn through the optical center of the lens. The resulting virtual image will be erect and smaller and will be in front of the object. This will be true for any location of the object, so only one sample construction is necessary.

Algebraic Considerations

The relationship governing the image formation in a thin lens is the same as it was for a curved mirror. Positive image distances occur when the image forms on the other side of the lens. A negative image distance implies a virtual image. A positive focal length implies a

convex lens, while a negative focal length implies a concave lens. Therefore, as before, we can write

$$\frac{1}{f} = \frac{1}{S_o} + \frac{1}{S_i}$$

and

$$m = \frac{h_i}{h_o} = \frac{-S_i}{S_o}$$

If two converging lenses are used in combination, separated by some distance x, the combined magnification, m, of the system is given by

$$m = m_1 m_2$$

SAMPLE PROBLEM

A 3-cm-tall object is placed 6 cm in front of a concave lens (f = 3 cm). Calculate the image distance and size.

Solution

We use the modified version of the mirror-lens equation:

$$S_i = \frac{(S_o f)}{(S_o - f)} \qquad \text{Recall that for a concave lens, } f < 0!$$

$$S_i = \frac{(6 \text{ cm})(-3 \text{ cm})}{6 \text{ cm} - (-3 \text{ cm})} = -1 \text{ cm}$$

$$h_i = h_o\left(-\frac{S_i}{S_o}\right) = \frac{(3 \text{ cm})(2 \text{ cm})}{6 \text{ cm}} = 1 \text{ cm}$$

SUMMARY

- Images are classified as being real or virtual.
- Real images are formed when light rays converge. Real images can be projected onto a screen and are always inverted in appearance.
- Virtual images are formed as the brain imagines that reflected or refracted light rays converge back from their diverging paths. Virtual images cannot be projected onto a screen and are always erect. Virtual images are found by tracing the rays backward.
- Plane mirrors, convex mirrors, and concave lenses always produce virtual images. The virtual images produced by convex mirrors and concave lenses are always smaller than the object.
- Concave mirrors and convex lenses produce both real and virtual images. The real images may be larger or smaller than the object, whereas the virtual images are always larger.

- For a curved mirror, the focal length is equal to half the radius of curvature.
- If an object is placed at the focal point of a concave mirror or a convex lens, no image will be formed.

Problem-Solving Strategies for Geometrical Optics

To solve ray-diagram problems, you must remember the types of light rays and understand how they reflect and refract using mirrors and lenses. Numerically, keep in mind that positive focal lengths imply concave mirrors and convex lenses.

Memorize all of the cases illustrated in this chapter, and remember that real images are always inverted. Even if a given problem does not require a construction, draw a sketch. Additionally, remember that the focal length of a lens is dependent on the frequency of light used and the material of which the lens is made.

PRACTICE EXERCISES

Multiple-Choice

1. Which material will produce a converging lens with the longest focal length?

 (A) Lucite
 (B) Crown glass
 (C) Flint glass
 (D) Quartz

2. An object is placed in front of a converging lens in such a way that the image produced is inverted and larger. If the lens were replaced by one with a larger index of refraction, the size of the image would

 (A) increase
 (B) decrease
 (C) increase or decrease, depending on the degree of change
 (D) remain the same

3. You wish to make an enlarged reproduction of a document using a copying machine. When you push the enlargement button, the lens inside the machine moves to a point

 (A) equal to f
 (B) equal to $2f$
 (C) between f and $2f$
 (D) beyond $2f$

4. A negative image distance means that the image formed by a concave mirror will be

 (A) real
 (B) erect
 (C) inverted
 (D) smaller

5. Real images are always produced by

 (A) plane mirrors

 (B) convex mirrors

 (C) concave lenses

 (D) convex lenses

6. The focal length of a convex mirror with a radius of curvature of 8 cm is

 (A) 4 cm

 (B) –4 cm

 (C) 8 cm

 (D) –8 cm

7. An object appears in front of a plane mirror as shown below:

Which of the following diagrams represents the reflected image of this object?

 (A)

 (B)

 (C)

 (D)

8. An object is located 15 cm in front of a converging lens. An image twice as large as the object appears on the other side of the lens. The image distance must be

 (A) 15 cm

 (B) 30 cm

 (C) 45 cm

 (D) 60 cm

9. A 1.6-meter-tall person stands 1.5 m in front of a vertical plane mirror. The height of his image is

 (A) 0.8 cm

 (B) 2.6 cm

 (C) 3.2 cm

 (D) 1.6 cm

Free-Response

1. Using a geometric-ray diagram construction, prove Newton's version of the lens equation:

$$f^2 = SS'$$

where f is the focal length of the lens, d is the distance from the object to the focal point, and S' is the distance of the image from the other focal point.

2. Prove that, if two thin convex lenses are touching, the effective focal length of the combination is given by the formula

$$\frac{1}{f} = \frac{1}{f_1} + \frac{1}{f_2}$$

3. An object is 25 cm in front of a converging lens with a 5-cm focal length. A second converging lens, with a focal length of 3 cm, is placed 10 cm behind the first one.

 (a) Locate the image formed by the first lens.
 (b) Locate the image formed by the second lens if the first image is used as an "object" for the second lens.
 (c) What is the combined magnification of this combination of lenses?

4. Why do passenger-side mirrors on cars have a warning that states: Objects are closer than they appear?

5. Two lenses have identical sizes and shapes. One is made from quartz ($n = 1.46$), and the other is made from glass ($n = 1.5$). Which lens would make a better magnifying glass?

6. Why do lenses produce chromatic aberration whereas spherical mirrors do not?

ANSWERS EXPLAINED
Multiple-Choice Problems

1. **(D)** The longest focal length will be produced by the material that refracts the least, that is, has the smallest index of refraction. Of the five choices, quartz has the lowest index of refraction.

2. **(B)** The lens formula can be rewritten as

$$S_i = \frac{S_o f}{S_o - f}$$

If the object remains in the same position relative to the lens, then using a larger index of refraction will imply a smaller focal length. The image will move closer to the lens and consequently will be smaller.

3. **(C)** To produce an enlarged real image, the object must be located between f and $2f$.

4. **(B)** In a concave mirror, a negative image distance implies a virtual image, which is enlarged and erect.

5. **(D)** Only a convex lens or a concave mirror can produce a real image.

6. **(B)** The radius of curvature of a spherical mirror is twice the focal length. However, in a convex mirror, the focal length is taken to be negative.

7. **(B)** The reflected image must point "away" from the mirror but on the other side, flipped over.

8. **(B)** The equation governing magnification in a converging lens is

$$M = \frac{S_i}{S_o}$$

Since $M = 2$ and $S_o = 15\,\text{cm}$, the image distance must be $S_i = 30\,\text{cm}$.

9. **(D)** A plane mirror produces a virtual image that is the same size as the object in all cases.

Free-Response Problems

1. A drawing of the situation is given below:

In this construction, we have used the thin lens approximation. On the left side of the lens,

$$AF = S \quad \text{and} \quad FO = f \,(\text{focal length})$$

On the right side,

$$FO = f \quad \text{and} \quad FC = S'$$

Since we have a thin lens,

$$AB = OH \quad \text{and} \quad OI = CD$$

Now, we have $\triangle FAB$ similar to $\triangle FOI$ and $\triangle FOH$ similar to $\triangle FCD$. Thus, the following sides are in proportion:

$$\frac{AB}{OI} = \frac{AF}{FO}$$

$$\frac{OH}{CD} = \frac{FO}{FC}$$

Thus, $f/S = S'/f$, using the relationships defined above. Therefore,

$$f^2 = SS'$$

as desired.

2. If we have two lenses in contact, the image of the first lens becomes a "negative" object for the second lens. For the first lens, we have

$$\frac{1}{f_1} = \frac{1}{S_o} + \frac{1}{S_{i1}}$$

where p is the object distance for the combination. For the second lens, we must now have

$$\frac{1}{f_2} = \frac{1}{S_o} + \frac{1}{S_{i2}}$$

If we combine these equations, we obtain

$$\frac{1}{f_1} + \frac{1}{f_2} = \frac{1}{S_o} + \frac{1}{S_{i2}}$$

Since the two thin lenses are in contact, S_{i2} can be considered the image distance from the first lens also. Therefore, if we set

$$\frac{1}{S_o} + \frac{1}{S_{i2}} = \frac{1}{f}$$

the combination of two thin lenses in contact behaves equivalently as a single lens with a focal length f, so that

$$\frac{1}{f} = \frac{1}{f_1} + \frac{1}{f_2}$$

3. (a) For the first lens, we have $f = 5\,\text{cm}$ and $S_o = 25$; thus

$$S_i = \frac{S_o f}{S_o - f} = \frac{(25)(5)}{25 - 5} = \frac{125}{20}$$

and the location of the image formed by the first lens is given by $S_i = 6.25\,\text{cm}$.

(b) Since $S = 10\,\text{cm}$ for the second lens (its distance from the first lens) and $S_i = 6.25$ for the first lens, the image q now serves as the new "object" at a distance $S'_o = 10 - 6.25 = 3.75$. The focal length of the second lens is $3\,\text{cm}$; therefore, the distance S'_i of the image formed by the second lens is

$$S'_i = \frac{(3.75)(3)}{3.75 - 3} = 15\,\text{cm}$$

(c) The combined magnification of the system is equal to the product of the separate magnifications. Since $m = S_i/S_o$, in general, we have

$$M_1 = \frac{6.25}{25} = 0.25$$

$$M_2 = \frac{15}{3.75} = 4$$

Therefore, the combined magnification of this combination of lenses is given by

$$M = M_1 M_2 = (0.25)(4) = 1$$

4. Passenger side mirrors are convex in shape. This distorts images because of the divergence of the light, making them appear to be smaller and more distant than they actually are.

5. Using the lens construction diagrams, we see that for case V the lens becomes a magnifying glass. Changing the focal length affects the size and location of the image. If the focal length is decreased, the image size and distance will increase. A shorter focal length is obtained by using a material with a higher index of refraction. Hence, glass would make a better magnifying glass.

6. Chromatic aberration is due to the dispersion of white light into the colors of the spectrum. Since a mirror does not disperse light on reflection, this problem does not occur. This observation was the motivation for Sir Isaac Newton to invent the reflecting telescope in 1671.

Fluids

STATIC FLUIDS

Fluids represent states of matter that take the shape of their containers. Liquids are referred to as *incompressible fluids*, while gases are referred to as *compressible fluids*. In a Newtonian sense, liquids do work by being displaced, while gases do work by compressing or expanding. As we shall see later, the compressibility of gases leads to other effects described by the subject of thermodynamics.

> **REMEMBER**
>
> Liquids are *incompressible* fluids, while **gases** are *compressible* fluids.

Fluids can exert pressure by virtue of their weight or force of motion. We have already defined the unit of pressure to be the pascal, which is equivalent to 1 N of force per square meter of surface area. An additional unit used in physics is the **bar**, where 1 bar = 100,000 Pa. Atmospheric pressure is sometimes measured in millibars.

PASCAL'S PRINCIPLE

In a fluid, static pressure is exerted on the walls of the container. Within the fluid these forces act perpendicular to the walls. If an external pressure is applied to the fluid, this pressure will be transmitted uniformly to all parts of the fluid. The last sentence is also known as **Pascal's principle** since it was developed by the French physicist Blaise Pascal.

Pascal's principle refers only to an external pressure. Within the fluid, the pressure at the bottom of the fluid is greater than at the top. We can also state that the pressure exerted on a small object in the fluid is the same regardless of the orientation of the object.

As an example of Pascal's principle consider the hydraulic press shown in Figure 16.1. The small-area piston A_1 has an external force \mathbf{F}_1 applied to it. At the other end, the large-area piston A_2 has some unknown force \mathbf{F}_2 acting on it. How do these forces compare? According to Pascal's principle, the force per unit area represents an external pressure which will be transmitted uniformly through the fluid. Thus, we can write

$$\frac{F_1}{A_1} = \frac{F_2}{A_2}$$

Referring to Figure 16.1, suppose a force of 10 N is applied to the small piston of area 0.05 m². If the large piston has an area of 0.15 m², what is the maximum weight the large piston can lift?

Figure 16.1

Solution

Since the secondary force is proportional to the ratio of the areas, $F_2 = 30$ N.

STATIC PRESSURE AND DEPTH

Figure 16.2 shows a tall column of liquid in a sealed container. What is the pressure exerted on the bottom of the container? To answer this question, we first consider the weight of the column of liquid of height h. Since $\mathbf{F_g} = m\mathbf{g}$ and $m = \rho V$, the weight is $\rho \mathbf{g} V$. This is the force applied to the bottom of the container.

Figure 16.2

Now, in a container with a regular shape, $V = AH$, where A is the cross-sectional area (in this case, we have a cylinder whose cross sections are uniform circles). Thus, $\mathbf{F} = \rho \mathbf{g} V = \rho \mathbf{g} Ah$. Using the definition of pressure, we obtain

$$P = \frac{F}{A} = \rho gh$$

If the container is open at the top, then air pressure adds to the pressure of the column of liquid. The total pressure can therefore be written as $p = p_{ext} + \rho g h$. Note that the pressure is a function of depth only, not container width or size.

SAMPLE PROBLEM

A column of mercury is held up at 1 atm of pressure in an open-tube barometer (see the accompanying diagram). To what height does it rise? The density of mercury is 13.6 times the density of water.

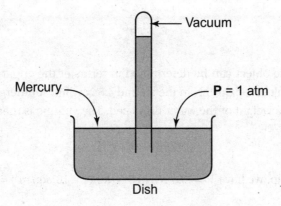

Solution

At 1 atm the pressure is 101 kPa. Thus, we can write

$$1.01 \times 10^5 \text{ N/m}^2 = (13.6 \times 10^3 \text{ kg/m}^3)(9.8 \text{ m/s}^2)h$$

$$h = 0.76 \text{ m} = 76 \text{ cm}$$

BUOYANCY AND ARCHIMEDES' PRINCIPLE

When an object is immersed in water, it feels lighter. In a cylinder filled with water, the action of inserting a mass in the liquid causes it to displace upward. The volume of the water displaced is equal to the volume of the object (even if it is irregularly shaped), as illustrated in Figure 16.3.

Figure 16.3 Measuring Volume by Water Displacement

Archimedes' principle states that the upward force of the water (called the **buoyant force**), F_B, is equal to the weight of the water displaced. Normally, one might think that an object floats if its density is less than water. This statement is only partially correct. A steel needle floats because of surface tension, and a steel ship floats because it displaces a volume of water equal to its weight.

The weight of the water displaced can be found mathematically. The fluid displaced has a weight $F_g = mg$. Now, the mass can be expressed in terms of the density of the liquid and its volume, $m = \rho V$. Hence, $F_g = \rho V g$. By letting V_d, represent the volume of displaced water, we obtain:

$$F_g = \rho g V_d$$

The volume of the object can be determined in terms of the apparent loss of weight in water. Suppose an object weighs 5 N in the air and 4.5 N when submerged in water. The difference of 0.5 N is the weight of the water displaced. The volume is therefore given by

$$V_f = \frac{\Delta m}{\rho_{\text{fluid}}} = \frac{\Delta F_g}{g\rho}$$

Using this relationship, we have $V_f = (0.5 \text{ N})/(9.8 \text{ N/kg})(1 \times 10^3 \text{ kg/m}^3) = 5.1 \times 10^{-5} \text{ m}^3$.

FLUIDS IN MOTION

The situation regarding static pressures in fluids changes when they are in motion. Microscopically, we could try to account for the motion of all molecular particles that make up the fluid, but this would not be very practical. Instead, we treat the fluid as a whole and consider what happens as the fluid passes through a given cross-sectional area each second. Sometimes the word *flux* is used to describe the volume of fluid passing through a given area each second.

Consider the fluid shown in Figure 16.4 moving uniformly with a velocity v in a time t through a segment of a cylindrical pipe. The distance traveled is given by the product vt. Since the motion is ideally smooth, there is no resistance offered by the fluid as different layers move relative to one another. This resistance is known as **viscosity**, and the type of fluid motion we are considering here is called **laminar flow**.

Figure 16.4

The rate of flow Q is defined to be the volume of fluid flowing out of the pipe each second (in m^3/s):

$$Q = \frac{vtA}{t} = vA$$

If the flow is laminar, then the **equation of continuity** states that the rate of flow Q will remain constant. Therefore, as the cross-sectional area decreases, the velocity must increase:

$$v_1 A_1 = v_2 A_2$$

BERNOULLI'S EQUATION

Consider a fluid moving through an irregularly shaped tube at two different levels given by h_1 and h_2 as shown in Figure 16.5. At the lower level, the fluid exerts a pressure \mathbf{P}_1 while moving through an area A_1 with a velocity \mathbf{v}_1. At the top, the fluid exerts a pressure \mathbf{P}_2 while moving through an area A_2 with a velocity \mathbf{v}_2. Bernoulli's equation is related to changes in pressure as a function of velocity.

Figure 16.5

Let us begin by considering the work done in moving the fluid from position 1 to position 2. The power generated is equal to the product of the pressure and the rate of flow ($\mathbf{P}R$), and so the work, which is equal to the product of power and time, can be written as

$$\Delta W = P_1 A_1 \mathbf{v}_1 t - P_2 A_2 \mathbf{v}_2 t = \frac{P_1 m}{\rho} - \frac{P_2 m}{\rho}$$

The change in the potential energy is given by

$$\Delta PE = m\mathbf{g}h_2 - m\mathbf{g}h_1$$

The change in kinetic energy is given by

$$\Delta KE = \frac{1}{2}m\mathbf{v}_2{}^2 - \frac{1}{2}m\mathbf{v}_1{}^2$$

Adding up both changes in energy and equating it with the work done, we obtain

$$\frac{P_1 m}{\rho} - \frac{P_2 m}{\rho} = m\mathbf{g}h_2 - m\mathbf{g}h_1 - \frac{1}{2}m\mathbf{v}_2{}^2 - \frac{1}{2}m\mathbf{v}_1{}^2$$

$$P_1 + \rho\mathbf{g}h_1 + \frac{1}{2}\rho\mathbf{v}_1^2 = P_2 + \rho\mathbf{g}h_2 + \frac{1}{2}\rho\mathbf{v}_2^2$$

TIP

Compare this equation and concept to the equation for the conservation of mechanical energy.

The last equation is known as **Bernoulli's equation**. Now let us consider some applications of this equation.

A Fluid at Rest

In Figure 16.6, we see a static fluid. The two layers at heights h_1 and h_2 have static pressures \mathbf{P}_1 and \mathbf{P}_2. Since the fluid is at rest, Bernoulli's equation reduces to

$$\Delta P = P_2 - P_1 = \rho\mathbf{g} \, \Delta h = \rho\mathbf{g}(h_2 - h_1)$$

The difference in pressure is just proportional to the difference in levels.

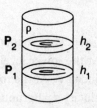

Figure 16.6

A Fluid Escaping Through a Small Orifice

Earlier in this chapter, we saw that the pressure difference is proportional to the difference in height. Suppose a small hole of circular area A is punched into the container below h_1 (Figure 16.7). This pressure difference will force the fluid out of the hole at a rate of flow $R = vA$. What is the velocity of the fluid as it escapes? And what is the rate of flow?

Figure 16.7

To answer these questions, we consider Bernoulli's equation as an analog of the conservation of energy equation. Let's choose the potential energy to be zero at h_1. The top fluid at h_2 is essentially at rest. In addition, the pressure at the top and the pressure at the orifice are both the same: atmospheric pressure. Therefore, the pressure term cancels. Thus, using Bernoulli's equation, we can solve for the flow rate:

$$\frac{1}{2}\rho v^2 = \rho g\,\Delta h$$

$$v = \sqrt{2g\,\Delta h}$$

$$R = vA = A\sqrt{2g\,\Delta h}$$

A Fluid Moving Horizontally

Consider a fluid moving horizontally through a tube that narrows in area. Bernoulli's equation states that as the velocity of a moving fluid increases, its static pressure decreases. We can analyze this in Figure 16.8.

Figure 16.8 Venturi Tube

Since the level is horizontal, $h_1 = h_2$ so we can eliminate the ρgh term. We can therefore write

$$P_1 + \frac{1}{2}\rho v_1^2 = P_2 + \frac{1}{2}\rho v_2^2$$

$$\Delta P = P_1 - P_2 = \frac{1}{2}\rho(v_2^2 - v_1^2)$$

SAMPLE PROBLEM

Water ($\rho = 1{,}000$ kg/m³) is flowing smoothly through a horizontal pipe that tapers from 1.5×10^{-3} m² to 0.8×10^{-3} m² in cross-sectional area. The pressure difference between the two sections is equal to 5,000 Pa. What is the volume flow rate of the water?

Solution

Since the water flows smoothly, we know that the volume flow rate is constant:

$$R = v_1 A_1 = v_2 A_2$$

We also know that from Bernoulli's equation

$$P_1 + \frac{1}{2}\rho v_1^2 + \rho g y_1 = P_2 + \frac{1}{2}\rho v_2^2 + \rho g y^2$$

But, since the pipe is horizontal, $y_1 = y_2$, and so the equation simplifies to

$$P_1 + \frac{1}{2}\rho v_1^2 = P_2 + \frac{1}{2}\rho v_2^2$$

We can simplify this by eliminating the velocities in each expression since

$$v_1 = \frac{R}{A_1} \quad \text{and} \quad v_2 = \frac{R}{A_2}$$

Thus,

$$P_1 + \frac{1}{2}\rho\frac{R^2}{A_1^2} = P_2 + \frac{1}{2}\rho\frac{R^2}{A_2^2}$$

We also know that $P_1 > P_2$ since pressure decreases with increasing velocity, and velocity increases with decreasing area. Thus we can write:

$$(P_1 - P_2) = \frac{1}{2}\rho R^2\left(\frac{1}{A_2^2} - \frac{1}{A_1^2}\right)$$

Since we know all values (including the pressure difference $P_1 - P_2$), we can substitute and solve for R, and we obtain $R = 2.99 \times 10^{-3}$ m³/s.

In aerodynamics, a wing moving in level flight has a lifting force acting on it exactly equal to its load. This force is caused by the pressure difference between the upper and lower surfaces of the wing. The wing is curved or *cambered* on top (see Figure 16.9), which has the effect of lowering the pressure on the top of wing (caused by faster-moving air molecules). It is this shape that causes the pressure difference and lift.

Figure 16.9 Airflow Pattern Over a Wing Section

SUMMARY

- Liquids are called incompressible fluids whereas gases are called compressible fluids.
- Pascal's principle states that in a confined fluid at rest, any change in pressure is transmitted undiminished throughout the fluid.
- The pressure in a confined fluid is proportional to the density of the fluid and its depth ($P = \rho g h$). A fluid open to the air has the pressure on top as well (P_0): $P = P_0 + \rho g h$.
- Archimedes' principle states that a submerged object will displace a volume of water equal to its own volume. A submerged object also experiences an upward force called the buoyant force, which is equal to the weight of the water displaced.
- An object will neither rise nor sink if it displaces a volume of water equal in weight to its own weight in the air.
- For laminar flow, $A_1 v_1 = A_2 v_2$.
- Bernoulli's principle states that for a fluid in motion, the static pressure will decrease with an increase in velocity. This principle helps explain the lifting force of an airplane wing. Bernoulli's principle is energy conservation for fluids: $P + \rho g h + \frac{1}{2} \rho v^2 = $ constant throughout the fluid.

Problem-Solving Strategies for Fluids

Solving fluid problems is similar to solving particle problems. We treat the fluid as a whole unit (i.e., macroscopically) as opposed to microscopically. The units of pressure must be either pascals or N/m$^2$ in order to use the formulas derived.

The concepts of Bernoulli's principle and Archimedes' principle should be thoroughly understood, as well as their applications and implications. Buoyancy is an important physical phenomenon and an important part of your overall physics education.

As always, drawing a sketch helps. Often, conceptual knowledge will be enhanced if you understand how the variables in a formula are related. Consider questions that involve changing one variable and observing the effect on others.

Multiple-Choice

1. The rate of flow of a liquid from a hole in a container depends on all of the following except

 (A) the density of the liquid
 (B) the height of the liquid above the hole
 (C) the area of the hole
 (D) the acceleration of gravity

2. A person is standing on a railroad station platform when a high-speed train passes by. The person will tend to be

 (A) pushed away from the train
 (B) pulled in toward the train
 (C) pushed upward into the air
 (D) pulled down into the ground

3. Bernoulli's equation is based on which law of physics?

 (A) conservation of linear momentum
 (B) conservation of angular momentum
 (C) Newton's first law of motion
 (D) conservation of energy

4. Which of the following expressions represents the power generated by a liquid flowing out of a hole of area A with a velocity \mathbf{v}?

 (A) (pressure) × (rate of flow)
 (B) (pressure)/(rate of flow)
 (C) (rate of flow)/(pressure)
 (D) (pressure) × (velocity)/(area)

5. Which of the following statements is an expression of the equation of continuity?

 (A) Rate of flow equals the product of velocity and cross-sectional area.
 (B) Rate of flow depends on the height of the fluid above the hole.
 (C) Pressure in a static fluid is transmitted uniformly throughout.
 (D) Fluid flows faster through a narrower pipe.

6. A moving fluid has an average pressure of 600 Pa as it exits a circular hole with a radius of 2 cm at a velocity of 60 m/s. What is the approximate power generated by the fluid?

 (A) 32 W
 (B) 62 W
 (C) 1,200 W
 (D) 45 W

7. Alcohol has a specific gravity of 0.79. If a barometer consisting of an open-ended tube placed in a dish of alcohol is used at sea level, to what height in the tube will the alcohol rise?

(A) 8.1 m
(B) 7.9 m
(C) 15.2 m
(D) 13.1 m

8. An ice cube is dropped into a mixed drink containing alcohol and water. The ice cube sinks to the bottom. From this, you can conclude

(A) that the drink is mostly alcohol
(B) that the drink is mostly water
(C) that the drink is equally mixed with water and alcohol
(D) nothing unless you know how much liquid is present

9. A 2-N force is used to push a small piston 10 cm downward in a simple hydraulic machine. If the opposite large piston rises by 0.5 cm, what is the maximum weight the large piston can lift?

(A) 2 N
(B) 40 N
(C) 20 N
(D) 4 N

10. Balsa wood with an average density of 130 kg/m₃ is floating in pure water. What percentage of the wood is submerged?

(A) 87%
(B) 13%
(C) 50%
(D) 25%

Free-Response

1. A U-tube open at both ends is partially filled with water. Benzene ($\rho = 0.897 \times 10^3 \text{ kg/m}^3$) is poured into one arm, forming a column 4 cm high. What is the difference in height between the two surfaces?

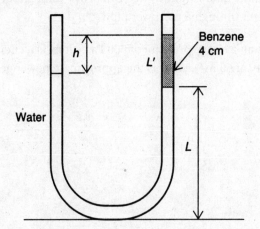

2. A Venturi tube has a pressure difference of 15,000 Pa. The entrance radius is 3 cm, while the exit radius is 1 cm. What are the entrance velocity, exit velocity, and flow rate if the fluid is gasoline ($\rho = 700$ kg/m³)?

3. A cylindrical tank of water (height H) is punctured at a height h above the bottom. How far from the base of the tank will the water stream land (in terms of h and H)? What must the value of h be such that the distance at which the stream lands will be equal to H?

4. Which has more pressure on the bottom? A large tank of water 30 cm deep or a cup of water 35 cm deep? Explain your answer.

5. Two paper cups are suspended by strings and hung near each other. They are separated by about 10 cm. When you blow air between them, the cups are attracted to one another. Explain why this occurs.

6. A cup of water is filled to the brim and held above the ground. Two holes on either side of the cup and horizontally level with one another are punched into the cup, causing water to run out. When the cup is released and allowed to fall, it is observed that no water escapes during the fall. Explain why this occurs.

ANSWERS EXPLAINED
Multiple-Choice Problems

1. **(A)** The flow rate of a liquid from a hole does not depend on the density of the liquid.

2. **(B)** Because of the Bernoulli effect, the speeding train reduces the air pressure between the person and the train. This pressure difference creates a force tending to pull the person into the train. Be very careful when standing on a train platform!

3. **(D)** Bernoulli's principle was developed as an application of conservation of energy.

4. **(A)** Power is expressed in J/s. The product of pressure (force divided by area) and flow rate (m³/s) leads to newtons times meters over seconds (J/s).

5. **(D)** The equation of continuity states that the product of velocity and area is a constant for a given fluid. A consequence of this is that a fluid moves faster through a narrower pipe.

6. **(D)** The power is equal to the product of the pressure and the flow rate. The flow rate is equal to the product of the velocity and the cross-sectional area (which is a circle of radius 0.02 m). The area is given by $\pi r^2 = 1.256 \times 10^{-3}$ m². When we multiply this area by the velocity and the pressure, we get 45.2 W as a measure of the generated power.

7. **(D)** The pressure exerted by the air is balanced by the column of liquid alcohol in equilibrium:

$$h = \frac{P}{\rho g} = \frac{1.01 \times 10^5 \text{ N/m}^2}{(790 \text{ kg/m}^3)(9.8 \text{ m/s}^2)} = 13.1 \text{ m}$$

8. **(A)** Since the density of alcohol is less than that of water, ice floats "lower" in alcohol than in water. From the given information, the drink appears to be mostly alcohol.

9. **(B)** We need to use the conservation of work-energy in this problem. The work done on the small piston must equal the work done by the large piston. Since the ratio of displacements is 20:1, the large piston will be able to support a maximum load of 40 N (since 2 N × 20 = 40 N).

10. **(B)** The percentage submerged is given by the ratio of its density to that of pure water (1,000 kg/m³). Thus, $130/1,000 = 0.13 = 13\%$.

Free-Response Problems

1. Let L' be the level of benzene that will float on top of the water, let L be the level of water, and let h be the difference in levels. Since the tube is open, the pressures are equalized at both ends. Thus, we can write

$$(L + L' - h)\mathbf{g}\rho_w = L'\mathbf{g}\rho_b + L\mathbf{g}\rho_w$$

$$h = L'\left(1 - \frac{\rho_b}{\rho_w}\right)$$

Since the ratio of the densities is 0.879 and $L' = 4$ cm, $h = 0.484$ cm.

2. Using Bernoulli's equation and the equation of continuity, we can write

$$\Delta \mathbf{P} = \frac{\rho}{2}\left(\mathbf{v}_2{}^2 - \mathbf{v}_1{}^2\right)$$

$$\mathbf{v}_1 A_1 = \mathbf{v}_2 A_2$$

$$\mathbf{v}_2 = \mathbf{v}_1 \frac{A_1}{A_2}$$

$$\Delta \mathbf{P} = \frac{\rho}{2}\mathbf{v}_1{}^2\left(1 - \frac{A_1{}^2}{A_2{}^2}\right)$$

From the given information, we know that the ratio of areas $A_1/A_2 = 9$. Thus, substituting all given values into the last equation yields $\mathbf{v}_1 = 0.732$ m/s, $R = 0.0021$ m³/s, and $\mathbf{v}_2 = 6.56$ m/s.

3. The change in potential energy must be equal to the change in horizontal kinetic energy:

$$m\mathbf{g}(H - h) = \left(\frac{1}{2}\right)m\mathbf{v}_x{}^2$$

$$\mathbf{v}_x = \sqrt{2\mathbf{g}(H - h)}$$

Now if we assume, as in projectile motion, that the horizontal velocity remains the same and the only acceleration of the stream is vertically downward because of gravity, we can write

$$\mathbf{x} = \mathbf{v}_x t$$

$$y = h = \frac{1}{2}\mathbf{g}t^2$$

$$t = \sqrt{\frac{2h}{\mathbf{g}}}$$

$$\mathbf{x} = 2\sqrt{h(H-h)}$$

For $\mathbf{x} = H$, we must have $h = H/2$, as can be easily verified using the preceding range formula.

4. The pressure at the bottom of a container of water depends on its depth and not on its volume. Thus, the pressure at the bottom of the 35-cm cup is greater.

5. Bernoulli's principle states that as the velocity of a moving fluid increases, the pressure it exerts decreases. Thus, blowing between the cups reduces the air pressure between them, causing a net force which pushes them together.

6. The water streams out of the holes because of the difference in pressure between the top and bottom of the cup. However, during free fall, both water and cup fall together and this prevents the water from coming out of the holes.

Thermodynamics

17

TEMPERATURE AND ITS MEASUREMENT

Temperature can be defined as the relative measure of heat. In other words, temperature defines what will lose and what will gain thermal energy when the energy is transferred. We can state even more simply that temperature is a measure of how "hot" or "cold" a body is (relative to your own body or another standard or arbitrary reference). Human touch is unreliable in measuring temperature since what feels hot to one person may feel cool to another.

During the seventeenth century, Galileo invented a method for measuring temperature using water and its ability to react to changes in heat content by expanding or contracting. Figure 17.1 shows a simple "thermometer" that consists of a beaker of water in which is inverted a tube with a circular bulb at the top. When thermal energy is added to the beaker, the level of water will rise.

TIP

Heat and temperature are not the same thing.

Heat added

Figure 17.1

For two reasons, however, water is not the best substance to use to measure temperature. First, water has a relatively high freezing and low boiling point; second, it has a peculiar variation in density as a function of temperature because of its chemical structure. Even so, the phenomenon of "thermal expansion" is an important topic not only in this context but also for engineering buildings, roads, and bridges. We will discuss this aspect in more detail later in the chapter.

Most modern thermometers (see Figure 17.2) use mercury or alcohol in a small capillary tube. In the metric system, the standard sea-level points of reference are the freezing point (0 degree) and boiling point (100 degrees) of water. This temperature scale, formerly known as the centigrade scale, is now called the Celsius scale after Anders Celsius. (The English Fahrenheit system is not used in physics.)

Figure 17.2

One difficulty with the Celsius scale is that the zero mark is not a true zero since a substance can be much colder than zero. Some gases, such as oxygen and hydrogen, do not even condense until their temperatures reach far below 0 degree Celsius. The discovery of a theoretical "absolute zero" temperature resulted in the so-called absolute or Kelvin temperature scale. A temperature of −273 degrees Celsius is redefined as "absolute zero" on the Kelvin scale. No temperature colder than absolute zero is possible. An easy way to convert from Celsius to Kelvin is to add the number 273 to the Celsius temperature. This just adds a scale factor that preserves the metric scale of the Celsius reading. In other words, there is still a 100-degree difference in temperature between melting ice and boiling water—273 K and 373 K, respectively. (Note that neither the word "degrees" nor the degree sign is used in expressing Kelvin temperatures.)

> Note that it is not actually possible to cool a real object all the way down to absolute zero. This is known as the third law of thermodynamics or Nernst's theorem.

MOLAR QUANTITIES

Under the conditions of STP (standard temperature (0°C) and pressure (1 atmosphere)), most gases behave according to a simple relationship among their pressures, volumes, and absolute temperatures. This **equation of state** applies to what is referred to as an **ideal gas**. A real gas, however, is very complex, and a large number of variables are required to understand all of the intricate movements taking place within it.

> **REMEMBER**
>
> Specifically, an ideal gas is one
>
> 1. That has only elastic collisions
> 2. That has no intermolecular forces and where gravity can be ignored
> 3. In which the molecules occupy a volume much smaller than the total volume available

To help us understand ideal gases, we introduce a quantity called the **molar mass**. In thermodynamics (and chemistry), the molar mass or **gram-molecular mass** is defined to be the mass of a substance that contains 6.02×10^{23} molecules (commonly referred to as a mole). This number is called **Avogadro's number** (N_A), and 1 mole of an ideal gas occupies a volume of 22.4 liters at zero degree Celsius. For example, the gram-molecular mass of carbon (C) is 12 grams, while the gram-molecular mass of oxygen (O_2) is 32 grams. If m represents the actual mass, the

number of moles of gas is given by the relationship $n = \dot{m}/M$, where M equals the gram-molecular weight. For example, 64 grams of oxygen equals 2 moles, and 36 grams of carbon equals 3 moles.

THE IDEAL GAS LAW EQUATION OF STATE

Imagine that we have an ideal gas in a sealed, insulated chamber such that no heat can escape or enter. Figure 17.3 shows an external force placed on the piston at the top of the chamber so that the pressure change causes the piston to move down. The chamber is a cylinder with cross-sectional area A and height h. If a constant force **F** is applied, work is done to move the piston (frictionless) a distance h. Thus, $W = \mathbf{F}h$, and since $h = V/A$, the work done is

$$W = \frac{\mathbf{F}V}{A} = PV$$

In other words, the work done (in this case) is equal to the product of the pressure and the volume.

If the temperature of the gas remains constant, this relationship is known as **Boyle's law** and can be expressed as

$$PV = \text{constant}$$

or

$$P_1V_1 = P_2V_2$$

Figure 17.3

Experiments demonstrate that, if a gas is enclosed in a chamber of constant volume, there is a direct relationship between the pressure in the chamber and the absolute Kelvin temperature of the gas: the ratio of pressure to absolute temperature in an ideal gas always remains constant (indicated by a diagonal, straight-line graph at constant volume). We can write this relationship algebraically as:

$$\frac{P}{T} = \text{constant}$$

or

$$\frac{P_1}{T_1} = \frac{P_2}{T_2}$$

where the temperatures must be in kelvins.

French scientist Jacques Charles (and, independently, Joseph Gay-Lussac) developed a relationship, commonly known as **Charles's law**, between the volume and the absolute temperature of an ideal gas at constant pressure. This law states that the ratio of volume and absolute temperature in an ideal gas remains constant; that is,

$$\frac{V_1}{T_1} = \frac{V_2}{T_2}$$

The three gas laws—pressure-temperature law, Boyle's, and Charles's—can be summarized by the one **ideal gas law**, which has four forms:

The first form is a direct consequence of all three gas laws:

$$\frac{P_1 V_1}{T_1} = \frac{P_2 V_2}{T_2}$$

where the temperatures must be in kelvins.

The second form states that the product of pressure and volume, divided by the absolute temperature, remains a constant:

$$\frac{PV}{T} = \text{constant}$$

The third and more general form of the ideal gas law (and the one found in most advanced textbooks) includes the number of moles of gas involved and a universal gas constant R:

$$PV = nRT$$

where $R = 8.31$ joules per mole · kelvin (J/mol · K).

Finally, if $n = N/N_A$, where N is the actual number of molecules and N_A is Avogadro's number, a constant $k = R/N_A$, called **Boltzmann's constant**, can be introduced, and the ideal gas law takes the form

$$PV = NkT$$

Again, the temperatures must always be in kelvins.

A confined gas at constant temperature has a volume of 50 m$^3$ and a pressure of 500 Pa. If it is compressed to a volume of 20 m$^3$, what is the new pressure?

Solution

We use Boyle's law:

$$P_1V_1 = P_2V_2$$

$$(500 \text{ Pa})(50 \text{ m}^3) = P_2(20 \text{ m}^3)$$

$$P_2 = 1,250 \text{ Pa}$$

A confined gas is at a temperature of 27°C when it has a pressure and volume of 1,000 Pa and 30 m$^3$, respectively. If the volume is decreased to 20 m$^3$ and the temperature is raised to 30°C, what is the new pressure?

Solution

We will use the ideal gas law, but we must remember that the temperatures must be in Kelvin!

$$27°C = 300 \text{ K}$$

$$30°C = 323 \text{ K}$$

Now,

$$\frac{(P_1V_1)}{T_1} = \frac{(P_2V_2)}{T_2}$$

$$\frac{(1,000 \text{ Pa})(30 \text{ m}^3)}{300 \text{ K}} = \frac{P_2(20 \text{ m}^3)}{323 \text{ K}}$$

Solving, we obtain

$$P_2 = 1,615 \text{ Pa}$$

KINETIC-MOLECULAR THEORY

What is thermal or internal energy? When thermal energy is exchanged, we call this heat. If an object is losing thermal energy, its total internal (or thermal) energy decreases. This can manifest in either a lowering of temperature or a phase change. Temperature is a proxy for microscopic kinetic energy. The energy associated with phase changes are microscopic potential energies. By microscopic, we mean the kinetic energies associated with the individual molecular velocities and the potential energies of relationships between the molecules within the substance. Kinetic-molecular theory refers to the fact that if an object remains in its current state, any thermal energy is mostly going to or coming from the kinetic energy of the individual molecules or atoms within the substance. Specifically for an ideal gas, all

thermal energy is in the form of molecular kinetic energy. Recall that one of the assumptions for an ideal gas is that the molecules are not interacting and have perfectly elastic collisions:

> **Average kinetic energy per molecule = $(3/2)kT$**

where k is the Boltzmann constant and T is the temperature in Kelvin. Therefore, the total thermal energy of an ideal gas is $(3/2)NkT$, where N is the number of molecules in the substance. Some molecules have higher speeds and thus higher kinetic energies. Some will have lower kinetic energies. However, the average is given by the formula above.

If one uses the kinetic energy formula $((1/2)mv^2)$ and solves for velocity, an expression is obtained for the root-mean-square (RMS) velocity:

$$v_{rms} = \sqrt{\frac{3kT}{m}}$$

Note that this does not represent the average speed of the molecules. RMS values are bigger than the actual mean speed. The exact relationship depends on the distribution of data.

SAMPLE PROBLEM

An ideal gas at 120 degrees Celsius has molecules with an average kinetic energy of what value? How many molecules would you need to have 0.5 joules of thermal energy?

Solution

$T = 120 + 273 = 393$ Kelvin

$KE_{average} = (3/2)kT = (3/2)(1.38 \times 10^{-23})(393) = 8.14 \times 10^{-21}$ joules

Number of molecules $= 0.5$ J$/(8.14 \times 10^{-21}$ J$) = 6.14 \times 10^{19}$ molecules

WORK DONE BY EXPANDING GASES

If a gas expands by displacing any substance, the gas is doing positive work to its environment. Therefore, the gas is transferring energy out of its internal energy into the environment. By the kinetic-molecular theory, this internal energy is in the kinetic energy of the molecules. This loss of energy, therefore, means its temperature will go down as the molecules slow down. Think of each individual collision of a molecule at the edge of the gas with its surroundings. In order to displace the external molecule it hits (the expansion part), the gas molecule must do some individual work and, in doing so, lower its own kinetic energy. As each gas molecule that hits the exterior goes through this, the average speed is lowered, which lowers the temperature of the entire gas.

Note that pressure times volume has units of energy. For expanding gases, the area under a pressure vs. volume curve is the work done by the gas (representing a loss of energy from the gas). For contracting gases, the area is the work being done to the gas (representing a gain in energy to the gas). If a gas is cycled through compression and expansion, the difference in areas represents the net work done by the gas.

If 2 m³ of gas at 2,000 Pa undergoes isobaric (constant pressure) compression to 1 m³, then is heated while held at that size such that its pressure is increased to 5,000 Pa, and then is allowed to undergo isobaric expansion to 3 m³, what is the net work done to the gas?

Solution

During the compression, the area under the curve is the rectangle represented by $P\Delta V = 2,000(2 - 1 \text{ m}^3) = 2,000$ J of work done **to** the gas. The heating at constant volume represents no work done as the area under the vertical line is zero. The final expansion represents work done **by** the gas of $P\Delta V = 5,000(3 - 1 \text{ m}^3) = 10,000$ J.

Net work done **to** the gas = +2,000 J – 10,000 J = –8,000 J.

In other words, the gas did +8,000 J of work to its surroundings.

Twenty cubic meters of an ideal gas is at 50°C and at a pressure of 50 kPa. If the temperature is raised to 200°C, and the volume is compressed by half, what is the new pressure of the gas?

Solution

We must first change all temperatures to kelvins:

$$50°C = 323 \text{ K} \quad \text{and} \quad 200°C = 473 \text{ K}$$

We now use the ideal gas law for two sets of conditions:

$$\frac{P_1 V_1}{T_1} = \frac{P_2 V_2}{T_2}$$

Substituting the appropriate values, we get

$$\frac{(50)(20)}{323} = \frac{(P_2)(10)}{473}$$

Solving for the pressure gives $P_2 = 146.4$ kPa.

THE FIRST LAW OF THERMODYNAMICS

If work is being done to an ideal gas at constant temperature, Boyle's law states that the work done is equal to the product of the pressure and the volume (this product remaining constant). A graph of Boyle's law, seen in Figure 17.4, is a hyperbola. Pressure and volume changes that include temperature changes and are adiabatic obey a different kind of inverse relationship, in which the volume is raised to a higher exponential power (making the hyperbola steeper).

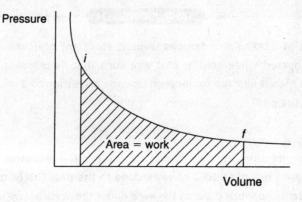

Figure 17.4

The pressure versus volume diagram for Boyle's law shows that the area enclosed by the curve from some initial state to a final state is equal to the work done.

The **first law of thermodynamics** is basically the law of conservation of energy. Let Q represent the change in heat energy supplied to a system, ΔU represent the change in internal molecular energy, and W represent the amount of net work done on the system. Then the first law of thermodynamics states that

$$\Delta U = Q + W$$

REMEMBER

Sign Conventions:

Q is "+" for thermal energy coming into gas and "–" for thermal energy leaving the gas

W is "+" for work done to the gas and "–" for work done by the gas to its surroundings

In thermodynamics, certain terms are often used and are worth defining:

Isothermal means "constant temperature."
Isobaric means "constant pressure."
Isochoric means "constant volume."
Adiabatic means "no gain or loss of heat to the system." (isolated)

An example of the application of each term is shown in Figure 17.5 in a pressure versus volume diagram.

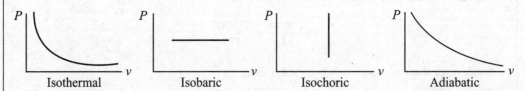

Figure 17.5

THE SECOND LAW OF THERMODYNAMICS AND HEAT ENGINES

No system is ideal. When a machine is manufactured and operated, heat is always lost because of friction. This friction creates heat that can be accounted for by the law of conservation of energy. Recall that heat flows from a hotter body to a cooler body. Thus, if there is a reservoir of heat at high temperature, the system will draw energy from that reservoir (hence its name). Only a certain amount of energy is needed to do work. The remainder is released

as exhaust at a lower temperature. This phenomenon was investigated by a French physicist named Sadi Carnot. Carnot was interested in the cyclic changes that take place in a heat engine, which converts thermal energy into mechanical energy.

In the nineteenth century, German physicist Rudolf Clausius coined the term *entropy* to describe an increase in the randomness or disorder of a system. These studies by Clausius and Carnot can be summarized as follows:

1. Heat never flows from a cooler to a hotter body of its own accord.
2. Heat can never be taken from a reservoir without something else happening in the system.
3. The entropy of any isolated system is always increasing.

These three statements embody the **second law of thermodynamics**: it is impossible to construct a cyclical machine that produces no other effect than to transfer heat continuously from one body to another at higher temperature.

Connected with the second law of thermodynamics is the concept of a reversible process. Heat flows spontaneously from hot to cold, and this action is irreversible unless acted upon by an outside agent. A system may be reversible if it passes from the initial to the final state by way of some intermediary equilibrium states. This reversible process, which can be represented on a pressure versus volume diagram, was studied extensively by Carnot.

A simple heat engine is shown in Figure 17.6.

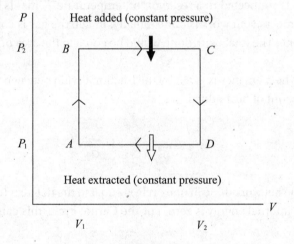

Figure 17.6

From point A to point B, pressure increases with no heat added or lost at constant volume. No work is done. From point B to point C, heat is absorbed from the outside as the gas expands at constant pressure. The work done is equal to $P_2(V_2 - V_1)$. From point C to point D, the volume is constant as the pressure decreases. No heat is added or lost and no work is done. Finally, from point D to point A, the volume decreases at constant pressure and heat is lost to the outside. The work done is equal to $P_1(V_1 - V_2)$.

In each isochoric change, $\Delta W = 0$ since there were no changes in volume. During isobaric changes,

$$\Delta W_2 = P_2(V_2 - V_1) \quad \text{and} \quad \Delta W_1 = P_1(V_1 - V_2)$$

The net work is equal to $(P_2 - P_1)(V_2 - V_1)$ and would be equal to the area of the rectangle in Figure 17.7.

The Carnot cycle is one in which adiabatic temperature changes occur as shown in Figure 17.7.

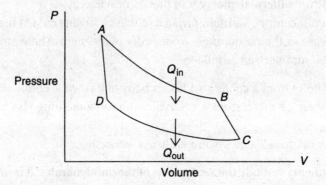

Figure 17.7

The isothermal changes occur from A to B and from C to D. The adiabatic changes are represented by segments BC and AD, in which no heat is gained or lost. Therefore, heat must be added in segment AB and released in CD. In other words, there is an isothermal expansion in AB at a temperature T_1. Heat is absorbed from the reservoir, and work is done. BC represents an adiabatic expansion in which an insulator has been placed in the container of the gas. The temperature falls, and work is done. In CD, we have an isothermal compression when the container is connected to a reservoir of temperature T_2 that is lower than T_1. Heat is released in this process, and work is done. Finally, in DA, the gas is compressed adiabatically and work is done. The total work done would be equal to the area of the figure enclosed by the graph.

The efficiency of heat engines is given by the fractional ratio between the total work done and the original amount of heat added:

$$\text{Efficiency} = \frac{W}{Q_1} = 1 - \frac{Q_2}{Q_1}$$

The reason is that the net work done in one cycle is equal to the net heat transferred $(Q_1 - Q_2)$, since the change in internal energy is zero. For the Carnot cycle, this can be rewritten as

$$\text{Efficiency} = 1 - \frac{T_2}{T_1}$$

where $T_1 > T_2$ and both temperatures are in kelvins.

A confined gas undergoes changes during a thermodynamic process as shown in the *P-V* diagram. Calculate the net energy added as heat during one cycle.

Solution

We can calculate the net energy by calculating the area *under* each segment of the graph. From $A \rightarrow B$, the work done *below* the diagonal segment is equal to 800 J. From $B \rightarrow C$, the area below the straight line segment is equal to 1,200 J. No work is done from $C \rightarrow A$ since we do not have a change in volume. Thus, the net energy is 800 J – 1,200 J = –400 J.

HEAT TRANSFER

Heat can be transferred by conduction, convection, or radiation.

Because metals contain a large number of free electrons, heat **conduction** is the main mode of heat transfer. If you have ever left a spoon in a cup of hot water for a long time, you have experienced heat conduction.

The rate of heat transfer ($\Delta Q/t$) through a solid slab of material (see Figure 17.8) depends on four quantities:

1. The temperature difference on either side of the slab (ΔT).
2. The thickness of the slab (L).
3. The frontal area of the slab (A).
4. The thermal conductivity (k) of the material. This is a number in units of watts per meter per degree Celsius (W/m · °C).

Figure 17.8

$$H = \frac{\Delta Q}{t} = \frac{kA\Delta T}{L}$$

Table 17.1 lists some typical thermal conductivities.

Heat can be transferred by **convection** in a gas or liquid as matter circulates throughout the system. For example, hot air is less dense and rises while cold air is more dense and sinks.

If the air above the ground is heated by the Sun, that air will rise and cool. This colder air will sink, and circulation will occur. A room can be heated by convection as hot air displaces cold air and circulates throughout the room. Convection currents can also be seen in water being heated. If a dye is placed into water that is being heated from below, the patterns formed will show the flow of convection.

If heat is transferred by means of electromagnetic waves (see Chapter 14), the process is known as **radiation**. Infrared waves from the Sun are a typical mechanism for heating the atmosphere. Radiation, like all waves, transfers energy only from place to place. Radiation does not require a material medium for propagation.

TABLE 17.1

Thermal Conductivities

Material	$k(\text{W/m} \cdot {}^\circ\text{C})$
Air	0.024
Aluminum	2.50
Brick	0.6
Brass	109
Concrete	0.8
Cork	0.04
Copper	385
Glass	0.8
Ice	1.6
Iron, steel	50
Silver	406

SUMMARY

- Pressure is defined as the force per unit area.
- One mole of an ideal gas occupies a volume of 22.4 liters and contains 6.02×10^{23} molecules (Avogadro's number) at STP.
- Boyle's law states that if a confined ideal gas is kept at constant temperature, then the product of the pressure and the volume remains constant (PV = constant).
- Charles's law states that if a confined ideal gas is kept at constant pressure, then there is a direct relationship between the volume and absolute temperature (V/T = constant).
- For an ideal gas, the relationship PV/T is equal to a constant.
- The first law of thermodynamics is essentially a restatement of the law of conservation of energy: $\Delta U = \Delta Q + \Delta W$.
- The second law of thermodynamics relates to an increase in entropy (randomness) in the universe and the fact that heat is always generated when work is done. It is therefore impossible to create an ideal machine without any losses due to heat.
- Ideal gases can be described using a statistical theory known as the kinetic theory of gases in which the molecules of a gas undergo elastic collisions and the temperature is a measure of the average kinetic energy of the molecules.
- Heat can be transferred by conduction, convection, or radiation.

Problem-Solving Strategies for Thermodynamics and the Kinetic Theory of Gases

It is important to remember that all temperatures must be converted to kelvins before doing any calculations. Also, since the units for the gas constant R and Boltzmann's constant k are in SI units, all masses or molecular masses must be in kilograms. For example, the molecular mass of nitrogen is usually given as 28 grams per mole. However, in an actual calculation, this must be converted to 0.028 kilogram per mole.

You also should remember that, unless a comparison relationship is used (such as Boyle's law or the preceding sample problem), all pressures must be in units of pascals (not kilopascals, atmospheres, or centimeters of mercury) and all volumes must be in cubic meters. However, in a comparison relationship, the chosen units are irrelevant (except for temperature, which is always in kelvins), and you can use atmospheres for pressure, or liters (1 liter = 1,000 cubic centimeters) for volume. The molar specific heat capacities depend on the number of moles, not the number of grams (the specific heat capacity).

PRACTICE EXERCISES

Multiple-Choice

1. At constant temperature, an ideal gas is at a pressure of 30 cm of mercury and a volume of 5 L. If the pressure is increased to 65 cm of mercury, the new volume will be

 (A) 10.8 L
 (B) 2.3 L
 (C) 0.43 L
 (D) 1.7 L

2. At constant volume, an ideal gas is heated from 75°C to 150°C. The original pressure was 1.5 atm. After heating, the pressure will be

 (A) doubled
 (B) halved
 (C) the same
 (D) less than doubled

3. At constant pressure, 6 m³ of an ideal gas at 75°C is cooled until its volume is halved. The new temperature of the gas will be

 (A) 174°C
 (B) 447°C
 (C) −99°C
 (D) 37.5°C

4. Water is used in an open-tube barometer. If the density of water is 1,000 kg/m³, what will be the level of the column of water at sea level?

 (A) 10.3 m
 (B) 12.5 m
 (C) 13.6 m
 (D) 11.2 m

5. As the temperature of an ideal gas increases, the average kinetic energy of its molecules

 (A) increases, then decreases
 (B) decreases
 (C) remains the same
 (D) increases

6. The product of pressure and volume is expressed in units of

 (A) pascals
 (B) kilograms per newton
 (C) watts
 (D) joules

7. Which of the following is equivalent to 1 Pa of gas pressure?

 (A) 1 kg/s^2
 (B) $1 \text{ kg} \cdot \text{m/s}$
 (C) $1 \text{ kg} \cdot \text{m}^2/\text{s}^2$
 (D) $1 \text{ kg/m} \cdot \text{s}^2$

8. What is the efficiency of a heat engine that performs 700 J of useful work from a reservoir of 2,700 J?

 (A) 74%
 (B) 26%
 (C) 35%
 (D) 65%

9. The first law of thermodynamics is a restatement of which law?

 (A) Conservation of charge
 (B) Conservation of energy
 (C) Conservation of entropy
 (D) Conservation of momentum

10. Which of the following graphs represents the relationship between pressure and volume for an ideal confined gas at constant temperature?

(A)

(B)

(C)

(D)

Free-Response

1. (a) How many molecules of helium are required to fill a balloon with a diameter of 50 cm at a temperature of 27°C?
 (b) What is the average kinetic energy of each molecule of helium?
 (c) What is the average velocity of each molecule of helium?

2. An engine absorbs 2,000 J of heat from a hot reservoir and expels 750 J to a cold reservoir during each operating cycle.
 (a) What is the efficiency of the engine?
 (b) How much work is done during each cycle?
 (c) What is the power output of the engine if each cycle lasts for 0.5 s?

3. A monatomic ideal gas undergoes a reversible process as shown in the pressure versus volume diagram below:

(a) If the temperature of the gas is 500 K at point A, how many moles of gas are present?
(b) For each cycle (AB, BC, and CA), determine the values of ΔW, ΔU, and ΔQ.

4. A glass window has dimensions of 1.2 m high, 1.0 m wide, and 5 mm thick. The outside temperature is 5°C, while the inside air temperature is 15°C.
(a) What is the conductive rate of heat transfer through the window?
(b) How much energy is transferred in one hour?

ANSWERS EXPLAINED
Multiple-Choice Problems

1. (**B**) At constant temperature, an ideal gas obeys Boyle's law. Since we are making a two-position comparison, we can use the given units for pressure and volume. Substituting the given values into Boyle's law, we obtain $(30)(5) = (65)(V_2)$, which implies that $V_2 = 2.3$ L.

2. (**D**) At constant volume, the changes in pressure are directly proportional to the changes in absolute Kelvin temperature. Therefore, even though the Celsius temperature is being doubled, the Kelvin temperature is not! Thus, the new pressure must be less than doubled.

 Alternatively, you can calcluate the new pressure since 75°C = 348 K and 150°C = 423 K. Thus $1.5/348 = P_2/423$, and $P_2 = 1.8$ atm (less than double). Again, since a comparison relationship is involved, we can keep the pressure in atmospheres for convenience.

3. (**C**) This is a Charles's law problem, and the temperatures must be in kelvins. Since 75°C = 348 K, we can write that $6/348 = 3/T_2$. However, the volume change is directly proportional to the Kelvin temperature change. Thus $T_2 = 174$ K = −99°C.

4. (**A**) The formula for pressure is $P = \rho g h$. The density of water is 1,000 kg/m³, and **g** = 9.8 m/s². We also know that at sea level $P = 101$ kPa, which must be converted to pascals or newtons per square meter. Thus $h = P/\rho \mathbf{g}$, and making the necessary substitutions gives $h = 10.3$ m (a very large barometer over 35 ft tall!).

5. **(D)** The absolute temperature of an ideal gas is directly proportional to the average kinetic energy of its molecules. Hence, the average kinetic energy increases with temperature.

6. **(D)** The units of the product PV are joules, the units of energy.

7. **(D)** One pascal is equivalent to 1 N/m$^2$, but 1 N is equal to 1 kg · m/s$^2$. Thus the final equivalency is $\dfrac{1\,\text{kg}}{\text{m}\cdot\text{s}^2}$.

8. **(B)** Efficiency = (700 J/2,700 J) × 100% = 26%.

9. **(B)** The first law of thermodynamics expresses the conservation of energy.

10. **(D)** Boyle's law relates pressure and volume in an ideal gas. This is an inverse relationship that looks like a hyperbola.

Free-Response Problems

1. (a) From the ideal gas formula, we know that $PV = NkT$, where N equals the number of molecules and k is Boltzmann's constant. For a 50-cm-diameter balloon, the radius will be 0.25 m. One atmosphere is equal to 101,000 Pa of pressure. The volume of a sphere is given by $V = (4/3)\pi R^3$, which equals 0.065 m$^3$ upon substitution.

 We know also that $N = PV/kT$, where T is equal to 300 K in this problem. Substituting all known values gives

 $$N = \frac{(101,000)(0.065)}{(1.38\times10^{-23})(300)} = 1.59\times10^{24} \text{ molecules}$$

 (b) The average kinetic energy of each molecule is equal to

 $$\overline{\text{KE}} = \frac{3}{2}kT = (1.5)(1.38\times10^{-23})(300) = 6.21\times10^{-21} \text{ J}$$

 (c) The average velocity of each molecule is given by

 $$v_{\text{rms}} = \sqrt{\frac{3RT}{m}} = \sqrt{\frac{(3)(8.31)(300)}{0.004}} = 1,367 \text{ m/s}$$

2. (a) The efficiency of the heat engine is given by the formula

 $$e = \frac{\Delta Q}{Q_{\text{hot}}} = \frac{2,000-750}{2,000} = 0.625 \text{ or } 62.5\%$$

 (b) The work done during each cycle is equal to

 $$\Delta Q = 2,000 - 750 = 1,250 \text{ J}$$

 (c) The power output each cycle equals the work done divided by the time:

 $$P = \frac{1,250}{0.5} = 2,500 \text{ W}$$

3. (a) Since we know the pressure, volume, and absolute temperature of the ideal (monatomic) gas at point A, we can use the ideal gas law, $PV = nRT$, to find the number of moles, n.

First, however, we must be in standard units: 7 atm = 707,000 Pa, and since 1 L = 0.001 m³, then 10 L = 0.01 m³. Thus:

$$n = \frac{(707,000)(0.01)}{(8.31)(500)} = 1.7 \text{ mol of gas}$$

(b) i. The cycle AB is isochoric, and so

$$\Delta W = 0$$

Thus, $\Delta U = \Delta Q$. Now, as the pressure decreases from 7 atm to 3 atm, the absolute temperature decreases proportionally. Thus we can write

$$\frac{7}{500} = \frac{3}{T_B}$$

which implies that the absolute temperature at point B is equal to 214.29 K. To find the change in the internal energy, we recall that

$$\Delta U = \frac{3}{2}nR\,\Delta T = (1.5)(1.7)(8.31)(-285.7)$$
$$= -6,054 \text{ J} = \Delta Q \text{ also!}$$

ii. The cycle BC is isobaric, and the decrease in volume from 10 L to 2 L is accompanied by a corresponding decrease in absolute temperature. We know from step (i) that the temperature at B is 214.29 K, so we can use Charles's law to find the temperature at point C. Also, the work done is negative since we are expelling energy to reduce pressure and volume. We can therefore write

$$\frac{10}{214.29} = \frac{2}{T_C}$$

which implies that the absolute temperature at point C is equal to 42.86 K. Therefore $\Delta T = -171.43$ K.

Now, in this process, work is done to compress the gas, and $W = P(V_C - V_B)$. The pressure is constant at $P = 3$ atm = 303,000 Pa, and $\Delta V = -8$ L = -0.008 m³.

Thus

$$\Delta W = (303,000)(-0.008) = -2,424 \text{ J}$$

To find ΔU, we note that the temperature change of the 1.7 moles was -171.43 K, and so

$$\Delta U = (1.5)(1.7)(8.31)(-171.43) = -363.69 \text{ J}$$

To find ΔQ, we use the first law of thermodynamics:

$$\Delta Q = \Delta U + \Delta W = -3,632.69 - 2,424 = -6,057 \text{ J}$$

iii. The last part of the reversible cycle puts back all the work and energy, a total of 12,111 J of heat (the sum of ΔQ in steps i and ii), that was removed in the first two steps. Thus, for CA,

$$\Delta Q = +12{,}111 \text{ J}$$

In a similar way, the total change in internal energy equaled $-9{,}686.69$ J. Thus, in cycle CA,

$$\Delta U = +9{,}686.69 \text{ J}$$

Finally,

$$\Delta W = \Delta Q - \Delta U = 12{,}111 - 9{,}686.69 = 2{,}424.31 \text{ J}$$

Notice that, since no work was done in step i, this is approximately equal to the work done in step ii!

4. (a) The formula for conductive heat transfer is $H = \dfrac{kA\Delta T}{L}$. First we need to change the glass thickness to meters

$$5 \text{ mm} = 0.005 \text{ m}$$

From Table 17.1, we see that the thermal conductivity of glass is

$$k = 0.8 \text{ W/m} \cdot \text{°C}$$

The area of the glass window is simply

$$A = (1.2 \text{ m})(1.0 \text{ m}) = 1.2 \text{ m}^2$$

By substituting in all the values and noting that $\Delta T = 10\text{°C}$, we get

$$H = \frac{(0.8\,W/m \cdot °C)(1.2\,m^2)(10°C)}{(0.005\,m)}$$
$$= 1{,}920\,W$$

(b) Since energy = power × time, the energy transferred in 1 hour (3,600 s) is

$$E = (1{,}920 \text{ J/s})(3{,}600 \text{ s}) = 6.912 \times 10^6 \text{ J}.$$

Twentieth-Century Physics | 18

KEY CONCEPTS

(THIS CHAPTER IS FOR AP PHYSICS 2 ONLY)
→ PHOTOELECTRIC EFFECT
→ COMPTON EFFECT AND PHOTON MOMENTUM
→ MATTER WAVES
→ SPECTRAL LINES
→ SPECIAL RELATIVITY
→ MASS-ENERGY EQVIVALENCE
→ ATOMIC STRUCTURE AND RUTHERFORD'S MODEL
→ THE BOHR MODEL
→ QUANTUM MECHANICS AND THE ELECTRON CLOUD MODEL
→ NUCLEAR STRUCTURE AND STABILITY
→ BINDING ENERGY
→ RADIOACTIVE DECAY
→ FISSION
→ FUSION

PHOTOELECTRIC EFFECT

Light has a very interesting effect on certain metals. Experimentally, it was observed that ultraviolet light could cause some metals to spark. Obviously, the light was causing electrons to be emitted from the metal. However, the basic mechanism was not understood. As we shall see, wave ideas about amplitude and frequency did not seem to make sense when applied to this experiment. Most troubling was the fact that raising the intensity of light (increasing the amplitude of the wave) could not cause electrons to be emitted if the frequency was too low. This phenomenon, called the **photoelectric effect**, defines a new view of light that has come to be known as the **quantum theory**. Developed by Albert Einstein, the quantum theory has been extended to particles as well as electromagnetic waves and forms the basis of modern physics.

The photoelectric effect can be studied in a more quantitative way. Figure 18.1 shows an evacuated tube that contains a photoemissive material. Many metals exhibit the photoelectric effect. On the other side of the tube is a collecting plate. The tube is connected to a microammeter, which can be used to measure the current generated by the emitted electrons. When exposed to light of suitable frequency, the ammeter will implicitly measure the number of electrons emitted per second. This number is sensitive only to the intensity of the electromagnetic wave applied. The minimum frequency that emits electrons is called the **threshold frequency** and is designated as f_0.

Figure 18.1

To measure the energy of the emitted electrons, we insert in the circuit a source of potential difference (Figure 18.2) such that the negative electrons approach a negatively charged side. This will create a braking force; and if we select the voltage properly, we can stop the current completely. The voltage that performs this feat is called the **stopping voltage** or **stopping potential** and is designated as V_0.

The energy of the electrons stopped by this voltage is equal to the product of the electrons' charge and the stopping voltage, eV_0. Since the stopping voltage is independent of the intensity of the light used (a violation of the wave theory of light), the stopping voltage measures the maximum kinetic energy of the emitted electrons.

Figure 18.2

As the frequency of light is slowly increased, there is a change in the maximum kinetic energy of the electrons. The fact that this energy is independent of the intensity of the light was used by Einstein to demonstrate that light consists of discrete or **quantized** packets of energy called **photons**. The energy of a given photon is directly proportional to its frequency.

To clarify this relationship, Figure 18.3 illustrates a typical graph of maximum kinetic energy versus frequency.

Figure 18.3

Starting with the threshold frequency, the graph is a straight line. For any frequency point, f, the slope of the line is given by

$$\text{Slope} = \frac{\text{KE}_{max}}{f - f_0} = h$$

This slope, referred to as **Planck's constant** and symbolized as h, has a value of

$$h = 6.63 \times 10^{-34} \text{ J/Hz} = 6.63 \times 10^{-34} \text{ J} \cdot \text{s}$$

Planck's constant originally appeared in the theoretical work of German physicist Max Planck. His mathematical discovery in 1900 of an elementary quantum of action helped explain the nature of radiation emitted from hot bodies. Planck's constant became a part of Einstein's quantum theory of light and Bohr's quantum theory of the hydrogen atom.

The above equation can be solved for the maximum kinetic energy:

$$\text{KE}_{max} = hf - hf_0$$

In this expression, known as the **photoelectric equation**, hf represents the energy of the original photon, while hf_0, called the **work function**, is a property of the metal. The quantity hf_0 is a measure of the minimum amount of energy needed to free an electron. It is designated in some textbooks by the Greek letter phi (ϕ) and in others by W_0. In this book, we use the latter designation for the work function.

Experiments with various metals yield some interesting results. Even though the different metals all have different threshold frequencies and, therefore, different work functions, they all obey the same photoelectric equation and have the same slope, h. A typical comparison graph of three metals, A, B, and C, is shown in Figure 18.4.

Figure 18.4

Einstein was awarded the Nobel Prize for Physics in 1921 for his explanation of the photoelectric effect. His suggestion of the photoelectric effect, whereby light behaves as packets of quantized energy (photons), was in direct conflict with the prevailing wave theory of light, as demonstrated by interference and diffraction. Thus, physicists in the early twentieth century were presented with **a dual nature of light**. Generally speaking, the coexistence of particle and wave descriptions for fundamental particles is known as **wave-particle duality**.

SAMPLE PROBLEM

Light with a frequency of 2×10^{15} Hz is incident on a piece of copper.

(a) What is the energy of the light in joules and in electron-volts?

(b) If the work function for copper is 4.5 eV, what is the maximum kinetic energy, in electron volts, of the emitted electrons?

Solution

(a) The energy in joules is given by $E = hf$. Thus,

$$E = hf = (6.63 \times 10^{-34})(2 \times 10^{15}) = 1.326 \times 10^{-18} \text{ J}$$

Since 1 eV = 1.6×10^{-19} J, we have

$$E = 8.28 \text{ eV}$$

(b) To find the maximum kinetic energy, we simply subtract the work function from the photon energy:

$$KE_{max} = 8.28 - 4.5 = 3.79 \text{ eV}$$

COMPTON EFFECT AND PHOTON MOMENTUM

In the early 1920s, American physicist Arthur Compton conducted experiments with X rays and graphite. He was able to demonstrate that, when an X-ray photon collides with an electron, the collision obeys the law of conservation of momentum. The scattering of photons due to this momentum interaction is known as the **Compton effect** (Figure 18.5). In the Compton effect, the scattered photon has a lower frequency than the incident photon.

Figure 18.5

The momentum of the photon is given by the relationship $\mathbf{p} = h/\lambda$. Thus X rays, because of their very high frequency, possess a large photon momentum. Even though we state that photons can have momentum, they do not possess what is called rest mass. If light can have

momentum as well as wavelength, the question now raised is, can particles have wavelength as well as momentum?

MATTER WAVES

If a beam of X rays is incident on a crystal of salt, the pattern that emerges is characteristic of the scattering of particles, not waves. If, however, a beam of electrons is incident on a narrow slit (Figure 18.6), the pattern that emerges is a typical wave diffraction pattern. Electron diffraction is one example of the dual nature of matter, which, under certain conditions, exhibits a wave nature. The circumstances are determined by experiment. If you perform an interference experiment with light, you will demonstrate its wave properties. If you do a photoelectric effect experiment, light will reveal its "particle-like" properties.

In the 1920s, French physicist Louis de Broglie used the dual nature of light to suggest that matter can have a "wavelike" nature, as indicated by its de Broglie wavelength. Since a photon's momentum is given by $\mathbf{p} = h/\lambda$, the wavelength can be transposed to give $\lambda = h/\mathbf{p}$.

Figure 18.6

Louis de Broglie suggested that, if the momentum of a particle, $\mathbf{p} = mv$, has a magnitude suitable to overcome the small magnitude of Planck's constant, a significant wavelength can be observed. The criterion, since mass is in the denominator of the expression for wavelength, is that the mass be extremely small (on the atomic scale). Thus, while electrons, protons, and neutrons might have wave characteristics, a falling stone, because of its large mass, would not exhibit any wavelike effects. The equation for the de Broglie wavelength of a particle is given by

$$\lambda = \frac{h}{mv}$$

Find the de Broglie wavelength for each of the following:

(a) A 10-g stone moving with a velocity of 20 m/s.

(b) An electron moving with a velocity of 1×10^7 m/s.

Solution

(a) Since $m = 10$ g $= 0.01$ kg, and $\lambda = h/mv$, we have

$$\lambda = \frac{6.63 \times 10^{-34}}{(0.01)(20)} = 3.315 \times 10^{-33} \text{ m}$$

(b) In this part we have

$$\lambda = \frac{h}{mv} = \frac{6.63 \times 10^{-34}}{(9.1 \times 10^{-31})(1 \times 10^{-7})} = 7.3 \times 10^{-11} \text{ m}$$

This aspect of particle motion, on a small scale, leads to the so-called **Heisenberg uncertainty principle**. Developed by Werner Heisenberg, also in the 1920s, this states that because of the wave nature of small particles (on an atomic scale) it is impossible to determine precisely both the simultaneous position and momentum of the particle. Any experimental attempt to observe the particle, the simple action of observing, will cause an inherent uncertainty since those photons will interact with the particles. Mathematically, the Heisenberg uncertainty principle states that

$$\Delta x \Delta p \geq \frac{h}{4\pi}$$

where h is Planck's constant.

SPECTRAL LINES

A hot source that emits white light is said to be **incandescent**. Its light, when analyzed with a prism, is broken up into a continuous spectrum of colors. (A **spectroscope** is a device that uses either a prism or a grating to create a spectrum.) If a colored filter is used over the incandescent source, light of only that one color will be emitted, and the spectrum will appear as a continuous band of that color.

If hydrogen gas contained at low pressure in a tube is electrically sparked, the gas will emit a bluish light. If that light is analyzed with a spectroscope, a discrete series of colored lines ranging from red to violet, rather than a continuous band of color, is revealed. When sparked, other chemical elements also show characteristic **emission line spectra** that are useful for chemical analysis. These spectra provided the evidence for Bohr to quantize the energy levels of electrons.

Figure 18.7 illustrates a typical hydrogen spectral series in the visible range of the electromagnetic spectrum. This series is often called the **Balmer series** in honor of Jakob Balmer, a Swiss mathematician who empirically studied the hydrogen spectrum in the late nineteenth century. In Figure 18.7, a hydrogen tube is excited and its light is passed through a narrow slit to provide a point source. This light is then passed through a prism or grating. Many emission lines are produced, but only the first four, designated as Hα (red), Hβ, Hλ, and Hδ (violet), are illustrated here. The wavelengths range from about 656 to about 400 nanometers.

Figure 18.7

SPECIAL RELATIVITY

In 1905, Einstein published several papers, one of which is now seen as answering the puzzling experimental observation that the speed of light is the same to all observers. Unlike any other relative velocity problem, light's speed does not change when you change reference frames. No matter the various speeds of different observers, they will each measure the exact same speed for any electromagnetic wave in a vacuum, 3×10^8 m/s (*c*). Rather than begin with the experimental evidence (most of which came after his paper), Einstein began with the theories of electricity and magnetism. When combined, these yield a speed for electromagnetic radiation of 3×10^8 m/s *independent of the speed of the source of the radiation.*

Instead of trying to tinker with the theories governing electricity and magnetism (which were, by that time, pretty well verified), Einstein took the universality of the speed of light as a fundamental property of space itself. He explained that all fields (or, more generally, any object with zero rest mass) propagate through space at this speed. In other words, what we call the speed of light is not just some property of light. It is the speed limit of the universe itself. To address the issue of how different observers could possibly measure the same speed when the observers have different velocities relative to each other, Einstein forces us to look at what it means to take measurements of both distance and time (obviously required when measuring speed). By careful analysis of the fact that two measurements need to be made (ending and starting points of the intervals in space or the intervals in time), he demonstrated that the idea of simultaneity is relative. Two events that may appear simultaneous to one observer will not appear so to another observer as the information about the two events must propagate at the finite speed of light.

This lack of simultaneity on the part of two independent observers led Einstein to conclude that different observers will not agree about intervals of space and time either. As people more commonly say, the two observers will not agree with each other's metersticks and stopwatches. Someone traveling at a different speed from you will appear to have shorter metersticks and slower clocks. If the difference in distance measured by each observer is divided by the difference in time measured by each observer, the values will cancel out. As a result, each observer will come up with the same number of meters traveled per second for electromagnetic radiation. This occurs because the speed of light is finite.

The equation for length contraction and time dilation both depend on the gamma factor, where v is the relative velocity between two observers:

$$\gamma^2 = 1/(1 - v^2/c^2)$$
$$\Delta T_{moving} = \gamma \Delta T_{rest}$$
$$\Delta D_{moving} = \Delta D_{rest}/\gamma$$

As surprising as Einstein's propositions are, they have been experimentally verified many times over. They are used every day by physicists who deal with high-velocity objects.

MASS-ENERGY EQUIVALENCE

In 1905 in a follow-up paper to his special theory of relativity published earlier that year, Einstein proposed that mass and energy are different manifestations of the same thing. In other words, neither mass nor energy is conserved by itself. Rather, it is the combination of the two. Mass can be changed into energy and vice versa via his famous relationship:

$$E = mc^2$$

where c is the speed of light. The speed of light is such a large number that everyday transfers of energy do not result in any meaningful change in mass. (However, a cooling coffee mug is indeed losing mass as it radiates away energy!) In low-mass, high-energy situations, the changes in mass due to energy loss or gain become impossible to ignore. For example, in nuclear fusion and fission, the total number of nucleons is the same before and after yet the total mass of the product nuclei are lower after energy has been released and are higher after energy has been absorbed. In fact, most of the mass of compound objects like atoms, molecules, and people comes from the bending energies within the nuclei of atoms. The individual quarks and electrons by themselves provide a very minor contribution to the total mass of everyday objects.

SAMPLE PROBLEM

A hot cup of coffee loses 50 joules of energy as it cools down. By how much has its mass decreased?

Solution

$$m = E/c^2 = 50 \text{ J}/(3 \times 10^8 \text{ m/s})^2 = 5.6 \times 10^{-14} \text{ kg}$$

It is not likely you will notice this loss when you lift the cup!

An electron meets a positron (the antiparticle of an electron, a positively charged electron), and they annihilate each other. How much energy is released?

Solution

$$E = mc^2 = (M_{electron} + M_{positron})c^2 = (2 \times 9.11 \times 10^{-31})(3 \times 10^8 \text{ m/s})^2 = 1.6 \times 10^{-13} \text{ J}$$

This value is over 1,000 times greater than the binding energy of electron in hydrogen atoms!

ATOMIC STRUCTURE AND RUTHERFORD'S MODEL

In 1896, French physicist Henri Becquerel was studying the phosphorescent properties of uranium ores. Certain rocks glow after being exposed to sunlight, and many physicists at that time were examining the light emanations from these ores.

One day, while engaged in such a study, Becquerel placed a piece of uranium ore in a drawer on top of some sealed photographic paper. Several days later, he found to his surprise that the paper had been exposed even though no light was incident on it! His conclusion was that radiation emitted by the uranium had penetrated the sealed envelope and exposed the paper.

Subsequent work by Marie and Pierre Curie revealed that this natural radioactivity, as they called it, came from the uranium itself and was a consequence of its instability as an atom. Also, Ernest Rutherford discovered (see Figure 18.8) that the radiation emitted yielded particles that were useful for further atomic studies.

Figure 18.8

When passed through a magnetic field, the emitted radiation split into three separate parts, called **alpha rays**, **beta rays**, and **gamma rays**. Analysis of their trajectories led to the conclusions that alpha particles, later identified as helium nuclei, are positively charged; beta particles, later identified as electrons, are negatively charged; and gamma rays, later identified to be photons, are electrically neutral.

J. J. Thomson, using the data available at the end of the nineteenth century, devised an early model of the atom based on the fact that all atoms are electrically neutral. After concluding that the atom is neutral overall and yet has electrons also associated with it, Thomson's model proposed that the atom consisted of a relatively large, uniformly

distributed, positive mass with negatively charged electrons embedded in it like raisins in a pudding (see Figure 18.9).

Figure 18.9 Thomson's Model of the Atom

In 1911, Rutherford and his co-workers decided to test Thomson's model using alpha-particle scattering. In the Thomson model, the positive charge was uniformly distributed. Since the negative electrons were embedded throughout the atom as well, the Coulomb force of attraction would weaken the deflecting force on a passing positively charged alpha particle.

Rutherford's procedure was to aim alpha particles at a thin metal foil (he used gold) and observe the scattering pattern on a zinc sulfide screen (Figure 18.10).

Figure 18.10

When the results were analyzed, Rutherford found that most of the alpha particles were not deflected. A few, however, were strongly deflected in hyperbolic paths because of the Coulomb force of repulsion. Since these forces were strong, Thomson's model was incorrect. Some alpha particles were scattered back close to 180 degrees (Figure 18.11).

Figure 18.11 Alpha Particle Scattering Trajectories

Rutherford's conclusion was that the atom consisted mostly of empty space and that the nucleus was a very small, densely packed, positive charge. The electrons, he proposed, orbited around the nucleus like planets orbiting the Sun.

Rutherford's model, however, had several major problems, including the fact that it could not account for the appearance of discrete emission line spectra. In Rutherford's model the electrons continuously orbited around the nucleus. This circular, "accelerated" motion should produce a continuous band of electromagnetic radiation, but it did not. Additionally, the predicted orbital loss of energy would cause an atom to disintegrate in a very short time and thus break apart all matter. This phenomenon, too, did not occur.

THE BOHR MODEL

Niels Bohr, a Danish physicist, decided in 1913 to study the hydrogen spectral lines again. Years earlier, Einstein had proposed a quantum theory of light, developing the concept of a photon and completely explaining the photoelectric effect.

Bohr observed that the Balmer formula for the hydrogen spectrum could be viewed in terms of energy differences. He then realized that these energy differences involved a new set of postulates about atomic structure. The main ideas of his theory are these:

1. Electrons do not emit electromagnetic radiation while in a given orbit (energy state).
2. Electrons cannot remain in any arbitrary energy state. They can remain only in discrete or quantized energy states.
3. Electrons emit electromagnetic energy when they make transitions from higher energy states to lower energy states. The lowest energy state is the **ground state**.

According to the Bohr theory, the energy of a photon is equal to the energy difference between two energy states (Figure 18.12).

Figure 18.12 Energy Level Diagram for Hydrogen

The different spectral series arise from transitions from higher energy states to specified lower energy states. The ultraviolet Lyman series occurs when electrons fall to level 1; the visible Balmer series, when electrons fall to level 2; the infrared Paschen series, when electrons fall to level 3. Thus, we can write that the energy, in joules, for an emitted photon is given by

$$f = \frac{E_{initial} - E_{final}}{h}$$

The energy level diagram for hydrogen is shown in Figure 18.12. The energy in a given state represents the amount of energy, called the **ionization energy**, needed to free an electron from the atom. A charged atom is termed an **ion**. Electron ionization energies were confirmed by experiments in 1914.

We designate the levels mathematically as negative so that the ionization level will have a value of zero; the energies carried away by emitted photons are always positive. Even though hydrogen has only one electron, the many atoms of hydrogen in a sample of this gas, coupled with the different probabilities of electrons being in any one particular state, produce the multiple lines that appear in the visible spectrum when the gas is "excited."

SAMPLE PROBLEM

What is the wavelength of a photon emitted when an electron makes a transition in a hydrogen atom from level 5 to level 3?

Solution

From level 5 to level 3 involves an energy difference of

$$E = (-0.54 \text{ eV}) - (-1.50 \text{ eV}) = 0.96 \text{ eV} = 1.536 \times 10^{-19} \text{ J}$$

Now, the frequency of the photon will be equal to

$$f = \frac{1.536 \times 10^{-19}}{6.63 \times 10^{-34}} = 2.3 \times 10^{14} \text{ Hz}$$

The wavelength of this photon is given by

$$\lambda = \frac{c}{f} = \frac{3 \times 10^{8}}{2.3 \times 10^{14}} = 1.3 \times 10^{-6} \text{ m}$$

(which is in the infrared part of the electromagnetic spectrum).

It is important to remember that an electron will make a transition from a lower to a higher energy state only when it absorbs a photon equal to a given possible ("allowed") energy difference. This is the nature of the quantization of the atom; the electron can exist only in a specified energy state. To change states, the electron must either absorb or emit a photon whose energy is proportional to Planck's constant and equal to the energy difference between two energy states.

The Heisenberg uncertainty principle, discussed in the section "matter waves" earlier in this chapter, introduces the element of "probability" in describing the nature of electron orbits and energy states. This subject is studied in the science of **quantum mechanics**, developed by Erwin Schrödinger and Werner Heisenberg.

QUANTUM MECHANICS AND THE ELECTRON CLOUD MODEL

The success of the Bohr model was limited to the hydrogen atom and certain hydrogen-like atoms (atoms with one electron in the outermost shell; single-ionized helium is an example). The wave nature of matter led to a problem in predicting the behavior of an electron in a strict Bohr energy state.

In 1926, physicist Erwin Schrödinger developed a new mechanics of the atom, then called **wave mechanics**, but later termed **quantum mechanics**. In the wave mechanics of

Schrödinger, the position of an electron was determined by a mathematical function called the **wave function**. This wave function was related to the probability of finding an electron in any one energy state. A **wave equation**, called the **Schrödinger equation**, was derived using ideas about time-dependent motion in classical mechanics.

The energy states of Bohr were now replaced by a probability "cloud." In this **cloud model** the electrons are not necessarily limited to specified orbits. A cloud of uncertainty is produced, with the densest regions corresponding to the highest probability of an electron being in a given state.

The use of probability to explain the structure of the atom led to intense debates between the proponents of the new quantum mechanics and one of its fiercest opponents, Albert Einstein. Einstein, who had helped to develop the quantum theory of light 20 years earlier, was not convinced that the universe could be determined by probability. To paraphrase, Einstein said he could not believe that God would play dice with the Universe. "God is subtle," he said, "but not malicious."

At about the same time that Schrödinger introduced his wave mechanics, Werner Heisenberg developed his **matrix mechanics** for the atom. Instead of using a wave analogy, Heisenberg developed a purely abstract, mathematical theory using matrices. Working with Heisenberg, Wolfgang Pauli advanced the so-called **Pauli exclusion principle**, which states that two electrons having the same spin orientations cannot occupy the same quantum state at the same time.

The new **quantum mechanics** was born when the two rival theories were shown to be equivalent. Electron spin was experimentally verified, and the theory proved to be more successful than the older Bohr theory in explaining atomic and molecular structures and leading to new ideas about solid-state physics and the subsequent development of lasers.

NUCLEAR STRUCTURE AND STABILITY

Experiments on nuclear masses using a **mass spectrograph**, which deflects the positively charged nuclei into curved paths with different radii, confirmed that the estimate of nuclear mass was too low. The nucleus could not, therefore, be made entirely of positively charged protons.

Physicists theorized that another electrically neutral particle, called the **neutron**, must be present since (a) all of the charge on the nucleus could be accounted for by the presence of the protons, (b) more neutral mass was needed, and (c) a method for countering the repulsive Coulomb forces created by the protons was required.

Thus, the question of nuclear stability depended on the particular structure of the nucleus. The work on radioactive decay by Rutherford and Marie and Pierre Curie confirmed that the radioactive disintegration of an atom is a nuclear phenomenon and is tied to stability as well.

The basic structure of the atom, using a Bohr-Rutherford planetary model, consists of a nucleus with a certain number of protons and neutrons (together called **nucleons**). The number of protons characterizes an element since no two elements have the same number of protons. This **atomic number**, Z, also measures the relative charge on the nucleus. The **mass number**, A, is a measure of the total number of nucleons (protons plus neutrons) in the nucleus. Both of these numbers are whole numbers. However, the actual nuclear mass is not a whole number since it is an average of many atoms of the same element.

Since an atom is electrically neutral, the initial numbers of protons and electrons are the same. Schematically, an atom is designated by a capital letter, possibly followed by one

lowercase letter, indicating the element it represents, with the two nuclear numbers A and Z written as a superscript and a subscript, respectively, on the left-hand side. For an unknown element X we write $_{Z}^{A}X$. The designation $_{1}^{1}H$ represents the element hydrogen, with one nucleon (a proton) and an atomic number of 1. Some elements have **isotopes**, that is, nuclei with the same number of protons but different numbers of neutrons. For example, the element helium is designated as $_{2}^{4}He$, where the 4 indicates 2 protons and 2 neutrons. An isotope of this atom is helium-3, designated as $_{3}^{2}He$. Some nuclear structures are illustrated in Figure 18.13.

Figure 18.13 Nuclear Structures

A neutron is slightly more massive than a proton. This represents the fact that a neutron has more energy contained within it than does a proton. A proton mass is approximately equal to

$$m_{p} = 1.673 \times 10^{-27} \text{ kg}$$

and a neutron mass to

$$m_{n} = 1.675 \times 10^{-27} \text{ kg}$$

Nuclear masses are usually expressed in **atomic mass units** (u). One atomic mass unit is defined to be equal to one-twelfth the mass of a carbon-12 isotope:

$$1 \text{ u} = 1.66 \times 10^{-27} \text{ kg}$$

On this scale, the proton's mass is given as 1.0078 atomic mass units, and the neutron's mass is given as 1.0087 atomic mass units.

If one looks at all stable isotopes of known nuclei (see Figure 18.14), something qualitatively interesting emerges. Experiments show that lighter nuclei have about the same number of protons as neutrons. However, heavier stable nuclei have more neutrons than protons. This suggests that the neutrons must somehow help overcome the repulsive forces in a tightly packed positive nucleus. Also, this **strong nuclear force** must operate within the short distances in an atomic nucleus. Unstable, radioactive nuclei lie off this stability curve (see Figure 18.13). As they decay, the alpha, beta, and other particle emissions **transmute** the original nucleus into a more stable one.

REMEMBER

Electric forces repel all protons away from each other, tearing apart the nucleus. Both protons and neutrons are bound by the strong nuclear force, holding the nucleus together. This balancing act of forces gives us both stable and unstable nuclei.

Figure 18.14 Proton-Neutron Plot

BINDING ENERGY

If we were to determine the total mass of a particular isotope, say $^4_2$He, based on the number of nucleons, we would arrive at a nucleus that was more massive than in reality. For example, the helium-4 nucleus contains two protons (each with a mass of 1.0078 u) and two neutrons (each with a mass of 1.0087 u). The total predicted mass would be 4.0330 u. Experimentally, however, the mass of the helium-4 nucleus is found to be 4.0026 u. The difference of 0.0304 u, called the **mass defect**, is proportional to the **binding energy** of the nucleus ($E = mc^2$).

Using Einstein's special theory of relativity, we know that mass can be converted to energy. The energy equivalent of 1 atomic mass unit is equal to 931.5 million electron volts (MeV). The binding energy of any nucleus is therefore determined by using the relationship

$$\text{BE (MeV)} = \text{Mass defect} \times 931.5 \text{ MeV/u}$$

In our example, the binding energy of the helium-4 nucleus is

$$\text{BE} = 0.0304 \times 931.5 = 28.3 \text{ MeV}$$

It is useful to think about the average binding energy per nucleon, which is equal to BE/A, where A = the mass number of the element. Thus, for helium-4, where $A = 4$,

$$\text{Avg BE} = \frac{28.3}{4} = 7.08 \text{ MeV per nucleon}$$

In Figure 18.15, a graph of average binding energy per nucleon is plotted against atomic number Z. The graph shows that a maximum point is reached at about $Z = 26$ (iron). The greater the average binding energy, the greater the stability of the nucleus. Thus, since hydrogen isotopes have less stability than helium isotopes, the **fusion** of hydrogen into helium increases the stability of the nucleus through the release of energy. Likewise, the unstable uranium isotopes yield more stable nuclei if they are split (**fission**) into lighter nuclei (also releasing energy).

Figure 18.15

RADIOACTIVE DECAY

Radioactivity was discovered in 1895 by Henri Becquerel, and the relationship between radio-activity and nuclear stability was studied by Pierre and Marie Curie. Ernest Rutherford pioneered the experiments of nuclear bombardment and introduced the word **transmutation** into the nuclear physics vocabulary. The discovery of alpha- and beta-particle emission from nuclei led to the use of these particles to probe the structure of the nucleus in the first decades of the twentieth century. Subsequent research showed the existence of positively charged electrons called **positrons**, and even negatively charged protons!

The question of how these particles could originate from a nucleus was answered using Einstein's theory of mass-energy equivalence ($E = mc^2$). Schematically, we have the following designations for some of these particles:

Proton (hydrogen nucleus): $_1^1\text{H}$

Neutron: $_0^1\text{n}$

Alpha particle (helium nucleus): $_2^4\text{He}$

Positron (positive electron): $_1^0\text{e}$

Beta particle (electron): $_{-1}^0\text{e}$

Photon: $_0^0\gamma$

Figure 18.16

When $^{238}_{92}U$, an isotope of uranium, decays, it emits an alpha particle according to the following equation:

$$^{238}_{92}U \rightarrow {}^{234}_{90}Th + {}^{4}_{2}He$$

When, in turn, the radioactive thorium isotope decays, it emits a beta particle (see Figure 18.16).

$$^{234}_{90}Th \rightarrow {}^{234}_{91}Pa + {}^{0}_{-1}e$$

In the first example, both the atomic number and the mass number changed as the uranium transmuted into thorium. In the decay of the thorium nucleus, however, only the atomic number changed. The reason is that in beta decay a neutron in the nucleus is converted into a proton, an electron, energy, and a particle called an **antineutrino**.

In addition to alpha and beta decay, there are several other scenarios for nuclear disintegration. In **electron capture**, an isotope of copper captures an electron into its nucleus and transmutes into an isotope of nickel:

$$^{64}_{29}Cu + {}^{0}_{-1}e \rightarrow {}^{64}_{28}Ni$$

In **positron emission**, the same isotope of copper decays by emitting a positron and transmutes into the same isotope of nickel:

$$^{64}_{29}Cu \rightarrow {}^{0}_{-1}e + {}^{64}_{28}Ni$$

Note that total charge and mass number are conserved in these reactions.

FISSION

Nuclear fission was discovered in 1939 by German physicists Otto Hahn and Fritz Strassman. When $^{235}_{92}U$, an isotope of uranium, absorbs a slow-moving neutron, the resulting instability will split the nucleus into two smaller (but still radioactive) nuclei and release a large amount of energy. The curve in Figure 18.15 shows that the binding energy per nucleon for uranium is lower than the values for other, lighter nuclei. One possible uranium fission reaction could occur as follows:

$$^{235}_{92}U + ^1_0n \rightarrow ^{140}_{54}Xe + ^{94}_{38}Sr + 2\,^1_0n + 200\,MeV$$

In controlled fission reactions, water or graphite is used as a **moderator** to slow the neutrons since they cannot be slowed by electromagnetic processes. The production of two additional neutrons means that a chain reaction is possible. In a fission reactor, cadmium control rods adjust the reaction rates to desirable levels. See Figure 18.17.

Figure 18.17

In the production of plutonium as a fissionable material, another isotope of uranium, $^{238}_{92}U$, is used. First, the uranium absorbs a neutron to form neptunium, a rare element. The neptunium then decays to form plutonium:

$$^{238}_{92}U + ^1_0n \rightarrow ^{239}_{92}U \rightarrow ^{239}_{93}Np + ^0_{-1}e$$
$$^{239}_{93}Np \rightarrow ^{239}_{94}Pu + ^0_{-1}e$$

FUSION

The binding energy curve (Figure 18.15) indicates that, if hydrogen can be fused into helium, the resulting nucleus will be more stable and energy can be released. In a fusion reaction,

isotopes of hydrogen known as deuterium $_1^2\text{H}$ and tritium $_1^3\text{H}$ are used. The following equations represent one kind of hydrogen fusion reaction, the kind that powers the Sun:

$$_1^1\text{H} + {_1^1\text{H}} \rightarrow {_1^2\text{H}} + {_1^0\text{e}} + 0.4\,\text{MeV}$$

$$_1^1\text{H} + {_1^2\text{H}} \rightarrow {_2^3\text{He}} + 5.5\,\text{MeV}$$

$$_2^3\text{He} + {_2^3\text{He}} \rightarrow {_2^4\text{He}} + 2\,{_1^1\text{H}} + 12.9\,\text{MeV}$$

In this reaction, hydrogen is first fused into deuterium. The deuterium is then fused with hydrogen to form the isotope helium-3. Finally, the helium-3 isotope is fused into the stable element helium.

In a different reaction, the isotope tritium is fused with deuterium to form the stable element helium in one step. This reaction powers the hydrogen (atomic) bomb:

$$_1^2\text{H} + {_1^3\text{H}} \rightarrow {_2^4\text{He}} + {_0^1\text{n}} + 17.6\,\text{MeV}$$

SUMMARY

- The photoelectric effect concludes that light consists of discrete packets of energy called photons.
- Each photon has an energy proportional to its frequency ($E = hf$).
- In the photoelectric effect, the maximum kinetic energy of the emitted electrons is independent of the intensity (number of photons) and depends directly on the frequency of the incident electromagnetic radiation.
- There is a minimum frequency needed to emit electrons called the threshold frequency.
- The maximum kinetic energy of the electrons can be measured by applying a negative electric potential across their paths called the stopping potential.
- The Compton effect demonstrates that photons have a momentum $\mathbf{p} = h/\lambda$.
- Louis de Broglie developed a theory of matter waves in which material particles have a wave-like behavior inversely proportional to their momentum ($\lambda = h/mv$).
- Spectral lines provide an observational demonstration of discrete energy transfers in an atom.
- Ernest Rutherford used alpha particles scattering off of gold foil to show that the atom consists of a small positively charged nucleus surrounded by negatively charged electrons.
- Niels Bohr developed a theory to explain spectral line emission as well as the predicted loss of electron energy according to classical radiation theory.
- In an atom, according to Bohr, electrons exist in certain discrete energy states. The lowest energy state is called the ground state. Spectral lines are emitted as electrons fall from higher to lower energy states.
- The frequency of emitted photons in a spectral series is proportional to the energy difference between levels ($hf = E_f - E_i$).
- In the quantum mechanical model developed by Erwin Schrödinger, Werner Heisenberg, and others, the atom is surrounded by a probability cloud of electrons due to the uncertainty of locating the exact location and momentum of the electrons (Heisenberg's uncertainty principle).
- The nucleus of an atom consists of neutrons and protons (both called nucleons).

- The number of protons (its charge) is called the atomic number.
- The number of protons and neutrons is called the atomic mass.
- Isotopes of nuclei contain the same number of protons, but a different number of neutrons.
- For light nuclei, the ratio of the number of protons to the number of neutrons is almost one-to-one. As atomic numbers increase, there tend to be more neutrons than protons in stable isotopes.
- The binding energy of the nucleus is found from Einstein's equation $E = mc^2$. It is the energy needed to bind the nucleus together and is observed because the actual mass of a nucleus is less than the additive sum of its constituent nucleons.
- Iron has the largest average binding energy per nucleon.
- Radioactive decay is the name given to the process of unstable isotopes (such as uranium), emitting particles and photons.
- Alpha decay is the process by which unstable nuclei emit helium nuclei.
- Beta decay is the process by which unstable nuclei emit electrons.
- Gamma decay is the process by which unstable nuclei emit photons.
- Fission is the process by which a heavy unstable nucleus (like uranium) is split into two smaller daughter nuclei by the absorption of a slow-moving neutron.
- Fusion is the process by which two light nuclei (such as deuterium) are fused into a more stable isotope (such as helium).
- Fusion does not produce radioactive by-products as fission does.
- The Sun and other stars are powered by the fusion of hydrogen into helium. Older stars may fuse helium into other, heavier elements.

Problem-Solving Strategies for Quantum Theory

Remember that the photoelectric effect demonstrates the particle nature of light and is independent of the intensity of the electromagnetic waves used. The number of photons is, however, proportional to the intensity of energy.

Note that in some problems energy is expressed in units of electron volts. This is convenient since the maximum kinetic energy is proportional to the stopping potential. Additionally, wavelengths are sometimes expressed in angstroms, and these values must be converted to meters. Be careful with units, and make sure that SI units are used in equations involving energies and other quantities.

Problem-Solving Strategies for the Nucleus

Solving nuclear equations requires that you remember two rules. First, make sure that you have conservation of charge. That means that all of the atomic numbers, which measure the number of protons (and hence the charge) should add up on both sides. However, to get the actual charge, you must multiply the atomic number by the proton charge in units of coulombs.

The second rule to consider is the conservation of mass. The mass numbers that appear as superscripts should add up. Any missing mass should be accounted for by the appearance of energy (sometimes designated by the letter Q). The mass energy equivalence is that 1 u is equal to 931.5 MeV. This second rule applies to problems involving binding energy and mass defect. Remember that an actual nucleus has less mass than the sum of its nucleons!

Multiple-Choice

1. How many photons are associated with a beam of light having a frequency of 2×10^{16} Hz and a detectable energy of 6.63×10^{-15} J?

 (A) 25

 (B) 500

 (C) 135

 (D) 8

2. A photoelectric experiment reveals a maximum kinetic energy of 2.2 eV for a certain metal. The stopping potential for the emitted electrons is

 (A) 1.2 V

 (B) 1.75 V

 (C) 3.5 V

 (D) 2.2 V

3. The work function for a certain metal is 3.7 eV. What is the threshold frequency for this metal?

 (A) 9×10^{14} Hz

 (B) 2×10^{15} Hz

 (C) 7×10^{14} Hz

 (D) 5×10^{15} Hz

4. In which kind of waves do the photons have the greatest momentum?

 (A) Radio waves

 (B) Microwaves

 (C) Red light

 (D) X ray

5. What is the momentum of a photon associated with yellow light that has a wavelength of 5,500 Å?

 (A) 1.2×10^{-27} kg · m/s

 (B) 1.2×10^{-37} kg · m/s

 (C) 1.2×10^{-17} kg · m/s

 (D) 1.2×10^{-30} kg · m/s

6. What is the de Broglie wavelength for a proton ($m = 1.67 \times 10^{-27}$ kg) with a velocity of 6×10^7 m/s?

 (A) 1.5×10^{14} m

 (B) 1.5×10^{-14} m

 (C) 4.8×10^{-11} m

 (D) 6.6×10^{-15} m

7. Which of the following statements is correct about emission line spectra?

 (A) All of the lines are evenly spaced.
 (B) All elements in the same chemical family have the same spectra.
 (C) Only gases emit emission lines.
 (D) All lines result from discrete energy differences.

8. Which electron transition will emit a photon with the greatest frequency?

 (A) $n = 1$ to $n = 4$
 (B) $n = 5$ to $n = 2$
 (C) $n = 3$ to $n = 1$
 (D) $n = 7$ to $n = 3$

9. An electron in the ground state of a hydrogen atom can absorb a photon with any of the following energies except

 (A) 10.2 eV
 (B) 12.1 eV
 (C) 12.5 eV
 (D) 12.75 eV

10. Which of the following statements about the atom is correct?

 (A) Orbiting electrons can sharply deflect passing alpha particles.
 (B) The nucleus of the atom is electrically neutral.
 (C) The nucleus of the atom deflects alpha particles into parabolic trajectories.
 (D) The nucleus of the atom contains most of the atomic mass.

11. Which of the following statements about the Bohr theory reflect how it differs from classical predictions about the atom?

 I. An electron can orbit without a net force acting.

 II. An electron can orbit about a nucleus.

 III. An electron can be accelerated without radiating energy.

 IV. An orbiting electron has a quantized angular momentum that is proportional to Planck's constant.

 (A) I and II
 (B) I and III
 (C) III and IV
 (D) II and IV

12. An electron makes a transition from a higher energy state to the ground state in a Bohr atom. As a result of this transition

 (A) the total energy of the atom is increased
 (B) the force of attraction on the electron is increased
 (C) the energy of the ground state is increased
 (D) the charge on the electron is increased

13. How many different photon frequencies can be emitted if an electron is in excited state $n = 4$ in a hydrogen atom?

 (A) 1
 (B) 3
 (C) 5
 (D) 6

14. A radioactive atom emits a gamma ray photon. As a result

 (A) the energy of the nucleus is decreased
 (B) the charge in the nucleus is decreased
 (C) the ground-state energy is decreased
 (D) the force on an orbiting electron is decreased

15. How many neutrons are in a nucleus of $^{213}_{84}\text{Po}$?

 (A) 84
 (B) 129
 (C) 213
 (D) 297

16. The nitrogen isotope $^{13}_{7}\text{N}$ emits a beta particle as it decays. The new isotope formed is

 (A) $^{14}_{7}\text{N}$
 (B) $^{13}_{6}\text{C}$
 (C) $^{13}_{8}\text{O}$
 (D) $^{14}_{8}\text{O}$

17. Which radiation has the greatest ability to penetrate matter?

 (A) X ray
 (B) Alpha particle
 (C) Gamma ray
 (D) Beta particle

18. In the following nuclear reaction, an isotope of aluminum is bombarded by alpha particles:

 $$^{27}_{13}\text{Al} + {}^{4}_{2}\text{He} \rightarrow {}^{30}_{15}\text{P} + \text{Y}$$

 Quantity Y must be
 (A) a neutron
 (B) an electron
 (C) a positron
 (D) a photon

19. When a gamma-ray photon is emitted from a radioactive nucleus, which of the following occurs?

 (A) The nucleus goes to an excited state.
 (B) The nucleus goes to a more stable state.
 (C) An electron goes to an excited state.
 (D) The atomic number of the nucleus decreases.

Free-Response

1. (a) Explain the implication of Planck's constant being larger than its present value.

 (b) Explain the basic theory behind electron diffraction.

2. The threshold frequency for calcium is 7.7×10^{14} Hz.

 (a) What is the work function, in joules, for calcium?
 (b) If light of wavelength 2.5×10^{-7} m is incident on calcium, what will be the maximum kinetic energy of the emitted electrons?
 (c) What is the stopping potential for the electrons emitted under the conditions in part (b)?

3. Explain why electrons are diffracted through a crystal.

4. Explain why increasing the intensity of electromagnetic radiation on a photoemissive surface does not affect the kinetic energy of the ejected photoelectrons. Why is this kinetic energy referred to as the "maximum kinetic energy"?

5. Why don't we speak of the wavelength nature of large objects such as cars or balls?

6. If a source of light from excited hydrogen gas is moving toward or away from an observer, what changes, if any, are observed in the emission spectral lines?

7. Given the isotope $^{56}_{26}$Fe, which has an actual mass of 55.934939 u:

 (a) Determine the mass defect of the nucleus in atomic mass units.
 (b) Determine the average binding energy per nucleon in units of million electron volts.

8. Why do heavier stable nuclei have more neutrons than protons?

9. Why are the conditions for the fusion of hydrogen into helium favorable inside the core of a star?

10. Explain the radioactive disintegration series of uranium-238 into stable lead-206 in terms of the neutron-proton plot.

11. Albert Einstein, in his special theory of relativity, stated that energy and mass were related by the expression $E = mc^2$. Explain how the concept of binding energy confirms this claim.

ANSWERS EXPLAINED
Multiple-Choice Problems

1. (**B**) If E equals the total detectable energy and E_p equals the energy of a photon, then

$$N = \frac{E}{E_p} = \frac{E}{hf} = \frac{6.63 \times 10^{-15} \text{ J}}{1.326 \times 10^{-17} \text{ J}} = 500$$

2. **(D)** By definition, 1 eV is the amount of energy given to one electron when placed in a potential difference of 1 V. Thus, if $KE_{max} = 2.2$ eV, the stopping potential must be equal to 2.2 V.

3. **(A)** The formula for the work function is $W_0 = hf_0$. The work function must be expressed in units of joules before dividing by Planck's constant:

$$f_0 = \frac{(3.7)(1.6 \times 10^{-19})}{6.63 \times 10^{-34}} = 8.9 \times 10^{14} \text{ Hz}$$

4. **(D)** Since $\mathbf{p} = h/\lambda$, the waves with the smallest wavelength will have the greatest photon momentum. Of the five choices, an X-ray photon has the smallest wavelength and thus the greatest momentum.

5. **(A)** The wavelength must first be converted to meters; then we can use $\mathbf{p} = h/\lambda$:

$$\mathbf{P} = \frac{6.63 \times 10^{-34}}{(5500)(1 \times 10^{-10})} = 1.2 \times 10^{-27} \text{ kg} \cdot \text{m/s}$$

6. **(D)** The formula for the de Broglie wavelength is $\lambda = h/mv$. Substituting the known values gives

$$\lambda = \frac{6.63 \times 10^{-34}}{(1.67 \times 10^{-27})(6 \times 10^7)} = 6.6 \times 10^{-15} \text{ m}$$

7. **(D)** Spectral emission lines are different for every atom or molecule, and the lines are not evenly spaced. They do, however, arise from energy difference transitions.

8. **(C)** Transitions to level 1 produce ultraviolet photons that have frequencies greater than those produced by transitions to other levels.

9. **(C)** An electron in the ground state can absorb a photon that has an energy equal to the energy difference between the ground state and any other level. Only 12.5 eV is not such an energy difference.

10. **(D)** "The nucleus of the atom contains most of the atomic mass" is a correct statement.

11. **(C)** The Bohr theory challenged classical theories by stating that an electron can be accelerated without radiating energy (statement III) and that its angular momentum is quantized and proportional to Planck's constant (statement IV).

12. **(B)** As an electron gets closer to the nucleus, the force of attraction on the electron increases.

13. **(D)** There are six possible photon frequencies emitted from state $n = 4$: (1) $n = 4$ to $n = 1$, (2) $n = 4$ to $n = 3$, (3) $n = 4$ to $n = 2$, (4) $n = 3$ to $n = 2$, (5) $n = 3$ to $n = 1$, (6) $n = 2$ to $n = 1$.

14. **(A)** Since photons do not have any rest mass, their emission releases nuclear energy only.

15. **(B)** The number of neutrons is given by

$$N = A - Z = 213 - 84 = 129$$

16. **(C)** The emission of a beta particle involves the transformation of a neutron into a proton and an electron. Thus, the total number of nucleons (Z) remains the same, but the number of protons increases by one. The new isotope is therefore oxygen-13.

17. **(C)** Gamma rays have the greatest energy with the greatest penetration power.

18. **(A)** We must have conservation of charge and mass. The subscripts already add up to 15 on each side, so we are left with a subscript of 0 for Y; the particle is therefore neutral. The superscripts on the right must add up to 31 to balance. Since the missing particle needs a superscript of 1, particle Y is a neutron.

19. **(B)** When radioactive nuclei emit photons, they settle down to a more stable state since no mass has been lost.

Free-Response Problems

1. (a) If Planck's constant were larger than its present value, an implication would be that the uncertainty principle, $\Delta p\, \Delta x \geq h/2\pi$, would apply to a domain of larger magnitude and we would see quantum effects occur at larger sizes as well.

 (b) Electron diffraction is based on the wave theory of matter. Since an electron has a sufficiently small mass, its de Broglie wavelength is large enough to be diffracted by small openings and thus to exhibit seemingly common wave properties. Scanning electron microscopes, although much more complex in theory, use the same basic principle.

2. (a) The work function is given by

$$w_0 = hf_0 = (6.63 \times 10^{-34})(7.7 \times 10^{14}) = 5.1 \times 10^{-19} \text{ J}$$

 (b) The frequency associated with a wavelength of 2.5×10^{-7} m is given by

$$f = \frac{c}{\lambda} = \frac{3 \times 10^8}{2.5 \times 10^{-7}} = 1.2 \times 10^{15} \text{ Hz}$$

The energy of the associated photon is equal to

$$E = hf = 7.956 \times 10^{-19} \text{ J}$$

The maximum kinetic energy of the emitted electrons is equal to the difference between this energy and the work function:

$$\text{KE}_{max} = 7.956 \times 10^{-19} - 5.1 \qquad 10^{-19} = 2.856 \times 10^{-19} \text{ J}$$

 (c) This maximum kinetic energy is equal to the product of the electron charge and the stopping potential. Thus:

$$V_0 = \frac{\text{KE}_{max}}{e} = \frac{2.856 \times 10^{-19}}{1.6 \times 10^{-19}} = 1.785 \text{ V}$$

3. The de Broglie wavelength of electrons is comparable to the spacing between molecules in the lattice structure of a crystal. Thus, the electrons have a wavelike characteristic, and the crystal acts like a diffraction grating.

4. In the quantum theory of light, each photon interacts with one, and only one, electron. Thus, if the energy of a photon is based on its frequency, the intensity of light is just

the number of photons. Thus, each electron emerges with the same kinetic energy. This is true for 1 or 1 billion electrons. Therefore, we refer to this kinetic energy as the "maximum kinetic energy."

5. Using the de Broglie formula (see sample problems), it is easy to see that the wavelength of a moving ball or car is much too small to be detected or have any significant wavelike interactions.

6. If the source of the radiation is moving toward or away from an observer, the spectral lines are shifted according to the Doppler effect. In stars, we see redshifts as the stars move away from Earth, and blueshifts as they move toward us.

7. (a) The actual mass of iron-56 is 55.934939 u. The total additive mass is determined by noting that this isotope of iron has 26 protons and 30 neutrons. Each proton has a mass of 1.0078 u, and each neutron has a mass of 1.0087 u. Thus the total constituent mass is

$$
\begin{aligned}
26(1.0078) &= 26.2028 \text{ u} \\
30(1.0087) &= 30.2610 \text{ u} \\
\hline
\text{Total mass} &= 56.4638 \text{ u}
\end{aligned}
$$

The mass defect of the nucleus is therefore the difference between this mass and the actual mass:

$$\text{Mass defect} = 56.463800 - 55.934939 = 0.528861 \text{ u}$$

(b) The binding energy is given by

$$\text{BE} = 0.528861 \times 931.5 = 492.63402 \text{ MeV}$$

The average binding energy per nucleon is

$$\text{Avg BE} = \frac{492.63402}{56} = 8.797 \text{ MeV}$$

8. Heavier nuclei have more protons, which increases the Coulomb force of repulsion between them. To maintain stability, extra neutrons are present to provide more particles for the strong nuclear force to act on and overcome this repulsive force (which is indifferent to charge).

9. The density, pressure, and temperature inside the core of a star are sufficient to overcome the natural repulsive tendency of hydrogen atoms to fuse into helium.

10. Radioactive uranium-238 is unstable and off the neutron-proton plot. Through the process of alpha and beta decay, the emission of neutrons and protons eventually brings the isotopes formed closer to that line of stable nuclei.

11. The release of energy and the missing mass in binding energy are accounted for completely using Einstein's formula. This is true for radioactivity decay, fission, and fusion, as well as matter-antimatter annihilation.

Practice
Tests

ANSWER SHEET
Practice Test 1

1. Ⓐ Ⓑ Ⓒ Ⓓ
2. Ⓐ Ⓑ Ⓒ Ⓓ
3. Ⓐ Ⓑ Ⓒ Ⓓ
4. Ⓐ Ⓑ Ⓒ Ⓓ
5. Ⓐ Ⓑ Ⓒ Ⓓ
6. Ⓐ Ⓑ Ⓒ Ⓓ
7. Ⓐ Ⓑ Ⓒ Ⓓ
8. Ⓐ Ⓑ Ⓒ Ⓓ
9. Ⓐ Ⓑ Ⓒ Ⓓ
10. Ⓐ Ⓑ Ⓒ Ⓓ
11. Ⓐ Ⓑ Ⓒ Ⓓ
12. Ⓐ Ⓑ Ⓒ Ⓓ
13. Ⓐ Ⓑ Ⓒ Ⓓ
14. Ⓐ Ⓑ Ⓒ Ⓓ
15. Ⓐ Ⓑ Ⓒ Ⓓ
16. Ⓐ Ⓑ Ⓒ Ⓓ
17. Ⓐ Ⓑ Ⓒ Ⓓ

18. Ⓐ Ⓑ Ⓒ Ⓓ
19. Ⓐ Ⓑ Ⓒ Ⓓ
20. Ⓐ Ⓑ Ⓒ Ⓓ
21. Ⓐ Ⓑ Ⓒ Ⓓ
22. Ⓐ Ⓑ Ⓒ Ⓓ
23. Ⓐ Ⓑ Ⓒ Ⓓ
24. Ⓐ Ⓑ Ⓒ Ⓓ
25. Ⓐ Ⓑ Ⓒ Ⓓ
26. Ⓐ Ⓑ Ⓒ Ⓓ
27. Ⓐ Ⓑ Ⓒ Ⓓ
28. Ⓐ Ⓑ Ⓒ Ⓓ
29. Ⓐ Ⓑ Ⓒ Ⓓ
30. Ⓐ Ⓑ Ⓒ Ⓓ
31. Ⓐ Ⓑ Ⓒ Ⓓ
32. Ⓐ Ⓑ Ⓒ Ⓓ
33. Ⓐ Ⓑ Ⓒ Ⓓ
34. Ⓐ Ⓑ Ⓒ Ⓓ

35. Ⓐ Ⓑ Ⓒ Ⓓ
36. Ⓐ Ⓑ Ⓒ Ⓓ
37. Ⓐ Ⓑ Ⓒ Ⓓ
38. Ⓐ Ⓑ Ⓒ Ⓓ
39. Ⓐ Ⓑ Ⓒ Ⓓ
40. Ⓐ Ⓑ Ⓒ Ⓓ
41. Ⓐ Ⓑ Ⓒ Ⓓ
42. Ⓐ Ⓑ Ⓒ Ⓓ
43. Ⓐ Ⓑ Ⓒ Ⓓ
44. Ⓐ Ⓑ Ⓒ Ⓓ
45. Ⓐ Ⓑ Ⓒ Ⓓ
46. Ⓐ Ⓑ Ⓒ Ⓓ
47. Ⓐ Ⓑ Ⓒ Ⓓ
48. Ⓐ Ⓑ Ⓒ Ⓓ
49. Ⓐ Ⓑ Ⓒ Ⓓ
50. Ⓐ Ⓑ Ⓒ Ⓓ

AP Physics 1

Practice Test 1

SECTION I: MULTIPLE-CHOICE

Time: 90 minutes
50 questions

> **DIRECTIONS:** Each of the questions or incomplete statements below is followed by four suggested answers or completions. Select the one (or two where indicated) that is best in each case. You have 90 minutes to complete this portion of the test. You may use a calculator and the information sheets provided in the appendix.

1. Two objects are thrown vertically upward from the same initial height. One object has twice the initial velocity of the other. Neglecting any air resistance, the object with the greater initial velocity will rise to a maximum height that is

 (A) twice that of the other object, assuming they have the same mass
 (B) twice that of the other object, independent of their masses
 (C) four times that of the other object, assuming they have the same mass
 (D) four times that of the other object, independent of their masses

2. A 2-kilogram cart has a velocity of 4 meters per second to the right. It collides with a 5-kilogram cart moving to the left at 1 meter per second. After the collision, the two carts stick together. Can the magnitude and the direction of the velocity of the two carts after the collision be determined from the given information?

 (A) No, since the collision is inelastic, we must know the energy lost.
 (B) Yes, the collision is elastic: 3/7 m/s left.
 (C) Yes, the collision is inelastic: 3/7 m/s right.
 (D) Yes, the speed is not 3/7 m/s.

3. Projectile X is launched at a 30-degree angle above the horizon with a speed of 100 m/s. Projectile Y is launched at a 60-degree angle with the same speed. Which of the following correctly compares the horizontal range and maximum altitude obtained by these two projectiles?

	Range	Altitude
(A)	X goes farther	X goes higher
(B)	Y goes farther	Y goes higher
(C)	X goes farther	Y goes higher
(D)	X and Y equal	Y goes higher

4. A 5 kg mass is sitting at rest on a horizontal surface. A horizontal force of 10 N will start the mass moving. What is the best statement about the coefficient and type of friction between the mass and the surface?

(A) >0.20 static

(B) <0.20 static

(C) <0.20 kinetic

(D) >0.20 kinetic

5. Which of the following graphs represents an object *moving* with no net force acting on it?

(A)

(B)

(C)

(D)

6. A projectile is launched horizontally with an initial velocity \mathbf{v}_0 from a height h. If it is assumed that there is no air resistance, which of the following expressions represents the vertical position of the projectile? In other words, $y(x) = ?$

 (A) $h - gv_0^2/2x^2$
 (B) $h - gv/2v_0^2$
 (C) $h - gx^2/2v_0^2$
 (D) $h - gx^2/v_0^2$

QUESTIONS 7 AND 8 ARE BASED ON THE INFORMATION AND DIAGRAM BELOW:

A 0.4-kilogram mass is oscillating on a spring that has a force constant of $k = 1,000$ newtons per meter.

7. Which of the following measurements would allow you to determine the maximum velocity experienced by the mass?

 (A) No additional information is required.
 (B) Minimum velocity
 (C) Maximum acceleration
 (D) None of these would allow you to determine maximum velocity.

8. Which of the following statements concerning the oscillatory motion described above is correct? (All statements refer to magnitudes.)

 (A) The maximum velocity and maximum acceleration occur at the same time.
 (B) The maximum velocity occurs when the acceleration is a minimum.
 (C) The velocity is always directly proportional to the displacement.
 (D) The maximum velocity occurs when the displacement is a maximum.

9. A bullet of known mass (m_1) is fired vertically into an initially stationary wood block of known mass (m_2). The resulting wood + bullet combined system is then measured to rise to a maximum height of h. Can the initial speed of the bullet be calculated from this information?

 (A) Yes. Solve $(m_1 + m_2)gh = \dfrac{1}{2}(m_1)v^2$.

 (B) Yes. Solve the momentum conservation of collision first and the energy conservation of the rising combination second.
 (C) No. We don't know if momentum is conserved during this collision.
 (D) No. We don't know enough details about the mechanical energy lost during the collision.

10. A 10 kg mass is being pulled horizontally by a constant force along a rough surface ($\mu_k = 0.1$) at constant velocity. Which of the following is the best statement regarding the constant force?

 (A) $= 10$ N
 (B) > 10 N
 (C) < 10 N
 (D) > 1 N

11. A 10-newton force is applied to two masses, 4 kilograms and 1 kilogram, respectively, that are in contact as shown below. The horizontal motion is along a frictionless plane. What is the magnitude of the contact force, **P**, between the two masses?

(A) 10 N
(B) 8 N
(C) 6 N
(D) 2 N

12. An object with mass m is dropped from height h above the ground. While neglecting air resistance, which formula best describes the power generated if the object takes time t to fall?

(A) mgh
(B) $mght$
(C) $mg^2t/2$
(D) mgh/t

13. A 1,500-kilogram car has a velocity of 25 meters per second. If it is brought to a stop by a nonconstant force in 10 to 15 seconds, can the magnitude of the impulse applied be determined?

(A) Yes, it is 37,500 N · s.
(B) No, you need to know the details about the nonconstant force.
(C) No, you must know the exact duration of the impulse.
(D) No, you must know the average force during and the duration of the impulse.

14. A block of mass M rests on a rough incline, as shown below. The angle of elevation of the incline is increased until an angle of q is reached. At that angle, the mass begins to slide down the incline. Which of the following is an expression for the coefficient of static friction μ?

(A) $\tan \theta$
(B) $\sin \theta$
(C) $\cos \theta$
(D) $1/(\cos \theta)$

15. A pendulum of a given length swings back and forth a certain number of times per second. If the pendulum now swings back and forth the same number of times but in twice the time, the length of the pendulum should be

(A) doubled
(B) quartered
(C) quadrupled
(D) halved

16. This graph of force versus time shows how the force acts on an object of mass m for a total time of T seconds. If the mass begins at rest, which is the correct method to find the final speed of the mass?

(A) Average value of this graph times total time divided by mass
(B) Area under this graph divided by mass
(C) Since the final force is zero, the object is at rest after time T
(D) Average slope of this graph divided by mass

17. A child of unknown mass is on a swing of unknown length that varies in height from 75 cm at its lowest height above the ground to a maximum height of 225 cm above the ground. Is there enough information to find speed of the swing at its lowest point?

(A) No, the child's mass must be known.
(B) No, the length of the swing must be known to determine the centripetal acceleration.
(C) Yes, it is 5.5 m/s.
(D) Yes, it is 4 m/s.

18. The gravitational force of attraction between two identical masses is 36 N when the masses are separated by a distance of 3 m. If the distance between them is reduced to 1 m, which of the following is true about the net gravitational field strength due to both masses being at the halfway point?

(A) It is 9 times stronger total.
(B) Not enough information is given to determine net gravitational field strength.
(C) Each mass's gravitation is 9 times stronger, so the net gravitational field strength is 18 times stronger.
(D) It is zero.

19. A 200-kilogram cart rests on top of a frictionless hill as shown below. Can the impulse required to stop the cart when it is at the top of the 10-meter hill be calculated?

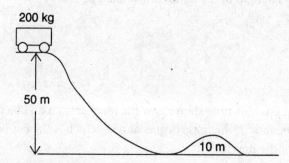

(A) No, more information about friction is required.
(B) No, more information about the impulse is required.
(C) Yes, calculate the velocity from free-fall kinematics and use this velocity in the change in momentum equation.
(D) Yes, calculate the speed from energy conservation and use this speed in the change in momentum equation.

20. An object of mass m starts at a height of H_1 with a speed of v_1. A few minutes later, it is at a height of H_2 and a speed v_2. Which of the following expressions best represents the work done to the mass by nongravitational forces to the object during this time?

(A) $mg(H_2 - H_1) + \frac{1}{2}m(v_2^2 - v_1^2)$
(B) $mg(H_2 - H_1) - \frac{1}{2}m(v_2^2 - v_1^2)$
(C) $\frac{1}{2}m(v_2^2 - v_1^2)$
(D) $\frac{1}{2}m(v_1^2 - v_2^2)$

21. An object with 0.2 kg mass is pushed down vertically onto an elastic spring ($k = 20$ N/m). The spring is compressed by 20 cm and then released such that the object will fly off. Which of the following will have the largest effect on increasing the maximum height the object will fly? (Assume no air resistance.)

(A) Halving the mass
(B) Doubling the compression distance
(C) Using a spring with a spring constant twice as big
(D) Doing the same experiment on a different planet with half the gravitational field strength

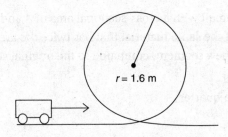

22. A cart with a mass of m needs to complete a loop-the-loop of radius r, as shown above. What is the approximate minimum velocity required to achieve this goal?

(A) $(gr)^{1/2}$

(B) $(5gr)^{1/2}$

(C) $2(gr)^{1/2}$

(D) $(2gr)^{1/2}$

QUESTIONS 23–25 ARE BASED ON THE FOLLOWING CIRCUIT:

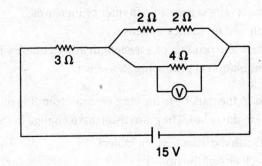

23. What is the equivalent resistance of the circuit?

(A) $6\,\Omega$

(B) $8\,\Omega$

(C) $11\,\Omega$

(D) $5\,\Omega$

24. What is the reading of the voltmeter across the 4-ohm resistor?

(A) 3 V

(B) 9 V

(C) 12 V

(D) 6 V

25. What is the current through the leftmost 2-ohm resistor?

(A) 3 A

(B) 1.5 A

(C) 0.75 A

(D) 1 A

26. A wire segment in a circuit with a cross-sectional area of A and length L is replaced by a wire segment made of the same material that has twice the area but half the length. The resistance of the new segment, compared to the original segment, will

(A) be reduced by half
(B) be reduced to one-quarter
(C) quadruple
(D) remain the same

27. In the fixed standing wave shown below (imagine a string of fixed length), what will happen to the wavelength and frequency if the wave speed is raised while the standing wave pictured remains unchanged?

3 m

(A) Wavelength increases while frequency remains the same.
(B) Wavelength remains the same while frequency increases.
(C) Both wavelength and frequency increase.
(D) Although we know the product of wavelength and frequency increases, we do not know what combination is producing this effect.

28. Bats can find objects in the dark by using echolocation (sending out a high-frequency sound and listening to the echo). They also listen for a change in the pitch of the echo to

(A) confirm the estimated distance of the object
(B) determine the velocity of the object
(C) determine whether the object is moving toward or away from them
(D) estimate the approximate composition of the object

29. A 340-hertz tuning fork sets an air column vibrating in fundamental resonance, as shown above. A hollow tube is inserted into a column of water, and the height of the tube is adjusted until strong resonance is heard. At approximately what length of the air column will this happen?

(A) 100 cm
(B) 75 cm
(C) 50 cm
(D) 25 cm

30. How many different directions can a two-dimensional vector have if its components are of equal magnitude?

 (A) One, at 45°
 (B) Two
 (C) Four
 (D) Infinite

31. Two vectors, **A** and **B**, have components $A_x = -2$, $A_y = 3$, $B_x = 5$, and $B_y = 1$. What is the approximate magnitude of the vector **A** + **B**?

 (A) 3
 (B) 4
 (C) 5
 (D) 7

32. As the angle between two vectors increases from 0° to 180°, the magnitude of their resultant

 (A) increases, only
 (B) increases and then decreases
 (C) decreases, only
 (D) decreases and then increases

33. At what angle should a projectile be launched in order to achieve the maximum range for a given initial velocity under no air resistance?

 (A) 90°
 (B) 30°
 (C) 45°
 (D) 60°

34. An object is dropped from a height of 45 m. Neglecting air resistance, what is the approximate velocity of the object as it hits the ground?

 (A) 10 m/s
 (B) 15 m/s
 (C) 20 m/s
 (D) 30 m/s

35. A boat moving due north crosses a river 240 meters wide with a velocity of 8 meters per second relative to the water. The river flows east with a velocity of 6 meters per second. How far downstream will the boat be when it has crossed the river?

 (A) 240 m
 (B) 180 m
 (C) 420 m
 (D) 300 m

A variable force acts on a 2-kilogram mass according to the graph below.

36. How much work was done while displacing the mass 10 meters?

(A) 40 J

(B) 38 J

(C) 32 J

(D) 30 J

37. What was the average force supplied to the mass for the entire 10-meter displacement?

(A) 3.2 N

(B) 1.2 N

(C) 4.4 N

(D) 4 N

38. A man weighing himself is standing on a bathroom scale in an elevator that is accelerating upward at a rate of 0.5 meter per second squared. By what percentage is the reading of the scale off from the person's true weight?

(A) 0% (accurate)

(B) 5% too high

(C) 5% too low

(D) 0.5% too high

39. A 50-kilogram person is sitting on a seesaw 1.2 meters from the balance point. On the other side, a 70-kilogram person is balanced. How far from the balance point is the second person sitting?

(A) 0.57 m

(B) 0.75 m

(C) 0.63 m

(D) 0.86 m

40. An object rolls down a steep incline with very little friction. At the same time, an object of equal mass slides down the same incline. Which one takes less time to get to the bottom?

(A) They take the same time.

(B) The rolling object takes less time.

(C) The sliding object takes less time.

(D) The answer depends on the rolling object's moment of inertia.

41. What is the value of g at a position above Earth's surface equal to Earth's radius?

(A) 9.8 N/kg

(B) 4.9 N/kg

(C) 2.45 N/kg

(D) 1.6 N/kg

42. If it takes 5 N to move 2 C of charge in a constant electric field, how much energy is needed to move 3 C of charge 40 cm in the same field?

(A) 2.5 J

(B) 7.5 J

(C) 2.0 J

(D) 3.0 J

43. If an object is spinning at 150 RPM (revolutions per minute) and comes to stop in 2 seconds, what is its average acceleration in radians/s²?

(A) -2.5π

(B) -2π

(C) -5π

(D) -10π

44. What is the work done by a horizontal spring (spring constant k) expanding from a compression distance x to an extension distance x to an attached mass?

(A) $2kx^2$

(B) $\frac{1}{2}kx^2$

(C) kx^2

(D) 0

45. If an isolated spinning object's moment of inertia is reduced by a factor of 3 by internal forces, how will its angular momentum change?

(A) Angular momentum will be 3 times its previous value.

(B) Angular momentum will be reduced to 1/3 its previous value.

(C) Angular momentum will be reduced to 1/9 its previous value.

(D) Angular momentum will remain unchanged.

46. If the tension in a taut string is increased, which of the following will also be increased when the fundamental frequency is struck? Select two answers.

(A) The velocity of propagation

(B) The frequency of the fundamental

(C) The wavelength of the fundamental

(D) The amplitude of the wave

47. A friend is balancing a fork on one finger. Which of the following are correct explanations of how he accomplishes this? Select two answers.

 (A) Total energy is conserved.
 (B) The fork's moment of inertia is zero.
 (C) The fork's center of mass is above his finger.
 (D) The fork's clockwise torque is equal to its counterclockwise torque.

48. Two tuning forks are struck at the same time. A beat frequency of 12 beats per second is observed. If one tuning fork has a frequency of 384 Hz, what could be the frequency of the second tuning fork? Select two answers.

 (A) 260 Hz
 (B) 372 Hz
 (C) 396 Hz
 (D) 408 Hz

49. A book rests on top of a table. Which of the following are an action-reaction pair described by Newton's third? Select two answers.

 (A) The weight of the book and the normal force of the table up on the book
 (B) The weight of the book and the weight of the table
 (C) The weight of the table and the upward pull of the table on Earth
 (D) The normal force up on the book from the table and the downward force on the table due to the book

50. Consider the impulse received by the first car in each of the following cases. In each case, the cars are at rest after the collision. In which two of the following cases will the car receive the same impulse? Select two answers.

 (A) A 5,000 kg car traveling at 10 m/s has a head-on collision with an equal and oppositely directed second car.
 (B) A 5,000 kg car traveling at 10 m/s has a head-on collision with a large building.
 (C) A 2,500 kg car traveling at 10 m/s has a head-on collision with an equal and oppositely directed second car.
 (D) A 2,500 kg car traveling at 5 m/s has a head-on collision with an equal and oppositely directed second car.

SECTION II: FREE-RESPONSE

Time: 90 minutes

5 questions

> DIRECTIONS: You have 90 minutes to complete this portion of the test. You may use a calculator and the information sheets provided in the appendix.

1. A group of students are given the following supplies: a stopwatch, a long string, various metersticks and protractors, and a large supply of various styles of predetermined masses.

 (a) Describe three short experimental procedures to determine the dependency of a simple pendulum's period of oscillation on amplitude, mass, and length. You may include a labeled diagram of your setup to help in your description. Indicate what measurements you would take and how you would take them. Include enough detail so that another student could carry out your procedure.

 (b) What are the expected results of each investigation? Sketch out what the data will look like in each of the three investigations (amplitude, mass, and length).

 (c) What are the common sources of error or expected deviations from ideal results that might happen during this investigation? Which of the three investigations might you expect to deviate the most from the ideal results and why?

 (d) Here are some raw data taken from the length vs. period investigation by a student who suspects there is a correlation between the two. Determine which variables to graph to produce a linear function. Graph this new data below, and interpret the slope of your best fit-line.

Length (cm)	Period (s)	?
10	0.62	
20	0.90	
30	1.09	
40	1.28	
55	1.48	
75	1.75	
85	1.85	

2. A mass m is resting at a height h above the ground. When released, the mass can slide down a frictionless track to a loop-the-loop of radius R as shown below.

(a) As the mass slides down the incline, it gains speed. However, the mass may or may not "make it" around the loop without falling out. Why and under what conditions will the mass travel around the loop without falling out? Why and under what conditions will it not complete the loop? Explain your reasoning qualitatively, making sure you address the normal force experienced by the mass.

(b) Two fellow students are arguing about whether the maximum possible R of a loop that the mass can make it around will be linearly dependent on height h or if the relationship will be some power law. Without solving for the relationship explicitly, indicate a line of reasoning that would settle this argument.

(c) Within the loop, the normal force is always acting in a centripetal direction. Explain why the normal force is not always equal to mv^2/R at each point. Are there any points along the loop where the normal force is equal to mv^2/R? Support your argument with free-body diagrams.

(d) If the minimum height h has been found for a fixed loop of size R but a rolling ball of mass m is substituted for the sliding mass, the ball will (indicate your choice):

_____ make it through the loop more easily

_____ pass through the loop the same as before

_____ fall out of the loop

Justify your answer qualitatively, with no equations or calculations.

3. Use the sketch to answer the following questions

(a) Use the qualitative keywords below to fill in the chart beneath with a brief description of the motion:

List 1: constant, increasing, decreasing

List 2: negative, positive, zero

Time Interval	Velocity (One Word From List 2)	Speed (One Word From List 1)	Acceleration (One Word From List 2)
$A \to B$			
$B \to C$			
$C \to D$			
$D \to E$			

(b) Which is faster, the average velocity from C to D or the average velocity from C to E? Explain your reasoning.

(c) What is the instantaneous velocity at point B? Explain your reasoning.

(d) Pick a couple of points on this graph that are not a realistic representation of a real-world object's motion. Explain what is problematic about these two points.

(e) Sketch a velocity versus time graph from this data. Label points A, B, C, D, and E.

4. A 2-kilogram mass is twirled in a vertical circle as shown. It is attached to a 2-meter rope. As the mass just clears the ground (point A), its velocity is 10 m/s to the right. Neglect any air resistance. When the mass reaches point B, it makes a 30-degree angle to the horizontal as shown.

(a) Describe qualitatively, using words and diagrams, the difference in the object's speed at point B if the twirling is done (i) at constant speed or (ii) at constant tension. Which would result in the greater speed at point B? Include an analysis of how the tension must change in part (i).

(b) At point B, the rope is released and the mass becomes a projectile. Assuming the rope has a uniform distribution of mass and remains attached to the flying object. Which of the following options best describe the projectile's range as compared with a launch without the rope?

_____ addition of rope makes no difference to the range

_____ addition of rope increases the range

_____ addition of rope decreases the range

Explain your reasoning.

(c) When twirling the object at constant speed, explain in terms of work and energy, how the constant speed is maintained. Is the path truly circular when the object's speed is maintained? In your explanation, be explicit about which forces are doing positive work and which are doing negative work.

5. You are given three 2-ohm resistors, some wire, a variable DC voltage supply, a voltmeter, and an ammeter.

(a) Draw a schematic diagram of a circuit that will produce an equivalent resistance of 3 ohms as well as measure the circuit current and source voltage.

(b) Which, if any, of these components are assumed to have zero internal resistance? Which, if any, of these components are assumed to have infinite resistance? Justify your choices.

(c) Trace out one complete loop in your circuit, and prove Kirchoff's loop rule. Once you set up your rule, assume a setting of 6 volts on the power supply. Verify your rule numerically.

(d) A student wishes to measure the voltage and current in a simple circuit using small lightbulbs instead of commercially manufactured resistors. She finds that after a short while, the current in the ammeter is decreasing. How might she account for this?

ANSWER KEY

1. **D**	14. **A**	27. **B**	40. **C**
2. **C**	15. **C**	28. **C**	41. **C**
3. **D**	16. **B**	29. **D**	42. **D**
4. **B**	17. **C**	30. **D**	43. **A**
5. **B**	18. **D**	31. **C**	44. **D**
6. **C**	19. **D**	32. **C**	45. **D**
7. **C**	20. **A**	33. **C**	46. **A, B**
8. **B**	21. **B**	34. **D**	47. **C, D**
9. **B**	22. **B**	35. **B**	48. **B, C**
10. **A**	23. **D**	36. **C**	49. **C, D**
11. **D**	24. **D**	37. **A**	50. **A, B**
12. **D**	25. **B**	38. **B**	
13. **A**	26. **B**	39. **D**	

ANSWERS EXPLAINED
Section I: Multiple-Choice

1. **(D)** Twice the initial vertical velocity will give twice the time in flight. Average vertical velocity will also be doubled. Displacement is the product of these two: $2 \times 2 = 4$.

 Alternatively, one could use $v^2 = v_0^2 + 2ad$ since v at the maximum height is zero. Since v_0 is doubled and then squared, the vertical displacement d must be 4 times bigger.

 Free-fall problems are independent of mass.

2. **(C)** Conservation of momentum:

 $$\mathbf{P}_{tot} = 2(+4) + 5(-1) = +3 \text{ kg m/s} = mv = (7 \text{ kg})v$$

 $$v = +3/7 \text{ m/s}$$

 The collision is inelastic since the carts stick together.

3. **(D)** Higher altitude is strictly a function of V_Y (Projectile Y). Range is a function of both V_X and V_Y such that the angles equally above and below 45 degrees (the max angle for range) will result in equal horizontal displacement. 30 degrees and 60 degrees are both 15 degrees off from 45 degrees.

4. **(B)** Since the 10 N force will start the mass moving, this must be greater than the static friction force holding the mass in place. The maximum **static** friction must be 10 N or less.

$$F_s < 10 \text{ N}$$

$$\mu N < 10 \text{ N}$$

$$\mu mg < 10 \text{ N}$$

$$\mu(5)(10) < 10$$

$$\mu < 1/5$$

5. **(B)** The object is moving, so the velocity is not zero. The object is not accelerating, so velocity is constant.

6. **(C)** In general:

$$y(t) = y_0 - v_{y0} - \frac{1}{2}gt^2$$

$$x(t) = v_{x0}t$$

Solve for t in the last equation. Then plug back into the first equation and substitute in $y_0 = h$, $v_{y0} = 0$, and $v_{x0} = v_0$:

$$y(x) = h - (0)(x/v_0) - \frac{1}{2}g(x/v_0)^2 = h - gx^2/(2v_0^2)$$

7. **(C)** Maximum acceleration allows you to determine maximum displacement:

$$ma = kA$$

Knowing the amplitude allows you to determine easily the maximum speed via energy conservation:

$$\frac{1}{2}kA^2 = \frac{1}{2}mv^2$$

8. **(B)** Maximum velocities happen when going through the equilibrium point (zero acceleration and zero displacement): all KE and no PE.

9. **(B)** Momentum is conserved during the collision, which enables us to solve for an initial upward velocity of the combination. Then energy conservation can be used to relate the height to that initial upward velocity. Choice (A) cannot be used because some unknown amount of mechanical energy will be lost by the bullet embedding itself in the wood.

10. **(A)** Constant velocity means no acceleration, so $\mathbf{F}_{net} = 0$.

$$F_{push} - F_{friction} = 0$$

$$F_{push} - \mu_k N = F_{push} - \mu_k mg = 0$$

$$F_{push} = \mu_k mg = (0.1)(10 \text{ kg})(10 \text{ m/s}^2) = 10 \text{ N}$$

11. **(D)** First find the acceleration of the system:

$$\mathbf{F}_{net} = m\mathbf{a}$$

$$10\text{ N} = (4 + 1\text{ kg})a$$

$$a = 2\text{ m/s}^2$$

The contact force, **P**, is the only force felt by the 1 kg mass:

$$\mathbf{F}_{net} = m\mathbf{a}$$

$$\mathbf{P} = (1\text{ kg})\,(2\text{ m/s}^2) = 2\text{ N}$$

12. **(D)** $P = \text{work}/t = FD/t = mgh/t$

13. **(A)** Impulse can be found by Ft if the details of the force are known or, alternatively, by:

$$\text{Impulse} = \Delta\mathbf{p} = (1{,}500\text{ kg})\,(0\text{ m/s} - 25\text{ m/s}) = -37{,}500\text{ N}\bullet\text{s}$$

Ignore the minus sign as the question asks about magnitude.

14. **(A)** When the block is at the maximum height, static friction is obtained:

$$\mathbf{F}_{net} = mg\sin\theta - \mu N = 0$$

$$mg\sin\theta - \mu(mg\cos\theta) = 0$$

$$\mu = (\sin\theta)/(\cos\theta) = \tan\theta$$

15. **(C)** Doubling the period requires a quadrupling of length:

$$T = 2\pi(l/g)^{\frac{1}{2}}$$

16. **(B)** Impulse = area of F vs T graph = $\Delta\mathbf{p} = m\mathbf{v}_f - 0$

Solving for $\mathbf{v}_f = (\text{area under graph})/m$

17. **(C)** Conservation of energy:

$$\frac{1}{2}mv^2 = mg\Delta h$$

$$\frac{1}{2}v^2 = g\Delta h = (10\text{ m/s}^2)(2.25\text{ m} - 0.75\text{ m})$$

$$v = (30)^{\frac{1}{2}} = 5.5\text{ m/s}$$

18. **(D)** Gravitational field strength halfway between any two equal masses is always zero as each contributes oppositely directed gravitational fields.

19. **(D)** Conservation of energy while on the frictionless hills can give the speed at the top of the hill:

$$\frac{1}{2}mv^2 = KE = mg\Delta h$$

Then impulse equals change in momentum can be used since the final momentum must be zero.

20. **(A)**

$$\text{Mechanical energy} = mgh + \frac{1}{2}mv^2$$

$$\text{Energy "lost" or "gained"} = mgH_2 + \frac{1}{2}mv_2{}^2 - \left(mgH_1 + \frac{1}{2}mv_1{}^2 \right)$$

Work by forces other than gravity = change in energy

21. **(B)** Energy conservation:

$$\frac{1}{2}kx^2 = mgh$$

Solving for h:

$$h = kx^2/2mg$$

Doubling x will quadruple the height, whereas all other factors will only double the height.

22. **(B)** Circular motion at the top:

$$\mathbf{F}_{\text{net}} = mg + N = mv^2/r$$

The lowest speed will be when there is no normal force ($N = 0$):

$$mg = mv^2/r$$

$$v_{\text{top}} = (gr)^{\frac{1}{2}}$$

KE at the bottom must give both this speed and PE to gain $2r$ in height:

$$E_{\text{bottom}} = E_{\text{top}}$$

$$\frac{1}{2}mv^2 = gm(2r) + \frac{1}{2}mv_{\text{top}}{}^2$$

$$\frac{1}{2}mv^2 = gm(2r) + \frac{1}{2}m(gr)$$

Solving for v:

$$v = (5gr)^{\frac{1}{2}}$$

23. **(D)** The two 2 Ω resistors are in series with each other: 2 Ω + 2 Ω = 4 Ω.

This 4 Ω equivalent resistance is in parallel with the existing 4 Ω resistor: ¼ Ω + ¼ Ω = ½ Ω. So the equivalent resistance for that section of the circuit is 2 Ω. This 2 Ω equivalent resistance is in series with the 3 Ω resistor: 2 Ω + 3 Ω = 5 Ω.

24. **(D)** The 15 volts must be split between the 3-ohm resistor and the 2-ohm equivalent resistance of the right-hand side (see answer 23). Voltage for the 4-ohm resistor is the same as the voltage across the 2-ohm equivalent resistance of the right-hand side:

$$V = (2/5)(15 \text{ V}) = 6 \text{ V}$$

25. **(B)** The 15-volt battery will supply 3 amps of current for the 5-ohm circuit:

$$V = IR$$

$$15 \text{ V} = (3A)(5 \text{ ohm})$$

This 3-amp current will split as it comes to the branching point before the 4-ohm resistor. Since both pathways have equal resistance (4 ohms), the current will split evenly: 1.5 amps.

26. **(B)** Resistance is determined by:

$$\rho L / A$$

The same material means the resistivity, ρ, is the same. Letting $L \to L/2$ and $A \to 2A$:

$$\rho L / A \to \rho(L/2)/(2A) = (\rho L/A)/4$$

27. **(B)** The wavelength is set by the length of the standing wave and the number of the harmonic. Therefore the wavelength remains the same. The frequency of the wave must have been raised to correspond to the higher wave speed: $\lambda f = v$.

28. **(C)** The Doppler effect can be used to determine relative speed toward or away from the source by looking at frequency shift in the reflected wave. Note that the velocity vector cannot be determined. Components of velocity not directed toward or away from the receiver do not contribute to the Doppler shift.

29. **(D)** The fundamental frequency in a half-pipe is ¼ wavelength:

$$\text{Wavelength} = \text{wave speed}/\text{frequency} = 340/340 = 1 \text{ m}$$

The pipe needs to be ¼ of this: 0.25 m = 25 cm.

30. **(D)** Any 45-45-90 triangle has sides of equal length. Therefore, a 45° vector would have equal length components. So would 135°, 225°, and 315°, as these vectors all form 45-45-90 triangles with their components.

31. **(C)** Add the components of the vectors:

$$A_x + B_x = -2 + 5 = 3$$

$$A_y + B_y = 3 + 1 = 4$$

Use the Pythagorean theorem on these net components:

$$3^2 + 4^2 = 5^2$$

32. **(C)** Maximum vector addition is when the two vectors are aligned (0°) and minimum is when they are opposite (180°). All values in between will steadily decrease the resultant from maximum to minimum.

33. **(C)** Maximum range is at 45° since this gives decent time in flight and decent horizontal velocity.

34. **(D)** First, find the time in flight:

$$h = \frac{1}{2}(10)t^2$$

$$45 = 5t^2$$

$$t = 3\text{s}$$

Now use this time to find the final speed:

$$v_f = at = (10 \text{ m/s}^2)(3 \text{ s}) = 30 \text{ m/s}$$

35. **(B)** Find time to cross the river using only perpendicular components:

$$D = V_y t$$

$$240 = 8t$$

$$t = 30 \text{ s}$$

Next find the downstream distance using the parallel component:

$$D = V_x t$$

$$D = (6 \text{ m/s}) (30 \text{ s}) = 180 \text{ m}$$

36. **(C)** Work is the area under the curve:

$$(4 \text{ N})(6 \text{ m}) + (2 \text{ N})(4 \text{ m}) = 24 \text{ J} + 8 \text{ J} = 32 \text{ J}$$

37. **(A)** work = $\mathbf{F}_{average}$ · displacement

$$32\,J = (\mathbf{F}_{average})(10\,m)$$

$$\mathbf{F}_{average} = 3.2\,N$$

38. **(B)** The bathroom scale reads the normal force:

$$F_{net} = N - mg = ma$$

$$0.5\,m/s^2 = 0.05g$$

$$N - mg = m(0.05g)$$

$$N = m(1.05g)$$

The reading will be 5% too high.

39. **(D)** Balanced means the torques are equal and opposite:

$$50\,kg \cdot g \cdot 1.2 = 70\,kg \cdot g \cdot x$$

$$x = 6/7 = 0.86$$

40. **(C)** Both objects start with same potential energy. However, the rolling object must use some of that potential energy for rotational energy, leaving less for linear kinetic energy. Therefore, the rolling object moves more slowly down the hill.

41. **(C)** Universal gravity (and the gravitational field) are $1/R^2$ laws; doubling R will quarter the field. Note that N/kg = m/s$^2$.

42. **(D)** First, find the electric field strength:

$$E = F/q = 5/2\,N/C$$

Now, find the work done:

$$W = \mathbf{F} \cdot \mathbf{D} = q\mathbf{E} \cdot \mathbf{D} = (3C)(5/2)(0.4\,m) = 3\,J$$

43. **(A)** First, convert RPMs to rad/s:

$$150\,rev/min \times (2\pi/1\,rev) \times (1\,min/60\,s) = 5\pi\,rad/s$$

$$acceleration = change\ in\ velocity/time = (0 - 5\pi\,rad/s)/(2\,s)$$
$$-2.5\pi\,rad/s^2$$

44. **(D)** $\frac{1}{2}kx^2$ of work is delivered to the mass while uncompressing, followed by $-\frac{1}{2}kx^2$ done while the mass extends the spring outward, totaling to 0 net work for the entire expansion. Alternatively, think about the velocity being zero and the beginning and end of that single oscillation. No change in kinetic energy occurs; therefore, no net work is done.

45. **(D)** No external torque → means momentum must be conserved.

46. **(A) and (B)** Higher tension means waves will propagate at higher speeds. Since the wavelength of the standing wave is fixed by the length of the string, the frequency of the fundamental must also increase.

47. **(C) and (D)** An object's center of mass is the balancing point by definition. The reason for this is that the moment arm on one side is the same as on the other. Therefore, the torque caused by gravity on either side will cancel.

48. **(B) and (C)** The beat frequency is caused by the difference between the two frequencies: $384 \pm 12 = 396$ or 372.

49. **(C) and (D)** Action–reaction pairs must be the same type of force and found on each partner of the force exchanging objects. The weight of an object is caused by the entire planet. Therefore, that reaction force is on the planet itself. Likewise, the normal forces exchanged between the bottom surface of the book and top surface of the table are an action-reaction pair.

50. **(A) and (B)** The cars will both experience an impulse of 50,000 N · s. The other two cases result in smaller impulses.

Section II: Free-Response

1. (a) This is really three separate investigations. In each case, students should measure the period repeatedly and then take the mean value.

 1. Amplitude versus period. Take a period measurement for 5 to 10 different amplitudes while keeping the mass and length the same. The amplitude can be controlled by pulling the string-mass combo out to a certain angle as measured by the protractor.
 2. Mass versus period. Take a period measurement for 5 to 10 different masses while keeping the amplitude and length constant.
 3. Length versus period. Take a period measurement for 5 to 10 different lengths while keeping the mass and amplitude constant. Length is measured from the pivot point to the center of mass.

(b) No correlation is expected for amplitude and mass variations. A nonlinear relationship is expected for length and period:

$$T_p = 2\pi(L/g)^{1/2}$$

(c) Beyond the usual random errors of measurement (especially when using a timer but minimized by taking the median value of a few trials each time), one predictable deviation is in the amplitude investigation. Pendulums actually behave as simple harmonic oscillators only under the conditions of small angles (small enough that sin θ is approximately θ). A large enough amplitude will require the pendulum to oscillate at larger angles. This means that at large amplitudes, one can predict the results to deviate from the expected as the gravitational force no longer acts as a simple restorative force.

One other possible source of systematic error would be in the mass investigation. As various masses are swapped out on a fixed length of string, the students may inadvertently be changing the length of the string when adding on different-sized masses. The length of the pendulum is from the pivot point to the *center of mass*. If the students did not compensate for this when adding larger masses by shortening

the string, they may see an artificial relationship at higher masses in their graph of mass versus period.

(d) To obtain a linear graph, one must plot T^2 versus L:

$$T^2 = (4\pi^2/g)L$$

The slope of this plot would then be equal to $4\pi^2/g$. Alternatively, one could plot T versus \sqrt{L}.

Length (cm)	Period (s)	T^2 (s²)
10	0.62	0.38
20	0.90	0.81
30	1.09	1.19
40	1.28	1.64
55	1.48	2.19
75	1.75	3.06
85	1.85	3.42

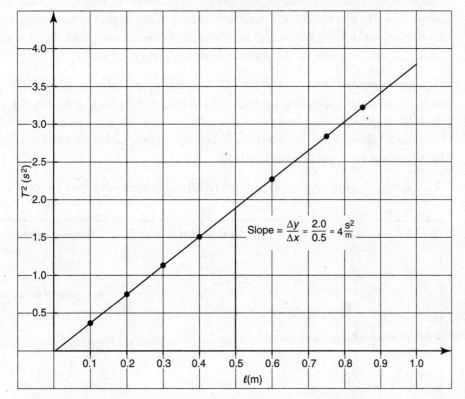

The measured slope is 4 s²/m. It can be compared to the theoretical prediction of slope:

$$4\pi^2/g = 4.02 \text{ s}^2/\text{m}$$

2. (a) As the value h is raised, the mass gains velocity at the bottom of the incline. As the mass slides around the inside of the loop, it will lose speed as it goes back up. The entire time the mass is inside the loop, it must be undergoing centripetal acceleration (specifically, its v^2/R must equal its inward acceleration). If the mass is moving too slowly to maintain its circular motion, it will fail to complete the loop. The centripetal force is supplied by the normal force throughout the trajectory (sometimes also with or against the force of gravity). If the normal force goes to zero, this indicates a loss of contact between the sliding mass and the track. The slowest speed will occur at the top of the loop. Therefore, this is the most likely place for the mass to fall. At the top, gravity is acting centripetally along with the normal force, so Newton's second law gives us:

$$N + mg = mv^2/R$$

As h gets smaller, the speed at the top will get smaller, which will decrease the right-hand side of the equation above. At some point, mv^2/R will get as small as mg, at which point the normal force will be at zero. Any speed greater than this will let the mass complete the loop. Any speed lower than this will cause the mass to fail to complete the loop.

(b) The object has gravitational potential energy in the beginning, which is linearly proportional to h. Part of the potential energy is transformed into kinetic energy at the top of the loop. Kinetic energy is proportional to v^2. However, centripetal force is also proportional to v^2 and the centripetal force is linear with respect to the normal force. It is this normal force going to zero that determines the critical speed. So the student who claims there is a linear dependence between h and R is correct.

(c) Because the normal force is not always the only centripetal force, it alone is not equal to mv^2/R. Generally speaking, a component of the force due to gravity is acting centripetally (top half of the loop) or centrifugally (bottom half of the loop). However, at the points halfway between the top and bottom, the normal force indeed is acting alone centripetally and is equal to mv^2/R.

The following drawings show only the radial component of the two forces (F_N, F_{gR}).

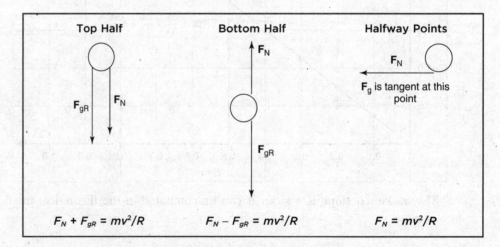

Tangent components of gravity speed up or slow down the object but do not participate in the centripetal acceleration.

(d) __X__ fall out of the loop

Since the original gravitational potential energy must now be going into rotation kinetic energy, less energy will be available for the tangential speed needed to make it through the loop. Since the height, h, was set minimally for the sliding block, the rolling object will not have enough linear kinetic energy for its tangential speed to clear the top of the loop.

3. (a)

Time Interval	Velocity (One Word From List 2)	Speed (One Word From List 1)	Acceleration (One Word From List 2)
$A \rightarrow B$	positive	decreasing	negative
$B \rightarrow C$	negative	increasing	negative
$C \rightarrow D$	positive	constant	zero
$D \rightarrow E$	zero	constant	zero

(b) The slope from C to D is steeper than the slope drawn from C to E. Therefore, the average velocity is greater from C to D.

(c) Point B is a turnaround point. The slope of a tangent line drawn at that point would be horizontal. For these reasons, the instantaneous velocity at this point is zero.

(d) Points C and D are not continuous, which means the slope at these points is undefined. Therefore the instantaneous velocity at these two points does not exist. Real-world motion is always continuous.

(e)

4. (a) (i) To maintain constant speed, the tension must be constantly adjusted as the object undergoes its centripetal motion. The tension will be lower at point B than it is at the bottom as there is a component of gravity "helping" the tension in the centripetal direction (as opposed to gravity acting centrifugally at point A):

$$F_{cA} = F_{cB} = mv^2/R$$

$$T_A - mg = T_B + mg \sin 30° = mv^2/R$$

$$T_B = T_A - mg(1 + \sin 30°)$$

(ii) Constant tension will result in a much higher speed at point B as the tension will be locked in at T_A above. Since the tension at point B will be higher than in

case (i), mv^2/R must be greater as well. Constants m and R mean the speed must be increased.

(b) __X__ addition of rope decreases the range

Although we are ignoring air friction in this problem, we must consider the effect of the additional mass. Although free-fall problems generally ignore mass, the rope will have an effect on the effective launch velocity. The end of the rope directly attached to the twirling mass has the same velocity as the object. However, the rest of the distributed mass is moving at a lower velocity (down to zero at the center of the circle). Therefore, the net effect of the added mass will be to decrease the launch velocity. In addition, recall that the equations of motion actually track the center of mass of an object. Since the center of mass for the combined rope-plus-object system is lower (the mass of the rope extends below the 2 kg mass), the combined rope-plus-object system is effectively being launched from a lower height. A lower launch velocity from a lower height will result in a shorter range for the projectile.

(c) While on the way up during the circular motion, the force due to gravity is doing negative work. The component of weight that is tangent does this negative work. Therefore to maintain the same kinetic energy, the tension must do some positive work. In order to accomplish this, the tension must supply an upward tangent component as well, i.e., the circle cannot be perfect. On the downward half of the circular motion, the positive and negative work roles of the tangent components of gravity and tension must reverse.

5. (a)

(b) Ammeters, wires, and power supplies are assumed to have zero internal resistance as they have no resistance indicated in the circuit diagram. If there were any resistance, unaccounted losses of voltage would occur in our circuit. When modeling actual resistance inside of components, an "internal" resistor is added to the circuit diagram.

Voltmeters would create a parallel path if they did not have infinite resistance. To the extent they have less than infinite resistance, the addition of voltmeters to the circuit would effectively lower the resistance, thereby lowering the voltage reading.

(c) Kirchhoff's loop rule states that the sum of voltages changing around the loop must be zero. As an example of this, start to the right of the power supply and trace a loop clockwise through the top parallel resistor and then the resistor to the right and back to our starting point. Tracing our changes in voltage:

$$+V - (I/2)R - IR = 0$$

For the entire circuit:

$$V = IR$$

$$6 = I(3)$$

$$I = 2 \text{ amps}$$

Loop rule:

$$+6 - (1)(2) - (2)(2) = 6 - 2 - 4 = 0$$

(d) The lightbulbs get hot very quickly, which increases their electrical resistance. This, in turn, reduces the current measured by the ammeter.

TEST ANALYSIS

NOTE: Because the AP Physics 1 and AP Physics 2 are new exams (first administered in 2015), there is no way of knowing exactly how the raw scores on the exams will translate into a 1, 2, 3, 4, or 5. The formula provided below is based on past practice for the AP Physics B and commonly accepted standards for grading. Additionally, the score range corresponding to each grade varies from exam to exam and thus the ranges provided below are approximate.

AP PHYSICS 1 PRACTICE TEST 1

Section I: Multiple-Choice

Note that the questions requiring two answers are to be graded as completely correct or incorrect.

$$\text{Number correct (out of 50)} = \frac{}{\text{Multiple-Choice Score}}$$

Section II: Free-Response

Grade each question individually using the following scale:

4: completely correct
3: substantially correct with minor errors
2: partially correct with some incorrect parts
1: a few correct attempts made, but no completely correct portions
0: completely incorrect or unanswered

$$\text{Question 1} = \frac{}{\text{(out of 4)}}$$

$$\text{Question 2} = \frac{}{\text{(out of 4)}}$$

$$\text{Question 3} = \frac{}{\text{(out of 4)}}$$

$$\text{Question 4} = \frac{}{\text{(out of 4)}}$$

$$\text{Question 5} = \frac{}{\text{(out of 4)}}$$

$$\text{Total} = \frac{}{\text{(out of 20)}} \times 2.5 = \frac{}{\text{Free-Response Score}}$$

Final Score

$$\frac{}{\text{Multiple-Choice Score}} + \frac{}{\text{Free-Response Score}} = \frac{}{\substack{\text{Final Score} \\ \text{(rounded to the nearest whole number)}}}$$

Final Score Range	AP Score
81–100	5
61–80	4
51–60	3
41–50	2
0–40	1

ANSWER SHEET
Practice Test 2

1. Ⓐ Ⓑ Ⓒ Ⓓ
2. Ⓐ Ⓑ Ⓒ Ⓓ
3. Ⓐ Ⓑ Ⓒ Ⓓ
4. Ⓐ Ⓑ Ⓒ Ⓓ
5. Ⓐ Ⓑ Ⓒ Ⓓ
6. Ⓐ Ⓑ Ⓒ Ⓓ
7. Ⓐ Ⓑ Ⓒ Ⓓ
8. Ⓐ Ⓑ Ⓒ Ⓓ
9. Ⓐ Ⓑ Ⓒ Ⓓ
10. Ⓐ Ⓑ Ⓒ Ⓓ
11. Ⓐ Ⓑ Ⓒ Ⓓ
12. Ⓐ Ⓑ Ⓒ Ⓓ
13. Ⓐ Ⓑ Ⓒ Ⓓ
14. Ⓐ Ⓑ Ⓒ Ⓓ
15. Ⓐ Ⓑ Ⓒ Ⓓ
16. Ⓐ Ⓑ Ⓒ Ⓓ
17. Ⓐ Ⓑ Ⓒ Ⓓ

18. Ⓐ Ⓑ Ⓒ Ⓓ
19. Ⓐ Ⓑ Ⓒ Ⓓ
20. Ⓐ Ⓑ Ⓒ Ⓓ
21. Ⓐ Ⓑ Ⓒ Ⓓ
22. Ⓐ Ⓑ Ⓒ Ⓓ
23. Ⓐ Ⓑ Ⓒ Ⓓ
24. Ⓐ Ⓑ Ⓒ Ⓓ
25. Ⓐ Ⓑ Ⓒ Ⓓ
26. Ⓐ Ⓑ Ⓒ Ⓓ
27. Ⓐ Ⓑ Ⓒ Ⓓ
28. Ⓐ Ⓑ Ⓒ Ⓓ
29. Ⓐ Ⓑ Ⓒ Ⓓ
30. Ⓐ Ⓑ Ⓒ Ⓓ
31. Ⓐ Ⓑ Ⓒ Ⓓ
32. Ⓐ Ⓑ Ⓒ Ⓓ
33. Ⓐ Ⓑ Ⓒ Ⓓ
34. Ⓐ Ⓑ Ⓒ Ⓓ

35. Ⓐ Ⓑ Ⓒ Ⓓ
36. Ⓐ Ⓑ Ⓒ Ⓓ
37. Ⓐ Ⓑ Ⓒ Ⓓ
38. Ⓐ Ⓑ Ⓒ Ⓓ
39. Ⓐ Ⓑ Ⓒ Ⓓ
40. Ⓐ Ⓑ Ⓒ Ⓓ
41. Ⓐ Ⓑ Ⓒ Ⓓ
42. Ⓐ Ⓑ Ⓒ Ⓓ
43. Ⓐ Ⓑ Ⓒ Ⓓ
44. Ⓐ Ⓑ Ⓒ Ⓓ
45. Ⓐ Ⓑ Ⓒ Ⓓ
46. Ⓐ Ⓑ Ⓒ Ⓓ
47. Ⓐ Ⓑ Ⓒ Ⓓ
48. Ⓐ Ⓑ Ⓒ Ⓓ
49. Ⓐ Ⓑ Ⓒ Ⓓ
50. Ⓐ Ⓑ Ⓒ Ⓓ

Practice Test 2

SECTION I: MULTIPLE-CHOICE

Time: 90 minutes
50 questions

> **DIRECTIONS:** Each of the questions or incomplete statements below is followed by four suggested answers or completions. Select the one (or two where indicated) that is best in each case. You have 90 minutes to complete this portion of the test. You may use a calculator and the information sheets provided in the appendix.

1. A block ($m = 1.5$ kg) is pushed along a frictionless surface for a distance of 2.5 meters, as shown above. How much work has been done if a force of 10 newtons makes an angle of 60 degrees with the horizontal?

 (A) Zero
 (B) 12.5 J
 (C) 21.6 J
 (D) 25 J

2. What is the instantaneous power due to the gravitational force acting on a 3-kilogram projectile the instant the projectile is traveling with a velocity of 10 meters per second at an angle of 30 degrees above the horizontal?

(A) 300 W

(B) 150 W

(C) −150 W

(D) −300 W

3. A hockey puck of an unknown mass is sliding along ice that can be considered frictionless with a velocity of 10 meters per second. The puck then crosses over onto a rough floor that has a coefficient of kinetic friction equal to 0.2. How far will the puck travel before friction stops it?

(A) 2.5 m

(B) 5 m

(C) 25 m

(D) Depends on the mass

4. A dart is placed onto a spring. The spring is stretched a distance x. By what factor must the spring's elongation be changed so that the maximum kinetic energy given to the dart is doubled?

(A) 1/2

(B) 2

(C) 4

(D) $\sqrt{2}$

QUESTIONS 5 AND 6 ARE BASED ON THE FOLLOWING INFORMATION:

A 10-kilogram projectile is launched at a 60° angle to the ground with a velocity of 200 m/s. Neglect air resistance.

5. Compare this projectile with a 5-kilogram projectile launched under the same conditions but at a 30° angle. The 5-kilogram projectile will

(A) go higher up and farther along the ground

(B) go equally high and equally far along the ground

(C) neither go as high nor as far along the ground

(D) not go as high but go equally far along the ground

6. As the launch angle is lowered to 45°, the maximum horizontal distance traveled by the projectile will

(A) decrease only

(B) increase only

(C) increase and then decrease

(D) decrease and then increase

7. An object of mass m rests on top of a spring that has been compressed by x meters. The force constant for this spring is k. The mass is not attached to the spring and will shoot upward when the spring is uncompressed. When released, how high will the mass rise?

(A) $mg - kx$

(B) kx^2/mg

(C) $(kx^2/2mg) - x$

(D) $(k/m)^{\frac{1}{2}}x$

8. Which of the following is the best method for finding a spring's force constant k?

(A) Hanging a known mass on the spring and dividing the weight by the length of spring

(B) Hanging several known masses on the spring, taking the average value of the mass, and dividing by the average length of the spring

(C) Hanging several known masses on the spring and finding the area under the curve after plotting force versus extension

(D) Hanging several known masses on the spring and finding the slope of the graph after plotting force versus extension

9. How much of a braking force is applied to a 2,500-kilogram car on the moon ($g = 1.6$ m/s$^2$) that has an initial velocity of 30 meters per second if the car is brought to a stop in 15 seconds?

(A) 5,000 N

(B) 6,000 N

(C) 8,000 N

(D) 25,000 N

10. A 1-kilogram object is moving to the right with a velocity of 6 meters per second. It collides with and sticks to a 2-kilogram mass, which is also moving to the right, with a velocity of 3 meters per second. What happens to the total kinetic energy during this collision?

(A) The kinetic energy is conserved because the collision is elastic.

(B) The kinetic energy is conserved even though the collision is not elastic.

(C) Some kinetic energy is lost during the collision even though total momentum is conserved.

(D) Some kinetic energy is lost during the collision because of the elastic nature of the collision.

11. A ball with a mass of 0.2 kilogram strikes a wall with a velocity of 3 meters per second. It bounces straight back with a velocity of 1 meter per second. What was the magnitude of the impulse delivered to this ball?

 (A) 0.2 kg · m/s
 (B) 0.4 kg · m/s
 (C) 0.6 kg · m/s
 (D) 0.8 kg · m/s

12. Which of the following is an equivalent expression for the maximum velocity attained by a mass m oscillating horizontally along a frictionless surface? The mass is attached to a spring with a force constant k and has an amplitude of A.

 (A) Ak/m
 (B) $A(k/m)^{1/2}$
 (C) mg/kA
 (D) $A2k/m$

13. A 0.5-kilogram mass is attached to a spring with a force constant of 50 newtons per meter. What is the total energy stored in the mass-spring system if the mass travels a distance of 8 cm in one cycle?

 (A) 0.5 J
 (B) 0.01 J
 (C) 0.04 J
 (D) 0.08 J

14. Which of the following expressions is equivalent to the magnitude of the escape velocity in terms of the magnitude of the orbital velocity v for a spacecraft?

 (A) $2v$
 (B) v
 (C) $4v$
 (D) $\sqrt{2}v$

15. Which of the following graphs correctly shows the relationship between magnitude of gravitational force and distance between two masses?

(A)

(B)

(C)

(D)

16. Standing wave nodes in a string occur every 20 cm. If the velocity of the incident waves is equal to 5 m/s and the length of the string is 80 cm, what is the frequency of the waves equal to?
 (A) 25 Hz
 (B) 6.25 Hz
 (C) 12.5 Hz
 (D) 3.125 Hz

17. Is it possible to make two wires of equal electrical resistance if one is made out of a much more conductive material?

 (A) No. The more conductive material will always have a lower resistance.
 (B) No. The less conductive material will always require a greater voltage to produce an equal current.
 (C) Yes. The less conductive wire must be made with a larger cross-sectional area.
 (D) Yes. The more conductive wire must be shorter.

18. A projectile is launched at a 30° angle to the ground with a velocity of 200 m/s. What is its speed at its maximum height?

 (A) 9.8 m/s
 (B) 100 m/s
 (C) 173 m/s
 (D) 200 m/s

19. A conical pendulum consists of a mass m attached to a light string of length L. The mass swings around in a horizontal circle, making an angle θ with the vertical as shown above. What is the magnitude of tension, T, in the string?

 (A) $mg/\cos\theta$
 (B) $mg\cos\theta$
 (C) $mg/\sin\theta$
 (D) $mg\sin\theta$

20. The magnitude of the one-dimensional momentum of a 2-kilogram particle obeys the relationship $p = 2t + 3$. What was the velocity of the particle at $t = 1$ second?

 (A) 5 m/s
 (B) 2 m/s
 (C) 1 m/s
 (D) 2.5 m/s

21. An object is experiencing a nonzero net force. Which of the following statements is most accurate?

 (A) The linear and angular momentums of the object are both definitely changing.
 (B) Although the linear momentum of the object is definitely changing, the angular momentum may not be.
 (C) Although the angular momentum of the object is definitely changing, the linear momentum may not be.
 (D) Neither the linear momentum nor the angular momentum is definitely changing.

22. A car with a 500-newton driver goes over a hill that has a radius of 50 meters as shown above. The velocity of the car is 20 meters per second. What are the approximate force and the direction that the car exerts on the driver?

(A) 900 N, up
(B) 400 N, down
(C) 100 N, up
(D) 500 N, up

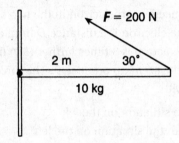

23. What is the net torque acting on the pivot supporting a 10-kilogram beam 2 meters long as shown above?

(A) 198 N · m
(B) −198 N · m
(C) −102 N · m
(D) 102 N · m

24. A trumpet player notices a string on a harp is beginning to vibrate when he plays a certain note on his trumpet. What is this an example of?

(A) Constructive interference
(B) Destructive interference
(C) Refraction
(D) Resonance

25. What is the ratio of the equivalent resistance of 2 resistors R in series to the same 2 resistors in parallel?

(A) 0.5
(B) 1
(C) 2
(D) 4

26. A 12-volt battery is advertised as a "40 amp hour" battery. The manufacturer is expressing that the battery has a capacity of

(A) 144,000 C
(B) 144,000 J
(C) 1,728,000 J
(D) 1,728,000 W

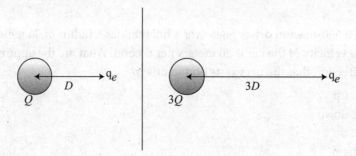

27. Compare the force experienced by an electron in the two situations shown above. In the situation on the left, the electron is a distance D from a positive charge Q. In the situation on the right, the electron is 3 times farther ($3D$) from 3 times as much positive charge ($3Q$) as in the scenario on the left. The force of electrical attraction in the scenario on the right will

(A) remain the same as the situation on the left
(B) be 3 times stronger than the situation on the left
(C) be 3 times weaker than the situation on the left
(D) be 9 times weaker than the situation on the left

28. An old record player could bring a disk up to its 45 RPM speed in less than a second. If the same size disk can also be brought up to a speed of 75 RPM in about the same amount of time on another player, compare the two torques.

(A) The torques would be the same as the moment of inertia of the two disks are the same.
(B) The torques would be the same because of the conservation of angular momentum.
(C) The torque would be larger in the second case as it requires a greater angular acceleration.
(D) The torque would be larger in the second case as it entails both a larger force and a larger lever arm.

QUESTIONS 29–31 REFER TO THE FOLLOWING INFORMATION:

Two small, identical metal spheres are projected at the same time from the same height by two identical spring guns. Each gun provides the same push on its sphere. However, one sphere is projected vertically upward while the other sphere is projected horizontally. The speed of each projectile as it emerges from the gun is the same. Frictional losses are negligible.

29. How does the speed of the vertically launched sphere compare to the speed of the horizontally launched sphere as they each hit the floor?

(A) It is the same.
(B) It is twice as great.
(C) It is greater but not necessarily twice as great.
(D) It is less.

30. How does the time required for the vertically projected sphere to hit the floor compare with that for the horizontally projected sphere?

(A) It is the same.
(B) It is twice as great.
(C) It is greater but not necessarily twice as great.
(D) It is less.

31. How does the work done by gravity to the vertically launched sphere compare to the work done by gravity to the horizontally launched sphere?

(A) It is the same.
(B) It is twice as great.
(C) It is greater but not necessarily twice as great.
(D) It is less.

QUESTIONS 32 AND 33 REFER TO THE FOLLOWING INFORMATION:

A racing car is speeding around a flat, circular track whose radius is 250 m. The car's speed is a constant 50 m/s, and the car has a mass of 2,000 kg.

32. The centripetal force necessary to keep the car in its circular path is provided by

(A) the engine
(B) the brakes
(C) friction
(D) the steering wheel

33. The magnitude of the car's centripetal force is equal to

(A) 10 N
(B) 400 N
(C) 4,000 N
(D) 20,000 N

QUESTIONS 34 AND 35 REFER TO THE FOLLOWING INFORMATION:

Two small masses, X and Y, are d meters apart. The mass of X is 4 times as great as the mass of Y. Mass X attracts mass Y with a gravitational force of 16 N.

34. The force with which Y attracts X is equal to

(A) 4 N
(B) 16 N
(C) 32 N
(D) 64 N

35. If the distance between X and Y is doubled, then X will attract Y with a force of

(A) 4 N
(B) 8 N
(C) 16 N
(D) 32 N

36. A projectile is launched at an angle such that it undergoes projectile motion. In the absence of any air resistance, which of the following statements is correct?

(A) The horizontal velocity increases during the flight.
(B) The horizontal velocity remains constant during the flight.
(C) The horizontal velocity decreases during the flight.
(D) The vertical acceleration changes during the flight.

37. Which of the following charges is NOT possible?

(A) 4.8×10^{-19} C
(B) 4.8×10^{-18} C
(C) 4.8×10^{-20} C
(D) -4.8×10^{-19} C

38. The sound of a moving siren from the west of you that is traveling toward you is transmitted through the air to your ear and is

(A) vibrating in a north-south direction
(B) vibrating in a west-east direction
(C) vibrating up and down
(D) vibrating in a corkscrew fashion

39. The sound of a moving siren from the west of you that is traveling toward you is transmitted through the air to your ear and is

(A) moving faster than the usual speed of sound
(B) heard at a lower frequency than usual
(C) heard at a higher frequency than usual
(D) heard at a lower amplitude than usual

40. A woman standing on a scale in an elevator notices that the scale reads her true weight. From this, she may conclude that

(A) the elevator must be at rest
(B) the elevator must be accelerating precisely at 9.8 m/s$^2$
(C) the elevator must be moving upward
(D) the elevator must not be accelerating

41. A planet has half the mass of Earth and half the radius. Compared with the acceleration due to gravity at the surface of Earth, the acceleration due to gravity at the surface of this planet is

(A) the same
(B) halved
(C) doubled
(D) quadrupled

42. Complete the analogy.

Force is to torque as _____ is to moment of inertia.

(A) momentum
(B) angular momentum
(C) angular acceleration
(D) mass

43. While standing on a moving train, you are suddenly thrown forward as the train stops. This effect can be best explained using Newton's law of

(A) inertia
(B) acceleration
(C) action and reaction
(D) universal gravity

44. For a falling object to reach terminal velocity (a constant downward speed), the magnitude of the force due to air friction must be

(A) negligible
(B) less than mg
(C) equal to mg
(D) greater than mg

45. An object is in free fall for T seconds. Compare its change in velocity during the first $T/2$ seconds with its change in velocity during the final $T/2$ seconds.

(A) They are the same.
(B) They are larger during the first interval.
(C) They are smaller during the first interval by a factor of ½.
(D) They are less than ½ as small during the first interval.

46. Which of the following must be zero if an object is spinning at a constant rate? Select two answers.

(A) Net torque
(B) Moment of inertia
(C) Angular momentum
(D) Angular acceleration

47. Which of the following could be used to calculate the time in flight for a horizontally launched projectile on Earth? Ignore friction. Select two answers.

(A) The launch speed
(B) The final vertical velocity
(C) The final horizontal velocity
(D) The initial height

48. As an ice skater draws her arms inward during a spin, which of the following remain constant? Select two answers.

(A) Her moment of inertia

(B) Her angular momentum

(C) Her angular velocity

(D) Her center of mass

49. A total of three forces, each with a magnitude of 5 N, are exerted on an object with a mass of 15 kg. Which of the following statements are true? Select two answers.

(A) The object may be accelerating at 1 m/s².

(B) The object might not be accelerating.

(C) The object might be accelerating at 2 m/s².

(D) The sum of the components of the object's acceleration must add up to the magnitude of its acceleration ($a_x + a_y = |\mathbf{a}|$).

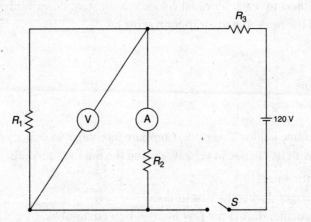

50. In the circuit above, with the switch closed, what will voltmeter *V* read? (*A* is an ammeter.) Select two answers.

(A) The voltage drop across R_1

(B) The voltage drop across ammeter *A*

(C) The voltage drop across R_2

(D) Zero

SECTION II: FREE-RESPONSE

Time: 90 minutes

5 questions

> DIRECTIONS: You have 90 minutes to complete this portion of the test. You may use a calculator and the information sheets provided in the appendix.

1. A group of students have been asked to determine the spring constant k of the following setup. They have a known mass and a very smooth tabletop. The only additional equipment they have is metersticks and rulers.

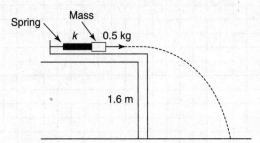

(a) Describe an experimental procedure to determine the spring constant k. You may wish to label the diagram above further to help in your description. Indicate what measurements you would take and how you would take them. Include enough detail so that another student could carry out your procedure.

(b) What are the expected results of the experiment? Determine your independent and dependent variables. Sketch out the expected graph. Derive the relationship you would expect to find.

(c) What common sources of error in your procedure might happen during this investigation? What steps could you take to minimize these errors?

(d) A group of students collected the following data; x is for the spring and D is along the ground. The students found a discontinuity in the behavior of the graph. Graph the data and determine a value for k. Offer a possible explanation for the discontinuity.

x (cm)	D (m)
1	0.21
2	0.41
3	0.59
4	0.8
5	0.99
6	1.19
7	1.22
8	1.28
9	1.34
10	1.46

2. An elevator ride consists of the following portions.

a. Initially, the elevator is on the ground floor and quickly speeds up in the upward direction on its way to the top floor.

b. Most of the trip upward is at a constant velocity.

c. Suddenly, near the top floor, the elevator comes to a stop just in time for the top floor.

d. Now the button for the first floor is pressed, and the elevator speeds downward suddenly.

e. Most of the trip downward is spent at constant velocity.

f. Suddenly, at the very bottom, the elevator comes to a stop.

(a) Draw a qualitative free-body diagram (showing the relative vector sizes) for each portion of the elevator ride as experienced by a passenger. Next to each, describe how the person would feel (normal, heavier than usual, lighter than usual, etc.).

(b) Explain the difference among the passenger's mass, gravitational weight, and apparent weight throughout the trip. When (if ever) are these the same, and when (if ever) are they different? Which quantities change during the trip, and which ones do not?

(c) Describe what would happen if, on the way up (during step (b)), the cables were to break. Ignore any frictional effect between the elevator itself and the elevator shaft. Be sure to include a discussion of the relative motion of the elevator car and the passenger. Your answer should include a discussion or sketch of the height above ground, the velocity, and the acceleration experienced by the passenger from the time of the break until the end of the motion.

(d) Sketch the expected behavior of the person's height as a function of time for situation (c) above. Also sketch the person's V_y as a function of time as well.

3. A long-distance, unmanned probe is sent to another planet. To keep it oriented correctly, the probe is given a lot of spin during the early part of the trip. However, when the probe is getting close to its destination, the spin is no longer desired. Two very long cables with mass at the end of each are extended while the probe is still in deep space. Once extended, the cables are released and the probe begins its landing sequence.

 (a) Explain qualitatively why the spinning will help the probe oriented correctly. Describe the underlying physics concepts using equations and diagrams as needed.

 (b) Explain what is accomplished by the action of extending and releasing the cables near the end of the probe's flight. Describe the underlying physics concepts using equations and diagrams as needed. Do the masses need to be a significant portion of the probe's mass for this procedure to be effective?

 (c) What happens to all of the probe's linear momentum when it lands on its destination planet? Describe qualitatively in terms of physics principles what happens during the landing.

4. Two cars are separated by 25 meters. Both are initially at rest. Then the car in front begins to accelerate uniformly at x meters per second squared. The second car, which is behind, begins to accelerate uniformly at y meters per second squared.

 (a) If the second car must catch up with the car in front within 10 seconds, what type of relationship must exist between y and x? Is there a maximum or minimum difference between the two accelerations? Explain using words and equations.

 (b) Given that the conditions in question (a) are being met (that is, the second car will catch up to the first within 10 seconds), is there any instant in time that the cars will have the same velocity? Will there be any interval of time over which both cars will have the same average velocity? Support your answers with graphs.

 (c) Given that the conditions in question (a) are being met (i.e., the second car will catch up to the first within 10 seconds) and that both cars are continuing to drive with constant velocity for an additional 10 seconds at their instantaneous speeds at the moment the second car has caught up with the first, which car will be ahead and by how much by the end of the trip? Answer this question qualitatively and algebraically. Specially determine the minimum and maximum differences in displacement if they can be found.

 (d) If both cars are on track to meet the conditions in question (a) (that is, the second car will catch up to the first within 10 seconds) but both cars are stopped after traveling 50 meters, which one will have expended the most energy? Assume both cars are identical in mass and fuel efficiency. Choose one of the following options, and justify your choice:

 _____ The first car expended more energy.

 _____ Both cars expended equal energy.

 _____ The second car expended more energy.

 _____ Which car expended more energy requires more knowledge of when exactly the second car catches up to the first car.

5. (a) A fellow student argues that you cannot use the formula $\frac{1}{2}gt^2$ to find the height of a very tall cliff (200 meters or so) when dropping a stone from the top and counting the seconds until impact at the bottom. He says that because of Newton's law of universal gravity, the acceleration is not constant during the fall. Using equations and calculations, both support and refute his argument. Would his argument have had greater, lesser, or the same power to persuade you if he was talking about a cliff on the Moon? Why or why not?

(b) Two masses, M and $9M$, are separated by a distance of d. At what distance and in what direction from the smaller mass should a third mass be placed such that the net gravitational force on this third mass is zero? There are two solutions. Find both.

ANSWER KEY

1. **B**	14. **D**	27. **C**	40. **D**
2. **C**	15. **B**	28. **C**	41. **C**
3. **C**	16. **C**	29. **A**	42. **D**
4. **D**	17. **C**	30. **C**	43. **A**
5. **D**	18. **C**	31. **A**	44. **C**
6. **B**	19. **A**	32. **C**	45. **A**
7. **C**	20. **D**	33. **D**	46. **A, D**
8. **D**	21. **B**	34. **B**	47. **B, D**
9. **A**	22. **C**	35. **A**	48. **B, D**
10. **C**	23. **C**	36. **B**	49. **A, B**
11. **D**	24. **D**	37. **C**	50. **A, C**
12. **B**	25. **D**	38. **B**	
13. **B**	26. **C**	39. **C**	

ANSWERS EXPLAINED

Section I: Multiple-Choice

1. **(B)** Work $= fd\cos 60° = (10\text{ N})(2.5)(0.5) = 12.5$ J

2. **(C)**

 Power $=$ work/time $= (fd\cos 120°)/T = (mg\cos 120°)(D/T)$

 $= (3)(10)(-0.5)(10\text{ m/s}) = -150$ W

3. **(C)**

$$W = \Delta KE$$

$$\mu ND\cos 180° = 0 - \frac{1}{2}mv^2$$

$$(\mu mgD)(-1) = -\frac{1}{2}mv^2$$

$$D = v^2/2\mu g = 100/(2 \times 0.2 \times 10) = 25 \text{ m}$$

4. **(D)** Conservation of energy:

$$KE = EPE = \frac{1}{2}kx^2$$

Since we need x^2 to double, increase x by $(2)^{1/2} = \sqrt{2}$.

5. **(D)** The 30° and 60° angles will have equal ranges but with the roles of V_x and V_y reversed. Therefore, the projectile launched at a 30° angle will not go as high. Note that mass does not enter into projectile motion problems.

6. **(B)** 45° gives the maximum range for a projectile as it is splitting the initial velocity evenly between vertical (giving you time in flight) and horizontal (giving you speed downrange). Angles above or below will have shorter ranges. Approaching the 45° angle will increase the range:

$$\text{Range} = (v_0{}^2/R)\sin 2q$$

7. **(C)**

$$\frac{1}{2}kx^2 = mgh$$

$h = kx^2/2mg$ above the starting point. Since the release point is a distance x above the starting point, we must subtract x from the answer.

8. **(D)** $F = kx$. So when graphing f versus x, k will be the slope. The extension of the spring is x when F is the force applied to the spring.

9. **(A)**

$$\mathbf{F}\Delta t = \Delta \mathbf{p}$$

$$(\mathbf{F})(15\text{ s}) = 0 - (2{,}500)(30) = -75{,}000 \text{ kg}\cdot\text{m/s}$$

$$\mathbf{F} = -5{,}000 \text{ N}$$

The negative sign indicates an opposing force. Note that weight is not needed in this calculation, so the value of g is irrelevant.

10. **(C)** Momentum is always conserved. However, kinetic energy is lost unless the collision is elastic, in which case the kinetic energy is also conserved:

$$\mathbf{p}_i = 1(+6) + 2(+3) = 12 \text{ kg m/s} = \mathbf{p}_f = 3\mathbf{v}_f$$

$$\mathbf{v}_f = 4 \text{ m/s}$$

Initial KE:

$$\left(\frac{1}{2}\right)(1)(6)^2 + \left(\frac{1}{2}\right)(2)(3)^2 = 27 \text{ J}$$

Final KE:

$$\left(\frac{1}{2}\right)(3)(4)^2 = 24 \text{ J}$$

3 joules are lost.

11. **(D)** Impulse $= \Delta\mathbf{p} = \mathbf{p}_f - \mathbf{p}_i = 0.2(-1) - (0.2)(3) = -0.8 \text{ kg} \cdot \text{m/s}$

12. **(B)**

$$\frac{1}{2}kA^2 = \text{total energy when } x = A \text{ (all PE, no KE)}$$

$$\frac{1}{2}mv_{\text{max}}^2 = \text{total energy when } x = 0 \text{ (all KE, no PE)}$$

Conservation of energy:

$$\frac{1}{2}kA^2 = \frac{1}{2}mv_{\text{max}}^2$$

$$v_{\text{max}} = (k/m)^{\frac{1}{2}}A$$

13. **(B)** In one cycle, the mass travels 4 amplitudes:

$$A = 0.02 \text{ m}$$

$$\text{Energy} = \frac{1}{2}kA^2 = \frac{1}{2}(50)(0.02)^2 = 0.01 \text{ J}$$

14. **(D)** Orbital velocity:

$$F_g = \text{centripetal force} = mv^2/R$$

$$GMm/R^2 = mv^2/R$$

$$v = (GM/R)^{\frac{1}{2}}$$

Escape velocity:

$$E_{\text{total}} > 0$$

$$\text{KE} + \text{PE} > 0$$

$$\frac{1}{2}mv^2 - GMm/R > 0 \text{ (using universal gravitational PE)}$$

$$v > (2GM/R)^{\frac{1}{2}}$$

15. **(B)** The gravitational force between two masses has a $1/R^2$ relationship (where R is the distance from center to center). Graph B shows the correct inverse relationship.

16. **(C)** Since node to node is half a wavelength:

$$\lambda = 0.4 \text{ m}$$

$$f = v/\lambda = 5/0.4 = 12.5 \text{ Hz}$$

17. **(C)** Resistivity is only part of the resistance of a wire:

$$R = \rho L / A$$

Therefore, a less conductive material (lower ρ) can be made equal in resistance to a more conductive material by making the less conductive material shorter and/or fatter (lower L or larger A).

18. **(C)** At maximum height, all speed is from V_x:

$$V_x = 200 \cos 30° = 173 \text{ m/s}$$

19. **(A)** Vertical forces must cancel:

$$T\cos\theta - mg = 0$$
$$T = mg/\cos\theta$$

20. **(D)** $v = p/m = (2 \times 1 + 3)/2 = 2.5 \text{ m/s}$

21. **(B)** Since $F\Delta t = \Delta p$, a net force will change the linear momentum. However, torque also involves the lever arm ($\tau = RF\sin\theta$). So despite having a nonzero net force, the net torque might still be zero.

22. **(C)** Circular motion:

$$F_{\text{net}} = mv^2/R$$
$$mg - N = mv^2/R$$

N is the force the car exerts on the driver:

$$mg - mv^2/R = (500 - 50)(20^2)/50 = 500 - 400 = 100 \text{ N}$$

Note that the correct answer can be found by simply knowing that the net force must be down and that the car must be pushing upward on the passenger.

23. **(C)** Take the center of mass to be 1 meter from the pivot:

$$\text{Net torque} = +mg(1)\sin 90° - 200(2)\sin 30°$$
$$= 98 - 200 = -102 \text{ N} \cdot \text{m}$$

24. **(D)** Resonance is the sympathetic vibration of an object when impacted by a wave with the same frequency as its own fundamental frequency of oscillation.

25. **(D)**

$$\text{Resistors in series} = 2R$$

$$\text{Resistors in parallel} = R/2$$

$$\text{Difference} = 1.5R$$

$$\text{Ratio} = 2R/(R/2) = 4$$

26. **(C)** Batteries store energy, which is measured in joules:

$$\text{Energy} = \text{power} \times \text{time} = I \times V \times \text{time} = (40\,\text{A})(12\,\text{V})(3{,}600\,\text{s})$$
$$= 1{,}728{,}000\,\text{J}$$

27. **(C)** Coulomb's law is kQ_1Q_2/R^2. Tripling Q_1 triples the force. Tripling R makes the force 9 times weaker. Net effect:

$$3 \times 1/9 = 1/3$$

28. **(C)**

$$\text{Torque} = I\alpha$$

$$\alpha = \text{angular acceleration} = \Delta\omega\,/\,\Delta t$$

Our only data provided are that the angular acceleration must be larger for the 75 RPM record and that the moment of inertia has not changed (same disk). Therefore, the torque supplied must be larger.

29. **(A)** Remember conservation of energy. Since both start at the same height (same PE) with the same kinetic energy, they will both hit the ground with same joules of energy (all KE). The same KE means the same speed since their masses are the same. Note that this does not imply that both components of velocity are the same. They are not. This implies that only the magnitudes of the final velocity vectors are the same.

30. **(C)** The vertically projected sphere will spend much more time in the air as it goes much higher. Without knowing the exact speed of the launch, it is not possible to say by what factor the time in flight is extended.

31. **(A)** The change in gravitational potential energy is the same for both. Therefore the work done by gravity is the same.

32. **(C)** Friction is the only force that is directed inward toward the center of the circle. By definition, all centripetal forces must be directed inward. To confirm this, imagine the path the car would take on a firictionless stretch of track.

33. **(D)** $mv^2/r = (2,000 \times 50^2)/250 = 20,000$ N

34. **(B)** Remember Newton's third law. The forces are equal and opposite.

35. **(A)** Universal gravity is a $1/R^2$ law. Doubling R makes the force 4 times weaker.

36. **(B)** No horizontal acceleration means no change in horizontal velocity.

37. **(C)** Charge is quantized (comes in integer multiples only) in units of $\pm1.6 \times 10^{-19}$ C.

38. **(B)** Sound is a longitudinal wave.

39. **(C)** The Doppler shift of waves that occurs when the source and receiver are moving toward each other causes a shorter wavelength and hence a higher frequency.

40. **(D)** The elevator must be traveling at constant velocity to insure the normal force (reading on the scale) is the same as her true weight. However, this velocity value can be any number: positive, zero, or negative.

41. **(C)** Remember that $g = Gm/R^2$. Half the mass means half the g. Half the R means $4 \times g$. Collect the changes:

$$\frac{1}{2} \times 4 = 2$$

42. **(D)** Forces cause mass to accelerate linearly. Torques cause moments of inertia to acceleration angularly.

43. **(A)** Inertia is the tendency of an object to continue its motion in the absence of other forces. As the train stops, the passengers continue forward until a force is brought to bear directly on them.

44. **(C)** Constant velocity means no acceleration. No acceleration means no net force. The friction opposing weight must be equal in magnitude to that weight.

45. **(A)** Constant acceleration means precisely that. For the same time interval, the change in velocity will be the same.

46. **(A) and (D)** Constant angular velocity means zero angular acceleration, which means no net torque.

47. **(B) and (D)** Since the vertical velocity is zero, only height is needed to determine the drop time:

$$H = \frac{1}{2}gt^2$$

Knowing the final vertical velocity would also allow one to determine the time since:

$$V_{yf} = 0 - gt$$

48. **(B) and (D)** The skater's center of mass must remain above her skates. Since no external torques are involved in drawing her arms inward, her momentum is conserved. Note that her moment of inertia decreases and her angular velocity increases.

49. **(A) and (B)** If the 3 forces are in the same direction, $F_{net} = 15$ N, which is the maximum possible force. In this situation, the acceleration is 1 m/s². If the 3 forces are 120° apart from each other in direction, they would add up to zero and produce no acceleration.

50. **(A) and (C)** Both R_1 and R_2 are connected in parallel to the same two points that the voltmeter is measuring the potential difference between. Therefore, the voltmeter reading is that same voltage drop for both R_1 and R_2. Note that an ideal ammeter has no resistance and thus experiences no voltage drop itself.

Section II: Free-Response

1. (a) For various measured compressions of the spring (x), measure horizontal range for the mass (R). Range should be measured along the floor from beneath the edge of the table to where the mass first hits the ground. Multiple trials for each compression x should be taken so that the average range of values can be determined.

 (b) The independent variable is the one the experimenter controls and manipulates directly. In this case, the independent variable is the compression x. The dependent variable is the one measured as a result of changes in the independent variable. In this case, the dependent variable is the range. Independent variables are graphed on the horizontal axis. Theoretical prediction:

$$\frac{1}{2}kx^2 = \frac{1}{2}mv^2$$

$$v = (k/m)^{1/2}x$$

This velocity is the horizontal projectile's velocity. The time in flight is found from the height of the table:

$$H = \frac{1}{2}gt^2$$

$$1.6 \text{ m} = 4.9t^2$$

$$t = 0.57 \text{ s}$$

$$R = vt = (k/m)^{\frac{1}{2}}xt = .57(k/m)^{\frac{1}{2}}x$$

Using the fixed values for m and t:

$$R = 0.806k^{\frac{1}{2}}x$$

(c) The major source of error is friction of the tabletop between the end of the spring and the edge of the table. Ensuring that this distance is small and that the surfaces involved are smooth will minimize this error.

(d)

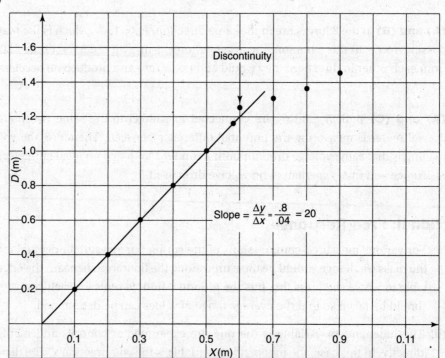

The discontinuity is probably caused by exceeding the limit of elasticity for this spring. Hooke's law assumes that the material is perfectly elastic and resumes its shape after being stretched or compressed:

$$\text{Slope} = 20 = 0.806k^{\frac{1}{2}} \text{ (from part (b))}$$

Solving for k:

$$k = 616 \text{ N/m}$$

2. (a)

a. **N** Upward acceleration, feel heavy

mg

b. **N** No acceleration, feel normal

mg

c. **N** Downward acceleration, feel light

mg

d. **N** Downward acceleration, feel light

mg

e. **N** No acceleration, feel normal

mg

f. **N** Upward acceleration, feel heavy

mg

(b) A person's mass is a measure of his or her inertia. This value does not change due to acceleration or changes in location. Gravitational weight is a force due to the interaction of the person's mass and the planet on which he or she is standing (including the distance between their centers). Although technically this value is slightly smaller as you get higher above sea level, the differences within a building on Earth are negligible. Apparent weight is the contact forces your body experiences, which give you your subjective experience of "weight." In this case, the normal force and the changing values of the normal force explain the changes the person would experience on the elevator ride.

(c) The elevator and passenger would experience free fall. The only force would be the downward $m\mathbf{g}$, and the normal force would be zero. Hence, the person would feel weightless. Since the car was on the way up when the cables broke, both passenger and elevator would maintain the same relative velocity to each other as both continued upward, slowed down, and then reversed direction and continued to speed up while falling. The entire time, the passenger would feel weightless.

(d)

3. (a) The spinning probe acts as a gyroscope since angular momentum is both a vector and conserved. The direction of the angular momentum requires an external torque to be changed. Therefore, barring some outside force, the probe will maintain the orientation it has when the angular velocity is given to its moment of inertia:

$$\mathbf{L} = I\omega$$

(b) By extending the masses outward from the probe's body, the moment of inertia of the spinning probe can be greatly increased. Note that the masses need not be that great in order to change the moment of inertia substantially as the distance, R, from the axis of rotation can be made quite large by using a long cable and the R term is squared in the moment of inertia calculation:

$$I = mR^2$$

Increasing the moment of inertia serves to slow the spin rate of the probe by decreasing the angular velocity in order to conserve angular momentum:

$$\mathbf{L} = I_{small}\omega_{large} = I_{large}\omega_{small}$$

(c) Linear momentum ($m\mathbf{v}$) of the probe-planet system must be conserved. Equal and opposite impulses ($\mathbf{F}\Delta t$) are delivered to the probe and the planet during impact. However, because of their vastly different masses, what is a major impulse to the probe turns out to be a moderate impulse to the entire planet and has almost no perceptible effect on the planet's motion:

$$M_{probe}\Delta\mathbf{V}_{big} - M_{big}\Delta\mathbf{V}_{small} = 0$$

4. (a) When the cars meet, the position of each car, relative to a common origin, must be the same. Since each car is starting from rest and accelerating uniformly:

$$d_1 = d_2$$

$$\frac{1}{2}xt^2 + 25 = \frac{1}{2}yt^2$$

$$y - x = 50/t^2$$

Clearly, the second car must have a larger acceleration ($y > x$). The difference between the two accelerations must increase as time to catch up (t) gets smaller. So there is no upper limit on how much faster car y must accelerate than car x to catch up within 10 seconds. There is, however, a lower limit on the difference. This can be found by examining the case when the second car takes the full 10 seconds:

$$y - x = 50/t^2 = 50/100 = 0.5$$

Thus we see that for the second car to catch up with the lead car within the first 10 seconds, the second car must accelerate at least 0.5 m/s² faster than the first car.

(b) No, they will never have either the same instantaneous speed or the same average speed. The second car is always faster:

The second car has a slope of y on this graph, while the first car has a slope of x. Since $y > x$, one can see that neither the instantaneous nor the average slopes of either of these plots is ever the same.

(c) The second car will be ahead as it will have the higher speed when the two meet Therefore, for the rest of the trip, the second car will cover more ground and come out ahead. To find out by how much, we can compare their speed when they meet:

$$v_1 = xt \qquad v_2 = yt$$

where t is the exact time (within the first 10 seconds) when they meet.

$$\Delta d = v_2(10) - v_1(10) = 10(yt - xt) = (y - x)10t$$

Substitute our algebraic expression from part (a):

$$\Delta d = 500/t$$

Once again, there is no upper bound on the difference in distance. However, there is a lower bound that can be found by setting t equal to 10 seconds:

$$\Delta d > 50 \text{ m}$$

(d) __X__ The second car expended more energy.

No matter the details, more work was done in moving the second car as it had the greater acceleration. Greater acceleration (with the same mass) means greater force. Since the displacements are the same, the greater force means more work:

$$W = Fd$$

5. (a) First, technically your fellow student is correct. As the top of the cliff is 200 meters farther from the center of Earth, the gravitational field experienced by the rock at the top of the cliff is technically weaker:

$$g_{top} = GM_{Earth}/(R + 200)^2 \quad \text{versus} \quad g_{bottom} = GM_{Earth}/(R)^2$$

Since the radius of Earth is 6.38×10^6 m, adding a mere 200 m does not make much of a difference:

$$200/(6.38 \times 10^6) = 3 \times 10^{-5}$$

Therefore for all practical purposes, the difference in gravitational field strength is so minimal that treating g as a constant acceleration is fairly reasonable.

On the moon, one would expect a greater deviance since 200 meters is a greater fraction of the Moon's radius (1.7×10^6). However, any decrease in the moon's gravitational effects would also be negligible;

$$200/(1.7 \times 10^6) = 1 \times 10^{-4}$$

(b) Somewhere along a line between M and $9M$ but closer to M should be a position such that the force of attraction for M will cancel the force of attraction for $9M$. Let the distance between the third mass (m) and M be x:

$$GmM/x^2 = Gm(9M)/(d - x)^2$$

Cancel and simplify:

$$9x^2 = (d - x)^2$$

Take the square root of both sides:

$$\pm 3x = d - x$$

This leads us to two solutions:

$$x = d/4$$

which is the expected solution between the masses and

$$x = -d/2$$

which is an unexpected solution on the outside of mass M along the same line. Note that in both solutions, the new mass m is 3 times farther away from $9M$ than it is from M.

TEST ANALYSIS

NOTE: Because the AP Physics 1 and AP Physics 2 are new exams (first administered in 2015), there is no way of knowing exactly how the raw scores on the exams will translate into a 1, 2, 3, 4, or 5. The formula provided below is based on past practice for the AP Physics B and commonly accepted standards for grading. Additionally, the score range corresponding to each grade varies from exam to exam and thus the ranges provided below are approximate.

AP PHYSICS 1 PRACTICE TEST 2

Section I: Multiple-Choice

Note that the questions requiring two answers are to be graded as completely correct or incorrect.

Number correct (out of 50) = $\overline{\text{Multiple-Choice Score}}$

Section II: Free-Response

Grade each question individually using the following scale:

4: completely correct
3: substantially correct with minor errors
2: partially correct with some incorrect parts
1: a few correct attempts made, but no completely correct portions
0: completely incorrect or unanswered

Question 1 = $\overline{\text{(out of 4)}}$

Question 2 = $\overline{\text{(out of 4)}}$

Question 3 = $\overline{\text{(out of 4)}}$

Question 4 = $\overline{\text{(out of 4)}}$

Question 5 = $\overline{\text{(out of 4)}}$

Total = $\overline{\text{(out of 20)}} \times 2.5 = \overline{\text{Free-Response Score}}$

Final Score

$\overline{\text{Multiple-Choice Score}} + \overline{\text{Free-Response Score}} = \overline{\underset{\text{(rounded to the nearest whole number)}}{\text{Final Score}}}$

Final Score Range	AP Score
81–100	5
61–80	4
51–60	3
41–50	2
0–40	1

ANSWER SHEET
Practice Test 1

AP PHYSICS 2—TEST 1

1. Ⓐ Ⓑ Ⓒ Ⓓ
2. Ⓐ Ⓑ Ⓒ Ⓓ
3. Ⓐ Ⓑ Ⓒ Ⓓ
4. Ⓐ Ⓑ Ⓒ Ⓓ
5. Ⓐ Ⓑ Ⓒ Ⓓ
6. Ⓐ Ⓑ Ⓒ Ⓓ
7. Ⓐ Ⓑ Ⓒ Ⓓ
8. Ⓐ Ⓑ Ⓒ Ⓓ
9. Ⓐ Ⓑ Ⓒ Ⓓ
10. Ⓐ Ⓑ Ⓒ Ⓓ
11. Ⓐ Ⓑ Ⓒ Ⓓ
12. Ⓐ Ⓑ Ⓒ Ⓓ
13. Ⓐ Ⓑ Ⓒ Ⓓ
14. Ⓐ Ⓑ Ⓒ Ⓓ
15. Ⓐ Ⓑ Ⓒ Ⓓ
16. Ⓐ Ⓑ Ⓒ Ⓓ
17. Ⓐ Ⓑ Ⓒ Ⓓ

18. Ⓐ Ⓑ Ⓒ Ⓓ
19. Ⓐ Ⓑ Ⓒ Ⓓ
20. Ⓐ Ⓑ Ⓒ Ⓓ
21. Ⓐ Ⓑ Ⓒ Ⓓ
22. Ⓐ Ⓑ Ⓒ Ⓓ
23. Ⓐ Ⓑ Ⓒ Ⓓ
24. Ⓐ Ⓑ Ⓒ Ⓓ
25. Ⓐ Ⓑ Ⓒ Ⓓ
26. Ⓐ Ⓑ Ⓒ Ⓓ
27. Ⓐ Ⓑ Ⓒ Ⓓ
28. Ⓐ Ⓑ Ⓒ Ⓓ
29. Ⓐ Ⓑ Ⓒ Ⓓ
30. Ⓐ Ⓑ Ⓒ Ⓓ
31. Ⓐ Ⓑ Ⓒ Ⓓ
32. Ⓐ Ⓑ Ⓒ Ⓓ
33. Ⓐ Ⓑ Ⓒ Ⓓ
34. Ⓐ Ⓑ Ⓒ Ⓓ

35. Ⓐ Ⓑ Ⓒ Ⓓ
36. Ⓐ Ⓑ Ⓒ Ⓓ
37. Ⓐ Ⓑ Ⓒ Ⓓ
38. Ⓐ Ⓑ Ⓒ Ⓓ
39. Ⓐ Ⓑ Ⓒ Ⓓ
40. Ⓐ Ⓑ Ⓒ Ⓓ
41. Ⓐ Ⓑ Ⓒ Ⓓ
42. Ⓐ Ⓑ Ⓒ Ⓓ
43. Ⓐ Ⓑ Ⓒ Ⓓ
44. Ⓐ Ⓑ Ⓒ Ⓓ
45. Ⓐ Ⓑ Ⓒ Ⓓ
46. Ⓐ Ⓑ Ⓒ Ⓓ
47. Ⓐ Ⓑ Ⓒ Ⓓ
48. Ⓐ Ⓑ Ⓒ Ⓓ
49. Ⓐ Ⓑ Ⓒ Ⓓ
50. Ⓐ Ⓑ Ⓒ Ⓓ

AP Physics 2

Practice Test 1

SECTION I: MULTIPLE-CHOICE

Time: 90 minutes
50 questions

> DIRECTIONS: Each of the questions or incomplete statements below is followed by four suggested answers or completions. Select the one (or two where indicated) that is best in each case. You have 90 minutes to complete this portion of the test. You may use a calculator and the information sheets provided in the appendix.

1. Which materials have the highest heat conductivity?

 (A) Gases because the individual particles move the fastest
 (B) Gases because they are the easiest to ionize
 (C) Metals because they are ductile and malleable
 (D) Metals because they have conduction layers

2. A gas is not able to do work under which of the following circumstances?

 (A) Isobaric because pressure is required for work to be done
 (B) Isobaric because constant force will produce no work
 (C) Isochoric because constant shape implies no changes in energy
 (D) Isochoric because no change in volume implies no displacement

3. Which of the following materials will exert the highest pressure on its bottom surface?

 (A) 1 liter of water in a puddle on the ground
 (B) 1 liter of water, frozen into a cube on the ground
 (C) 1 liter of water in a tall, thin, vertical tube
 (D) 1 liter of water, frozen into a cube, floating in liquid water

4. Heating up a gas by 100 degrees would require the least amount of energy if those degrees were

 (A) Kelvin since there are no negative Kelvin degrees

 (B) Celsius since water boils at 100 degrees Celsius

 (C) Kelvin since absolute zero is zero in Kelvin

 (D) Fahrenheit since each of its degree changes are smaller than those in either the Celsius or Kelvin scales

QUESTIONS 5 AND 6 ARE BASED ON THE FOLLOWING GRAPHS:

5. Which graph best represents the relationship between pressure and volume for an ideal confined gas at constant temperature?

 (A) I

 (B) II

 (C) III

 (D) IV

6. Which graph best represents the relationship between the average kinetic energy of the molecules in an ideal gas and its absolute temperature?

(A) I
(B) II
(C) III
(D) IV

7. The diagram above shows a leaf electroscope that has been charged positively by a negatively charged rod. Which of the following statements is correct?

(A) The electroscope was charged by conduction.
(B) The electroscope was charged by contact.
(C) If the rod is brought closer, protons will move to the top of the electroscope.
(D) If the rod is brought closer, electrons will be repelled from the top of the electroscope.

QUESTIONS 8 AND 9 ARE BASED ON THE CIRCUIT SHOWN BELOW:

8. What is the maximum charge stored in the 2-farad capacitor?

(A) 4 C
(B) 16 C
(C) 10 C
(D) 8 C

9. What is the maximum energy stored in the 8-farad capacitor?

 (A) 64 J

 (B) 256 J

 (C) 32 J

 (D) 128 J

10. What is the equivalent capacitance of the circuit shown above?

 (A) 7/10 F

 (B) 10/7 F

 (C) 7 F

 (D) 14/5 F

11. An electron (charge e, mass m) is trapped in a circular path because of a uniform perpendicular magnetic field **B**. The velocity of the electron is **v**, and the radius of the path is r. Which of the following expressions represents the angular velocity ω?

 (A) $(\mathbf{B}er/m)^{\frac{1}{2}}$

 (B) $(\mathbf{B}e/rm)^{\frac{1}{2}}$

 (C) $\mathbf{B}e/m$

 (D) $2\pi\mathbf{B}e/m$

QUESTIONS 12 AND 13 ARE BASED ON THE FOLLOWING INFORMATION AND DIAGRAM:

$$\times \times \times \times$$
$$\times \times \times \times$$
$$\times \times \boxed{\times \times} \quad v = 4\,\tfrac{m}{s} \longrightarrow$$
$$\times \times \boxed{\times \times}$$
$$0.2\ m$$
$$\times \times \times \times$$

$B = 10\ T$

A square wire frame is pulled to the right with a velocity of 4 meters per second across and out of an inward uniform magnetic field of strength 10 teslas. The length of each side of the frame is 0.2 meter.

12. What is the magnitude of the induced motional electromotive force in the wire as it leaves the field?

(A) 40 V

(B) 20 V

(C) 8 V

(D) 16 V

13. As the wire is moved to the right, a force appears to oppose it. This force's opposing direction is best explained by

(A) Lenz's law because an opposing force keeps the flux from changing

(B) Faraday's law because the changing flux induces emf

(C) Lenz's law because the force must be in the negative direction

(D) Faraday's law since decreasing flux always produces negative forces

14. A shadow is formed by a point source of light. Upon closer inspection, the edges of the shadow seem to be diffuse and fuzzy. This phenomenon is probably caused by

(A) dispersion as the different wavelengths of light focus at different points

(B) refraction as the rays are bent by their contact with the shadow-forming surface

(C) diffraction as the waves nearest the edge of the shadow-forming surface are sources for waves going into the shadow region

(D) dispersion as the different wavelengths are traveling at slightly different speeds in the new medium

15. A light ray is incident on a glass-air interface as shown above. Which path will the light ray follow after it enters the air?

(A) *A* or *B*

(B) *B* or *C*

(C) *E*

(D) *D*

16. As the angle of incidence for a ray of light passing from glass to air increases, the critical angle of incidence for the glass

(A) increases

(B) decreases

(C) increases and then decreases

(D) remains the same

17. Which of the following statements about a diverging mirror is correct?

 (A) The mirror must be concave in shape.
 (B) The images are sometimes larger than the actual objects.
 (C) The images are always upright.
 (D) The images are sometimes real.

18. Which of the following waves cannot be polarized?

 (A) Sound waves because they are longitudinal
 (B) Waves on a string because they lack amplitude
 (C) X rays because they are too short
 (D) Microwaves because they have too low of a frequency

19. The "flapping" of a flag in the wind is best explained using

 (A) Archimedes' principle
 (B) Bernoulli's principle
 (C) Newton's principle
 (D) Pascal's principle

20. In a photoelectric effect experiment, the emitted electrons could be stopped with a retarding potential of 12 volts. What was the maximum kinetic energy of these electrons?

 (A) 1.92×10^{-18} J
 (B) 12 J
 (C) 1.6×10^{-19} eV
 (D) 1.92×10^{-18} eV

21. As a single photon of light enters a new medium with a higher index of refraction, the photon's energy

 (A) decreases as the wave speed is now lower
 (B) decreases as its wavelength is now shorter
 (C) remains constant because its speed is the same
 (D) remains constant because its frequency remains the same

22. If an electron and an alpha particle were moving with the same velocity, which one would have the smaller de Broglie wavelength?

 (A) The electron since its charge is negative
 (B) The electron since it has only one unit of elementary charge
 (C) The alpha particle since it is heavier
 (D) The alpha particle since it has two units of elementary charge

QUESTIONS 23 AND 24 ARE BASED ON THE FOLLOWING SIMULATED ENERGY LEVEL DIAGRAM FOR A MYTHICAL HYDROGEN-LIKE ATOM:

5 ————————————	−4.2 eV
4 ————————————	−5.7 eV
3 ————————————	−6.3 eV
2 ————————————	−8.2 eV
1 ————————————	−15.2 eV

23. How much energy is required to ionize an atom with an electron in level 3?

 (A) 8.1 eV
 (B) 6.3 eV
 (C) 15.2 eV
 (D) 2.5 eV

24. Which of the following level transitions will result in the emission of a photon with the highest frequency?

 (A) 1 to 3
 (B) 5 to 2
 (C) 1 to 2
 (D) 2 to 1

25. One atomic mass unit is defined to be equal to

 (A) 1/2 the mass of a hydrogen molecule
 (B) 1/12 the mass of the carbon atom
 (C) 1/16 the mass of the oxygen atom
 (D) the mass of an isolated proton

26. How many neutrons are contained in the isotope $^{238}_{92}\text{U}$?

 (A) 92
 (B) 100
 (C) 146
 (D) 330

27. In the reaction below, what is the mass number for particle X?

$$^{27}_{13}\text{Al} + ^{4}_{2}\text{He} \rightarrow ^{30}_{15}\text{P} + \text{X}$$

 (A) 1
 (B) 2
 (C) 0
 (D) −1

28. A device that takes mechanical energy and converts it into electrical energy is

 (A) a solenoid
 (B) an electric motor
 (C) a transformer
 (D) a generator

29. Radon gas ($^{222}_{86}\text{Rn}$) is radioactive with a half-life of 4 days as it undergoes alpha decay. A sample is sealed in an evacuated tube for more than 1 week. At that time, the presence of a second gas is detected. This gas is most probably

 (A) hydrogen
 (B) helium
 (C) nitrogen
 (D) argon

30. According to the scale of binding energy per nucleon, which atom has the most stable nuclear isotope?

 (A) Hydrogen because it cannot decay into anything
 (B) Hydrogen because it can exist with only one nucleon
 (C) Iron because its nucleons are the most tightly bound
 (D) Iron because it is in the middle of the periodic table

31. The colors observed in thin films like soap bubbles are caused by

 (A) reflection and interference
 (B) refraction and reflection
 (C) diffraction and interference
 (D) polarization and reflection

32. As the number of lines per cm on a diffraction grating is increased (or the slit spacing is decreased in a two-slit diffraction pattern),

 (A) the spacing between the spectral lines increases
 (B) the spacing between the spectral lines decreases
 (C) the intensity of the spectral lines increases
 (D) the intensity of the spectral lines decreases

33. Which is storing more energy, a 20-microfarad capacitor charged up by a 6-volt source or a 10-microfarad capacitor charged up by a 12-volt source?

 (A) They both store the same amount of energy.
 (B) Neither is storing energy.
 (C) The 20-microfarad capacitor is storing more energy.
 (D) The 10-microfarad capacitor is storing more energy.

34. What is the function of a moderator in a fission reactor?

 (A) Control the number of neutrons
 (B) Act as a source of fissionable material
 (C) Control the costs of running the reactor
 (D) Control the half-life of the radioactive material

35. Compare the energy and speed of a 30 MHz photon with those of a 15 MHz photon.

 (A) They have the same speed and energy.
 (B) The 30 MHz photon has higher speed and energy.
 (C) The 30 MHz photon has higher energy but the same speed.
 (D) The 30 MHz photon has lower energy but the same speed.

36. An electric motor has an effective resistance of 30 ohms, using 4 amperes of current when plugged into a 120-volt outlet. As the motor heats up, its effective resistance increases. Which statement best describes the power consumption of the motor?

 (A) It starts off at 480 W and goes down from there as 4^2R as it heats up.
 (B) It starts off at 480 W and goes up from there as 4^2R as it heats up.
 (C) It starts off at 480 W and goes down from there as $120^2/R$ as it heats up.
 (D) It starts off at 480 W and goes up from there as $120^2/R$ as it heats up.

37. Which of the following correctly describes the magnetic field near a long, straight wire?

(A) The field consists of straight lines perpendicular to the wire.
(B) The field consists of straight lines parallel to the wire.
(C) The field consists of radial lines originating from the wire.
(D) The field consists of concentric circles centered on the wire.

38. Electrons are being shot into a uniform magnetic field. The angles of the electrons' velocity vary as they are being shot. A magnetic force will be exerted on all electrons except those that are

(A) perpendicular to the field
(B) parallel to the field
(C) at a 45° angle to the field
(D) either perpendicular or parallel to the field, depending on the strength of the field

39. On which of the following does the magnetic field inside a solenoid of N turns not depend?

(A) The core material
(B) The length of the solenoid
(C) The radius of the solenoid
(D) The number of turns of wire

40. Which of the following statements about the adiabatic expansion of an ideal gas is correct?

(A) The temperature may change during the expansion.
(B) The process must be isothermal.
(C) No change will occur in the internal energy.
(D) The gas cannot do any work during the expansion.

41. Which of the following processes is not involved in an ideal Carnot cycle?

(A) Isothermal expansion
(B) Isobaric expansion
(C) Adiabatic expansion
(D) Adiabatic compression

42. A charged rod attracts a suspended pith ball. The ball remains in contact with the rod for a few seconds and then is visibly repelled. Which of the following statements must be correct?

(A) The pith ball is negatively charged at the end of the process.
(B) The rod is negatively charged.
(C) The pith ball remained neutral throughout the process.
(D) The rod has less charge on it at the end of the process than at the beginning.

43. The ratio of Coulomb's constant k to the magnetic constant k is equal, where c is the speed of light, to

 (A) c^2
 (B) c
 (C) \sqrt{c}
 (D) $2c$

44. Comparing gravitational fields to electric fields shows that they are very similar. Which of the following is a major difference?

 (A) Gravitational fields do not have direction, whereas electric fields do.
 (B) Gravitational fields do not have equipotential lines associated with them, whereas electric fields do.
 (C) Gravitational field lines show the direction of force for positive mass, whereas electric field lines show the direction for negative charge.
 (D) Gravitational field lines do not have sources, whereas electric field lines can be sourced by positive charges.

45. Bernoulli's equation for fluids is essentially

 (A) Newton's laws for fluids
 (B) energy conservation for fluids
 (C) momentum conservation for fluids
 (D) Bernoulli's equation is not based on any of these

46. Which of the following transformations could a transformer accomplish? Select two answers.

 (A) Increasing input AC voltage
 (B) Increasing input AC current
 (C) Increasing input DC voltage
 (D) Increasing input DC current

47. Which of the following are synonyms for voltage? Select two answers.

 (A) Electromotive force
 (B) Electrical potential energy
 (C) Potential difference
 (D) amp · hr

48. Which of the following can produce polarized light? Select two answers.

 (A) A liquid crystal display (LCD)
 (B) Reflection
 (C) Refraction
 (D) Fluorescent bulbs

```
5 ————————————————  −4.2 eV
4 ————————————————  −5.7 eV
3 ————————————————  −6.3 eV
2 ————————————————  −8.2 eV

1 ————————————————  −15.2 eV
```

49. What energies could be associated with a photon emitted during an overall transition from level 4 to level 2 of the diagram above? Select two answers.

 (A) 1.9 eV
 (B) 5.7 eV
 (C) 2.5 eV
 (D) 6.3 eV

50. The electric field near the surfaces of a rectangular solid conducting object with 15 microcoulombs of extra charge can be described as which of the following? Select two answers.

 (A) Directed normally outward near the outside surfaces
 (B) Uniform in strength near all outside surfaces
 (C) Zero on the inside
 (D) Directed normally inward near the inside surfaces

SECTION II: FREE-RESPONSE

Time: 90 minutes
4 questions

> **DIRECTIONS:** You have 90 minutes to complete this portion of the test. You may use a calculator and the information sheets provided in the appendix.

1. A laser of unknown wavelength is provided to students along with a screen with two closely spaced slits (1.67 μm) cut in it. Students are also provided with metersticks.

 (a) Describe an experimental procedure to determine the wavelength of the laser. You may include a labeled diagram of your setup to help in your description. Indicate what measurements you would take and how you would take them. Include enough detail so that another student could carry out your procedure.

 (b) What are the common sources of error or expected deviations from ideal results that might happen during this investigation?

 (c) If the wavelength of the laser is 632.8 nm and the two-slit screen indicates spacing of 1.67 μm, determine some reasonable expected measurement a student might make in the procedure outlined above. Estimate a margin of error for each measurement, and justify this margin of error.

2. Use the electric field drawing below to answer the questions. *A, B,* and *C* are physical sources of charge. Points *e, d,* and *f* are points within the field.

(a) Describe the relative amount of charge and type (positive or negative) at each of locations *A*, *B*, and *C*. Explain your answers.

(b) Rank the relative strength of the net electric field at each of points *e*, *d*, and *f*. Explain your answer.

(c) By extending the existing sketch, sketch out what the field lines would look like from very far away from these charges. Assume no other charges are present.

(d) On the sketch above, draw a single, complete equipotential surface that runs through point *f*.

(e) How can there always be electric potential at point *f* and yet the electrical potential energy sometimes be zero?

(f) If a proton was placed at point *f*, in what direction (if any) would it experience a force? Would its change in electrical potential energy be negative or positive as it moved in response to this electrical force? Explain your reasoning.

(g) Repeat the answers to the questions in part (f) but for an electron placed at point *e*.

3. An ideal gas expands from points *A* to *C* along three possible paths.

(a) Is it expected that final temperature at point *C* be path dependent? Justify your answer qualitatively with no calculations.

(b) Discuss and compare the flow of thermal energy along the three paths (*AC*, *ABC*, *ADC*). Indicate the direction of heat for each pathway (into or out of the gas) and the relative amount of thermal energy involved. Justify your answer qualitatively with no calculations.

(c) Calculate the work done along path:
 i. *ABC*
 ii. *AC*
 iii. *ADC*

(d) Is there a way to go from *A* to *C* with no thermal energy exchanged with the environment? If so, describe and sketch the path on a *P-V* diagram.

(e) Is there a way to go from *A* to *C* with no temperature change? If so, describe and sketch the path on a *P-V* diagram.

4. Given the following information:

$$\text{Proton mass} = 1.0078 \text{ u}$$
$$\text{Neutron mass} = 1.0087 \text{ u}$$
$$\text{Mass of } {}^{226}_{88}\text{Ra} = 226.0244 \text{ u}$$

(a) Determine the mass defect for this isotope of radium.

(b) What does this mass defect represent? Explain both qualitatively and quantitatively.

(c) If radium-88 naturally undergoes alpha decay, write down a nuclear reaction for this process. Be sure to show any energy required (Q) or released by this process. If a new element is formed and you are unsure of its symbol, you may use an X to represent that new element. Use the same isotope notation as that given in the information above.

(d) In the reaction in part (c), compare the total mass defects on the reactant side to the mass defect found in part (a):

_____ The reactants have the same mass defect.

_____ The reactants have a larger mass defect.

_____ The reactants have a smaller mass defect.

Justify your choice qualitatively, without using equations.

ANSWER KEY

1. **D**	14. **C**	27. **A**	40. **A**
2. **D**	15. **C**	28. **D**	41. **B**
3. **C**	16. **D**	29. **B**	42. **D**
4. **D**	17. **C**	30. **C**	43. **A**
5. **C**	18. **A**	31. **A**	44. **D**
6. **A**	19. **B**	32. **A**	45. **B**
7. **D**	20. **A**	33. **D**	46. **A, B**
8. **B**	21. **D**	34. **A**	47. **A, C**
9. **B**	22. **C**	35. **C**	48. **A, B**
10. **B**	23. **B**	36. **C**	49. **A, C**
11. **C**	24. **D**	37. **D**	50. **A, C**
12. **C**	25. **B**	38. **B**	
13. **A**	26. **C**	39. **C**	

ANSWERS EXPLAINED
Section I: Multiple-Choice

1. **(D)** Metal atoms are closely packed in a lattice formation. They also have free conduction layer electrons. Both of these factors contribute to a metal's efficiency at transferring heat.

2. **(D)** Work requires displacement along with the force provided by the pressure of the gas. Therefore isochoric processes (no volume changes) involve no work.

3. **(C)** Pressure equals density times height times g. The tall tube of water will have the most height and thus the greatest pressure at its bottom surface.

4. **(D)** A change of 1 Kelvin is the same change in temperature as 1 degree Celsius. Only the zero point is different. However, 180 degrees Fahrenheit spans 100 degrees Kelvin or Celsius.

5. **(C)** Since $PV = nRT =$ constant, P and V must have an inverse relationship.

6. **(A)** Temperature is proportional to kinetic energy.

7. **(D)** The electroscope was charged by induction since it is oppositely charged. Bringing the negative charges closer will drive electrons down toward the leaves as protons are not free to move.

8. **(B)** Each capacitor receives the full 8 V from the battery because the capacitors are in series:

$$C = Q/V$$

$$2 \text{ F} = Q/8 \text{ V}$$

$$Q = 16 \text{ C}$$

9. **(B)** $\frac{1}{2}CV^2 = \frac{1}{2}(8)(8)^2 = 256$ J

10. **(B)** The capacitors with 4 F and 1 F are in parallel. Therefore, they are equivalent to one 5 F capacitor. This 5 F and the 2 F are in series:

$$1/5 + 1/2 = 7/10$$

$$10/7 \text{ F}$$

11. **(C)** Magnetic force causing centripetal acceleration:

$$e v \mathbf{B} = mv^2/r$$

Solve for v:

$$v = e\mathbf{B}r/m$$

This tangential v is equal to ωr:

$$\omega = v/r = (e\mathbf{B}/m)$$

12. **(C)** emf $= \mathbf{B}lv = (10)(0.2)(4) = 8$ V

13. **(A)** Lenz's law states that the induced emf always opposes the change in flux. Since the flux is decreasing, the current induced will be clockwise to add to the existing field. The upward current on the left-hand side of the loop will create a force to the left.

14. **(C)** Diffraction is the bending of wave fronts around obstacles or through openings. In this case, diffraction occurs around the edges of the object causing the shadow.

This will cause the edge of the shadow to be slightly less than fully dark at the edges.

15. **(C)** From moving from glass to air, light will speed up. As the light speeds up, it will pivot away from the normal.

16. **(D)** The critical angle is set by the ratio of the indices of refraction.

17. **(C)** Divergent mirrors are convex and produce virtual images that are upright and reduced.

18. **(A)** Polarization is a property of transverse waves. Sound is longitudinal.

19. **(B)** The moving air next to the flag changes the pressure, moving the flag from side to side.

20. **(A)** The stopping potential is how the KE of the emitted electrons is measured:

$$1 \text{ electron} \times 12 \text{ V} = 12 \text{ eV} = 1.92 \times 10^{-18} \text{ J}$$

21. **(D)** The energy of a photon is associated with its frequency:

$$hf = E$$

Entering a new medium may affect wave speed and wavelength but does not affect frequency.

22. **(C)** Since $\lambda = h/mv$, the particle with the larger mass—the alpha particle—will yield the smaller wavelength.

23. **(B)** Energy levels are negative to indicate a bound state. The energy should be raised to zero for the electron to be free.

24. **(D)** Photon emission occurs when electrons transition to a lower level. The largest difference in energy emits the highest frequency:

$$E = hf$$

25. **(B)** C-12 has been set by convention as the standard setting isotope for amu. A particular isotope had to be chosen because the binding energies in different elements and isotopes contribute to slightly different average mass values for the constituent nucleons.

26. **(C)** 238 nucleons – 92 protons = 146 neutrons

27. **(A)** The total mass number (upper number) on each side of the reaction must be equal.

28. **(D)** A generator creates electrical power by harnessing mechanical energy. An electric motor does the opposite. A solenoid creates a magnet from current. A transformer transforms AC voltage into a higher or lower voltage.

29. **(B)** Radon undergoes alpha decay. Since alpha particles are the nuclei of helium, the new gas is most likely helium because these alpha particles have picked up some electrons.

30. **(C)** Iron has the most stable nucleus since it has the greatest binding energy per nucleon of all the nuclei. Fusion of lighter elements stop being energy producing when they fuse up to Fe. Fission of heavier elements stop being energy releasing after fissioning down to Fe.

31. **(A)** The interference between the ray reflecting off of the top boundary and another ray bouncing off of the lower boundary either produces some bright colors (constructive interference) or does not produce certain colors (destructive interference).

32. **(A)** Remember that $d\sin\theta = m\lambda$. Since d is getting smaller as the number of lines per cm increases, $\sin\theta$ is getting bigger—spreading out the peaks.

33. **(D)** Compare $\frac{1}{2}CV^2$ for each capacitor:

$$\frac{1}{2}(20)(6)^2 = 360\,\text{microjoules}$$

$$\frac{1}{2}(10)(12)^2 = 720\,\text{microjoules}$$

34. **(A)** The moderator absorbs neutrons to manage the rate at which the chain reaction propagates.

35. **(C)** All electromagnetic radiation travels at the same speed. However, frequency is directly proportional to energy.

36. **(C)**

$$P = IV = (4A)(IR) = (4A)(4A)(30\text{ ohms}) = 480\text{ W}$$

As the motor heats up, the effective resistance increases so that the motor draws less current at the same voltage. Therefore, power decreases. You can't use 4^2R since the 4 amps will be changing.

37. **(D)** Magnetic field lines loop around the moving charges.

38. **(B)** There is no magnetic force when the field and the moving charges are in the same direction.

39. **(C)** Inside the solenoid, the field is uniform and depends on the current, N, L, and permeability of the core.

40. **(A)** Adiabatic means no heat transfer. However, work may change the internal energy that, in turn, may change the temperature.

41. **(B)** A Carnot cycle is an altering cycle of adiabatic and isothermal operations.

42. **(D)** For attraction to take place, the pith ball must either have a charge opposite that of the rod or be neutral and undergoing induced charge separation. There is no way to tell what this initial state is without additional information. However, since the pith ball repels at the end of the process, the original charge on the rod must have been partially transferred to the pith ball such that the rod and the pith ball now have the same charge (opposites repel). Because the rod has lost some of its original charge, it is less charged in the end than it was in the beginning.

43. **(A)** $(1/4\pi\varepsilon)/(\mu/4\pi) = 1/\mu\varepsilon = c^2$

44. **(D)** Gravitational fields are generated by mass, which are sinks of the field only. Electric fields are generated by both positive charges and negative charges. Positive charges are the source of electric field lines, whereas negative charges are the sinks. There is no comparable negative mass.

45. **(B)** Bernoulli's equation is derived from conservation of energy as it pertains to fluids.

46. **(A) and (B)** As long as the input is alternating (not direct) in nature, a transformer can either step up the voltage (stepping down the current) or step down the voltage (stepping up the current).

47. **(A) and (C)** Electromotive force (emf) is voltage, as is potential, electric potential, and potential difference. Electric potential energy is the actual energy present (measured in joules, not volts!) when charge is present in the field.

48. **(A) and (B)** LCD by nature of the long-chain molecules involved emit polarized light. Reflected light can be partially or completely polarized depending on the angle.

49. **(A) and (C)** If the electron falls straight to $N = 2$, then a 2.5 eV photon is emitted. If the electron falls first to $N = 3$ and then to $N = 2$, two photons are emitted: first a 0.6 eV photon and then a 1.9 eV photon.

50. **(A) and (C)** Conductors always have excess charge on their outer surface such that all internal fields have canceled out. External fields likewise must leave the surface perpendicularly. If either of these conditions is not true, the extra charges will move around until these conditions are met. The field will not be uniform in strength, however, as the excess charge will be more concentrated near the corners of the solid.

SECTION II: FREE-RESPONSE

1. (a) Shine the laser light through the two slits in such a way that the slits are far away from a wall of the room. Note where the projected points of light are located on the wall. You should see the primary bright dot directly in front of the laser and one (or more) less bright spots to either side. The screen with the slits may need to be rotated in order to bring all the bright spots in line (at the same height). Measure the distance from the slits to the wall (L) and the distances between the dots on the wall (x).

Using the 2-slit diffraction pattern formula:

$$d \sin \theta = m\lambda$$

Use small angle approximation and first-order maxima:

$$d(x/L) = (1)\lambda$$

$$\lambda = xd/L$$

where x is the average distance between bright spots, L is the distance between the grating and wall, and d is the distance between the two slits.

(b) The usual errors in measurement will happen when measuring L and x. The small-angle approximation itself is an approximation. So it is important that $x \ll L$. To the extent that this is not possible, then there is an error associated with replacing $\sin\theta$ with x/L.

(c)

$$x/L = \lambda/d = (632.8 \text{ nm})/(1.67 \times 10^{-6}) = (632.8 \times 10^{-9})/(1.67 \times 10^{-6}) = 0.379$$

A typical L that might be obtained in a classroom is $L = 4$ meters, which would give an x of 1.5 meters.

Assuming these measurements were made with a meter stick, a margin of error of half the smallest increment gives ± 0.005 m minimum. However, the bright spots themselves have a size and the meterstick may need to be moved during the measurement. Both of these factors will increase the error in measurement; ± 0.05 m seems to be a reasonable compounding of these errors.

2. (a) The number of field lines indicates the amount of charge. The direction of field lines indicates the type of charge:

amount of charge A (positive) > amount of charge C (positive) > amount of charge B (negative)

(b) The strength of the field is proportional to the density of the field lines:

field at e > field at f > field at d

(c) From very far away, the details of the actual charge distribution will not matter. The field will look like that of a positive point charge with the 7 unconnected field lines coming out uniformly.

(d) Equipotential lines should intersect electric field lines perpendicularly, do not have direction, and are continuous.

(e) Electric potential comes from the source charge and does not require a test charge to be present in the field. Electrical potential energy exists only if there is a test charge present within the field: EPE = qV.

(f) A proton would follow the field direction at its location, so up and to the right at point f. Positive charges go from high voltage to low voltage:

$$\Delta V < 0, \text{ so } q\Delta V < 0$$

Electrical potential energy decreases while electrical potential decreases.

(g) Electrons will experience a force in the opposite direction from the field lines, so straight toward A at point e. Negative charges go from low voltage to high voltage:

$$\Delta V > 0, \text{ so } q\Delta V < 0$$

since q is negative. Electrical potential energy decreases while electrical potential increases.

3. (a) No, the temperature is a state function of pressure and volume. So the temperature at point C is not path dependent.

(b)

$$\Delta U = Q + W$$

For an ideal gas, the change in internal energy (ΔU) is fixed by the change in the temperature. So the difference in thermal energy exchange (Q) will be dictated by the amount of work done on each path (see part (c) for a calculation of work). Without doing a calculation, we can visually tell which path is doing more work by examining the areas under the pathways. The product PV is lower at point C than at point A. Therefore, we can conclude that the temperature is lower at point C (ideal gas law $PV = nRT$). Since the temperature is decreasing, ΔU is negative while all the work done by the gas represents a loss of energy as well. The difference between the given pathway and an adiabatic expansion (see answer (d)) represents the amount of thermal energy exchanged with the environment (Q).

Path AC represents moderate work done by the gas, requiring some thermal energy to be added to the gas during the process but not as much as path ABC, which represents the most work done by the gas. Since pathway ABC is so far from adiabatic, it will require significant thermal energy to be added to the gas. Finally, path ADC is the least amount of work done and the only pathway to require thermal energy to be given to the environment from the gas.

(c) The work done is going to be equal to the area under each segment of the P-V graph. Also recall that 1 atm = 101 kPa = 101,000 N/m² and 1 L = 0.001 m³:

$$\text{Pa} \cdot \text{m}^3 = \text{J}$$

i. Along path ABC, no work is done from $B \rightarrow C$ because there is no change in volume. Thus the area is just the area under $AB = (8\text{ atm})(6\text{ L}) = 4{,}848$ J.

ii. Along path AC, the total area is equal to:

$$\frac{1}{2}(6\text{ atm})(6\text{ L}) + (2\text{ atm})(6\text{ L}) = 3{,}030\text{ J}$$

iii. Along path ADC, no work is done from $A \rightarrow D$ because there is no change in volume. Thus the area is just the area under DC:

$$(2\text{ atm})(6\text{ L}) = 1{,}212\text{ J}$$

(d) Yes, if the expansion is adiabatic, you can go from *A* to *C* with no thermal energy exchanged. This would connect point *A* and point *C* with a steep hyperbola. In this case, the work done is solely responsible for the change in internal energy as no heat is involved.

(e) Yes, if the expansion is isothermal, you can go from *A* to *C* with no temperature change, In this case, thermal energy will have to be added to the system at the same rate as work is being done by the gas in order to effect no ΔU, This would connect point *A* and point *C* with a hyperbola but one less steep than in part (d).

4. (a) To find the mass defect, we first find the total constituent mass:

88 protons: $m = (88)(1.0078) = 88.6864$ u

138 neutrons: $m = (138)(1.0087) = 139.2006$ u

M(total) = 227.8870 u

Then we have:

Mass defect = 227.8870 u − 226.0244 u = 1.8626 u

(b) The mass defect represents the binding energy holding the nucleus together. This energy can be found by using Einstein's equation $E = mc^2$.

Using the conversion factor from the Table of Information for AP Physics 2:

1 u = 931 MeV/c^2 and $E = mc^2$

The total binding energy (BE) is

BE = (931.5 MeV/u)(1.8626 u) = 1,735.0119 MeV

The binding energy per nucleon is

BE/nucleons = 1,735.0119/226 = 7.677 MeV

(c) $$^{226}_{88}\text{Ra} \rightarrow\, ^{222}_{86}\text{Rn} + ^{4}_{2}\text{He} + Q$$

or

$$^{226}_{88}\text{Ra} \rightarrow\, ^{222}_{86}\text{X} + ^{4}_{2}\text{He} + Q$$

(d) __X__ The reactants have a larger mass defect.

Since this reaction is energy releasing, energy has left the nuclei. This energy has come from the mass, so the mass defect must be increased. The nucleons in the reactant side have greater binding energy on average than those on the product side.

TEST ANALYSIS

NOTE: Because the AP Physics 1 and AP Physics 2 are new exams (first administered in 2015), there is no way of knowing exactly how the raw scores on the exams will translate into a 1, 2, 3, 4, or 5. The formula provided below is based on past practice for the AP Physics B and commonly accepted standards for grading. Additionally, the score range corresponding to each grade varies from exam to exam and thus the ranges provided below are approximate.

AP PHYSICS 2 PRACTICE TEST 1

Section I: Multiple-Choice

Note that the questions requiring two answers are to be graded as completely correct or incorrect.

Number correct (out of 50) = $\overline{\hspace{2cm}}$ Multiple-Choice Score

Section II: Free-Response

Grade each question individually using the following scale:

4: completely correct
3: substantially correct with minor errors
2: partially correct with some incorrect parts
1: a few correct attempts made, but no completely correct portions
0: completely incorrect or unanswered

Question 1 = $\overline{\hspace{2cm}}$ (out of 4)

Question 2 = $\overline{\hspace{2cm}}$ (out of 4)

Question 3 = $\overline{\hspace{2cm}}$ (out of 4)

Question 4 = $\overline{\hspace{2cm}}$ (out of 4)

Total = $\overline{\hspace{2cm}}$ (out of 16) $\times 3.125 = \overline{\hspace{2cm}}$ Free-Response Score

Final Score

$\overline{\hspace{2cm}}$ Multiple-Choice Score $+$ $\overline{\hspace{2cm}}$ Free-Response Score $=$ $\overline{\hspace{2cm}}$ Final Score (rounded to the nearest whole number)

Final Score Range	AP Score
81–100	5
61–80	4
51–60	3
41–50	2
0–40	1

ANSWER SHEET
Practice Test 2

1. Ⓐ Ⓑ Ⓒ Ⓓ
2. Ⓐ Ⓑ Ⓒ Ⓓ
3. Ⓐ Ⓑ Ⓒ Ⓓ
4. Ⓐ Ⓑ Ⓒ Ⓓ
5. Ⓐ Ⓑ Ⓒ Ⓓ
6. Ⓐ Ⓑ Ⓒ Ⓓ
7. Ⓐ Ⓑ Ⓒ Ⓓ
8. Ⓐ Ⓑ Ⓒ Ⓓ
9. Ⓐ Ⓑ Ⓒ Ⓓ
10. Ⓐ Ⓑ Ⓒ Ⓓ
11. Ⓐ Ⓑ Ⓒ Ⓓ
12. Ⓐ Ⓑ Ⓒ Ⓓ
13. Ⓐ Ⓑ Ⓒ Ⓓ
14. Ⓐ Ⓑ Ⓒ Ⓓ
15. Ⓐ Ⓑ Ⓒ Ⓓ
16. Ⓐ Ⓑ Ⓒ Ⓓ
17. Ⓐ Ⓑ Ⓒ Ⓓ

18. Ⓐ Ⓑ Ⓒ Ⓓ
19. Ⓐ Ⓑ Ⓒ Ⓓ
20. Ⓐ Ⓑ Ⓒ Ⓓ
21. Ⓐ Ⓑ Ⓒ Ⓓ
22. Ⓐ Ⓑ Ⓒ Ⓓ
23. Ⓐ Ⓑ Ⓒ Ⓓ
24. Ⓐ Ⓑ Ⓒ Ⓓ
25. Ⓐ Ⓑ Ⓒ Ⓓ
26. Ⓐ Ⓑ Ⓒ Ⓓ
27. Ⓐ Ⓑ Ⓒ Ⓓ
28. Ⓐ Ⓑ Ⓒ Ⓓ
29. Ⓐ Ⓑ Ⓒ Ⓓ
30. Ⓐ Ⓑ Ⓒ Ⓓ
31. Ⓐ Ⓑ Ⓒ Ⓓ
32. Ⓐ Ⓑ Ⓒ Ⓓ
33. Ⓐ Ⓑ Ⓒ Ⓓ
34. Ⓐ Ⓑ Ⓒ Ⓓ

35. Ⓐ Ⓑ Ⓒ Ⓓ
36. Ⓐ Ⓑ Ⓒ Ⓓ
37. Ⓐ Ⓑ Ⓒ Ⓓ
38. Ⓐ Ⓑ Ⓒ Ⓓ
39. Ⓐ Ⓑ Ⓒ Ⓓ
40. Ⓐ Ⓑ Ⓒ Ⓓ
41. Ⓐ Ⓑ Ⓒ Ⓓ
42. Ⓐ Ⓑ Ⓒ Ⓓ
43. Ⓐ Ⓑ Ⓒ Ⓓ
44. Ⓐ Ⓑ Ⓒ Ⓓ
45. Ⓐ Ⓑ Ⓒ Ⓓ
46. Ⓐ Ⓑ Ⓒ Ⓓ
47. Ⓐ Ⓑ Ⓒ Ⓓ
48. Ⓐ Ⓑ Ⓒ Ⓓ
49. Ⓐ Ⓑ Ⓒ Ⓓ
50. Ⓐ Ⓑ Ⓒ Ⓓ

Practice Test 2

SECTION I: MULTIPLE-CHOICE

Time: 90 minutes
50 questions

> **DIRECTIONS:** Each of the questions or incomplete statements below is followed by four suggested answers or completions. Select the one (or two where indicated) that is best in each case. You have 90 minutes to complete this portion of the test. You may use a calculator and the information sheets provided in the appendix.

1. In a photoelectric effect experiment, increasing the intensity of the incident electromagnetic radiation will

 (A) increase only the number of emitted electrons
 (B) have no effect on any aspect of the experiment
 (C) increase the maximum kinetic energy of the emitted electrons
 (D) increase the stopping potential of the experiment

2. In a vacuum, all photons have the same

 (A) frequency
 (B) wavelength
 (C) velocity
 (D) amplitude

3. Which of the following photons has the largest momentum?

 (A) X ray
 (B) Ultraviolet
 (C) Infrared
 (D) None of these has momentum

4. Which element will not release energy via either fusion or fission?

(A) Hydrogen
(B) Iron
(C) Helium
(D) Neon

5. Photons can scatter electrons, and the trajectories of the electrons will obey the law of conservation of momentum. These facts are observed in the

(A) Rutherford scattering experiment
(B) Michelson-Morley experiment
(C) Compton effect
(D) Doppler effect

6. How many neutrons are contained in the isotope $^{211}_{84}Po$?

(A) 84
(B) 211
(C) 295
(D) 127

7. Look at the following reaction:

$$^{6}_{3}Li + X \rightarrow ^{7}_{4}Be + ^{1}_{0}n$$

What is element X?

(A) $^{1}_{1}H$
(B) $^{3}_{1}H$
(C) $^{4}_{2}He$
(D) $^{2}_{1}H$

8. As hydrogen is fused into helium, the stability of the new nuclei, compared with that of hydrogen, will

(A) be greater because of greater binding energy per nucleon
(B) be less because of greater binding energy per nucleon
(C) be greater because of smaller binding energy per nucleon
(D) be less because of smaller binding energy per nucleon

9. Which of the following particles are not deflected by an electromagnetic field?

(A) Neutron
(B) Proton
(C) Positron
(D) Alpha particle

10. A ray of light is incident from a slower medium (smaller than the critical angle) to one that is faster. The refracted ray will

(A) not refract at all
(B) refract toward the normal
(C) refract away from the normal
(D) "refract" at 90 degrees such that it does not actually enter the faster medium

11. As a large object (such as a 3,000 kg car) accelerates, what is the trend in its de Broglie wavelength?

(A) Its de Broglie wavelength gets smaller.
(B) Its de Broglie wavelength gets bigger.
(C) Its de Broglie wavelength remains the same.
(D) Any object with rest mass would have to go faster than the speed of light to have a measureable de Broglie wavelength.

12. In Boyle's law, the units for the product PV are equivalent to

(A) newtons
(B) pascals
(C) joules
(D) cubic meters

13. Heat conduction through a slab of a certain material depends on all of the following EXCEPT

(A) area
(B) temperature difference between the face of the materials
(C) thickness of the material
(D) specific heat capacity of the material

QUESTIONS 14–16 ARE BASED ON THE FOLLOWING INFORMATION:

An RC circuit is wired such that a 10 μF capacitor is connected in series with a 5 Ω resistor and a 6 V battery.

14. What will be the total charge that flows into one side of the capacitor?

(A) 50 C
(B) 2 C
(C) 6×10^{-5} C
(D) 5×10^{-4} C

15. Which of the following graphs best represents the increase of charge in the capacitor while attached to a constant voltage source?

(A)

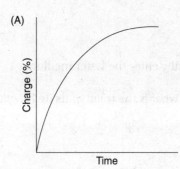

(B)

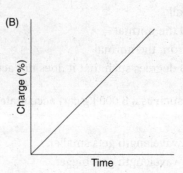

(C)

(D)

16. What is the value of the total energy stored in the capacitor?

(A) 1.8×10^{-4} J
(B) 6×10^{-5} J
(C) 3×10^{-5} J
(D) 2×10^{-5} J

17. Anti-reflecting coatings on objects are often made to be one-fourth of a wavelength thick. These coatings reduce some reflected intensities primarily because of

(A) reflection and refraction
(B) reflection and interference
(C) reflection and polarization
(D) dispersion and refraction

18. The time between maximum electric field strength magnitudes at a fixed location in a vacuum as an electromagnetic wave with a wavelength of 6 meters passes by is

(A) 5×10^{7} s
(B) 2×10^{-8} s
(C) 1×10^{-8} s
(D) 2.5×10^{7} s

19. What is the buoyant force experienced by a 10 kg cylinder with a volume of 2×10^{-2} m$^3$ that is completely submerged in water (density $\rho = 1{,}000$ kg/m$^3$)?

(A) 200 N

(B) 2,000 N

(C) 20 N

(D) 100 N

QUESTIONS 20–24 REFER TO THE FOLLOWING INFORMATION:

Light with a wavelength of 5.4×10^{-7} meters falls on two slits that are separated by a distance of 1.0×10^{-3} meters. An interference pattern forms on a screen 2 meters away.

20. What is the energy of each photon of this light?

(A) 3×10^{8} J

(B) 4×10^{-8} J

(C) 3×10^{-33} J

(D) 4×10^{-19} J

21. What is the approximate distance between the central bright band and the next bright band?

(A) 2 m

(B) 1.08×10^{-3} m

(C) 2.7×10^{-3} m

(D) 3.6×10^{-2} m

22. The dark and bright interference pattern observed on the screen is caused by

(A) reflection and refraction

(B) refraction and diffraction

(C) polarization and interference

(D) diffraction and interference

23. If the distance between the slits and the screen is increased, the pattern spacing will

(A) increase

(B) decrease

(C) increase and then decrease

(D) remain the same

24. If light with a shorter wavelength is used in an experiment, the pattern separation will

(A) increase

(B) decrease

(C) increase and then decrease

(D) remain the same

25. As light enters a slower medium (index of refraction N_2) from a faster one (index of refraction N_1), its wavelength is observed to be cut down to 1/3 of its previous value. What is the ratio of N_2/N_1?

(A) 1.0

(B) 3.0

(C) 0.33

(D) The frequency and/or wavelength must be specified.

26. What is the critical angle for light within a transparent material ($N = 2.0$) when immersed in water ($N = 1.3$)?

(A) 30°

(B) 60°

(C) 41°

(D) No critical angle in this situation

27. A doubly ionized helium atom is accelerated by a potential difference of 400 V. The maximum kinetic energy of the ion is equal to

(A) 400 eV

(B) 200 eV

(C) 1,600 eV

(D) 800 eV

28. A neutral body is rubbed and becomes positively charged by

(A) gaining protons

(B) losing electrons

(C) gaining electrons

(D) losing protons

29. If an ideal fluid (density ρ) traveling down a horizontal pipe at a speed v_1 enters a new pipe of ½ the radius, its pressure will change by

(A) $2\rho v_1^2$

(B) $4\rho v_1^2$

(C) $7.5\rho v_1^2$

(D) $16\rho v_1^2$

30. Lenz's law is an electrical restatement of which conservation law?

(A) Linear momentum

(B) Angular momentum

(C) Charge

(D) Energy

31. A single electron traveling 2 cm away from a wire of current (2 amps) along a parallel trajectory to the wire's current will experience a force

(A) of 0 N since the wire has no net charge

(B) directed radially away from the wire

(C) directed radially toward the wire

(D) parallel to the wire

32. An electron is moving perpendicularly through a pair of crossed electric and magnetic fields (with magnitudes E and B, respectively) with constant velocity. The fields are perpendicular to each other. Which expression represents the speed of the electron?

(A) EB

(B) $2EB$

(C) E/B

(D) B/E

33. Photons with energy of 8 eV are incident on a metal surface that emits electrons in a photoelectric effect experiment. If the emitted electrons can be stopped with a potential of 5 volts, the work function for this metal is at least

(A) 13 eV

(B) 8 eV

(C) 5 eV

(D) 3 eV

34. An object is placed 15 centimeters in front of a concave spherical mirror whose radius of curvature is 12 centimeters. Which statement is correct about the image formed?

(A) The image will be larger than the object and virtual.

(B) The image will be smaller than the object and virtual.

(C) The image will be larger than the object and real.

(D) The image will be smaller than the object and real.

35. The isotope decays $^{13}_{7}N$ by emitting a positron. Which of the following isotopes is the direct decay product?

(A) $^{13}_{6}C$

(B) $^{12}_{6}C$

(C) $^{12}_{7}N$

(D) $^{13}_{8}O$

36. Energy from the Sun is generated by

(A) the fusion of helium into hydrogen

(B) the fusion of hydrogen into helium

(C) the fission of uranium

(D) the fission of helium into hydrogen

37. If a permanent magnet is cut in half halfway between its north and south poles, you will then have

(A) a north pole piece strongly attracted to the south pole piece

(B) two pieces of magnetic material with no overall poles

(C) two smaller magnets, each with its own north and south poles

(D) the north pole piece slightly positive and the south pole piece slightly negative

38. A solid conducting sphere is carrying a certain amount of overall positive charge. The electrical potential within the sphere will

(A) follow a $1/R$ relationship, diminishing toward zero as you move toward the center
(B) follow a $1/R^2$ relationship, diminishing toward zero as you move toward the center
(C) rise toward a fixed high number (depending on the amount of charge) as you move toward the center
(D) be constant throughout

39. The voltage between the plates of a fully charged parallel plate capacitor will

(A) be constant throughout
(B) fall linearly as you move from the positive plate to the negative plate
(C) fall quadratically as you move from the positive plate to the negative plate
(D) fall exponentially as you move from the positive plate to the negative plate

40. What does the electric field resemble if the field is a far distance outside of a fully charged 5 F capacitor that is charged by a 12 V battery?

(A) The electric field will resemble that of a 60 C point charge.
(B) The electric field will be uniform and directed toward the capacitor.
(C) The electric field will be uniform and directed away from the capacitor.
(D) There will be no measurable electric field due to the capacitor.

41. An electron is observed to be moving in a clockwise circular path when viewed from above. Which statement best describes the magnetic field causing this?

(A) The magnetic field is directed upward.
(B) The magnetic field is directed downward.
(C) The magnetic field is directed radially in the place of the circular path.
(D) No magnetic field is present.

42. A perpetual motion machine is an object with moving internal parts that never stop moving. Which concept best explains why an isolated perpetual motion machine is not possible?

(A) Conservation of energy
(B) Thermal conductivity
(C) Increase of entropy
(D) Conservation of momentum

43. One mole of helium is compared with one mole of nitrogen gas. Both gases are at the same temperature and pressure. Which statement is true?

(A) The helium gas takes up less volume than the nitrogen gas because helium is a lighter molecule.
(B) The helium gas molecules are moving faster on average than the nitrogen molecules because helium is a lighter molecule.
(C) The speed of sound through the nitrogen gas will be faster since the nitrogen molecule is heavier.
(D) The force delivered per area by the bouncing molecules of helium will be smaller than that from the nitrogen molecules since helium is a lighter molecule.

44. The fact that two oncoming headlights of a car cannot be resolved at large distances (i.e., the two light sources are seen as one) is best described by

(A) wave interference
(B) refraction
(C) dispersion
(D) diffraction

45. The Sun's light strikes the ground and heats it, which in turn heats the air in contact with the ground. This warm air rises and allows cooler air to rush in. What is the sequence of thermal energy transfer events?

(A) Convection → conduction → convection
(B) Radiation → conduction → convection
(C) Radiation → convection → conduction
(D) Conduction → conduction → convection

46. Which of the following are true about a fully charged capacitor in a circuit? Select two answers.

(A) It has a net charge of zero.
(B) It effectively allows current to pass through it.
(C) It has a voltage difference of zero across it.
(D) It can act as an emf source.

47. If small, plastic ball X attracts a similar ball Y but repels a third ball Z, which of the following are true? Select two answers.

(A) Y may be oppositely charged from Z.
(B) Z may be neutral.
(C) Y may be neutral.
(D) X may be neutral.

48. An electron traveling in a northward direction is momentarily deflected upward. What can accomplish this? Select two answers.

(A) A downward electric field
(B) A westward magnetic field
(C) An upward electric field
(D) An eastward magnetic field

49. A resistor and capacitor are in parallel with each other and embedded in a larger circuit. Initially, there is current running through the resistor only; there is an open switch next to the uncharged capacitor. Then the switch is closed, allowing the capacitor to charge. Consider the resistor from before the switch was closed and after the capacitor is allowed to fully charge. Which of the following statements are true? Select two answers.

(A) The current going through the resistor is the same.
(B) The voltage drop across the resistor is the same.
(C) The current through the resistor has dropped significantly.
(D) The voltage drop across the resistor has dropped significantly.

50. A solid, uncharged conducting sphere is placed within a strong external electric field. Which of the following statements are true? Select two answers.

(A) A surface charge will be induced on the sphere.

(B) The electric field within the sphere will be zero.

(C) The external electric field away from the sphere will be significantly altered by the presence of the sphere.

(D) The sphere will be induced to have a net charge.

SECTION II: FREE-RESPONSE

Time: 90 minutes

4 questions

DIRECTIONS: You have 90 minutes to complete this portion of the test You may use a calculator and the information sheets provided in the appendix.

1. A group of students are given two resistors (100 ohm and 200 ohm), a single capacitor (15 mF), two switches, 2 voltmeters, 2 ammeters, a 12-volt battery, and many alligator clip-style wires that can be used to connect these elements. The students are instructed to use these elements to determine the effect of adding a capacitor in parallel to an existing simple circuit.

 (a) Describe how these elements could be set up to monitor the voltage across both resistors and the current through them. The capacitor along with one of the resistors should be controlled by a switch such that they can be part of the circuit or not as the switch is opened or closed. The second resistor should be in parallel with the capacitor-resistor combination. You should include a labeled circuit diagram of your setup to help in your description.

 (b) Indicate what procedure to follow with your circuit design in order to determine the voltage and current of both resistors with and without the capacitor in the circuit. Include enough detail so that another student could carry out your procedure.

 (c) Based on the given values and assuming ideal conditions, predict the results of your procedure in part (b). Give numerical predictions for steady-state behaviors. Give a qualitative description of any changes over time that you expect to see.

 (d) Describe what effect the internal resistance of the battery might have on the students' actual results in part (c). Additionally, explain and describe the effects that any resistance within the ammeters themselves might have on the students' results.

 (e) Describe qualitatively what would happen to the reading on both voltmeters and ammeters if, after the capacitor is fully charged, the battery is suddenly removed from the circuit, leaving an open circuit in its place.

2. A ray of light is incident on an unknown transparent substance from the air. The angle of incidence is 40°, and the angle of refraction is 22°.

 (a) Explain why these measurements indicate that a change in speed must be happening as the light changes medium. Qualitatively justify whether the speed of light in the unknown transparent substance is higher or lower than that of air.

 (b) Calculate the absolute index of refraction for this substance. Calculate the velocity of light in this substance.

 (c) The substance is now submerged in glycerol ($n = 1.47$). Calculate the critical angle of incidence for light going from the unknown substance into glycerol. Explain why there is no critical angle when going the other way, from glycerol into the substance.

 (d) The substance is now shaped into a convex lens. How does the focal length of this lens compare with the focal length of a similar-shaped lens made out of crown glass ($n = 1.52$)? Justify your answer.

3. A student is investigating an unknown radioactive source with a Geiger counter. The Geiger counter clicks when it detects ionizing radiation but does not distinguish between alpha, beta, and gamma particles. The number of clicks indicates the number of ionizing events happening in the Geiger counter device due to the radiation it receives. The student puts a piece of paper between the radioactive source and the Geiger counter and does not notice a change in the clicking rate. However, the addition of one sheet of aluminum foil does decrease the rate. When several sheets of aluminum foil are layered in a thickness of about a centimeter, there are no clicks at all.

(a) What type of radiation is being emitted? Justify your choice by describing alpha, beta, and gamma particles and how they interact with matter.

(b) What is happening to the atomic number and mass number within each atom that emits this radiation? Is it possible to predict which radioactive atoms within the sample will be emitting the radiation next?

(c) Is the binding energy per nucleon within the radioactive atoms changing as the radiation is being emitted? If so, is the binding energy per nucleon going up or down? Justify your answer with a qualitative explanation.

(d) If the half-life of the radioactive material being investigated is 12 hours, what will happen to the click rate of the Geiger counter after 3 days?

4. A single electron in an excited energy state transitions down to a lower energy state within an atom. A photon is emitted.

(a) Which of the following about the photon is uniquely fixed by the electron's transition? Justify your answer.
 ____Speed
 ____Wavelength
 ____Frequency

(b) Does the relativistic mass of this atom increase, decrease, or remain the same during this action? Justify your response qualitatively using equations as necessary.

(c) Imagine that the emitted photon is eventually absorbed in deep space by a different electron. This absorbing electron is heading straight toward the emitted photon at a speed of 0.5 c, where c is the speed of light.
 i. From the absorbing electron's point of view, what will be the speed of the emitted photon?
 ii. After absorption, will the electron speed up, slow down, or continue at the same speed?
 Justify your answers.

ANSWER KEY

1. **A**	14. **C**	27. **D**	40. **D**
2. **C**	15. **A**	28. **B**	41. **B**
3. **A**	16. **A**	29. **C**	42. **C**
4. **B**	17. **B**	30. **D**	43. **B**
5. **C**	18. **C**	31. **B**	44. **D**
6. **D**	19. **A**	32. **C**	45. **B**
7. **D**	20. **D**	33. **D**	46. **A, D**
8. **A**	21. **B**	34. **D**	47. **A, C**
9. **A**	22. **D**	35. **A**	48. **A, D**
10. **C**	23. **A**	36. **B**	49. **A, B**
11. **A**	24. **B**	37. **C**	50. **A, B**
12. **C**	25. **C**	38. **D**	
13. **D**	26. **C**	39. **B**	

ANSWERS EXPLAINED
Section I: Multiple-Choice

1. **(A)** Increasing the intensity will increase the number of photons per second but not change any aspect of the individual absorption event.

2. **(C)** In a vacuum, all photon travel at c, which is the speed of light.

3. **(A)** According to Compton, the momentum of a photon is $p = hf/c$. The photon with the highest frequency has the highest momentum.

4. **(B)** Iron, with the highest binding energy per nucleon of any element listed, will not release any energy via fusion or fission.

5. **(C)** Compton's 1923 paper described his experiment in which momentum is conserved in a photon-electron collision.

6. **(D)** 211 (number of nucleons) – 84 (number of protons) = 127

7. **(D)** Both the mass number (top number) and the atomic numbers (bottom numbers) must add up to the same total before and after the reaction.

8. **(A)** The fusion of hydrogen into helium releases energy. So the helium nucleus must be lower in energy (more stable) than the previous nuclei.

9. **(A)** An object must have charge in order to interact with electromagnetic fields.

10. **(C)** Rays going from slow to fast mediums refract away from the normal up until the critical angle, at which point no more refraction occurs.

11. **(A)** Since $\lambda = h/mv$, as v gets bigger, wavelength decreases.

12. **(C)** $PV = (N/m^2)(m^3) = N \cdot m = J$

13. **(D)** Heat capacity is related to energy absorption and temperature change, not to the transfer of thermal energy (heat).

14. **(C)**

$$C = Q/V$$

$$Q = CV = (10 \times 10^{-6})\,(6) = 6 \times 10^{-5}\ C$$

15. **(A)** The charging is exponential and approaches the fixed value of the previous problem.

16. **(A)** $\frac{1}{2}CV^2 = \frac{1}{2}\left(10 \times 10^{-6}\right)(6)^2 = 1.8 \times 10^{-4}\ J$

17. **(B)** Two rays are reflected: one from the top of the quarter-wavelength thickness and one from the bottom. The ray from the bottom will meet the top layer reflection exactly one-half wavelength out of phase: destructive interference.

18. **(C)** Maximum magnitude will happen every half a wavelength (peak to trough). The speed of electromagnetic waves is 3×10^8 m/s. So the time for half a wave to pass is $3/(3 \times 10^8) = 10^{-8}$ s.

19. **(A)** Buoyancy force = weight of displaced water = $\rho Vg = (1,000)(2 \times 10^{-2})(10) = 200$ N

20. **(D)** $E = hf = hc/\lambda = (6.63 \times 10^{-34})(3 \times 10^8)/(5.4 \times 10^{-7}) = 3.68 \times 10^{-19}$ J

21. **(B)**

$$d\sin\theta = m\lambda$$

$$dx/L = m\lambda$$

$$x = m\lambda L/d = (1)(5.4 \times 10^{-7})(2)/(1.0 \times 10^{-3}) = 1.08 \times 10^{-3} \text{ m}$$

22. **(D)** The diffracted light from each slit spreads out and interferes with the light from the other slit to produce the pattern.

23. **(A)** Answer 21 shows that $x = m\lambda L/d$. If L increases, then x increases.

24. **(B)** Answer 21 shows that $x = m\lambda L/d$. If λ decreases, then x decreases.

25. **(C)** Changes in wavelength are proportional to changes in wave speed:

$$v_2 = v_1/3$$

$$N_2/N_1 = (c/v_1)/(c/v_2) = v_2/v_1 = 1/3$$

26. **(C)** Use Snell's law, and set the refracted angle to 90°:

$$2.0\sin\theta_c = 1.3\sin 90°$$

$$\theta_c = \sin^{-1}(1.3/2) = 40.5° \approx 41°$$

27. **(D)** Energy $= qV = (2e)(400 \text{ V}) = 800 \text{ eV}$

28. **(B)** Objects become positive by losing electrons.

29. **(C)** Use the continuity equation:

$$A_1v_1 = A_2v_2$$

If the radius is halved, the area is $\dfrac{1}{4}$. Therefore, the new speed in the narrower pipe is 4 times bigger ($v_2 = 4v_1$).

Use the Bernoulli equation:

$$P_1 + \frac{1}{2}\rho v_1^2 = P_2 + \frac{1}{2}\rho v_2^2$$

$$P_1 - P_2 = \frac{1}{2}\rho v_2^2 - \frac{1}{2}\rho v_1^2 = \frac{1}{2}\rho\left(16v_1^2 - v_1^2\right) = 7.5\rho v_1^2$$

30. **(D)** Conservation of energy is the underlying principle. By opposing the change in flux, Lenz's law is trying to keep the field energy constant.

31. **(B)** The wire sets up a circular magnetic field. The electron is traveling perpendicularly to the magnetic field. The right-hand rules dictates that the magnetic field lines are counterclockwise when looking directly at the oncoming current. Since the electron is negatively charged, crossing the electron's velocity with the field direction results in an outward force:

$$\mathbf{F} = q\mathbf{v} \times \mathbf{B}$$

32. **(C)** Since the velocity is constant, the magnetic force must be canceling the electric force:

$$qE = qvB$$

$$v = E/B$$

33. **(D)**

$$8 \text{ eV} = W + \text{KE}$$

$$\text{KE} = 5 \text{ eV or less}$$

$$W = 3 \text{ eV or more}$$

34. **(D)** The object is located beyond the center of curvature. Therefore, the image will be real, inverted, and diminished.

35. **(A)** Positron emission reduces the atomic number by 1 but leaves the mass number unchanged.

36. **(B)** Hydrogen fusing into helium occurs at the core of the Sun.

37. **(C)** At the break point, a new north pole and a new south pole will be found such that each smaller piece will have its own north and south poles. The two poles of a magnet can never be isolated.

38. **(D)** Inside of a conductor, there is no electric field. The voltage will be constant throughout and equal to the voltage on the surface of the object.

39. **(B)** The constant electric field implies a linear fall in voltage as you move from the positive plate to the negative plate.

40. **(D)** The net charge on a capacitor is zero as it carries an equal amount of opposite charge. From far away, no dipole characteristic will emerge, and no field will be detected.

41. **(B)** There must be an inwardly directed force to keep the electron circulating. The electron moving clockwise represents a counterclockwise current. The right-hand rule requires a downward magnetic field to produce an inward force.

42. **(C)** Since the entropy of an isolated system must increase, some heat must be generated by the operation of the machine. This heat comes at the loss of available energy to make the machine work. Over time, the machine will run out of energy due to the increasing entropy.

43. **(B)** Since both gases are at the same temperature, their molecules must have the same average kinetic energy. Therefore, the less massive helium molecules must be moving faster in order to produce the same $\frac{1}{2}mv^2$.

44. **(D)** As the light leaves the headlights, they begin to diffract. From far enough away, each beam of light has diffracted such that their central maximums overlap and thus can no longer be distinguished.

45. **(B)** The Sun's light being absorbed by the ground is radiation. The ground heating the air in contact with it is conduction. Air movement caused by heat is convection.

46. **(A) and (D)** Net charge on a capacitor is always zero because equal and opposite charges build up on either side of it. Once fully charged, the energy stored within the capacitor can be used to send charges in the opposite direction from which they came into the capacitor if the two sides are allowed to form a closed loop.

47. **(A) and (C)** X and Z must have the same charge (not neutral) since they repel. Y, however, can either be oppositely charged or be neutral. If it is neutral, Y is attracted to X by induced charge separation.

48. **(A) and (D)** An eastward magnetic field and a southward current yields upward force by the right-hand rule. A downward electric field will exert an upward force on a negative particle.

49. **(A) and (B)** Since the capacitor is in parallel with the resistor and eventually charged up to the voltage available, the resistor will experience the same voltage and current both before and after the charging is complete.

50. **(A)** and **(B)** The electric field will induce a charge separation on the surface of the conductor. However, the conductor's interior will remain without any fields, as always occurs with electrostatics.

Section II: Free-Response

1. (a) Ammeters must be in series with their resistors. Voltmeters must be in parallel with their resistors. The capacitor must be in series with a switch and in parallel with one of the resistors in order to have a complete circuit when the switch is open. In order not to create a temporary short circuit when the switch is closed, a second resistor must be placed in series with the capacitor. One possible circuit diagram would look like this.

(b) After connecting the circuit above, leave the switch open. Then check the reading of the ammeter and voltmeter along the bottom pathway. (The other ammeter and voltmeter should each read zero.) Now close the switch and wait for the readings to settle down on all 4 meters. This will not happen instantaneously.

(c) With the switch open:

$V_2 = 0$	$I_2 = 0$
$V_1 = 12$ V	$I_1 = 0.06$ A

After the switch is closed, V_2 and I_2 will initially pop up to 12 V and 0.12 A, respectively. However, they will quickly fall back down to zero as the capacitor charges. V_1 and I_1 remain unchanged throughout. The steady state after the switch is closed:

$V_2 = 0$ (all 12 V will be on the capacitor)	$I_2 = 0$
$V_1 = 12$ V	$I_1 = 0.06$ A

(d) Internal resistance of the battery will reduce the voltage available to the circuit as a function of the current drawn. Specifically, during the steady-state solutions, V_1 will measure less than 12 V and I_1 will be less than 0.06 A. During the transition time just after the switch is closed, the voltage and current will fall further as more current will be drawn at first for the capacitor. The greater current drawn during the charging of the capacitor will cause the 12-volt battery to use more of its voltage on its internal resistance. Ammeters having resistance will increase the resistance of the entire circuit, meaning a lower current drawn from the battery. This lower current will result in less voltage actually being used than the expected 12 V across the resistor.

(e) There would still be a closed path for the capacitor to discharge through because both resistors would now be in series. The capacitor would quickly discharge. Both ammeters would have the same readings, which would quickly go to zero. V_1 would be twice that of V_2 while the capacitor discharges, but they, too, would quickly go to zero.

2. (a) The change in angle as the ray of light changes medium is due to a change in speed. Just as a rolling cylinder will pivot if one end of it comes into contact with a rougher surface, so too will the ray of light pivot as it changes speed when crossing from one medium into another. Since the light is pivoting toward the normal, the new medium must be a slower one.

(b) Use:

$$n_1 \sin \theta_1 = n_2 \sin \theta_2$$

Since air has the index of refraction $n_1 = 1.00$, we have:

$$n_2 = \frac{\sin \theta_1}{\sin \theta_2} = \frac{\sin 40°}{\sin 22°} = 1.72$$

Use the relationship between velocity and index of refraction to find the new speed:

$$v = c/n = (3 \times 10^8)/1.72 = 1.74 \times 10^8 \text{ m/s}$$

(c) For the critical angle, we know that the angle of refraction will be 90°:

$$\sin \theta_c = n_2/n_1 = 1.47/1.74 = 0.8448$$

$$\theta_c = 58°$$

There was no critical angle when reversing the direction because total internal reflection can happen only when going from a slower medium to a faster one (i.e., higher n to lower n). This is so because going from a slower medium to a faster medium refracts the light away from the normal, toward the surface. This creates a limiting case (called the critical angle) that refracts light all the way to the surface itself (90-degree refraction). Angles beyond this don't work; no refraction occurs. When going from a faster medium to a slower medium, the light ray refracts toward the normal. So there is always a refracted solution and, hence, no critical angle.

(d) The focal length of the lens made from the unknown substance will be shorter than the focal length of the lens made from crown glass. Since the index of refraction of the unknown substance is greater than that of crown glass, light will refract more. Thus the converging point for the focal length will be closer to the lens.

3. (a) Beta particles are being emitted. Alpha particles are stopped by paper, and gamma rays would penetrate the aluminum foil easily. Alpha particles are so easily stopped because they are big and highly charged. Beta particles have a single quantum of charge and are quite small, so they are harder to stop. Gamma rays are high-frequency electromagnetic radiation and carry no charge. Thus they are the most difficult to stop.

(b) It is not possible to predict which specific radioactive atom will decay next. The process is random but defined by a certain probability. Upon emission of a beta particle, the atom will lose 4 units of mass and have its atomic number reduced by 2.

(c) The daughter nuclei will be more stable than before the beta particle was emitted. Therefore, its binding energy/nucleon will be higher. Another way to think about this is that the ejected electron is taking away energy in addition to its mass, leaving the daughter nuclei with a greater mass deficit per nucleon than before ($E = mc^2$).

(d) With a half-life of 12 hours, 3 days equals 6 half-lives. Therefore, the amount of radio-active atoms in the sample will have been reduced by approximately $(1/2)^6$ after 3 days. As a result, the click rate on the Geiger counter would also be reduced by this factor (1/64).

4. (a) __X__ Frequency The electron transition is a definitive amount of energy. Energy is conserved, and therefore the photon has a definite amount of energy. The energy of a photon is proportional to frequency only:

$$E = hf$$

Therefore, the definite energy difference corresponds to a unique frequency. The wave speed is determined by the medium through which the light travels. Wavelength (λ), in turn, is determined by the frequency (f), which is set by energy, and also by the wave speed (v), which is set by medium:

$$\lambda = v/f$$

(b) Since the photon is carrying energy out of the atom, the relativistic mass of the atom does indeed decrease by precisely Einstein's famous relationship:

$$\Delta m = \Delta E/c^2$$

where ΔE is the hf of the photon emitted and c is the speed of light

(c) (i) According to the special relativity theorem, all inertial observers will measure the same speed of light. Therefore, whose point of view we are discussing is moot. All observers will see the emitted photon of light traveling at c in a vacuum.

(ii) Photons do carrying momentum ($p = h/\lambda$). So this absorption event can be modeled as a head-on collision, which will slow down the electron since net momentum must be conserved.

TEST ANALYSIS

NOTE: Because the AP Physics 1 and AP Physics 2 are new exams (first administered in 2015), there is no way of knowing exactly how the raw scores on the exams will translate into a 1, 2, 3, 4, or 5. The formula provided below is based on past practice for the AP Physics B and commonly accepted standards for grading. Additionally, the score range corresponding to each grade varies from exam to exam and thus the ranges provided below are approximate.

AP PHYSICS 2 PRACTICE TEST 2

Section I: Multiple-Choice

Note that the questions requiring two answers are to be graded as completely correct or incorrect.

$$\text{Number correct (out of 50)} = \overline{\text{Multiple-Choice Score}}$$

Section II: Free-Response

Grade each question individually using the following scale:

4: completely correct
3: substantially correct with minor errors
2: partially correct with some incorrect parts
1: a few correct attempts made, but no completely correct portions
0: completely incorrect or unanswered

$$\text{Question 1} = \overline{\text{(out of 4)}}$$

$$\text{Question 2} = \overline{\text{(out of 4)}}$$

$$\text{Question 3} = \overline{\text{(out of 4)}}$$

$$\text{Question 4} = \overline{\text{(out of 4)}}$$

$$\textbf{Total} = \overline{\text{(out of 16)}} \times 3.125 = \overline{\text{Free-Response Score}}$$

Final Score

$$\overline{\text{Multiple-Choice Score}} + \overline{\text{Free-Response Score}} = \overline{\substack{\text{Final Score} \\ \text{(rounded to the nearest whole number)}}}$$

Final Score Range	AP Score
81–100	5
61–80	4
51–60	3
41–50	2
0–40	1

Appendix

Table of Information for AP Physics 1

Useful Constants

Rest mass of the proton	$m_p = 1.67 \times 10^{-27}$ kg
Rest mass of the neutron	$m_n = 1.67 \times 10^{-27}$ kg
Rest mass of the electron	$m_e = 9.11 \times 10^{-31}$ kg
Magnitude of the electron charge	$e = 1.60 \times 10^{-19}$ C
Speed of light	$c = 3 \times 10^8$ m/s
Coulomb's law constant	$k = (1/4)\pi\varepsilon_0 = 9 \times 10^9$ N \cdot m$^2$/C$^2$
Acceleration due to gravity at Earth's surface	$g = 9.8$ m/s$^2$
Universal gravitational constant	$G = 6.67 \times 10^{-11}$ m$^3$/(kg \cdot s$^2$)

Unit Symbols

Meter, m	Hertz, Hz	Watt, W	Degree Celsius, °C
Kilogram, kg	Newton, N	Coulomb, C	
Second, s	Joule, J	Volt, V	
Ampere, A		Ohm, Ω	
Kelvin, K			

Prefixes

Factor	Prefix	Symbol
10^{12}	Tera-	T
10^9	Giga-	G
10^6	Mega-	M
10^3	Kilo-	k
10^{-2}	Centi-	c
10^{-3}	Milli-	m
10^{-6}	Micro-	μ
10^{-9}	Nano-	n
10^{-12}	Pico-	p

Values of Trigonometric Functions for Common Angles

θ	0°	30°	37°	45°	53°	60°	90°
$\sin\theta$	0	$\dfrac{1}{2}$	$\dfrac{3}{5}$	$\dfrac{\sqrt{2}}{2}$	$\dfrac{4}{5}$	$\dfrac{\sqrt{3}}{2}$	1
$\cos\theta$	1	$\dfrac{\sqrt{3}}{2}$	$\dfrac{4}{5}$	$\dfrac{\sqrt{2}}{2}$	$\dfrac{3}{5}$	$\dfrac{1}{2}$	0
$\tan\theta$	0	$\dfrac{\sqrt{3}}{3}$	$\dfrac{3}{4}$	1	$\dfrac{4}{3}$	$\sqrt{3}$	∞

Formula Sheet for AP Physics 1

Mechanics

$v = v_0 + at$

$x = x_0 + v_0 t + \dfrac{1}{2} at^2$

$v^2 = v_0{}^2 + 2a(x - x_0)$

$\Sigma F = F_{net} = ma$

$F_{fric} \leq \mu N$

$a_c = \dfrac{v^2}{r}$

$\tau = rF \sin \theta$

$p = mv$

$F \Delta t = \Delta p$

$K = \dfrac{1}{2} mv^2$

$\Delta U_g = mg \Delta y$

$\Delta E = W = Fd \cos \theta$

$P_{avg} = \dfrac{\Delta E}{\Delta t}$

$\theta = \theta_0 + \omega_0 t + \dfrac{1}{2} \alpha t^2$

$\omega = \omega_0 + \alpha t$

$x = A \cos(2\pi ft)$

$\Sigma \tau = \tau_{net} = I\alpha$

$T = rF \sin \theta$

$L = I\omega$

$\Delta L = \tau \Delta t$

$K = \dfrac{1}{2} I\omega^2$

$\rho = m/V$

$F_s = -kx$

$U_s = \dfrac{1}{2} kx^2$

$T_s = 2\pi \sqrt{\dfrac{m}{k}}$

$T_p = 2\pi \sqrt{\dfrac{\ell}{g}}$

$T = \dfrac{1}{f} = \dfrac{2\pi}{w}$

$F_G = -\dfrac{Gm_1 m_2}{r^2}$

$U_G = -\dfrac{Gm_1 m_2}{r}$

a = acceleration

F = force

f = frequency

h = height

I = rotational inertia

K = kinetic energy

k = spring constant

L = angular momentum

ℓ = length

m = mass

N = normal force

P = power

p = momentum

r = radius or distance

T = period

t = time

U = potential energy

V = volume

v = velocity or speed

ω = angular speed

W = work done on a system

x = position

α = angular acceleration

θ = angle

ρ = density

τ = torque

μ = coefficient of friction

Electricity

$F = \dfrac{1}{4\pi \varepsilon_0} \dfrac{q_1 q_2}{r^2}$

$I_{avg} = \dfrac{\Delta Q}{\Delta t}$

$R = \dfrac{\rho \ell}{A}$

$V = IR$

$P = IV$

$R_s = \sum_i R_i$

$\dfrac{1}{R_p} = \sum_i \dfrac{1}{R_i}$

A = area

d = distance

F = force

I = current

ℓ = length

P = power

Q = charge

q = point charge

R = resistance

r = distance

t = time

V = electrical potential

v = velocity or speed

ρ = resistivity

θ = angle

Waves	Geometry and Trigonometry

Waves

$$v = f\lambda$$

f = frequency
v = speed
λ = wavelength

Geometry and Trigonometry

Rectangle

$$A = bh$$

Triangle

$$A = \frac{1}{2}bh$$

Circle

$$A = \pi r^2$$

$$C = 2\pi r$$

Parallelepiped

$$V = \ell w h$$

Cylinder

$$V = \pi r^2 \ell$$

$$S = 2\pi r\ell + 2\pi r^2$$

Sphere

$$V = \frac{4}{3}\pi r^3$$

$$S = 4\pi r^3$$

A = area
C = circumference
V = volume
S = surface area
b = base

h = height
ℓ = length
w = width
r = radius

Right Triangle

$$a^2 + b^2 = c^2$$

$$\sin\theta = \frac{a}{c}$$

$$\cos\theta = \frac{b}{c}$$

$$\tan\theta = \frac{a}{b}$$

Table of Information for AP Physics 2

Useful Constants

1 atomic mass unit	$1 \text{ u} = 1.66 \times 10^{-27} \text{ kg} = 931 \text{ MeV}/c^2$
Rest mass of the proton	$m_p = 1.67 \times 10^{-27} \text{ kg}$
Rest mass of the neutron	$m_n = 1.67 \times 10^{-27} \text{ kg}$
Rest mass of the electron	$m_e = 9.11 \times 10^{-31} \text{ kg}$
Magnitude of the electron charge	$e = 1.60 \times 10^{-19} \text{ C}$
Avogadro's number	$N_0 = 6.02 \times 10^{23} \text{ per mol}$
Universal gas constant	$R = 8.32 \text{ J}/(\text{mol} \cdot \text{K})$
Boltzmann's constant	$k_B = 1.38 \times 10^{-23} \text{ J/K}$
Speed of light	$c = 3 \times 10^8 \text{ m/s}$
Planck's constant	$h = 6.63 \times 10^{-34} \text{ J} \cdot \text{s} = 4.14 \times 10^{-15} \text{ eV} \cdot \text{s}$
1 electron volt	$1 \text{ eV} = 1.6 \times 10^{-19} \text{ J}$
Vacuum permittivity	$\varepsilon_0 = 8.85 \times 10^{-12} \text{ C}^2/\text{N} \cdot \text{m}^2$
Coulomb's law constant	$k = (1/4)\pi\varepsilon_0 = 9 \times 10^9 \text{ N} \cdot \text{m}^2/\text{C}^2$
Vacuum permeability	$\mu_0 = 4\pi \times 10^{-7} \text{ Wb}/(\text{A} \cdot \text{m})$
Magnetic constant	$k' = \mu_0/4\pi = 10^{-7} \text{ Wb}/(\text{A} \cdot \text{m})$
Acceleration due to gravity at Earth's surface	$g = 9.8 \text{ m/s}^2$
Universal gravitational constant	$G = 6.67 \times 10^{-11} \text{ m}^3/(\text{kg} \cdot \text{s}^2)$
1 atmosphere pressure	$1 \text{ atm} = 1.0 \times 10^5 \text{ N/m}^2 = 1.0 \times 10^5 \text{ Pa}$

Unit Symbols

Meter, m	Mole, mol	Watt, W	Farad, F
Kilogram, kg	Hertz, Hz	Coulomb, C	Tesla, T
Second, s	Newton, N	Volt, V	Degree Celsius, °C
Ampere, A	Pascal, Pa	Ohm, Ω	Electron volt, eV
Kelvin, K	Joule, J	Henry, H	

Prefixes

Factor	Prefix	Symbol
10^{12}	Tera-	T
10^{9}	Giga-	G
10^{6}	Mega-	M
10^{3}	Kilo-	k
10^{-2}	Centi-	c
10^{-3}	Milli-	m
10^{-6}	Micro-	μ
10^{-9}	Nano-	n
10^{-12}	Pico-	p

Values of Trigonometric Functions for Common Angles

θ	0°	30°	37°	45°	53°	60°	90°
$\sin\theta$	0	$\dfrac{1}{2}$	$\dfrac{3}{5}$	$\dfrac{\sqrt{2}}{2}$	$\dfrac{4}{5}$	$\dfrac{\sqrt{3}}{2}$	1
$\cos\theta$	1	$\dfrac{\sqrt{3}}{2}$	$\dfrac{4}{5}$	$\dfrac{\sqrt{2}}{2}$	$\dfrac{3}{5}$	$\dfrac{1}{2}$	0
$\tan\theta$	0	$\dfrac{\sqrt{3}}{3}$	$\dfrac{3}{4}$	1	$\dfrac{4}{3}$	$\sqrt{3}$	∞

Formula Sheet for AP Physics 2

Mechanics

$v = v_0 + at$

$x = x_0 + v_0 t + \dfrac{1}{2}at^2$

$v^2 = v_0^2 + 2a(x - x_0)$

$\Sigma \mathbf{F} = \mathbf{F}_{net} = m\mathbf{a}$

$F_{fric} \leq \mu N$

$a_c = \dfrac{v^2}{r}$

$\tau = rF\sin\theta$

$\mathbf{p} = m\mathbf{v}$

$\mathbf{J} = \mathbf{F}\Delta t = \Delta \mathbf{p}$

$K = \dfrac{1}{2}mv^2$

$\Delta U_g = mgh$

$W = F\Delta r\cos\theta$

$P_{avg} = \dfrac{W}{\Delta t}$

$\theta = \theta_0 + \omega_0 t + \dfrac{1}{2}\alpha t^2$

$\omega = \omega_0 + \alpha t$

$x = A\cos(\omega t) = A\cos(2\pi f t)$

$x_{cm} = \Sigma m_i x_i / \Sigma m_i$

$\Sigma\tau = \tau_{net} = I\alpha$

$T = rF\sin\theta$

$L = I\omega$

$\Delta L = \tau\Delta t$

$K = \dfrac{1}{2}I\omega^2$

$P = Fv\cos\theta$

$\mathbf{F}_s = -k\mathbf{x}$

$U_s = \dfrac{1}{2}kx^2$

$T_s = 2\pi\sqrt{\dfrac{m}{k}}$

$T_p = 2\pi\sqrt{\dfrac{\ell}{g}}$

$T = \dfrac{1}{f}$

$F_G = -\dfrac{Gm_1 m_2}{r^2}$

$U_G = -\dfrac{Gm_1 m_2}{r}$

a = acceleration
F = force
f = frequency
h = height
I = rotational inertia
J = impulse
K = kinetic energy
k = spring constant
L = angular momentum
ℓ = length
m = mass
N = normal force
P = power
p = momentum
r = radius or distance
T = period

t = time
U = potential energy
V = volume
v = velocity or speed
W = work done on a
 system
x = position
α = angular
 acceleration
θ = angle
τ = torque
ω = angular speed
μ = coefficient of
 friction

Electricity and Magnetism

$F = \dfrac{1}{4\pi\varepsilon_0}\dfrac{q_1 q_2}{r^2}$

$\mathbf{E} = \dfrac{\mathbf{F}}{q}$

$U_E = qV = \dfrac{1}{4\pi\varepsilon_0}\dfrac{q_1 q_2}{r}$

$E_{avg} = -\dfrac{V}{d}$

$V = \dfrac{1}{4\pi\varepsilon_0}\dfrac{q}{r}$

$C = \dfrac{Q}{V}$

$C = \dfrac{\varepsilon_0 A}{d}$

$U_c = \dfrac{1}{2}QV = \dfrac{1}{2}CV^2$

$I_{avg} = \dfrac{\Delta Q}{\Delta t}$

$R = \dfrac{\rho\ell}{A}$

$E = \dfrac{q}{4\pi\varepsilon_0 r}$

$V = IR$

$P = IV$

$C_p = \sum_i C_i$

$\dfrac{1}{C_s} = \sum_i \dfrac{1}{C_i}$

$R_s = \sum_i R_i$

$\dfrac{1}{R_p} = \sum_i \dfrac{1}{R_i}$

$F_B = qvB\sin\theta = q\mathbf{v} \times \mathbf{B}$

$F_B = BI\ell\sin\theta = I\boldsymbol{\ell} \times \mathbf{B}$

$B = \dfrac{\mu_0}{2\pi}\dfrac{I}{r}$

$\phi_m = BA\cos\theta = \mathbf{B} \cdot \mathbf{A}$

$\varepsilon_{avg} = -\dfrac{\Delta\phi_m}{\Delta t}$

$\varepsilon = B\ell v$

A = area
B = magnetic field
C = capacitance
d = distance
E = electric field
ε = emf
F = force
I = current
ℓ = length
P = power
Q = charge
q = point charge
R = resistance

r = distance
t = time
U = potential
 (stored) energy
V = electrical
 potential
v = velocity or speed
ρ = resistivity
θ = angle
ϕ_m = magnetic flux

Fluid Mechanics and Thermal Physics

$P = P_0 + \rho gh$

$F_{buoy} = \rho Vg$

$A_1 v_1 = A_2 v_2$

$P + \rho gy + \frac{1}{2}\rho v^2 = \text{const.}$

$P = \dfrac{F}{A}$

$PV = nRT = Nk_BT$

$\rho = m/V$

$\dfrac{Q}{\Delta t} = \dfrac{kA\Delta T}{L}$

$K = \dfrac{3}{2}k_BT$

$W = -P\Delta V$

$\Delta U = Q + W$

A = area
F = force
h = depth
k = thermal conductivity
K = kinetic energy
L = thickness
n = number of moles
N = number of molecules
P = pressure
Q = energy transferred to a system by heat

T = temperature
t = time
U = internal energy
V = volume
v = velocity or speed
W = work done on a system
y = height
ρ = density

Modern Physics

$E = hf$

$K_{max} = hf - \phi$

$E = mc^2$

$\lambda = \dfrac{h}{p}$

E = energy
f = frequency
K = kinetic energy
m = mass

p = momentum
λ = wavelength
ϕ = work function

Waves and Optics

$v = f\lambda$

$n = \dfrac{c}{v}$

$n_1 \sin \theta_1 = n_2 \sin \theta_2$

$\dfrac{1}{s_i} + \dfrac{1}{s_0} = \dfrac{1}{f}$

$\Delta L = m\lambda$

$d \sin \theta = m\lambda$

$M = \dfrac{h_i}{h_0} = -\dfrac{s_i}{s_0}$

d = separation
f = frequency or focal length
h = height
L = distance
M = magnification
m = an integer

n = index of refraction
s = distance
v = speed
λ = wavelength
θ = angle

Geometry and Trigonometry

Rectangle

$A = bh$

Triangle

$A = \dfrac{1}{2}bh$

Circle

$A = \pi r^2$

$C = 2\pi r$

Parallelepiped

$V = \ell wh$

Cylinder

$V = \pi r^2 \ell$

$S = 2\pi r\ell + 2\pi r^2$

Sphere

$V = \dfrac{4}{3}\pi r^3$

$S = 4\pi r^3$

Right Triangle

$a^2 + b^2 = c^2$

$\sin \theta = \dfrac{a}{c}$

$\cos \theta = \dfrac{b}{c}$

$\tan \theta = \dfrac{a}{b}$

A = area
C = circumference
V = volume
S = surface area
b = base

h = height
ℓ = length
w = width
r = radius

Glossary

A

absolute index of refraction For a transparent material, a number that represents the ratio of the speed of light in a vacuum to the speed of light in the material.

absolute temperature A measure of the average kinetic energy of the molecules in an object; on the Kelvin scale, equal to the Celsius temperature of an object plus 273.

absolute zero The theoretical lowest possible temperature, designated as 0 K.

absorption spectrum A continuous spectrum crossed by dark lines representing the absorption of particular wavelengths of radiation by a cooler medium.

acceleration A vector quantity representing the time rate of change of velocity.

action A force applied to an object that leads to an equal but opposite reaction; the product of total energy and time in units of joules times seconds; the product of momentum and position, especially in the case of the Heisenberg uncertainty principle.

activity The number of decays per second of a radioactive atom.

adiabatic In thermodynamics, referring to the process that occurs when no heat is added or subtracted from the system.

alpha decay The spontaneous emission of a helium nucleus from certain radioactive atoms.

alpha particle A helium nucleus that is ejected from a radioactive atom.

alternating current An electric current that changes its direction and magnitude according to a regular frequency.

ammeter A device that, when placed in series, measures the current in an electric circuit; a galvanometer with a low-resistance coil placed across it.

ampere (A) The SI unit of electric current, equal to 1 C/s.

amplitude The maximum displacement of an oscillating particle, medium, or field relative to its rest position.

angle of incidence The angle between a ray of light and the normal to a reflecting or transparent surface at the location where the ray intercepts the surface.

angle of reflection The angle between a reflected light ray and the normal to a mirror or other reflecting surface at the location where the ray intercepts the surface.

angle of refraction The angle between an emerging light ray in a transparent material and the normal to the surface at the location where the ray first enters the material.

angstrom (Å) A unit of wavelength measurement equal to 1×10^{-10} m.

antinodal lines A region of maximum displacement in a medium where waves are interacting with each other.

Archimedes' principle A body wholly or partially immersed in a fluid will be buoyed up by a force equal to the weight of the fluid it displaces.

armature The rotating coil of wire in an electric motor.

atomic mass unit (u) A unit of mass equal to one-twelfth the mass of a carbon-12 nucleus. Older texts use the abbreviation "amu."

atomic number The number of protons in an atom's nucleus.

atmosphere (atm) A unit of pressure, equal to 101 kPa at sea level.

average speed A scalar quantity equal to the ratio of the total distance to the total elapsed time.

Avogadro's number The number of molecules in 1 mole of an ideal gas, equal to 6.02×10^{23}. Named for Italian chemist/physicist Amedeo Avogadro.

B

Balmer series In a hydrogen atom, the visible spectral emission lines that correspond to electron transitions from higher excited states to lower level 2.

battery A combination of two or more electric cells.

beats The interference caused by two sets of sound waves with only a slight difference in frequency.

becquerel (Bq) A unit of radioactive decay, equal to one decay event per second.

Bernoulli's principle If the speed of a fluid particle increases as it travels along a streamline, the pressure of the fluid must decrease.

beta decay The spontaneous ejection of an electron from the nuclei of certain radioactive atoms.

beta particle An electron that is spontaneously ejected by a radioactive nucleus.

binding energy The energy required to break apart an atomic nucleus; the energy equivalent of the mass defect.

Boltzmann's constant In thermodynamics, a constant equal to the ratio of the universal gas constant, R, to Avogadro's number, N_A, equal to 1.38×10^{-23} J/K. Named for German physicist Ludwig Boltzmann.

Boyle's law At constant temperature, the pressure in an ideal gas varies inversely with the volume of the gas. Named for British physicist/chemist Robert Boyle.

bright-line spectrum The display of brightly colored lines on a screen or photograph indicating the discrete emission of radiation by a heated gas at low pressure.

C

capacitance The ratio of the total charge to the potential difference in a capacitor.

capacitor A pair of conducting plates, with either a vacuum or an insulator between them, used in an electric circuit to store current.

Carnot cycle In thermodynamics, a sequence of four steps in an ideal gas confined in a cylinder with a movable piston (a Carnot engine). The cycle includes an isothermal expansion, an adiabatic expansion, an isothermal compression, and an adiabatic compression. Named for French physicist Sadi Carnot.

Cartesian coordinate system A set of two or three mutually perpendicular reference lines, called axes and usually designated as x, y, and z, that are used to define the location of an object in a frame of reference; a coordinate system named for French scientist Rene Descartes.

cathode ray tube An evacuated gas tube into which a beam of electrons is projected. Their energy produces an image on a fluorescent screen when deflected by external electric or magnetic fields.

Celsius temperature scale A metric temperature scale in which, at sea level, water freezes at 0°C and boils at 100°C. Named for Swedish astronomer Anders Celsius.

center of curvature A point that is equidistant from all other points on the surface of a spherical mirror; a point equal to twice the focal length of a spherical mirror.

center of mass The weighted mean distribution point where all the mass of an object can be considered to be located; the point at which, if a single force is applied, translational motion will result.

centripetal acceleration The acceleration of mass moving uniformly in a circle at a constant speed directed radially inward toward the center of the circular path.

centripetal force The deflecting force, directed radially inward toward a given point, that causes an object to follow a circular path.

chain reaction In nuclear fission, the uncontrolled reaction of neutrons splitting uranium nuclei and creating more neutrons that continue the process on a self-sustained basis.

Charles's law At constant pressure, the volume of an ideal gas varies directly with the absolute temperature of the gas. Named for J. A. C. Charles.

chromatic aberration In optics, the defect in a converging lens that causes the dispersion of white light into a continuous spectrum, with the result that the lens refracts the colors to different focal points.

coefficient of friction The ratio of the force of friction to the normal force when one surface is sliding (or attempting to slide) over another surface.

coherent Referring to a set of waves that have the same wavelength, frequency, and phase.

component One of two mutually perpendicular vectors that lie along the principal axes in a coordinate system and can be combined to form a given resultant vector.

concave lens A diverging lens that causes parallel rays of light to emerge in such a way that they appear to diverge away from a focal point behind the lens.

concave mirror A converging spherical mirror that causes parallel rays of light to converge to a focal point in front of the mirror.

concurrent forces Two or more forces that act at the same point and at the same time.

conductor A substance, usually metallic, that allows the relatively easy flow of electric charges.

conservation of energy A principle of physics that states that the total energy of an isolated system remains the same during all interactions within the system.

conservation of mass-energy A principle of physics that states that, in the conversion of mass into energy or energy into mass, the total mass-energy of the system remains the same.

conservation of momentum A principle of physics that states that, in the absence of any external forces, the total momentum of an isolated system remains the same.

conservative force A force such that any work done by this force can be recovered without any loss; a force whose work is independent of the path taken.

constructive interference The additive result of two or more waves interacting with the same phase relationship as they move through a medium.

continuous spectrum A continuous band of colors, consisting of red, orange, yellow, green, blue, and violet, formed by the dispersion or diffraction of white light.

control rod A device, usually made of cadmium, that is inserted in a nuclear reactor to control the rate of fission.

converging lens A lens that will cause parallel rays of light incident on its surface to refract and converge to a focal point; a convex lens.

converging mirror A spherical mirror that will cause parallel rays of light incident on its surface to reflect and converge to a focal point; a concave mirror.

convex lens See **converging lens**.

convex mirror See **diverging mirror**.

coordinate system A set of reference lines, not necessarily perpendicular, used to locate the position of an object within a frame of reference by applying the rules of analytic geometry.

core The interior of a solenoidal electromagnet, usually made of a ferromagnetic material; the part of a nuclear reactor where the fission reaction occurs.

coulomb (C) The SI unit of electrical charge, defined as the amount of charge 1 A of current contains each second.

Coulomb's law The electrostatic force between two point charges is directly proportional to the product of the charges and inversely proportional to the square of the distance separating them. Named for French physicist Charles-Augustin de Coulomb.

critical angle of incidence The angle of incidence to a transparent substance such that the angle of refraction equals 90° relative to the normal drawn to the surface.

current A scalar quantity that measures the amount of charge passing a given point in an electric circuit each second.

current length A relative measure of the magnetic field strength produced by a length of wire carrying current, equal to the product of the current and the length.

cycle One complete sequence of periodic events or oscillations.

D

damping The continuous decrease in the amplitude of mechanical oscillations due to a dissipative force.

deflecting force Any force that acts to change the direction of motion of an object.

derived unit Any combination of fundamental physical units.

destructive interference The result produced by the interaction of two or more waves with opposite phase relationships as they move through a medium.

deuterium An isotope of hydrogen containing one proton and one neutron in its nucleus; heavy hydrogen (a component of heavy water).

dielectric An electric insulator placed between the plates of a capacitor to alter its capacitance.

diffraction The ability of waves to pass around obstacles or squeeze through small openings.

diffraction grating A reflecting or transparent surface with many thousands of lines ruled on it, used to diffract light into a spectrum.

direct current Electric current that is moving in one direction only around an electric circuit.

dispersion The separation of light into its component colors or spectrum.

dispersive medium Any medium that produces the dispersion of light; any medium in which the velocity of a wave depends on its frequency.

displacement A vector quantity that determines the change in position of an object by measuring the straight-line distance and direction from the starting point to the ending point.

dissipative force Any force, such as friction, that removes kinetic energy from a moving object; a nonconservative force.

distance A scalar quantity that measures the total length of the path taken by a moving object.

diverging lens A lens that causes parallel rays of light incident on its surface to refract and diverge away from a focal point on the other side of the lens; a concave lens.

diverging mirror A spherical mirror that causes parallel rays of light incident on its surface to reflect and diverge away from a focal point on the other side of the mirror.

Doppler effect The apparent change in the wavelength or frequency of a wave as the source of the wave moves relative to an observer. Named for Austrian physicist Christian Doppler.

dynamics The branch of mechanics that studies the effects of forces on objects.

E

elastic collision A collision between two objects in which there is a rebounding and no loss of kinetic energy occurs.

elastic potential energy The energy stored in a spring when work is done to stretch or compress it.

electrical ground The passing of charges to or from Earth to establish a potential difference between two points.

electric cell A chemical device for generating electricity.

electric circuit A closed conducting loop consisting of a source of potential difference, conducting wires, and other devices that operate on electricity.

electric field The region where an electric force is exerted on a charged object.

electric field intensity A vector quantity that measures the ratio of the magnitude of the force to the magnitude of the charge on an object.

electromagnet A coil of wire, wrapped around a ferromagnetic core (usually made of iron), that generates a magnetic field when current is passed through it.

electromagnetic field The field produced by an electromagnet or moving electric charges.

electromagnetic induction The production of a potential difference in a conductor due to the relative motion between the conductor and an external magnetic field, or due to the change in an external magnetic flux near the conductor.

electromagnetic spectrum The range of frequencies covering the discrete emission of energy from oscillating electromagnetic fields; included are radio waves, microwaves, infrared waves, visible light, ultraviolet light, X rays, and gamma rays.

electromagnetic wave A wave generated by the oscillation of electric charges producing interacting electric and magnetic fields that oscillate in space and travel at the speed of light in a vacuum.

electromotive force (emf) The potential difference caused by the conversion of different forms of energy into electrical energy; the energy per unit charge.

electron A negatively charged particle that orbits a nucleus in an atom; the fundamental carrier of negative electric charge.

electron capture The process in which an orbiting electron is captured by a nucleus possessing too many neutrons with respect to protons; also called K-capture.

electron cloud A theoretical probability distribution of electrons around the nucleus due to the Heisenberg uncertainty principle. The most probable location for an electron is in the densest regions of the cloud.

electron volt (eV) A unit of energy related to the kinetic energy of a moving charge and equal to 1.6×10^{-19} J.

electroscope A device for detecting the presence of static charges on an object.

elementary charge The fundamental amount of charge of an electron.

emf See **electromotive force**.

emission spectrum The discrete set of colored lines representing the electromagnetic energy produced when atomic compounds are excited into emitting light because of heat, sparks, or atomic collisions.

energy A scalar quantity representing the capacity to work.

energy level One of several regions around a nucleus where electrons are considered to reside.

entropy The degree of randomness or disorder in a thermodynamic system.

equilibrant The force equal in magnitude and opposite in direction to the resultant of two or more forces that brings a system into equilibrium.

equilibrium The balancing of all external forces acting on a mass; the result of a zero vector sum of all forces acting on an object.

escape velocity The velocity attained by an object such that, if coasting, the object would not be pulled back toward the planet from which it came.

excitation The process by which an atom absorbs energy and causes its orbiting electrons to move to higher energy levels.

excited state In an atom, the situation in which its orbiting electrons are residing in higher energy levels.

F

farad (F) A unit of capacitance equal to 1 C/V.

Faraday's law of electromagnetic induction The magnitude of the induced emf in a conductor is equal to the rate of change of the magnetic flux. Named for British chemist/physicist Michael Faraday.

ferromagnetic substances A metal or a compound made of iron, cobalt, or nickel that produces very strong magnetic fields.

field A region characterized by the presence of a force on a test body like a unit mass in a gravitational field or a unit charge in an electric field.

field intensity A measure of the force exerted on a unit test body; the force per unit mass; the force per unit charge.

first law of thermodynamics A statement of the conservation of energy as applied to thermodynamic systems: The change in energy of a system is equal to the change in the internal energy plus any work done by the system.

fission The splitting of a uranium nucleus into two smaller, more stable nuclei by means of a slow-moving neutron, with the release of a large amount of energy.

flux A measure, in webers, of the product of the perpendicular component of a magnetic field crossing an area and the magnitude of the area.

flux density A measure, in webers per square meter, of the field intensity per unit area.

focal length The distance along the principal axis from a lens or spherical mirror to the principal focus.

focus The point of convergence of light rays caused by a converging mirror or lens; either of two fixed points in an ellipse that determines its shape.

force A vector quantity that corresponds to any push or pull due to an interaction of matter that changes the motion of an object.

force constant See **spring constant**.

forced vibration A vibration caused by the application of an external force.

frame of reference A point of view consisting of a coordinate system in which observations are made.

free-body diagram A diagram that illustrates all of the forces acting on a mass at any given time.

frequency The number of completed periodic cycles per second in an oscillation or wave motion.

friction A force that opposes the motion of an object as it slides over another surface.

fuel rods Rods packed with fissionable material that are inserted into the core of a nuclear reactor.

fundamental unit An arbitrary scale of measurement assigned to certain physical quantities, such as length, time, mass, and charge, that are considered to be the basis for all other measurements. In the SI system, the fundamental units used in physics are the meter, kilogram, second, ampere, kelvin, and mole.

fusion The combination of two or more light nuclei to produce a more stable, heavier nucleus, with the release of energy.

G

galvanometer A device used to detect the presence of small electric currents when connected in series in a circuit.

gamma radiation High-energy photons emitted by certain radioactive substances.

gravitation The mutual force of attraction between two uncharged masses.

gravitational field strength A measure of the gravitational force per unit mass in a gravitational field.

gravity Another name for gravitation or the gravitational force; the tendency of objects to fall to Earth.

ground state The lowest energy level of an atom.

H

heat The energy observed due to particle collisions in matter; the energy produced when matter interacts with particles that are colliding randomly with each other, as in a gas.

hertz (Hz) The SI unit of frequency, equal to 1 s^{-1}.

Hooke's law The stress applied to an elastic material is directly proportional to the strain produced. Named for English scientist Robert Hooke.

I

ideal gas A gas for which the assumptions of the kinetic theory are valid.

image An optical reproduction of an object by means of a lens or mirror.

impulse A vector quantity equal to the product of the average force applied to a mass and the time interval in which the force acts; the area under a force versus time graph.

induced potential difference A potential difference created in a conductor because of its motion relative to an external magnetic field.

induction coil A transformer in which a variable potential difference is produced in a secondary coil when a direct current, applied to the primary, is turned on and off.

inelastic collision A collision in which two masses interact and stick together, leading to an apparent loss of kinetic energy.

inertia The property of matter that resists the action of applied force trying to change the motion of an object.

inertial frame of reference A frame of reference in which the law of inertia holds; a frame of reference moving with constant velocity relative to Earth.

instantaneous velocity The slope of a tangent line to a point in a displacement versus time graph.

insulator A substance that is a poor conductor of electricity because of the absence of free electrons.

interference The interaction of two or more waves, producing an enhanced or a diminished amplitude at the point of interaction; the superposition of one wave on another.

interference pattern The pattern produced by the constructive and destructive interference of waves generated by two point sources.

isobaric In thermodynamics, referring to a process in which the pressure of a gas remains the same.

isochoric In thermodynamics, referring to a process in which the volume of a gas remains the same.

isolated system A combination of two or more interacting objects that are not being acted upon by external force.

isotope An atom with the same number of protons as a particular element but a different number of neutrons.

J

joule (J) The SI unit of work, equal to $1 \text{ N} \cdot \text{m}$; the SI unit of mechanical energy, equal to $1 \text{ kg} \cdot \text{m}^2/\text{s}^2$.

junction The point in an electric circuit where a parallel connection branches off.

K

K-capture See **electron capture.**

kelvin (K) The SI unit of absolute temperature, defined in such a way that 0 K equals –273°C.

Kepler's first law The orbital paths of all planets are elliptical. Named for German astronomer Johannes Kepler.

Kepler's second law A line from the Sun to a planet sweeps out equal areas in equal time.

Kepler's third law The ratio of the cube of the mean radius to the Sun to the square of the period is a constant for all planets orbiting the Sun.

kilogram (kg) The SI unit of mass.

kilojoule (kJ) A unit representing 1000 J.

kilopascal (kPa) A unit representing 1000 Pa.

kinematics In mechanics, the study of how objects move.

kinetic energy The energy possessed by a mass because of its motion relative to a frame of reference.

kinetic friction The friction induced by sliding one surface over another.

kinetic theory of gases The theory that all matter consists of molecules that are in a constant state of motion.

Kirchhoff's first law The algebraic sum of all currents at a junction in a circuit equals zero. Named for German physicist Gustav Kirchhoff.

Kirchhoff's second law The algebraic sum of all potential drops around any closed loop in a circuit equals zero.

L

laser A device for producing an intense coherent beam of monochromatic light; an acronym for *l*ight *a*mplification by the *s*timulated *e*mission of *r*adiation.

law of inertia See **Newton's first law of motion.**

lens A transparent substance, with one or two curved surfaces, used to direct rays of light by refraction.

Lenz's law An induced current in a conductor is always in a direction such that its magnetic field opposes the magnetic field that induced it. Named for German physicist Emil Lenz.

line of force An imaginary line drawn in a gravitational, electrical, or magnetic field that indicates the direction a test particle would take while experiencing a force in that field.

longitudinal wave A wave in which the oscillating particles vibrate in a direction parallel to the direction of propagation.

M

magnet An object that exerts a force on ferrous materials.

magnetic field A region surrounding a magnet in which ferrous materials or charged particles experience a force.

magnetic field strength The force on a unit current length in a magnetic field.

magnetic flux density The total magnetic flux per unit area in a magnetic field.

magnetic pole A region on a magnet where magnetic lines of force are most concentrated.

mass The property of matter used to represent the inertia of an object; the ratio of the net force applied to an object and its subsequent acceleration as specified by Newton's second law of motion.

mass defect The difference between the actual mass of a nucleus and the sum of the masses of the protons and neutrons it contains.

mass number The total number of protons and neutrons in an atomic nucleus.

mass spectrometer A device that uses magnetic fields to cause nuclear ions to assume circular trajectories and then determines the masses of the ions based on their charges, the radius of the path, and the external field strength.

mean radius For a planet, the average distance to the Sun.

meter (m) The SI unit of length.

moderator A material, such as water or graphite, that is used to slow neutrons in a fission reaction.

mole (mol) The SI unit for the amount of substance containing Avogadro's number of molecules.

moment arm distance A line drawn from a pivot point.

momentum A vector quantity equal to the product of the mass and the velocity of a moving object.

monochromatic light Light consisting of only one frequency.

N

natural frequency The frequency with which an elastic body will vibrate if disturbed.

net force The resultant force acting on a mass.

neutron A subatomic particle, residing in the nucleus, that has a mass comparable to that of a proton but is electrically neutral.

newton (N) The SI unit of force, equal to $1 \text{ kg} \cdot \text{m/s}^2$.

Newton's first law of motion An object at rest tends to remain at rest, and an object in motion tends to remain in motion at a constant velocity, unless acted upon by an external force; the law of inertia. Named for British mathematician/physicist Sir Isaac Newton.

Newton's second law of motion The acceleration of a body is directly proportional to the applied net force; $\mathbf{F} = m\mathbf{a}$.

Newton's third law of motion For every action, there is an equal, but opposite, reaction.

nodal line A line of minimum displacement when two or more waves interfere.

nonconservative force A force, such as friction, that decreases the amount of kinetic energy after work is done by or against the force.

normal A line perpendicular to a surface.

normal force A force that is directed perpendicularly to a surface when two objects are in contact.

nuclear force The force between nucleons in a nucleus that opposes the Coulomb force repulsion of the protons; the strong force.

nucleon Either a proton or a neutron as it exists in a nucleus.

O

ohm (Ω) The SI unit of electrical resistance, equal to 1 V/A.

Ohm's law In a circuit at constant temperature, the ratio of the potential difference to the current is a constant (called the resistance). Named for German physicist Georg Ohm.

optical center The geometric center of a converging or diverging lens.

P

parallel circuit A circuit in which two or more devices are connected across the same potential difference and provide an alternative path for charge flow.

pascal (Pa) The SI unit of pressure, equal to 1 N/m^2.

Pascal's principle A change in the pressure applied to an enclosed fluid is transmitted undiminished to every portion of the fluid and to the walls of the containing vessel.

period The time, in seconds, to complete one cycle of repetitive oscillations or uniform circular motion.

permeability The property of matter that affects an external magnetic field in which the material is placed, causing it to align free electrons within the substance and hence magnetizing it; a measure of a material's ability to become magnetized.

phase The relative position of a point on a wave with respect to another point on the same wave.

photoelectric effect The process by which surface electrons in a metal are freed through the incidence of electromagnetic radiation above a certain minimum frequency.

photon A single packet of electromagnetic energy.

Planck's constant A universal constant representing the ratio of the energy of a photon to its frequency; the fundamental quantum of action, having a value of 6.63×10^{-34} kg \cdot m$^2$/s. Named for German physicist Max Planck.

polar coordinate system A coordinate system in which the location of a point is determined by a vector from the origin of a Cartesian coordinate system and the acute angle it makes with the positive horizontal axis.

polarization The process by which the vibrations of a transverse wave are selected to lie in a preferred plane perpendicular to the direction of propagation.

polarized light Light that has been polarized by passing it through a suitable filter.

positron A subatomic particle having the same mass as an electron but a positive electrical charge.

potential difference The difference in work per unit charge between any two points in an electric field.

potential energy The energy possessed by a body because of its vertical position relative to the surface of Earth or any other arbitrarily chosen base level.

power The ratio of the work done to the time needed to complete the work.

pressure The force per unit area.

primary coil In a transformer, the coil connected to an alternating potential difference source.

principal axis An imaginary line passing through the center of curvature of a spherical mirror or the optical center of a lens.

prism A transparent triangular shape that disperses white light into a continuous spectrum.

pulse A single vibratory disturbance in an elastic medium.

Q

quantum A discrete packet of electromagnetic energy; a photon.

quantum theory The theory that light consists of discrete packets of energy that are absorbed or emitted in units.

R

radioactive decay The spontaneous disintegration of a nucleus due to its instability.

radius of curvature The distance from the center of curvature to the surface of a spherical mirror.

ray A straight line used to indicate the direction of travel of a light wave.

real image An image formed by a converging mirror or lens that can be focused onto a screen.

refraction The bending of a light ray when it passes obliquely from one transparent substance to another in which its velocity is different.

resistance The ratio of the potential difference across a conductor to the current in the conductor.

resistivity A property of matter that measures the ability of that substance to act as a resistor.

resolution of forces The process by which a given force is decomposed into a pair of perpendicular forces.

resonance The production of sympathetic vibrations in a body, at its natural vibrating frequency, caused by another vibrating body.

rest mass The mass of an object when the object is not moving.

rotational equilibrium The situation when the vector sum of all torques acting on a rotating mass equals zero.

rotational inertia The ability of a substance to resist the action of a torque; moment of inertia.

S

scalar A physical quantity, such as mass or speed, that is characterized by magnitude only.

second (s) The SI unit of time.

secondary coil In a transformer, a coil in which an alternating potential difference is induced.

second law of thermodynamics Heat flows only from a hot body to a cold one; the entropy of the universe is always increasing.

series circuit A circuit in which electrical devices are connected sequentially in a single conducting loop, allowing only one path for charge flow.

sliding friction A force that resists the sliding motion of one surface over another; kinetic friction.

Snell's law For light passing obliquely from one transparent substance to another, the ratio of the sine of the angle of incidence to the sine of the angle of refraction is equal to the relative index of refraction for the two media. Named for Willebrord Snell.

solenoid A coil of wire used for electromagnetic induction.

specific heat The amount of energy, in kilojoules, needed to change the temperature of 1 kg of a substance by 1°C.

speed A scalar quantity measuring the time rate of change of distance.

spherical aberration In a converging spherical mirror or a converging lens, the inability to properly focus parallel rays of light because of the shape of the mirror or lens.

spring constant The ratio of the applied force and resultant displacement of a spring.

standard pressure At sea level, 1 atm, which is equal to 101.3 kPa.

standing wave A stationary wave pattern formed in a medium when two sets of waves with equal wavelength and amplitude pass through each other, usually after a reflection.

starting friction The force of friction overcome when one of two objects begins to slide over the other.

static electricity Stationary electric charges.

static friction The force that prevents one object from sliding over another.

statics The study of the forces acting on an object that is at rest relative to a frame of reference.

superposition The ability of waves to pass through each other, interfere, and then continue on their way unimpeded.

T

temperature The relative measure of warmth or cold relative to a standard; see also **absolute temperature**.

tesla (T) The SI unit of magnetic field strength, equal to 1 W/m^2.

test charge A small, positively charged mass used to detect the presence of a force in an electric field.

thermionic emission The emission of electrons from a hot filament.

thermometer An instrument that makes a quantitative measurement of temperature based on an accepted scale.

third law of thermodynamics The temperature of any system can never be reduced to absolute zero.

threshold frequency The minimum frequency of electromagnetic radiation necessary to induce the photoelectric effect in a metal.

torque The application, from a pivot, of a force at right angles to a designated line that tends to produce circular motion; the product of a force and a perpendicular moment arm distance.

total internal reflection The process by which light is incident on a medium in which its velocity would increase at an angle greater than the critical angle of incidence.

total mechanical energy In a mechanical system, the sum of the kinetic and potential energies.

transmutation The process of changing one atomic nucleus into another by radioactive decay or nuclear bombardment.

transverse wave A wave in which the vibrations of the medium or field are at right angles to the direction of propagation.

U

uniform circular motion Motion around a circle at a constant speed.

uniform motion Motion at a constant speed in a straight line.

unit An arbitrary scale assigned to a physical quantity for measurement and comparison.

universal law of gravitation The gravitational force between any two masses is directly proportional to the product of their masses, and inversely proportional to the square of the distance between them.

V

vector A physical quantity that is characterized by both magnitude and direction; a directed arrow drawn in a Cartesian coordinate system used to represent a quantity such as force, velocity, or displacement.

velocity A vector quantity representing the time rate of change of displacement.

virtual focus The point at which the rays from a diverging lens would meet if they were traced back with straight lines.

virtual image An image, formed by a mirror or lens, that cannot be focused onto a screen.

visible light The portion of the electromagnetic spectrum that can be detected by the human eye.

volt (V) The SI unit of potential difference, equal to 1 J/C.

voltmeter A device used to measure the potential difference between two points in a circuit when connected in parallel; a galvanometer with a high-resistance coil placed in series with it.

volt per meter (V/m) The SI unit of electric field intensity, equal to 1 N/C.

W

watt (W) The SI unit of power, equal to 1 J/s.

wave A series of periodic disturbances in an elastic medium or field.

wavelength The distance between any two successive points in phase on a wave.

weber (Wb) The SI unit of magnetic flux, equal to $1 \text{ T} \times 1 \text{ m}^2$.

weight The force of gravity exerted on a mass at the surface of a planet.

work A scalar measure of the relative amount of change in mechanical energy; the product of the magnitude of the displacement of an object and the component of applied force in the same direction as the displacement; the area under a graph of force versus displacement.

work function The minimum amount of energy needed to free an electron from the surface of a metal using the photoelectric effect.

Index

How to Use the CD-ROM

The software is not installed on your computer; it runs directly from the CD-ROM. Barron's CD-ROM includes an "autorun" feature that automatically launches the application when the CD is inserted into the CD-ROM drive. In the unlikely event that the autorun feature is disabled, follow the manual launching instructions below.

Windows®
1. Click on the Start button and choose "My Computer" or "Computer."
2. Double-click on the CD-ROM drive, which is named **AP_PHYSICS**.
3. Double-click **AP_PHYSICS.exe** to launch the program.

MAC®
1. Double-click the CD-ROM icon.
2. Double-click the **AP_PHYSICS** icon to start the program.

SYSTEM REQUIREMENTS

Windows

2.33 GHz or faster x86-compatible processor, or Intel Atom™
1.6 GHz or faster processor for netbook class devices
Microsoft® Windows® XP, Windows Server 2008, Windows Vista® Home Premium, Business, Ultimate, or Enterprise (including 64 bit editions) with Service Pack 2, Windows 7, or Windows 8 Classic
512MB of RAM (1 GB recommended)

Mac OS

Intel® Core™ Duo 1.83 GHz or faster processor
Mac OS X v10.6, v10.7, v10.8, or v10.9
512MB of RAM (1 GB recommended)